Per move

DISCARDED

MEDIA CENTER
RAYMOND MIDDLE SCHOOL

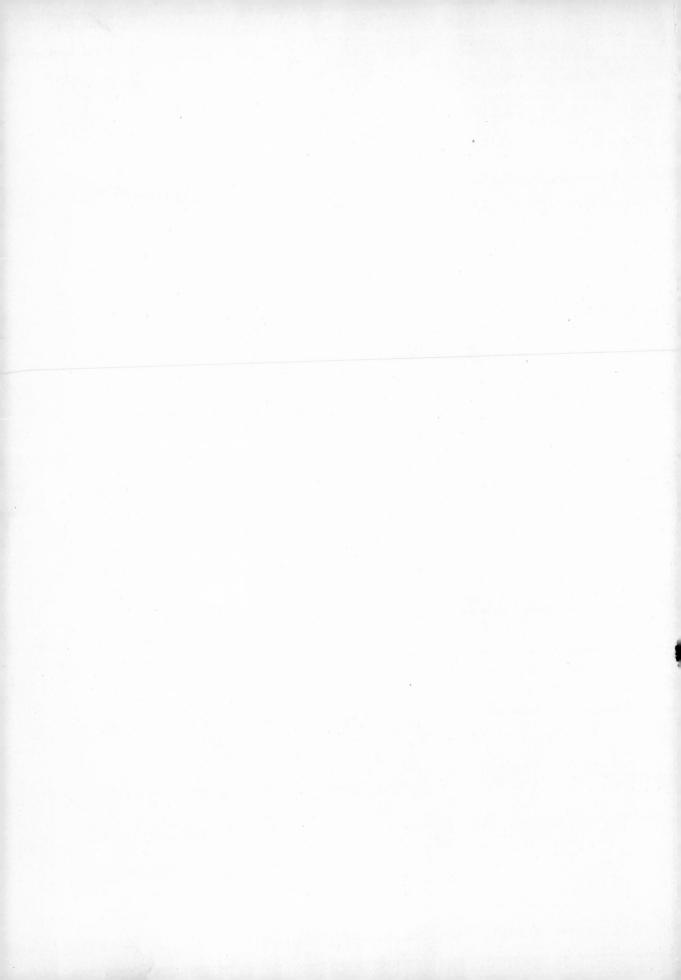

HISTORY of ART for YOUNG PEOPLE

H. W. JANSON ANTHONY F. JANSON

HISTORY of

Third Edition, Revised and Expanded

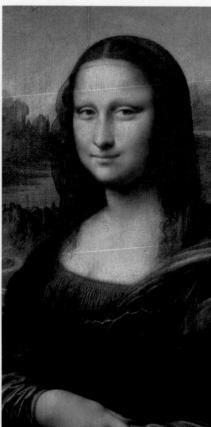

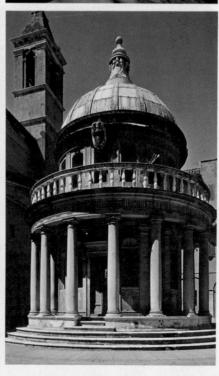

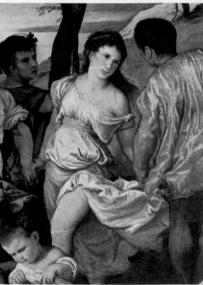

ART for YOUNG PEOPLE

HARRY N. ABRAMS, INC., PUBLISHERS, NEW YORK

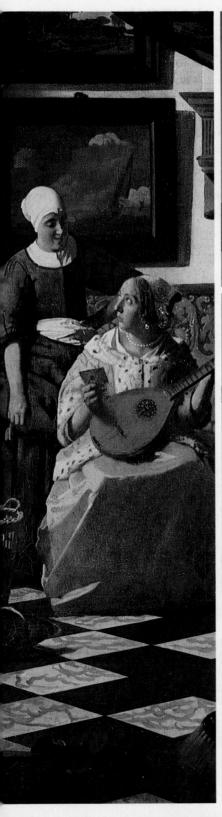

Introduction 6

PART ONE: HOW ART BEGAN 12

The Magic Art of Cavemen and Primitive Peoples

The Old Stone Age The New Stone Age Primitive Art 18

Art for the Dead—Egypt

The Old Kingdom The New Kingdom

Temples, Palaces, and Citadels— The Ancient Near East and the Aegean

Mesopotamia 32 Persia The Aegean 40

Greek Art 46

Painting 46 Temples Sculpture 56

Etruscan Art

Roman Art 70 Architecture Sculpture 73 Painting 79

Map: The Ancient World Synoptic Table I

PART TWO: THE MIDDLE AGES

Early Christian and Byzantine Art 88 Early Christian Art Byzantine Art 96

The Earlier Middle Ages in the West 102 The Dark Ages Carolingian Art 107

Romanesque Art 116 Architecture

Sculpture 123 Painting 126

Ottonian Art 111

Third Edition 1987

Editor: Sheila Franklin Lieber **Designer: Judith Michael** Photo Research: J. Susan Sherman

Base maps by Paul Pugliese Map typography by Julie Duquet

For identification of title page images, see figures 42, 83,161, 207, 214, 221, 278, 340, 376, 448, 483. For images on pages 12-13, 86-87, 166-67, 300-301, see figures 67, 159, 197, 423.

Library of Congress Cataloging-in-Publication Data

Janson, H. W. (Horst Woldemar), [date]. History of art for young people.

Bibliography: p. 456 Includes index. Summary: Surveys the history of art, including paintings, sculpture, architecture, and photography, from cave paintings to modern art. 1. Art—History. [1. Art—History] I. Janson, Anthony F. II. Title. [N5300.J33 1987] 709 86-17207 ISBN 0-8109-1098-5

Copyright © 1971, 1987 Harry N. Abrams, B.V., The Netherlands

Published in 1987 by Harry N. Abrams, Incorporated, New York All rights reserved. No part of the contents of this book may be reproduced without the written permission of the publishers

This book is also published by Abrams/Prentice-Hall under the title A Basic History of Art

The original edition of History of Art for Young People was written by H. W. Janson with Samuel Cauman

Times Mirror Books

Printed and bound in Japan

Towns, Cathedrals, and Gothic Art 131 Architecture 131

Sculpture 1150–1420 140 Painting 1200–1400 147

Map: The Middle Ages 162 Synoptic Table II 164

PART THREE: THE RENAISSANCE 166

The "New Age" 168

Late Gothic Painting
North of the Alps 170

Renaissance vs. "Late Gothic" 170 Swiss and French Painting 183 The Graphic Arts 184

The Early Renaissance in Italy 186

Sculpture 186 Architecture 193 Painting 196

The High Renaissance in Italy 207

Leonardo 207 Michelangelo 211 Bramante 217 Raphael 218 Giorgione 220 Titian 220

Mannerism and Other Trends 224

Painting 224 Sculpture 233 Architecture 235

The Renaissance in the North 237

Germany 237 The Netherlands 247 France 249

The Baroque in Italy, Flanders, and Spain 250

The Golden Age of Dutch Painting 264

The Age of Versailles 274

Painting 275 Architecture 278 Sculpture 281

Rococo 282

Map: The Renaissance 294 Synoptic Table III 296 PART FOUR: THE MODERN WORLD 300

Introduction302Neoclassicism303Architecture303Painting304Sculpture308

The Romantic Movement 309

Architecture 309 Sculpture 312 Painting 314

Realism and Impressionism 328

Painting 328 Sculpture 340

Post-Impressionism 342

Painting 342 Sculpture 354

Art in Our Time 357

Expressionism 357 Abstraction 365 Fantasy 376 Newer Trends 383 Sculpture 402 Architecture 416

Photography 424

Romantic Photography 424
Realist Photography 427
Twentieth-Century Photography 432
The School of Paris 433
The Stieglitz School 435
The New Objectivity 438
The Heroic Age 439
Photomontage and Photogram 441
Photography Today 442

Map: The World 446 Synoptic Table IV 448

Glossary 453
Books for Further Reading 456
Index 460
List of Credits 472

Introduction

Imagination

We all dream. That is imagination at work. To imagine means simply to make an image—a picture—in our minds. Human beings are not the only creatures who have imagination. Even animals dream. Clearly, however, there is a profound difference between human and animal imagination. Men are the only creatures who can tell one another about imagination in stories or pictures.

There are many different ways our imaginations can be triggered. When we are ill in bed and have nothing to do, a ceiling crack on which we have kept our eye may begin to look like an animal or a tree. Our imagination adds the lines that were not there before. So it is with an inkblot (fig. 1), which will remind us of other things, although it was made by accident. Psychologists know this and have made up inkblot tests to find out what is in our minds, for each of us, depending on the sort of person he is, sees a different picture in the same blot.

The imagination is one of the most mysterious facets of mankind. It can be regarded as the connector between the conscious and the subconscious, where most of our brain activity takes place. It is the very glue that holds man's personality, intellect, and spirituality together. Because the imagination responds to all three, it acts in lawful, if unpredictable, ways determined by the psyche and the mind.

The imagination is important for allowing us to conceive of all kinds of possibilities in the future and to understand the past in a way that has real survival value. It is a fundamental part of our make-up. The ability to make art, in contrast, must have been acquired relatively recently in the course of evolution. The record of man's earliest art is lost to us. Man has been walking the earth for some two million years, but the oldest prehis-

toric art that we know of was made only about twenty-five thousand years ago, though it was undoubtedly the culmination of a long development no longer traceable. Even the most "primitive" ethnographic art represents a late stage of development within a stable society.

Who were the first artists? In all likelihood, they were shamans. Like the legendary Orpheus, they were believed to have divine powers of inspiration and could enter the underworld of the subconscious in a deathlike trance; but, unlike ordinary mortals, they were then able to return to the realm of the living. With the shaman's unique ability to penetrate the unknown and his rare talent for expressing it through art, he gained control over the forces hidden in man and nature. Even today the artist remains a magician whose work can mystify and move us—an embarrassing fact to civilized man, who does not readily relinquish his veneer of rational control.

Art and Meaning

What is art? Why does man create it? Few questions provoke such heated debate and provide so few satisfactory answers. Yet, if we cannot come to any definitive conclusions, there is still a good deal we can say. Surely one reason that man creates is because of an irresistible urge to recast himself and his environment in ideal form. Art represents its creator's deepest understanding and highest aspirations; at the same time, the artist often plays an important role as the articulator of shared beliefs. That is why a great work contributes to our vision of life and leaves us profoundly moved. A masterpiece has this effect upon many people. In other words, it can bear the closest scrutiny and withstand the test of time.

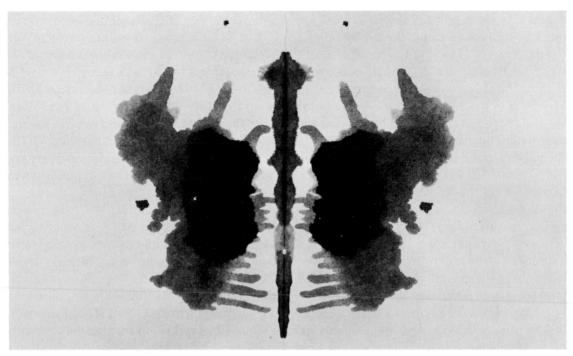

1. Inkblot on folded paper

Art enables us to communicate our understanding in ways that cannot be expressed otherwise. Truly a picture is worth a thousand words, not only in its descriptive value but also in its symbolic significance. In art, as in language, man is above all an inventor of symbols to convey complex thoughts in new ways. We must think of art not in terms of everyday prose but as poetry, which is free to rearrange conventional vocabulary and syntax in order to convey new, often multiple meanings and moods. A painting likewise suggests much more than it states. And like a poem, the value of art lies equally in what it says and how it says it. But what is the meaning of art? What is it trying to say? Artists often provide no clear explanation, since the work is the statement itself. If they could say it in words, they would surely be writers instead.

Art has been called a visual dialogue, for it expresses its creator's imagination just as surely as if he were speaking to us, though the object itself is mute. Even the most private artistic statements can be understood on some level, even if only on an intuitive one. For there to be a dialogue, however, requires our active participation. If we cannot literally talk to a work of art, we can at least learn how to respond to it. The process is similar to learning a foreign language. We must learn the style and outlook of a country, period, and artist if we are to understand the work properly. Taste is conditioned solely by culture, which is so varied that it is impossible to reduce art to any one set of precepts. It would seem, therefore, that absolute qualities in art elude us, that we cannot escape viewing works of art in the context of time and circumstance. How indeed could it be otherwise. so long as art is still being created all around us, opening our eyes almost daily to new experiences and thus forcing us to readjust our sights?

Creativity

What do we mean by making? If, in order to simplify our problem, we concentrate on the

visual arts, we might say that a work of art must be a tangible thing shaped by human hands. Now let us look at the striking Bull's Head by Picasso (fig. 2), which consists of nothing but the seat and handlebars of an old bicycle. How meaningful is our formula here? Of course the materials used by Picasso are man-made, but the seat and handlebars in themselves are not works of art. While we feel a certain jolt when we first recognize the ingredients of this visual pun, we also sense that it was a stroke of genius to put them together in this unique way, and we cannot very well deny that it is a work of art. Yet the handiwork—the mounting of the seat on the handlebars—is ridiculously simple. What is far from simple is the leap of the imagination by which Picasso recognized a bull's head in these unlikely objects; that, we feel, only he could have done. Clearly, then, we must be careful not to confuse the making of a work of art with manual skill or craftsmanship. Even the most painstaking piece of craft does not deserve to be called a work of art unless it

2. Pablo Picasso. Bull's Head. 1943. Bronze cast of handlebars and seat of a bicycle, height $16\frac{1}{8}$ ". Galerie Louise Leiris, Paris

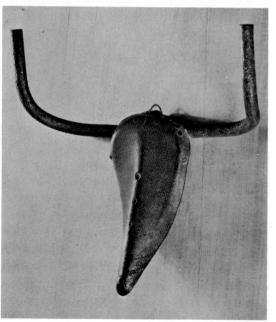

involves a leap of the imagination.

But if this is true, are we not forced to conclude that the real making of a work of art takes place in the artist's mind? No, that is not so, either. Without the execution of the idea, there would be no work of art. Moreover, the artist himself would not feel the satisfaction of having created something on the basis of his leap of the imagination alone and he could never be sure that it would really work unless he put it into effect.

Thus the artist's hands, however modest the task they may have to perform, play an essential part in the creative process. Our Bull's Head is, of course, an ideally simple case, involving only one leap of the imagination and a single manual act in response to it. The leap of the imagination is sometimes experienced as a flash of inspiration, but only rarely does a new idea emerge full-blown like Athena from the head of Zeus. Instead, it is usually preceded by a long gestation period in which all the hard work is done without finding the key to the solution to the problem. At the critical point, the imagination makes connections between seemingly unrelated parts and then recombines them. The creative process consists of a long series of leaps of the artist's imagination and his attempts to give them form by shaping the material accordingly. Thus, he gradually gives birth to his work by defining more and more of the image, until at last all of it has been given visible form.

Our metaphor of birth comes closer to the truth than would a description of the process in terms of a transfer or projection of the image from the artist's mind, for the making of a work of art is both joyous and painful, replete with surprises, and in no sense mechanical. We have, moreover, ample testimony that the artist himself tends to look upon his creation as a living thing. Perhaps that is why creativity was once a concept reserved for God, as only He could give material form to an idea. Indeed, the artist's labors are much like the Creation as told in the Bible and lat-

er as expressed so eloquently by Michelangelo, who described the anguish and glory of the creative experience when he spoke of "liberating the figure from the marble that imprisons it."

Clearly, then, the making of a work of art has little in common with what we ordinarily mean by "making." It is a strange and risky business in which the maker never quite knows what he is making until he has actually made it; or, to put it another way, it is a game of find-and-seek in which the seeker is not sure what he is looking for until he has found it. Whereas the craftsman only attempts what he knows to be possible, the artist is always driven to attempt the impossible—or at least the improbable or unimaginable. No wonder the artist's way of working is so resistant to any set rules, while the craftsman's way encourages standardization and regularity. We acknowledge this difference when we speak of the artist as creating instead of merely making something.

The urge to penetrate unknown realms, to achieve something original, may be felt by every one of us now and then. What sets the real artist apart is not so much the desire to seek, but that mysterious ability to find, which we call talent. We also speak of it as a "gift," implying that it is a sort of present from some higher power; or as "genius," a term which originally meant that a higher power-a kind of "good demon"-inhabits the artist's body and acts through him. All we can really say about talent is that it must not be confused with aptitude. Aptitude is what the craftsman needs; it means a better-thanaverage knack for doing something that any ordinary person can do. An aptitude is fairly constant and specific; it can be measured with some success by means of tests which permit us to predict future performance. Creative talent, on the other hand, seems utterly unpredictable; we can spot it only on the basis of past performance. And even past performance is not enough to assure us that a given artist will continue to produce on the same level.

Originality

Originality, then, is what distinguishes art from craft. Unfortunately, it is also very hard to define; the usual synonyms—uniqueness, novelty, freshness—do not help us very much, and the dictionaries tell us only that an original work must not be a copy. Thus, if we want to rate works of art on an "originality scale" our problem does not lie in deciding whether or not a given work is original but in establishing just exactly *how* original it is.

Every work of art occupies its own specific place in the spectrum of what we call tradition. Without tradition—the word means "that which has been handed down to us"—no originality would be possible; it provides, as it were, the firm platform from which the artist makes his leap of the imagination. The place where he lands will then become part of the web and serve as a point of departure for further leaps. And for us, too, the web of tradition is equally essential. Whether we are aware of it or not, tradition is the framework within which we inevitably form our opinions of works of art and assess their degree of originality.

Likes and Dislikes

Deciding what is art and rating a work of art are two separate problems; if we had an absolute method for distinguishing art from nonart, it would not necessarily enable us to measure quality. People have long been in the habit of compounding the two problems into one; quite often when they ask, "Why is that art?" they mean, "Why is that good art?" Since the experts do not post exact rules, the layman is apt to fall back upon his final line of defense: "Well, I don't know anything about art but I know what I like."

It is a formidable roadblock, this stock phrase, in the path of understanding between expert and layman. Are there really people who know nothing about art? If we except small children and the victims of severe mental illness or deficiency, our answer must be no, for we cannot help knowing something about it. Art is so much a part of the fabric of human living that we encounter it all the time, even if our contacts with it are limited to the lowest common denominator of popular taste. Still, it is art of a sort; and since it is the only art most people ever experience, it molds their ideas on art in general. When they say, "I know what I like," they really mean, "I like what I know (and I reject whatever fails to match the things I am familiar with)"; such likes are not in truth theirs at all, but have been imposed on them by habit and circumstance, without any personal choice. To like what we know and to distrust what we do not know is an age-old human trait. But why should so many of us cherish the illusion of having made a personal choice in art when in actual fact we have not? There is another unspoken assumption here, which goes something like this: "Since art is such an 'unruly' subject that even the experts keep disagreeing with each other, my opinion is as good as theirs—it's all a matter of subjective preference. In fact, there must be something wrong with a work of art if it takes an expert to appreciate it." That, too, is a false assumption. To see why, we must consider why the artist creates—and for whom.

Self-Expression and Audience

All art involves self-expression. Most of us are familiar with the famous Greek myth of the sculptor Pygmalion who carved such a beautiful statue of the nymph Galatea that he fell in love with it and embraced her when Venus made his sculpture come to life. Recently the myth has been given a fresh interpretation by John de Andrea (fig. 3) that tells us a good deal about creativity by reversing the roles. Now it is the artist, lost in thought, who is oblivious to the statue's gaze. She is

clearly based on a real model rather than an ideal conception, and is still in the process of "coming to life" as the artist has not finished painting her white legs. The illusion is so convincing that we wonder which figure is real and which one is dreaming of the other, the artist or the sculpture? De Andrea makes us realize that to the artist, the creative act is a labor of love that brings art to life.

But can we not also say that it is the work of art which gives birth to the artist? The birth of a work of art is an intensely private experience, yet it must, as a final step, be shared by the public, in order for the birth to be successful. The artist does not create merely for his own satisfaction, but wants his work approved by others. In fact, the hope for approval may be what makes him want to create in the first place, and the creative process is not completed until the work has found an audience. In the end, works of art exist in order to be liked rather than to be debated.

Perhaps we can resolve the paradox once we understand what the artist means by "public." He is concerned not with the public as a statistical entity but with his particular public, his audience; quality matters more to him than quantity. The audience whose approval looms so large in the artist's mind is a limited and special one, not the general public: the merits of the artist's work can never be determined by a popularity contest. The one qualification that members of that audience all have in common is an informed love of works of art—an attitude at once discriminating and enthusiastic that lends particular weight to their judgments. They are, in a word, experts, people whose authority rests on experience rather than theoretical knowledge.

The active minority which we have termed the artist's primary audience draws its recruits from a much larger and more passive secondary audience, whose contact with works of art is less direct and continuous. This group, in turn, shades over into the vast

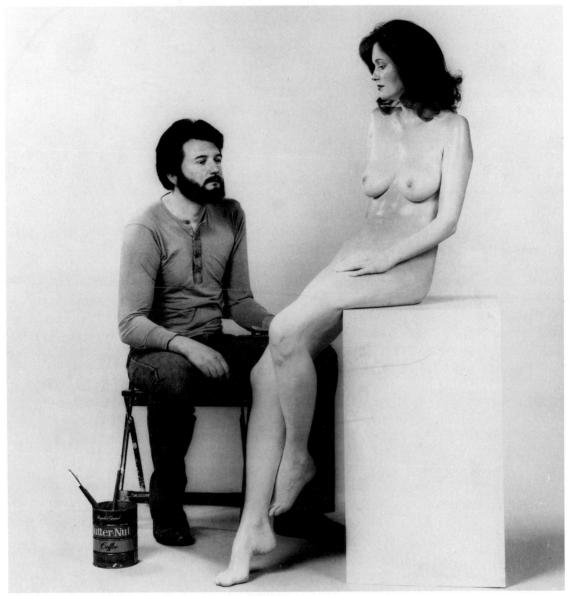

3. John de Andrea. *The Artist and His Model*. 1980. Polyvinyl, polychromed in oil; lifesize. Collection Foster Goldstrom, Dallas and San Francisco

numbers of those who believe they "don't know anything about art," the layman pureand-simple. What distinguishes the layman, as we have seen before, is not that he actually *is* pure and simple but that he likes to think of himself as being so. In reality, there is no sharp break, no difference in kind, between him and the expert, only a difference in degree. The road to expertness invites anyone with an open mind and a capacity to absorb

new experiences. As we travel on it, as our understanding grows, we shall find ourselves liking a great many more things than we had thought possible at the start, yet at the same time we shall gradually acquire the courage of our own convictions, until—if we travel far enough—we know how to make a meaningful individual choice among works of art. Then we shall be able to say, with some justice, that we know what we like.

PART ONE
How Art
Began

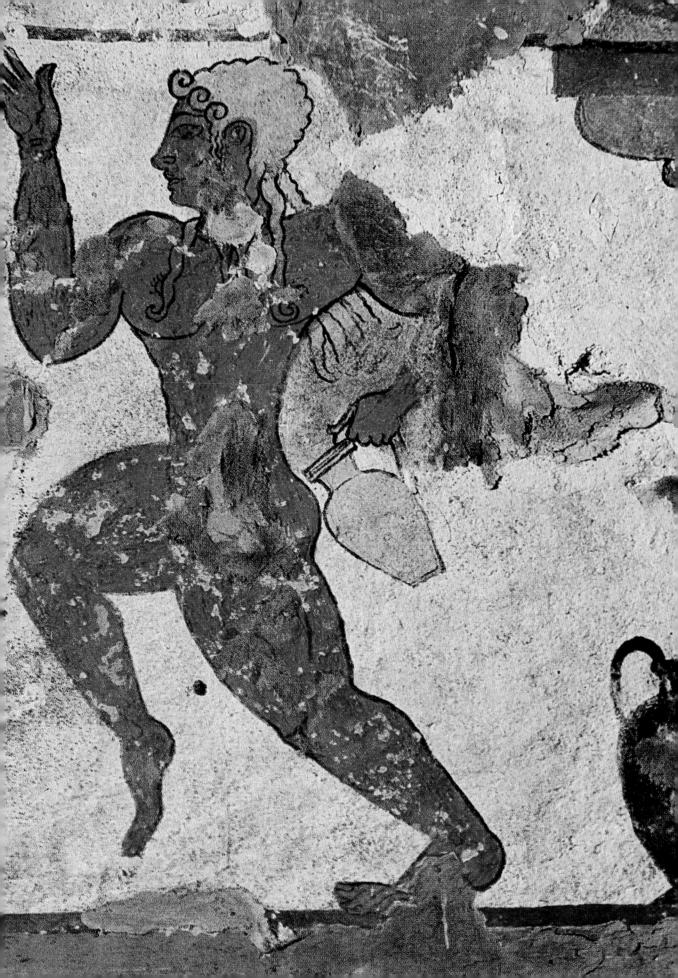

The Magic Art of Cavemen and Primitive Peoples

THE OLD STONE AGE

When did man start creating works of art? What did they look like? What prompted him to do so? Every history of art must begin with these questions—and with the admission that we cannot answer them. Our earliest ancestors began to walk on the earth with two feet about two million years ago, but not until some six hundred thousand years later do we meet the earliest traces of man the toolmaker. He must have been using tools all along, for apes will pick up a stick to knock down a banana, or a stone to throw at an enemy. The *making* of tools is a more complex matter. It demands first of all the ability to think of sticks or stones as "fruit knockers" or "bone crackers" even at times when they are not needed for such purposes. Once man was able to do that, he discovered that some sticks and stones had a handier shape than others and put them aside for future use—he "appointed" them as tools because he had begun to link form and function. Some of these stones have survived; they are large pebbles or chunks of rock showing the marks of repeated use for the same operation, whatever that may have been. The next step was for man to try chipping away at these tools-byappointment so as to improve their shape. This is the earliest craft of which we have evidence, and with it we enter a phase of human development known as the Old Stone Age.

Cave Art

It is during the late stages of the Old Stone Age, which began about thirty-five thousand years ago, that we encounter the earliest works of art known to us. These, however, already show an assurance and refinement far removed from any humble beginnings; they must have been preceded by thousands of years of slow growth about which we know nothing at all. At that time, the last Ice Age was drawing to a close in Europe, and the climate between the Alps and Scandinavia resembled that of present-day Alaska. Reindeer and other large herbivores roamed the plains and valleys, preyed upon by the ancestors of today's lions and tigers-and by our own ancestors. These men lived in caves or in the shelter of overhanging rocks. Many such sites have been discovered, and scholars have divided up the "cavemen" into several groups, each named after a characteristic site. Among these it is the so-called Aurignacians and Magdalenians who stand out as especially gifted artists.

The most striking works of Old Stone Age art are the images of animals painted on the rock surfaces of caves, such as those in the cave of Lascaux, in the Dordogne region of France (fig. 4). Bison, deer, horses, and cattle race across walls and ceiling in wild profusion, some simply outlined in black, others filled in with bright earth colors, but all showing the same uncanny sense of life. Even more impressive is the Wounded Bison on the ceiling of the cave at Altamira in northern Spain (fig. 5): the dying animal has collapsed, yet even in this helpless state it has lowered its head in self-defense. We are amazed not only by the keen observation, the assured, vigorous outlines, the subtly controlled shading that lends bulk and roundness to the forms, but even more perhaps by the power and dignity of this creature in its final agony.

How did this art develop? What purpose did it serve? And how did it happen to sur-

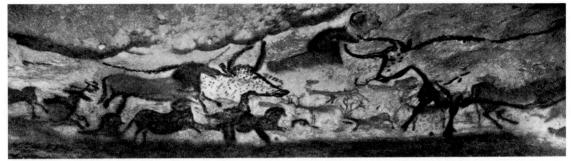

4. Frieze of Animals (wall painting). c. 15,000-10,000 B.C. Cave of Lascaux (Dordogne), France

vive intact over so many thousands of years? The last question can be answered readily enough: the pictures rarely occur near the mouth of a cave, where they would be open to easy view (and destruction), but only in the darkest recesses, as far from the entrance as possible. Hidden away as they are in the bowels of the earth, these images must have served a purpose far more serious than mere

decoration. There can be little doubt, in fact, that they were part of a magic ritual to ensure a successful hunt. We gather this not only from their secret location and from the lines representing spears or darts that are often found pointing at the animals, but also from the disorderly way the images are placed on top of each other (as in fig. 4). Apparently, for the men of the Old Stone Age

5. Wounded Bison (cave painting). c. 15,000-10,000 B.C. Altamira, Spain

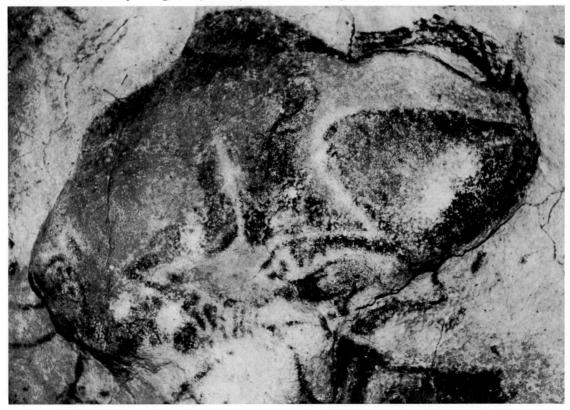

there was no clear distinction between image and reality; by making a picture of an animal they meant to bring the animal itself within their grasp, and in "killing" the image they thought they had killed the animal's vital spirit. Hence every image could serve only once—when the killing ritual had been performed, it was "dead" and could be disregarded. The magic worked, too, we may be sure. Hunters whose courage was thus fortified were bound to be more successful when slaying these formidable beasts with their primitive weapons. Nor has the emotional basis for this kind of magic been lost even today; people have been known to tear up the photograph of someone they have come to hate.

Still, there remains a good deal that puzzles us about the cave paintings. Why are they in such inaccessible places? And why are they so marvelously lifelike? Could not the "killing" magic have been practiced just as effectively on less realistic images? Perhaps the Magdalenian cave pictures are the final phase of a development that began as simple killing magic but shifted its meaning when the animals became scarce (apparently the big herds withdrew northward as the climate of Central Europe grew warmer). If so, the main purpose of the Lascaux and Altamira paintings may have been not to "kill" but to "make" animals—to increase their supply. Could it be that the Magdalenians had to practice their fertility magic in the bowels of the earth because they thought of the earth itself as a living thing from whose womb all other life springs? This would help to explain the admirable realism of these images, for an artist who believes he is actually "creating" an animal is more likely to strive for this quality than one who merely sets up an image for the kill. Some of the cave pictures even provide a clue to the origin of this fertility magic: the shape of the animal often seems to have been suggested by the natural formation of the rock, so that its body coincides with a bump or its contour follows a vein or crack. A Stone Age hunter, his mind filled with thoughts of the big game on which he depended for survival, would have been quite likely to recognize such animals among the rock surfaces of his cave and to attribute deep significance to his discovery. It is tempting to think that those who were particularly good at finding such images gained a special status as artist-magicians and were permitted to perfect their image-hunting instead of having to face the dangers of the real hunt, until finally they learned to make images with little or no aid from chance formations.

Objects

Apart from large-scale cave art, Old Stone Age men also produced small hand-size carvings in bone, horn, or stone, cut by means of flint tools. They, too, seem to have originated with chance resemblances. At an earlier stage, Stone Age men had been content to collect pebbles in whose natural shape they saw

6. Venus of Willendorf. c. 15,000-10,000 B.C. Stone, height 4%". Museum of Natural History, Vienna

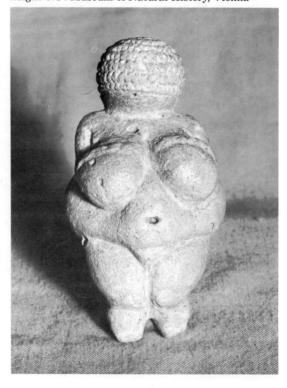

a "magic" representational quality; the more fully worked pieces of later times still reflect this attitude. Thus the so-called *Venus of Willendorf* in Austria (fig. 6), one of several such fertility figurines, has a bulbous roundness of form that may suggest an egg-shaped "sacred pebble."

THE NEW STONE AGE

The art of the Old Stone Age in Europe marks the highest achievement of a way of life that could not survive beyond the special conditions created by the receding ice of the Ice Age which was ending. Between c. 10,000 and 5,000 B.C. the Old Stone Age came to an end when men made their first successful attempts to domesticate animals and food grains—one of the truly revolutionary steps in human history, even though the revolution extended over several thousand years. Old Stone Age man had led the unsettled life of a hunter and food gatherer, reaping where nature sowed and thus at the mercy of forces he could neither understand nor control. Once men had learned how to assure their food supply by their own efforts, they settled down in permanent village communities; a new discipline and order entered their lives. There is, then, a basic difference between the

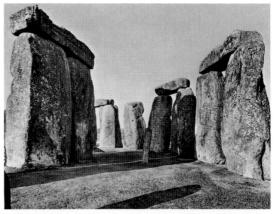

7. Stonehenge. c. 1800–1400 B.C. Diameter of circle 97', height of stones above ground 13½'. Salisbury Plain, Wiltshire, England

New Stone Age and the Old, even though men still depended on stone as the material of their main tools and weapons. The new mode of life brought forth a number of new crafts and inventions long before the earliest appearance of metals: pottery, weaving and spinning, basic methods of architectural construction. We know all this from New Stone Age settlements that have been uncovered by excavation. But these remains tell us very little, as a rule, of the spiritual condition of New Stone Age men; they include stone implements of ever greater technical refine-

8. The Great Circle. Stonehenge, England

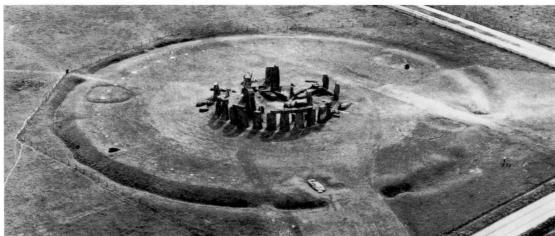

ment and a vast variety of clay vessels covered with abstract ornamental patterns, but hardly anything comparable to the art of the Old Stone Age. Yet the change-over from hunting to husbandry must have brought about profound changes in man's view of himself and the world, and it seems hard to believe that these did not find expression in art. There may be a vast chapter in the development of art here that is lost simply because New Stone Age artists worked in wood and other impermanent materials.

One exception to this general rule is the great stone circle at Stonehenge in southern England (figs. 7, 8), the best preserved of several such megalithic, or "large stone," monuments. Its purpose was religious; apparently the sustained effort required to build it could be compelled only by faith—a faith that almost literally demanded the moving of mountains. The entire structure is oriented toward the exact point where the sun rises on the longest day of the year, and therefore it must have served a sun-worshiping ritual. Even today, Stonehenge has an awe-inspiring, superhuman quality, as if it were the work of a forgotten race of giants. Whether a monument such as this should be termed architecture is a matter of definition; we tend to think of architecture in terms of enclosed interiors, yet we also have landscape architects, the designers of parks and gardens; nor would we want to deny the status of architecture to open-air theaters or stadiums. Perhaps we ought to consult the ancient Greeks, who coined the word. To them, "archi-tecture" meant something higher than ordinary "tecture" (that is, "construction," or "building"), a structure set apart from the merely practical, everyday kind by its scale, order, permanence, or solemnity of purpose. A Greek would certainly have called Stonehenge architecture. And we, too, shall have no difficulty in doing so once we understand that it is not necessary to enclose space in order to define or articulate it. If architecture is "the art of shaping space to human needs and

aspirations," then Stonehenge more than meets the test.

PRIMITIVE ART

There are only a few human groups for whom the Old Stone Age has lasted until the present day. Modern survivors of the New Stone Age are far easier to find. They include all of the so-called primitive societies of tropical Africa, the Americas, and the South Pacific. "Primitive" is an unfortunate word: it suggests-quite wrongly-that these societies represent the original condition of mankind and has thus come to be burdened with all sorts of emotional overtones. Still, no other single term will do better. Primitive art, despite its limitless variety, shares one dominant trait: the imaginative reshaping, rather than the careful observation, of the forms of nature. Its concern is not the visible world but the invisible, disquieting world of spirits. To the primitive mind, everything is alive with powerful spirits—men, animals, plants, the earth, rivers and lakes, the rain, the wind, sun and moon. All these spirits had to be appeased, and it was the task of art to provide suitable dwelling places for them and thus to "trap" them. Such a trap is the splendid ancestor figure from New Guinea (fig. 9). It belongs to a large class of similar objects, ancestor worship being perhaps the most persistent feature of primitive society. The entire design is centered on the head, with its intensely staring shell-eyes, while the body—as in primitive art generally—has been reduced to a mere support. The bird emerging from behind the head represents the ancestor's spirit or life force. Its soaring movement, contrasted with the rigidity of the human figure, forms a compelling image and a strangely familiar one, for our own tradition, too, includes the "soul bird," from the dove of the Holy Spirit to the albatross of the Ancient Mariner, so that we find ourselves responding to a work of art that at first glance might seem both puzzling and alien.

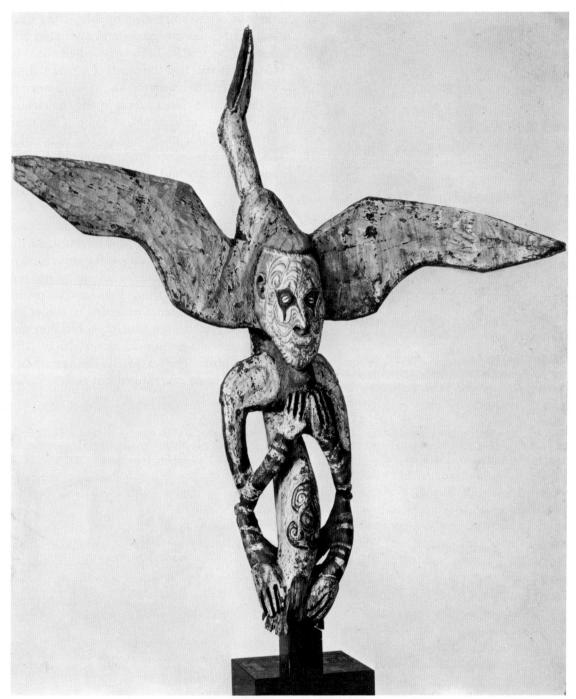

9. Male Figure Surmounted by a Bird, from the Sepik River, New Guinea. 19th–20th century. Wood, height 48''. Washington University Art Collection, St. Louis

Masks and Costumes

In dealing with the spirit world, primitive man was not content with rituals or offerings before his spirit traps. He needed to act out his relations with the spirit world through dances and similar dramatic ceremonials in which he himself could temporarily assume

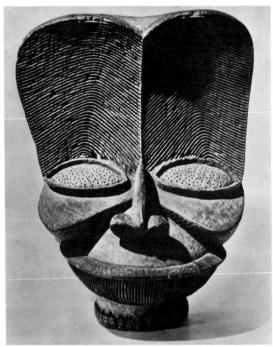

10. Mask, from the Bamenda area, Cameroons. 19th–20th century. Wood, height 26½". Rietberg Museum, Zurich (E. v.d. Heydt Collection)

11. Mask, from the Gazelle Peninsula, New Britain. 19th–20th century. Bark cloth, height 18". Museo Nacional de Antropología, Mexico

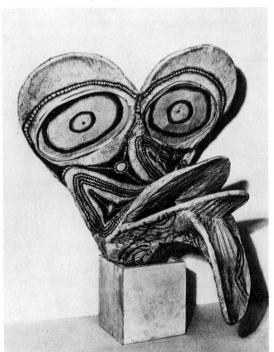

the role of the spirit trap by disguising himself with elaborate masks and costumes. Nor has the fascination of the mask died out even today; we still feel the thrill of a real change of identity when we wear one at Halloween or carnival time. Masks form by far the richest chapter in primitive art, and one of the most puzzling. Their meaning is often impossible to ascertain, since the ceremonies they served usually had elements of secrecy that were jealously guarded from the uninitiated. This emphasis on the mysterious and spectacular not only heightened the emotional impact of the ritual, it also encouraged the makers of masks to strive for imaginative new effects, so that masks in general are less bound by tradition than other kinds of primitive art. The example in figure 10 shows the symmetry of design and the precision and sharpness of carving characteristic of African sculpture. The features of the human face have not been rearranged but restructured,

12. Mask (Eskimo), from southwest Alaska. Early 20th century. Wood, height 22". Museum of the American Indian, Heye Foundation, New York

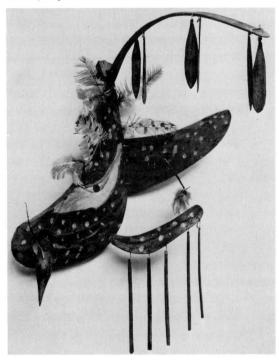

as it were, with the tremendous eyebrows arching above the rest like a protective canopy. The solidity of these shapes becomes strikingly evident as we turn to the fluid, ghostly features of a mask from the island of New Britain in the South Pacific (fig. 11). It is meant to represent an animal spirit, said to be a crocodile. Even stranger is the Eskimo mask from southwest Alaska (fig. 12). The single eye and the mouth full of teeth are the only recognizable details to the outsider, yet to those who know how to "read" this assembly of shapes it is the condensed representation of a tribal myth about a swan that drives white whales to the hunters.

Painting

Compared to sculpture, painting plays a subordinate role in primitive society. Although widely used to color wood carvings or the human body, sometimes with intricate ornamental patterns, it could establish itself as an independent art only under exceptional conditions. Thus the Indian tribes inhabiting the arid Southwest of the United States developed the unique art of sand painting (fig. 13). The technique, which demands considerable skill, consists of pouring powdered rock or earth of various colors on a flat bed of sand. Despite (or perhaps because of) the fact that these pictures are impermanent and must be made fresh for each occasion, the designs are rigidly traditional; they are also rather abstract, like any fixed pattern that is endlessly repeated. The compositions may be likened to recipes, prescribed by the medicine man and "filled" under his supervision by the painter, for the main use of sand paintings is in ceremonies of healing. That these are sessions of great emotional intensity on the part of both doctor and patient is well attested by our illustration. Such a close union-or even, at times, identity—of priest, healer, and artist may be difficult to understand today. But to primitive man, trying to bend nature to his needs by magic and ritual, the three functions must have appeared as different aspects of a single process. And the success or failure of that process was to him quite literally a matter of life and death.

13. Sand painting ritual for a sick child (Navaho). Arizona

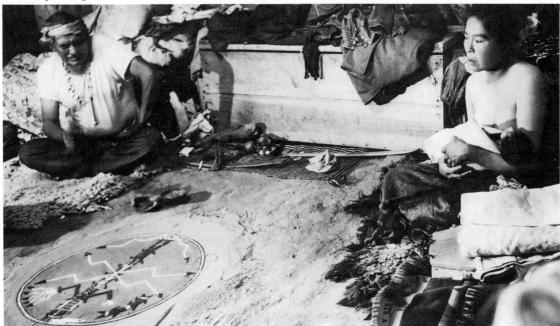

Art for the Dead—Egypt

History, we are often told, begins with the invention of writing, some five thousand years ago. This makes a convenient landmark, for the absence of written records is surely one of the key differences between prehistoric and historic societies. Obviously, prehistory was far from uneventful: the road from hunting to husbandry is a long and arduous one. The beginning of history, then, means a sudden increase in the speed of events, a shifting from low into high gear. And we shall see that it also means a change in the *kinds* of events.

Prehistory might be defined as that phase of human evolution during which man as a species learned how to survive in a hostile environment; his achievements were responses to threats of physical extinction. With the domestication of animals and food plants, he had won a decisive battle in this war. But the hunting-to-husbandry revolution placed him on a level at which he might well have remained indefinitely, and in many parts of the globe man was content to stay there. In a few places, however, the balance of primitive society was upset by a new threat, posed not by nature but by man himself: competition for grazing land among tribes of herdsmen or for arable soil among farming communities. Such a situation might be resolved in one of two ways: constant tribal warfare could reduce the population, or the people could unite in larger and more disciplined social units for the sake of group efforts (such as building fortifications, dams, or irrigation canals) that no loosely organized tribal society would have been able to achieve. Conflicts of this kind arose in the Nile valley and that of the Tigris and Euphrates some six thousand years ago and generated enough pressure to produce a new kind of society, very much more complex and efficient than had ever ex-

isted before. These societies quite literally made history; they not only brought forth "great men and great deeds" but also made them memorable. (To be memorable, an event has to be more than "worth remembering"; it must happen quickly enough to be grasped by man's memory. Prehistoric events were too slow-paced for that.) From then on, men were to live in a new, dynamic world where their capacity to survive was threatened not by the forces of nature but by conflicts arising either within society or through competition between societies. These efforts to cope with his human environment have proved a far greater challenge to man than his struggle with nature.

The invention of writing was an early and indispensable achievement of the historic civilizations of Egypt and Mesopotamia. We do not know the beginnings of its development, but it must have taken several centuries after the new societies were already past their first stage. History was well under way by the time writing could be used to record historic events. Egyptian civilization has long been regarded as the most rigidly conservative ever known. There is some truth in this belief, for the basic pattern of Egyptian institutions, beliefs, and artistic ideas was formed between 3000 and 2500 B.C. and kept reasserting itself for the next two thousand years, so that all Egyptian art, at first glance, tends to have a certain sameness. Actually, Egyptian art alternates between conservatism and innovation, but is never static. Some of its great achievements had a decisive influence on Greece and Rome. We can thus feel ourselves linked to the Egypt of five thousand years ago by a continuous, living tradition.

The history of Egypt is divided into dynas-

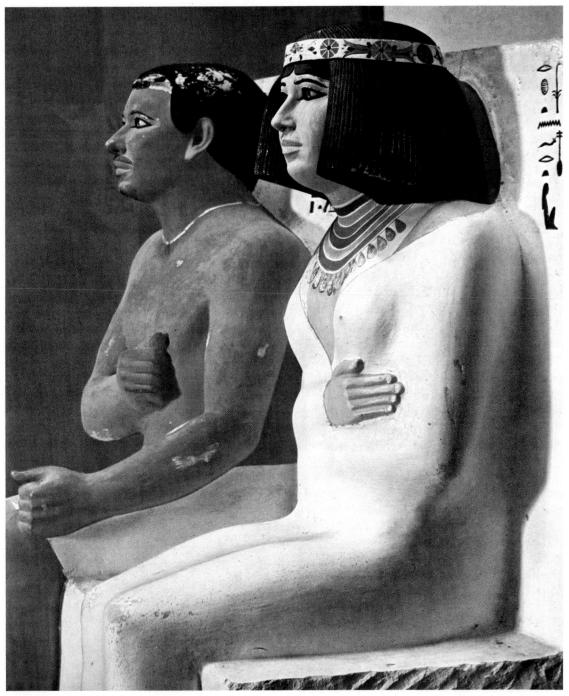

14. Prince Rahotep and His Wife Nofret. c. 2580 B.C. Painted limestone, height 471/4". Egyptian Museum, Cairo

ties of rulers, in accordance with ancient Egyptian practice, beginning with the First Dynasty, shortly before 3000 B.C. This method of counting historic time conveys at once the strong Egyptian sense of continuity and

the overwhelming importance of the pharaoh (king), who was not only the supreme ruler but a god. All kings claim to rule in the name or by the grace of some superhuman authority (that is what makes them superior to tri-

bal chiefs); the pharaoh transcended them all—his kingship was not delegated to him from above but was absolute, divine. We do not know exactly how the early pharaohs established their claim to divinity, but we know that they molded the Nile valley into a single, effective state and increased its fertility by regulating the annual floods of the river waters through dams and canals.

Of these public works nothing remains today. Our knowledge of Egyptian civilization rests almost entirely on the tombs and their contents, since little has survived of ancient Egyptian palaces and cities. This is no accident, for these tombs were built to endure forever. Yet the Egyptians did not view life on this earth mainly as a road to the grave; their cult of the dead is a link with the New Stone Age, but the meaning they gave it was quite devoid of that dark fear of the spirits of the dead which dominates primitive ancestor cults. Their attitude was, rather, that man can provide for his own happy afterlife by equipping his tomb as a kind of shadowy replica of his daily environment for his spirit, the ka, to enjoy, and by making sure that the ka would have a body to dwell in (his own mummified corpse, or, as a substitute, a statue of himself).

THE OLD KINGDOM

Sculpture

At the threshold of Egyptian history stands a work of art that is also a historic document: a carved slate palette (fig. 15) celebrating the victory of Narmer, king of Upper Egypt, over Lower Egypt, the oldest known image of a historic personage identified by name. It already shows most of the features characteristic of Egyptian art. But before we concern ourselves with these, let us first "read" the scene. That we are able to do so is another indication that we have left primitive art behind, for the meaning of the relief is made clear not only by means of the hieroglyphic

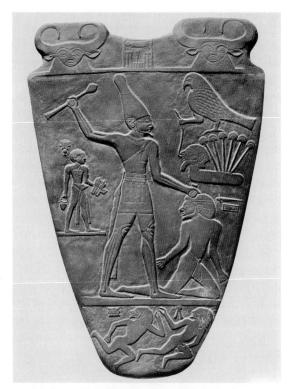

15. Palette of King Narmer, from Hierakonpolis.c. 3000 B.C. Slate, height 25". Egyptian Museum, Cairo

labels, but also through the rational orderliness of the design. Narmer has seized an enemy by the hair and is about to slay him with his mace; two more fallen enemies are placed in the bottom compartment (the small rectangular shape next to the one on the left stands for a fortified town). In the upper right we see a complex bit of picture writing: a falcon above a clump of papyrus plants holds a tether attached to a human head that "grows" from the same soil as the plants. This image actually repeats the main scene on a symbolic level—the head and the papyrus plants stand for Lower Egypt, while the victorious falcon is Horus, the god of Upper Egypt. Clearly, Horus and Narmer are the same: a god triumphs over human foes. Hence, Narmer's gesture must not be taken as representing a real fight. The enemy is helpless from the very start, and the slaving is a ritual, rather than a physical effort. We gather this from the fact that Narmer has

taken off his sandals (the court official behind him carries them in his left hand), an indication that he is standing on holy ground. The same notion recurs in the Old Testament when the Lord commands Moses to remove his shoes before He appears to him in the burning bush.

The new inner logic of the Narmer palette is readily apparent, even though the modern notion of showing a scene as it would appear to a single observer at a single moment is as alien to the Egyptian artist as it had been to his Stone Age predecessors. He strives for clarity, not illusion, and therefore picks the most telling view in each case. But he imposes a strict rule on himself: when he changes his angle of vision, he must do so by ninety degrees, as if he were sighting along the edges of a cube. He thus acknowledges only three possible views: full face, strict profile, and vertically from above. Any intermediate position embarrasses him (note the oddly rubber-like figures of the fallen enemies). Moreover, he is faced with the fact that the standing human figure, unlike that of an animal, does not have a single main profile but two competing profiles, so that, for the sake of clarity, he must combine these views. How he does this is clearly shown in the figure of Narmer: eye and shoulders in frontal view, head and legs in profile. The method worked so well that it was to survive for twenty-five hundred years, in spite—or perhaps because—of the fact that it does not lend itself to representing movement or action. The frozen quality of the image would seem to be especially suited to the divine nature of the pharaoh; ordinary mortals act, he simply is.

The "cubic" approach to the human form can be observed most strikingly in Egyptian sculpture in the round, such as the splendid group of the pharaoh Mycerinus and his queen (fig. 16). The artist must have started out by drawing the front and side views on the faces of a rectangular block and then worked inward until these views met. Only

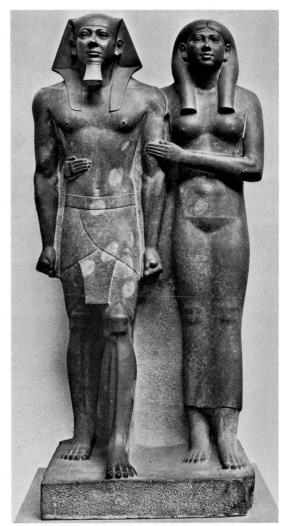

16. Mycerinus and His Queen, from Giza. c. 2500 B.C. Slate, height 56". Museum of Fine Arts, Boston

in this way could he have achieved figures of such overpowering three-dimensional firmness and immobility. What magnificent vessels for the ka to inhabit! Both have the left foot placed forward, yet there is no hint of a forward movement. The group also affords an interesting comparison of male and female beauty as interpreted by a fine sculptor, who knew not only how to contrast the structure of the two bodies but also how to emphasize the soft, swelling form of the queen through a thin, close-fitting gown.

The sculptor who carved the statues of Prince Rahotep and his wife Nofret (fig. 14)

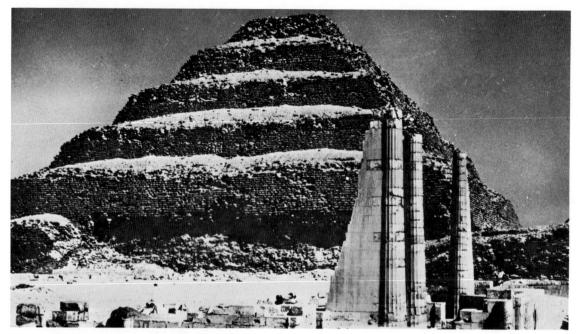

17. Step Pyramid, Funerary District of King Zoser, Saqqara. c. 2650 B.C.

was less subtle in this respect. They owe their strikingly lifelike appearance to the vivid coloring, which they must have shared with other such statues but which has survived completely intact only in a few instances. The darker body color of the prince has no individual significance; it is the standard masculine complexion in Egyptian art. The eyes have been inlaid with shining quartz to make them look as alive as possible, and the portrait character of the faces is very pronounced.

Architecture

When we speak of the Egyptians' attitude toward death and afterlife, we must be careful to make it clear that we do not refer to the average man but only to the small aristocratic caste clustered around the royal court. There is still a great deal to be learned about the origin and significance of Egyptian tombs, but the concept of afterlife they reflect apparently applied only to the privileged few because of their association with the immortal pharaohs. The standard form of these tombs was the mastaba, a squarish mound faced with brick or stone, above a burial chamber that was deep underground and linked with the mastaba by a shaft. Inside the mastaba there is a chapel for offerings to the ka and a secret cubicle for the statue of the deceased. Royal mastabas grew to conspicuous size and soon developed into pyramids. The earliest is probably that of King Zoser (fig. 17) at Saqqara, a step pyramid suggestive of a stack of mastabas as against the smooth-sided later examples at Giza.

Pyramids were not isolated structures but were linked with vast funerary districts, with temples and other buildings which were the scene of great religious celebrations during the pharaoh's lifetime as well as after. The most elaborate of these is the funerary district around the pyramid of Zoser: its creator, Imhotep, is the first artist whose name has been recorded in history, and deservedly so, since his achievement—or what remains of it—is most impressive even today. Egyptian architecture had begun with structures made of mud bricks, wood, reeds, and other light materials. Imhotep used cut stone, but

his repertory of architectural forms still reflects shapes and devices developed during that earlier phase. Thus we find columns always "engaged" rather than freestanding—which echo the bundles of reeds or the wooden supports that used to be set into mudbrick walls to give them added strength. But the very fact that these members no longer had their original function made it possible for Imhotep and his fellow architects to redesign them so as to make them serve a new, expressive purpose (fig. 18).

The development of the pyramid reaches its climax during the Fourth Dynasty in the famous triad of great pyramids at Giza (fig. 19), all of them of the familiar, smooth-sided shape. They originally had an outer casing of carefully dressed stone, which has disappeared except near the top of the pyramid of Chefren. Clustered about the three great pyramids are several smaller ones and a large number of mastabas for members of the royal family and high officials, but the unified funerary district of Zoser has given way to a simpler arrangement; adjoining each of the great pyramids to the east is a funerary temple, from which a processional causeway leads to a second temple at a lower level, in the Nile valley, at a distance of about a third of a mile. Next to the valley temple of the sec-

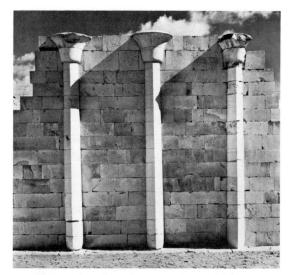

18. Papyrus half-columns, North Palace, Funerary District of King Zoser, Saggara. c. 2650 B.C.

ond pyramid, that of Chefren, stands the Great Sphinx carved from the live rock (fig. 20), perhaps an even more impressive embodiment of divine kingship than the pyramids themselves. The royal head rising from the body of a lion towers to a height of sixtyfive feet, and bore, in all probability, the features of Chefren (damage inflicted upon it during Islamic times has obscured the details of the face). Its awesome majesty is such that a thousand years later it could be regarded as an image of the sun-god.

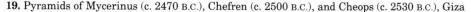

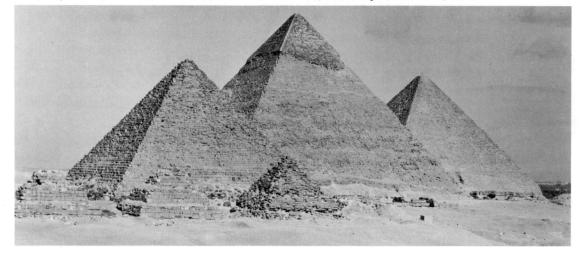

Enterprises of this huge scale mark the high point of pharaonic power. After the end of the Fourth Dynasty (less than two centuries after Zoser) they were never attempted again, although pyramids on a much more modest scale continued to be built. The world has always marveled at the sheer size of the great pyramids as well as at the technical accomplishment they represent; but they have also come to be regarded as symbols of slave labor-thousands of men forced by cruel masters to serve the aggrandizement of absolute rulers. Such a picture may well be unjust: certain records have been preserved indicating that the labor was paid for, so that we might be nearer the truth in considering these monuments as vast "public work projects" providing a form of economic security for a good part of the population.

THE NEW KINGDOM

After the collapse of centralized pharaonic power at the end of the Sixth Dynasty, Egypt entered a period of political disturbances and ill fortune that was to last almost seven hundred years. During most of this time, effective authority lay in the hands of local or

20. The Great Sphinx. Old Kingdom. c. 2500 B.C. Height 65'. Giza

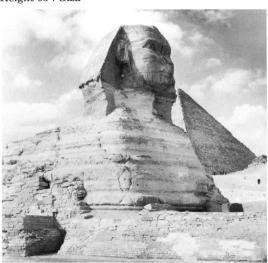

regional overlords, who revived the old rivalry of North and South. Many dynasties followed one another in rapid succession, but only two, the Eleventh and Twelfth, are worthy of note. The latter constitute the Middle Kingdom (2134-1785 B.C.), when a series of able rulers managed to reassert themselves against the provincial nobility. However, the spell of divine kingship, having once been broken, never regained its old effectiveness, and the authority of the Middle Kingdom pharaohs tended to be personal rather than institutional. Soon after the close of the Twelfth Dynasty, the weakened country was invaded by the Hyksos, a western Asiatic people of somewhat mysterious origin, who seized the Delta area and ruled it for 150 years until their expulsion by the princes of Thebes about 1570 B.C.

The five hundred years following the expulsion of the Hyksos, and comprising the Eighteenth, Nineteenth, and Twentieth Dynasties, represent the third Golden Age of Egypt. The country, once more united under strong and efficient kings, extended its frontiers far to the east, into Palestine and Syria (hence this period is also known as the Empire). The climactic period of power and prosperity came between c. 1500 and the end of the reign of Ramesses III in 1162 B.C. New Kingdom art covers a vast range of styles and quality, from rigid conservatism to brilliant inventiveness, from oppressively massive ostentation to the most delicate refinement. Like the art of Imperial Rome fifteen hundred years later, it is almost impossible to summarize in terms of a representative sampling. Different strands are interwoven into a fabric so complex that any choice of monuments is bound to seem arbitrary. All we can hope to accomplish is to convey some of the flavor of its variety.

Architecture

The divine kingship of the pharaoh was asserted in a new way during the New King-

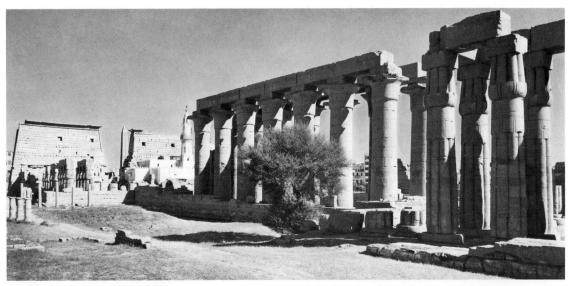

21. Court and pylon of Ramesses II (c. 1260 B.C.) and colonnade and court of Amenhotep III (c. 1390 B.C.), Temple of Amun-Mut-Khonsu, Luxor

dom: by association with the god Amun, whose identity had been fused with that of the sun-god Ra, and who became the supreme deity, towering above the lesser gods as the pharaoh towered above the provincial nobility. Thus vast architectural energies were devoted to the building of huge temples of Amun under royal sponsorship, such as that at Luxor (fig. 21). Its plan is characteristic of the general pattern of later Egyptian temples. The façade (fig. 21, far left) consists of two massive walls, with sloping sides, that flank the entrance; this gateway, or pylon, leads to a court, a pillared hall, a second court, and another pillared hall, beyond which is the temple proper. The entire sequence of courts, halls, and temple was enclosed by high walls that shut off the outside world. Except for the monumental façade, such a structure is designed to be experienced from within; ordinary worshipers were confined to the courts and could but marvel at the forest of columns that screened the dark recesses of the sanctuary. The columns had to be closely spaced, for they supported the stone beams (lintels) of the ceiling, and these had to be short to keep them from breaking under their own weight. Yet the architect has consciously exploited this condition by making the columns far heavier than they need be. As a result, the beholder feels almost crushed by their sheer mass. The overawing effect is certainly impressive, but also rather vulgar when measured against the earlier masterpieces of Egyptian architecture. We need only compare the papyrus columns at Luxor with their ancestors at Saqqara (see fig. 18) to realize how little of Imhotep's genius still survives here.

Akhenaten; Tutankhamen

The growth of the Amun cult produced an unexpected threat to royal authority: the priests of Amun grew into a caste of such wealth and power that the king could maintain his position only with their consent. One remarkable pharaoh, Amenhotep IV, tried to defeat them by proclaiming his faith in a single god, the sun-disk Aten. He changed his name to Akhenaten, closed the Amun temples, and moved the capital to a new site. His attempt to place himself at the head of a new monotheistic faith, however, did not outlast his reign (1372–1358 B.C.), and under his successors orthodoxy was speedily restored. During the long period of Egypt's decline,

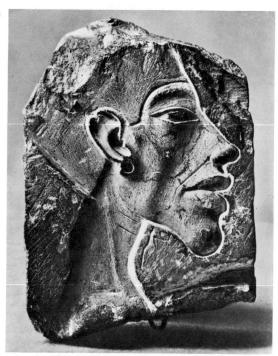

22. Akhenaten (Amenhotep IV). c. 1365 B.C. Limestone, height $3\frac{1}{8}$ ". State Museums, Berlin

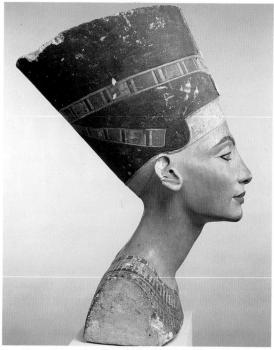

23. *Queen Nofretete.* c. 1360 B.C. Limestone, height about 20". State Museums, Berlin

after 1000 B.C., the country became ever more priest-ridden, until, under Greek and Roman rule, Egyptian civilization came to an end in a welter of esoteric religious doctrines.

Akhenaten was a revolutionary not only in his faith but in his artistic tastes as well, consciously fostering a new style and a new ideal of beauty. The contrast with the past is strikingly evident in a low-relief portrait of Akhenaten (fig. 22); compared with works in the traditional style (see fig. 15), this head seems at first glance like a brutal caricature, with its oddly haggard features and overemphatic, undulating outlines. Still, we can perceive its kinship with the justly famous bust of Akhenaten's queen, Nofretete (fig. 23), one of the masterpieces of the "Akhenaten style." What distinguishes this style is not greater realism so much as a new sense of form that seeks to unfreeze the traditional immobility

of Egyptian art; not only the contours but the plastic shapes, too, seem more pliable and relaxed, antigeometric, as it were.

The old religious tradition was quickly restored after Akhenaten's death, but the artistic innovations he encouraged could be felt in Egyptian art for some time to come. Even the face of Akhenaten's successor, Tutankhamen, as it appears on his gold coffin, betrays an echo of the Akhenaten style (fig. 24). Tutankhamen, who died at the age of eighteen, owes his fame entirely to the accident that his is the only pharaonic tomb discovered in our times with most of its contents undisturbed. The sheer material value of the tomb is staggering. (Tutankhamen's gold coffin alone weighs 250 pounds.) To us, the exquisite workmanship of the coffin, with the rich play of colored inlays against the polished gold surfaces, is even more impressive.

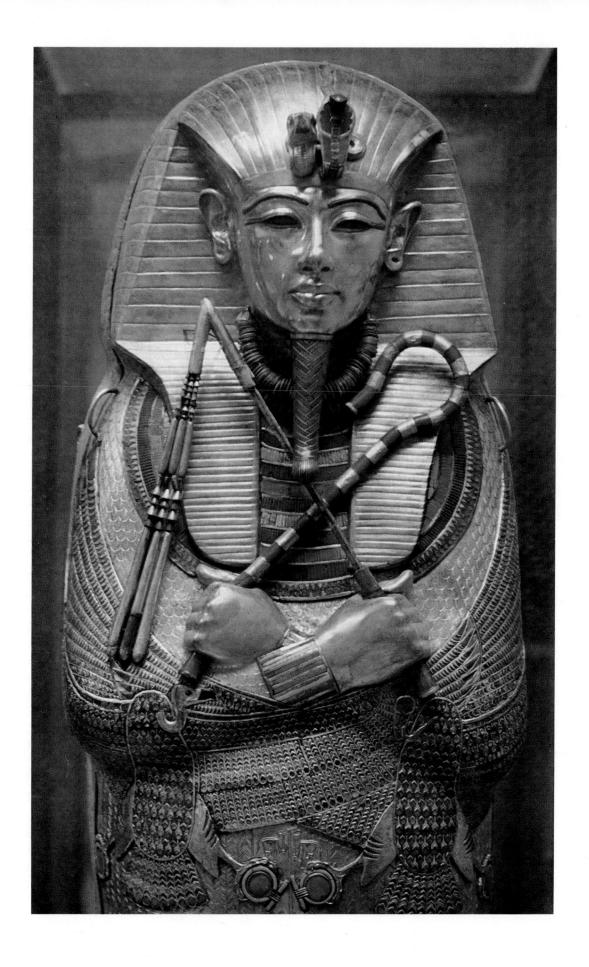

Temples, Palaces, and Citadels— The Ancient Near East and the Aegean

MESOPOTAMIA

It is an odd and astonishing fact that man should have emerged into the light of history in two separate places at just about the same time. Between 3500 and 3000 B.C., when Egypt was being united under pharaonic rule, another great civilization arose in Mesopotamia, the "land between the rivers." And for close to three millennia, the two rival centers retained their distinct character. even though they had contact with each other from their earliest beginnings. The pressures that forced the inhabitants of both regions to abandon the pattern of prehistoric village life may well have been the same. But the valley of the Tigris and Euphrates, unlike that of the Nile, is not a narrow fertile strip protected by deserts; it resembles a wide, shallow trough with few natural defenses, easily encroached upon from any direction. Thus the area proved almost impossible to unite under a single ruler. The political history of ancient Mesopotamia has no underlying theme such as divine kingship provides for Egypt; local rivalries, foreign invasions, the sudden upsurge and equally sudden collapse of military power—these are its substance. Even so. there was a remarkable continuity of cultural and artistic traditions. These are very largely the creation of the founding fathers of Mesopotamian civilization, whom we call Sumerians after Sumer, the region near the confluence of the Tigris and Euphrates which they inhabited.

The origin of the Sumerians remains obscure. Sometime before 4000 B.C. they came to southern Mesopotamia from Persia, founded a number of city-states, and developed their distinctive form of writing in cuneiform

(wedge-shaped) characters on clay tablets. Unfortunately, the tangible remains of this Sumerian civilization are very scanty compared to those of ancient Egypt; for lack of stone, the Sumerians built only in mud brick and wood, so that almost nothing is left of their architecture except the foundations. Nor did they share the Egyptians' concern with the hereafter, although a few richly endowed tombs have been found in the city of Ur. Our knowledge of Sumerian civilization thus depends very largely on chance fragments-including vast numbers of inscribed clay tablets-brought to light by excavation. Still, in recent decades we have learned enough to form a general picture of the achievements of this vigorous, inventive, and disciplined people.

Each Sumerian city-state had its own local god, who was its "king" and owner. He in return was expected to plead the cause of his subjects among his fellow deities who controlled the forces of nature, such as wind and weather, fertility, and the heavenly bodies. The community also had a human ruler, the steward of the divine sovereign who transmitted the god's commands. Nor was divine ownership treated as a pious fiction; the god was quite literally thought to own not only the territory of the city-state but the labor power of the population and its products as well. The result was a "theocratic socialism," a planned society centered on the temple. It was the temple that controlled the pooling of labor and resources for such enterprises as building dikes or irrigation ditches, and it collected and distributed a large part of the harvest. All this required the keeping of de-

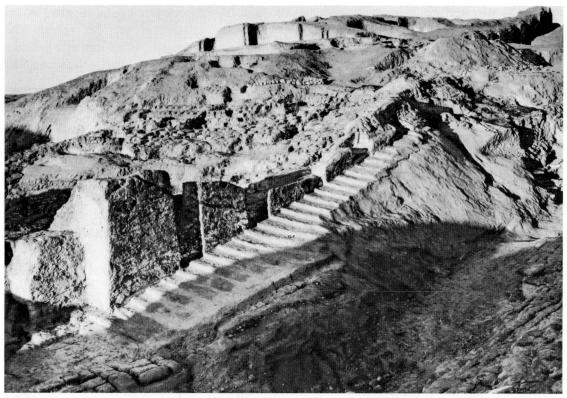

25. The "White Temple" on its ziggurat, Uruk (present-day Warka). c. 3500-3000 B.C.

26. Plan of the "White Temple" on its ziggurat, Uruk (after H. Frankfort)

tailed written records, hence early Sumerian inscriptions deal mainly with economic and administrative matters, although writing was a priestly privilege.

Architecture

The dominant role of the temple as the center of both spiritual and physical existence is strikingly conveyed by the layout of Sumerian cities. The houses clustered about a sacred area that was a vast architectural complex embracing not only shrines but workshops, storehouses, and scribes' quarters as well. In their midst, on a raised platform, stood the temple of the local god. These platforms soon reached the height of true man-made mountains, comparable to the pyramids of Egypt in the immensity of effort required and in their

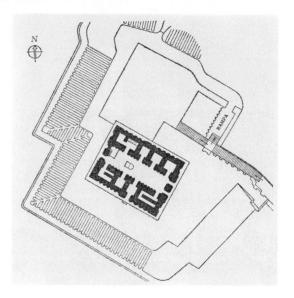

effect as great landmarks towering above the featureless plain. They are known as ziggurats. The most famous of them, the biblical Tower of Babel, has been completely destroyed, but a much earlier example, built before 3000 B.C. and thus several centuries older than the first of the pyramids, survives at Warka, the site of the Sumerian city of Uruk (called Erech in the Bible). The mound, its sloping sides reinforced by solid brick masonry, rises to a height of forty feet; stairs and ramps lead up to the platform on which stands the sanctuary, called the "White Temple" because of its whitewashed brick exterior (figs. 25, 26). Its heavy walls, articulated by regularly spaced projections and recesses, are sufficiently well preserved to suggest something of the original appearance of the structure. We must view the ziggurat and temple as a whole: the entire complex is planned in such a way that the worshiper, starting at the bottom of the stairs on the east side, is forced to go around as many corners as possible before he reaches the temple's main room. The processional path, in other words, resembles a sort of angular spiral. This "bent-axis approach" is a fundamental characteristic of Mesopotamian religious architecture, in contrast to the straight single axis of Egyptian temples.

Sculpture

The image of the god to whom the "White Temple" was dedicated is lost—it was probably Anu, the god of the sky. Other temples have yielded stone statuary, such as the group of figures from Tell Asmar (fig. 27), contemporary with the pyramid of Zoser. The tallest represents Abu, the god of vegetation, the second largest a mother goddess, the rest priests and worshipers. What distinguishes the two deities is not only their size but the

27. Statues, from the Abu Temple, Tell Asmar. c. 2700-2500 B.C. Marble, height of tallest figure about 30". The Iraq Museum, Baghdad, and The Oriental Institute, University of Chicago

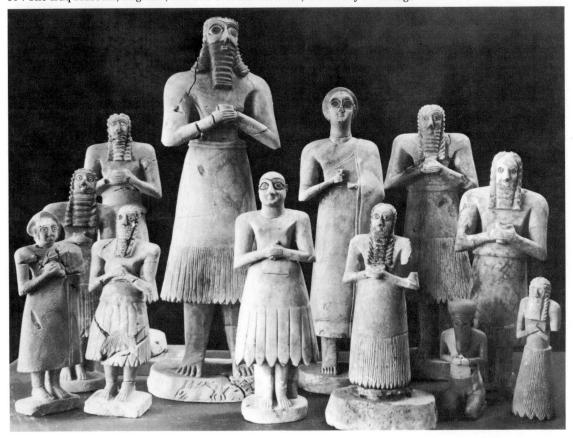

larger diameter of the pupils of their eyes, although the eyes of all the figures are enormous. Their insistent stare is emphasized by colored inlays. Clearly, the priests and worshipers were meant to communicate with the two gods through their eyes. "Representation" here has a very direct meaning: the gods were believed to be present in their images, and the statues of the worshipers served as stand-ins for the persons they portrayed. Yet none of them indicates any attempt to achieve an individual likeness—the bodies as well as the faces are rigorously simplified and schematic so as to avoid distracting attention from the eyes, the "windows of the soul." If the Egyptian sculptor's sense of form was essentially cubic, that of the Sumerian was based on the cone and the cylinder: arms and legs have the roundness of pipes, and the long skirts worn by all these figures are as smoothly curved as if they had been turned on a lathe. Even in later times, when Mesopotamian sculpture had acquired a far richer repertory of shapes, this quality asserts itself again and again.

The conic-cylindrical simplification of the Tell Asmar statues is characteristic of the carver, who works by cutting his forms out of a solid block. A far more flexible and realistic style prevails among the Sumerian sculpture that was made by addition rather than subtraction (that is, either modeled in soft materials for casting in bronze or put together by combining such varied substances as wood, gold leaf, and lapis lazuli). Some pieces of the latter kind, roughly contemporary with the Tell Asmar figures, have been found in the tombs at Ur which we mentioned earlier. They include the fascinating object shown in figure 28, an offering stand in the shape of a billy goat rearing up against a flowering tree. The animal, marvelously alive and energetic, has an almost demonic power of expression as it gazes at us from between the branches of the symbolic tree. And well it might, for it is sacred to the god Tammuz and thus embodies the male principle in nature.

Such an association of animals with deities is a carry-over from prehistoric times; we find it not only in Mesopotamia but in Egypt as well (see the falcon of Horus in fig. 15). What distinguishes the sacred animals of the Sumerians is the active part they play in mythology. Much of this lore, unfortunately, has not come down to us in written form, but tantalizing glimpses of it can be caught in pictorial representations such as those on an inlaid panel from a harp (fig. 29) that was recovered together with the offering stand at Ur. The hero embracing two human-headed bulls was so popular a subject that its design has become a rigidly symmetrical formula, but the other sections show animals performing a variety of human tasks in lively and precise fashion: the wolf and the lion carry food and drink to an unseen banquet, while the ass, bear, and deer provide musical entertainment (the harp is the same type as the instrument to which the panel was attached). At the bottom, a scorpion-man and a goat carry some objects they have taken from a large vessel. The artist who created these scenes was far less constrained by rules than were his contemporaries in Egypt; although he, too, places his figures on ground lines, he is not afraid of overlapping forms or foreshortened shoulders. We must be careful, however, not to misinterpret his purpose—what may strike us as delightfully humorous was probably meant to be viewed with perfect seriousness. If we only knew the context in which these actors play their roles! Nevertheless, we may regard them as the earliest known ancestors of the animal fable that later flourished in the West from Aesop to La Fontaine.

Babylon

After the middle of the third millennium B.C., the Semitic inhabitants of northern Mesopotamia drifted south in ever larger numbers until they outweighed the Sumerian stock. Although they adopted Sumerian

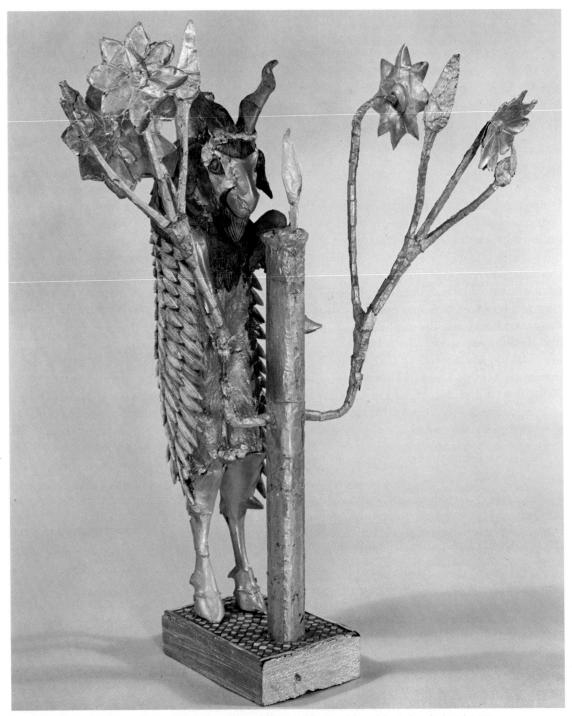

28. Billy Goat and Tree, offering stand, from Ur. c. 2600 B.C. Wood, gold, and lapis lazuli; height 20". The University Museum, Philadelphia

civilization, they were less bound by the tradition of theocratic socialism; it was they who produced the first Mesopotamian rulers who openly called themselves kings and proclaimed their ambition to conquer their neighbors. Few of them succeeded; the sec-

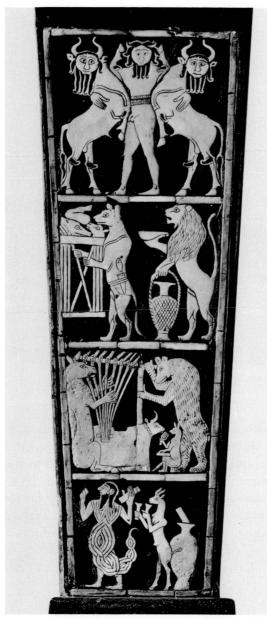

29. Soundbox of a harp, from Ur. c. 2600 B.C. Bitumen with shell inlay, height $8\frac{1}{2}$ ". The University Museum, Philadelphia

ond millennium B.C. was a time of almost continuous turmoil. By far the greatest figure of the age was Hammurabi, under whose rule Babylon became the cultural center of Mesopotamia. His most memorable achievement is his law code, justly famous as the earliest written uniform body of laws and

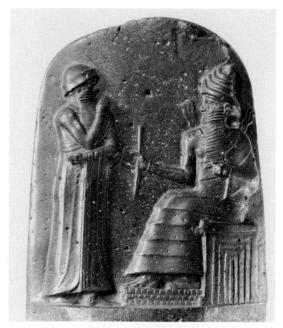

30. Top of stone slab inscribed with the law code of Hammurabi. c. 1760 B.C. Diorite, height of slab 7', height of relief 28". The Louvre, Paris

amazingly rational and humane in conception. He had it engraved on a tall stone slab, the top of which shows Hammurabi confronting the sun-god Shamash (fig. 30). The ruler's right arm is raised in a speaking gesture, as if "the favorite shepherd" were reporting to the divine king. The relief here is so high that the two figures almost give the impression of statues sliced in half. As a result, the sculptor has been able to render the eyes in the round. Hammurabi and Shamash gaze at each other with a force and directness that recall the statues from Tell Asmar (see fig. 27), whose enormous eyes indicate an attempt to establish the same relationship between god and man in an earlier phase of Mesopotamian civilization.

Assyrians

The most copious archaeological finds date from the third major phase of Mesopotamian history, that between c. 1000 and 500 B.C., which was dominated by the Assyrians. This people had slowly expanded from the city-

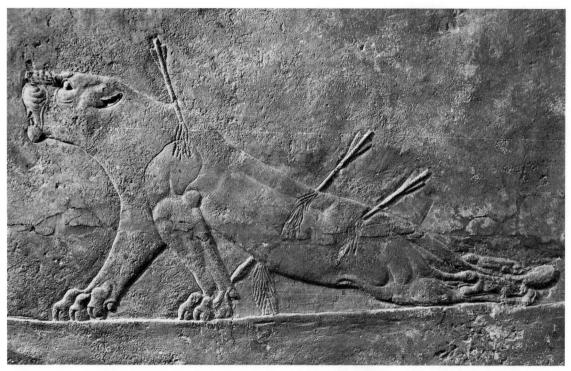

31. Dying Lioness, from Nineveh. c. 650 B.C. Limestone, height of figure 13¾". British Museum, London

state of Assur on the upper course of the Tigris until they ruled the entire country. At the height of its power, the Assyrian Empire stretched from the Sinai peninsula to Armenia. The Assyrians, it has been said, were to the Sumerians what the Romans were to the Greeks. Their civilization depended on the achievements of the South, but reinterpreted them to fit its own distinctive character. Much of Assyrian art is devoted to glorifying the power of the king, either by detailed depictions of his military conquests or by showing the sovereign as the killer of lions. These royal hunts were ceremonial combats (the animals were released from cages within a square formed by soldiers with shields) in which the king reenacted his ancient role as supreme shepherd who kills the predators menacing the communal flock. Here Assyrian art rises to impressive heights, especially in the splendid reliefs of lion hunts from Nineveh. Strange as it seems, the finest images in these scenes are not the king and his retinue but the lions. By endowing them with magnificent strength and courage, the sculptor exalts the king who is able to slay such formidable adversaries. The *Dying Lioness* (fig. 31) stands out not only for the subtle gradations of the carved surface, which convey all the weight and volume of the body despite the shallowness of the relief, but for the tragic grandeur of the creature's final agony.

Neo-Babylonians

The Assyrian Empire fell before an invasion from the east. At that time the commander of the Assyrian army in southern Mesopotamia made himself king of Babylon; under him and his successors the ancient city had a final brief flowering between 612 and 539 B.C., before it was conquered by the Persians. The best known of these "Neo-Babylonian" rulers was Nebuchadnezzar, the builder of the Tower of Babel. Unlike the Assyrians,

the Neo-Babylonians used baked and glazed bricks for their buildings, because they were farther removed from the sources of stone slabs. This technique, too, had been developed in Assyria, but now it was used on a far larger scale, both for surface ornament and for architectural reliefs. Its distinctive effect is evident in the Ishtar Gate of Nebuchadnezzar's sacred precinct in Babylon, which has been rebuilt from the thousands of individual glazed bricks that covered its surface (fig. 32). The stately procession of bulls, dragons, and other animals of molded brick within a framework of vividly colored ornamental bands has a grace and gaiety far removed from Assyrian art. Here, for the last time, we sense again that special genius of ancient Mesopotamian art in the portrayal of animals.

PERSIA

Persia, the mountain-fringed high plateau to the east of Mesopotamia, takes its name from the people who occupied Babylon in 539 B.C. and became the heirs of what had been the Assyrian Empire. Today the country is called Iran, its older and more suitable name, since the Persians, who put the area on the map of world history, were latecomers who had arrived on the scene only a few centuries before they began their epochal conquests. Inhabited continuously since prehistoric times, Iran always seems to have been a gateway for migratory tribes from the Asiatic steppes to the north as well as from India to the east. Since nomadic tribes leave no permanent monuments or written records, we can trace their wanderings only by a careful study of the objects they buried with their dead. Such objects, of wood, bone, or metal, represent a distinct kind of portable art which we call the nomad's gear: weapons, bridles for horses, buckles, clasps and other articles of adornment, cups, bowls, etc. They have been found over a vast area, from Siberia to Central Europe, from Iran to

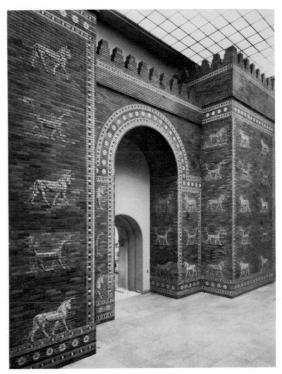

32. The Ishtar Gate (restored), from Babylon. c. 575 B.C. Glazed brick. State Museums, East Berlin

Scandinavia. They have in common not only a jewel-like concentration of ornamental design but also a repertory of forms known as the "animal style." And one of the sources of this style appears to be ancient Iran. The main feature of animal style, as the name suggests, is the decorative use of animal motifs, in a rather abstract and imaginative manner. The pole top ornament (fig. 33) consists of a symmetrical pair of rearing ibexes, with vastly elongated necks and horns; originally, we suspect, they were pursued by a pair of lions, but the bodies of the latter have been absorbed into those of the ibexes, whose necks have been pulled out to dragon-like slenderness.

Achaemenids

After conquering Babylon in 539 B.C., Cyrus assumed the title "King of Babylon" along with the ambitions of the Assyrian rulers. The empire he founded continued to expand

under his successors; Egypt as well as Asia Minor fell to them, and Greece escaped the same fate only by the narrowest of margins. At its high tide, under Darius I and Xerxes (523–465 B.C.), the Persian Empire was far larger than its Egyptian and Assyrian predecessors together. Moreover, this vast domain endured for two centuries—it was toppled by Alexander the Great in 331 B.C.—and during most of its life it was ruled both efficiently and humanely. For an obscure tribe of nomads to have achieved all this is little short of miraculous. Within a single generation, the Persians not only mastered the complex machinery of imperial administration but also evolved a monumental art of remarkable originality to express the grandeur of their rule.

Despite their genius for adaptation, the Persians retained their own religious belief

33. Pole top ornament, from Luristan. 9th-7th century B.C. Bronze, height 7½". British Museum, London

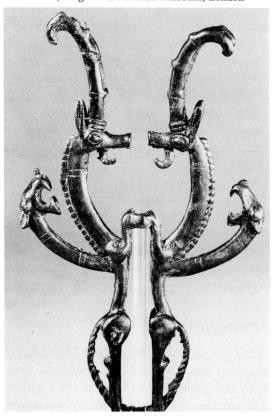

derived from the prophecies of Zoroaster; this was a faith based on the dualism of Good and Evil, embodied in Ahuramazda (Light) and Ahriman (Darkness). Since the cult of Ahuramazda centered on fire altars in the open air, the Persians had no religious architecture. Their palaces, on the other hand, were huge and impressive structures. The most ambitious one, at Persepolis, was begun by Darius I in 518 B.C. It had a vast number of rooms, halls, and courts assembled on a raised platform. Influences from every corner of the Empire have been combined in such a way that the result is a new, uniquely Persian style. Thus, at Persepolis columns are used on a grand scale. The Audience Hall of Darius, a room 250 feet square, had a wooden ceiling supported by 36 columns 40 feet tall, a few of which are still standing (fig. 34). Such a massing of columns suggests Egyptian architecture (compare fig. 21), and Egyptian influence does indeed appear in the ornamental detail of the bases and capitals, but the slender, fluted shaft of the Persepolis columns is derived from the Ionian Greeks in Asia Minor, who are known to have furnished artists to the Persian court.

THE AEGEAN

If we sail from the Nile Delta northwestward across the Mediterranean, our first glimpse of Europe will be the eastern tip of Crete. Beyond it, we find a scattered group of small islands, the Cyclades, and, a little farther on, the mainland of Greece, facing the coast of Asia Minor across the Aegean Sea. To archaeologists, "Aegean" is not merely a geographical term; they have adopted it to designate the civilizations that flourished in this area during the third and second millenniums B.C., before the development of Greek civilization proper. There are three of these, closely interrelated yet distinct from each other: that of Crete, called Minoan after the legendary Cretan king Minos; that of the small islands north of Crete (Cycladic); and

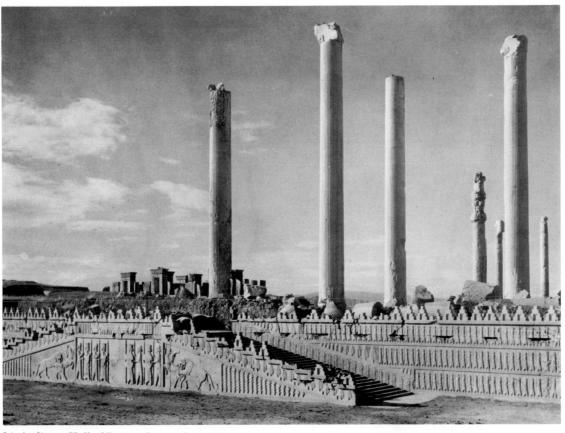

34. Audience Hall of Darius, Persepolis. c. 500 B.C.

that of the Greek mainland (Helladic). Each of them has in turn been divided into three phases, Early, Middle, and Late, which correspond, very roughly, to the Old, Middle, and New Kingdom in Egypt. The most important remains, and the greatest artistic achievements, date from the latter part of the Middle and from the Late phase.

Cycladic Art

The people who inhabited the Cycladic islands between about 2600 and 1100 B.C. have left hardly any trace apart from their modest stone tombs. The things they buried with their dead are remarkable in one respect only: they include a large number of marble idols of a peculiarly impressive kind. Almost all of them represent a standing nude female figure with arms folded across the chest, presumably the mother and fertility goddess known to us from Asia Minor and the ancient Near East, whose ancestry reaches far back to the Old Stone Age (see fig. 6). They also share a distinctive shape, which at first glance recalls the angular, abstract qualities of primitive sculpture: the flat, wedge shape of the body, the strong, columnar neck, and the tilted, oval shield of the face, featureless except for the long, ridgelike nose. Within this narrowly defined and stable type, however, the Cycladic idols show wide variations in scale (from a few inches to lifesize) as well as form. The best of them, such as that in figure 35, have a disciplined refinement utterly beyond the range of Stone Age or primitive art. The longer we study this piece, the more we come to realize that its qualities can only be described as "elegance" and "sophistication," however incongruous such terms may

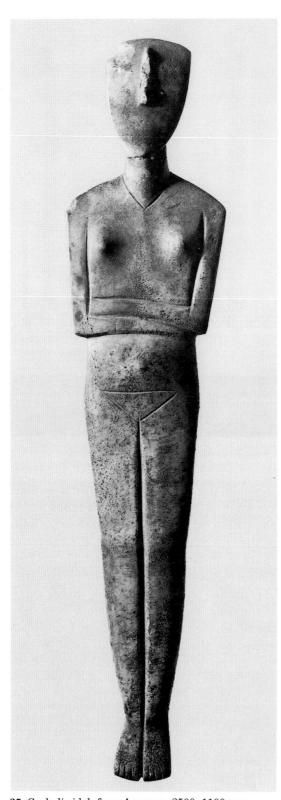

35. Cycladic idol, from Amorgos. $2500-1100~\mathrm{B.C.}$ Marble, height 30''. Ashmolean Museum, Oxford

seem in our context. What an extraordinary feeling for the organic structure of the body there is in the delicate curves of the outline, in the hints of convexity marking the knees and abdomen.

Minoan Art

Minoan civilization is by far the richest, as well as the strangest, of the Aegean world. What sets it apart, not only from Egypt and the Near East but also from the Classical civilization of Greece, is a lack of continuity that appears to have deeper causes than archaeological accident. In surveying the main achievements of Minoan art, we cannot really speak of growth or development; they appear and disappear so abruptly that their fate must have been determined by external forces—sudden violent changes affecting the entire island—about which we know little or nothing. Yet the character of Minoan art, which is gay, even playful, and full of rhythmic motion, conveys no hint of such threats.

The first of these unexpected shifts occurred about 2000 B.C., when the Cretans created not only their own system of writing but an urban civilization as well, centering on several great palaces. At least three of them, Knossos, Phaistos, and Mallia, were built in short order. Hardly anything is left today of this sudden spurt of large-scale building activity, for the three palaces were all destroyed at the same time, about 1700 B.C.; after an interval of a hundred years, new and even larger structures began to appear on the same sites, only to suffer destruction, in their turn, about 1500 B.C. It is these "new" palaces that are our main source of information on Minoan architecture. The one at Knossos, called the Palace of Minos, was the most ambitious, covering a vast territory and composed of so many rooms that it survived in Greek legend as the labyrinth of the Minotaur. It has been carefully excavated and partially restored. In the building's architecture there was no striving for unified. monumental effect. The individual units are

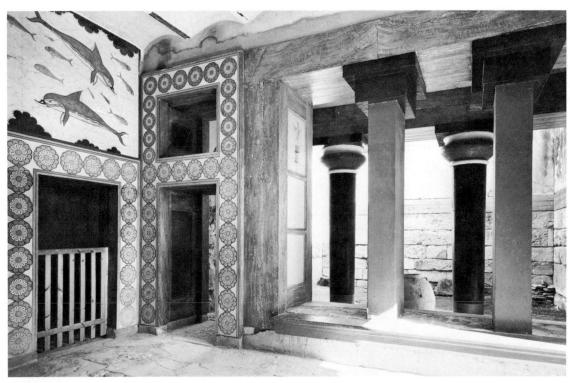

36. Queen's Chamber, Palace of Minos, Knossos, Crete. c. 1500 B.C.

generally rather small and the ceilings low (fig. 36), so that even those parts of the structure that were several stories high could not have seemed very tall. Nevertheless, the numerous porticoes, staircases, and air shafts must have given the palace a pleasantly open, airy quality; and some of the interiors, with their richly decorated walls, retain their atmosphere of intimate elegance to this very day. The masonry construction of Minoan palaces is excellent throughout, but the columns were always of wood. Although none has survived, their characteristic form (the smooth shaft tapering downward, topped by a wide, cushion-shaped capital) is known from representations in painting and sculpture. About the origins of this type of column, which in some contexts could also serve as a religious symbol, or about its possible links with Egyptian architecture, we can say nothing at all.

After the catastrophe that had wiped out the earlier palaces, and a century of slow recovery, there was what seems to our eyes an explosive increase in wealth and an equally remarkable outpouring of creative energy. The most surprising aspect of this sudden efflorescence, however, is its great achievement in painting. Unfortunately, the "naturalistic" murals that once covered the walls of the new palaces have survived only in small fragments, so that we hardly ever have a complete composition, let alone the design of an entire wall. A great many of them were scenes from nature showing animals and birds among luxuriant vegetation. Marine life (as seen in the fish and dolphin fresco in fig. 36) was also a favorite subject of Minoan painting, and the marine feeling pervades everything else as well; we sense it even in the "Toreador Fresco," the largest and most dynamic Minoan mural recovered so far, also from the Palace of Minos (fig. 37; the darker patches are the original fragments on which the restoration is based). The conventional title should not mislead us: what we see here is

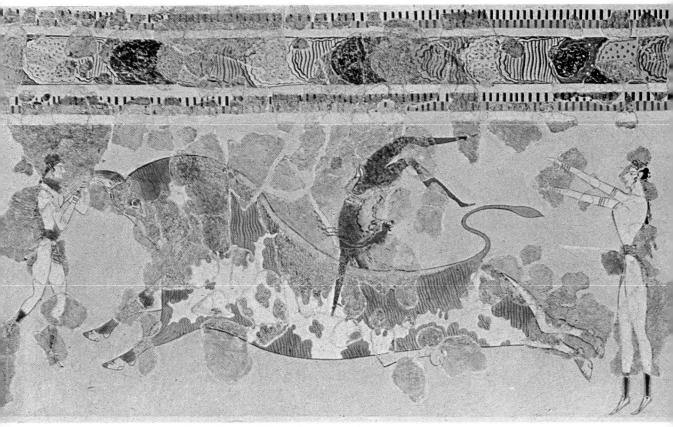

37. "Toreador Fresco," from the Palace of Minos, Knossos, Crete. c. 1500 B.C. Height about $24\frac{1}{2}$ " (including upper border). Archaeological Museum, Heraklion, Crete

not a bullfight but a ritual game in which the performers vault over the back of the animal. Two of the slim-waisted athletes are girls, differentiated (as in Egyptian art) mainly by their lighter skin color. That the bull was a sacred animal, and that bull-vaulting played an important role in Minoan religious life, is beyond doubt; scenes such as this still echo in the Greek legend of the youths and maidens sacrificed to the Minotaur. If we try, however, to "read" the fresco as a description of what actually went on during these performances, we find it strangely ambiguous. Do the three figures show successive phases of the same action? How did the youth in the center get onto the back of the bull, and in what direction is he moving? Scholars have even consulted rodeo experts without getting clear answers to these questions. All of which does not mean that the Minoan artist was deficient—it would be absurd to blame him for failing to accomplish what he never intended to do in the first place—but that fluid, effortless ease of movement was more important to him than factual precision or dramatic power. He has, as it were, idealized the ritual by stressing its harmonious, playful aspect to the point that the participants behave like dolphins gamboling in the sea.

Mycenaean Art

Along the southeastern shores of the Greek mainland there existed during Late Helladic times (c. 1600-1100~B.C.) a number of settlements that corresponded in many ways to

those of Minoan Crete. They, too, were grouped around palaces. Their inhabitants have come to be called Mycenaeans, after Mycenae, the most important of these settlements. Since the works of art unearthed there by excavation often showed a strikingly Minoan character, the Mycenaeans were at first regarded as having come from Crete, but it is now agreed that they were the descendants of the earliest Greek tribes, who had entered the country soon after 2000 B.C.

For some four hundred years these people had led an inconspicuous pastoral existence in their new homeland; their modest tombs have yielded only simple pottery and a few bronze weapons. Toward 1600 B.C., however, they suddenly began to bury their dead in deep shaft graves and, a little later, in conical stone chambers, known as beehive tombs. This development reached its height toward 1300 B.C. in such impressive structures as the one shown in figure 38, built of concentric layers of precisely cut stone blocks. Its discoverer thought it far too ambitious for a tomb and gave it the misleading name "The Treasury of Atreus." Burial places as elaborate as this can be matched only in Egypt during the same period.

Apart from such details as the shape of the columns or decorative motifs of various sorts, Mycenaean architecture owes little to the Minoan tradition. The palaces on the mainland were hilltop fortresses surrounded by defensive walls of huge stone blocks, a type of construction quite unknown in Crete. The Lion Gate at Mycenae (fig. 39) is the most impressive remnant of these massive ramparts, which inspired such awe in the Greeks of later times that they were regarded as the work of the Cyclopes (a mythical race of one-eyed giants). Another aspect of the Lion Gate foreign to the Minoan tradition is the great stone relief over the doorway. The two lions flanking a symbolic Minoan column have a grim, heraldic majesty. Their function as guardians of the gate, their tense, muscular bodies, and their symmetrical design again

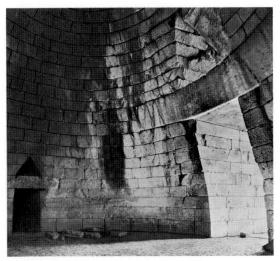

38. Interior, Treasury of Atreus, Mycenae. с. 1300-1250 в.с.

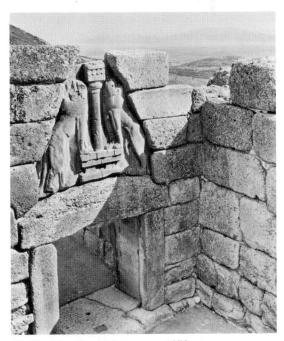

39. The Lion Gate, Mycenae. c. 1250 B.C.

suggest an influence from the ancient Near East. We may at this point recall the Trojan War, immortalized in Homer's Iliad, which brought the Mycenaeans to Asia Minor soon after 1200 B.C.; it seems likely, however, that they began to sally eastward across the Aegean, for trade or war, much earlier than that.

Greek Art

The works of art we have come to know so far are like fascinating strangers: we approach them fully aware of their alien background and of the "language difficulties" they present. As soon as we come to the sixth century B.C. in Greece, however, our attitude undergoes a change: these are not strangers but relatives, we feel—older members of our own family. It is just as well to remember, as we turn to these "ancestors" of ours, that the continuous tradition that links us to the ancient Greeks is a handicap as well as an advantage: we must be careful, in looking at Greek originals, not to let our memories of their countless later imitations get in the way.

The Mycenaeans and the other clans described by Homer were the first Greek-speaking tribes to wander into the peninsula, around 2000 B.C. Then, around 1100 B.C., others came, overwhelming and absorbing those who were already there. Some of the late arrivals, the Dorians, settled on the mainland: others, the Ionians, spread out to the Aegean islands and Asia Minor. A few centuries later they ventured into the waters of the western Mediterranean, founding colonies in Sicily and southern Italy. Though the Greeks were united by language and religious beliefs, old tribal loyalties continued to divide them into city-states. The intense rivalry among these for power, wealth, and status undoubtedly stimulated the growth of ideas and institutions; but in the end they paid dearly for their inability to compromise, at least sufficiently to broaden their concept of state government. The Peloponnesian War (431–404 B.C.), in which the Spartans and their allies defeated the Athenians, was a catastrophe from which Greece never recovered.

PAINTING

Geometric Style

The formative phase of Greek civilization embraces about four hundred years, from c. 1100 to 700 B.C. Of the first three centuries of this period we know very little, but after about 800 B.C. the Greeks rapidly emerge into the full light of history. That period also saw the full development of the oldest characteristically Greek style in the fine arts, the so-called Geometric. We know it only from painted pottery and small-scale sculpture (monumental architecture and sculpture in stone did not appear until the seventh centu-

40. Dipylon vase. 8th century B.C. Height 42½". The Metropolitan Museum of Art, New York (Rogers Fund)

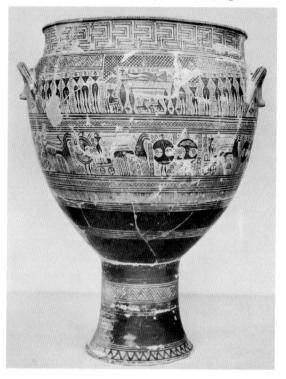

ry). At first the pottery had been decorated only with abstract designs—triangles, checkers, concentric circles—but toward 800 B.C. human and animal figures began to appear within the geometric framework, and in the most mature examples these figures could form elaborate scenes. Our specimen (fig. 40), from the Dipylon cemetery in Athens, belongs to a group of very large vases that served as grave monuments; its bottom has holes through which liquid offerings could filter down to the dead below. On the body of the vessel we see the deceased lying in state, flanked by figures with their arms raised in a gesture of mourning, and a funeral procession of chariots and warriors on foot. The most remarkable thing about this scene is that it contains no reference to an afterlife; its purpose is purely commemorative. Here lies a worthy man, it tells us, who was

41. Psiax. Hercules Strangling the Nemean Lion. Attic black-figured amphora, from Vulci. Archaic period. c. 525 B.C. Height 19". Museo Civico, Brescia, Italy

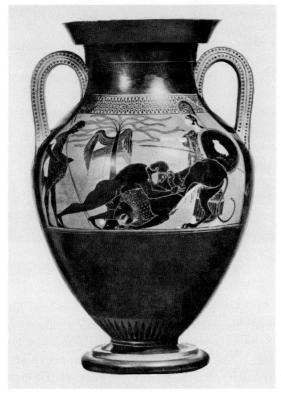

mourned by many and had a splendid funeral. Did the Greeks, then, have no conception of a hereafter? They did, but the realm of the dead to them was a colorless, ill-defined region where the souls, or "shades," led a feeble and passive existence without making any demands upon the living.

Archaic Style

Toward 700 B.C. Greek art, stimulated by an increased trade with Egypt and the Near East, began to absorb powerful influences from these regions that put flesh on the bare bones of the Dorians' Geometric images. From the later seventh century to about 480 B.C., this amalgamation produced what we call the "Archaic style"; while it does not yet have the balance and perfection of the "Classical style," which followed in the later part of the fifth century B.C., the Archaic style has an appealing freshness that makes many persons consider it the most vital phase of Greek art.

Black-Figure

By about the middle of the sixth century B.C., vase painters in particular were so highly esteemed that the best of them signed their works. The scene of Hercules strangling the Nemean lion on Psiax's amphora (figs. 41, 42) is a far cry from the conventionalized figures of the Geometric style. The two heavy bodies almost seem united forever in their grim struggle; incised line and touches of colored detail have been kept to a minimum so as not to break up the compact black mass, yet both figures show such a wealth of anatomical knowledge and skillful use of foreshortening that they give an amazing illusion of existing in the round.

Unlike most earlier art, Psiax's vase tells a story. Narrative painting tapped a nearly inexhaustible source of subjects from Greek myths and legends. These tales were the re-

42. Psiax. Hercules Strangling the Nemean Lion (detail of figure 41)

sult of mixing local Doric and Ionic deities and heroes into the pantheon of Olympian gods and Homeric sagas. They also represent a comprehensive attempt to understand the world. The Greeks grasped the internal meaning of events in terms of fate and human character rather than the accidents of history, in which they had little interest before c. $500\,\mathrm{B.C.}$ The main focus was on explaining why the legendary heroes of the past

seemed incomparably greater than men of the present. Some were historical figures, including Hercules, who was the king of Tiryns, but all were believed to have been descended from gods, themselves very human in quality, who had children with mortals. This lineage explained the hero's extraordinary powers. Such an outlook helps us to understand the strong appeal exerted on the Greek imagination by Oriental lions and monsters. Hercules in his struggle re-

minds us of the hero on the soundbox of the harp from Ur (see fig. 29). Both show a hero facing the unknown forces of life embodied by terrifying mythical creatures. The Nemean lion likewise serves to underscore the hero's might and courage.

Red-Figure

Psiax must have felt that the silhouette-like black-figured technique made the study of

43. The Foundry Painter. Lapith and Centaur. Interior of attic red-figured ware. Archaic period. c. 490–480 B.C. Diameter 15". Staatliche Antikensammlungen, Munich

foreshortening unduly difficult, for in some of his vases he tried the reverse procedure, leaving the figures red and filling in the background. This red-figured technique gradually replaced the older method toward 500 B.C. Its advantages are well shown in figure 43, a kylix of c. 490-480 B.C. by an unknown master nicknamed the Foundry Painter. The details of the Lapith and Centaur are now freely drawn with the brush, rather than laboriously incised, so the artist depends far less on the profile view than before; instead, he exploits the internal lines of communication that permit him to show boldly foreshortened and overlapping limbs, precise details of costume (note the pleated skirt), and interesting facial expressions. He is so fascinated by all these new effects that he has made the figures as large as he possibly could. They almost seem to burst from

44. The Achilles Painter. Attic white-ground vase (detail). Classical period. c. 440–430 B.C. Height 16". Private collection

their circular frame, and a piece of the Lapith's helmet has actually been cut off.

The Lapith and Centaur are counterparts to Hercules and the Nemean lion. But just as the style has changed, so has the meaning of this combat: the painting now stands for the victory of civilization over barbarianism and ultimately of man's rational and moral side over his animal nature.

Classical Style

According to literary sources, Greek artists of the Classical period, which began around 480 B.C., achieved great breakthroughs in painting, including the mastering of illusionistic space. Unhappily, we have no murals or panels to verify this claim; and vase painting by its very nature could echo the new concept of pictorial space only in rudimentary fashion. Still, there are vessels that form an exception to this general rule; we find them mostly in a special class of vases, the lekythoi (oil jugs) used as funerary offerings. These had a white coating on which the painter could draw as freely, and with the same spatial effect, as his modern successor using pen and paper. The white ground, in both cases, is treated as empty space from which the sketched forms seem to emerge—if the draftsman knows how to achieve this. Not many lekythos painters were capable of bringing off the illusion. Foremost among them was the unknown artist, nicknamed the Achilles Painter, who drew the woman in figure 44. Our chief interest is the masterly draftsmanship; with a few lines, sure, fresh, and fluid, the artist not only creates a three-dimensional figure but reveals the body beneath the drapery as well. How does he manage to persuade us that these shapes exist in depth rather than merely on the surface of the vase? First of all, by his command of foreshortening. But the "internal dynamics" of the lines are equally important, their swelling and fading, which make some contours stand out boldly while others merge

45. The Battle of Issus or Battle of Alexander and the Persians. Roman copy, from Pompeii, of a Hellenistic painting. 1st century B.C. Mosaic, 8'11"×16'9½". National Museum, Naples, Italy

with one another or disappear into the white ground.

Considering its artistic advantages, we might expect the white-ground technique to have been more generally adopted. Such. however, was not the case. Instead, from the mid-fifth century on, the impact of monumental painting gradually transformed vase painting as a whole into a satellite art that tried to reproduce large-scale compositions in a kind of shorthand dictated by its own limited technique. We can get some idea of what Greek wall painting looked like from later copies and imitations. For example, the mosaic from Pompeii showing The Battle of Issus (fig. 45) probably reflects a famous Greek painting of about 315 B.C. depicting the defeat of the Persian king Darius by Alexander the Great. The scene is far more complicated and dramatic than anything from earlier Greek art. And for the first time it shows something that actually happened, without the symbolic overtones of Hercules Strangling the Nemean Lion or the Lapith and Centaur. In character and even in appearance, it is close to Assyrian reliefs commemorating specific historic events.

TEMPLES

The Greek achievement in architecture has been identified since ancient Roman times with the creation of the three Classical architectural orders: the Doric, Ionic, and Corinthian. Of these, the Doric may well claim to be the basic order, being older and more sharply defined than the Ionic; the Corinthian is a variant of the latter. What do we mean by "architectural order"? The term is used only for Greek architecture (and its descendants), and rightly so, for none of the other architectural systems known to us has produced anything like it. Perhaps the simplest way to make clear the unique character of the Greek orders is this: there is no such thing as "the Egyptian temple" or "the Gothic church"—the individual buildings, however much they may have in common, are so varied that we cannot distill a generalized type from them—while "the Doric temple" is a real entity that inevitably forms in our minds as we examine the monuments themselves. This abstraction is not, of course, an ideal against which we may measure the degree of perfection of any given Doric temple; it sim-

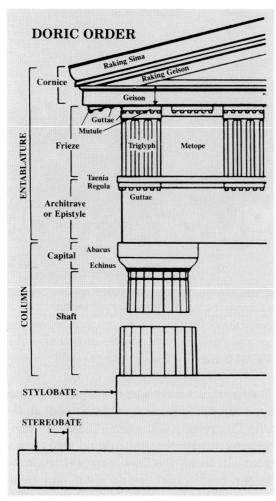

46. The Doric and Ionic orders (after Grinnell)

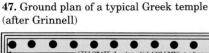

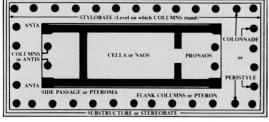

ply means that the elements of which a Doric temple is composed are extraordinarily constant in number, in kind, and in their relation to one another. Doric temples all belong to the same clearly recognizable family; they

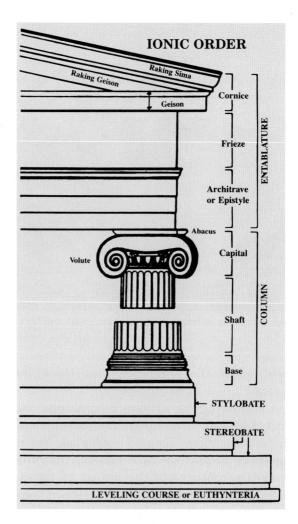

show an internal consistency, a mutual adjustment of parts, that gives them a unique quality of wholeness and organic unity.

Doric Order

The term Doric order refers to the standard parts, and their sequence, making up the exterior of any Doric temple. Let us note the three main divisions in figure 46: the stepped platform, the columns, and the entablature (which includes everything that rests on the columns). The column consists of the shaft, made of sections (drums) and marked with vertical grooves called flutes, and the capital, which supports the horizontal stone blocks of

the architrave. Above the architrave are the frieze and the cornice. On the long sides of the temple, the cornice is horizontal; on the short sides (or façades) it is split open so as to enclose the pediment between its upper and lower parts.

The plans of Greek temples are not directly linked to the orders. The basic features of all of them are so much alike that it is useful to study them from a generalized "typical" plan (fig. 47). The nucleus is the cella or naos (the room where the image of the deity is placed), and the entrance porch (pronaos) with two columns flanked by pilasters. Often a second porch is added behind the cella, for symmetry. In large temples, this central unit is surrounded by a row of columns (the colonnade, also called the peristyle).

How did the Doric temple originate? Its essential features were already well established about 600 B.C., but how they developed, and why they congealed so rapidly into a system, as it seems they did, remains a puzzle to which we have few reliable clues. The notion that temples ought to be built of stone, with large numbers of columns, must have come from Egypt; the fluted half-columns at Saqqara (see fig. 18) strongly suggest the Doric column. Egyptian temples, it is true, are designed to be experienced from the inside, while the Greek temple is arranged so that the exterior matters most (religious ceremonies usually took place out of doors, in front of the temple façade). But might not a Doric temple be interpreted as the columned hall of an Egyptian sanctuary turned inside out? The Greeks also owed something to the Mycenaeans—we have seen an elementary kind of pediment in the Lion Gate, and the capital of a Mycenaean column is rather like a Doric capital (compare fig. 39). There is, however, a third factor: to what extent can the Doric order be understood as a reflection of wooden structures? Our answer to this thorny question will depend on whether we believe that architectural form follows function and technique, or whether we accept the striving for beauty as a motivating force. The truth may well lie in a combination of both these approaches. At the start, Doric architects certainly imitated in stone some features of wooden temples, if only because these features served to identify the building as a temple. But when they became enshrined in the Doric order, it was not from blind conservatism; by then, the wooden forms had been so thoroughly transformed that they were an organic part of the stone structure.

Paestum

Of the ancient Greek buildings here illustrated, the oldest is the "Basilica" in Paestum (fig. 48, background); near this south-Italian town a Greek colony flourished during the Archaic period. The Temple of Poseidon (fig. 48, foreground) was erected about a hundred years later. How do the two temples differ? The "Basilica" looks low and sprawling-and not only because its roof is lost-while the Temple of Poseidon, by comparison, appears tall and compact. The difference is partly psychological, produced by the outline of the columns which, in the "Basilica," are more strongly curved and are tapered to a relatively tiny top. This makes one feel that they bulge with the strain of supporting the superstructure, and that the slender tops, even though aided by the widely flaring cushionlike capitals, are just barely up to the job. This sense of strain has been explained on the grounds that Archaic architects were not fully familiar with their new materials and engineering procedures, but such a view judges the building by the standards of later temples—and overlooks the expressive vitality of the building, as of a living body, the vitality we also sense in the Archaic Kouros (see fig. 51).

In the Temple of Poseidon the exaggerated curvatures have been modified; this, combined with a closer ranking of the columns, literally as well as expressively brings the

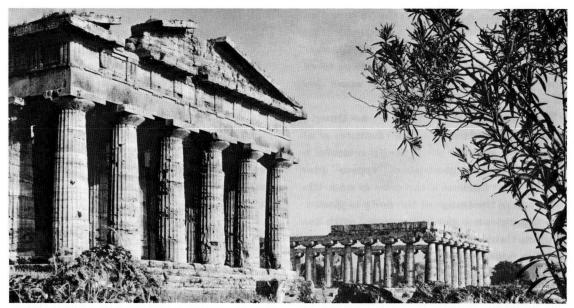

48. The Temple of Poseidon (foreground; c. 460 B.C.) and the "Basilica" (background; c. 550 B.C.), Paestum, Italy

stresses between supports and weight into more harmonious balance. Perhaps because the architect took fewer risks, the building is better preserved than the "Basilica," and its air of self-contained repose parallels the "Hera" (see fig. 52) in the field of sculpture.

Athens

As the most perfect embodiment of the Classical period of Greek architecture, the Parthenon (fig. 49) takes us a step further toward harmonious completeness. Although it is only a few years younger than the Temple of Poseidon, the fact that it was built in Athens, then at the peak of its glory and wealth, ensured it the best of design, material, and workmanship. In spite of its greater size it seems less massive than the earlier temple; rather, the dominant impression is one of festive, balanced grace. A general lightening and readjustment of the proportions accounts for this: the horizontal courses above the columns are not so wide in relation to their length; the framework of the gable projects less insistently; and the columns, in addition to being slenderer, are more widely spaced.

The curvature of the columns and the flare of the capitals are also discreetly lessened, adding to the new sense of ease. Instead of resembling an Archaic Atlas, straining to hold up the weight of a world placed on his shoulders, the Parthenon performs with apparent facility. Unobtrusive refinements of proportion and line, measurable but not immediately apparent, add to the overall impression of springy vitality: horizontal elements, such as the steps, are not straight but curve upward slightly toward the middle; the columns tilt inward; and the interval between each corner column and its neighbor is smaller than the standard interval used in the rest of the colonnade. Such intentional departures from strict geometric regularity are not made of necessity; they give us visual reassurance that the points of greatest stress are supported, and provided with a counterstress as well.

Shortly afterward an impressive gateway, the Propylaea (fig. 50), was built upon the rough, irregular hill which one has to climb to reach the Parthenon. It is fascinating to see how the familiar elements of the Doric order are here adapted to a totally different purpose and a difficult terrain. The architect

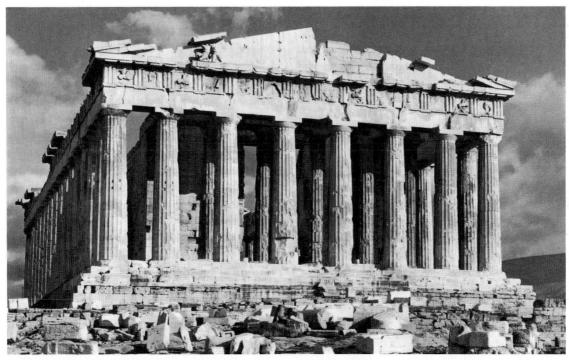

49. Ictinus and Callicrates. The Parthenon (view from the west), Acropolis, Athens. 448-432~B.C.

50. The Propylaea (view from the west; 437-432~B.C.) by Mnesicles and the Temple of Athena Nike (upper right; 427-424~B.C.), Acropolis, Athens.

has acquitted himself nobly: not only does the gateway fit the steep and craggy hillside, it transforms it from a rude passage among the rocks into a majestic overture to the sacred precinct above.

Ionic Order

Next to the Propylaea is the elegant little Temple of Athena Nike (fig. 50, right), displaying the slenderer proportions and the scroll capitals of the Ionic order. The previous development of the order is known only in very fragmentary fashion, and it did not really become an order in the strict sense until the Classical period. Even then it continued to be rather more flexible than the Doric order. In pre-Classical times, the only Ionic structures on the Greek mainland had been the small treasuries built by eastern Greek states at Delphi in their regional styles. Hence the Athenian architects who took up the Ionic order about 450 B.C. thought of it, at first, as suitable only for small temples of simple plan. Such a building is the Temple of Athena Nike, probably built 427-424 B.C. from a design prepared twenty years earlier by Callicrates. Its most striking feature is the Ionic column, which differs from the Doric not only in body but also in spirit (see fig. 46). The column rests on an ornately profiled base of its own; the shaft is more slender, and there is less tapering and swelling; the capital shows a large double scroll, or volute, between the echinus and abacus, which projects strongly beyond the width of the shaft. That these details add up to an entity very distinct from the Doric column becomes clear as soon as we turn from the diagram to an actual building. How shall we define it? The Ionic column is, of course, lighter and more graceful than its mainland cousin; it lacks the latter's muscular quality. Instead, it evokes the echo of a growing plant, of something like a formalized palm tree. And this vegetal analogy is not sheer fancy, for we have early ancestors, or relatives, of the Ionic capital that

bear it out. If we were to pursue these plant-like columns all the way back to their point of origin, we would eventually find ourselves at Saqqara, where we encounter not only "proto-Doric" supports but the wonderfully graceful papyrus half-columns of figure 18, with their curved, flaring capitals. It may well be, then, that the Ionic column, too, had its ultimate source in Egypt, but instead of reaching Greece by sea, as we suppose the proto-Doric column did, it traveled a slow and tortuous path by land, through Syria and Asia Minor.

In the end, the greatest achievement of Greek architecture was much more than just beautiful buildings. Greek temples are governed by a structural logic which makes them look stable because of the precise arrangement of their parts. The Greeks tried to regulate their temples in accordance with nature's harmony by constructing them of measured units which were so proportioned that they would all be in perfect agreement. ("Perfect" was as significant an idea to the Greeks as "forever" was to the Egyptians.) Now men could create organic unities, not by copying nature, not by divine inspiration, but by design. Thus their temples seem to be almost alive. They achieved this triumph chiefly by expressing the structural forces active in buildings. In the Classical period, expressions of force and counterforce in both Doric and Ionic temples were proportioned so exactly that their opposition produced the effect of a perfect balancing of forces, and harmonizing of sizes and shapes. This, then, is the real reason why, for so many centuries, the orders have been considered the only true basis for beautiful architecture. They are so perfect that they could not be surpassed, only equaled.

SCULPTURE

While enough examples of metalwork and ivory carvings of Near Eastern and Egyptian origin have been found on Greek soil to ac-

count for their influence on Greek vase painting, the origins of monumental sculpture and architecture in Greece are a different matter. To see such things, the Greeks had to go to Egypt or Mesopotamia. There is no doubt that they did so (we know that there were small colonies of Greeks in Egypt at the time), but this does not explain why the Greeks should have developed a sudden desire during the seventh century B.C., and not before, to create such things for themselves. The mystery may never be cleared up, for the oldest existing examples of Greek stone sculpture and architecture show that Egyptian tradition had already been well assimilated, and that skill to match was not long in developing.

Archaic Style

Let us begin by comparing a late seventhcentury statue of a Greek youth, called a Kouros (fig. 51), with the statue of Mycerinus (see fig. 16). The similarities are certainly striking: in both we note the same cubic character, as though the sculptor were still conscious of the original block of stone; the broad-shouldered, slim silhouettes; the position of the arms with their clenched hands; the stance with the left leg forward; the emphatic rendering of the kneecaps; and the wiglike curls of the Greek boy that resemble the headdress worn by the pharaoh. Judged by the Egyptian level of accomplishment the Archaic Greek example seems somewhat awkward—oversimplified, rigid, less close to nature. But the Greek statue has some virtues that cannot be measured in Egyptian terms. First of all, it is freestanding. In the entire history of art there are no earlier examples of a sculptor's being daring enough to liberate a lifesize figure completely from the surrounding block of stone. What had doubtless started as a timid precaution against breakage of arms, or the crumbling of the legs under the weight of the body, became a convention. Here, however, the artist has carved away every bit of "dead" stone except

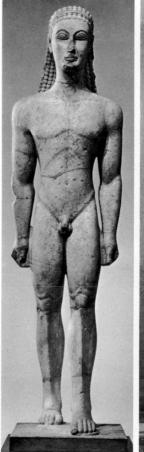

51. (*left*) Standing Youth (Kouros). c. 600 B.C. Marble, height 6'1½". The Metropolitan Museum of Art, New York (Fletcher Fund, 1932)

52. (*right*) "Hera," from Samos. c. 570–560 B.C. Marble, height 6'4". The Louvre, Paris

for the tiny bridges that connect the fists to the thighs. This is a matter not merely of technical daring but of a new intention: it was important to the Greek artist to dissociate his statue from inert matter, the better to approximate the living being that it represented. Unlike Mycerinus, who looks as though he could stand in the same pose till the end of time, the Kouros is tense with a vitality that seems to promise movement. The calm, distant gaze of the Egyptian prince has been replaced by larger-than-life, wideopen eyes that remind us of early Mesopotamian art (see fig. 27).

53. Maiden, from Chios (?). c. 520 B.C. Marble, height 21%. Acropolis Museum, Athens

Statues of the Kouros type were produced in great quantity during the Archaic period, destined for temple offerings or graves. Like the decorated vases of the period, some of them were signed ("So-and-so made me"); but whether they represent gods, or donors, or victors in athletic games, nobody knows for sure. Since they vary but little in their essen-

tials, we assume that they were meant to represent an ideal—a godlike man, or a manlike god.

The male figures show best the innovations that give Greek sculpture its particular character, but there is no dearth of female statues of the same period. Since these were invariably clothed, skirts and shawls fill in those empty spaces that make the contrast so clear between Greek sculpture and all that came before it. Nevertheless, the Kore, as the female statue type is called, shows more variations than the Kouros. In part these are due to local differences in dress, but the drapery itself posed a problem—how to relate it to the body—and artists solved it in various ways. The "Hera" (fig. 52), so called because of her impressive size and because she was found in the ruins of the Temple of Hera on the island of Samos, is slightly later than our Kouros (see fig. 51). This smooth-skirted figure with the folds of her hem fanning out over a circular base seems to have evolved from a column rather than from a rectangular block. But the majestic effect of the statue depends not so much on its closeness to an abstract shape as on the way the column has blossomed forth with the swelling softness of a living body. Following the unbroken upward sweep of the lower folds of drapery, the eye slows to the gently curving hips, torso, and breast. If we turn back to figure 16, we realize suddenly that Mycerinus' wife, with far more explicit anatomy, looks squat and lifeless by comparison.

The maiden of figure 53 in many ways seems akin to the "Hera" from Samos: in fact, she probably came from Chios, another island of Ionian Greece. The architectural grandeur of her ancestress has now given way to ornate, refined grace. The garments still loop around the body in spiraling curves, but the intricate play of folds and pleats has become almost an end in itself. The maiden's hair has been given a similar treatment, and her face wears a soft, almost natural expression—the so-called "Archaic smile."

54. Battle of Gods and Giants, portion from the north frieze of the Treasury of the Siphnians, Delphi. c. 530 B.C. Marble, height 26". Museum, Delphi

Architectural Sculpture

When the Greeks began to build their temples in stone, they fell heir to age-old traditions of architectural sculpture as well. The Egyptians covered the walls and even the columns of their buildings with reliefs, but these carvings were so shallow that they had no weight or volume of their own. The guardian figures of the Lion Gate at Mycenae are of a different type (see fig. 39): although they are carved in high relief on a huge slab, this slab is thin and light compared to the Cyclopean blocks around it. In building the gate, the architect had left an empty triangle

above the lintel, for fear that the weight of the wall above would crush it, and then filled the hole with the relief panel. This kind of architectural sculpture is a separate entity, not merely a modified wall surface. The Greeks followed the Mycenaean example—in their temples, stone sculpture is confined to the pediment (the "empty triangle" between the ceiling and the sloping sides of the roof) and to the zone immediately below it (the "frieze")—but they retained the narrative wealth of Egyptian reliefs. The *Battle of Gods and Giants* (fig. 54), part of a frieze, is

55. Dying Warrior, from the east pediment of the Temple at Aegina. c. 490 B.C. Marble, length 6'. Glyptothek, Munich

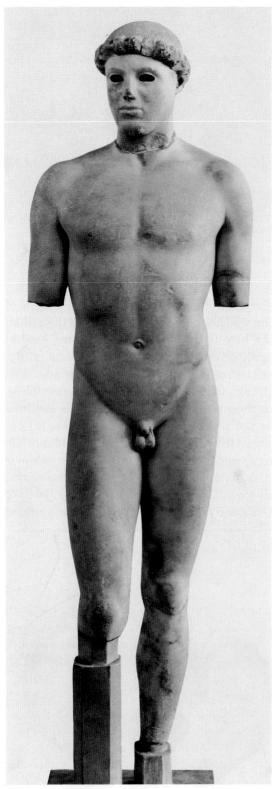

56. Standing Youth (The Kritios Boy). c. 480 B.C. Marble, height 34". Acropolis Museum, Athens

executed in very high relief with deep undercutting (the hind leg of one of the lions has broken off because it was completely detached from the background). The sculptor has taken full advantage of the spatial possibilities of this bold technique; the projecting ledge at the bottom has become a stage on which to place the figures in depth. As they recede from us, the carving becomes shallower, yet even the farthest plane is not allowed to merge into the background. The result is a condensed but very convincing space that permits a dramatic interplay among the figures such as we have not seen before. Not only in the physical but in the expressive sense, a new dimension has here been conquered.

Meanwhile, in pedimental sculpture, relief has been abandoned altogether. Instead, we find separate statues placed side by side in complex dramatic sequences designed to fit the triangular frame. The most ambitious ensemble of this kind, that of the east pediment of the Temple at Aegina, was created about 490 B.C., and thus brings us to the final stage in the evolution of Archaic sculpture. The figures were found in pieces on the ground and are now in the Glyptothek in Munich. Among the most impressive is the fallen warrior from the left-hand corner (fig. 55), whose lean, muscular body seems marvelously functional and organic. That in itself, however, does not explain his great beauty, much as we may admire the artist's command of the human form in action. What really moves us is his nobility of spirit, whether in the agony of dying or in the act of killing. This man, we sense, is suffering-or carrying out-what fate has decreed, with tremendous dignity and resolve. And this communicates itself to us in the very feel of the magnificently firm shapes of which he is composed.

Classical Style

Sometimes things that seem simple are the hardest to achieve. Greek sculptors of the Late Archaic period (see figs. 51, 54) were

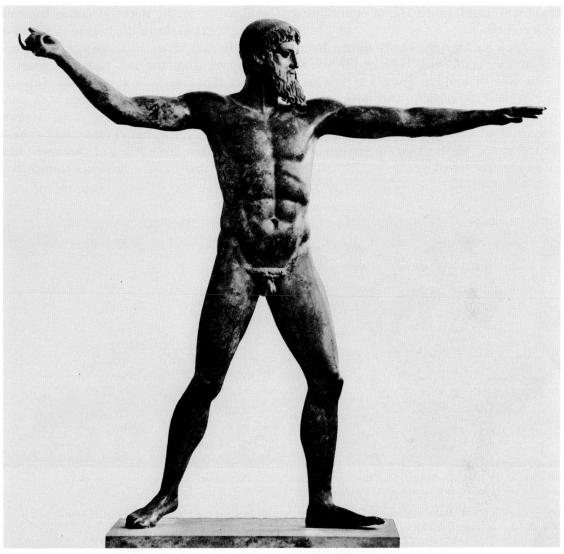

57. Poseidon (Zeus?). c. 460-450 B.C. Bronze, height 6'10". National Museum, Athens

adept at representing battle scenes full of struggling, running figures, but their free-standing statues also have an unintentional military air, as of soldiers standing at attention. It took over a century after our Kouros was made before the Greeks discovered the secret of making a figure stand "at ease." *The Kritios Boy* (fig. 56), named after the Athenian sculptor to whom it has been attributed, is the first statue we know that "stands" in the full sense of the term. Just as in military drill, this is simply a matter of allowing the weight of the body to shift from equal distri-

bution on both legs (as is the case with the Kouros, even though one foot is in front of the other), to one leg. The resulting stance—called *contrapposto* (or counterpoise)—brings about all kinds of subtle curvatures: the bending of the "free" knee results in a slight swiveling of the pelvis, a compensating curvature of the spine, and an adjusting tilt of the shoulders. Like the refined details of the Parthenon, these variations have nothing to do with the statue's ability to maintain itself erect but greatly enhance its lifelike impression; in repose, it will still seem capa-

ble of movement; in motion, of maintaining its stability.

Life now suffuses the entire figure; hence the Archaic smile, the "sign of life," is no longer needed, and has given way to a serious, pensive expression. The forms, moreover, have a new naturalism and harmonious proportion which together provide the basis for the strong idealization characteristic of all subsequent Greek art. Stability in the midst of action becomes outright grandeur in the bronze *Poseidon* or *Zeus* (fig. 57), an over-lifesize statue that was recovered from the sea near the coast of Greece. The pose, to be sure, is that of an athlete, but it is not merely a moment in some continuing exercise; rather, it is an aweinspiring gesture that reveals the power of the god. Here, the hurling of a weapon (originally, we may be sure, he held a thunderbolt

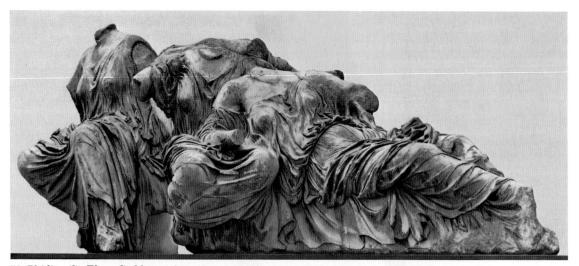

58. Phidias (?). *Three Goddesses*, from the east pediment of the Parthenon. c. 438–432 B.C. Marble, over lifesize. British Museum, London

59. Scopas (?). *Greeks Battling Amazons*, portion from the east frieze of the Mausoleum, Halicarnassus. 359–351 B.C. Marble, height 35". British Museum, London

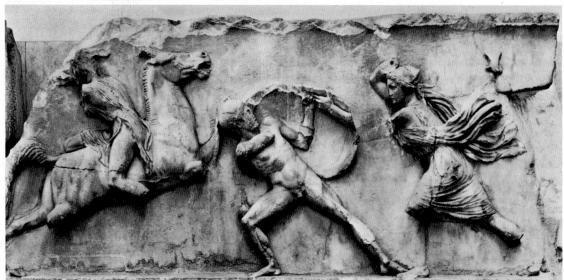

or a trident in his right hand) is a divine attribute, not an act of war.

Battered though it is, the group of *Three* Goddesses (fig. 58) that originally belonged to the scene in the east pediment of the Parthenon, showing the birth of Athena from her father's head, is a good example of that other quality mentioned above: the possibility of action even in repose. Though all are seated, or even half-reclining, the turning of the bodies under the elaborate folds of their costumes makes them seem anything but static. In fact they seem so capable of arising that it is hard to imagine them "shelved" up under the gable. Perhaps the sculptors who achieved such lifelike figures also found this incongruous; at any rate, the sculptural decoration of later buildings tended to be placed in areas where they would seem less boxed in.

This Athenian style, so harmonious in both feeling and form, did not long survive the defeat of Athens by Sparta in the Peloponnesian War. Building and sculpture continued in the same tradition for another three centuries, but without the subtleties of the Classical age whose achievements we have just discussed. The post-Classical, or "Hellenistic," style spread far and wide around the Mediterranean shores, but in a sense it turned backward to the scenes of violent action so popular in the Archaic period. Scopas, who was very probably the sculptor of the frieze showing Greeks Battling Amazons (fig. 59), was familiar with the figure style of the Parthenon, but he has rejected its rhythmic harmony, its flow of action from one figure to the next. His sweeping, impulsive gestures require a lot of elbow room. Judged by Parthenon standards, the composition lacks continuity, but it makes up for this in bold innovation (note, for instance, the Amazon seated backward on her horse) as well as heightened expressiveness.

In many more instances than we would like, the most famous works of Greek sculptors of the fifth and fourth centuries B.C. have been lost and only copies are preserved.

There is some doubt whether the famous Hermes by Praxiteles (fig. 60) is the original, or a copy made some three centuries later. If it is the latter, however, it is a very skillful copy, for it fits perfectly the qualities for which Praxiteles was admired in his own day. The lithe grace, the play of gentle curves, the feeling of complete relaxation (enhanced by an outside support for the figure to lean against) are quite the opposite of Scopas' energetic innovations. The Hermes' bland, lyrical charm is further enhanced by the caressing treat-

60. Praxiteles. *Hermes*. c. 330–320 B.C. (or copy?). Marble, height 7'1". Museum, Olympia

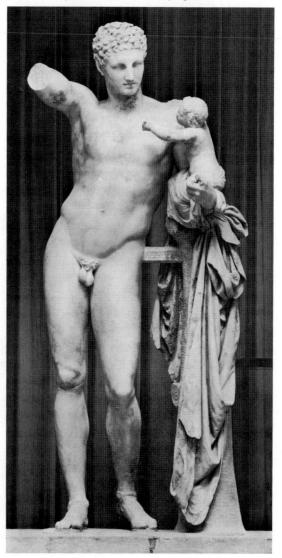

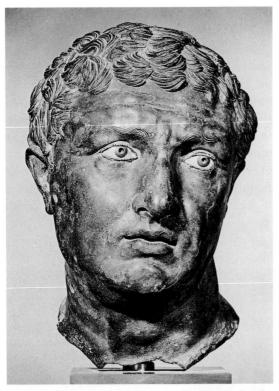

61. Portrait Head, from Delos. c. 80 B.C. Bronze, height 12¾". National Museum, Athens

ment of the surfaces: the meltingly soft, "veiled" features, and even the hair, which has been left comparatively rough for contrast, all share a misty, silken quality. Here, for the first time, there is an attempt to modify the stony look of a statue by giving to it this illusion of an enveloping atmosphere.

Hellenistic Style

Compared to Classical statues, the sculpture of the Hellenistic age often shows a more pronounced realism and expressiveness, as well as a greater experimentation with drapery and pose, which often exhibits considerable torsion. These changes should be seen as a valid, even necessary, attempt to extend the subject matter and dynamic range of art in accordance with a new temperament and outlook. The difference in psychology is suggested by the *Portrait Head* in figure 61. The serenity of Praxiteles' *Hermes* is replaced by a troubled look. And for the first time, this is

62. *Dying Gaul.* Roman copy after a bronze original of c. 230–220 B.C., from Pergamum. Marble, lifesize. Capitoline Museum, Rome

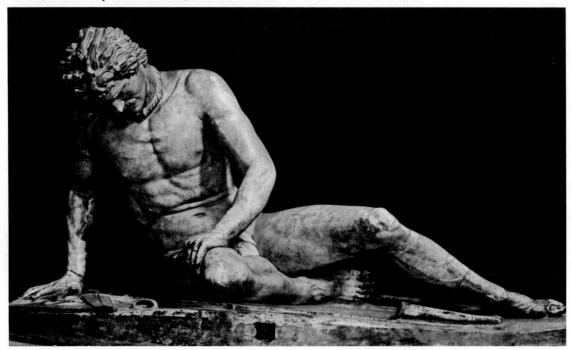

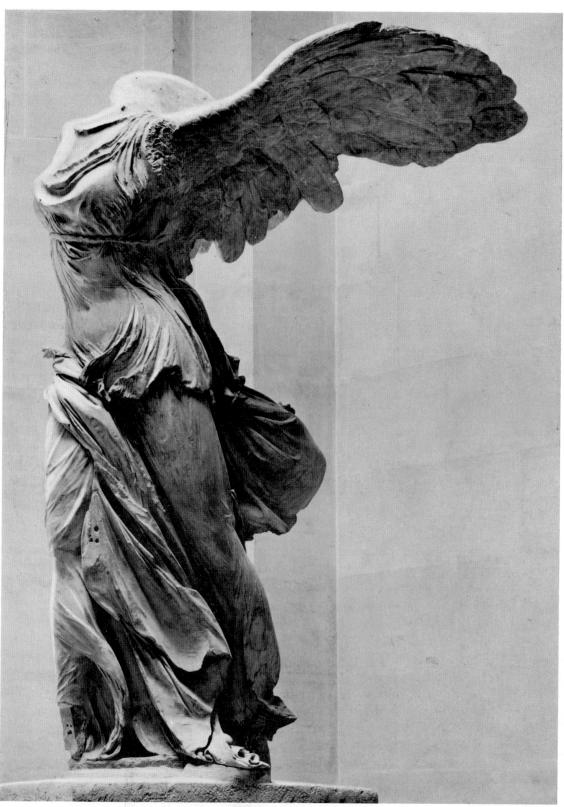

63. Nike of Samothrace. c. 200–190 ${\tt B.C.}$ Marble, height 8'. The Louvre, Paris

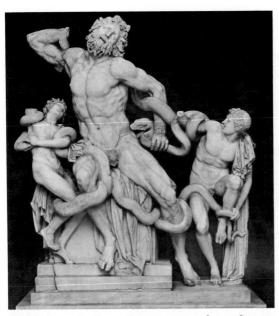

64. The Laocoön Group. Roman copy, perhaps after Agesander, Athenodorus, and Polydorus of Rhodes (present state, former restorations removed). 1st century A.D. Marble, height 7'. Vatican Museums, Rome

an individual portrait, something that was inconceivable in earlier Greek art, which emphasized ideal, heroic types. The features have an unprecedented softness as well, and must have been modeled in wax, not clay, before being cast.

This more human conception is found again in the Dying Gaul (fig. 62), an ancient copy in marble of one of a number of bronze statues dedicated by Attalus I of Pergamum (a city in northwestern Asia Minor) shortly before 200 B.C. to commemorate his victory over invading Gauls. The sculptor who conceived the figure must have known the Gauls well, for he has carefully rendered the ethnic type in the facial structure and in the bristly shock of hair. The torque around the neck is another characteristically Celtic feature. Otherwise, however, the Gaul shares the heroic nudity of Greek warriors, such as those on the Aegina pediments (see fig. 55); and if his agony seems infinitely more realistic in comparison, it still has considerable dignity and pathos. Clearly, the Gauls were not considered unworthy foes. "They knew how to die, barbarians though they were," is the thought conveyed by the statue. Yet we also sense something else, an animal quality that had never before been part of the Greek image of man. Death, as we witness it here, is a very concrete physical process: no longer able to move his legs, the Gaul puts all his waning strength into his arms, as if to prevent some tremendous invisible weight from crushing him against the ground.

Even more dramatic is the Nike of Samothrace (fig. 63)—the goddess of victory who has just alighted on the prow of a warship; her great wings spread wide, she is still partially airborne by the powerful headwind against which she advances. The invisible force of onrushing air becomes a tangible reality that balances the forward thrust of the figure and shapes every fold of the wonderfully animated drapery. This is not merely a relationship between the statue and the space which the sculptor imagined it inhabiting, but an interdependence more active than we have seen before. Nor shall we see it again for a long time. The Nike deserves her fame as the greatest work of Hellenistic sculpture.

By the end of the second century B.C. much of Greek sculpture was made on commission for Rome, the rising power of the Mediterranean region and a center of great admiration for Greek learning and art. The Laocoön Group (fig. 64) was dug up in Rome in 1506. Long accepted as a Greek original and identified with a group by Agesander, Athenodorus, and Polydorus of Rhodes that the Roman writer Pliny mentions, now it is thought to be a Roman copy or reconstruction of a Late Hellenistic work. The piece made a tremendous impression upon Italian sculptors, notably Michelangelo, at the time it was unearthed. Today we tend to find the group (which had special significance for the founding of Rome) somewhat contrived and its pathos and dynamism self-conscious, even though the straining figures remind us of the dramatic style invented by Scopas.

Etruscan Art

Strange as it may seem, we know very little about the early Etruscans. According to the Classical Greek historian Herodotus, they left their homeland of Lydia in Asia Minor and settled in the area between Florence and Rome which is known to this day as Tuscany. But they may be a people whose presence on Italian soil goes back much further. If so, the sudden flowering of Etruscan civilization from about 700 B.C. onward could have resulted from a fusion of this prehistoric Italian stock with small but powerful groups of seafaring invaders from Lydia during the course of the eighth century. Interestingly enough, such a hypothesis comes very close to the legendary origin of Rome.

Be that as it may, the Italian peninsula did not emerge into the light of history until fairly late. The Bronze Age came to an end there only in the eighth century B.C., about the time the earliest Greeks began to settle along the southern shores of Italy and in Sicily. The seventh and sixth centuries B.C. saw the Etruscans at the height of their power, which extended over a large part of central Italy. But the Etruscans, like the Greeks, never formed a unified nation, and they were never more than a loose federation of city-states. By the end of the third century B.C., all of them lost their independence to Rome, which had once been ruled by Etruscan kings.

Sculpture

Etruscan civilization thus coincides largely with the Archaic age in Greece. It was during this period, especially toward the end of the sixth and in the early years of the fifth century, that Etruscan art showed its greatest vigor under the Greek Archaic influence. But

Etruscan artists did not simply imitate their Hellenic models, as we can see from the *Apollo* in figure 65, which has long been acknowl-

65. Apollo, from Veii. c. 510 B.C. Terra-cotta, height 69". Museo Nazionale di Villa Giulia, Rome

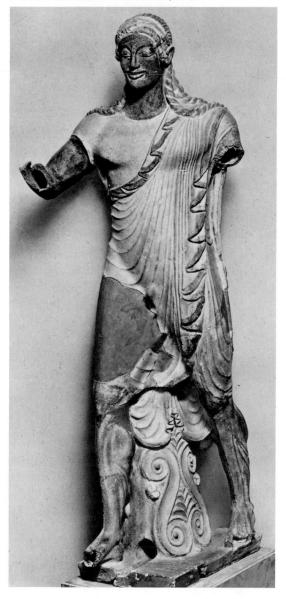

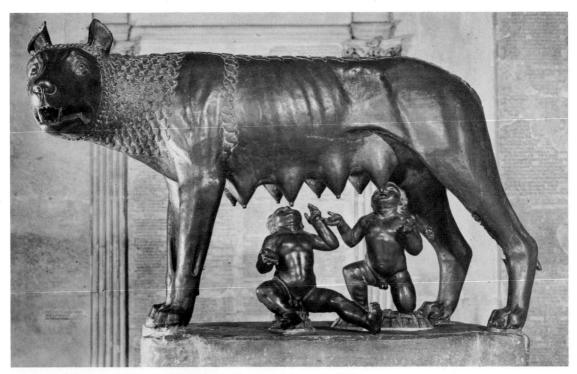

66. She-Wolf. c. 500 B.C. Bronze, height 331/2". Capitoline Museum, Rome

edged as the masterpiece of Etruscan Archaic sculpture. His massive body, completely revealed beneath the ornamental striations of the drapery; the sinewy, muscular legs; the hurried, purposeful stride—all these betray an expressive power that has no counterpart in freestanding Greek statues of the same date. Likewise, the famous bronze statue of a she-wolf (fig. 66; the two infants are Renaissance additions) has the same awesome quality in the wonderful ferocity of her expression and the latent physical power of the body and legs.

Tombs

We would know practically nothing about the Etruscans at first hand were it not for their elaborate tombs, which the Romans did not molest when they destroyed or rebuilt Etruscan cities and which, therefore, have survived intact until modern times. Those of the late sixth and early fifth centuries B.C. are filled with a wonderfully rich array of murals. Since nothing of the sort has survived in Greek territory, they are uniquely important, not only as an Etruscan achievement, but also as a possible reflection of Greek wall painting. Figure 67 shows a pair of ecstatic dancers from a tomb in Tuscany; the passionate energy of their movements strikes us as characteristically Etruscan rather than Greek in spirit. Of particular interest is the transparent garment of the woman, which lets the body shine through. In Greece, this differentiation appears only a few years earlier, in the final phase of Archaic vase painting. The contrasting body color of the two figures continues a practice introduced by the Egyptians more than two thousand years before (see fig. 14). But how are we to understand the purpose of such murals? We do not know precisely what ideas the Archaic Etruscans held about man's afterlife. They may have regarded the tomb as an abode not only for the body but for the soul as well. Or perhaps they believed that by filling the tomb with dancing and similar pleasures they

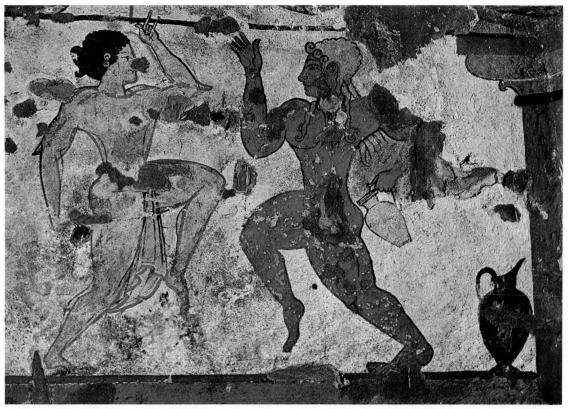

67. Two Dancers (detail of wall painting). c. 480-470 B.C. Tomb of the Lionesses, Tarquinia

could induce the soul to remain in the city of the dead and, therefore, not haunt the realm of the living.

During the fifth century, the Etruscan view of the hereafter must have gradually become a good deal more complex and less festive. We notice the change immediately in a cinerary container carved soon after 400 B.C. (fig. 68). A woman sits at the foot of the couch, but she is not the wife of the young man. Her wings indicate that she is the demon of death, and the scroll in her left hand records the fate of the deceased. The young man is pointing to it as if to say, "Behold, my time has come." The thoughtful, melancholy air of the two figures may be due to some extent to the influence of Classical Greek art which pervades the style of our group. At the same time, however, a new mood of uncertainty and regret is reflected: man's destiny is in the hands of inexorable supernatural forces; death is the great divide rather than a continuation, albeit on a different plane, of life on earth. In later tombs, the demons of death gain an ever more fearful aspect; other, more terrifying demons enter the scene, often battling against benevolent spirits for possession of the soul of the deceased.

68. Youth and Demon of Death (cinerary container). Early 4th century B.C. Stone (pietra fetida), length 47". Archaeological Museum, Florence

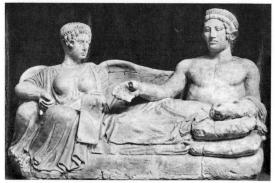

Roman Art

Among the civilizations of the ancient world. that of the Romans is far more accessible to us than any other, for they have left us a vast literary legacy which permits us to trace their history with a wealth of detail that never ceases to amaze us. Yet, paradoxically, few questions are more difficult to answer than "What is Roman art?" The Roman genius, so clearly recognizable in every other sphere of human activity, becomes oddly elusive when we ask whether there was a characteristic Roman style in the fine arts. Why is this so? The most obvious reason is the great admiration the Romans had for Greek art of every period and variety. Not only did they import Greek originals of earlier date by the thousands and have them copied in even greater numbers, their own productions were clearly based on Greek sources, and many of their artists were of Greek origin. But beyond the different subject matter, the fact is that, as a whole, the art produced under Roman auspices does look distinctly different from Greek art and has positive non-Greek qualities expressing different intentions. Thus we must not insist on evaluating Roman art by the standards of Greek art, next to which it might superficially appear to be a final decadent phase. The Roman Empire was an extraordinarily open, cosmopolitan society which absorbed national or regional traits into a common all-Roman pattern that was homogeneous and diverse at the same time. The "Roman-ness" of Roman art must be found in this complex pattern, rather than in a single and consistent quality of form.

ARCHITECTURE

If the autonomy of Roman sculpture and painting has been questioned, Roman archi-

tecture is a creative feat of such magnitude as to remove all such doubts. From the very start its growth reflected a specifically Roman way of public and private life. The Romans learned a great deal about the art of building from the Etruscans. According to Roman writers the Etruscans were masters of architectural engineering, of town planning, and of surveying. Little remains aboveground of either Etruscan or early Roman architecture; but such works as we have, plus the information collected from recent excavations, show that the Etruscans were, in fact, highly skilled builders. This heritage was to be of particular importance as Rome expanded her rule around the shores of the Mediterranean and toward the less populous north of Europe, building new cities to serve as seats of colonial government. Perhaps the single most important feature of this Etruscan legacv was the true arch, made up of wedgeshaped sections that lock each other securely in place. Not that the Etruscans invented the arch: its use dates as far back as the Egyptians, but they, and the Greeks after them, seem to have considered it merely a useful "beast of burden," and not a form beautiful enough to be used for its own sake. In ancient Mesopotamia it occasionally appeared aboveground in city gates; but it remained for the Etruscans to make it fully "respectable."

The growth of the capital city of Rome is hardly thinkable without the arch and the vaulting systems derived from it: the barrel vault—a half-cylinder; the groin vault, which consists of two barrel vaults intersecting each other at right angles; and the dome.

Greek buildings, however beautiful, were seldom built with a view to accommodating a large crowd of people under one roof; even the temples were considered houses of the gods rather than gathering places for worshipers. Whether the Romans became "indoor people" because of the climate, which seems to have been colder in those days than it is now (forests populated with wolves and bears extended nearly the whole length of the peninsula), or whether the sheer numbers of the population necessitated large administrative buildings and gathering places, the fact remains that Greek models, although much admired, no longer sufficed. Small buildings, such as a votive chapel or a family mausoleum, might imitate a Greek example; but when it came to supplying the citizenry with everything it needed, from water to entertainment on a vast scale, radical new forms had to be invented, and cheaper materials and quicker methods had to be used.

Colosseum

The Colosseum (fig. 69), a huge amphitheater in the center of the old city which could seat fifty thousand spectators, is still one of the largest buildings anywhere. Its core is made of a kind of concrete, and it is a masterpiece of engineering and efficient planning, with miles of vaulted corridors to ensure the smooth flow of traffic to and from the arena. It utilizes the arch, the barrel vault, and the groin vault. The exterior, dig-

nified and monumental, reflects the subdivisions of the interior, but clothed and accentuated in cut stone. There is a fine balance between the vertical and horizontal members that frame the endless series of arches. Reverence for Greek architecture is still visible in the use of half-columns and pilasters reflecting the Greek orders; structurally these have become ghosts—the building would still stand if one stripped them off—but aesthetically they are important, for through them the enormous façade becomes related to the human scale.

Pantheon

The same innovations in engineering and materials permitted the Romans to create vast covered spaces as well. The best preserved of these is the Pantheon (figs. 70, 71), a very large, round temple dedicated, as the name indicates, to all the gods. The portico, originally preceded by a colonnaded forecourt which blocked off the view we now have of the circular walls, looks like the standard entrance to a typical Roman temple (derived from Greek temple façades, with columns in the Corinthian order). All the more breathtaking, then, is the sight as we step through the tall portals, and the great domed space opens before us with dramatic suddenness.

69. The Colosseum, Rome. 72-80 A.D.

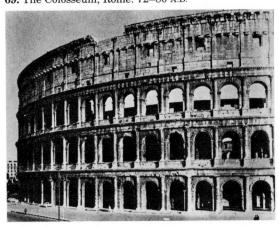

70. The Pantheon, Rome. 118-25 A.D.

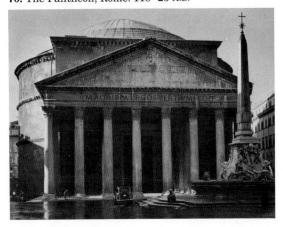

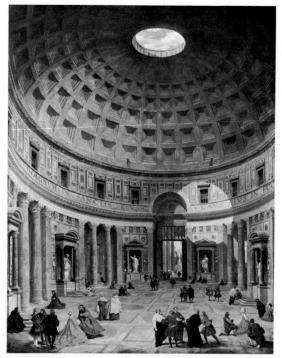

71. The Interior of the Pantheon, painting by G. P. Pannini, c. 1750 A.D. National Gallery of Art, Washington, D.C. (Kress Collection)

That the architects did not have an easy time with the engineering problems of supporting the huge hemisphere of a dome may be deduced from the heavy plainness of the exterior wall. Nothing on the outside gives any hint of the airiness and elegance of the interior; photographs fail to capture it, and even the painting (fig. 71) that we use to illustrate it does not do it justice. The height from the floor to the opening of the dome (called the "oculus," or "eye") is exactly that of the diameter of the dome's base, thus giving the proportions perfect balance. The weight of the dome is concentrated on the eight solid sections of wall; between them, with graceful columns in front, niches are daringly hollowed out of the massive concrete, and these, while not connected with each other, give the effect of an open space behind the supports, making us feel that the walls are less thick and the dome much lighter than is actually the case. The multicolored marble panels and

paving stones are still essentially as they were, but originally the dome was gilded to resemble "the golden dome of heaven."

Though it is hard to believe, the essential features of this awesome temple were already described (although on a smaller scale) a century earlier by the architect Vitruvius—for the construction of steam rooms in public baths. In these, the oculus could be covered by a bronze lid that opened and closed to regulate the temperature. Nor was the Pantheon the only huge building to be derived from similar designs for the popular bath establishments that were placed conveniently in various quarters of the city. The Basilica of Constantine (fig. 72), probably the largest roofed space in ancient Rome, is another example. Only one side, consisting of three enormous barrel vaults, still stands today; the center tract (or "nave") was covered by three groin vaults and rose a good deal higher. Since a groin vault is like a canopy, with all the weight concentrated at the four corners, the wall surfaces in between could be pierced by windows, called a "clerestory." Like the niches in the Pantheon, these helped break up the ponderous mass and made it seem less overpowering. We meet echoes of this vaulting system in many later buildings, from churches to railway stations.

72. The Basilica of Constantine, Rome. c. 310-20 A.D.

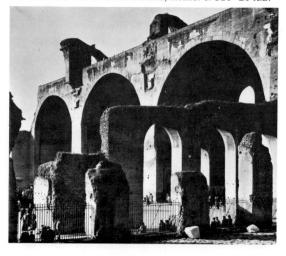

Palace of Diocletian

In discussing the new forms based on arched, vaulted, and domed construction, we have noted the Roman architect's continued allegiance to the Classical Greek orders. While he no longer relied on them in the structural sense, he remained faithful to their spirit; column, architrave, and pediment might be merely superimposed on a vaulted brick-andconcrete core, but their shape, as well as their relationship to each other, still followed the original grammar of the orders. Only when the Roman Empire was in decline did this reverential attitude give way to unorthodox ideas, as in the Palace of Diocletian (fig. 73) on the coast of present-day Yugoslavia. Here the architrave between the two center columns is curved, echoing the arch of the doorway below; on the left we see an even more revolutionary device—a series of arches resting directly on columns. Thus, on the eve of the victory of Christianity, the marriage of arch and column was finally legitimate. Their union, indispensable for the subsequent development of architecture, seems so natural that we wonder why it was ever opposed.

SCULPTURE

Although there is no doubt that the Romans created a bold new architecture, the question of whether they had anything original to give to the field of sculpture has been hotly disputed, and for quite understandable reasons. A taste for opulent decoration, both exterior and interior, led to wholesale importation of Greek statuary, when it could be obtained, or mass copying of Greek—sometimes even of Egyptian—models. There are entire categories of Roman sculpture which deserve to be called "deactivated echoes" of Greek creations, emptied of their former meaning and reduced to the status of refined works of craftsmanship. On the other hand, certain

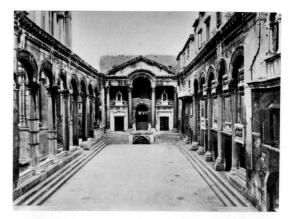

73. Peristyle, Palace of Diocletian, Split, Yugoslavia. c. 300 A.D.

kinds of sculpture had serious and important functions in ancient Rome, and it is these that continue the living sculptural tradition. Portraiture and narrative reliefs are the two aspects of sculpture most conspicuously rooted in the real needs of Roman society.

Portrait Bust

The portrait bust in figure 74, dating from the beginning of the Republican era, is probably one of the first permanent embodiments of a much older tradition that we know about from literary sources. When the head of a prominent family died, a wax image was made of his face, and these images were preserved by subsequent generations and carried in the funeral processions of the family. Starting as ancestor worship back in prehistoric times, this custom became a convenient way to demonstrate the importance and continuity of a family—a habit that continues practically unbroken to our own day in the displaying of family portraits. Wax, however, is a very impermanent material, and for some reason—perhaps a crisis of self-confidence—it became important to the patrician families of Rome in the first century B.C. to put these ancestor likenesses into a more enduring substance. What differentiates the portrait bust illustrated from a late, expressive example of Greek sculpture? Can we say

74. *Portrait of a Roman.* c. 80 B.C. Marble, lifesize. Palazzo Torlonia, Rome

75. Trajan. c. 100 A.D. Marble, lifesize. Museum, Ostia

that it has any new, specifically Roman qualities? At first it may strike us as nothing more than the detailed record of a facial to-

pography, sparing neither wrinkle nor wart. Yet the sculptor has exercised a choice among which wrinkles to emphasize and which features (the jutting lower lip, for instance) to make a little larger-than-life. The face emerges as a specifically Roman personality—stern, rugged, iron-willed. It is a "father image" of frightening authority; one that can be imagined to rule not merely a family, but a colony or even an empire. Perhaps this fierce expression is inherited from Etruscan sculpture (see fig. 66); by contrast, even the agonized face of Laocoön (see fig. 64) seems lacking in forcefulness.

It may seem surprising that when the Republic, under Julius Caesar, gave way to the Empire (shortly after this head was made), portraiture lost something of its intense individuality. Depictions of the emperors such as Trajan (fig. 75), while not lacking in recognizable personality, set the fashion for more heroic and idealized likenesses. One suspects that as the Empire became larger, more complex, and more difficult to govern, the rulers were at great pains to give the impression that they were cool in the face of any and all crises. The Greeks had given the world unsurpassable forms in conjuring up gods in the guise of men; the Romans now went back to these forms to elevate the images of men to the level of gods.

A portrait which succeeds in being human, in the noblest sense of the word, is the equestrian statue of the emperor Marcus Aurelius (fig. 76); as a learned man, his ideal was the ancient Greek "philosopher-king" who ruled by wisdom rather than by force and cunning. Astride his noble horse (which seems, like its master, to control itself rather than to be controlled) he gazes downward at the passerby with an expression of lofty calm tinged with compassion.

Alas, the turmoil of the overextended Empire had already begun. Soon the ruler's supernatural power, whether conferred by divinity or wisdom, no longer seemed plausible, especially (as was increasingly the case

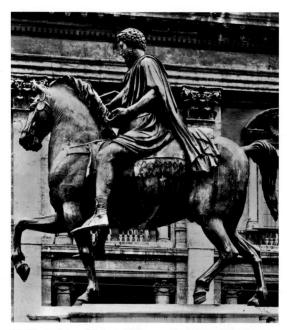

76. Equestrian Statue of Marcus Aurelius. 161–80 A.D. Bronze, over lifesize. Piazza del Campidoglio, Rome

in the third century A.D.) if he had been merely a successful general who attained the throne by overthrowing his predecessor. Such a man was Philippus the Arab (fig. 77), who reigned for five brief years, 244 to 249 A.D. What a portrait it is! For realism, feature by feature, it is as stark as the Republican bust; but here the aim is expressive rather than documentary: all the dark passions of the human mind—fear, suspicion, cruelty stand revealed with a directness that is almost unbelievable. The face of Philippus mirrors all the violence of the time, yet in a strange way it moves us to pity: there is a psychological nakedness about it that recalls a brute creature, cornered and doomed. Clearly, the agony of the Roman world was not only physical but spiritual.

So, too, were the glories of its dwindling years; or so they must have seemed to Constantine the Great (fig. 78), reorganizer of the Roman State and the first Christian emperor. No mere bust, this head is one of several remaining fragments of a colossal statue (the head alone is over eight feet tall) that once

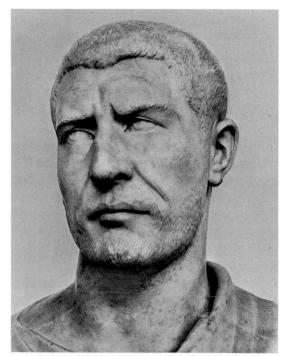

77. Philippus the Arab. 244—49 A.D. Marble, lifesize. Vatican Museums, Rome

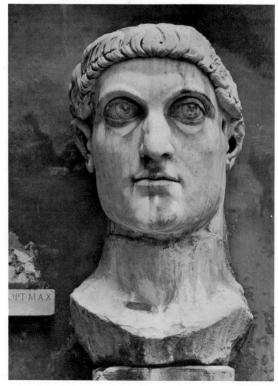

stood in Constantine's gigantic basilica (see fig. 72). In this head everything is so out of proportion to the scale of ordinary men that we feel crushed by its immensity. The impression of being in the presence of some unimaginable power was deliberate, we may be sure, for it is reinforced by the massive, immobile features out of which the huge, radi-

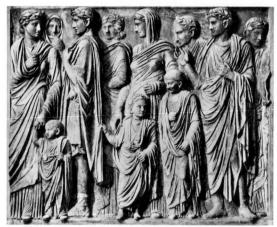

79. Imperial Procession, portion from the frieze of the Ara Pacis, Rome. 13–9 B.C. Marble, height 63"

ant eyes stare with hypnotic intensity. All in all, it tells us less about the way Constantine looked than about his view of himself and his exalted office.

Narrative Relief

It is almost with the feeling of ridding ourselves of an insupportable weight that we turn back to the early years of the Empire to investigate another type of sculpture, the narrative relief. The Ara Pacis, or "peace altar" (fig. 79), was built for Augustus Caesar, nephew and successor to Julius Caesar, and the first to call himself "Emperor." For him. the present and the future looked bright and promising, and he could confidently celebrate Peace, by name and also in spirit. There is a self-assurance about this procession which does not depend upon superhuman intervention, and a kind of joyful dignity that puts us in mind of the Parthenon sculptures when Athens, too, serene in her leadership, could not foresee the bad times so soon to

80. Spoils from the Temple in Jerusalem, relief in the passageway of the Arch of Titus, Rome. 81 A.D. Marble, height 7'10"

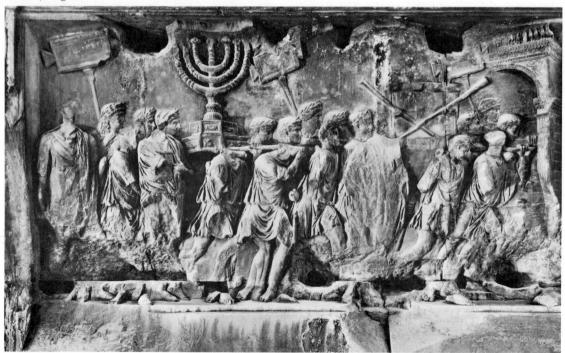

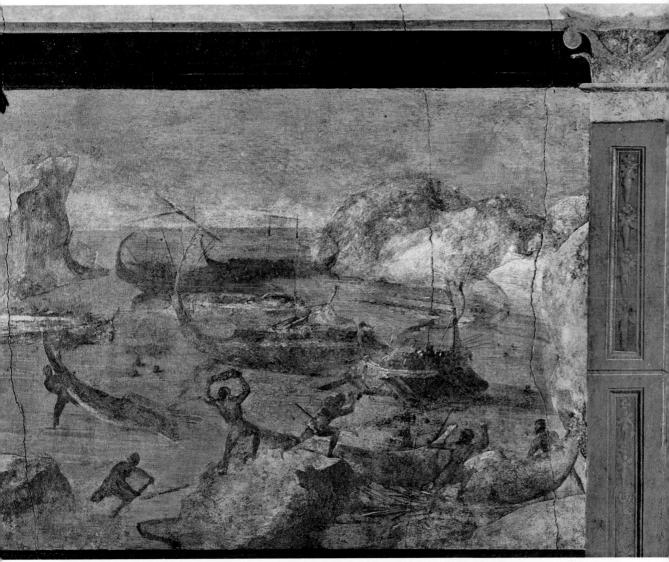

81. The Laestrygonians Hurling Rocks at the Fleet of Odysseus, panel of Odyssey Landscapes, wall painting from a house on the Esquiline Hill. Late 1st century B.C. Vatican Museums, Rome

come. But there are also many things that differentiate the Ara Pacis from its Greek predecessor. The procession here is a specific occasion rather than a timeless and impersonal event. The participants, at least so far as they belong to the imperial family, were meant to be identifiable portraits, including the children dressed in miniature togas, still too young to understand the solemnity of the occasion (note the little boy tugging at the mantle of the young man in front of him,

while turning toward an older child who smilingly tells him to behave). In addition to taking delight in humanizing details, the sculptor has made advances in composition: there is a greater concern to give an illusion of spatial depth than in Greek reliefs, so that some of the faces farthest removed from us (such as the veiled young woman facing the youth whose cloak is being pulled) seem to be embedded in the stone of the background.

This illusion of depth given to a shallow

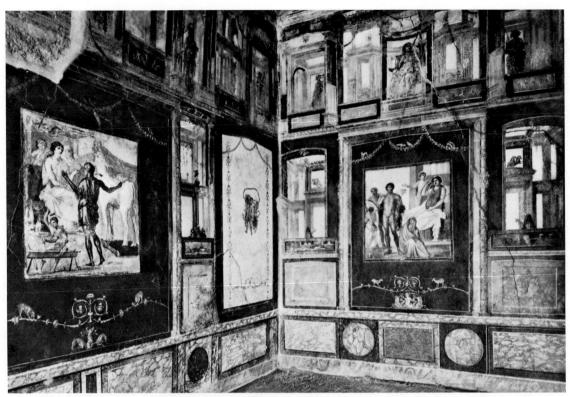

82. The Ixion Room, House of the Vettii, Pompeii. 63-79 A.D.

83. Scenes of a Dionysiac Mystery Cult (wall painting). c. 50 B.C. Villa of the Mysteries, Pompeii (see colorplate on title page)

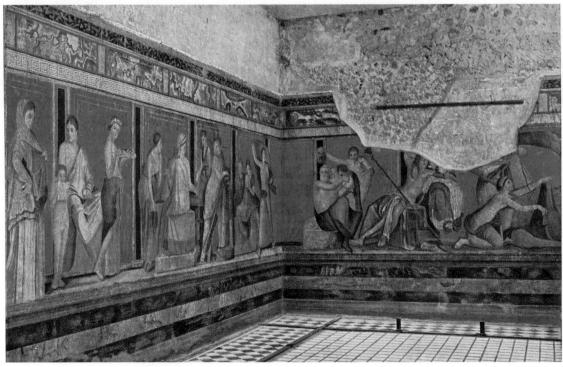

space reached its most complete development in the large narrative panels that formed part of a triumphal arch erected in 81 A.D. to commemorate the victories of the emperor Titus. One of them (fig. 80) shows the victory procession held after Rome conquered Jerusalem; the booty displayed includes the seven-branched candlestick from the temple. and other sacred objects. The forward surge of the crowd is rendered with striking success: on the right, the procession turns away from us and disappears through an arch placed obliquely to the background plane so that only the nearer half actually emerges from it—a radical but effective device for conveying the depth of the scene.

PAINTING

Very little of either Greek or Roman painting has been preserved—and that little is largely thanks to the eruption of Mount Vesuvius in 79 A.D., which buried buildings erected during a relatively short time span, leaving us to wonder what sort of painting came before and after this catastrophe. What does remain is apt to strike the beholder as the most exciting, as well as the most baffling, aspect of art under Roman rule. That famous Greek designs were copied and even Greek painters imported, nobody will dispute; but the number of cases where a direct link can be surely established with the older art is small indeed. We have already seen one example, The Battle of Issus mosaic (see fig. 45).

Frescoes

Movable pictures on panels, such as we think of nowadays when we speak of "paintings," were not frequent in Roman times; or if they were, they have all disappeared like the wax ancestor images. Rather, pictures were included in the fresco decorations (on more permanent surfaces of hard plaster) of interiors, such as the Ixion Room (fig. 82) from the House of the Vettii in Pompeii. While these

scenes hardly ever give the impression of straightforward copies after Hellenistic originals, they often have the somewhat disjointed character of compilations of motifs from various sources. The panels are set into an elaborate ensemble combining imitation (painted) marble paneling and fantastic architectural vistas seen through make-believe windows. The illusion of surface textures and distant views has an extraordinary degree of three-dimensional reality; but as soon as we try to analyze the relationship of the various parts to each other, we find ourselves confused, and we quickly realize that the Roman painters had no systematic grasp of spatial depth.

When landscapes take the place of architectural features, however, the virtues of the Roman painter's approach outweigh its limitations. This is strikingly demonstrated by the Odyssey Landscapes, a continuous stretch of panorama subdivided into eight large panels, each illustrating an episode from the adventures of Odysseus (Ulysses). One of them has been recently cleaned, and is reproduced here in figure 81 to show the original brilliance of the tones. The airy, bluish atmosphere creates a wonderful impression of light-filled space that envelops and binds together all the forms within this warm Mediterranean fairyland, where the human figures seem to play no more than an incidental role. Only upon further reflection do we realize how frail the illusion of coherence is: if we were to try mapping this landscape, we would find it as ambiguous as the architectural decorations discussed above.

Villa of the Mysteries

There exists one monument whose sweeping grandeur of design and coherence of style are unique in Roman painting: the great frieze in one of the rooms in the Villa of the Mysteries just outside Pompeii (fig. 83). The artist who created the frieze in the Villa of the Mysteries has placed his figures on a narrow ledge of

green against a regular pattern of red panels separated by strips of black, a kind of running stage on which they enact their strange and solemn ritual. Who are they, and what is the meaning of the cycle? Many details remain puzzling, but the program as a whole represents various aspects of the Dionysiac Mysteries, a semisecret cult of very ancient origin that had been brought to Italy from Greece. Many of the poses and gestures are taken from the repertory of Classical Greek art, yet they lack the studied and self-conscious quality we call Classicism. An artist of exceptional greatness of vision has filled these forms with new life. Whatever his relation to the famous masters of Greek painting whose works are lost to us forever, he was their legitimate heir.

Portraits

It would be strange indeed if portraiture, which forms such an outstanding part of Rome's particular contribution to the history of sculpture, had not also existed in painting. Pliny, the Roman historian, mentions it as an

established custom in Republican Rome. A few miniatures, painted on glass, have survived from the third century A.D., or later; however, if we want to get some idea of what Roman painted portraits looked like we must turn, strangely enough, to Egypt. There, in the region of the Faiyum, a strange Romanized version of the traditional Egyptian mummy-case has been found. Before Egypt came under Roman dominion, the heads of mummy-cases were provided with conventionalized masks, modeled in stone, wood, or plaster; now these were replaced by painted portraits of the dead, executed in lifelike colors on wooden panels. The very fine portrait of a boy (fig. 84) is as sparkling and natural as anyone might wish, exhibiting a sureness of touch on the part of the artist that has rarely been surpassed. As in the sculptured busts, the artist has magnified and stressed certain features: the eyes, for example, are exaggeratedly large. But in this happy instance the stylization has not been made with the intention of overawing us (as in the case of Constantine's hypnotic stare, fig. 78), but only to recall the attractive personality of a beloved child.

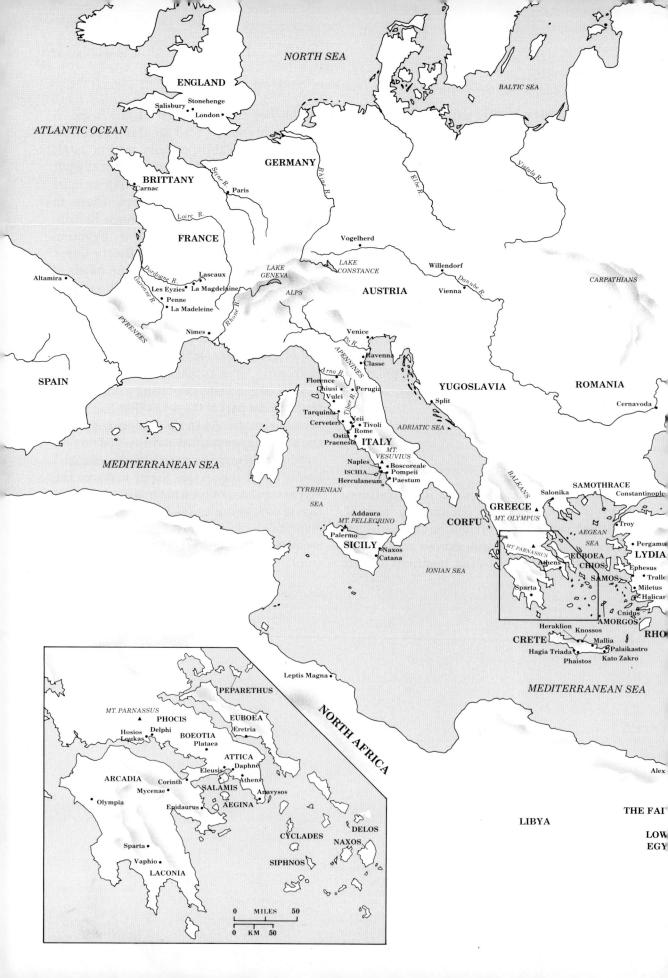

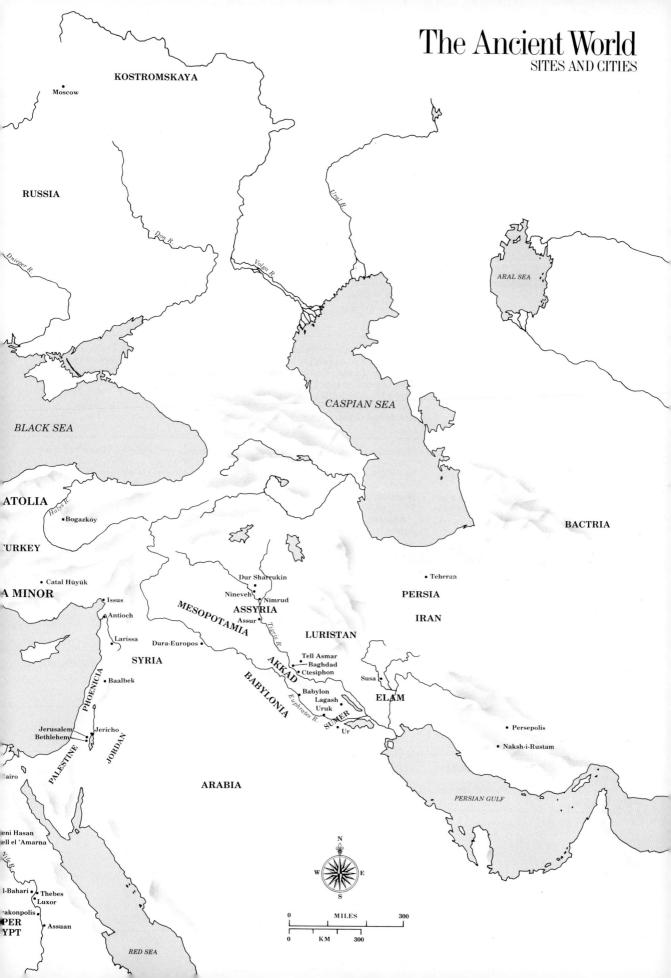

Synoptic Table I

]	POLITICAL HISTORY	RELIGION, LITERATURE	SCIENCE, TECHNOLOGY
-	Sumerians settle in lower Mesopotamia	Pictographic writing, Sumer, c. 3500	Wheeled carts, Sumer, c. 3500–3000 Sailboats used on Nile c. 3500 Potter's wheel, Sumer, c. 3250
	Old Kingdom, Egypt (dynasties I–VI), c. 3100–2155 Early dynastic period, Sumer, c. 3000– 2340; Akkadian kings 2340–2180	Hieroglyphic writing, Egypt, c. 3000 Cuneiform writing, Sumer, c. 2900 Divine kingship of the pharaoh Theocratic socialism in Sumer	First bronze tools and weapons, Sumer
		Calcof Hammunghi e 1760	Bronze tools and weapons in Egypt
	Middle Kingdom, Egypt, 2134–1785 Hammurabi founds Babylonian dynasty c. 1760 Flowering of Minoan civilization c. 1700– 1500 New Kingdom, Egypt, c. 1570–1085	Code of Hammurabi c. 1760 Monotheism of Akhenaten (r. 1372–1358) Book of the Dead, first papyrus book, XVIII Dynasty	Canal from Nile to Red Sea Mathematics and astronomy flourish in Babylon under Hammurabi Hyksos bring horses and wheeled vehicle to Egypt c. 1725
	Jerusalem capital of Palestine; rule of David; of Solomon (died 926) Assyrian Empire c. 1000–612 Persians conquer Babylon 539; Egypt 525 Romans revolt against Etruscans, set up republic 509	Hebrews accept monotheism Phoenicians develop alphabetic writing c. 1000; Greeks adopt it c. 800 First Olympic games 776 Homer (fl. c. 750–700), Illiad and Odyssey Zoroaster, Persian prophet (born c. 660) Aeschylus, Greek playwright (525–456)	Coinage invented in Lydia (Asia Minor) c. 700–650; soon adopted by Greeks Pythagoras, Greek philosopher (fl. c. 520
	Persian Wars in Greece 499–478 Periclean Age in Athens c. 460–429 Peloponnesian War, Sparta against Athens, 431–404 Alexander the Great (356–323) occupies Egypt 333; defeats Persia 331; conquers Near East	Sophocles, Greek tragic playwright (496–406) Euripides, Greek tragic playwright (died 406) Socrates, philosopher (died 399) Plato, philosopher (427–347); founds Academy 386 Aristotle, philosopher (384–322)	Travels of Herodotus, Greek historian, c. 460–440 Hippocrates, Greek physician (born 469) Euclid's books on geometry (fl. c. 300–280) Archimedes, physicist and inventor (287–212)
	Rome dominates Asia Minor and Egypt; annexes Macedonia (and thereby Greece) 147		Invention of paper, China
	Julius Caesar dictator of Rome 49–44 Emperor Augustus (r. 27 B.CA.D. 14)	Golden Age of Roman literature: Cicero, Catullus, Vergil, Horace, Ovid, Livy	Vitruvius' De architectura
	Jewish rebellion against Rome 66–70; de- struction of Jerusalem Eruption of Mt. Vesuvius buries Pompeii, Herculaneum 79	Crucifixion of Jesus c. 30 Paul (died c. 65) spreads Christianity to Asia Minor and Greece	Pliny the Elder, <i>Natural History</i> , dies in Pompeii 79 Seneca, Roman statesman
	Emperor Trajan (r. 98–117) rules Roman Empire at its largest extent Emperor Marcus Aurelius (r. 161–180)		Ptolemy, geographer and astronomer (died 160)
	Shapur I (r. 242–272), Sassanian king of Persia Emperor Diocletian (r. 284–305) divides Empire	Persecution of Christians in Roman Empire 250–302	

NOTE: Figure numbers of black-and-white illustrations are in (italics). Colorplate numbers are in (bold face). Duration of papacy or reign is indicated by the abbreviation ${\bf r}$.

ARCHITECTURE	SCULPTURE	PAINTING
"White Temple" and ziggurat, Uruk $(25, 26)$		
Step pyramid and funerary district of Zoser, Saqqara, by Imhotep (17, 18) Sphinx, Giza (20) Pyramids at Giza (19)	Palette of Narmer (15) Statues from Abu Temple, Tell Asmar (27) Offering stand and harp from Ur (28, 29) Prince Rahotep and His Wife Nofret (14) Mycerinus and His Queen (16) Cycladic idol from Amorgos (35)	
Stonehenge, England $(7,8)$ Palace of Minos, Knossos, Crete (36) Temple of Amun-Mut-Khonsu, Luxor (21) Treasury of Atreus, Mycenae (38)	Stele of Hammurabi (30) Heads of Akhenaten and Nofretete (22, 23) Coffin of Tutankhamen (24) Lion Gate, Mycenae (39)	"Toreador Fresco" (37)
Ishtar Gate, Babylon (32) "Basilica," Paestum (48)	Pole top ornament from Luristan (33) Reliefs from Nineveh (31) Standing Youth (Kouros) (51) "Hera" from Samos (52) North frieze from Treasury of the Siphnians, Delphi (54) Maiden from Chios (53) Apollo from Veii (65)	Dipylon vase (40) Black-figured amphora by Psiax (41, 42)
Palace, Persepolis (34) Temple of Poseidon, Paestum (48) Temples on Acropolis, Athens: Parthenon (49) ; Propylaea (50) ; Temple of Athena Nike (50)	She-Wolf from Rome (66) East pediment from Aegina (55) Standing Youth (The Kritios Boy) (56) Poseidon (Zeus?) (57) East pediment from the Parthenon (58) East frieze from the Mausoleum, Halicarnassus (59) Hermes by Praxiteles (60) Cinerary container (68) Dying Gaul (62)	Lapith and Centaur, red-figured ware (43) Tomb of Lionesses, Tarquinia (67) White-ground ware (44) The Battle of Issus (45)
2	Nike of Samothrace (63) Laocoön Group (64)	
	Portrait of a Roman (74) Portrait Head from Delos (61) Ara Pacis ("peace altar"), Rome (79)	Odyssey Landscapes (81) Villa of the Mysteries, Pompeii (83)
Colosseum, Rome (69)	Arch of Titus, Rome (80)	House of the Vettii, Pompeii (82)
Pantheon, Rome (70, 71)	Trajan (75) Equestrian statue of Marcus Aurelius, Rome (76)	Portrait of a Boy, the Faiyum (84)
	Philippus the Arab (77)	

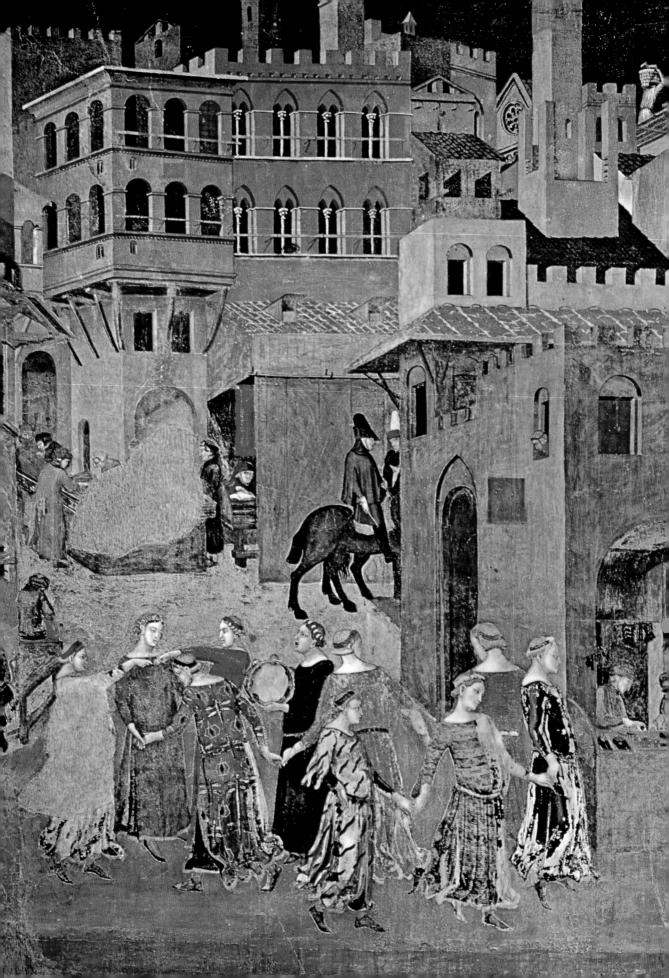

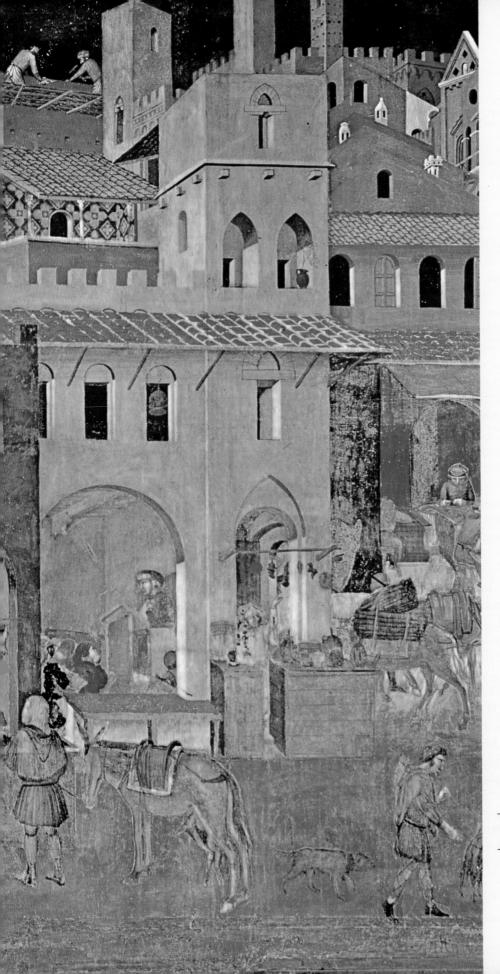

PART TWO
The
Middle
Ages

Early Christian and Byzantine Art

In 323 A.D. Constantine the Great made a fateful decision, the consequences of which are still felt today: he resolved to move the capital of the Roman Empire to the Greek town of Byzantium, which henceforth was to be known as Constantinople. In taking this step, the emperor acknowledged the growing strategic and economic importance of the eastern provinces (a development that had been going on for some time). The new capital also symbolized the new Christian basis of the Roman State, since it was in the heart of the most thoroughly Christianized region of the Empire. Constantine could hardly have foreseen that shifting the seat of imperial power would result in splitting the realm, yet within a hundred years the division had become an accomplished fact, even though the emperors at Constantinople did not relinquish their claim to the western provinces. The latter, ruled by western Roman emperors, soon fell prey to invading Germanic tribes-Visigoths, Vandals, Ostrogoths, Lombards. By the end of the sixth century the last trace of centralized authority had disappeared. The Eastern, or Byzantine, Empire, in contrast, survived these onslaughts, and under Justinian (527-65 A.D.) reached new power and stability. With the rise of Islam a hundred years later, the African and Near Eastern parts of the Empire were overrun by conquering Arab armies; in the eleventh century, the Turks occupied a large part of Asia Minor, while the last Byzantine possessions in the West (in southern Italy) fell to the Normans. Yet the Empire, with its domain reduced to the Balkans and Greece, held on till 1453, when the Turks finally conquered Constantinople itself.

The division of the Roman Empire soon led

to a religious split as well. At the time of Constantine, the bishop of Rome, deriving his authority from St. Peter, was the acknowledged head—the pope—of the Christian Church. His claim, however, soon came to be disputed; differences in doctrine began to develop, and eventually the division of Christendom into a Western, or Catholic, Church and an Eastern, or Orthodox, Church became all but final. The differences between them went very deep: Roman Catholicism maintained its independence from imperial or any other state authority, and became an international institution reflecting its character as the Universal Church. The Orthodox Church, in contrast, was based on the union of spiritual and secular authority in the person of the emperor. It was thus dependent on the State, exacting a double allegiance from the faithful but sharing the vicissitudes of political power. We will recognize this pattern as the Christian adaptation of a very ancient heritage, the divine kingship of Egypt and Mesopotamia; if the Byzantine emperors, unlike their pagan predecessors, could no longer claim the status of gods, they kept a unique and equally exalted role by placing themselves at the head of the Church as well as the State. Nor did the tradition die with the fall of Constantinople. The tsars of Russia claimed the mantle of the Byzantine emperors, and Moscow became "the third Rome": thus the Russian Orthodox Church was closely tied to the State, as was its Byzantine parent body.

It is the religious even more than the political separation of East and West that makes it impossible to discuss the development of Christian art in the Roman Empire under a single heading. "Early Christian" does not, strictly speaking, define a style; it refers, rather, to any work of art produced by or for Christians during the time prior to the splitting off of the Orthodox Church—roughly, the first five centuries of our era. "Byzantine art," on the other hand, designates not only the art of the Eastern Roman Empire, but a specific quality of style as well. Since this style grew out of certain tendencies that can be traced back to the time of Constantine, or even earlier, there is no sharp dividing line between the two until after the reign of Justinian, who was not only conversant with artistic currents in both parts of the Empire, but almost succeeded in reuniting them politically as well. Soon after him, however, Celtic and Germanic peoples fell heir to the civilization of late Roman antiquity, of which Early Christian art had been a part, and transformed it into that of the Middle Ages. The East experienced no such break; there, late antiquity lived on, although the Greek and Oriental elements came increasingly to the fore at the expense of the Roman heritage. As a consequence Byzantine civilization never experienced the flux and fusion that created medieval art: "The Byzantines may have been senile," as one historian has observed, "but they remained Greeks to the end."

EARLY CHRISTIAN ART

Before Constantine, Rome was not yet the official center of the faith; older and larger Christian communities existed in the great cities of North Africa and the Near East, such as Alexandria and Antioch, and they probably had artistic traditions of their own of which we seem to catch glimpses in the mainstream of art at a much later date. Actually, our knowledge of them is scanty in the extreme; for the first three centuries of the Christian Era we have little to go on when trying to trace the evolution of art in the service of the new religion. The only exception is the painting found on the walls of catacombs,

the underground passages in which the Roman Christians buried their dead.

Painting

If the dearth of material from the more flourishing Eastern Christian colonies makes it difficult to judge these pictures in a larger context, they nevertheless tell us a good deal about the spirit of the communities that sponsored them. The burial rite and safeguarding of the tomb were of vital concern to the Early Christians, whose faith rested on the hope of eternal life in paradise. The imagery of the catacombs, as can be seen in the painted ceiling in figure 85, clearly expresses this otherworldly outlook, although the forms are in essence still those of pre-Christian Roman painting. Thus we recognize the compartmental divisions as a late and highly simplified echo of the illusionistic architectural schemes in Pompeian painting; and the modeling of the figures, too, though debased in the hands of an artist of very modest ability, also betrays its descent from the same Roman idiom. But the catacomb painter has used this traditional vocabulary to convey a new, symbolic content, so that to him the original meaning of the forms was a matter of small interest. Even the geometric framework shares in the new task: the great circle

85. Painted ceiling, Catacomb of SS. Pietro e Marcellino, Rome. Early 4th century A.D.

suggests the Dome of Heaven, much as the ceiling of the Pantheon was meant to (see p. 72), but here the oculus in the center has been connected to the outer ring by four pairs of brackets, a simple device that forms the Cross, the main symbol of the faith. In the central medallion we see a youthful shepherd with a sheep on his shoulders. It is true that this form, too, can be traced as far back as the Archaic Greeks, but here it has become an emblem of Christ the Saviour-the Good Shepherd. The semicircular compartments contain episodes from the legend of Jonah: on the left he is cast from the ship; on the right he emerges from the whale; and at the bottom, safe again on dry land, he meditates upon the mercy of the Lord. This Old Testament miracle enjoyed immense favor in Early Christian art, as proof of the Lord's power to rescue the faithful from the jaws of death. The standing figures, their hands raised in a traditional gesture of prayer, represent members of the Church pleading for divine help.

Architecture

With the triumph of Christianity as the State religion under Constantine, an almost overnight blossoming of church architecture began in both halves of the Empire. Before that, congregations had not been able to meet in public, and services were held inconspicuously in the houses of the wealthier members; now impressive new buildings were wanted, for all to see. Early Christian basilicas cannot be wholly explained in terms of their pagan Roman predecessors, although the latter served well as a point of departure, combining the spacious interior necessary for the performing of Christian ritual before a congregation, with imperial associations that proclaimed the exalted status of the new State religion. But, in addition, the Christian basilica had to serve as the Sacred House of God; for this reason the entrances, which in Roman secular basilicas had been along the

86. (above) Sant' Apollinare in Classe (aerial view), Ravenna. 533–49 A.D.

87. (opposite) Interior (view toward the apse), Sant' Apollinare in Classe, Ravenna

flanks so as to provide many doorways for people bent on a variety of errands, were concentrated at one end in Christian basilicas, usually facing west. At the opposite end of the long nave was the altar, the focus of the ritual. This emphasis on the longitudinal axis is easily seen in the exterior view of Sant' Apollinare in Classe (fig. 86), a church built on Italian soil during the reign of Justinian. If we except the round bell tower (campanile) on the left, we will find many features to remind us of pagan buildings that have already been discussed: the transverse porch (narthex) which welcomes the visitor to the sacred building, while at the same time obscuring the view of what is to come, is a small-scale, simplified reminder of the portico of the Pantheon (see p. 71). The row of arches, echoed by a matching arcade in the interior, is a form of architecture pioneered under the emperor Diocletian (see p. 73); the clerestory, too, had appeared earlier in Roman basilicas (see p. 72); and turning to the interior view (fig. 87), we may note that the eastern end, where the altar was placed, is set off from the rest by a frame reminiscent of a Roman triumphal arch (see the one in fig.

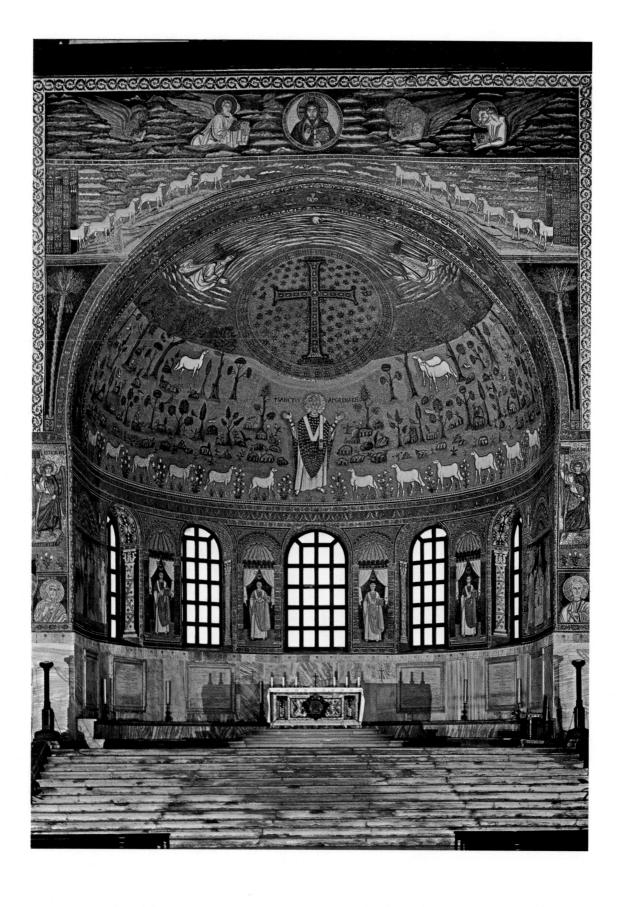

80). What is new here, in addition to the more expert use of the column-plus-arch construction, is the astonishing contrast between the plain brick exterior, which (unlike Classical temples) is merely an envelope for the interior, and the explosion of vivid colors and rich materials within. Having left the workaday world outside, we find ourselves in a shimmering realm of light, where precious marble and glittering mosaics evoke the unearthly splendor of the Kingdom of God.

Mosaics

Although the Romans, too, produced mosaics (see fig. 45), they had used marble tesserae having a limited range of colors; these mosaics were more suitable for floor decoration than for walls. The vast and intricate wall mosaics in Early Christian churches really have no precedent, either for expanse or for technique. Instead of stone, the tesserae are made of glass; they are brilliant in color but not rich in tonal gradations, so that they do not lend themselves readily to the copying of painted pictures. Instead, with each tiny square of glass also acting as a reflector, a glittering, screenlike effect is produced, as intangible as it is dazzling. If the exterior of

88. The Parting of Lot and Abraham. c. 430 A.D. Mosaic. Santa Maria Maggiore, Rome

Sant' Apollinare strikes us as unassuming—even antimonumental in comparison with previous building styles—the interior is its perfect complement. Here the dematerialization of the construction is turned to positive account, for the purpose of achieving an "illusion of unreality."

To transport the spectator into realms of glory was not, of course, the only purpose of these mosaics. Like the modest beginnings of Christian art (see fig. 85) they contain symbols of the faith (in Sant' Apollinare the Cross is plainly visible in the oculus that opens onto the starry skies, where Christ presides in the highest realm of heaven, flanked by the symbols of the four Evangelists). Sometimes they also illustrate scenes from both Old and New Testaments, thus serving the unlettered as picture-Bibles. The Parting of Lot and Abraham (fig. 88) is one frame of a long series that decorates the nave of Santa Maria Maggiore in Rome. The idea of making such a series, as well as some of the pictorial devices that the mosaicist has used (such as the "grape clusters" of heads arising behind the relatively few bodies that occupy the foreground), may well have been derived from Roman narrative reliefs. But the Early Christian artist was not constrained by the need to make a specific event look real; these biblical scenes, whose stories were known already to most of the faithful, were not so much illustrations as symbolic events with a didactic purpose. Here, for instance, Abraham and his clan (the left-hand group) are about to go one way-the way of righteousness-while Lot and his family, about to exit right, are departing for Sodom, toward depravity and ruin.

Illustrated Manuscripts

For church use and the devotions of the learned there were also illustrated Bibles. The development of the book format itself is not entirely clear: we know that the Egyptians made a paper-like substance, only more

brittle, out of papyrus reeds. Their "books," however, were scrolls to be unrolled as one read. This was not an ideal surface for painted illustration, for the repeated bending and unbending of each section would tend to make the paint flake off. The Torah, the sacred scriptures that are read at each service in synagogues, still preserves this ancient format. Not until Late Hellenistic times did a better substance become available: parchment, or vellum (thin, bleached animal hide). It was strong enough to be creased without breaking, and thus made possible the kind of bound book (technically known as a codex) that we still have today. Between the first and the fourth centuries A.D. this gradually replaced the scroll, greatly enhancing the range of painted illustration (or, as it is called, illumination) so that it became the small-scale counterpart of murals, mosaics, or panel pictures. One of the oldest illustrated manuscripts preserved, the Vatican Vergil, probably executed in Italy about the time of the Santa Maria Maggiore mosaics, reflects this tradition, although the quality of the miniatures is far from inspired (fig. 89); the picture, separated from the rest of the page by a heavy frame, has the effect of a winLORSITANTIMICUIS HORIOS QUACCUAACOLINDI
ORMARICAM FRIANDIFIRIQUI ACSARIMISTI
QUOQ MODOTO IS CAUDER INTIMIBARILIS
FIURIDISAMUA IZAFTORIUS QUE UTERHER BAM
CRESCERTINUENTRE RICUCUMIS NECSERACOMANTI
NACISSUMAUTE LEXITACULS SEUMINACANTELL
TAILENTIS HIDERAS FIAMANTIS LITERAMIYATOS

89. Miniature from the *Vatican Vergil*. Early 5th century A.D. Vatican Library, Rome

dow, and in the landscape we find remnants of deep space, perspective, and the play of light and shade.

Jacob Wrestling with the Angel (fig. 90) comes from one of the oldest extant examples of an Old Testament book, though it must have been preceded by others which have been lost. This codex, called the Vienna Gen-

esis, was written in silver (now turned black) on purple-tinted vellum, and adorned with brilliantly colored miniatures; the effect is not unlike that produced by the mosaics which we have discussed. The scene itself does not show a single event, but a whole sequence strung out along a U-shaped path, so that progression in space also becomes progression in time. This method, known as continuous narration, has a long ancestry going back to sculptured relief, and possibly to scroll books. Here it permits the painter to pack a maximum of content into the area of the page at his disposal, and the continuous episodes were probably meant to be "read," like the letters themselves, rather than taken in all at once as a composition.

Sculpture

Compared to painting and architecture, sculpture played a secondary role in Early Christian times. The Old Testament prohibition of "graven images" was thought to apply with particular force to large cult statues—the idols worshiped in pagan temples. To

avoid the taint of idolatry, religious sculpture had to develop from the very start in an antimonumental direction. Shallow carving, small-scale forms, and lacelike surface decoration came to be its characteristics. The earliest works of sculpture that can be called "Christian" are sarcophagi made for the wealthier members of the congregation; beginning about the middle of the third century, they differ from pagan sarcophagi not so much in form as in the subject matter of the decoration. At first this consisted of a somewhat limited repertory, such as we have seen in the catacomb painting: the Good Shepherd, Jonah, etc. (see fig. 85). The sarcophagus of Junius Bassus (fig. 91) of a century later, however, shows a richly expanded repertory of subjects, taken from both the Old and the New Testaments, reflecting the new, out-in-the-open position of Christianity now that it was the established State religion and no longer had to allude to the faith in cryptic, symbolic terms. Junius Bassus himself was a Roman prefect.

To those of us who are familiar with only the later formulation of Christ's image, as a

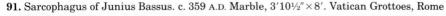

bearded and often suffering man, it may at first be difficult to recognize Him at all in these scenes. Youthful and serene, He sits enthroned in heaven (a bearded figure, personifying the sky, holds up His throne) between Saints Peter and Paul (center panel, upper row); nor does He seem troubled in the scene of Christ before Pontius Pilate, which occupies the two panels directly to the right, where He stands, scroll in hand, like some young philosopher expounding his views. This aspect of Christ is in keeping with the Christian thought of the period that stressed His divinity and His power to redeem us from death, rather than the torments that He took on when He became flesh. This dignified conception lent itself well to a revival of some Classical features of composition and figures. Such revivals occurred quite frequently during the two centuries after Christianity had become the official religion: paganism still had many adherents (Junius Bassus himself was converted only shortly before his death) who may have fostered such revivals; there were important leaders of the Church who favored a reconciliation of Christianity with the Classical heritage; and the imperial courts, both East and West, always remained aware of their institutional links with pre-Christian times. Whatever the reasons, we must be glad that the Roman Empire in transition preserved, and thus helped transmit, a treasury of forms and an ideal of beauty that might have been irretrievably lost.

Panels and Reliefs

All this holds true particularly for a class of objects whose artistic importance far exceeds their physical size: the ivory panels and other small-scale reliefs in precious materials. Designed for private ownership and meant to be enjoyed at close range, they often mirror a collector's taste, a refined aesthetic sensibility not found among the large, official enterprises sponsored by Church or State. Such a piece is an ivory leaf (fig. 92) done soon after

92. The Archangel Michael (leaf of a diptych). Early 6th century A.D. Ivory, 17×5 ½". British Museum, London

500 in the Eastern Roman Empire. It shows a Classicism that has become an eloquent vehicle of Christian content. The majestic archangel is clearly a descendant of the Winged Victories of Graeco-Roman art, down to the richly articulated drapery. Yet the power he heralds is not of this world; nor does he inhabit an earthly space. The architectural niche against which he appears has lost all threedimensional reality; its relationship to him is purely symbolic and ornamental, so that he seems to hover rather than to stand (notice the position of the feet on the steps). It is this disembodied quality, conveyed through Classically harmonious forms, that gives him so compelling a presence.

BYZANTINE ART

The reign of Emperor Justinian marks the point at which the ascendancy of the Eastern Roman Empire over the Western became complete and final. Justinian himself was an art patron on a scale unmatched since Constantine's day; the works he sponsored or promoted have an imperial grandeur that fully justifies the acclaim of those who have termed his era a Golden Age. They also display an inner coherence of style which links them more strongly with the future of Byzantine art than with the art of the preceding centuries.

Architecture

Ironically enough, the richest array of the monuments of this period survives today not in Constantinople, but in the city of Ravenna, in Italy. We have already seen one of them, Sant' Apollinare in Classe, which—better than examples of Early Christian buildings in Rome itself—preserves unaltered the appearance, structural features, and decoration of the earliest churches. But there was another type of structure that had entered the tradition of Christian architecture in Constantinian times: round or polygonal build-

ings crowned with a dome. They had been developed, we will recall, as part of the elaborate Roman baths; the design of the Pantheon was derived from that source (see p. 72). Similar structures had been built to serve as monumental tombs, or mausoleums, by the pagan emperors. In the fourth century, this type of building is given a Christian meaning in the baptisteries (where the bath becomes a sacred rite) and funerary chapels linked with basilican churches. San Vitale, the most important church built in Ravenna under Justinian, has an octagonal plan with a domed

93. San Vitale, Ravenna. 526-47 A.D.

94. Interior (view from the apse), San Vitale, Ravenna

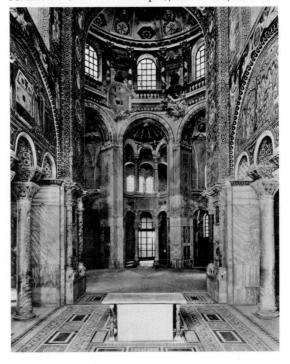

central core (fig. 93). In this central-plan church we find only the merest remnants of the longitudinal axis of the Early Christian basilica. The complexity of the exterior is matched by the spatial richness of the interior (fig. 94), with its lavish decoration. Remembering Sant' Apollinare in Classe, built at the same time on a straightforward basilican plan, we are particularly struck by the alien character of San Vitale, which is derived mainly from Constantinople, where domed churches were preferred. How did it happen that the East favored a type of church building (as distinct from baptisteries and mausoleums) so radically different from the basilica and-from the Western point of view-so ill-adapted to Christian ritual? After all, had not the design of the basilica been backed by the authority of Constantine himself? Many different reasons have been

suggested—practical, religious, political. All of them may be relevant, yet, if the truth be told, they fall short of a really persuasive explanation. In any event, from the time of Justinian domed, central-plan churches were to dominate the world of Orthodox Christianity as thoroughly as the basilican plan dominated the architecture of the medieval West.

Among the surviving buildings of Justinian's reign, by far the greatest is Hagia Sophia (The Church of the Holy Wisdom) in Constantinople (figs. 95, 96). Built in 532–37, it was so famous in its day that even the names of the architects, Anthemius of Tralles and Isidorus of Miletus, have come down to us. The design of Hagia Sophia presents a unique combination of elements; it has the longitudinal axis of an Early Christian basilica, but the central feature of the nave is a square compartment crowned by a

95. Anthemius of Tralles and Isidorus of Miletus. Hagia Sophia, Istanbul. 532-37 A.D.

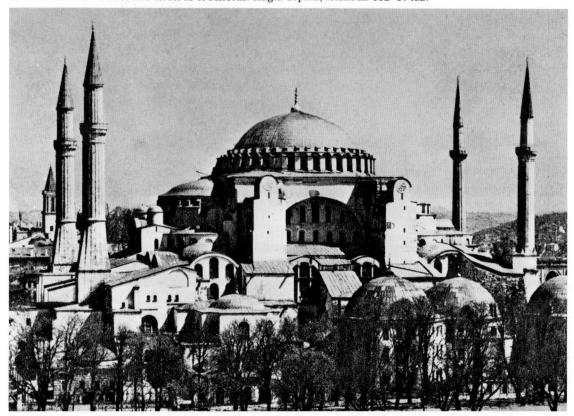

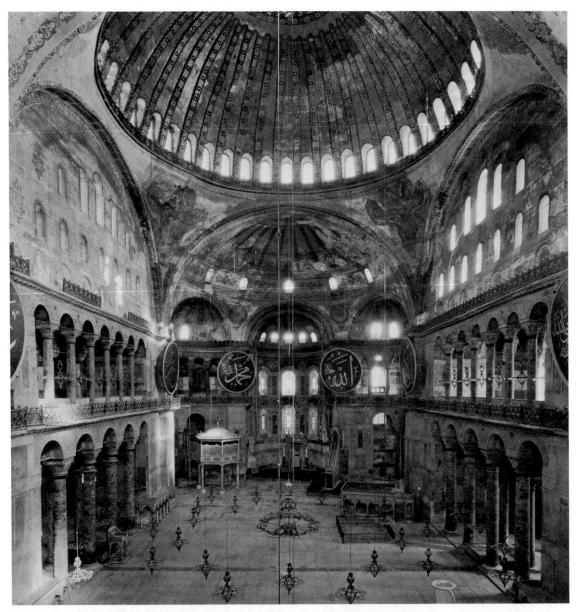

96. Interior, Hagia Sophia, Istanbul

huge dome abutted at either end by half-domes, so that the effect is that of a huge oval. The weight of the dome is carried on four enormous arches; the walls below the arches have no supporting function at all. The transition from the square formed by the four arches to the circular rim of the dome is made by spherical triangles, called pendentives. This device permits the construction of taller, lighter, and more economical domes than

the older method (as seen in the Pantheon). We do not know the ancestry of this useful scheme, but Hagia Sophia is the first example of its use on a monumental scale, and it was epoch-making; henceforth it was to be a basic feature of Byzantine architecture and, somewhat later, of Western architecture as well. The plan and size will recall the Basilica of Constantine (see fig. 72), the greatest monument associated with the ruler for

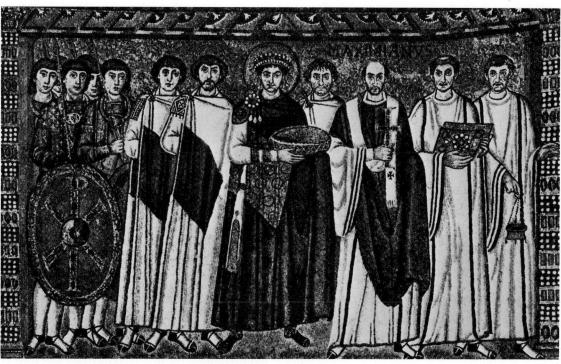

97. Justinian and Attendants. c. 547 A.D. Mosaic. San Vitale, Ravenna

whom Justinian had a particular admiration. Hagia Sophia thus unites East and West, past and future, in a single overpowering synthesis. Once we are within, all sense of weight disappears, as if the material, solid aspects of the structure had been banished to the outside; nothing remains but an expanding space that inflates, like so many sails, the apsidal recesses, the pendentives, and the dome itself. The golden glitter of the mosaics (covered over when the Muslims captured the city, and now only partially restored) must have completed the "illusion of unreality."

Mosaics

It is only fitting that we use, as an example of the mosaics of Justinian's reign, the portrait of the emperor himself, surrounded by his courtiers, which has survived in good condition in the Church of San Vitale in Ravenna (fig. 97). The design, and perhaps the workmen, must have come directly from the imperial workshop. Here we find a new ideal of human beauty: extraordinarily tall, slim figures, with tiny feet, small, almond-shaped faces dominated by large eyes, and bodies that seem capable only of ceremonial gestures and the display of magnificent costumes. Every hint of movement or change is carefully excluded—the dimensions of time and of earthly space have given way to an eternal present amid the golden translucency of heaven, and the solemn frontal images seem to present a celestial rather than a secular court. This union of spiritual and political authority accurately reflects the "divine kingship" of Byzantine emperors.

Painting and Sculpture

The development of Byzantine painting and sculpture after the age of Justinian was disrupted by the Iconoclastic Controversy, which began with an imperial edict of 726 prohibiting religious images and raged for more than a hundred years. The roots of the

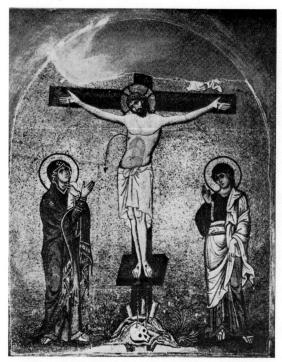

98. The Crucifixion. 11th century. Mosaic. Monastery Church, Daphnē, Greece

conflict went very deep: on the plane of theology they involved the basic issue of the relationship of the human and divine in the person of Christ, while socially and politically they reflected a power struggle between State and Church. The edict did succeed in reducing the production of sacred images greatly, but failed to wipe it out altogether, so that there was a fairly rapid recovery after the victory of the iconophiles in 843. Iconoclasm seems to have brought about a renewed interest in secular art, which was not affected by the ban. This may help to explain the astonishing reappearance of Late Classical motifs in the art of the Second Golden Age.

The finest works of the Second Golden Age show a Classicism that has been harmoniously merged with the spiritualized ideal of human beauty we encountered in the art of Justinian's reign. Among these, the Crucifixion mosaic at Daphnē (fig. 98) enjoys special fame. The statuesque, dignified figures seem

extraordinarily organic and graceful compared to those of the Justinian mosaic at San Vitale (see fig. 97). The most important aspect of their Classical heritage, however, is emotional rather than physical; it is the gentle pathos conveyed by their gestures and facial expressions, a restrained and noble suffering of the kind we first met in Greek art of the fifth century B.C. (see pp. 59-60). Early Christian art had been devoid of this quality. Its view of Christ stressed the Saviour's divine wisdom and power, rather than His sacrificial death. In The Crucifixion we no longer find the youthful, heroic Christ that we saw in the Junius Bassus reliefs (see fig. 91); the tilt of the head, the sagging lines of the body, the expression of suffering make a powerful appeal to the beholder's emotions. This compassionate quality was perhaps the greatest achievement of later Byzantine art, even though its full possibilities were to be explored not in Byzantium, but in the medieval West.

Not that it disappeared completely from Byzantine art, but after centuries of repetition, exquisiteness of craftsmanship rather than expressive impact came to dominate such images. The Madonna Enthroned (fig. 99) is a work of this kind. The graceful drapery folds, the tender expression are still there; but they have become strangely abstract. The throne (which looks rather like a miniature Colosseum) has lost any semblance of solid three-dimensionality, as have the bodies—although some modeling is still to be found in the faces. With gold as a background, and gold used to pick out all the highlights of the forms, the effect cannot be called either flat or spatial; rather, it is transparent, for everywhere the golden background shines through, as though the picture were lit from behind. Panels such as ours, called icons (sacred images), should be viewed as the aesthetic offspring of mosaics, rather than as the descendants of the Classical panel painting tradition from which they spring (see fig. 82)

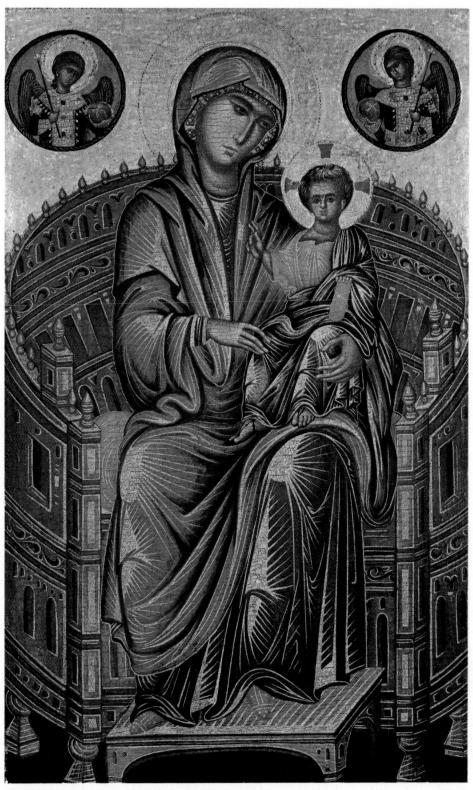

99. Madonna~Enthroned. Late 13th century. Tempera on panel, $32\times19\frac{1}{2}$ ". National Gallery of Art, Washington, D.C. (Mellon Collection)

The Earlier Middle Ages in the West

When we think of the great civilizations of our past, we tend to do so in terms of visible monuments that have come to symbolize the distinctive character of each: the pyramids of Egypt, for example; or the Parthenon of Athens; the Colosseum of Rome-all were made famous (or infamous) by the part that they played in the history of their times. In such a review, the Middle Ages would undoubtedly be represented by a Gothic cathedral; we have many to choose from, but whichever one we pick, it will be well north of the Alps, although in territory that formerly belonged to the Roman Empire. And if we were to spill a bucket of water in front of the cathedral, the water would eventually make its way to the English Channel, rather than to the Mediterranean. This is the most important single fact about the Middle Ages: the center of gravity of European civilization had shifted to what had been the northern boundaries of the Roman world. The Mediterranean, for so many centuries the great highway of commercial and cultural exchange for all the lands along its shores, had become a barrier, a border zone.

In the preceding chapter we became familiar with some of the events that paved the way for the shift: the removal of the imperial capital to Constantinople; the growing split between the Catholic and Orthodox faiths; and the decay of the Western half of the Roman Empire under the impact of invasions by Germanic tribes. Yet these tribes, once they had settled down in their new land, accepted the framework of late Roman, Christian civilization: the new states they founded, on the northern coast of Africa, and in Spain, Gaul, and northern Italy, were Mediterranean-oriented, provincial states along the

borders of the Byzantine Empire, subject to the pull of its greater military, commercial, and cultural power. The reconquest of the lost Western provinces remained a serious political goal of Byzantine emperors until the middle of the seventh century. This possibility ceased to exist when a completely unforeseen new force made itself felt in the East: the Arabs, under the banner of Islam, were overrunning the Near Eastern and African provinces of Byzantium. By 732, within a century after the death of Muhammad, they had occupied North Africa as well as most of Spain, and threatened to add southwestern France to their conquests.

It would be difficult to exaggerate the impact upon the Christian world of the lightning-like advance of Islam. With more than enough to do to keep this new force at bay in its own backyard, the Byzantine Empire lost its bases in the western Mediterranean. Left exposed and unprotected, Western Europe was forced to develop its own resources, political, economic, and spiritual. The Church of Rome broke its last ties with the East and turned for support to the Germanic North, where the Frankish kingdom, under the leadership of the energetic Carolingian dynasty, aspired to the status of imperial power in the eighth century. When the pope, in the year 800, bestowed the title of emperor upon Charlemagne, he solemnized the new order of things by placing himself and all of Western Christendom under the protection of the king of the Franks and Lombards. He did not, however, subordinate himself to the newly created Catholic emperor; the legitimacy of the latter depended on the pope, whereas hitherto it had been the other way around (the emperor in Constantinople had always

ratified the newly elected popes). This interdependent dualism of spiritual and political authority, of Church and State, was to distinguish the West from both the Orthodox East and the Islamic South. Outwardly it was symbolized by the fact that, although the emperor had to be crowned by the pope in Rome, he did not live there; Charlemagne built his capital at the center of his effective power, in Aachen, where Belgium, Germany, and the Netherlands meet today.

THE DARK AGES

The labels we use for historical periods tend to be like the nicknames of people: once established, they are almost impossible to change, even though they may no longer be suitable. Those who coined the term "Middle Ages" thought of the entire thousand years that came between the fifth and fifteenth centuries as an age of darkness, an empty interval between Classical antiquity and its revival, the Renaissance in Italy. Since then, our view of the Middle Ages has completely changed: we no longer think of the period as "benighted," but as the "Age of Faith." With the spread of this new, positive conception, the idea of darkness has become confined more and more to the early part of the Middle Ages, roughly between the death of Justinian and the reign of Charlemagne. Perhaps we ought to pare down the Dark Ages even further: there was a great deal of activity in that darkness while the economic, political, and spiritual framework of Western Europe was being established; and as we shall now see, the same period also gave rise to some important artistic achievements.

Germanic

The Germanic tribes that had entered Western Europe from the east during the declining years of the Roman Empire carried with them, in the form of nomads' gear, an ancient and widespread artistic tradition, the socalled animal style (see p. 39). Examples of it have been found in the form of bronzes in Iran, and gold in southern Russia. A combination of abstract and organic shapes, formal discipline and imaginative freedom, it became an important element in the Celto-Germanic art of the Dark Ages, such as the goldand-enamel purse cover (fig. 100) from the grave of an East Anglian king who died in 654. Four pairs of motifs are symmetrically arranged on its surface; each has its own distinctive character, an indication that the motifs have been assembled from different sources. One of them, the standing man between two confronted animals, has a very long history indeed: we first saw it in figure 29—a panel more than three thousand years older. The eagles pouncing on ducks also date back a long way, to carnivore-and-victim motifs. The design just above them, however, is of more recent origin. It consists of fighting animals whose tails, legs, and jaws are elongated into bands forming a complex interlacing pattern. Interlacing bands, as an ornamental device, had existed in Roman and even Mesopotamian art (see fig. 29, bottom row), but their combination with the animal style, as shown here, seems to have been an invention of the Dark Ages.

Metalwork, in a variety of materials and techniques and often of exquisitely refined craftsmanship, had been the principal medium of the animal style. Such objects, small, durable, and eagerly sought after, account

100. Purse cover, from the Sutton Hoo Ship-Burial. Before 655 A.D. Gold with garnets and enamels. British Museum, London

101. Animal Head, from the Oseberg Ship-Burial. c. 825 A.D. Wood, height about 5". University Museum of Antiquities, Oslo

for the rapid diffusion of its repertory of forms. They "migrated" not only in the geographic sense, but also technically and artistically into other materials-wood, stone, even manuscript illumination. Wooden specimens, as we might expect, have not survived in large quantities; most of them come from Scandinavia, where the animal style flourished longer than anywhere else. The splendid animal head of the early ninth century (fig. 101) is a terminal post that was found, along with much other equipment, in a buried Viking ship at Oseberg in southern Norway. Like the motifs on the purse cover, it shows a peculiar composite quality: the basic shape of the head is surprisingly realistic, as are certain details (teeth, gums, nostrils), but the surface has been spun over with interlacing and geometric patterns that betray their derivation from metalwork.

Irish

This pagan Germanic version of the animal style is reflected in the earliest Christian works of art north of the Alps as well. In order to understand how they came to be produced, however, we must first acquaint ourselves with the important role played by the Irish, who, during the Dark Ages, assumed the spiritual and cultural leadership of Western Europe. The period 600-800 A.D. deserves, in fact, to be called the Golden Age of Ireland. Unlike their English neighbors, the Irish had never been part of the Roman Empire; thus the missionaries who carried the Gospel to them from the south in the fifth century found a Celtic society, entirely barbarian by Roman standards. The Irish readily accepted Christianity, which brought them into contact with Mediterranean civilization, but without becoming Rome-oriented. Rather, they adapted what they had received in a spirit of vigorous local independence. The institutional framework of the Roman Church, being essentially urban, was ill suited to the rural character of Irish life. Irish Christians preferred to follow the example of the desert saints of North Africa and the Near East who had left the temptations of the city in order to seek spiritual perfection in the solitude of the wilderness. Groups of such hermits, sharing a common ideal of ascetic discipline, had founded the earliest monasteries. By the fifth century, monasteries had spread as far north as western Britain, but only in Ireland did monasticism take over the leadership of the Church from the bishops. Irish monasteries, unlike their desert prototypes, soon became seats of learning and the arts; they also developed a missionary fervor that sent Irish monks preaching to the heathen and founding monasteries in northern Britain as well as on the European mainland. These Irishmen not only speeded the conversion to Christianity of Scotland, northern France, the Netherlands, and Germany; they also established the monastery as a cultural center throughout the European countryside. Although their Continental foundations were taken over before long by the monks of the Benedictine order, who were advancing north from Italy during the seventh and

 $\textbf{102.} \ \textbf{Cross page, from the } \textit{Lindisfarne Gospels. c. 700 A.D. Manuscript illumination. British Museum, London \\ \textbf{A.D. Manuscript illumination. British Museum, London } \textbf{A.D. Manuscript illumination.} \textbf{A.D. Manuscript i$

eighth centuries, Irish influence was to be felt within medieval civilization for several hundred years to come.

In order to spread the Gospel, the Irish monasteries had to produce copies of the Bible and other Christian books in large numbers. Their writing workshops (scriptoria) also became centers of artistic endeavor, for a manuscript containing the Word of God was looked upon as a sacred object whose visual beauty should reflect the importance of its contents. Irish monks must have known Early Christian illuminated manuscripts, but here again, as in so many other respects, they developed an independent tradition instead of simply copying their models. While pictures illustrating biblical events held little interest for them, they did devote much effort to decorative embellishment. The finest of these manuscripts belong to the Hiberno-Saxon style, combining Celtic and Germanic

103. The Crucifixion (from a book cover?). 8th century A.D. Bronze. National Museum of Ireland, Dublin

elements, which flourished in those monasteries founded by Irishmen in Saxon England. The Cross page in the Lindisfarne Gospels (fig. 102) is an imaginative creation of breathtaking complexity; the miniaturist, working with a jeweler's precision, has poured into the compartments of his geometric frame an animal interlace so dense and so full of controlled movement that the fighting beasts on the Sutton Hoo purse cover seem childishly simple in comparison. It is as if the world of paganism, embodied in biting, clawing monsters, had here suddenly been subdued by the superior authority of the Cross. In order to achieve this effect our artist has had to impose an extremely severe discipline upon himself. His "rules of the game," for example, demand that organic and geometric shapes must be kept separate; that within the animal compartments every line must turn out to be part of the animal's body, if we take the trouble to trace it back to its point of origin. There are also rules, too complex to go into here, governing symmetry, mirror-image effects, and repetitions of shape and color. Only by working these out for ourselves can we hope to enter into the spirit of this strange, mazelike world.

Of the representational images they found in Early Christian manuscripts, the Hiberno-Saxon illuminators generally retained only the symbols of the four Evangelists, since these could be translated into their ornamental idiom without difficulty. The bronze plaque (fig. 103), probably made for a book cover, shows how helpless they were when given the image of man to copy. In his attempt to reproduce an Early Christian composition, our artist suffered from an utter inability to conceive of the human frame as an organic unit, so that the figure of Christ becomes disembodied in the most elementary sense; head, arms, and feet are separate elements, attached to a central pattern of whorls, zigzags, and interlacing bands. Clearly, there is a wide gulf between the Celto-Germanic and the Mediterranean traditions, a gulf that this Irish artist did not know how to bridge. Much the same situation prevailed elsewhere during the Dark Ages; even the Lombards, on Italian soil, did not know what to do with human images.

CAROLINGIAN ART

The empire built by Charlemagne did not endure for long. His grandsons divided it into three parts, and proved incapable of effective rule even in these, so that political power reverted to the local nobility. The cultural achievements of his reign, in contrast, have proved far more lasting; this very page would look different without them, for it is printed in letters whose shapes derive from the script in Carolingian manuscripts. The fact that these letters are known today as Roman rather than Carolingian recalls another aspect of the cultural reforms sponsored by Charlemagne: the collecting and copying of ancient Roman literature. The oldest surviving texts of a great many Classical Latin authors are to be found in Carolingian manuscripts which, until not long ago, were mistakenly regarded as Roman: hence their lettering, too, was called Roman. This interest in preserving the Classics was part of an ambitious attempt to restore ancient Roman civilization (see also p. 110), along with the imperial title. Charlemagne himself took an active hand in this revival, through which he expected to implant the traditions of a glorious past in the minds of the semibarbarian people of his realm. To an astonishing extent, he succeeded. Thus the "Carolingian revival" may be termed the first—and in some ways the most important—phase of a genuine fusion of the Celto-Germanic spirit with that of the Mediterranean world.

Architecture

The fine arts played an important role in Charlemagne's cultural program from the very start. On his visits to Italy, he had be-

104. Odo of Metz. Interior, Palace Chapel of Charlemagne, Aachen. 792-805 A.D.

come familiar with the architectural monuments of the Constantinian era in Rome, and with those of the reign of Justinian in Ravenna; his own capital at Aachen, he felt, must convey the majesty of empire through buildings of an equally impressive kind. His famous Palace Chapel (fig. 104) is, in fact, directly inspired by the Church of San Vitale in Ravenna (see fig. 94). To erect such a structure on Northern soil was a difficult undertaking: columns and bronze gratings had to be imported from Italy, and expert stonemasons must have been hard to find. The design, by Odo of Metz (probably the earliest architect north of the Alps known to us by name), is by no means a mere echo of its model but a vigorous reinterpretation, with bold structural parts that outline and balance the clear, forthright divisions of the interior space.

The importance of the monasteries, which were encouraged by Charlemagne, is vividly suggested by a unique document of the period: the large drawing of a plan for a monas-

tery, preserved in the Chapter Library of St. Gall in Switzerland (fig. 105). Its basic features seem to have been decided upon at a council held near Aachen in 816-17, and then this copy was sent to the abbot of St. Gall for his guidance in rebuilding the monastery. We may regard it, therefore, as a standard plan, to be modified according to local needs. (Our reproduction renders the exact lines of the original, but omits the explanatory inscriptions.) The monastery is a complex, self-contained unit, occupying a rectangle about five hundred by seven hundred feet. The main entry, from the west (left), passes between stables and a hostelry toward a gate which admits the visitor to a colonnaded semicircular portico, flanked by two round towers which must have loomed impressively above the lower outbuildings. It emphasizes the church as the center of the

monastic community. The church is a basilica with a semicircular apse and an altar at either end, though the eastern end is given emphasis by a raised choir (with steps leading up to it) preceded by a space, partially screened off from the nave and organized transversally to it, which can be called a transept—a term that we shall meet again in later church plans. The nave and aisles, containing numerous other altars, do not form a single, continuous space but are subdivided into compartments by screens. There are several entrances: two beside the western apse, others on the north and south flanks. This entire arrangement reflects the functions of a monastery church, designed for the devotional needs of the monks, rather than for a congregation of laymen. Adjoining the church to the south, there is an arcaded cloister with a well in the middle; around this are grouped

00

105. Plan of a monastery. 819–30 A.D. Ink on parchment. Chapter Library, St. Gall, Switzerland

106. Upper cover of binding, from the Lindau~Gospels. c. 870 A.D. Gold and jewels, $13\%\times10\%$. The Pierpont Morgan Library, New York

the monks' dormitories (east side), a dining hall and kitchen (south side), and a cellar. The three large buildings to the north of the church are a guesthouse, a school, and the abbot's house. To the east are the infirmary, novices' quarters and chapel, the cemetery (marked by a large cross), a garden, and coops for chickens and geese. The south side is occupied by workshops, barns, and other service buildings. There is, needless to say, no monastery exactly like this anywhere—even in St. Gall the plan was not carried out as drawn—yet its layout conveys an excellent notion of the character of such establishments throughout the Middle Ages.

Manuscripts and Book Covers

We know from literary sources that Carolingian churches contained murals, mosaics, and relief sculpture, but these have disappeared almost entirely. Smaller, portable works of art, including books, have, however, survived in considerable numbers. The scriptoria of the various monasteries tended to produce book illuminations which can be grouped into distinct styles, though all of them went back to Late Classical models. Those that were produced in Aachen itself, under Charlemagne's watchful eye, are very close to the originals. As we look at the picture of St. Matthew from a manuscript (fig. 107) said to have been found in the tomb of Charlemagne and, in any event, closely linked with his court at Aachen, we find it hard to believe that such a work could have been executed in Northern Europe about the year 800. Whoever the artist was—Byzantine, Italian, or Frank—he shows himself fully conversant with the Roman tradition of painting, down to the acanthus ornament on the wide frame, which emphasizes the "window" aspect of the picture. The St. Matthew represents the most orthodox phase of the Carolingian revival; it is the visual counterpart of copying the text of a Classical work of literature. But perhaps more interesting, if somewhat later, is the Gospel Book of Arch-

107. St. Matthew, from the Gospel Book of Charlemagne. c. 800 A.D. Kunsthistorisches Museum, Vienna

108. St. Mark, from the Gospel Book of Archbishop Ebbo of Reims. 816–35 A.D. Manuscript illumination.
Municipal Library, Epernay, France

bishop Ebbo of Reims (fig. 108). The St. Mark from this book has many features that will

remind us of the Enthroned Christ from the sarcophagus of Junius Bassus (see fig. 91) made some five hundred years earlier: the seated "stance," with one foot advanced; the diagonal drape of the upper part of the toga; the square outline of the face; even the hands, one holding a scroll or codex, the other with a quill pen that is added to what must once have been an expository gesture; and the throne on which Christ is seated in the earlier sculpture has exactly the same kind of animal legs as St. Mark's seat. But now the figure is filled with electrifying energy that sets everything in motion; the drapery swirls, the hills heave upward in the background, the vegetation seems tossed about by a whirlwind, and even the acanthus-leaf pattern on the frame assumes a strange, flamelike character. The Evangelist himself has been transformed from a Roman philosopher into a man seized with the frenzy of divine inspiration, an instrument for the recording of the Word of God. This dependence on the Will of the Lord, so powerfully expressed here, marks the contrast between the Classical and the medieval image of what Man is. But the means of expression—the dynamism of line that distinguishes our miniature from its Classical predecessors—recalls the passionate movement we found in the ornamentation of Irish manuscripts of the Dark Ages.

The influence of the Reims school can still be felt in the reliefs of the bejeweled front cover of the Lindau Gospels (fig. 106), a work of the third quarter of the ninth century. This masterpiece of the goldsmith's art shows how splendidly the Celto-Germanic metalwork tradition of the Dark Ages adapted itself to the Carolingian revival. The main clusters of semiprecious stones are not set directly on the gold ground, but raised on claw feet or arcaded turrets so that light can penetrate beneath them and make them glow. Interestingly enough, the crucified Christ betrays no hint of pain or death, and this, along with His youthful, beardless face, again takes us back to the spirit of the earliest Christian images

of the Saviour, as yet untouched by human agony. He seems to stand, rather than hang, His arms spread wide in what one might almost call a welcoming gesture. To endow Him with human suffering was not yet conceivable, even though the expressive means were at hand, as we can see in the lamenting figures that surround Him.

OTTONIAN ART

In 870, about the time that the *Lindau Gos*pels cover was made, the remains of Charlemagne's empire were ruled by his two surviving grandsons: Charles the Bald, the West Frankish king, and Louis the German, the East Frankish king, whose domains corresponded roughly to the France and Germany of today. Their power was so weak, however, that Continental Europe once again lay exposed to attack. In the south, the Muslims resumed their depredations: Slavs and Magyars advanced from the east; and Vikings from Scandinavia ravaged the north and west. These Norsemen (the ancestors of today's Danes and Norwegians) had been raiding Ireland and Britain by sea from the late eighth century on; now they invaded northwestern France as well, occupying the area that has, ever since, been called Normandy. Once established there, they soon adopted Christianity and Carolingian civilization, and, from 911 on, their leaders were recognized as dukes, nominally subject to the authority of the king of France. During the eleventh century, the Normans assumed a role of great importance in shaping the political and cultural destiny of Europe, with William the Conqueror being crowned king in England, while other Norman nobles expelled the Arabs from Sicily and the Byzantines from south Italy. In Germany, meanwhile, after the death of the last Carolingian monarch in 911, the center of political power had shifted north to Saxony. The Saxon kings (919–1024) then reestablished an effective central government; the greatest

of them, Otto I, also revived the imperial ambitions of Charlemagne. After marrying the widow of a Lombard king, he extended his rule over most of Italy and had himself crowned emperor by the pope in 962. From then on, the Holy Roman Empire was to be a German institution. Or perhaps we ought to call it a German dream, for Otto's successors never managed to consolidate their claim to sovereignty south of the Alps. Yet this claim had momentous consequences, since it led the German emperors into centuries of conflict with the papacy and local Italian rulers, linking North and South in a love-hate relationship whose echoes can be felt to the present day.

Sculpture

During the Ottonian period, from the midtenth century to the beginning of the eleventh, Germany was the leading nation of Europe, politically as well as artistically. German achievement in both areas began as a revival of Carolingian traditions but soon developed new and original traits. These are impressively brought home to us if we compare the Christ on the *Lindau Gospels* cover (see fig. 106) with The Gero Crucifix (fig. 109) in the Cathedral of Cologne. The two works are separated by little more than a hundred years' interval, but the contrast between them suggests a far greater span. In The Gero Crucifix we meet an image of the Saviour new to Western art, although a restrained beginning toward this interpretation (see fig. 98) was already in the making somewhat earlier in Byzantine art. We do not belittle the genius of the Ottonian sculptor by pointing this out, nor need we be surprised that Eastern influence should have been strong in Germany at this time, for Otto II had married a Byzantine princess, establishing a direct link between the two imperial courts. It remained for the German sculptor to transform the Byzantine image with its gentle pathos into large-scale sculptural terms, imbued with an

109. The Gero Crucifix. c. 975–1000 A.D. Wood, height 6'2". Cathedral of Cologne

expressive realism that has been the main strength of German art ever since. How did he arrive at this startling conception? Particularly bold is the forward bulge of the heavy body, which makes the physical strain on arms and shoulders seem almost unbearably real. The deeply incised, angular features of the face are a mask of agony from which all life has fled. The pervasive presence of Spirit, so new and striking in the St. Mark of the Ebbo Gospels (see fig. 108), acquires added meaning if paired with this graphic visualization of its departure.

Architecture

The tutor of Otto II's son and heir, Otto III, was a cleric named Bernward, who later became bishop of Hildesheim, where he ordered built the Benedictine Abbey Church of St. Michael (whose interior is shown in fig. 110). The plan (fig. 111), with its two choirs and

110. Interior (view toward the west, before World War II), St. Michael's, Hildesheim. 1001-33

111. Reconstructed plan of St. Michael's, Hildesheim

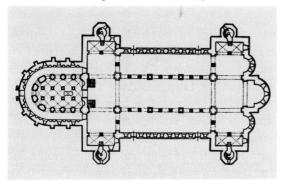

lateral entrances, recalls the monastery church of the St. Gall plan (see fig. 105). But in St. Michael's the symmetry is carried much further: not only are there two identical transepts, with crossing towers and stair turrets, but the supports of the nave arcade, instead of being uniform, consist of pairs of columns separated by square piers. This alternating system divides the arcade into three equal units of three openings each; the first and third units are correlated with the entrances, thus echoing the axis of the transepts. Since, moreover, the aisles and nave are unusually wide in relation to their length, Bernward's intention must have been to achieve a harmonious balance between the longitudinal and transverse axes throughout the structure. The western choir was raised above the level of the rest of the church, so as to accommodate a half-subterranean basement chapel, or crypt, apparently a special sanctuary of St. Michael, which could be entered both from the transept and from the west.

How much importance Bernward himself attached to the crypt at St. Michael's can be gathered from the fact that he commissioned a pair of richly sculptured bronze doors which were probably meant for the two entrances leading from the transept to the ambulatory (they were finished in 1015, the year the crypt was consecrated). The idea of commissioning a pair of large bronze doors for the church may have come to him as the result of a visit to Rome, where ancient examples, perhaps Byzantine ones too, existed. The Bernward doors, however, differ from these; they are divided into broad, horizontal fields, rather than vertical panels, and each field contains a biblical scene in high relief. Our detail (fig. 112) shows Adam and Eve after the Fall. Below it, in inlaid letters remarkable for their Classical Roman character, is part of the dedicatory inscription, with the date and Bernward's name. In these figures we find nothing of the monumental spirit of The Gero Crucifix: they seem far smaller than they actually are, so that one might easily mistake them for a piece of goldsmith's work such as the *Lindau Gospels* cover. The entire composition must have been derived from an illuminated manuscript: the oddly stylized bits of vegetation have a good deal of the twisting, turning movement we recall from Irish miniatures. Yet the story is conveyed with splendid directness and expressive force. The accusing finger of the Lord, seen against a great void of blank surface, is the focal point of the drama; it points to a cringing Adam, who passes the blame to his

112. Adam and Eve Reproached by the Lord, from the doors of Bishop Bernward for St. Michael's. 1015. Bronze, about 23×43 ". Hildesheim Cathedral

mate, while she, in turn, passes it to the dragon-like serpent at her feet.

Manuscripts

The same intensity of glance and gesture characterizes Ottonian manuscript painting, which blends Carolingian and Byzantine elements into a new style of extraordinary power and scope. Perhaps its finest achievement—and one of the great masterpieces of medieval art—is the Gospel Book of Otto III, from which we reproduce the scene of Christ washing the feet of the Disciples (fig. 113). It contains echoes of ancient painting, filtered through Byzantine art; the soft pastel hues of the background recall the illusionism of Roman landscapes (see fig. 81), and the architectural frame around Christ is a late descendant of the sort of painted architectural perspectives that decorated Pompeian houses (see fig. 82). That these elements have been misunderstood by the Ottonian artist is

obvious enough; but he has also put them to a new use: what was once an architectural vista now becomes the Heavenly City-the House of the Lord, filled with golden celestial space, as against the atmospheric earthly space without. The figures have undergone a similar transformation: in Classical art this composition had been used to represent a doctor treating his patient. Now, St. Peter takes the place of the sufferer, and Christ-still beardless and young here—that of the doctor. A shift of emphasis from physical to spiritual action is conveyed not only through glances and gestures, but also by nonrealistic scale relationships: Christ and St. Peter are larger than the other figures; Christ's "active" arm is longer than the "passive" one; and the eight Disciples who merely watch have been compressed into a space so small that we are conscious of them only as so many eyes and hands. Even the Early Christian crowd-cluster from which this derives (see fig. 88) is not quite so literally disembodied.

113. Christ Washing the Feet of Peter, from the Gospel Book of Otto III. c. 1000 A.D. Manuscript illumination.

Romanesque Art

Looking back over the ground we have covered in this book so far, a thoughtful reader will be struck by the fact that many of the labels used to designate the art of a given place and period might serve equally well for a general history of civilization. They have been borrowed from technology (e.g., the Stone Age, or the Bronze Age), or from geography, ethnology, or religion, although in our context they also designate artistic styles. There are two notable exceptions to this rule: Archaic and Classical are both primarily terms of style; they refer to qualities of form rather than to the setting in which these forms were created. Why don't we have more terms of this sort? We do-but only for the art of the last nine hundred years. The men who first conceived the history of art as an evolution of styles started out with the conviction that art had already developed to a single climax: Greek art from the age of Pericles to that of Alexander the Great. This style they called Classical (that is, perfect). Everything that came before was termed Archaic-still old-fashioned and tradition-bound, but striving in the right direction. The style that followed the peak did not deserve a special term since it had no positive qualities of its own, being merely an echo or a decadence of Classical art. The early historians of medieval art followed a similar pattern; to them the great climax was the Gothic style (the term itself, however, was invented by lovers of the Classical, and was meant to indicate that medieval art was the work of Goths, or barbarians). This flourished from the thirteenth to the fifteenth century. For whatever was notvet-Gothic they invented the term "Romanesque"; in doing so they were thinking mainly of architecture: pre-Gothic churches,

they noted, were round-arched, solid, and heavy, rather like the ancient Roman style of building, as against the pointed arches and the soaring lightness of Gothic structures.

In this sense, all of medieval art before 1200 could be called Romanesque if it showed any link at all with the Mediterranean tradition. But this usually happened only when an ambitious ruler, like Charlemagne, had dreams of reconstituting the Roman Empire and becoming emperor himself, with all the glorious trappings of old. Such Classical revivals rose and fell with the political fortunes of the dynasties that sponsored them. However, the style that is given the name "Romanesque" had a much broader base: it sprang up throughout Western Europe at about the same time, embracing a host of regional styles, distinct yet closely related in many ways, and without a single central source. In this it resembled the art of the Dark Ages which, as we have indicated, wandered with the nomadic tribes that came from Asia, all the way across Northern and Central Europe, picking up local modifications or putting old forms to new uses.

The welding of all these components into a coherent style during the second half of the eleventh century was not done by any single force, but by a variety of factors that made for a new burst of vitality throughout the West. Christianity had at last triumphed everywhere in Europe; the threat of hostile invading cultures around its outer edges had been stilled, either because their momentum gave out or because they were conquered or assimilated. There was a growing spirit of religious enthusiasm, reflected in the greatly increased pilgrimage traffic to sacred sites, and culminating, from 1095 on, in the cru-

sades to liberate the Holy Land. Equally important was the reopening of Mediterranean trade routes by the navies of Venice, Genoa, and Pisa, and the revival of trade and manufacturing, with the consequent growth of city life. During the turmoil of the Early Middle Ages, the towns of the Western Roman Empire had shrunk greatly (the population of Rome, about one million in 300 A.D., fell to less than fifty thousand at one time); some were deserted altogether. From the eleventh century on, they began to regain their importance; new towns sprang up everywhere, and an urban middle class of craftsmen and merchants established itself between the peasantry and the landed nobility. In many respects, then, Western Europe between 1050 and 1200 A.D. did indeed become a great deal more "Romanesque" than it had been since the sixth century, recapturing some of the trade patterns, the urban quality, and the military strength of ancient imperial times. The central political authority was lacking, to be sure (even the empire of Otto I did not extend much farther west than modern Germany does), but the central spiritual authority of the pope took its place, to some extent, as a unifying force. The international army that responded to Pope Urban II's call to the First Crusade was more powerful than anything a secular ruler could have raised for that purpose.

ARCHITECTURE

The quickening of energy in both spiritual and secular enterprise is responsible for the greatest single change that we discern in Romanesque architecture: the amazing number of new buildings which were begun all over Europe at about the same period. An eleventh-century monk, Raoul Glaber, summed it up well when he triumphantly exclaimed that the world was "putting on a white mantle of churches." These churches were not only more numerous than those of the Early Middle Ages, they were also generally larger, more richly articulated, and more "Roman

looking," for their naves now had vaulted roofs instead of wooden ones, and their exteriors, unlike those of Early Christian, Byzantine, Carolingian, and Ottonian churches, were decorated with both architectural ornament and sculpture. Romanesque monuments of the first importance are distributed over an area that might well have represented the world—the Catholic world, that is to Raoul Glaber: from northern Spain to the Rhineland, from the Scottish-English border to central Italy. The richest crop, the greatest variety of regional types, and the most adventurous ideas are to be found in France. If we add to this group those destroyed or disfigured buildings whose original design is known to us through archaeological research, we have a wealth of architectural invention unparalleled by any previous era.

Southwestern France

Let us begin our sampling—it cannot be more than that—with St.-Sernin in the southern French town of Toulouse (figs. 114-16). The plan immediately strikes us as much more complex and more fully integrated than the plans of earlier structures, with the possible exception of Hagia Sophia. Its outline is an emphatic Latin cross, of the kind that appears in the mosaic half-dome in Sant' Apollinare (see fig. 87), with the stem longer than the three other projecting parts (the Greek cross, used as a symbol in the Eastern Orthodox Church, has all arms of the same length, rather like the cross inscribed in a circle that we saw in our earliest Christian paintings; see fig. 85). The nave is the largest space compartment, but it is extended by the transverse arms (called the transept) where more pilgrims could be accommodated to witness the sacred ritual which was concentrated in the smallest compartment of all, the apse at the east end. Unlike the plan of the monastery church in St. Gall (see fig. 105), where altars and chapels for special devotions are scattered fairly evenly throughout the enclo-

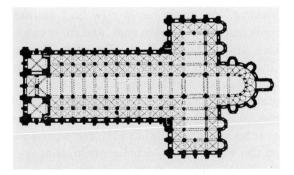

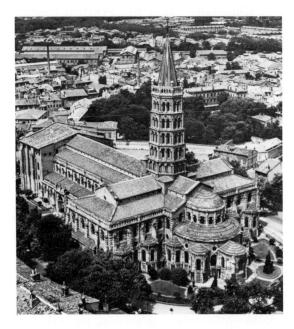

115. (below left) St.-Sernin (aerial view), Toulouse. c. 1080-1120

116. (below right) Nave and choir, St.-Sernin, Toulouse

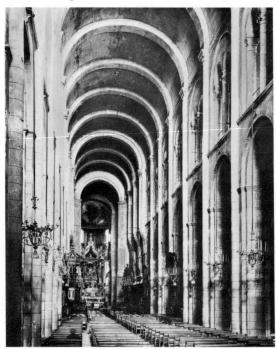

sure, and where the transept, though identifiable, tends to merge with the altar space at the east end, this church was plainly meant to accommodate large crowds of lay worshipers. The nave is flanked by two aisles on either side, the inner aisle continuing around the arms of the transept and the apse, thus forming a complete ambulatory (which means "for walking") circuit, anchored to the two towers on either side of the main entrance (these can clearly be seen in the plan, but not in the superstructure). Chapels extrude from the ambulatory along the eastern edge of the transept arms, and all around the apse; the longest one at the eastern tip was usually dedicated to the Virgin Mary, and is thus often referred to as the Lady Chapel. This type of apse with its elaborations of chapels and ambulatory is called a "pilgrimage choir"; pilgrims could "make the rounds" of the chapels even when there was no Mass being celebrated at the main altar.

The plan shows that the aisles of St.-Sernin were groin-vaulted throughout, and that the measurements of these compartments logically form the basic unit, or module, for all the other dimensions: the width of the central space of the nave, for example, equals twice the width of one compartment in the aisle. On the exterior this rich articulation is further enhanced by the different roof levels of the aisles, set off against the higher gables of

nave and transept, and the cluster of semicircular roofs, large and small and at every level, that cover the complex eastern end. Even necessary structural features, such as the thick pier buttresses between the windows, which serve to stabilize the outward thrust of the ceiling vaults, become decorative assets, as is the tower over the crossing (although this was completed in Gothic style, and is taller than originally intended). The two façade towers unfortunately were never completed.

As we enter the nave (fig. 116), we are impressed by its tall proportions, the architectural elaboration of the walls, and the dim indirect lighting, which is filtered through the aisles and the gallery above them, before reaching the nave. The contrast between St.-Sernin and a typical Early Christian basilica, such as Sant' Apollinare (see fig. 87), with its simple "blocks" of space and unobtrusive masonry, does indeed point up the kinship between St.-Sernin and Roman buildings, such as the Colosseum (see fig. 69), that have vaults, arches, engaged columns, and pilasters all firmly knit within a coherent order. Yet the forces whose interaction is expressed in the nave of St.-Sernin are no longer the physical, "muscular" forces of Graeco-Roman architecture, but spiritual forces—spiritual forces of the kind that we have seen governing the human body in Carolingian miniatures or Ottonian sculpture. The half-columns running the entire height of the nave wall would appear just as unnaturally drawn-out to an ancient Roman beholder as the arm of Christ in figure 113. They seem to be driven upward by some tremendous, unseen pressure, hastening to meet the transverse arches that subdivide the barrel vault of the nave. Their insistent rhythm propels us forward toward the eastern end of the church, with its light-filled apse and ambulatory (now partially obscured by a large altar of later date).

In thus describing our experience we do not, of course, mean to suggest that the archi-

tect consciously set out to achieve these effects. For him, beauty and engineering were inseparable; if vaulting the nave so as to eliminate the fire hazards of a wooden roof was a practical aim, it was also a challenge to see how high he could build it (a vault gets more difficult to sustain, the higher it is from the ground) in honor of the Lord, to make His house grander and more impressive. The ambitious height required the galleries over the aisles to carry the thrust of the central barrel vault and ensure its stability. Thus, the "mysterious" semigloom of the interior was not a calculated effect, but merely the result of the windows having to be at some distance from the center of the nave. St.-Sernin serves to remind us that architecture, like politics, is "the art of the possible," and that the designer here, as elsewhere, is successful to the extent that he explores the limits of what was possible for him under those particular circumstances, structurally and aesthetically.

Western France

Since the west end of St.-Sernin with its towers was never completed, we shall examine Notre-Dame-la-Grande in Poitiers, a town in the west of France, for a lavish example of the Romanesque church façade (fig. 117). Low and wide, it has elaborately bordered arcades housing large seated or standing figures; below these, deeply recessed within a framework of arches resting on stumpy columns, is the main entrance. A wide band of relief extends from the center arch all across the façade until it is finally terminated by the two towers with their taller bundles of columns and open arcades, looking rather like fantastic chessmen. Their conical helmets match the height of the center gable (which rises above the height of the actual roof behind it). No doubt the columns, with their Classical foliage capitals, and the arches are every bit as "Roman" as those used in St.-Sernin. Yet we feel that the whole is neither rational nor organic, even though it provides a visual feast. Perhaps the designer

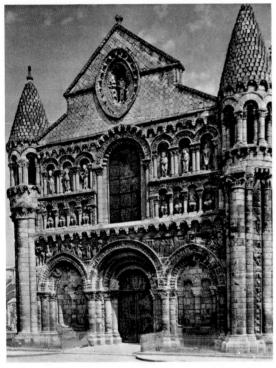

117. West façade, Notre-Dame-la-Grande, Poitiers. Early 12th century

had never studied actual Roman buildings, but had received their repertory of forms through Roman sarcophagi (which were abundant throughout the south of France); examples such as that of Junius Bassus (see fig. 91) are decorated with a kind of two-story "doll's house" that serves to frame the various biblical figures.

Normandy and England

Farther north, in Normandy, the west façade evolved in an entirely different direction. That of the Abbey Church of St.-Etienne at Caen (fig. 118), founded by William the Conqueror soon after his successful invasion of England, offers a complete contrast to Notre-Dame-la-Grande. Decoration is at a minimum and even contrasts of the lesser architectural members are played down; four huge buttresses divide the front of the church into three vertical sections, and the vertical impetus continues triumphantly in the two

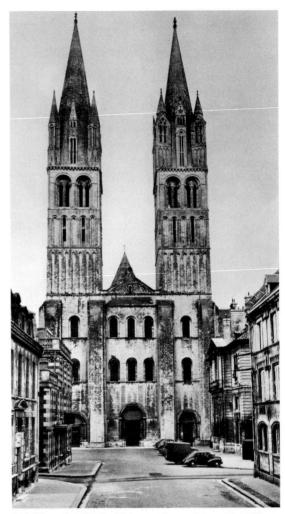

118. West façade, St.-Etienne, Caen. Begun c. 1068

splendid towers whose height would be impressive enough even without the tall Early Gothic spires on top. Where St.-Sernin strikes us as full-bodied and "muscular," St.-Etienne is cool and composed: a structure to be appreciated, in all its refinement of proportions, by the mind rather than the visual or tactile faculties. And, in fact, the thinking that went into Anglo-Norman architecture (for William started to build in England, too) is responsible for the next great breakthrough in structural engineering that made possible the soaring churches of the Gothic period.

For an example of Romanesque on English

soil, we turn to the interior of Durham Cathedral, begun in 1093 (fig. 119), just south of the Scottish border. The nave that we see here is actually one-third wider than St.-Sernin, and it has a greater overall length: four hundred feet, which places it among the largest churches of medieval Europe. Despite its width, the nave may have been designed from the start to be vaulted; and this vault is of great interest, for it represents the earliest systematic use (the east end vaulting was completed in 1107) of the ribbed groin vault over a three-story nave. The aisles, which we can glimpse through the arcade, consist of the same sort of nearly square groin-vaulted compartments that are familiar to us from St.-Sernin; but the bays of the nave, separated by strong transverse arches, are decidedly oblong. They are groin-vaulted in such a way that the ribs, used at the junctures of the intersections, form a double-X design, dividing the vault into seven sections, rather than the conventional four. Since the nave bays are twice as long as the aisle bays, the heavy transverse arches occur only at the odd-numbered piers of the nave arcade; thus the piers alternate in size, the larger ones, where the thrust of the vaulting is greatest, being of compound shape (that is, bundles of column shafts and pilaster shafts attached to a square or oblong core), the others cylindrical. But how did the architect come upon this peculiar solution? Let us assume that he was familiar with earlier churches on the order of St.-Sernin, and started out by designing a barrel-vaulted nave with galleries over the aisles, and no windows to light the nave directly. While he was doing so, it suddenly occurred to him that by putting groin vaults over the nave as well as the aisles, he would gain a semicircular area at the ends of each transverse vault; this area, since it had no essential supporting function, could be broken through to make windows. The result would be a pair of Siamese-twin groin vaults, divided into seven compartments, in each bay of the nave. The weight and thrust would be

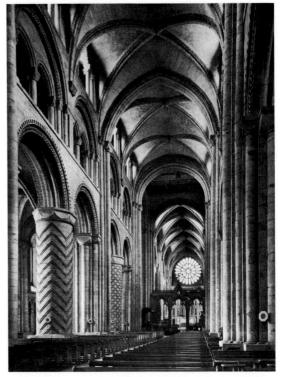

119. Nave (view toward the east), Durham Cathedral. 1093-1130

concentrated at six securely anchored points at the gallery level, and thence led down to the piers and columns below. The ribs, of course, were necessary to provide a skeleton, so that the various curved surfaces between them could be filled in with masonry of minimum thickness, thus reducing both weight and thrust.

We do not know whether this ingenious scheme was actually invented in Durham, but it could not have been created much earlier, for it is still in the experimental stage here; while the transverse arches at the crossing are round, those farther along toward the west end of the nave are slightly pointed, indicating a continuous search for improvements. Aesthetically, the nave of Durham is one of the finest in all Romanesque architecture; the sturdiness of the alternating piers makes a wonderful contrast with the dramatically lighted, sail-like surfaces of the vaults.

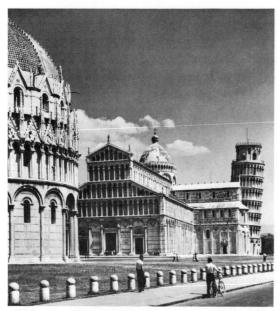

120. Pisa Cathedral, Baptistery, and Campanile (view from the west). 1053-1272

Italy

Turning to central Italy, which had been part of the heartland of the original Roman Empire, we might expect it to have produced the noblest Romanesque of them all, since surviving Classical originals were close at hand to study. It comes as a slight shock, therefore, to realize that such was not the case: all of the rulers having ambitions to revive "the grandeur that was Rome," with themselves in the role of emperor, were in the north of Europe. The spiritual authority of the pope, reinforced by considerable territorial holdings, made imperial ambitions in Italy difficult. New centers of prosperity, whether arising from seaborne commerce or local industries. tended rather to consolidate a number of small principalities, which competed among themselves or aligned themselves from time to time, if it seemed politically profitable, with the pope or the German emperor. Lacking the urge to re-create the old Empire, and furthermore having Early Christian church buildings as readily accessible as Classical Roman architecture, the Tuscans were content to continue what are basically Early

Christian forms, but enlivened them with decorative features inspired by pagan Roman architecture. If we take one of the best preserved Tuscan Romanesque examples, the Cathedral complex of Pisa (fig. 120), and compare it on the one hand with the view of Sant' Apollinare in Ravenna (see fig. 86), and on the other with the view of St.-Sernin in Toulouse (see fig. 115), we are left in little doubt as to which is its closer relation. True, it has grown taller than its ancestor, and a large transept has altered the plan to form a Latin cross, with the consequent addition of a tall lantern rising above the intersection. But the essential features of the earlier basilica type, with its files of flat arcades and even the detached bell tower (the famous "Leaning Tower of Pisa," which was not planned that way but began to tilt because of weak foundations), still continue, much as we see them in Sant' Apollinare.

The only deliberate revival of the antique Roman style was in the use of a multicolored marble "skin" on the exteriors of churches

121. Baptistery, Florence. c. 1060-1150

(Early Christian examples, we recall, tended to leave the outsides plain). Little of this is left in Rome, a great deal of it having literally been "lifted" for the embellishment of later structures; but the interior of the Pantheon (see fig. 71) still gives us some idea of it, and we can recognize the desire to emulate such marble inlay in the Baptistery in Florence (fig. 121). The green and white marble paneling follows severely geometric lines. The blind arcades are eminently Classical in proportion and detail; the entire building, in fact, exudes such an air of Classicism that the Florentines themselves came to believe, a few hundred years later, that it had originally been a temple of Mars, the Roman god of war. We shall have to return to this Baptistery again, since it was destined to play an important part in the Renaissance.

SCULPTURE

The revival of monumental stone sculpture is even more astonishing than the architectural achievements of the Romanesque era, since neither Carolingian nor Ottonian art had shown any tendencies in this direction. Freestanding statues, we will recall, all but disappeared from Western art after the fifth century; stone relief survived only in the form of architectural ornament or surface decoration, with the depth of the carving reduced to a minimum. Thus the only continuous sculptural tradition in early medieval art was of sculptures-in-miniature: small reliefs and occasional statuettes, made of metal or ivory. Ottonian art, in works such as the bronze doors of Bishop Bernward, had enlarged the scale of this tradition but not its spirit; and truly large-scale sculpture, represented by the impressive Gero Crucifix (see fig. 109), was limited almost entirely to wood.

Southwestern France

Just when and where the revival of stone sculpture began we cannot say with assur-

122. Apostle. c. 1090. St.-Sernin, Toulouse

ance, but if any one area has a claim to priority it is southwestern France and northern Spain, along the pilgrimage roads leading to Santiago de Compostela. The link with the pilgrimage traffic seems logical enough, for architectural sculpture, especially when applied to the exterior of a church, is meant to appeal to the lay worshiper rather than to the members of a closed monastic community. Like Romanesque architecture, the rapid development of stone sculpture between 1050 and 1100 reflects the growth of religious fervor among the lay population in the decades before the First Crusade. Of course a carved

123. South portal (portion), St.-Pierre, Moissac. Early 12th century. Stone

image in stone, being three-dimensional and tangible, is more "real" than a painted one, and to a cleric steeped in the abstractions of theology and edgy about any signs of a revival of idolatry, this might have seemed a frivolous, even dangerous novelty. St. Bernard of Clairvaux, writing in 1127, denounced the sculptured decoration of churches as a vain folly and diversion that tempts us "to read in the marble rather than in our books." His warning was not much heeded, however; to the unsophisticated, any large piece of sculpture inevitably did have something of the

quality of an idol, but that very fact is what gave it such great appeal: praying before a statue of a saint made the worshiper feel that his prayers were going in the right direction, not wafting into the thin air that might or might not transmit them to heaven.

The Apostle from St.-Sernin (fig. 122) has a strongly Classical air, indicating that our artist must have had a close look at late Roman sculpture (of which there are considerable remains in southern France). The design as a whole, on the other hand-the solemn frontality of the figure, its placement in the architectural frame—derives from a Byzantine source, in all likelihood an ivory panel descended from The Archangel Michael in figure 92. Yet in enlarging such a miniature, the carver of our relief has also reinflated it: the niche is a real cavity, the hair a round, close-fitting cap, the body severe and blocklike. Our Apostle has, in fact, much the same dignity and directness as the sculpture of Archaic Greece.

Some distance north of Toulouse stands the Abbey Church of St.-Pierre at Moissac; its south portal displays a richness of invention that would have made St. Bernard wince. In figure 123 we see the magnificent trumeau (the center post supporting the lintel of the doorway) and the western jamb. Both have a scalloped profile—apparently a bit of Moorish influence—and within these outlines human and animal forms are treated with the same incredible flexibility, so that the spidery Prophet on the side of the trumeau seems perfectly adapted to his precarious perch. He even remains free to cross his legs in a dancelike movement, and to turn his head toward the interior of the church as he unfurls his scroll. But what of the crossed lions that form a symmetrical zigzag on the face of the trumeau—do they have a meaning? So far as we know, they simply "animate" the shaft, as the interlacing beasts of Irish miniatures (whose descendants they are) animated the compartments assigned them. In manuscript illumination, this tradition had never died out; our sculptor has undoubtedly been influenced by it, just as the agitated movement of the Prophet has its ultimate origin in miniature painting. Yet we cannot fully account for the presence of the lions in terms of their effectiveness as ornament. They belong to a vast family of savage or monstrous creatures in Romanesque art that retain their demoniacal vitality even though they are compelled—like our lions to perform supporting functions. Their purpose, therefore, is also expressive; they embody dark forces that have been domesticated into guardian figures, or banished to a position that holds them fixed for all eternity, however much they may snarl in protest.

Burgundy

In Romanesque churches the tympanum (the lunette inside the arch above the lintel) of the main portal is usually given over to a composition centered on the Enthroned Christ, most often the Apocalyptic Vision of the Last Judgment—the most awesome scene of Christian art. At Autun Cathedral this subject has been visualized with singular expressive force. Our figure 124 shows part of the right half of the tympanum, with the weighing of the souls. At the bottom, the dead rise from their graves in fear and trembling; some are already beset by snakes or gripped by huge, clawlike hands. Above, their fate quite literally hangs in the balance, with devils yanking at one end of the scales and angels at the other. The saved souls cling, like children, to the hem of the angelic garments, while the condemned are seized by grinning demons and cast into the mouth of Hell. These devils betray the same nightmarish imagination we observed in the pre-Romanesque animal style; but their cruelty, unlike that of the animal monsters, goes unbridled; they enjoy themselves to the full in their grim occupation. No visitor, having "read in the marble" (to speak with St. Bernard), could fail to enter the church in a chastened spirit.

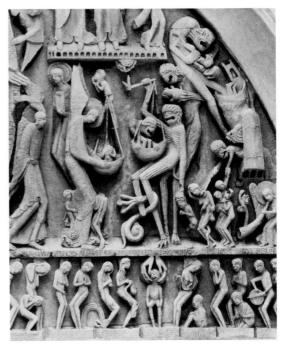

124. Last Judgment (detail), west tympanum, Autun Cathedral. c. 1130–35. Stone

The Meuse Valley

The emergence of distinct artistic personalities in the twelfth century is rarely acknowledged, perhaps because it contravenes the widespread assumption that all medieval art is anonymous. It does not happen very often, of course, but it is no less significant for all that. In the valley of the Meuse River, which runs from northeastern France into Belgium and Holland, there had been a particularly strong awareness of Classical sources since Carolingian times (the Lindau Gospels cover, fig. 106, and the Ebbo Gospels, fig. 108, originated in this region); it continued to be felt during the Romanesque period. Interestingly enough, the revival of individualism and personality may often be linked with a revival of ancient art, even if the Classical influence did not always produce monumental works. "Mosan" Romanesque sculpture excelled in metalwork, such as the splendid bronze baptismal font (fig. 125) of 1107-18 in Liège, which is the masterpiece of the earliest artist

125. Renier of Huy. Baptismal font. 1107–18. Bronze, height 25". St. Barthélemy, Liège

126. Ewer, from Meuse Valley. c. 1130. Gilt bronze, height 71/4". Victoria & Albert Museum, London (Crown Copyright Reserved)

of the region whose name we know: Renier of Huy. The vessel rests on twelve oxen (symbolizing the Apostles), like Solomon's basin in the Temple at Jerusalem as described in the Bible. The reliefs make an instructive contrast with those of Bernward's doors (see fig. 112) since they are about the same height. Instead of the rough, expressive power of the Ottonian panel, we find here a harmonious balance of design, a subtle control of the sculptured surfaces, and an understanding of organic structure that, in medieval terms, are amazingly Classical. The figure seen from the back (beyond the tree on the left in our picture), with its graceful turning movement and Greek-looking drapery, might almost be mistaken for an ancient work.

Of freestanding bronze sculpture, only one example of the period has survived; but related to it are the countless bronze water ewers, in the shapes of lions, dragons, and various monsters, that came into use during the twelfth century for the ritual washing of the priest's hands during Mass. These vessels—another instance of monsters doing menial service for the Lord—were of Near Eastern inspiration. The beguiling specimen reproduced in figure 126 is descended from the winged beasts of Persian art, transmitted to the West through trade with the Islamic world.

PAINTING

Unlike architecture and sculpture, Romanesque painting shows no sudden revolutionary developments that set it apart immediately from Carolingian or Ottonian. Nor does it look any more "Roman." This does not mean that painting was less important than it had been before: it merely emphasizes the greater continuity of the pictorial tradition, especially in manuscript illumination. Nevertheless, soon after the year 1000 we find the beginnings of a painting style which corresponds to—and often anticipates—the monumental qualities of Romanesque sculpture. As in the case of architecture and sculpture, Romanesque painting developed a wide

127. (opposite) St. John the Evangelist, from the Gospel Book of Abbot Wedricus. Shortly before 1147. Manuscript illumination. Société Archéologique, Avesnes, France

variety of regional styles; its greatest achievements emerged from the monastic scriptoria of northern France, Belgium, and southern England. The works produced in this area are so closely related in style that at times it is impossible to be sure on which side of the English Channel a given manuscript belongs. Thus, the style of the wonderful miniature of St. John (fig. 127) has been linked with both Cambrai and Canterbury. The prevalent tendency of Romanesque painting toward uncompromising linearity has here been softened by Byzantine influence, without losing any of the energetic rhythm that it inherited from the Reims school of illumination. But ultimately the style of such a page as this goes back to the Celto-Germanic tradition (see fig. 102), to the precisely controlled dynamics of every contour, in both the main figure and the frame, that unite the varied elements of the composition into a coherent whole, even though in this instance human and floral forms may be copied from Carolingian or Byzantine models. The unity of the page is conveyed not only by style, but by content as well. The Evangelist "inhabits" the frame in such a way that we could not remove him from it without cutting off his ink supply (proffered by the donor of the manuscript, Abbot Wedricus), his source of inspiration (the dove of the Holy Spirit, in the hand of God), or his identifying symbol, the eagle.

The linearity and the simple, closed contours of a painting style such as this lend themselves very well to other mediums and to changes in scale (murals, tapestries, stained-glass windows, sculptured reliefs). The so-called *Bayeux Tapestry* is an embroidered strip of cloth 230 feet long illustrating William the Conqueror's invasion of England; in our detail (fig. 128), which shows the Battle of Hastings, the main scene is enclosed by two border strips performing a function not unlike the frame around the *St. John* (see above). Partly it is purely decorative (the upper tier with birds and animals), but partly it

is integral to the central action (the lower strip is full of dead warriors and horses and thus forms part of the story). Devoid of nearly all the pictorial refinements of Classical painting (see fig. 45), it nevertheless manages to give us an astonishingly vivid and detailed account of warfare in the eleventh century; the massed discipline of the Graeco-Roman scene is gone, and this is not due to the artist's ineptitude at foreshortening and overlapping, but to a new kind of individualism that makes of each combatant a potential hero, whether by dint of force or cunning (observe how the soldier who has just fallen from the horse that is somersaulting with its hind legs in the air is, in turn, toppling his adversary by yanking at the saddle girth of his mount).

Firm outlines and a strong sense of pattern are equally characteristic of Romanesque wall painting. The Building of the Tower of Babel (fig. 129) is taken from the most impressive surviving cycle, on the nave vault of the church at St.-Savin-sur-Gartempe. It is an intensely dramatic design; the Lord Himself, on the far left, participates directly in the narrative as He addresses the builders of the growing structure. He is counterbalanced, on the right, by the giant Nimrod, the leader of the enterprise, who frantically passes blocks of stone to the masons atop the tower, so that the entire scene becomes a great test of strength between God and Man, somewhat reminiscent of the hand-to-hand combat in the Bayeux Tapestry.

Soon after the middle of the twelfth century, an important change in style begins to make itself felt in Romanesque painting on either side of the English Channel. The Crossing of the Red Sea (fig. 130), one of many enamel plaques that make up a large altarpiece at Klosterneuburg by Nicholas of Verdun, shows that lines have suddenly regained their ability to describe three-dimensional shapes. The drapery folds no longer lead an ornamental life of their own but suggest the rounded volume of the body under-

128. The Battle of Hastings, portion of the Bayeux Tapestry. c. 1073–83. Wool embroidery on linen, height 20''. Town Hall, Bayeux

129. The Building of the Tower of Babel, portion of painted nave vault. Early 12th century. St.-Savin-sur-Gartempe

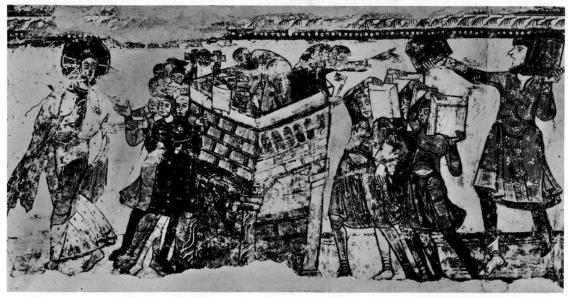

neath. Here, at last, we meet the pictorial counterpart of that Classicism which we saw earlier in the baptismal font of Renier of Huy at Liège (see fig. 125). That the new style should have had its origin in metalwork (which includes not only casting, but also engraving, enameling, and goldsmithing) is not as strange as it might seem, for its essential qualities are sculptural rather than pictorial.

In these "pictures on metal," Nicholas straddles the division between sculpture and painting, as well as that between Romanesque and Gothic art. Although the *Klosterneuburg Altar* was completed well before the end of the twelfth century, there is an understandable inclination to rank it as a harbinger of the style to come, rather than the culmination of a style that had been. Indeed,

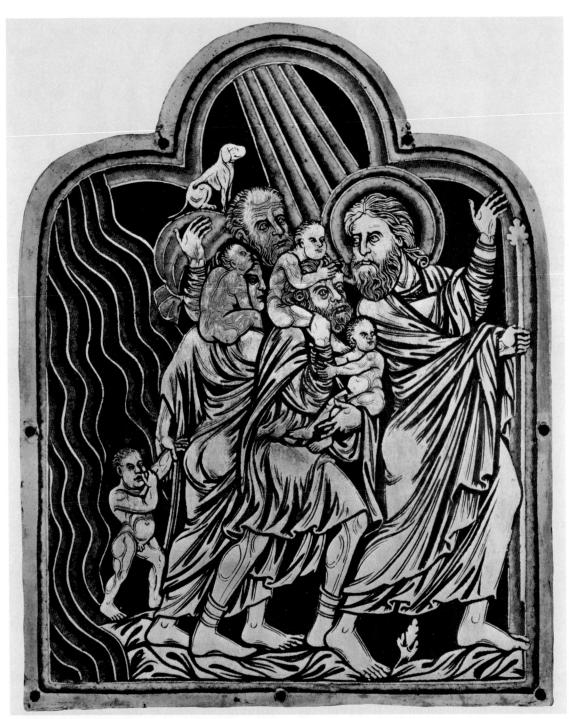

130. Nicholas of Verdun. The Crossing of the Red Sea, from Klosterneuburg Altar. 1181. Enamel plaque, height 51/2''. Klosterneuburg Abbey, Austria

the altarpiece was to have a profound impact upon the painting and sculpture of the next fifty years, when the astonishing humanity of Nicholas' art found a ready response in a Europe that was generally reawakening to a new interest in man and the natural world.

Towns, Cathedrals, and Gothic Art

ARCHITECTURE

Time and space, we have been taught, are interdependent. Yet we tend to think of history as the unfolding of events in time without sufficient awareness of their unfolding in space—we visualize it as a stack of chronological layers, or periods, each layer having a specific depth that corresponds to its duration. For the remote past, where our sources of information are scanty, this simple image works reasonably well. It becomes less and less adequate as we draw closer to the present and our knowledge grows more precise. Thus we cannot define the Gothic era in terms of time alone; we must consider the changing surface area of the layer as well as its depth.

At the start, about 1150, this area was small indeed. It embraced only the province known as the Ile-de-France (that is, Paris and vicinity), the royal domain of the French kings. A hundred years later, most of Europe from Sicily to Iceland had "gone Gothic" with only a few Romanesque pockets left here and there; through the Crusaders, the new style had even been introduced in the Near East. About 1450 the Gothic area had begun to shrink—it no longer included Italy—and about 1550 it had disappeared almost entirely. The Gothic layer, then, has a rather complicated shape, its depth including nearly four hundred years in some places and a hundred and fifty at the least in others. This shape, moreover, does not emerge with equal clarity in all the visual arts. The term Gothic was coined for architecture, and it is in architecture that the characteristics of the style are most easily recognized. Only during the past hundred years have we become accustomed to speak of Gothic sculpture and painting. There is, as we shall see, some un-

certainty even today about the exact limits of the Gothic style in these fields. The evolution of our concept of Gothic art suggests the way the new style actually grew: it began with architecture, and for about a century—from c. 1150 to 1250, during the Age of the Great Cathedrals—architecture retained its dominant role. Gothic sculpture, at first severely architectural in spirit, tended to become less and less so after 1200; its greatest achievements are between the years 1220 and 1420. Painting, in turn, reached a climax of creative endeavor between 1300 and 1350 in central Italy. North of the Alps, it became the leading art after about 1400. We thus find, in surveying the Gothic area as a whole, a gradual shift of emphasis from architecture to painting, or, better perhaps, from architectural to pictorial qualities. (Characteristically enough, Early Gothic sculpture and painting both reflect the discipline of their monumental setting, while Late Gothic architecture and sculpture strive for "picturesque" effects rather than clarity and firmness.) Overlying this broad pattern there is another one: international diffusion as against regional independence. Starting as a local development in the Ile-de-France, Gothic art radiates from there to the rest of France and to all Europe, where it comes to be known as opus modernum or francigenum ("modern" or "French work"). In the course of the thirteenth century, the new style gradually loses its "imported" flavor; regional variety begins to reassert itself. Toward the middle of the fourteenth century, we notice a growing tendency for these regional achievements to influence each other until, about 1400, a surprisingly homogeneous "International Gothic" style prevails almost everywhere. Shortly thereafter, this unity breaks apart: Italy, with Florence in the lead, creates a radically new art, that of the Early Renaissance, while north of the Alps, Flanders assumes an equally commanding position in the development of Late Gothic painting and sculpture. A century later, finally, the Italian Renaissance becomes the basis of another international style. With this skeleton outline to guide us, we can now explore the unfolding of Gothic art in greater detail.

France: St.-Denis

The origin of no previous architectural style can be pinpointed as exactly as that of Gothic. It was born between 1137 and 1144 in the rebuilding, by Abbot Suger, of the royal Abbey Church of St.-Denis just outside the city of Paris. If we are to understand how it came to be just there, and just then, we must acquaint ourselves with the special relationship among St.-Denis, Suger, and the French monarchy. The kings of France claimed their authority from the Carolingian dynastic tradition. But their power was eclipsed by that of the nobles who, in theory, were their vassals; the only area they ruled directly was the Ile-de-France, and they often found their authority challenged even there. Not until the early twelfth century did the royal power begin to expand; and Suger, as chief adviser to Louis VI, played a key role in the process. He forged the alliance between the monarchy and the Church, which brought the bishops of France (and the cities under their authority) to the king's side, while the king, in turn, supported the papacy in its struggles against the German emperors. Suger, however, championed the monarchy not only on the plane of practical politics but on that of "spiritual politics"; by investing the royal office with religious significance, by glorifying it as the strong arm of justice, he sought to rally the nation behind the king. His architectural plans for St.-Denis must be understood in this context, for the church, founded in the late eighth century, enjoyed a dual prestige that made it ideally suitable for Suger's purpose: it was the shrine of the Apostle of France, the sacred protector of the realm, as well as the chief memorial of the Carolingian dynasty (Charlemagne as well as his father, Pepin, had been consecrated there as kings). Suger wanted to make the Abbey the spiritual center of France, a pilgrimage church to outshine the splendor of all the others, the focal point of religious as well as patriotic emotion. But in order to become the visible embodiment of such a goal, the old edifice would have to be enlarged and rebuilt. The great abbot himself described the campaign in such eloquent detail that we know more about what he desired to achieve than we do about the final result, for the west façade and its sculpture are sadly mutilated today, and the east end (the choir), which Suger regarded as the most important part of the church, has been much altered. Because of the disappointing visual remains of Suger's church today, we must be content here to take note of its importance—and important it was: every visitor, it seems, was overwhelmed by its extraordinary impact, and within a few decades the new style had spread far beyond the confines of the Ile-de-France.

Notre-Dame

Although St.-Denis was an abbey, the future of Gothic architecture lay in the towns rather than in rural monastic communities. There had been a vigorous revival of urban life, we will recall, since the early eleventh century; this movement continued at an accelerated pace, and the growing weight of the cities made itself felt not only economically and politically, but in countless other ways as well: bishops and the city clergy rose to new importance; cathedral schools and universities took the place of the monasteries as centers of learning (see p. 137), while the artistic efforts

of the age culminated in the great cathedrals. That of Notre-Dame ("Our Lady") at Paris, begun in 1163, reflects the salient features of Suger's St.-Denis more directly than any other. Let us begin by comparing the plan (fig. 131) with that of a Romanesque church (see fig. 114): it is very much more compact and unified, with the double ambulatory of the choir continuing directly into the aisles, the stubby transept barely exceeding the width of the façade. In preparation for what we shall find in the view of the interior, we may also take note of the vaulting system: each bay (except for the crossing and the apse) along the central axis has an oblong shape, divided by a rib system that we have not met heretofore; outlined by transverse ribs, each compartment is then not only subdivided by two crossed ribs (the groin vault familiar to us from the aisles of St.-Sernin and other churches), but also bisected by a third rib, the ends of each rib corresponding to a column on the floor of the nave. This is known as a sexpartite vault. Although not identical with the vaulting system that we found in Durham Cathedral (see fig. 119—the "Siamesetwin" groin vault), it continues the kind of experimentation that was begun in the Norman Romanesque to find ways of lightening the load of masonry between the supports. In the interior (fig. 132) we find other echoes of Norman Romanesque in the galleries above the inner aisles and the columns used in the nave arcade. Here, also, the use of pointed arches, which was pioneered in the western bays of the nave at Durham, has become systematic throughout the building. The two halves of a pointed arch, by eliminating the part of the round arch that responds the most to the pull of gravity, brace each other; the pointed arch thus exerts less outward pressure than the semicircular arch, and, depending on the angle at which the two sections meet, it can be made as steep as one wishes. The potentialities of the engineering advances that grew out of this discovery are already evident in Notre-Dame: the large

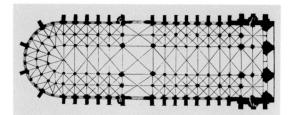

131. Plan of Notre-Dame, Paris. 1163-c. 1250

132. Nave and choir, Notre-Dame, Paris. 1163-c. 1200

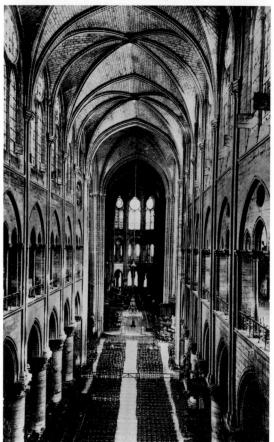

clerestory windows, the lightness and slenderness of the forms, which reflect that of the ribs of the vault, create the "weightless" effect that we associate with Gothic interiors. In contrast to the heavily emphasized moldings of St.-Sernin, the walls here are left plain, which makes them seem thinner. Gothic, too, is the "verticalism" of the nave's interior. This depends less on the actual proportions—some Romanesque churches are

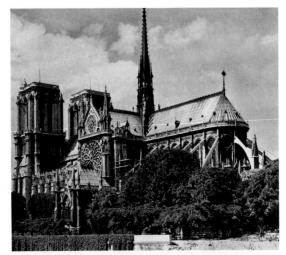

133. Notre-Dame (view from the southeast), Paris

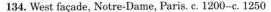

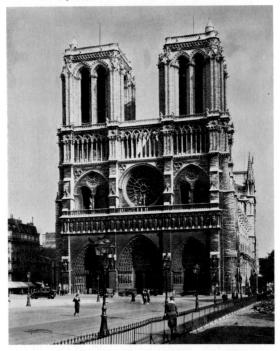

equally tall, relative to their width—than on the constant accenting of the verticals and on the sense of ease with which the height has been attained.

In Notre-Dame the buttresses (the "heavy bones" of the structure that ultimately take the weight and thrust of the vaulting) are not visible from the inside. The plan shows them as massive blocks of masonry that stick out from the building like a row of teeth. From the outside (fig. 133) we can see that above the level of the aisle compartments, each of these buttresses turns into a diagonally pitched arch that reaches upward to meet the critical spot between the clerestory windows where the outward thrust of the nave vault is concentrated. These arches, called "flying buttresses," will remain one of the characteristic features of Gothic architecture. Although they certainly owed their origin to functional considerations, they soon became aesthetically important as well, and apart from supplying actual support, they were used to "express" support in a variety of ways.

The most monumental aspect of the exterior of Notre-Dame is the west façade (fig. 134). Except for its sculpture, which suffered heavily during the French Revolution and is for the most part the product of the restorer's art, it retains its original appearance. The design reflects the façade of St.-Denis, which, in turn, had been derived from Norman Romanesque façades such as that of St.-Etienne at Caen (see fig. 118), where we find the same basic features: the pier buttresses that reinforce the corners of the towers and divide the façade into three parts; the placing of the portals; the three-story arrangement. The rich sculptural decoration, however, recalls the façades of the west of France (see fig. 117). Much more important than these resemblances are the qualities that distinguish the façade of Notre-Dame from its Romanesque ancestors. Foremost among these is the way all the details have been integrated into a harmonious whole, a formal discipline that also embraces the sculpture, which is no longer permitted the spontaneous (and often uncontrolled) growth that we found on some Romanesque churches. At the same time, the cubic severity of the unadorned front of St.-Etienne has been transformed into its very opposite: lacelike arcades, vast portals, and windows dissolve the continuity of the wall surfaces, making a huge, openwork screen of the whole. How rapidly this tendency advanced during the first half of the thirteenth century can be seen by comparing the west façade with the somewhat later portal of the south transept (visible in fig. 133): in the former, the rose window (as the round windows in Gothic churches are called) is deeply recessed, and the stone tracery that makes the pattern is clearly set off from the masonry in which it is imbedded; in the latter, by contrast, we cannot distinguish the tracery of the window apart from its frame: a continuous web covers the whole area.

Though we may trace this or that feature of Gothic architecture back to some Romanesque source, the how and why of its success are a good deal more difficult to explain. Here we encounter an ever-present controversy: to the advocates of the functionalist approach, Gothic architecture has seemed the result of advances in engineering that made it possible to build more efficient vaults, to concentrate their thrust at a few critical points, and thus eliminate the solid walls of the Romanesque. But is that all there is to it? We must return briefly to Abbot Suger, who tells us himself that he was hard put to it to bring together artisans from many different regions for his project. This would lend substance to the idea that all he needed was good technicians; yet, if that had been all, he would have found himself with nothing but a conglomeration of different regional styles in the end. Suger's account, however, stresses insistently that "harmony," the perfect relationship among parts, is the source of beauty, since it exemplifies the laws according to which divine reason has constructed the universe; the "miraculous" light flooding through the "most sacred" windows becomes the Light Divine, a mystic revelation of the spirit of God. Whether or not he was the architect of St.-Denis, his was the guiding spirit which made Gothic churches more than just the sum of their parts.

Chartres; Rouen

Alone among all major Gothic cathedrals, Chartres still retains most of its original stained-glass windows. The magic of its interior (fig. 135), unforgettable to anyone who has experienced it on the spot, can hardly be suggested on the printed page. Photographs inevitably exaggerate the brightness of the windows and thus make them look like "holes" instead of "translucent walls." In reality, the windows admit far less light than one might expect; they act mainly as huge multicolored diffusing filters that change the quality of ordinary daylight, endowing it with the poetic and symbolic values so highly praised by Abbot Suger.

After the basic plan of the Gothic church, as exemplified in the Cathedral of Notre-Dame (see fig. 131), had been found to be satisfactory and the heretofore unimagined flexibility of the groin vault based on the pointed arch had been grasped, the further evolution of Gothic architecture in France became ever more daring in testing the limits to which this kind of construction could be carried. Naves became ever loftier, buttresses lacier, until in a few cases they did collapse. Perhaps the purpose of glorifying the divine order, as Abbot Suger had set out to do, imperceptibly turned into a kind of Tower of Babel contest, which as we recall ended disastrously. Still, it is amazing to find that so much Flamboyant ("flamelike") Gothic, as the last phase is called, has stood up. The undulating patterns of curve and countercurve of the pierced-stone ornament in St.-Maclou in Rouen (fig. 136) are so luxuriant that it almost becomes a game of hideand-seek to locate the "bones" of the building. The architect has turned into a virtuoso who overlays the structural skeleton with a web of decoration so dense and fanciful that structure becomes almost completely obscured.

One of the truly astonishing things about Gothic architecture is the enthusiastic adoption that this "royal French style" found

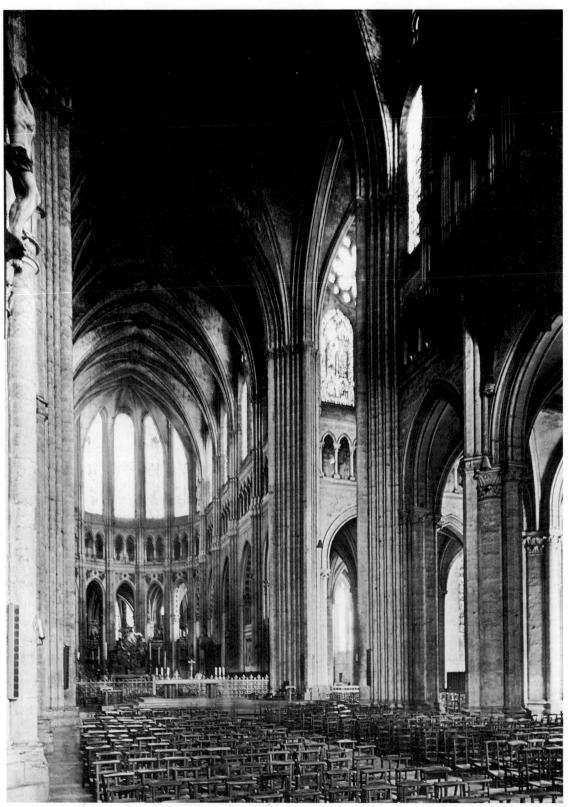

135. View of the nave, Chartres Cathedral. 1194-1220

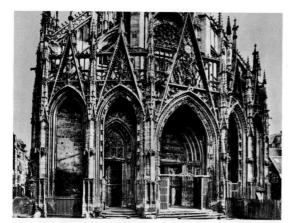

136. West façade, St.-Maclou, Rouen. Begun 1434

abroad. Even more remarkable was its ability to acclimate itself to a variety of local conditions—so much so, in fact, that the Gothic monuments of England, Germany, and other countries have become objects of intense national pride in modern times. A number of reasons, singly or in combination, might be brought forward to explain this rapid spread: the superior skill of French architects and stone carvers; the vast prestige of French centers of learning, such as the Cathedral School of Chartres or the University of Paris; the vigor of the Cistercian order (founded in France) that built Gothic churches wherever it founded new abbeys. Ultimately, however, the international victory of Gothic art seems to have been due to the extraordinary persuasive power of the style itself, which kindled the imagination and aroused religious feelings even among people who were far removed from the cultural climate of the Ilede-France.

England

That England should have proved particularly receptive to the new style is hardly surprising. Yet English Gothic did not grow directly out of the Anglo-Norman Romanesque which had contributed so much of the technical experimentation that went into the realization of St.-Denis. Early English Gothic, although

given its start by imported French architects. soon developed its own style, best exemplified in Salisbury Cathedral (fig. 137). We realize at once how different it is from the French example—and also how futile it would be to judge it by French Gothic standards, for its setting, in the middle of the open countryside, does not require it to rise high in order to dominate the clustered core of a city like Paris; nor had it the same mission as St.-Denis, to give spiritual sanction to a royal dynasty. By accepting certain French features, such as the emphasis placed on the main portal by the tall windows above it, it proclaims the new era in architecture—even if these features sometimes look like afterthoughts (note the flying buttresses, which seem structurally unnecessary). With its two strongly projecting transepts and its sprawling façade terminating in stumpy turrets, Salisbury has also retained important features from the Romanesque style. It gives us the impression of spaciousness and ease, as though it were comfortable not only in its setting, but in its links to the Anglo-Norman past.

The spire that rises above the crossing is about a hundred years later than the rest of

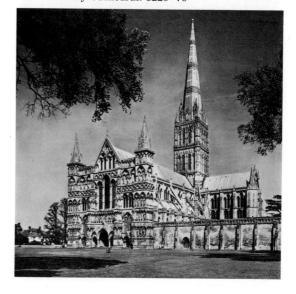

the building, and it indicates the rapid development of English Gothic toward a more pronounced verticality. The choir of Gloucester Cathedral (fig. 138), in the English Late Gothic ("Perpendicular") style, is more akin to French church interiors, despite the repetition of small, identical tracery forms in the great window which recalls the repetition of carved motifs on the Salisbury façade. The vaulting displays an innovation which, although later adopted on the Continent, is truly English: the blossoming of the ribs into a multiple-strand ornamental network, obscuring the boundaries between the bavs and their subdivisions, and giving the interior a greater visual unity. Even though the English style developed independent of French Flamboyant ornament, there is obviously an artistic kinship between these two varieties of intricately worked architectural decoration.

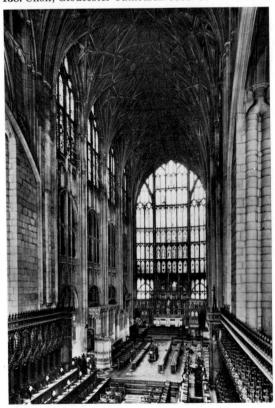

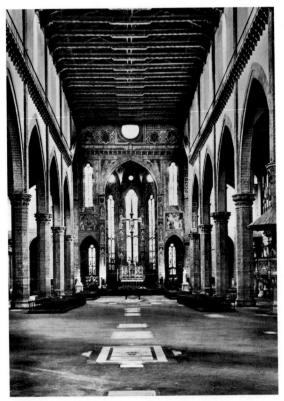

139. Nave and choir, Santa Croce, Florence. Begun c. 1295

Italy

Italian Gothic architecture stands apart from that of the rest of Europe. Judged by the style of the Ile-de-France, most of it hardly can be called Gothic at all. Yet it produced structures of singular beauty and impressiveness. We must be careful to avoid too rigid or technical a standard in approaching these monuments, lest we fail to do justice to their unique blend of Gothic qualities and Mediterranean tradition. The Franciscan Church of Santa Croce in Florence (fig. 139) is a masterpiece of Gothic, even though it has wooden ceilings instead of groin vaults. This surely was a matter of deliberate choice rather than of technical or economic necessity, evoking the simplicity of Early Christian basilicas and thereby linking Franciscan poverty with the tradition of the early Church. There is no trace of the Gothic structural system, except

for the groin-vaulted choir; the walls remain intact as continuous surfaces (Santa Croce owes part of its fame to its wonderful murals); and there are no flying buttresses, since the wooden ceilings do not require them. Why, then, speak of Santa Croce as Gothic? Surely the use of the pointed arch is not enough to justify the term. Yet we sense immediately that this interior space creates an effect fundamentally different from either Early Christian or Romanesque architecture. The nave walls have the weightless, "transparent" qualities we saw in Northern Gothic churches, and the dramatic massing of windows at the eastern end forcefully conveys the dominant role of light. Judged in terms of its emotional impact, Santa Croce is Gothic beyond doubt; it is also profoundly Franciscan-and Florentine-in the monumental simplicity of the means by which this impact is achieved.

If in Santa Croce the architect's main concern was an impressive interior, Florence Cathedral (fig. 140) was planned as a great landmark towering above the entire city. Its most striking feature is the huge octagonal dome (compare Pisa Cathedral, fig. 120), covering a central pool of space that makes the nave look like an afterthought. The actual building of the dome, and the details of its design, belong to the early fifteenth century. Apart from the windows and doorways, there is nothing Gothic about the exterior of Florence Cathedral. The solid walls, encrusted with geometric marble inlays, are a perfect match for the Romanesque Baptistery across the way (see fig. 121); and a separate bell tower, in accordance with Italian tradition (see figs. 86, 120), takes the place of the façade tower familiar to us from French Gothic churches. The west façade, so dramatic a feature in French cathedrals, never achieved the same importance in Italy. It is remarkable how few Italian Gothic façades were ever carried near completion (those of Santa Croce and Florence Cathedral are both modern). Among those that were, the finest is Or-

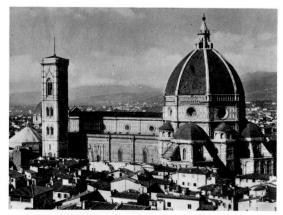

140. Florence Cathedral. Begun by Arnolfo di Cambio, 1296; dome by Filippo Brunelleschi, 1420–36

141. Lorenzo Maitani and others. West façade, Orvieto Cathedral. Begun c. 1310

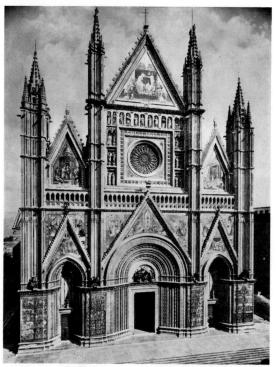

vieto Cathedral (fig. 141); it makes an instructive comparison with Tuscan Romanesque façades (see fig. 120) on the one hand, and French Gothic façades on the other (see fig. 134). Many of its ingredients clearly derive from the latter source, and its screenlike lightness, too, is unmistakably Gothic. Yet these features have been superimposed on

what is essentially a basilican façade like that of Pisa Cathedral; the towers have been reduced to turrets so as not to compete with the central gable, and the entire design has a strangely small-scale quality that has nothing to do with its actual size. The Orvieto façade, unlike that of Notre-Dame in Paris, lacks a dominant motif, so that its elements seem "assembled" rather than merged into a single whole. Except for the modest-sized rose window and the doorways, the Orvieto façade has no real openings, and large parts of it consist of framed sections of wall area. Yet we experience these not as solid, material surfaces but as translucent, since they are filled with brilliantly colored mosaics—an effect equivalent to Gothic stained glass in the North.

The secular buildings of Gothic Italy convey as distinct a flavor as the churches. There is nothing in the cities of Northern Europe to match the impressive grimness of the Palazzo Vecchio (fig. 142), the town hall of Flor-

142. Palazzo Vecchio, Florence. Begun 1298

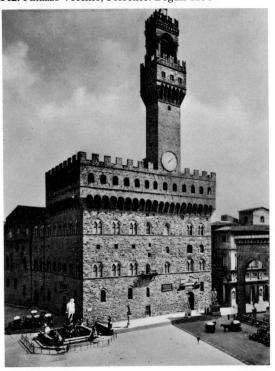

ence. Fortress-like structures such as this reflect the factional strife—among political parties, social classes, and prominent families-so characteristic of life within the Italian city-states. The wealthy man's home (or palazzo, a term denoting any large urban house) was quite literally his castle, planned both to withstand armed assault and to proclaim the owner's importance. The Palazzo Vecchio, while larger, follows the same pattern. Behind its battlemented walls, the city government could feel well protected from the wrath of angry crowds. The tall tower not only symbolizes civic pride but has an eminently practical purpose: dominating the city as well as the surrounding countryside, it served as a lookout against enemies from within or without.

SCULPTURE 1150-1420

France

The portals of the west façade of St.-Denis were far larger and even more richly decorated than those of Romanesque churches. They paved the way for the admirable west portals of Chartres Cathedral (fig. 143), begun about 1145 under the influence of St.-Denis, but even more ambitious in conception. These probably represent the oldest full-fledged examples of Gothic sculpture. Comparing them with a Romanesque portal such as St.-Pierre's (see fig. 123), we are impressed first by a new sense of order, as if all the figures had suddenly come to attention, conscious of their responsibility to the architectural framework. Symmetry and clarity have taken the place of crowding and frantic movement; figures are no longer entangled with each other, but stand out separately, so that the whole carries much better over a long distance. Particularly striking is the treatment of the door jambs, lined with long figures attached to columns (fig. 144). Instead of being treated essentially as reliefs carved into (or protruding from) the masonry, these are stat-

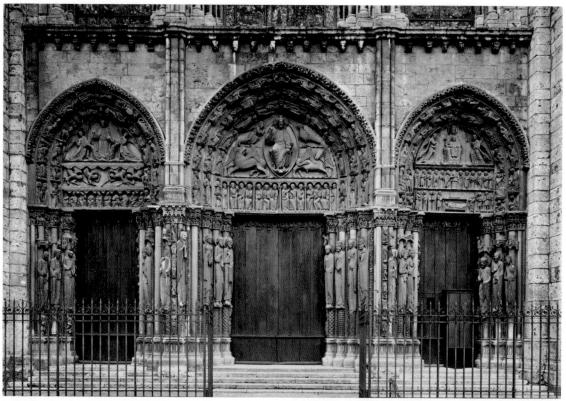

143. West portals, Chartres Cathedral. c. 1145-70 (for view of interior, see figure 135)

ues, each with its own axis; in theory, at least, they could be detached from their supports. Apparently this first step since the end of Classical times toward recapturing monumental stone sculpture in the round could be taken only by "borrowing" the cylindrical shape of the column for the figures. This method traps them into a certain air of immobility, yet the heads already show a gentle, human quality that evinces the search for more realism. It is as though Gothic sculptors had to relive the same experiences as Archaic sculptors in Greece (see fig. 52). Realism is, of course, a relative term whose meaning varies greatly according to circumstances; on the Chartres west portals it appears to spring from a reaction against the demoniacal aspects of Romanesque art, a reaction that may be seen not only in the calm, solemn spirit of the figures, but also in the rational discipline of the underlying symbolic scheme. The

subtler aspects of this symbolic program can only be understood by minds well versed in theology; but its main elements are simple enough to be grasped by anyone imbued with the fundamentals of the Bible. The jamb statues, a continuous sequence linking all three portals, represent the Prophets, kings, and queens of the Old Testament; their purpose is to acclaim the rulers of France as the spiritual descendants of biblical rulers, and alsoan idea insistently stressed by Abbot Suger—the harmony of secular and spiritual rule. Christ Himself appears enthroned above the main doorway as Judge and Ruler of the Universe, flanked by the symbols of the four Evangelists, with the Apostles assembled below, and the twenty-four Elders of the Apocalypse in the archivolts above. The right-hand tympanum shows His incarnation with scenes from His life below, and personifications of the liberal arts (human

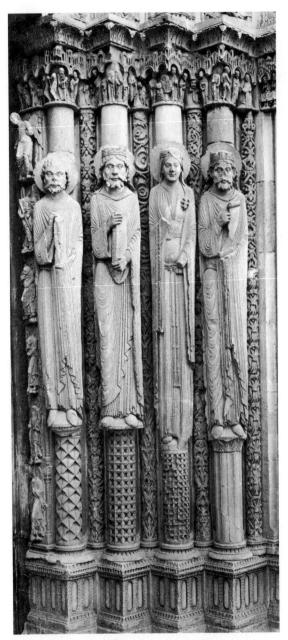

144. Jamb statues, from west portals, Chartres Cathedral. Begun 1145

wisdom paying homage to divine wisdom) above. In the left-hand tympanum, finally, we see the timeless Heavenly Christ, the Christ of the Ascension, framed by the signs of the zodiac, and their earthly counterparts, the labors of the months—an ever-repeating cycle of the year.

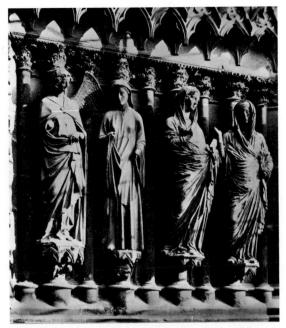

145. Annunciation and Visitation, center portal of west façade, Reims Cathedral. c. 1225–45. Stone, over lifesize

Instructive programs of this type remained a constant feature of Gothic cathedrals; but styles of sculpture developed rapidly, and varied from region to region. The vast sculptural program for Reims Cathedral had made it necessary to bring together masters and entire workshops from various other building sites, and so we have there a compact sampling of several styles. On the right side of figure 145 we see the encounter between the Virgin Mary and St. Elizabeth (the Visitation); so expert is the Classicism of these figures that, at first glance, they seem almost to have stepped out of the Ara Pacis relief (see fig. 79). No longer governed, as the Chartres figures were, by the strictly vertical columns, they turn toward each other with the same human warmth that links the two older children in the Ara Pacis.

In the *Annunciation* group (fig. 145, left) the Virgin is in a severe style, with a rigidly vertical body axis and straight, tubular folds meeting at sharp angles. The angel, in contrast, is conspicuously graceful: we note the tiny, round face framed by a cap of curls, the

emphatic smile, the strong S-curve of the slender body, the ample, richly accented drapery. This "elegant style," created about 1240 by Parisian masters working for the royal court, was such a success that it soon became the standard formula for High Gothic sculpture all over Europe.

A slightly later group (fig. 146) in the interior of Reims Cathedral offers a new pictorialism: light and shade now give the deeply recessed figures an atmospheric setting which we have not seen before. Again there is a contrast of styles: Abraham, clad in contemporary armor, is quite bluntly realistic, whereas the priest Melchizedek exhibits a further elaboration of the "courtly" style of the angel in the previous picture. So rich is the intricate drapery that the body almost disappears beneath it—a characteristic that was to become more and more pronounced as Gothic progressed toward its final stage.

Germany

Though artists from all over Europe came to be trained in the great cathedral workshops of France, the style that they took home with them rapidly acquired some of the character of older native traditions. Thus, the relief showing *The Kiss of Judas* (fig. 147), part of the choir screen of Naumburg Cathedral in Germany, makes us recall the dramatic emotionalism of the much earlier *Gero Crucifix* (see fig. 109), here brought to a theatrical pitch by the contrast of Christ's meekness and the passionate wrath of the sword-wielding St. Peter.

Gothic art, as we have come to know it so far, reflects a desire to endow the traditional themes of Christianity with an ever-greater emotional appeal. It is not surprising, therefore, that Germany played a particular role, near the end of the thirteenth century, in developing a new kind of religious imagery, designed to serve private devotions. The most characteristic and widespread of these images is the so-called *Pietà* (an Italian word de-

146. Melchizedek and Abraham, interior west wall, Reims Cathedral. After 1251. Stone

147. The Kiss of Judas, on choir screen, Naumburg Cathedral. c. 1250–60. Stone

rived from the Latin *pietas*, the root word for both "piety" and "pity"), a representation of the Virgin grieving over the dead Christ. No such scene occurs in the Scriptures; it was invented as a counterpart to the familar Madonna and Child. Our example (fig. 148), like most such groups, is carved of wood and vividly painted. Realism here has become purely a vehicle of expression—the agonized faces

148. Pietà. Early 14th century. Wood, height $34\frac{1}{2}$ ". Provinzialmuseum, Bonn

and Christ's blood-encrusted wounds are enlarged to an almost grotesque degree, so as to arouse an overwhelming sense of horror and pity.

The Pietà, with its emaciated, puppet-like bodies, reaches an extreme in the negation of the physical aspects of the human figure. After 1350 a reaction set in, and we again find an interest in weight and volume, coupled with a new impulse to explore tangible reality. The climax was reached about 1400, in the works of Claus Sluter, a Netherlandish sculptor working at the court of Burgundy. His Moses Well (fig. 149), so called for the group of Old Testament Prophets around the base, including Moses (right) and Isaiah (left), explores sculptural style in two new directions: the Isaiah shows a realism that ranges from the most minute details of the costume to the surprisingly individualized head; the Moses, a new sense of weight and

149. Claus Sluter. *The Moses Well.* 1395–1406. Stone, height of figures about 6'. Chartreuse de Champmol, Dijon

volume. Note that the soft, swinging lines seem to reach out, determined to capture as much of the surrounding space as possible.

Italy

Italian Gothic sculpture, like Italian Gothic architecture, stands apart from that of the rest of Europe. It probably began in the extreme south, in Apulia and Sicily, which were part of the domain of the German emperor Frederick II. The works made for him have fared badly, but he seems to have favored the Classical style of the *Visitation* group (see fig. 145, right) at Reims Cathe-

dral, which fitted well with the imperial image of himself.

Such was the style of Nicola Pisano, who came to Tuscany from southern Italy about 1250 (the year of Frederick II's death). In 1260 he finished a marble pulpit for the Baptistery of Pisa Cathedral (see fig. 120, foreground), from which we illustrate The Nativity (fig. 150); turning back briefly to the Ixion Room decorations (see fig. 82), we can spot certain types—the semireclining figure, or the crouching one—that have here been revived twelve hundred years later. But the treatment of space in our relief is certainly different: instead of the ample, if imprecise, atmosphere that envelops the Roman scenes. this is a kind of shallow box filled to bursting with solid forms that tell not only the story of the Nativity itself, but all the episodes (Annunciation to Mary, Annunciation to the Shepherds) associated with it. There is no precise counterpart of this in Northern Gothic sculpture, and Nicola must have gotten it from the late Roman style which is also reflected in figure 88, with its crowded space.

Half a century after the Baptistery pulpit, Nicola's son, Giovanni Pisano, made sculpture that was much more in tune with the mainstream of Gothic style. His *Madonna* (fig. 151) still has the rather squat proportions and the Roman facial type that we saw in his father's work, but these have been combined with such up-to-date Gothic traits as the S-curved stance. The weightiness of the Classical top half of the figure would make us fear that the Gothic bottom half might collapse under the burden, had Giovanni not used the drapery lines to buttress the top-heavy composition.

By about 1400, at the time of the International Style (see pp. 131, 154), French influence had been thoroughly assimilated in Italy. Its foremost representative was a Florentine, Lorenzo Ghiberti, who, in 1401–2, won a competition for a pair of richly decorated bronze doors for the Baptistery in Florence. We reproduce the trial relief that he

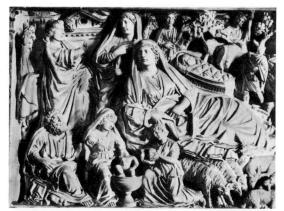

150. Nicola Pisano. *The Nativity*, panel on pulpit, Baptistery, Pisa. 1259–60. Marble, $33\frac{1}{2} \times 43$ "

151. Giovanni Pisano. *Madonna*. c. 1315. Marble, height 27". Prato Cathedral

submitted, showing *The Sacrifice of Isaac* (fig. 152); the perfection of craftsmanship, which reflects his training as a goldsmith, makes it easy to understand why he won the prize. If the composition seems somewhat lacking in dramatic force, that was in line with the taste of the period, for the realism of

the International Style, which developed out of the same courtly art in France that had earlier produced the smiling angel of Reims (see figure at left, fig. 145), did not extend to the realm of the emotions. This also seems to have suited Ghiberti's own lyrical temperament; but however much he may have owed

152. Lorenzo Ghiberti. The Sacrifice of Isaac. 1401–2. Gilt bronze, 21×17 ". National Museum, Florence

to French influence, Ghiberti remained thoroughly Italian in one respect-his admiration for ancient sculpture, as evidenced by the beautiful nude body of Isaac.

Spatial depth, so notably absent in Nicola's Nativity (see fig. 150), has been greatly advanced by Ghiberti; for the first time since Classical antiquity, we experience the flat background not as a limiting "wall" but as empty space from which the figures emerge toward the beholder (note especially the angel in the upper right-hand corner). While Ghiberti was no revolutionary himself, he prepares for the great revolution in the arts that we call the Florentine Renaissance, in the second quarter of the fifteenth century.

PAINTING 1200-1400

France: Stained Glass; Manuscripts

Though Abbot Suger's St.-Denis had an immediate effect in changing the course of architecture and sculpture, it did not demand any radical change of style in painting. Suger himself places a great deal of emphasis on the miraculous effect of stained glass, which was used in ever-increasing quantities as the new architecture made room for more and larger windows. Yet the technique of stained-glass painting had already been perfected in Romanesque times, and the style of the designs did not change quickly, even though the amount of stained glass required in the new cathedrals caused it to displace manuscript illumination as the leading form of painting. Working in the cathedral workshops, the window designers came to be influenced more and more by the style of the sculptors. The majestic *Habakkuk* (fig. 153), one of a series of windows representing Old Testament Prophets, is the direct kin of statues like the Visitation group at Reims (see fig. 145), and the descendant of Nicholas of Verdun's reviv-

153. Habakkuk. c. 1220. Stained-glass window, height about 14'. Bourges Cathedral

al of Classicism a generation before. To create a figure of true monumentality in this medium is something of a miracle in itself: the primitive methods of medieval glass manufacture made it impossible to produce large panes, so that these works are not painting on glass, but "painting with glass," except for linear details that were added in black or brown. More laborious than the mosaicist's technique, that of the window-maker involved the fitting together, by means of lead strips, of odd-shaped fragments that followed the contours of his design. Well suited to abstract ornamental pattern, stained glass tends to resist any attempt at three-dimensional effects. Yet in the compositions of a master the maze of leaded puzzle pieces could resolve itself into figures that have a looming monumentality, such as the Habakkuk.

After 1250 architectural activity declined and the demand for stained glass began to slacken. By then, however, miniature painting had caught up with the new style pioneered in stone and glass. However, the centers of production now shifted from monastic scriptoria to urban workshops run by laymen—the ancestors of our modern publishing houses. Some names in this secular breed of illuminators now become known to us; an instance is Master Honoré of Paris, who did the miniatures in the *Prayer Book of*

154. Master Honoré. *David and Goliath*, from the *Prayer Book of Philip the Fair*. 1295. Manuscript illumination. Bibliothèque Nationale, Paris

Philip the Fair. In the scene of David and Goliath (fig. 154) the figures do not seem very firmly anchored to the ground, but the attention given to modeling indicates that stone sculpture, such as in figure 146, has been carefully studied. Here, too, a still-timid wish seems to be at work to give the figures a real space of their own to move in. Against the patterned background, Master Honoré has placed a stage-prop landscape; and since the figures obviously cannot step very far to the rear, they assert their mobility by stepping forward onto the frame.

Italy: Frescoes; Altar Panels

We must now turn our attention to Italian painting, which at the end of the thirteenth century produced an explosion of creative energy as spectacular and far-reaching in its effects as the rise of the Gothic cathedral in France. A single glance at Giotto's mural Christ's Entry into Jerusalem (fig. 155) will convince us that we are faced with a truly revolutionary development here. How, we wonder, could a work of such monumental power have been produced by a contemporary of Master Honoré? Oddly enough, when we delve into the background of Giotto's art, we find it arose from the same "old-fashioned" attitude that we met in Italian Gothic architecture and sculpture; as a result, panel painting, mosaics, and murals—techniques that had never taken firm root north of the Alps—were kept alive in Italy. At the very same time when stained glass became the dominant pictorial art in the north of Europe, a new wave of Byzantine influence overwhelmed the lingering Romanesque elements in Italian painting. There is a certain irony in the fact that this neo-Byzantine style (or "Greek manner," as the Italians called it) appeared soon after the conquest of Constantinople in 1204 by the armies of the Fourth Crusade—one thinks of the way Greek art had captured the taste of the victorious Romans of old. The Greek manner prevailed un-

155. Giotto. Christ's Entry into Jerusalem. 1305-6. Fresco. Arena Chapel, Padua

til almost the end of the thirteenth century, so that Italian painters were able to absorb the Byzantine tradition far more thoroughly than ever before. In the same years, as we recall, architects and sculptors were assimilating the Gothic style, and toward 1300 this spilled over into painting. It was the interaction of these two currents that produced the new style, of which Giotto is the greatest exponent.

The historical process outlined above will make more sense to us if we consider a fine example of "Greek manner" Italian painting, in conjunction with Giotto's *Entry into Jerusalem*. For this purpose, a panel that shows the same subject and was painted about the same time by the Sienese master Duccio di Buoninsegna, is especially instructive (fig. 156).

Duccio

In contrast to what we have seen of Northern Gothic painting, here the struggle to create pictorial space seems to have been won. Duccio had mastered enough of the devices of Hellenistic-Roman illusionism to know how to create space in depth by the placement of various architectural features which lead the viewer from the foreground and up the path, through the city gate. Whatever the faults of Duccio's perspective, his architecture demonstrates a capacity to contain and define space in a manner vastly more intelligible than anything medieval art had produced, and superior to most Classical settings and their Byzantine derivatives. Gothic elements are present, too, in the soft modeling of human forms, and the unmistakable desire on the part of the artist to give his scene lively, even contemporary, touches in order to make us feel that "we are there" (thus, the contemporary costumes and the woebegone expressions in Master Honoré's David and Goliath, and the up-to-date Gothic tower, pennant aflutter, in the Duccio panel).

Giotto

In Giotto, we meet an artist of far bolder and more dramatic temper. Giotto was less close to the Greek manner from the start, and he was a wall painter by instinct, rather than a panel painter. His *Entry into Jerusalem* ultimately derives from the same sort of Byzantine composition as Duccio's, although the figure style is another matter entirely, and develops out of the sculpture of Nicola and

Giovanni Pisano (see figs. 150, 151). But where Duccio had enriched the traditional scheme, spatially as well as in narrative detail, Giotto subjects it to a radical simplification. The action proceeds parallel to the picture plane; landscape, architecture, and figures have been reduced to the essential minimum; and the limited range and intensity of tones in fresco painting (watercolors applied to the freshly plastered wall) further emphasizes the austere quality of Giotto's art, as against the jewel-like brilliance of Duccio's panel.

Yet it is Giotto who succeeds in overwhelming us with the reality of the event. How does this come about? First of all, the action takes place in the foreground, much as is the case in the tiny French miniature where we noted that some figures were almost advancing toward us out of the frame (see fig. 154). On Giotto's much larger scale, however, and placed so that the beholder's eye-level is at the same height as the heads of the figures, the picture space seems to be a continuation of the space we are standing in. Nor does Giotto have to make his characters step in our direction in order to have them "jump out at us": their forcefully modeled three-dimensionality is so convincing that they seem almost as solid as sculpture in the round. With Giotto, the figures create their own space, and architecture is kept to the minimum required by the narrative. Its depth, consequently, is produced by the combined volumes of the overlapping bodies in the picture, but within these limits it is very persuasive. To those who first saw painting of this sort, the effect must have been as sensational as the first Cinerama films in our own day; and his contemporaries praised him as equal, or even superior, to the greatest of the ancient painters because his forms seemed so lifelike that they could be mistaken for reali-

156. (opposite) Duccio. Christ Entering Jerusalem, from the back of the Maestà Altar. 1308–11. Panel, $40\frac{1}{2}\times21\frac{1}{8}$ ". Cathedral Museum, Siena

157. (opposite) Simone Martini. The Road to Calvary. c. 1340. Tempera on panel, $9\% \times 6\%$ ". The Louvre, Paris

ty itself. His boast was that painting is superior to sculpture—not an idle boast, for Giotto does indeed mark the start of what might be called "the era of painting" in Western art. Yet his aim was not merely to rival statuary; rather, he wanted the total impact of the whole scene to hit the spectator all at once. If we look at earlier pictures, we find our glance traveling at a leisurely pace from detail to detail, until we have surveyed the entire area. But Giotto does not invite us to linger over small things, nor to wander back into the picture space, and even the groups of figures are to be taken as blocks, rather than agglomerations of individuals. Christ stands out alone, in the center, and at the same time bridges the gap between the advancing Apostles on the left and the bowing townspeople on the right. The more we study the picture, the more we realize that its majestic firmness and clarity harbor great depths of expressiveness.

There are few men in the entire history of art to equal the stature of Giotto as a radical innovator. His very greatness, however, tended to dwarf the next generation of Florentine painters. Siena was more fortunate in this respect, for Duccio had never had the same overpowering impact; so it is there, rather than in Florence, that the next step is taken in the development of Italian Gothic painting.

Simone Martini

Simone Martini, who painted the tiny but intense *Road to Calvary* (fig. 157) about 1340, may well have been the most distinguished of Duccio's disciples. He spent the last years of his life in Avignon, the town in southern France that served as the residence-in-exile of the popes during most of the fourteenth century. Our panel, originally part of a small altar, was probably done there. In its spark-

ling colors, and especially in the architectural background, it still echoes the art of Duccio (see fig. 156). The vigorous modeling of the figures, on the other hand, as well as their dramatic gestures and expressions, betray the influence of Giotto. While Simone Martini is not much concerned with spatial clarity, he proves to be an extraordinarily acute observer; the sheer variety of costumes and physical types, the wealth of human incident, create a sense of down-to-earth reality very different from both the lyricism of Duccio and the grandeur of Giotto.

The Lorenzetti Brothers

This closeness to everyday life also appears in the work of the brothers Pietro and Ambrogio Lorenzetti, but on a more monumental scale and coupled with a keen interest in problems of space. The boldest spatial experiment is Pietro's triptych of 1342, The Birth of the Virgin (fig. 158), where the painted architecture has been correlated with the real architecture of the frame in such a way that the two are seen as a single system. Moreover, the vaulted chamber where the birth takes place occupies two panels—it continues unbroken behind the column that divides the center from the right wing. The left wing represents an anteroom which leads to a vast and only partially glimpsed hall, suggesting the interior of a Gothic church. Here the picture surface begins to assume the quality of a transparent window, which shows the same kind of space that we know from daily experience. The same procedure enabled Ambrogio Lorenzetti, in his fresco Good Government in the Siena city hall, to unfold a comprehensive view of the town before our eyes (fig. 159). In order to show the life of a well-run city-state, he had to fill the streets and houses with teeming activity; his plausible organization of the many people and buildings comes from a combination of Duccio's panoramic picture space with the immediacy of Giotto's sculptural picture space.

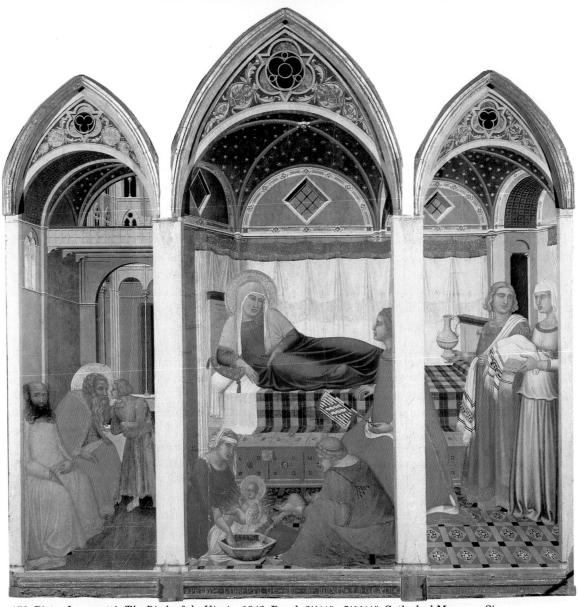

158. Pietro Lorenzetti. The Birth of the Virgin. 1342. Panel, $6'1\frac{1}{2}" \times 5'11\frac{1}{2}"$. Cathedral Museum, Siena

159. Ambrogio Lorenzetti. Good Government (portion). 1338–40. Fresco. Palazzo Pubblico, Siena

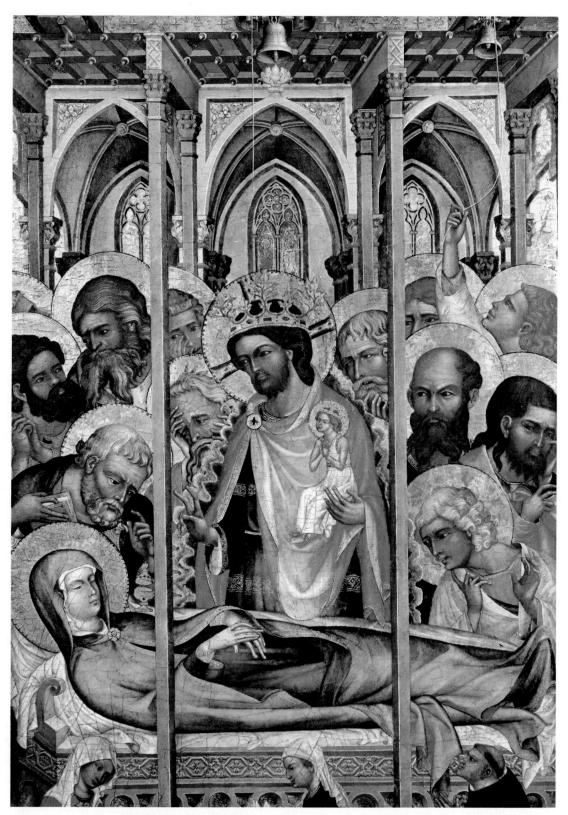

 $\textbf{160.} \ \ \textbf{Bohemian Master}. \ \textit{Death of the Virgin}. \ 1350-60. \ \ \textbf{Panel}, \ 39 \times 27\%''. \ \ \textbf{Museum of Fine Arts, Boston}$

Northern Gothic

We are now in a position to return to Gothic painting north of the Alps; for what happened there in the latter half of the fourteenth century was determined in large measure by the influence of the great Italians. One of the chief gateways of Italian influence was the city of Prague, which in 1347 became the residence of Emperor Charles IV and rapidly developed into an international center second only to Paris. The Death of the Virgin (fig. 160) was painted by a Bohemian, about 1360. Although he probably knew the work of the Sienese masters only at second or third hand, the architectural interior betrays its descent from works such as Pietro Lorenzetti's Birth of the Virgin. Italian, too, is the vigorous modeling of the heads and the overlapping of the figures that enhance the threedimensional quality of the composition. Still, the Bohemian Master's picture is no mere echo of Italian painting: the gestures and facial expressions convey an intensity of emotion that represents the finest heritage of Northern Gothic art.

The International Style

Toward the year 1400, the merging of Northern and Italian traditions had given rise to a single dominant style throughout Western Europe. This International Style was not confined to painting—we have used the same term for the sculpture of the period—but painters clearly played the main role in its development.

Broederlam

Among the most important was Melchior Broederlam, a Fleming who worked for the court of the duke of Burgundy in Dijon. The panel shown in figure 161, one of a pair of shutters for an altar shrine which he did in 1394–99, is really two pictures within a single frame; the temple of the *Presentation in the Temple* and the landscape of the *Flight*

into Egypt stand abruptly side by side, even though the artist has made a half-hearted effort to persuade us that the landscape extends around the building. Compared to Pietro and Ambrogio Lorenzetti's, Broederlam's picture space still strikes us as naïve in many ways-the architecture looks like a doll's house, and the details of the landscape are quite out of scale with the figures. Yet the panel conveys a far stronger feeling of depth than we have found in any previous Northern work. The reason for this is the subtlety of the modeling; the softly rounded shapes, the dark, velvety shadows create a sense of light and air that more than make up for any shortcomings of scale or perspective. The same soft, pictorial quality—a hallmark of the International Style—appears in the ample, loosely draped garments with their fluid curvilinear patterns of folds, which remind us of Sluter and Ghiberti (see figs. 149, 152). Our panel also exemplifies another characteristic of the International Style: its "realism of particulars," the same kind of realism we encountered first in Gothic sculpture (see fig. 144) and somewhat later among the marginal designs of manuscripts. We find it in the carefully rendered foliage and flowers, in the delightful donkey (obviously drawn from life), and in the rustic figure of St. Joseph, who looks and behaves like a simple peasant and thus helps to emphasize the delicate, aristocratic beauty of the Virgin. It is this painstaking concentration on detail that gives Broederlam's work the flavor of an enlarged miniature rather than of large-scale painting, even though the panel is more than five feet tall.

The Limbourg Brothers

That book illumination remained the leading form of painting in Northern Europe at the time of the International Style, despite the growing importance of panel painting, is well attested by the miniatures of the Very Rich Book of Hours of the Duke of Berry. Produced

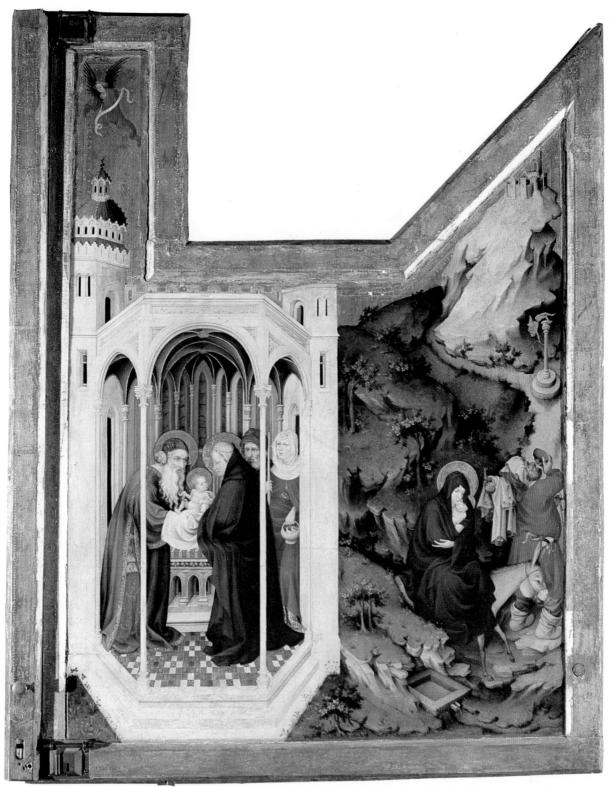

161. Melchior Broederlam. Presentation in the Temple and Flight into Egypt. 1394–99. Tempera on panel, 64×51 ". Museum of Fine Arts, Dijon

 $\textbf{162.} \ \textbf{The Limbourg Brothers}. \ \textit{February}, \ \textbf{from the } \textit{Very Rich Book of Hours of the Duke of Berry}. \ \textbf{c. 1415}. \\ \textbf{Manuscript illumination}. \ \textbf{Musée Condé}, \ \textbf{Chantilly}$

 $\textbf{163.} \ \textbf{The Limbourg Brothers}. \ \textit{April}, \ \textbf{from the } \textit{Very Rich Book of Hours of the Duke of Berry}. \ \textbf{c. 1415}. \\ \textbf{Manuscript illumination}. \ \textbf{Mus\'ee Cond\'e}, \ \textbf{Chantilly}$

for the brother of the king of France, a man of far from admirable character but the most lavish art patron of his day, this luxurious book of hours represents the most advanced phase of the International Style. The artists were Pol de Limbourg and his two brothers, a group of Flemings who, like Claus Sluter, the sculptor, had settled in France; but they must have visited Italy as well, for their work includes a large number of motifs, and some en-

tire compositions, borrowed from the great masters of Florence and Siena. The *Very Rich Book of Hours* contains a group of remarkable calendar pages. Calendar cycles depicting the labors of each month had long been an established part of medieval art (see p. 142). The Limbourg Brothers, however, enlarged such examples into panoramas of man's life in nature. Thus the *February* miniature (fig. 162), the earliest snow landscape in the histo-

ry of Western art, gives an enchantingly lyrical account of village life in the dead of winter. Here the promise of the Broederlam panel has been fulfilled, as it were: landscape, architectural interiors and exteriors are harmoniously united in deep, atmospheric space. Even such intangible, evanescent things as the frozen breath of the maid, the smoke curling from the chimney, and the clouds in the sky have become "paintable." Some of the calendar pages, such as April (fig. 163), are devoted to the life of the nobility. Once more we marvel at the wealth of realistic detail. Yet the figures display an odd lack of individuality. They are all of the same type, in face as well as stature: aristocratic mannequins of superhuman slenderness who are differentiated only by the luxuriance and variety of their clothing. Surely the gulf between them and the peasants of the February miniature could not have been greater in real life than it appears in these pictures!

From the courtly throng of the April page it is but a step to the three Magi and their train in the altarpiece by Gentile da Fabriano, the

greatest Italian painter of the International Style (fig. 164). The costumes here are as colorful, the draperies as ample and softly rounded, as in the North. The Holy Family on the left almost seems in danger of being overwhelmed by the gay and festive pageant pouring down upon it from the hills in the distance. Again we admire the marvelously well-observed animals, which now include not only the familiar ones but hunting leopards, camels, and monkeys. (Such creatures were eagerly collected by the princes of the period, many of whom kept private zoos.) The Oriental background of the Magi is further emphasized by the Mongolian facial cast of some of their companions. It is not these exotic touches, however, that mark our picture as the work of an Italian master but something else, a greater sense of weight, of physical substance, than we could hope to find among the Northern representatives of the International Style. Gentile, despite his love of fine detail, is obviously a painter used to working on a monumental scale, rather than a manuscript illuminator at heart.

The Middle Ages

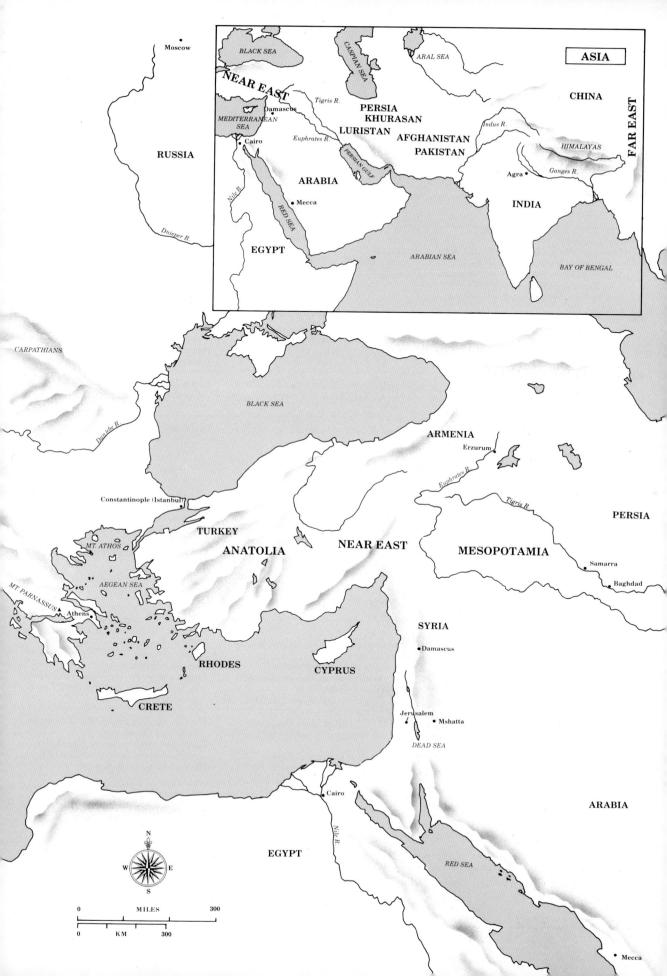

Synoptic Table II

Great Papal Schism (since 1378) settled

1417; pope returns to Rome

00	POLITICAL HISTORY	RELIGION, LITERATURE	SCIENCE, TECHNOLOGY
	Constantine the Great (r. 324–37) Roman Empire split into Eastern and Western branches 395	Christianity legalized by Edict of Milan 313; state religion 395 St. Augustine, St. Jerome	
	Rome sacked by Visigoths 410 Fall of Western Roman Empire 476 "Golden Age" of Justinian 527–65	St. Patrick (died c. 461) founds Celtic Church in Ireland 432 Split between Eastern and Western Churches begins 451	Silk cultivation brought to eastern Medi- terranean from China
	Muhammad (570–632) Byzantium loses Near Eastern and African provinces to Muslims 642–732 Muslims invade Spain 711–18; defeated by Franks, Battle of Tours 732 Independent Muslim state established in Spain 756	Isidore of Seville, encyclopedist (died 636) Koran 652 Beowulf, English epic, early 8th cent. Iconoclastic Controversy 726–843	Paper-making introduced into Near East from China Stirrup introduced into Western Europe c. 600
,	Charlemagne (r. 768–814) crowned emperor of Romans by pope 800 Alfred the Great (r. 871–99?), Anglo-Saxon king of England	Carolingian revival of Latin classics Earliest printed book, China, 868	Earliest documented church organ, Aa- chen, 822 Horse collar adopted in Western Europe, makes horses efficient draft animals
	Otto I crowned emperor by pope 962 Otto II (r. 973–83) defeated by Muslims in southern Italy	Monastic order of Cluny founded 910 Conversion of Russia to Orthodox Church c. 990	Earliest application of waterpower to industry
0	Normans arrive in Italy 1016 William the Conqueror defeats Harold at Battle of Hastings 1066 Reconquest of Spain from Muslims begins 1085 First Crusade 1095–99 takes Jerusalem	College of Cardinals formed to elect pope 1059 Cistercian order founded 1098 Chanson de Roland, French epic c. 1098	Leif Ericsson sails to North America 1002
	King Henry II founds Plantagenet line in England 1154 Frederick Barbarossa (r. 1155–90) titles himself "Holy Roman Emperor," tries to dominate Italy	Rise of universities (Bologna, Paris, Oxford); faculties of law, medicine, theology Peter Abelard, French philosopher and teacher (1079–1142) Omar Khayyam, Persian poet (fl. c. 1100) Flowering of French vernacular literature (epics, fables, chansons); age of the troubadours	Earliest manufacture of paper in Europe by Muslims in Spain Earliest use of magnetic compass for navigation Earliest documented windmill in Europe 1180
0	Fourth Crusade (1202–4) conquers Constantinople Latin Empire in Constantinople 1204–61 Magna Carta limits power of English kings 1215 Louis IX (r. 1226–70), king of France Philip IV (r. 1285–1314), king of France	St. Dominic (1170–1221) founds Dominican order; Inquisition established to combat heresy St. Francis of Assisi (died 1226) St. Thomas Aquinas, Italian scholastic philosopher (died 1274) Dante Alighieri, Italian poet (1265–1321)	Marco Polo travels to China and India c. 1275–93 Arabic (actually Indian) numerals introduced in Europe First documented use of spinning wheel in Europe 1298, replaces distaff and spindle
300	Exile of papacy in Avignon 1309–76 Hundred Years' War between England and France begins 1337 Black Death throughout Europe 1347–50	John Wycliffe (died 1384) challenges church doctrine; translates Bible into English Petrarch, first humanist (1304–1374) Canterbury Tales by Chaucer c. 1387 Decameron by Boccaccio 1387	First large-scale production of paper in Italy and Germany Large-scale production of gunpowder; earliest known use of cannon 1326 Earliest cast iron in Europe

Jan Hus, Czech reformer, burned at stake

stake for heresy and sorcery 1431

for heresy 1415; Joan of Arc burned at

Gutenberg invents printing with movable

type 1446-50

 $\label{eq:note:power} \begin{tabular}{l} NOTE: Figure \ numbers \ of \ black-and-white \ illustrations \ are \ in \ (italics). \ Colorplate \ numbers \ are \ in \ (bold \ face). \ Duration \ of \ papacy \ or \ reign \ is \ indicated \ by \ the \ abbreviation \ r. \end{tabular}$

ARCHITECTURE	SCULPTURE	PAINTING	
Palace of Diocletian, Split (73) Basilica of Constantine, Rome (72)	Colossal statue of Constantine (78) Sarcophagus of Junius Bassus, Rome (91)	Catacomb of SS. Pietro e Marcellino, Rome (85)	- 30 <u>(</u>
S. Vitale, Ravenna (93, 94) Hagia Sophia, Istanbul (95, 96) S. Apollinare in Classe, Ravenna (86)	Archangel Michael, diptych leaf (92)	Mosaics, Sta. Maria Maggiore, Rome (88) Vatican Vergil (89) Vienna Genesis (90) Mosaics, S. Apollinare in Classe and S. Vitale, Ravenna (87, 97)	
	Sutton Hoo ship-burial treasure (100)	Lindisfarne Gospels (102)	- 60 0
Palace Chapel of Charlemagne, Aachen (104) Monastery plan, St. Gall (105)	Crucifixion (from a book cover?) (103) Oseberg ship-burial (101) Crucifixion relief, cover of Lindau Gospels (106)	Gospel Book of Charlemagne (107) Gospel Book of Archbishop Ebbo of Reims (108)	- 800
	Gero Crucifix, Cologne Cathedral (109)		- 900
St. Michael's, Hildesheim (110, 111) Pisa Cathedral complex (120) Baptistery, Florence (121) StEtienne, Caen (118) StSernin, Toulouse (114–16) Durham Cathedral (119)	Bronze doors of Bishop Bernward, Hildesheim (112) Apostle, StSernin, Toulouse (122)	Gospel Book of Otto III (113) Mosaics, Daphnē (98) Bayeux Tapestry (128)	- 1000
Notre-Dame-la-Grande, Poitiers (117) Notre-Dame, Paris (131–34) Chartres Cathedral (135)	South portal, StPierre, Moissac (123) Baptismal font, St. Barthélemy, Liège, by Renier of Huy (125) Ewer from Meuse Valley (126) Last Judgment tympanum, Autun Cathedral (124) West portals, Chartres Cathedral (143, 144) Klosterneuburg Altar, by Nicholas of Verdun (130)	Nave vault murals, StSavin-sur-Gartempe (129) Gospel Book of Abbot Wedricus (127)	- 1100
Salisbury Cathedral (137) Sta. Croce, Florence (139) Florence Cathedral (140) Palazzo Vecchio, Florence (142)	West portal (145) and interior west wall sculpture (146), Reims Cathedral Choir screen, Naumburg Cathedral (147) Pulpit, Baptistery, Pisa, by Nicola Pisano (150)	Stained glass, nave clerestory, Bourges Cathedral (153) Madonna Enthroned, icon (99) Prayer Book of Philip the Fair, by Master Honoré (154)	1200
Orvieto Cathedral (141) Gloucester Cathedral (138) StMaclou, Rouen (136)	Madonna, Prato Cathedral, by Giovanni Pisano (151) Pietà, Bonn (148) Moses Well, Dijon, by Claus Sluter (149)	Arena Chapel frescoes, Padua, by Giotto (155) Maestà Altar, Siena, by Duccio (156) Good Government fresco, Palazzo Publico, Siena, by Ambrogio Lorenzetti (159) Road to Calvary, by Simone Martini (157) Birth of the Virgin triptych, Siena, by Pietro Lorenzetti (158) Death of the Virgin, by Bohemian Master (160) Altar wings, Dijon, by Melchior Broederlam (161)	1300
	Competition relief for Baptistery doors, Florence, by Ghiberti (152)	Very Rich Book of Hours of the Duke of Berry, by Limbourg Brothers (162, 163) Adoration of the Magi altar, by Gentile da Fabriano (164)	1400

PART THREE The Renaissance

The "New Age"

In discussing the transition from Classical antiquity to the Middle Ages, we were able to point to a great crisis—the rise of Islam separating the two eras. No comparable event divides the Middle Ages from the Renaissance. The fifteenth and sixteenth centuries did witness far-reaching developments: the fall of Constantinople and the Turkish conquest of southeastern Europe: the journeys of exploration that led to the founding of overseas empires in the New World, in Africa, and in Asia, with the subsequent rivalry of Spain and England as the foremost colonial powers; the deep spiritual crises of Reformation and Counter Reformation. But none of these can be said to have produced the new era. By the time they occurred, the Renaissance was well under way. Thus it is no surprise that scholars debating the causes of the Renaissance disagree, like the proverbial blind men trying to describe an elephant. Even if we disregard those few who would deny the existence of the animal altogether, we are left with a wide range of views. Every branch of historical study has developed its own image of the period. While these images overlap, they do not coincide, so that our concept of the Renaissance may vary as we focus on its fine arts, music, literature, philosophy, politics, economics, or science. Perhaps the one point on which most experts agree is that the Renaissance had begun when people realized they were no longer living in the Middle Ages.

This statement is not as simple-minded as it sounds, for the Renaissance was the first period in history to be aware of its own existence and to coin a label for itself. Medieval man did not think he belonged to an age dis-

tinct from Classical antiquity; the past, to him, consisted simply of "B.C." and "A.D."; history, from this point of view, is made in Heaven rather than on earth. The Renaissance, by contrast, divided the past not according to the divine plan of salvation, but on the basis of human action. It saw Classical antiquity as the era when man had reached the peak of his creative powers, an era brought to a sudden end by the barbarians who destroyed the Roman Empire. In the thousand-year interval of "darkness" which then followed, little was accomplished, but now at last this "time inbetween" or "Middle Ages" had given way to a revival of all those arts and sciences that flourished in ancient times. The present could thus be fittingly labeled a "rebirth"renaissance in French and, by adoption, in English. The origin of this revolutionary view of history can be traced back to the 1330s in the writings of the Italian poet Petrarch, the first of the great men who initiated the Renaissance. That it should have begun in the mind of one man is itself a telling comment on the new era, for Petrarch embodies two salient features of the Renaissance: individualism and humanism. Individualism—a new self-awareness and selfassurance—enabled him to claim, against all established authority, that the "age of faith" was actually an era of darkness, and that the "benighted pagans" of antiquity represented the most enlightened stage of history. Humanism, to Petrarch, meant a belief in the importance of what we still call "the humanities" or "humane letters" (as against divine letters, the study of Scripture): the pursuit of learning in languages, literature, history, and philosophy for its own end, in a secular

rather than religious framework. Again he set a pattern because the humanists, the new breed of scholar following him, became the intellectual leaders of the Renaissance.

Yet Petrarch and his successors did not want to revive Classical antiquity lock, stock, and barrel. By interposing the concept of "a thousand years of darkness" between themselves and the ancients, they acknowledged—unlike medieval Classicists—that the Graeco-Roman world was now irretrievably dead. Its glories could be revived only in the mind, across the barrier of the "dark ages," by rediscovering the full greatness of ancient achievements in art and thought and by trying to compete with them on an ideal plane. The aim of the Renaissance was not to duplicate the works of antiquity but to equal and perhaps to surpass them. In practice, this

meant that the authority granted to the ancient models was far from unlimited. The humanists did not become neo-pagans but went to great lengths seeking to reconcile Classical philosophy with Christianity; and architects continued to build churches, not pagan temples, but in doing so they used an architectural vocabulary based on the study of Classical structures. Renaissance physicians admired the anatomical handbooks of the ancients, but they discovered errors when they matched the books against the direct experience of the dissection table, and learned to rely on the evidence of their own eyes. It is a fundamental paradox that the desire to return to the Classics, based on a rejection of the Middle Ages, brought to the new era not the rebirth of antiquity but the birth of Modern Man.

Late Gothic Painting North of the Alps

RENAISSANCE VS. "LATE GOTHIC"

As we narrow our focus from the Renaissance as a whole to the Renaissance in the fine arts, we are faced with some questions that are still being debated: Did it, like Gothic art, originate in a specific center, or in several places at the same time? Should we think of it as one new, coherent style, or as a new attitude that might be embodied in more than one style? So far as architecture and sculpture are concerned, there is general agreement that the Renaissance began in Florence soon after 1400. In painting, the situation is less clear-cut. Some scholars believe that the first Renaissance painter was Giotto-an understandable claim, since his achievement (and that of his contemporaries in Siena) had revolutionized painting throughout Europe (see p. 148). Nevertheless, it took a second revolution, a century after Giotto, for Renaissance painting to be born, and this revolution began independently both in Florence and in the Netherlands. The twin revolutions were linked by a common aim—the conquest of the visible world beyond the limits of the International Gothic style—yet they were sharply separated in almost every other respect. While the new realism of Florentine painting after about 1420 is clearly part of the Early Renaissance movement, we have no satisfactory name for its counterpart in the North. The label "Late Gothic," often applied to it, hardly does justice to its special character, although the term has some justification. It indicates, for instance, that the creators of the new style in Flanders, unlike their Italian contemporaries, did not reject the International Style; rather, they took it as their point of departure, so that the break with the past was less abrupt in the North than in the South. It also reminds us that fifteenth-century architecture in the North remained firmly rooted in the Gothic tradition. Whatever we choose to

call the style of Northern painters at this time, their environment was clearly Late Gothic. How could they create a genuinely post-medieval style in such a setting? Would it not be more reasonable to regard their work, despite its great importance, as the final phase of Gothic painting? If we treat them here as the Northern counterpart of the Early Renaissance, we do so for several reasons. The great Flemish masters whose work we are about to examine were as much admired in Italy as they were at home, and their intense realism had a conspicuous influence on Early Renaissance painting. Moreover, they have a close parallel in the field of music: from about 1420 on, the Netherlands produced a school of composers so revolutionary as to dominate the development of music throughout Europe for the next hundred years. A contemporary said of them that nothing worth listening to had been composed before their time. An analogous claim might well have been made for the new school of Flemish painters.

The Master of Flémalle

The first phase of the pictorial revolution in Flanders is represented by an artist known as the Master of Flémalle. He was probably Robert Campin, the foremost painter of Tournai, who is recorded there from 1406 until his death in 1444. Among his finest works is the Annunciation, the center panel of the Merode Altarpiece, done soon after 1425 (fig. 165). Comparing it with the Franco-Flemish pictures of the International Style (see fig. 161), we recognize that it belongs within that tradition; yet we also find in it a new pictorial experience. For the first time, we have the sensation of actually looking through the surface of the panel into a spatial world with all the essential qualities of everyday reality: unlimited depth, stability, continuity, and completeness. The painters of the International Style had never aimed at such consistency; their pictures have the enchanting quality of fairy tales where the scale and relationship of things can be shifted at will, where fact and fancy mingle without conflict. Campin, in contrast, has undertaken to tell the truth, the whole truth, and nothing but the truth. He does not yet do it with ease—his

objects, overly foreshortened, tend to jostle each other in space. But, with obsessive determination, he defines every aspect of every last object: its individual shape and size, its color, material, texture, and its way of responding to light (note the surface reflections and sharply defined shadows). The *Merode Annunciation*, in short, transports us quite abruptly from the aristocratic world of the International Style to the household of a

165. The Master of Flémalle (Robert Campin?). Annunciation, center panel of the Merode Altarpiece. c. 1425-28. Oil on panel, $25\frac{1}{4} \times 24\frac{7}{8}$ ". The Metropolitan Museum of Art, New York (Purchase. The Cloisters Collection)

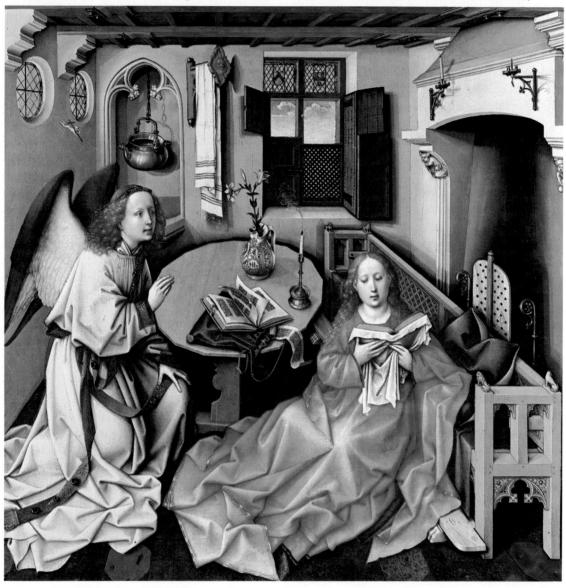

Flemish burgher. This is the earliest Annunciation in panel painting that occurs in a fully equipped domestic interior. Campin has here faced a problem no one had met before: how to transfer a supernatural event (the angel announcing to Mary that she will bear the Son of God) from a symbolic setting to an everyday environment, without making it look either trivial or incongruous. He has solved the problem by a method known as "disguised symbolism," which means that any detail within the picture, however casual, may carry a symbolic message. Thus the lilies denote the Virgin's chastity, and the shiny water basin and the towel on its rack are not merely household equipment but further tributes to Mary as the "vessel most clean" and the "well of living waters." Perhaps the most intriguing symbol is the candle next to the lilies. It was extinguished only moments ago; but why, in broad daylight, had it been lit, and what made the flame go out? Has the divine radiance of the Lord's presence overcome the material light? Or did the flame itself represent the divine light, now extinguished to show that God has become man, that in Christ "the Word was made flesh"? Clearly, the entire wealth of medieval symbolism survives in our picture, but it is so immersed in the world of everyday appearances that we are often left to doubt whether a given detail demands symbolic interpretation. How, we wonder, could Campin pursue simultaneously what we tend to regard as opposite goals, realism and symbolism? To him, apparently, the two were interdependent, rather than in conflict. He must have felt that he had to "sanctify" everyday reality with the maximum of spiritual significance in order to make it worth painting. This deeply reverential attitude toward the physical universe as a mirror of divine truth helps us to understand why in our panel even the least conspicuous details are rendered with the same concentrated attention as the sacred figures; potentially, at least, everything is symbol, and thus merits an equally exacting scrutiny.

If we compare our colorplate of the *Merode* Annunciation with that of an earlier panel painting (see fig. 160) we become aware of another revolutionary quality of Campin's work. The jewel-like brightness of the older picture, its pattern of brilliant hues and lavish use of gold, have given way to a color scheme far less decorative but much more flexible and differentiated. The subdued tints-muted greens, bluish or brownish grays—show a new subtlety, and the scale of intermediate shades is smoother and has a wider range. All these effects are essential to the realistic style of Campin; they were made possible by the use of oil, the medium he was among the first to exploit. The basic technique of medieval painting had been tempera, in which the powdered pigments were mixed ("tempered") with diluted egg yolk. It produced a thin, tough, quick-drying coat admirably suited to the medieval taste for highkeyed, flat color surfaces. Oil, in contrast, was a viscous, slow-drying medium. It could vield a vast range of effects, from thin, translucent films (called "glazes") to the thickest impasto (a dense layer of creamy, heavy-bodied paint). It also permitted the blending of colors right on the panel, which produced a continuous scale of hues that included rich, velvety dark shades unknown before. Without oil, the Flemish masters' conquest of visible reality would have been much more limited. Thus, from the technical point of view, too, they were the "fathers of modern painting," for oil was to become the painter's basic medium everywhere.

Van Eyck

Needless to say, the full range of effects made possible by oil was not discovered all at once, nor by any one man. Campin contributed less than Jan van Eyck, a somewhat younger and much more famous artist, who was long credited with the actual "invention" of oil painting. About Jan's life and career we know a good deal, while his older brother Hubert, ap-

parently also a painter, remains a disputed figure. There are several works that may have been painted by either of the two, including the pair of panels showing the Crucifixion and the Last Judgment (fig. 166). Scholars agree that their date is between 1420 and 1425, if not on whether Jan or Hubert was the author. The style of these panels has much in common with that of the Merode Annunciation—the all-embracing devotion to the visible world, the deep space, the angular drapery folds, less graceful but far more realistic than the unbroken loops of the International Style. Yet the individual forms are not so tangible, they seem less isolated, less "sculptural"; and the sweeping sense of space comes not so much from violent foreshortening as from subtle changes of light and color. If we inspect the Crucifixion slowly, from the foreground figures to the distant city of Jerusalem and the snow-capped peaks beyond, we see a gradual decrease in the intensity of local colors and in the contrast of light and dark. Everything tends toward a uniform tint of light bluish gray, so that the farthest mountain range merges with the color of the sky. This optical phenomenon is known as "atmospheric perspective," since it results from the fact that the atmosphere is never wholly transparent. Even on the clearest day, the air between us and the things we are looking at acts as a hazy screen that interferes with our ability to see distant shapes and colors clearly; as we approach the limit of visibility, it swallows them altogether. Atmospheric perspective is more fundamental to our perception of deep space than linear perspective, which records the diminution in the apparent size of objects as their distance from the observer increases. It is effective not only in faraway vistas; in the Crucifixion. even the foreground seems enveloped in a delicate haze that softens contours, shadows. and colors. The entire scene has a continuity and harmony quite beyond Campin's pictorial range. Clearly, the Van Eycks used the oil medium with extraordinary refinement.

Viewed as a whole, the Crucifixion seems singularly devoid of drama, as if the scene had been becalmed by some magic spell. Only when we concentrate on the details do we become aware of the violent emotions in the faces of the crowd beneath the Cross, and the restrained but profoundly touching grief of the Virgin and her companions in the foreground. In The Last Judgment, this dual aspect of the Eyckian style takes the form of two extremes: above the horizon, all is order and calm, while below it—on earth and in the realm of Satan—the opposite condition prevails. The two states thus correspond to Heaven and Hell, contemplative bliss as against physical and emotional turbulence. The lower half, clearly, was the greater challenge to the artist's imaginative powers. The dead rising from their graves with frantic gestures of fear and hope, the damned being torn apart by devilish monsters more frightful than any we have seen before, all have the awesome reality of a nightmare—a nightmare "observed" with the same infinite care as the natural world of the Crucifixion.

The Ghent Altarpiece (figs. 167, 168, 169). the greatest monument of early Flemish painting, presents problems so complex that our discussion must be limited to bare essentials. The inscription informs us that the work, begun by Hubert, was completed by Jan in 1432. Since Hubert died in 1426, the altarpiece was presumably made in the seven-year span between 1425 and 1432. We may expect it, therefore, to introduce to us the next phase of the new style, following that of the pictures we have discussed so far. Although its basic form is a triptych—a central body with two hinged wings-each of the three units consists of four separate panels, and since, in addition, the wings are painted on both sides, the altarpiece has a total of twenty component parts of assorted shapes and sizes. The ensemble makes what has rightly been called a "super-altar," overwhelming but far from harmonious, which could not have been planned this way from

166. Hubert and/or Jan van Eyck. Crucifixion; $The\ Last\ Judgment$. c. 1420–25. Tempera and oil on canvas transferred from panel, each panel $22^{1/4}\times7^{3/4}$ ". The Metropolitan Museum of Art, New York (Fletcher Fund, 1933)

167–69. Hubert and Jan van Eyck. *The Ghent Altarpiece*. Completed 1432. Oil on panel, 11'3"×14'5". St. Bavo, Ghent. 167. (above left) altarpiece open; 168. (above right) detail of Adam and Eve; 169. (below) altarpiece closed

the start. Apparently Jan took over a number of panels left unfinished by Hubert, completed them, added some of his own, and assembled them at the behest of the wealthy donor whose portrait we see on the outside of the altar. To reconstruct this train of events, and to determine each brother's share, is a fascinating but treacherous game. Suffice it to say that Hubert remains a somewhat shadowy figure; his style, overlaid with retouches by Jan, can probably be found in the four central panels, although these did not belong together originally. The upper three, whose huge figures in the final arrangement crush the multitude of small ones below, were intended, it seems, to form a self-contained triptych: the Lord between the Virgin Mary and St. John the Baptist. The lower panel and the four flanking it probably formed a separate altarpiece, the Adoration of the Lamb, symbolizing Christ's sacrificial death. The two panels with music-making angels may have been planned by Hubert as a pair of organ shutters. If this set of conjectures is correct, the two tall, narrow panels showing Adam

and Eve (fig. 168) are the only ones added by Jan to Hubert's stock. They certainly are the

most daring of all: the earliest monumental nudes of Northern panel painting (hardly less than lifesize), magnificently observed, and caressed by the most delicate play of light and shade. Their quiet dignity—and their prominent place in the altar—suggests that they should remind us not so much of Original Sin as of man's creation in God's own image. Actual evil, by contrast, is represented in the small, violently expressive scenes above, which show the story of Cain and Abel. Still more extraordinary, however, is the fact that the Adam and Eve were designed specifically for their present positions in the ensemble. Acknowledging that they would really appear this way to the spectator whose eye-level is below the bottom of the panels, Jan van Eyck has depicted them in accordance with this abnormal viewpoint and thereby established a new, direct relationship between picture space and real space.

The outer surfaces of the two wings (fig. 169) were evidently planned by Jan as one coherent unit. Here, as we would normally expect, the largest figures are not above, but in the lower tier. The two St. Johns (painted in grays to simulate sculpture, like the scenes of Cain and Abel), the donor, and his wife, each in his separate niche, are the immediate kin of the Adam and Eve panels. The upper tier has two pairs of panels of different width; the artist has made a virtue of this awkward necessity by combining all four into one interior. Such an effect, we recall, had first been created almost a century earlier (compare fig. 158), but Jan, not content with perspective devices alone, heightens the illusion by painting the shadows cast by the frames of the panels on the floor of the Virgin's chamber. Interestingly enough, this Annunciation resembles, in its homely detail, the Merode Altarpiece, thus providing a valuable link between the two great pioneers of Flemish realism.

Donors' portraits of splendid individuality occupy conspicuous positions in both the

170. Jan van Eyck. *Man in a Red Turban* (*Self-Portrait*?). 1433. Oil on panel, $10\frac{1}{4} \times 7\frac{1}{8}$ ". The National Gallery, London (Reproduced by courtesy of the Trustees)

Merode and the Ghent altarpieces. A renewed interest in realistic portraiture had developed in the mid-fourteenth century, but not until the Master of Flémalle did the portrait play a major role in Northern painting. In addition to donors' portraits, we now begin to encounter in growing numbers small, independent likenesses whose peculiar intimacy suggests that they were treasured keepsakes. One of the most fascinating is Jan van Eyck's Man in a Red Turban of 1433 (fig. 170), which may well be a self-portrait—the slight strain about the eyes seems to come from gazing into a mirror. Every detail of shape and texture has been recorded with almost microscopic precision. Jan does not suppress the sitter's personality, yet this face, like all of Jan's portraits, remains a psychological puzzle. The stoic calm of his portraits

surely reflects his conscious ideal of human character rather than his indifference or lack of insight.

The Flemish cities where the new style of painting flourished—Tournai, Ghent, Bruges —rivaled Florence as centers of international banking and trade. Their foreign residents included many Italian businessmen. For one of these, perhaps a member of the Arnolfini family, Jan van Eyck painted his largest and most remarkable portrait, the Wedding Portrait (fig. 171). In the picture the young couple is solemnly exchanging marriage vows in the privacy of the bridal chamber. They seem to be quite alone, but as we look at the mirror behind them, we discover in the reflection that two other persons have entered the room. One must be the artist, since the words above the mirror (fig. 172), in florid legal lettering, tell us that "Johannes de eyck fuit hic" (Jan van Eyck was here) and the date, 1434. Jan's role, then, is that of a witness; the panel purports to show exactly what he saw and has the function of a pictorial marriage certificate. Yet the setting, however realistic, is replete with disguised symbolism of the most subtle kind, conveying the sacramental nature of marriage. The single candle in the chandelier, burning in broad daylight, stands for the all-seeing Christ; the shoes which the couple have taken off remind us that this is "holy ground" (see p. 25); even the little dog is an emblem of marital fidelity. Here, as in the Merode Annunciation, the natural world is made to contain the world of the spirit in such a way that the two actually become one.

Rogier van der Weyden

In the work of Jan van Eyck, the exploration of the reality made visible by light and color had reached a limit that was not to be surpassed for another two centuries. Rogier van der Weyden, the third great master of early Flemish painting, set himself a different

though equally important task: to recapture, within the framework of the new style created by his predecessors, the emotional drama, the pathos, of the Gothic past. We can see this immediately in his early masterpiece, The Descent from the Cross (fig. 173), painted about the same time as the Wedding Portrait. The modeling here is sculpturally precise, with brittle drapery folds like those of Campin, while the soft half-shadows show the influence of Jan van Eyck. Yet Rogier is far more than a mere follower of the two older men; what he owes to them he uses for ends that are not theirs but his. The outward event (the lowering of Christ's body from the Cross) concerns him less than the world of human feeling: the artistic ancestry of these griefstricken gestures and faces lies in Gothic sculpture such as the Bonn Pietà (see fig. 148) and the lamenting angels of Sluter's Moses Well (see fig. 149). Indeed, Rogier has staged the scene in a shallow architectural shrine, as if his figures were colored statues, thus focusing our entire attention on the foreground. No wonder that Rogier's art, which has been well described as "at once physically barer and spiritually richer than Jan van Eyck's," set an example for countless other artists. So great was the authority of his style that between 1450 and 1500 it had supreme influence not only in European painting north of the Alps, but in sculpture as well.

Hugo van der Goes; Geertgen

Among the artists who followed Rogier van der Weyden, few succeeded in escaping from the great master's shadow. The most dynamic of these was Hugo van der Goes, an unhappy genius whose tragic end suggests an unstable personality peculiarly interesting to us today. After a spectacular rise to fame in the cosmopolitan atmosphere of Bruges, he decided in 1478, when he was about forty years of age, to enter a monastery as a lay brother; for some time he continued to paint,

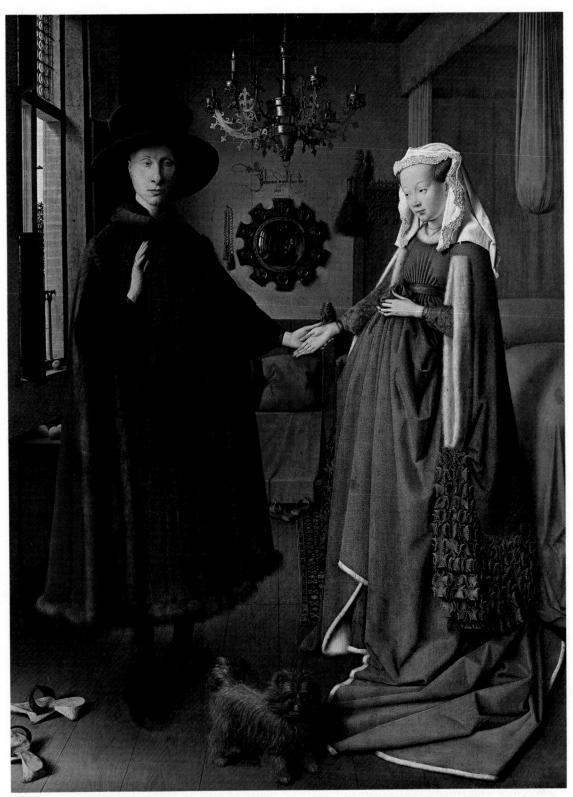

171. Jan van Eyck. Wedding Portrait. 1434. Oil on panel, $33\times22^{1/2}$ ". The National Gallery, London (Reproduced by courtesy of the Trustees)

but increasing fits of depression drove him to the verge of suicide, and four years later he was dead. His most ambitious work, the huge altarpiece he completed about 1476 for Tommaso Portinari, is an awesome achievement (fig. 174). While we need not search it for hints of Hugo's future mental illness, it nonetheless evokes a tense, explosive personality. In the wings, for instance, the kneeling members of the Portinari family are dwarfed by their patron saints, whose gigantic size characterizes them as beings of a higher order, like Joseph and the Virgin Mary, and by the

172. Jan van Eyck. Wedding Portrait (detail of figure 171)

173. Rogier van der Weyden. The Descent from the Cross. c. 1435. Oil on panel, $7'2^5\%'' \times 8'7^1\%''$. The Prado, Madrid

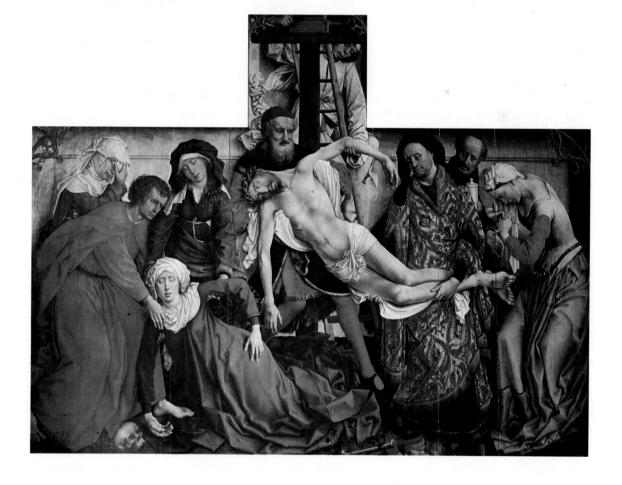

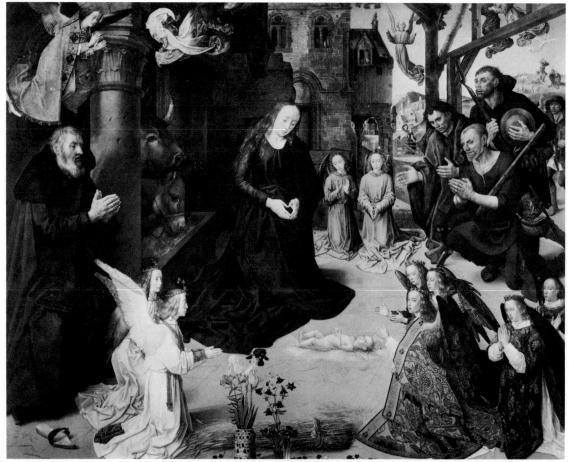

174. Hugo van der Goes. Center panel of *The Portinari Altarpiece*. c. 1476. Oil on panel, $8'3\frac{1}{2}'' \times 10'$. Uffizi Gallery, Florence

shepherds of the Nativity in the center panel, who share the same huge scale. There is striking contrast between the frantic excitement of the shepherds and the ritual solemnity of all the other figures. These field hands, gazing in breathless wonder at the newborn Child, react to the dramatic miracle of the Nativity with a wide-eyed directness never attempted before.

During the last quarter of the fifteenth century there were no painters in Flanders comparable to Hugo van der Goes, and the most original artists appeared farther north, in Holland. To one of these, Geertgen tot Sint Jans of Haarlem, we owe the enchanting *Nativity* reproduced in figure 175, a picture as daring, in its quiet way, as the center panel of

The Portinari Altarpiece. The idea of a nocturnal Nativity, illuminated mainly by radiance from the Christ Child, goes back to the International Style (see fig. 164), but Geertgen, applying the pictorial discoveries of Jan van Eyck, gives new, intense reality to the theme. The magic effect of his little panel is greatly enhanced by the smooth, simplified shapes that record the impact of light with striking clarity: the manger is a rectangular trough; the heads of the angels, the Infant, and the Virgin are as round as objects turned on a lathe.

Bosch

If Geertgen's uncluttered, "abstract" forms

sters in the left wing), and we are all destined for Hell, the Garden of Satan (fig. 176, right). Despite Bosch's deep pessimism, there is an innocence, even a haunting poetic beauty, in this panorama of sinful mankind. Consciously, he was a stern moralist painting a visual sermon, every detail packed with didactic meaning. Unconsciously, however, he must have been so enraptured by the sensuous appeal of the world of the flesh that the images he coined tend to celebrate what they are meant to condemn. That, surely, is why *The Garden of Delights* still evokes so strong a response today, even though we no longer understand every word of the sermon.

SWISS AND FRENCH PAINTING

We must now glance briefly at fifteenth-century art in the rest of Northern Europe. After about 1430, the new realism of the Flemish masters began to spread into France and Germany until, by the middle of the century, its influence was paramount from Spain to the Baltic. Among the countless artists (many of them still anonymous) who turned out provincial adaptations of Netherlandish painting, only a few were gifted enough to impress us today with a distinctive personality. One of the earliest and most original was Conrad Witz of Basel, whose altarpiece for the Gene-

178. Conrad Witz. The Miraculous Draught of Fishes. 1444. Panel, $51 \times 61''$. Museum, Geneva

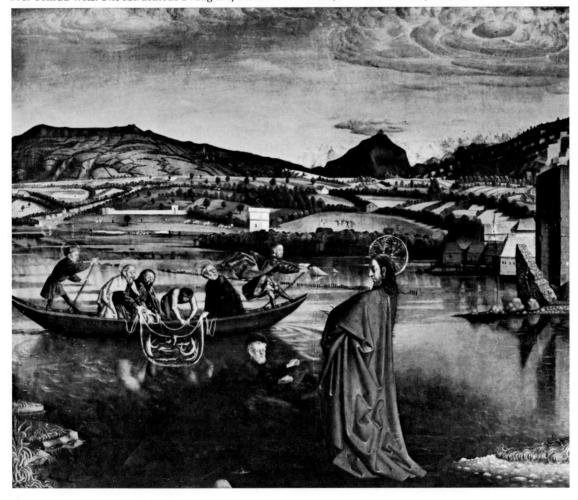

179. Southern French Master. The Avignon Pietà. c. 1470. Oil on panel, $5'4'' \times 7'2''$. The Louvre, Paris

va Cathedral, painted in 1444, includes the remarkable panel shown in figure 178. To judge from the drapery, he must have had close contact with Campin. But it is the setting more than the figures that attracts our interest, and here the influence of the Van Eycks seems dominant. Nevertheless, Witz was an explorer in his own right, who knew more about the optical properties of water than any painter of that time (note especially the bottom of the lakeshore in the foreground). The landscape, too, is an original venture, representing a specific part of the shore of the Lake of Geneva—the earliest "portrait" landscape that we know.

A Flemish style, influenced by Italian art. characterizes the most famous of all French fifteenth-century pictures, The Avignon Pietà (fig. 179). As its name indicates, the panel comes from the extreme south of France. It was probably painted by an artist of that region, but the name of this important master is not recorded, and we know no other works by his hand. All we can say about his background is that he must have been thoroughly familiar with the art of Rogier van der Weyden, for the figure types and the expressive content of The Avignon Pietà could be derived from no other source. At the same time, the design, magnificently simple and stable, is Italian rather than Northern (we first saw

these qualities in the art of Giotto). Southern, too, is the bleak, featureless landscape emphasizing the monumental isolation of the figures. The distant buildings behind the donor on the left have an unmistakably Islamic flavor: did the artist mean to place the scene in an authentic Near Eastern setting? However that may be, he has created from these various features an unforgettable image of heroic pathos.

THE GRAPHIC ARTS

Printing

Germany's chief contribution to fifteenthcentury art was the development of printing. for pictures as well as books. The earliest typeset printed books were produced in the Rhineland soon after 1450. The new technique spread all over Europe and grew into an industry that had the most profound effect on Western civilization. Printed pictures, however, had hardly less importance; without them, the printed book could not have replaced the work of the medieval scribe and illuminator so quickly and completely. The oldest pictorial printing technique is the woodcut, printed from wooden blocks carved in relief (the areas meant to remain white being hollowed out). The earliest examples all show the familiar qualities of the International Style (fig. 180), but they have a flat, ornamental pattern; forms are defined by simple, heavy contours. Since the outlines were meant to be filled in with color, these prints often recall stained glass (see fig. 153) more than the miniatures which they replaced. They were a popular art, on a level that did not attract masters of high ability until shortly before 1500. A single wood block yielded thousands of copies, to be sold for a few pennies apiece, bringing the individual ownership of pictures within everyone's reach for the first time in our history.

180. St. Dorothy. c. 1420. Woodcut. Staatliche Graphische Sammlung, Munich

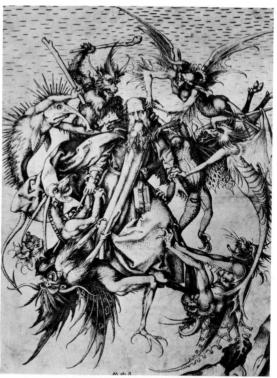

181. Martin Schongauer. *The Temptation of St. Anthony*. c. 1480–90. Engraving. The Metropolitan Museum of Art, New York (Rogers Fund, 1920)

Engraving: Schongauer

Engraving, somewhat younger than woodcuts, was a more sophisticated medium from the start. Unlike woodcuts, engravings are printed not from a raised design but from Vshaped grooves cut into a copper plate with a steel tool known as a burin, so that fine lines are very much easier to achieve. The oldest examples we know, dating from around 1430, already show the influence of the great Flemish painters. Nor do engravings share the anonymity of early woodcuts: individual hands can be distinguished almost from the beginning; dates and initials appear soon after; and the most important engravers of the later fifteenth century are known to us by name. The greatest of them, Martin Schongauer, might be called the Rogier van der

Weyden of engraving, since his prints are full of Rogierian motifs and expressive devices. Yet Schongauer had his own powers of invention; his finest prints have a complexity of design, spatial depth, and richness of texture that are fully equivalent to panel paintings. The Temptation of St. Anthony (fig. 181) masterfully combines savage expressiveness and formal precision, violent movement and ornamental stability. The longer we look at it. the more we marvel at its range of tonal values, the rhythmic beauty of the engraved line, and the artist's ability to render every conceivable surface texture merely by varying his burin's attack upon the plate. He was not to be surpassed by any later engraver in this respect.

The Early Renaissance in Italy

When we discussed the new style of painting that arose in Flanders about 1420, we did not try to explain why this revolution took place where and when it did. This does not mean, however, that no explanation is possible. It is simply that we do not yet fully understand the link between the great Flemish painters and the social, political, and cultural setting in which they worked. Regarding the origins of Early Renaissance art in Florence, we are in a better position. In the years around 1400, Florence faced an acute threat to its independence from the powerful duke of Milan, who was trying to bring all of Italy under his rule. Florence remained the only serious obstacle to his ambition. The successful resistance of the city gave rise to a new, civicpatriotic kind of humanism, which hailed Florence as the "new Athens," the champion of freedom as well as the home of arts and letters. So, in the midst of the crisis, the Florentines embarked upon a vast campaign to embellish their city with monuments worthy of the "new Athens." The huge investment was itself no guarantee of artistic quality, but it provided a splendid opportunity for creative talent of every kind. From the start, the visual arts were considered essential to the resurgence of the Florentine spirit. They had been classed with the crafts, or "mechanical arts," throughout antiquity and the Middle Ages: now, for the first time, they were given the rank of liberal arts. A century later, this claim was to win general acceptance in the Western world. What does it imply? The liberal arts, by a tradition going back to Plato, comprised the intellectual disciplines necessary for a gentleman's education-math-(geometry, arithmetic, musical ematics theory), dialectic, grammar, rhetoric, and philosophy: the fine arts were excluded because they were "handiwork" having no basis in theory. Thus, when the artist gained admission to this select group, the nature of his work had to be redefined: he came to be looked upon as a man of ideas, not a mere manipulator of materials, and the work of art was viewed as the visible record of his creative mind. This meant that works of art ought not to be judged by fixed standards of craftsmanship. Soon everything that bore a great master's imprint—drawings, sketches, fragments, unfinished pieces—was eagerly collected. The artist's own outlook, too, underwent a change; now in the company of scholars and poets, he often became a man of learning and literary culture, who might write poems, an autobiography, or treatises on art theory (until then, there had been only "pattern books" for artists). As another consequence of their new social status, artists tended to develop into one of two contrasting personality types: the man of the world, at ease in aristocratic society, or the solitary genius, likely to be in conflict with his patrons. It is remarkable how soon this modern view of art and artists became a living reality in Early Renaissance Florence.

SCULPTURE

Donatello

The first half of the fifteenth century is the heroic age of the Early Renaissance. Florentine art, dominated by the original creators of the new style, held an undisputed position of leadership. To trace its beginnings, we must discuss sculpture first, for the great upsurge of civic art patronage had begun with a com-

petition for the Baptistery doors (see pp. 145–46) and for some time involved mainly sculptural projects.

Donatello was the greatest sculptor of the fifteenth century. We have clearly entered a new epoch when we look at his St. George (fig. 182), carved in marble for a niche of the Church of Or San Michele around 1415. Here is the first statue we have seen since ancient times that can stand by itself, or, put another way, the first to recapture the full meaning of Classical counterpoise (for a discussion of counterpoise turn to p. 61). The artist has mastered at one stroke the central achievement of ancient sculpture: he has treated the human body as an articulated structure capable of movement. Its armor and its drapery are a secondary structure shaped by the body underneath; unlike any Gothic statue, this St. George can take off his clothes. And, also unlike any Gothic statue, he can be taken away from his architectural setting and lose none of his immense authority. His stance, with his weight placed on the forward leg, conveys the idea of readiness for combat (the right hand originally held a weapon). The controlled energy of his body is echoed in his eyes, which seem to scan the horizon for the approaching enemy. For this St. George, slaver of dragons, is a proud and heroic defender of the "new Athens."

The unidentified Prophet (fig. 183) nicknamed Zuccone ("Pumpkinhead"), for a reason that should be obvious, was carved some eight years later for the bell tower of the Cathedral. It has long enjoyed special fame as a striking example of Donatello's realism, and it is indeed realistic—far more so than any ancient statue or its nearest rivals, the Prophets of The Moses Well (see fig. 149). But, we may ask, what kind of realism have we here? Instead of following the traditional image of Prophets, as Sluter did in The Moses Well, Donatello has invented an entirely new type; how did he conceive it? Surely not by observing the people around him. More likely, he imagined the personalities of the

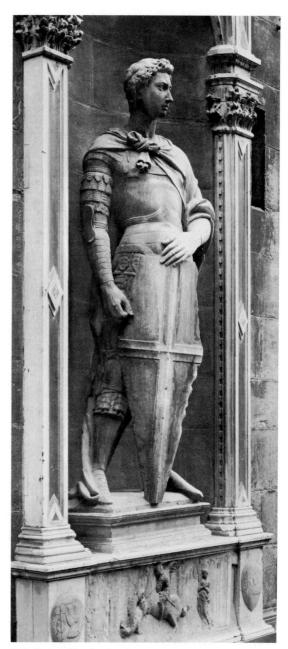

182. Donatello. *St. George*. c. 1415–17. Marble, height 6′10″. Or San Michele, Florence (statue now in the National Museum, replaced here by a bronze copy)

Prophets from the biblical accounts of them. He gained the impression, we may assume, of divinely inspired orators haranguing the multitude, and this in turn reminded him of the Roman orators he had seen in ancient sculpture. Hence the Classical costume of the *Zuccone*, whose mantle falls from his shoul-

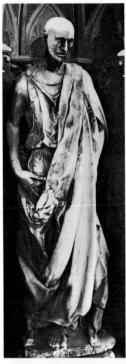

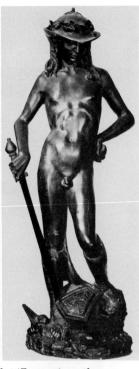

183. (*left*) Donatello. *Prophet* (*Zuccone*), on the campanile of Florence Cathedral. 1423–25. Marble, height 6'5" (original now in the Cathedral Museum, Florence)

184. (right) Donatello. David. c. 1430–32. Bronze, height 621/4". National Museum, Florence

der like a toga (see fig. 79), and the fascinating head, ugly yet noble, like late Roman portraits (see fig. 77). The Florentines themselves soon forgot that the *Zuccone* was meant to be a Prophet, and thought him a portrait of one of their own statesmen. As for Donatello, he seems to have regarded the *Zuccone* with pride as a particularly hardwon achievement; it is the first of his works to carry his signature.

Donatello had learned the technique of bronze sculpture as a youth by working under Ghiberti (see p. 145). It was in this material that, a few years after the *Zuccone*, he produced a *David* (fig. 184), the first freestanding lifesize nude statue since antiquity. The Middle Ages would surely have regarded the *David* as an idol, and Donatello's contemporaries, too, must have felt uneasy about it; for many years it remained the only work of

its kind. The statue must be understood as a civic-patriotic public monument identifying David—weak but favored by the Lord—with Florence, and Goliath with Milan, which had threatened Florence about 1400 and was now warring against it once more in the mid-1420s. David's nudity is most readily explained as a reference to the Classical origin of Florence, and his wreathed hat as the opposite of Goliath's helmet: peace vs. war. Donatello has chosen to model an adolescent boy, not a full-grown youth like the athletes of Greece, so that the skeletal structure here is less fully enveloped in swelling muscles; nor does he articulate the torso according to the Classical pattern (compare fig. 56). In fact his David resembles an ancient statue only in its marvelous counterpoise. If the figure nevertheless conveys a profoundly Classical air, the reason lies beyond its anatomical perfection; as in ancient statues, the body speaks to us more eloquently than the face, which by Donatello's standards is strangely devoid of individuality.

Donatello was invited to Padua in 1443 to produce an equestrian monument of Gattamelata, the recently deceased commander of the Venetian armies (fig. 185). This statue, the artist's largest freestanding work in bronze, still stands in its original position on a tall pedestal near the façade of the church dedicated to St. Anthony of Padua. We already know its chief precedent, the mounted Marcus Aurelius in Rome (see fig. 76). Without directly imitating this work, the Gattamelata shares its material, its impressive scale, and its sense of balance and dignity; Donatello's horse, a heavy-set animal fit to carry a man in full armor, is so large that the rider must dominate it by his authority of command, rather than by physical force. In the new Renaissance fashion, the statue is not part of a tomb; it was designed solely to immortalize the fame of a great soldier. Nor is it the self-glorifying statue of a sovereign, but a monument authorized by the Republic of Venice, in special honor of distinguished

and faithful service. To this purpose, Donatello has coined an image that is a complete union of ideal and reality; the general's armor combines modern construction with Classical detail; the head is powerfully individual, and yet endowed with a truly Roman nobility of character.

Ghiberti

One of the most important sculptors left in Florence after Donatello's departure was Lorenzo Ghiberti. After the great success of his first Baptistery doors, he had been commissioned to do a second pair, which were to be dubbed the "Gates of Paradise." Its reliefs, unlike those of the first doors (see fig. 152), were large and set in simple square frames (fig. 186). The hint of spatial depth we saw in The Sacrifice of Isaac has now grown in The Story of Jacob and Esau into a complete setting for the figures that goes back as far as the eye can reach. We can imagine the figures leaving the scene—the deep, continuous space of this "pictorial relief" in no way depends on their presence. How did Ghiberti achieve this effect? In part by varying the degree of relief, with the forms closest to the beholder being modeled almost in the round—a method familiar to us from ancient art (see figs. 54, 79, 80). Far more important, however, is the carefully controlled recession of figures and architecture, causing their apparent size to diminish systematically (rather than haphazardly, as before) as their distance from the beholder increases. This system, which we call scientific perspective. was one of the fundamental innovations that distinguish Early Renaissance art from everything that had gone before, as well as from the great Flemish masters of realism, who had achieved the effect of unlimited depth in their pictures by empirical means, through subtle gradations of light and color. Scientific perspective was not discovered by Ghiberti, nor by a painter, but by Filippo Brunelleschi, the creator of Early Renaissance architec-

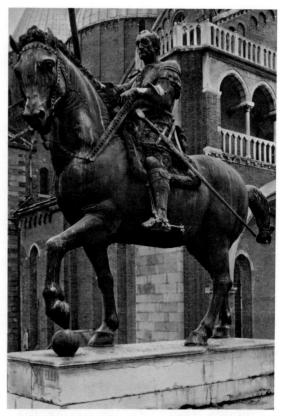

185. Donatello. Equestrian Monument of Gattamelata. 1445–50. Bronze, over lifesize. Piazza del Santo, Padua

ture (the building in Ghiberti's relief, fig. 186, is designed in this new style). His purpose, apparently, was to find a method of making visual records of architecture on a flat surface in such a way that the depth of the foreshortened flanks of buildings could be measured as precisely as the height or width of the façade. The details of the system need not concern us here, beyond saying that it is a geometric procedure analogous to the way the camera lens projects a perspective image on the film. Its central feature is the vanishing point, toward which a set of lines will seem to converge. If these lines are perpendicular to the picture plane, their vanishing point will be on the horizon, corresponding exactly to the position of the beholder's eye. Brunelleschi's discovery in itself was scientific rather than artistic, but both sculptors and painters took it up enthusiastically.

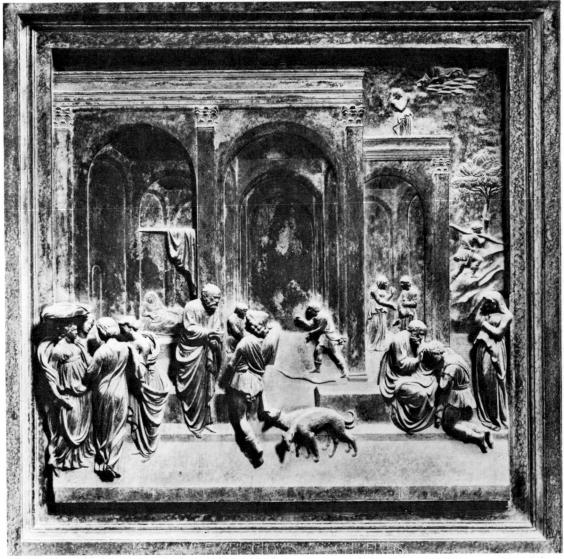

186. Lorenzo Ghiberti. *The Story of Jacob and Esau*, panel of the "Gates of Paradise." c. 1435. Gilt bronze, $31\frac{1}{4}$ " square. Baptistery, Florence

Here at last was a theoretical basis for representing the visible world, proving that the fine arts were now indeed "liberal" rather than "mechanical"!

Luca della Robbia

Ghiberti aside, the only significant sculptor in Florence after Donatello left was Luca della Robbia. He devoted himself almost exclusively to sculpture in terra-cotta—a cheaper and less demanding medium than marble—which he covered with enamel-like glazes to mask its surface and make it impervious to weather. His finest works in this technique, such as *The Resurrection* in figure 187, have both dignity and charm. The white glaze creates the impression of marble, with a deep blue for the background. Other colors were confined almost entirely to the decorative framework of Luca's reliefs.

187. Luca della Robbia. The Resurrection. 1442–45. Glazed terra-cotta, 6'6¾"×8'8½". Cathedral, Florence

The Portrait Bust

By 1450 the great civic campaign of art patronage had petered out, and Florentine artists had to depend mainly on private commissions. This put the sculptors at a disadvantage; and since the monumental tasks were few, they concentrated on works of moderate size and cost for individual patrons, such as bronze statuettes and portrait busts. A fine early example of this new class of "domestic sculpture" is the marble bust of Giovanni Chellini (fig. 188) by Antonio Rossellino, a master who rose to prominence in the 1450s. It represents a highly esteemed aged physician, whose personality—at once sardonic and kindly-has been observed with fine precision. Comparing it with Roman heads (see figs. 74, 75, 77), we find that the Florentine doctor radiates a human warmth and individuality far beyond any at-

188. Antonio Rossellino. Giovanni Chellini. 1456.Marble, height 20". Victoria & Albert Museum, London

tained in ancient times. He is linked to his Roman predecessors only by the idea of portrait sculpture in the round as an effective—and enduring—substitute for the sitter's real presence.

189. Antonio del Pollaiuolo. *Hercules and Antaeus*. c. 1475. Bronze, height 18" (with base). National Museum, Florence

Pollaiuolo

The popularity of portrait busts after about 1450 suggests a demand for works to be shown in the homes of individual art patrons. The collecting of sculpture, widely practiced in ancient times, apparently ceased during the Middle Ages; the taste of kings and feudal lords—those who could afford to collect for personal pleasure—ran to gems, jewelry, goldsmith's work, illuminated manuscripts, and precious fabrics. The habit was reestablished in fifteenth-century Italy as an aspect of the "revival of antiquity." Humanists and artists first collected ancient sculpture, especially small bronzes, which were numerous and of convenient size; before long, contemporary artists began to cater to the spreading vogue, with portrait busts and with small bronzes of their own "in the manner of the

ancients." A particularly fine piece of this kind (fig. 189) is by Antonio del Pollaiuolo. who represents a sculptural style very different from that of the marble carvers we discussed before. Trained as a goldsmith and metalworker, probably in the Ghiberti workshop, he was deeply impressed by the late styles of both Donatello and Castagno (see p. 200 and fig. 198), as well as by ancient art. From these sources, he evolved the distinctive manner that appears in our Hercules and Antaeus. To create a freestanding group of two figures in violent struggle, even on a small scale, was a daring idea in itself; even more astonishing is the way Pollaiuolo has endowed his composition with a centrifugal impulse: limbs seem to radiate in every direction from a common center, and we see the full complexity of their movements only when we turn the statuette before our eyes. Despite its strenuous action, the group is in perfect balance. To stress the central axis, Pollaiuolo, as it were, grafted the upper part of Antaeus onto the lower part of his adversary. There is no precedent for this design among earlier statuary groups of any size, ancient or Renaissance; our artist has simply given a third dimension to a composition from the field of drawing or painting. He himself was a painter and engraver as well as a bronze sculptor, and we know that about 1465 he did a large picture of Hercules and Antaeus, now lost, for the Medici Palace (our statuette also belonged to the Medici).

Verrocchio

Although Pollaiuolo, during the late years of his career, did two monumental bronze tombs for St. Peter's in Rome, he never had an opportunity to execute a large-scale freestanding statue. For such works we must turn to his slightly younger contemporary, Andrea del Verrocchio, the greatest sculptor of his day and the only one to share some of Donatello's range and ambition. A modeler as well as a carver—we have works of his in marble, terra-cotta, silver, and bronze—he combined

elements from Antonio Rossellino and Antonio del Pollaiuolo into a unique synthesis. He was also a respected painter and the teacher of Leonardo da Vinci (something of a misfortune, for ever since, he has been the object of slighting comparisons).

His most popular work in Florence, because of its location in the courtyard of the Palazzo Vecchio as well as its perennial charm, is the Putto with Dolphin (fig. 190). It was designed as the center of a fountain—the dolphin is spouting a jet of water, as if responding to the hug it has to endure—for one of the Medici villas near Florence. The term putto (plural, putti) designates one of the nude, often winged, children that accompany more weighty subjects in ancient art; they personify spirits of various kinds (such as the spirit of love, in which case we call them cupids), usually in a gay and playful way. They were reintroduced during the Early Renaissance, both in their original identity and as child angels. The dolphin associates Verrocchio's Putto with the Classical kind. Artistically, however, he is closer to Pollaiuolo's Hercules and Antaeus than to ancient art, despite his larger size and greater sense of volume. Again the forms fly out in every direction from a central axis, but here the movement is graceful and continuous rather than jagged and broken; the stretched-out leg, the dolphin, and the arms and wings fit into an upward spiral, making the figure seem to revolve before our eyes.

ARCHITECTURE

Brunelleschi

Although Donatello was its greatest and most daring master, he had not created the Early Renaissance style in sculpture all by himself. The new architecture, on the other hand, did owe its existence to one man, Filippo Brunelleschi. Ten years older than Donatello, Brunelleschi had begun his career as a sculptor. After failing to win the compe-

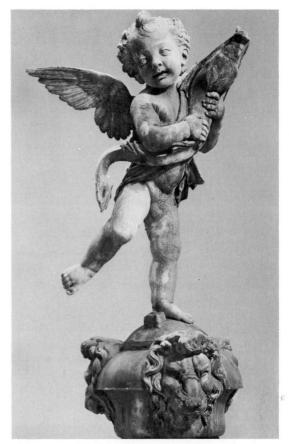

190. Andrea del Verrocchio. Putto with Dolphin. c. 1470. Bronze, height 27" (without base). Palazzo Vecchio, Florence

tition of 1401-2 for the first Baptistery doors, he reportedly went to Rome with Donatello. He studied the architectural monuments of the ancients, and seems to have been the first to take exact measurements of these structures. His discovery of scientific perspective may well have grown out of his search for an accurate method of recording their appearance on paper.

Brunelleschi's architecture, as reflected in the interior of the Church of San Lorenzo (fig. 191), strikes us first of all as a conscious return to the vocabulary of the Greeks and Romans: round arches instead of pointed arches, columns instead of piers, barrel vaults and domes in preference to groin vaults. But Brunelleschi did not revive these

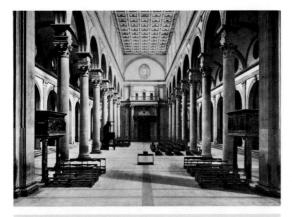

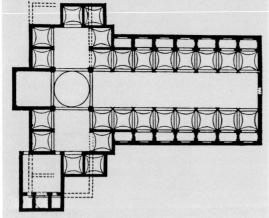

191. Filippo Brunelleschi. Interior and plan, San Lorenzo, Florence. 1421–69

forms out of mere antiquarian enthusiasm. What attracted him to them was what, from the medieval point of view, must have seemed their chief drawback: their inflexibility. A Classical column, unlike a medieval column or pier, is strictly defined and selfsufficient, and its shape can be varied only within narrow limits (the ancients, we recall, thought of it as comparable to the human body); the Classical round arch has only one possible shape, a semicircle; and the Classical architrave and all its details are subject to the strict rules of the orders of ancient architecture. Brunelleschi's aim was to rationalize architectural design, and for this he needed the standardized and regular vocabulary of the ancients, based on the circle and the square. The secret of their buildings, he thought, was harmonious proportion—the same ratios of simple whole numbers that determine musical harmony, for they recur throughout the universe and must thus be of divine origin. The theory of proportions provided him with the syntax, as it were, that ruled the use of his architectural vocabulary. Looking at the interior of San Lorenzo, we immediately sense its cool, controlled quality; unlike a Gothic church interior, which invites us to move forward and explore what seems an architectural miracle, San Lorenzo reveals itself to us completely as soon as we set foot inside it.

San Lorenzo, with its wooden ceiling over the nave, recalls the interior of Santa Croce (see fig. 139) translated into Early Renaissance terms. A similar process of rationalization reshaped another traditional building type, the palazzo. When the Medici, the most powerful family in Florence, had a new palace built for them in the 1440s (fig. 192), their architect, Michelozzo, produced a design recalling the fortress-like older structures (see

192. Michelozzo. Palazzo Medici-Riccardi, Florence. Begun 1444

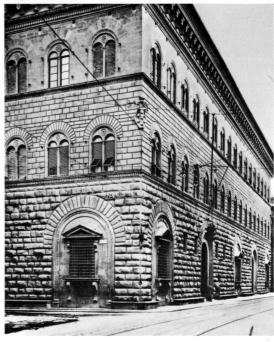

fig. 142; the windows on the ground floor of the Medici Palace were added a century later). But the three stories are in a graded sequence, each complete in itself: the lowest is built of rough-hewn, "rustic" masonry like the Palazzo Vecchio; the second of smooth-faced blocks with "rusticated" (that is, indented) joints; the surface of the third is unbroken. On top of the structure rests, like a heavy lid, a strongly projecting cornice inspired by those of Roman temples, emphasizing the finality of the three stories.

Alberti

Brunelleschi's death in 1446 brought to the fore Leone Battista Alberti, whose career as an architect had been long delayed. A highly educated humanist, Alberti was at first interested in the fine arts only as a theorist; he studied the monuments of ancient Rome, composed the earliest treatises on sculpture and painting, and began a third treatise, on architecture. He then started to practice art as a dilettante and developed into an architect of outstanding ability. In his last work, the Church of Sant' Andrea in Mantua (fig. 193), he accomplished a seemingly impossible feat: he superimposed a Classical temple front on the traditional basilican church façade (see figs. 120, 141). To harmonize this "marriage," he used pilasters instead of columns, thus stressing the continuity of the wall surface. They are of two sizes: the smaller ones sustain the arch over the huge center niche, while the larger ones form what is known as a "colossal" order, including all three stories of the façade. So intent was Alberti on harmonious proportions that he inscribed the entire design within a square.

Nevertheless, as a basilican church, Sant' Andrea does not conform to the ideal shape of sacred buildings defined in Alberti's treatise on architecture. He explains there that the plan of such structures should be either circular or of a shape derived from the circle

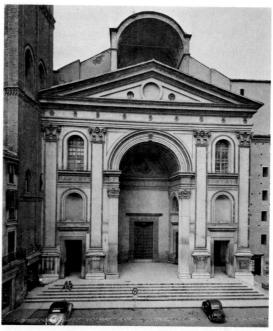

193. Leone Battista Alberti. Sant'Andrea, Mantua. Designed 1470

194. Giuliano da Sangallo. Santa Maria delle Carceri, Prato. 1485

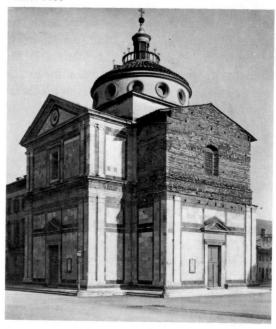

(square, hexagon, etc.), because the circle is the only perfect shape and therefore a direct image of divine reason. And he points to the Pantheon (see figs. 70, 71) as a precedent. That such a central-plan structure was ill adapted to Catholic ritual made no difference to Alberti; a church, he believed, must be a visible embodiment of "divine proportion," and the central plan alone permitted attainment of this aim. When he formulated these ideas, he could not yet cite any modern example. Toward the end of the century, however, after his treatise became widely known, the central-plan church gained general acceptance. An early and distinguished specimen is Santa Maria delle Carceri in Prato (fig. 194), near Florence, by Giuliano da Sangallo. It conforms closely to Alberti's ideal: except for the dome, the entire structure would fit neatly inside a cube, since its height (up to the drum of the dome) equals its length and width. By cutting into the corners of this cube, Giuliano has formed a Greek cross. The dimensions of the four arms stand in the simplest possible ratio to those of the cube: their length is one half their width, their width one half their height. They are barrel-vaulted, and the dome rests on these vaults. There can be no doubt that Giuliano wanted his dome to accord with the age-old tradition of the Dome of Heaven; the single round opening in the center and the twelve on the perimeter clearly refer to Christ and the Apostles.

PAINTING

Masaccio

Although Early Renaissance painting did not appear until the early 1420s, some years after Brunelleschi's first designs for San Lorenzo, its inception is the most extraordinary of all; this new style was launched, single-handed, by a young genius named Masaccio, who was only twenty-four years old at the time he painted *The Holy Trinity* fresco in Santa Maria Novella (fig. 195). The new style was by then well established in sculpture and architecture, making his task easier, but his achievement remains stupendous nevertheless. Here, as in the case of the *Merode An-*

nunciation (see fig. 165) we seem to plunge into a new environment, a realm of monumental grandeur rather than the concrete, everyday reality of Robert Campin. What the Trinity fresco brings to mind is not the immediate past (see fig. 164) but Giotto's art, with its sense of large scale, its compositional severity and sculptural volume. Yet the differences are as striking as the similarities: for Giotto, body and drapery form a single unit, as if both had the same substance, while Masaccio's figures, like Donatello's (see fig. 183), are "clothed nudes," their drapery falling like real fabric. The setting, equally up-todate, reveals a thorough command of both scientific perspective and Brunelleschi's new architecture. This barrel-vaulted chamber is no mere niche, but a deep space in which the figures could move freely if they wished. And—for the first time in history—we are given all the needed data to measure the depth of this painted interior, to draw its plan, and to duplicate the structure in three dimensions. It is, in a word, the earliest example of a rational picture space. For Masaccio, it must also have been a symbol of the universe ruled by divine reason.

In Masaccio's *Trinity*, as well as in Ghiberti's later relief panel, the new rational picture space is independent of the figures; they inhabit it but do not create it; take away the architecture and you take away the figures' space. We could go even further and say that scientific perspective depends not just on architecture, but on this particular *kind* of architecture, so different from Gothic.

Veneziano

Masaccio had died too young (at the age of only twenty-seven) to found a "school," and his style was too bold to be taken up immediately by his contemporaries. Their work, for the most part, combines his influence with lingering elements of the International Style. Then, in 1439, a gifted painter from Venice, Domenico Veneziano, came to Flor-

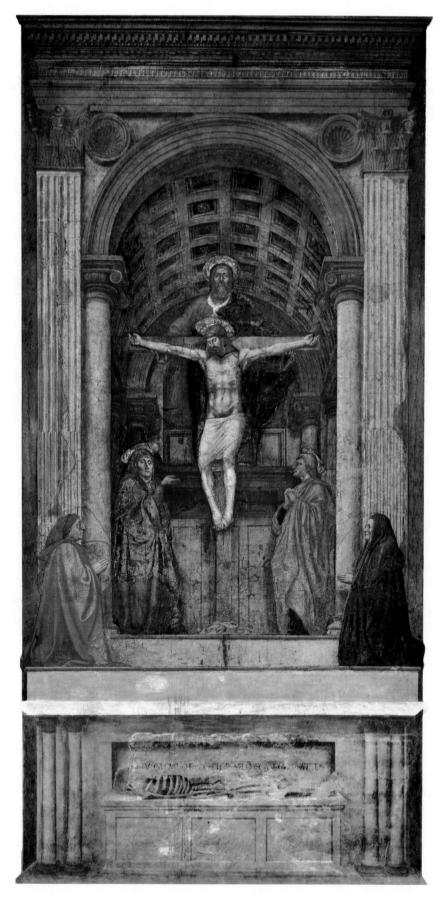

195. Masaccio. The Holy Trinity. 1425. Fresco. Santa Maria Novella, Florence

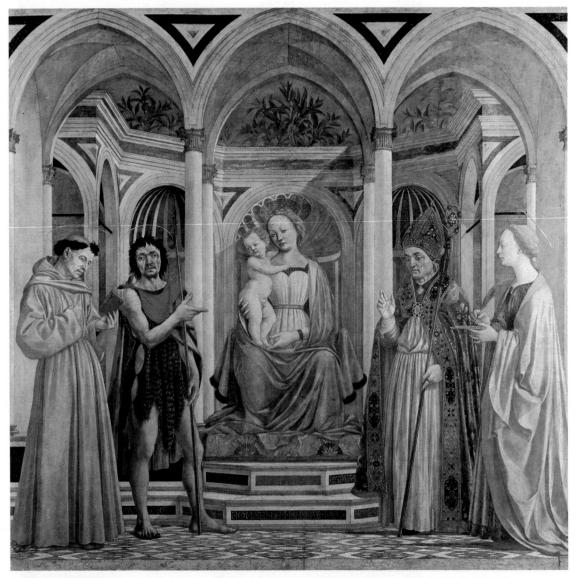

196. Domenico Veneziano. Madonna and Child with Saints. c. 1445. Tempera on panel, $6'7\frac{1}{2}" \times 6'11\frac{7}{8}"$. Uffizi Gallery, Florence

ence. We can only guess at his age (he was probably born about 1410), training, and previous work. He must, however, have been in sympathy with the spirit of Early Renaissance art, for he quickly became a thoroughgoing Florentine-by-choice, and a master of great importance in his new home. His *Madonna and Child with Saints* shown in figure 196 is one of the earliest examples of a new type of altar panel that was to prove tremendously popular from the mid-fifteenth centu-

ry on, the so-called *Sacra Conversazione* ("sacred conversation"). The scheme includes an enthroned Madonna, framed by architecture, and flanked by saints who may converse with her, with the beholder, or among themselves. Looking at Domenico Veneziano's panel, we can understand the wide appeal of the *Sacra Conversazione*. The architecture and the space it defines are supremely clear and tangible, yet elevated above the everyday world; and the figures, while echoing the

formal solemnity of their setting, are linked with each other and with us by a thoroughly human awareness. We are admitted to their presence, but they do not invite us to join them; like spectators in a theater, we are not allowed "on stage." (In Flemish painting, by contrast, the picture space seems a direct extension of the beholder's everyday environment; compare fig. 165). The basic elements of our panel were already present in Masaccio's Trinity fresco; Domenico Veneziano must have studied it carefully, for his St. John looks at us while pointing toward the Madonna, repeating the glance and gesture of Masaccio's Virgin. Domenico's perspective setting is worthy of the older master, although the slender proportions and colored inlays of his architecture are less severely Brunelleschian. His figures, too, are balanced and dignified like Masaccio's, but without the same weight and bulk. The slim, sinewy bodies of the male saints, with their highly individualized, expressive faces, show Donatello's influence (see fig. 183). In his use of color, however, Domenico owes nothing to Masaccio; unlike the great Florentine master, he treats color as an integral part of his work, and the Sacra Conversazione is quite as remarkable for its color scheme as for its composition. The blond tonality, its harmony of pink, light green, and white set off by strategically placed spots of red, blue, and yellow, reconciles the decorative brightness of Gothic panel painting with the demands of perspective space and natural light. Ordinarily, a Sacra Conversazione is an indoor scene, but this one takes place in a kind of loggia flooded with sunlight streaming in from the right (note the cast shadow behind the Madonna). The surfaces of the architecture reflect the light so strongly that even the shadowed areas glow with color. Masaccio had achieved a similar quality of light. In this Sacra Conversazione, the older master's discovery is applied to a far more complex set of forms. and integrated with Domenico's exquisite color sense. The influence of its distinctive

tonality can be felt throughout Florentine painting of the second half of the century.

Piero della Francesca; Castagno

When Domenico Veneziano settled in Florence, he had as an assistant a young man from southeastern Tuscany named Piero della Francesca, who became his most important disciple and one of the truly great artists of the Early Renaissance. Surprisingly enough, Piero left Florence after a few years, never to return.

Piero's most impressive work, a fresco cycle in the Church of San Francesco in Arezzo, dates from 1450 to 1460. Its many scenes tell the legend of the True Cross (the origin and history of the Cross used for Christ's Crucifixion). The section illustrated in figure 197 shows Helena, the mother of the emperor Constantine, discovering the True Cross and the two crosses of the thieves crucified on either side of Christ (all three crosses had been hidden by enemies of the Faith). At the left they are being lifted out of the ground, and at the right the True Cross is identified through its power to bring a dead youth back to life. Piero's figures have all the harsh grandeur of Masaccio's (see fig. 195). They seem to belong to a lost heroic race, beautiful and strong and silent. Their inner life is conveyed by glances and gestures, not by facial expressions. Above all, they have a gravity, both physical and emotional, that makes them kin to Classical Greek sculpture. How did Piero arrive at these memorable images? Using his own testimony, we may say that they were born of his passion for perspective. More than any artist of his day, he believed in scientific perspective as the basis of painting; in a treatise full of rigorous mathematics—the first of its kind—he demonstrated how perspective applied to stereometric bodies and architectural shapes, and to the human form. This mathematical outlook permeates all his work. He saw a head, an arm, or a piece of drapery as variations or compounds of

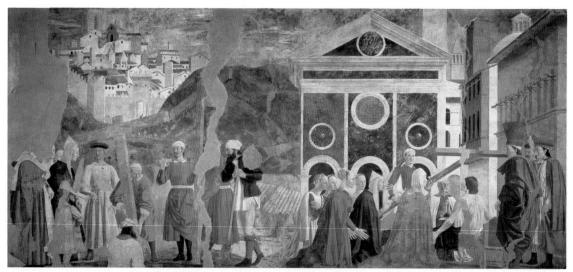

197. Piero della Francesca. The Discovery and Proving of the True Cross. c. 1460. Fresco. San Francesco, Arezzo

198. Andrea del Castagno. *David.* c. 1450–57. Paint on leather, height 45½". National Gallery of Art, Washington, D.C. (Widener Collection)

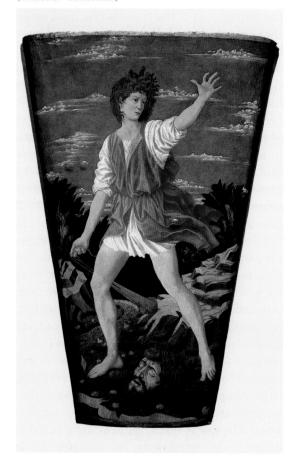

spheres, cylinders, cones, cubes, and pyramids, and he endowed the visible world with the impersonal clarity and permanence of mathematics. We may call him the earliest ancestor of the abstract artists of our own-time, for they, too, work with systematic simplifications of natural forms. It is not surprising that Piero's fame today is greater than ever before.

The Florentines must have regarded Piero's style as somewhat outmoded, for in the 1450s a new trend made its appearance in Florentine painting. We see it in the remarkable David by Andrea del Castagno (fig. 198), a work contemporary with Piero's Arezzo frescoes. Solid volume and statuesque immobility have given way to graceful movement, conveyed by both the pose and the windblown hair and drapery; the modeling has been minimized, so that the David seems to be in relief rather than in the round, with the forms now defined mainly by their undulating outlines.

Botticelli

This dynamic linear style was to dominate the second half of the century in Florentine art and strongly influenced the last great

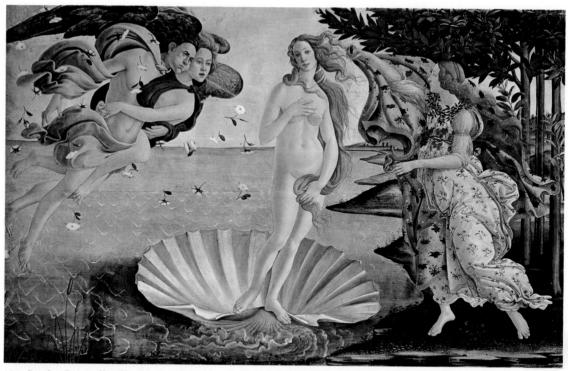

199. Sandro Botticelli. The Birth of Venus. c. 1480. Tempera on canvas, $5'8\%'' \times 9'1\%''$. Uffizi Gallery, Florence

Early Renaissance painter of Florence, Sandro Botticelli, whose best-known pictures were done for the so-called Medici circle. This consisted of the patricians, literati, and scholars surrounding Lorenzo the Magnificent, the head of the Medici family and, for all practical purposes, the ruler of the city. It was for one member of this group that Botticelli did his Birth of Venus (fig. 199). The shallow modeling and the emphasis on outline produce an effect of low relief rather than of solid, three-dimensional shapes; we note an unconcern with deep space—the grove on the right-hand side of the Venus functions as an ornamental screen. Botticelli evidently was not very interested in the rigors of anatomy. His bodies are attenuated, drained of all weight and muscular power; they appear to float even when they touch the ground. All this seems to deny the basic values of the founding fathers of Renaissance art. Still, the picture does not look medieval; the bodies. ethereal though they be, retain their voluptuousness, and they enjoy full freedom of

movement. To understand this paradox, we must consider the general use of Classical subjects in Early Renaissance art. During the Middle Ages, the forms used in Classical art had become divorced from Classical subject matter; pictures of the pagan gods were based on literary descriptions rather than Classical images. Only toward 1450 did Classical form begin to rejoin Classical content. Botticelli's Venus is the first monumental image, since Roman times, of the nude goddess derived from Classical statues of Venus. Moreover, the subject is clearly meant to be serious, even solemn. How could such images be justified in a Christian civilization? In the Middle Ages, Classical myths had at times been interpreted didactically as allegories of Christian ideas. Europa abducted by the bull, for instance, could be declared to signify the soul redeemed by Christ. But to fuse the Christian faith with ancient mythology required a more sophisticated argument than such forced interpretations. This was provided by the Neo-Platonic philosophers, who

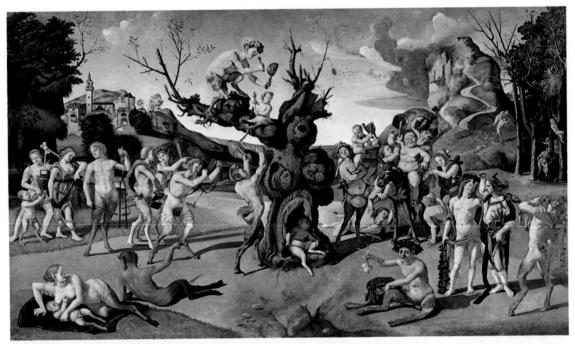

200. Piero di Cosimo. *The Discovery of Honey*. c. 1498. Oil on panel, $31\frac{1}{4} \times 50\frac{5}{8}$ ". Worcester Art Museum, Massachusetts

enjoyed tremendous prestige in the late fifteenth century and subsequently. They believed that the life of the universe, including that of man, was linked to God by a spiritual circuit continuously ascending and descending, so that all revelation—from the Bible, Plato, or Classical myths—was one. Similarly, they proclaimed that beauty, love, and beatitude, being phases of this circuit, were one. Thus the Neo-Platonists could invoke the "celestial Venus" (the nude Venus born of the sea) interchangeably with the Virgin Mary as the source of "divine love." This celestial Venus, it was said, dwells purely in the sphere of mind, while her twin, the ordinary Venus, engenders "human love." Botticelli's picture, then, has a quasi-religious meaning. As baptism is a "rebirth in God," so the birth of Venus evokes the hope for "rebirth" from which the Renaissance takes its name (see p. 168). Thanks to the fluidity of Neo-Platonic doctrine, the possible associations to be linked with our picture are almost limitless. All of them, however, "dwell in the sphere of mind," and Botticelli's Venus would hardly be a fit vessel for them if she were less ethereal.

Piero di Cosimo: Ghirlandaio

Figure 200, a panel by Botticelli's contemporary Piero di Cosimo, illustrates a view of pagan mythology diametrically opposed to that of the Neo-Platonists. Instead of "spiritualizing" the pagan gods, it brings them down to earth as beings of flesh and blood. In this alternate theory, man had slowly risen from a barbaric state through the discoveries and inventions of a few exceptionally gifted individuals; gratefully remembered by posterity, these men were finally accorded the status of gods. The Discovery of Honey refers to the central episode, a group of satyrs busying themselves about an old willow tree. They have discovered a swarm of bees, and are trying to collect the honey, from which they will produce mead. Behind them, to the right, some of their companions are about to discover the source of another fermented beverage;

they are climbing trees to collect wild grapes. Beyond is a barren rock, while on the left there are gentle hills and a town. This contrast does not imply that the satyrs are city dwellers; it merely juxtaposes civilization, the goal of the future, with untamed nature. Here the "culture hero" is Bacchus, who appears in the lower right-hand corner, a tipsy grin on his face, next to his lady-love, Ariadne. Despite their Classical appearance, Bacchus and his companions do not resemble the frenzied revelers of ancient mythology. They have an oddly domestic air, suggesting a fun-loving family clan on a picnic. The brilliant sunlight, the rich colors, and the farranging landscape make the scene a still more plausible extension of everyday reality. We can well believe that Piero di Cosimo, in contrast to Botticelli, admired the great

201. Domenico Ghirlandaio. An Old Man and His Grandson. c. 1480. Tempera on panel, $24\frac{1}{2} \times 18^{"}$. The Louvre, Paris

Flemish realists, and this landscape would be

inconceivable without the strong influence of

The Portinari Altarpiece (compare fig. 174).

Not only Piero was receptive to the realism of the Flemings; Domenico Ghirlandaio, another contemporary of Botticelli, shared this attitude. His panel of an old man with his grandson (fig. 201), while lacking the pictorial delicacy of Flemish portraits, nevertheless reflects their precise attention to surface texture and facial detail. But no Northern painter could have rendered as well as Ghirlandaio the tender human relationship between the little boy and his grandfather. Psychologically, our panel plainly bespeaks its Italian origin.

Mantegna

We must now turn to Early Renaissance art in northern Italy. It developed only toward 1450, since the Gothic tradition was strong in this area. We shall leave aside north Italian architecture and sculpture between 1450 and 1500, since the major works are by imported Florentines. We must, however, take a glance at painting in and around Venice, for during those years a great tradition was born there that was to flourish for the next three centuries.

Florentine masters had been carrying the new style to Venice and the neighboring city of Padua since the 1420s, but they evoked only rather timid local responses until, shortly before 1450, the young Andrea Mantegna emerged as an independent master. Next to Masaccio, Mantegna was the most important painter of the Early Renaissance; and he, too, was a precocious genius, fully capable at seventeen of carrying out commissions on his own, such as the frescoes in the Eremitani Church in Padua. They were almost entirely destroyed in 1944—perhaps the most serious artistic loss during World War II. The scene shown in figure 202, St. James Led to His Execution, is the most dramatic of the cycle because of its daring "worm's-eye" perspective. which is based on the beholder's actual evelevel (the horizon is below the bottom of the

202. Andrea Mantegna. St. James Led to His Execution. c. 1455. Fresco. Ovetari Chapel, Church of the Eremitani, Padua (destroyed 1944)

picture). The architectural setting looms large, as in Masaccio's *Trinity* (see fig. 195). Its main feature, a triumphal arch, although not a direct copy of any Roman monument, looks so authentic that it might as well be.

Mantegna's devotion to the visible remains of antiquity, his desire for almost archaeological authenticity, can also be seen in the costumes of the Roman soldiers. But these figures, lean and firmly constructed, are

203. Giovanni Bellini. St. Francis in Ecstasy. c. 1485. Oil on panel, $48\frac{1}{2} \times 55^{\prime\prime}$. The Frick Collection, New York (Copyright)

clearly of Florentine ancestry; Mantegna owed most to Donatello, who had spent ten years in Padua. The large crowd of bystanders generates a powerful emotional tension, which erupts in real physical violence on the far right; and the great spiral curl of the banner echoes the turbulence below.

Bellini

If Mantegna's style impresses us with its dramatic force, his brother-in-law in Venice, Giovanni Bellini, was a poet of light and color. Bellini was slow to mature; his finest pictures, such as St. Francis in Ecstasy (fig. 203),

date from the last decades of the century or later. The saint is here so small in comparison to the setting that he seems almost incidental, yet his mystic rapture before the beauty of the visible world sets our own response to the view that is spread out before us, ample and intimate at the same time. He has left his wooden pattens behind and stands barefoot on holy ground, like Moses in the Lord's presence (see p. 25). Bellini surely knew and admired the work of the great Flemish painters (Venice had strong trade links with the North), and he shared their tender regard for every detail of nature, and their use of oil rather than tempera. Unlike

the Northerners, however, he knew how to define the beholder's spatial relationship to the landscape; the rock formations in the foreground are clear and firm, like architecture rendered by the rules of scientific perspective.

Perugino

Rome, long neglected during the papal exile in Avignon, became once more, in the later fifteenth century, an important center of art patronage. The most ambitious pictorial project of those years was the decoration of the walls of the Sistine Chapel about 1482. Among the artists who carried out this large cycle of Old and New Testament scenes we encounter most of the important painters of central Italy, including not only Botticelli and Ghirlandaio, but also Pietro Perugino, who painted The Delivery of the Keys (fig. 204). Born near Perugia in Umbria (the region southeast of Tuscany), Perugino maintained close ties with Florence. His early development had been decisively influenced

by Verrocchio, as the statuesque balance and solidity of the figures in The Delivery of the Keys still suggest. The gravely symmetrical design conveys the special importance of the subject in this particular setting (the authority of St. Peter as the first pope—and that of all his successors—rests on his having received the keys to the Kingdom of Heaven from Christ Himself). A number of contemporaries, with powerfully individualized features, witness the solemn event. Equally striking is the vast expanse of the background, its two Roman triumphal arches (both modeled on the Arch of Constantine) flanking a domed structure in which we recognize the ideal church of Alberti's Treatise on Architecture. The spatial clarity, the mathematically exact perspective of this view, are the heritage of Piero della Francesca, who spent much of his later life working for Umbrian clients, notably the duke of Urbino. And also from Urbino, shortly before 1500. Perugino received a pupil whose fame soon obscured his own—Raphael, the most classic master of the High Renaissance.

204. Pietro Perugino. The Delivery of the Keys. 1482. Fresco. Sistine Chapel, The Vatican, Rome

The High Renaissance in Italy

It used to be taken for granted that the High Renaissance followed upon the Early Renaissance as naturally as noon follows morning. The great masters of the sixteenth century— Leonardo, Bramante, Michelangelo, Raphael, Titian—were thought to have shared the ideals of their predecessors, but to have expressed them so completely that their names became synonyms of perfection. They represented the climax, the classic phase, of Renaissance art, just as the architects and sculptors of Athens had brought Greek art to its highest point in the later fifth century B.C. This view also explained why these two classic phases were so brief: if art develops along the pattern of a ballistic curve, its highest point cannot be expected to last more than a moment, and must be followed by a decadent phase, "Hellenistic" in the one case, "Late Renaissance" in the other.

Today we have a less assured, but also a less arbitrary, estimate of what, for lack of a better term, we still call the High Renaissance. In some respects, it was indeed the culmination of the Early Renaissance, while in others it represented a departure. Certainly the tendency to view the artist as a sovereign genius was never stronger. Men of genius were thought to be set apart from ordinary mortals by the divine inspiration guiding their efforts, and were called "divine," "immortal," and "creative" (before 1500, creating, as distinct from making, had been the privilege of God alone). This cult of genius had a profound effect on the artists themselves: it spurred them on to vast and ambitious goals, often unattainable, and their faith in the divine origin of inspiration led them to rely on subjective standards of truth and beauty, rather than on the universally

valid rules acknowledged by the Early Renaissance (such as scientific perspective and the ratios of music harmony). That may be the reason why the great artists of the High Renaissance did not set the pace for a broadly based "period style" that could be practiced on every level of quality. The High Renaissance produced very few minor masters; it died with the men who created it, or even before. Of the great personalities mentioned above, only Michelangelo and Titian lived beyond 1520. In pointing out the limited and precarious nature of the High Renaissance, however, we do not mean to deny its tremendous impact upon later art. For most of the next three hundred years, the great personalities of the early sixteenth century loomed so large that their predecessors seemed to belong to a forgotten era. When they were finally rediscovered, people still acknowledged the High Renaissance as the turning point by referring to all painters before Raphael as "the Primitives."

Leonardo da Vinci

One of the strange and compelling aspects of the High Renaissance is the fact that its key monuments were all produced between 1495 and 1520, despite the differences in age of the men who created them (Bramante was born in 1444, Titian about 1490). Leonardo, though not the oldest of the group, is the earliest of the High Renaissance masters. Conditions in Florence did not favor him after he had completed his training under Verrocchio; at the age of thirty he went to work for the duke of Milan—as military engineer, architect, sculptor, and painter—leaving behind unfinished a large Adoration of the Magi. The

205. Leonardo da Vinci. Adoration of the Magi (detail). 1481–82. Underpainting on panel, size of area shown about 24×30 ". Uffizi Gallery, Florence

panel's remarkable—and indeed, revolutionary—feature is the way it is painted. Our detail (fig. 205) shows the area to the right of center, which is more nearly finished than the rest; the forms seem to materialize softly and gradually, never quite detaching themselves from a dusky realm. Leonardo, unlike Castagno or Botticelli, thinks not of outlines, but of three-dimensional bodies made visible in varying degrees by light. In the shadows, these shapes remain incomplete, their contours merely implied. In this method of modeling (called chiaroscuro, "light-and-dark") the forms no longer stand abruptly side by side. And there is a comparable emotional continuity as well: the gestures and faces of the crowd convey with touching eloquence the reality of the miracle—the newborn Christ—they have come to behold.

Toward the end of his stay in Milan, Leonardo tried to apply this method of painting to a fresco of the Last Supper (fig. 206). Unhappily, the mural began to deteriorate within a few years, since the artist had experimented with an oil-tempera medium that did not adhere well to the wall. Yet what remains is more than enough to explain why The Last Supper became famous as the first classic statement of the ideals of the High Renaissance. Viewing the composition as a whole, we see at once its balanced stability; only afterward do we discover that this balance has been achieved by the reconciliation of competing, even conflicting, claims. In Early Renaissance art, the architecture often threatens to overpower the figures (see figs. 186, 202). Leonardo, in contrast, began with the figure composition, and the architecture

206. Leonardo da Vinci. The Last Supper. c. 1495–98. Mural. Santa Maria delle Grazie, Milan

had merely a supporting role from the start, even though it obeys all the rules of scientific perspective. The central vanishing point is behind the head of Christ in the exact middle of the picture, thus becoming charged with symbolic significance. Equally plain is the symbolic function of the main opening in the rear wall; its pediment acts as the architectural equivalent of a halo. We thus tend to see the setting almost entirely in relation to the figures, rather than as a preexisting entity. We can test this by covering the upper third of the picture: the composition then looks like a frieze, the grouping of the Apostles is less clear, and the calm triangular shape of Christ becomes merely passive, instead of acting as a physical and spiritual focus. The Saviour, presumably, has just spoken the fateful words, "One of you shall betray me," and the Disciples are asking, "Lord, is it I?" But to view the scene as one particular moment in a psychological drama hardly does justice to Leonardo's intentions. The gesture of Christ is one of submission to the divine will, and of offering. It hints at Christ's main act at the Last Supper, the institution of the Eucharist ("Jesus took bread...and said, Take, eat; this is my body. And he took the cup...saying, Drink ye all of it; for this is my

blood..."). And the Apostles are not merely responding; each reveals his own personality, his own relationship to the Saviour. (Note the dark, defiant profile of Judas that sets him apart from the rest.) They exemplify what the artist wrote in one of his notebooks, that the highest aim of painting is to depict "the intention of man's soul" through gestures and the movements of limbs—a dictum that refers not to momentary emotional states but to man's inner life as a whole.

In 1499, the duchy of Milan fell to the French, and Leonardo returned to a Florence very different from the city he remembered. The Medici had been expelled, and Florence was briefly a republic again. There Leonardo painted his most famous portrait, the Mona Lisa (fig. 207). The chiaroscuro we noted in the Adoration is now so perfected that it seemed miraculous to his contemporaries. The forms are built from layers of glazes so gossamer-thin that the entire panel seems to glow with a gentle light from within. But the fame of the Mona Lisa comes not from this pictorial subtlety alone; even more intriguing is her psychological fascination. Why, among all the smiling faces ever painted, has this one been singled out as "mysterious"? Perhaps because, as a portrait, the picture

does not fit our expectations. The features are too individual for an ideal type, yet the element of idealization is so strong that it blurs the sitter's character. Once again the artist has brought two opposites into harmonious balance. The smile, too, may be read in two ways: as the echo of a mood, and as a timeless, symbolic expression. Clearly, the *Mona Lisa* embodies a quality of maternal tenderness which was to Leonardo the essence of womanhood. Even the landscape, composed mainly of rocks and water, suggests elemental generative forces.

In the later years of his life, Leonardo devoted himself more and more to his scientific interests. Art and science had first been united in Brunelleschi's discovery of perspective; Leonardo's work is the climax of this trend. The artist, he believed, must know all the

207. (opposite) Leonardo da Vinci. Mona Lisa. c. 1503–5. Oil on panel, 30×21 ". The Louvre, Paris

208. (below) Leonardo da Vinci. Embryo in the Womb. c. 1510. Ink. Royal Library, Windsor Castle (Crown Copyright Reserved)

laws of nature, and the eye was to him the perfect instrument for gaining such knowledge. The extraordinary scope of his own inquiries is attested by the hundreds of drawings and notes which he hoped to incorporate into an encyclopedic set of treatises. How original he was as a scientist is still a matter of debate, but in one field his importance is undisputed: he created the modern scientific illustration, an essential tool for anatomists and biologists. A drawing such as the *Embryo in the Womb* (fig. 208) combines vivid observation with the clarity of a diagram, or—to paraphrase Leonardo's own words—sight and insight.

Michelangelo

The concept of genius as divine inspiration, a superhuman power granted to a few rare individuals and acting through them, is nowhere exemplified more fully than in Michelangelo. Not only his admirers viewed him in this light; he himself, steeped in Neo-Platonism, accepted the idea of his genius as a living reality, although it seemed to him at times a curse rather than a blessing. Conventions, standards, and traditions might be observed by lesser spirits; he could acknowledge no authority higher than the dictates of his genius. Unlike Leonardo, for whom painting was the noblest of the arts because it embraced every visible aspect of the world, Michelangelo was a sculptor—more specifically, a carver of marble statues—to the core. Art, for him, was not a science but "the making of men," analogous to divine creation. Only the "liberation" of real, three-dimensional bodies from recalcitrant matter could satisfy the urge within him. Painting, he believed, should imitate the roundness of sculptured forms, and architecture, too, must partake of the organic qualities of the human figure. Michelangelo's faith in the image of man as the supreme vehicle of expression gave him a sense of kinship with Classical sculpture closer than that of any other Re-

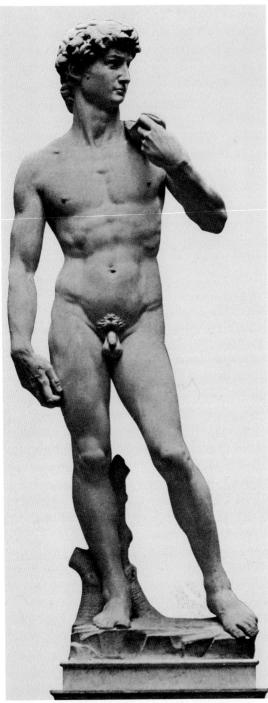

209. Michelangelo. *David*. 1501–4. Marble, height of figure 13'5". Academy, Florence

naissance artist, although he admired Giotto, Masaccio, and Donatello. Yet, as a Neo-Platonist, he looked upon the body as the earthly prison of the soul—noble, surely, but a prison nevertheless. This dualism endows his figures with their extraordinary pathos; outwardly calm, they seem stirred by an overwhelming psychic energy that can find no true release in physical action.

The unique qualities of Michelangelo's art are fully present in the David (fig. 209), the earliest monumental statue of the High Renaissance, commissioned in 1501, when the artist was twenty-six. The huge figure was put at the left of the entrance to the Palazzo Vecchio as the civic-patriotic symbol of the Florentine Republic (see fig. 142; a modern copy has now replaced the original). This role was a suitable one for the David. Without the head of Goliath, he looks challenging—not a victorious hero but the champion of a just cause. Nude, like Donatello's bronze David (see fig. 184), he boldly faces the world, vibrant with pent-up energy. But the style of the figure proclaims an ideal very different from Donatello's. Michelangelo had just spent several years in Rome, and had been strongly impressed with the emotion-filled, muscular bodies of Hellenistic sculpture. Their heroic scale, their superhuman beauty and power, and the swelling volume of their forms became part of Michelangelo's style, and through him part of Renaissance art in general. Still, the *David* could never be taken for an ancient statue. In the *Laocoön* (see fig. 64) and similar works, the body "acts out" the spirit's agony, while the David, characteristically, is both calm and tense.

The Sistine Chapel

Soon after, Michelangelo was called to Rome by Pope Julius II, the greatest and most ambitious of Renaissance popes, for whom he designed an enormous tomb. After a few years, however, the pope changed his mind and set the reluctant artist to work on the ceiling fresco of the Sistine Chapel (fig. 210). Driven by his desire to resume the tomb project, Michelangelo finished the entire ceiling in four

210. Interior, Sistine Chapel (showing Michelangelo's ceiling fresco and Last Judgment), The Vatican, Rome

years (1508–12). He produced a masterpiece of truly epochal importance. The ceiling is a huge organism with hundreds of figures rhythmically distributed within the painted architectural framework, dwarfing the earlier murals below by its size, and still more by

its compelling inner unity. In the central area, subdivided by five pairs of girder arches, are nine scenes from Genesis, from the Creation of the World (at the far end of the Chapel) to the Drunkenness of Noah. The theological scheme behind the choice of these

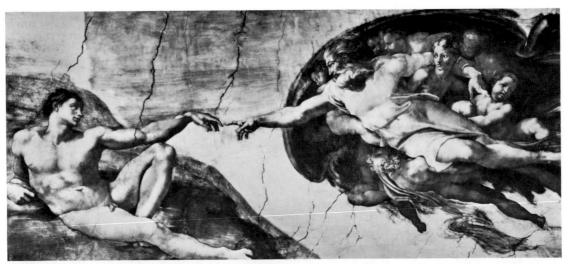

211. Michelangelo. *The Creation of Adam*, portion of the Sistine Chapel ceiling. 1508–12. Fresco. The Vatican, Rome

212. Michelangelo. *The Last Judgment* (detail, with self-portrait). 1534–41. Fresco. Sistine Chapel, The Vatican, Rome

scenes and the rich program surrounding them—the nude youths, the medallions, the Prophets and sibyls, the scenes in the spandrels—has not been fully explained, but we know that it links the early history of man and the coming of Christ, the beginning of time and its end (*The Last Judgment* on the wall above the altar). How much responsibility did Michelangelo have for the program?

He was not a man to submit to dictation, and the subject matter as a whole fits his cast of mind so perfectly that his own desires cannot have conflicted strongly with those of his patron. What greater theme could he wish than the Creation, Man's Fall, and Man's ultimate reconciliation with the Lord? Michelangelo has been called a poor colorist—unjustly, as the recently undertaken cleaning of the frescoes has revealed. The range of his palette is astonishing. Contrary to what had been thought, the heroic figures have anything but the quality of painted sculpture. Full of life, they act out their epic roles in illusionistic "windows" that puncture the architectural setting.

A detailed survey of the ceiling would fill a book; we shall have to be content with *The Creation of Adam* (fig. 211), the most famous of the major scenes. It shows not the physical molding of Adam's body but the passage of the divine spark—the soul—and thus achieves a dramatic juxtaposition of Man and God unrivaled by any other artist. The relationship between the earth-bound Adam and the figure of God rushing through the sky becomes even more meaningful when we realize that Adam strains not only toward his Creator but toward Eve, whom he sees, yet unborn, in the shelter of the Lord's left arm.

When Michelangelo returned to the Sistine Chapel over twenty years later, the Western world was gripped by the spiritual and political crisis of the Reformation (see p. 244). We observe with shocking directness how the mood has changed as we turn from the radiant vitality of the ceiling fresco to the somber vision of The Last Judgment. Mankind, Blessed and Damned alike, huddles together in tight clumps, pleading for mercy before a wrathful God (figs. 210, 212). Seated on a cloud below the Lord is the Apostle Bartholomew, holding a human skin to represent his martyrdom (he had been flayed). The face on that skin is not the saint's, however; it is Michelangelo's own. In this grimly sardonic self-portrait the artist has left his personal confession of guilt and unworthiness.

The Medici Chapel

The interval between the Sistine Ceiling and The Last Judgment coincided with the papacies of Leo X and Clement VII; both were members of the Medici family and preferred to employ Michelangelo in Florence. His activities centered on San Lorenzo, the Medici church, where Leo X had decided to build a chapel containing four monumental tombs for members of the family. Michelangelo worked on the project for fourteen years, completing the chapel and two tombs. It is the artist's only work where his statues remain in the setting planned specifically for them (fig. 213 shows the tomb of Giuliano). The design of the monument is strangely impersonal: there is no inscription, two allegorical figures (Day on the right, Night on the left) recline on the sarcophagus, and the statue of Giuliano, in Classical military garb, bears no resemblance to the deceased. ("A thousand years from now, nobody will want to know what he really looked like" Michelangelo is said to have remarked.) What is the meaning of the monument? The question, put countless times, has never found a definitive answer. Michelangelo's plans for the Medici

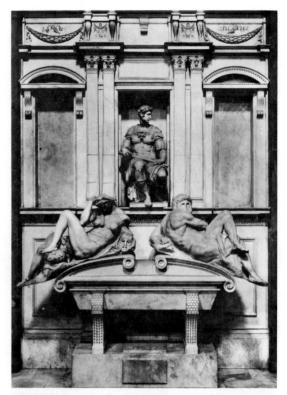

213. Michelangelo. Tomb of Giuliano de' Medici. 1524-34. Marble, height of central figure 71". New Sacristy, San Lorenzo, Florence

tombs underwent so many changes while the work was under way that the present state of the monuments can hardly be the final solution; rather, the dynamic process of design was arbitrarily halted by the artist's departure for Rome in 1534. Day and Night were certainly planned for horizontal surfaces, not for the curved lid of the present sarcophagus. Perhaps they were not even intended for this particular tomb. Giuliano's niche is too narrow and shallow to hold him comfortably. Other figures and reliefs were planned, but never executed. Yet the tomb of Giuliano remains a compelling visual unit. The great triangle of the statues is held in place by a network of verticals and horizontals whose slender, sharp-edged forms heighten the roundness and weight of the sculpture. In the brooding menace of Day and the disturbed slumber of Night, the dualis of body and soul is expressed with unforget ble grandeur.

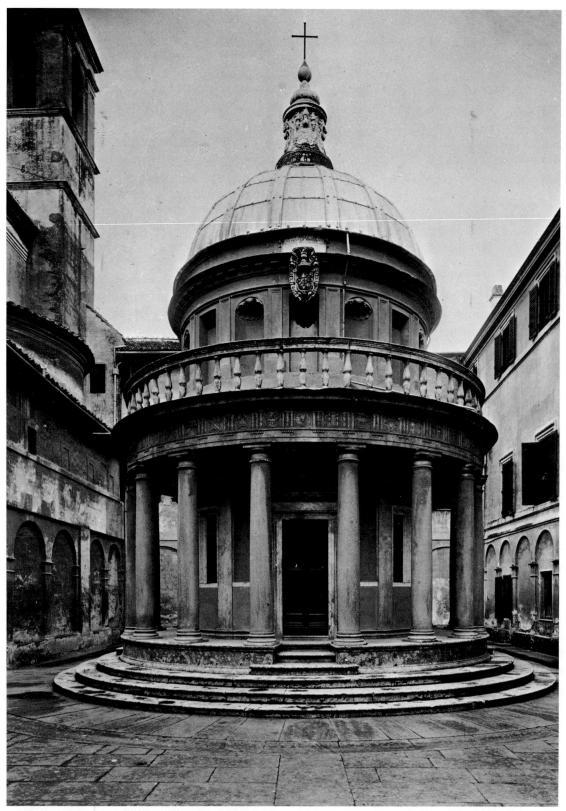

 $\textbf{214.}\ Donato\ Bramante.\ The\ Tempietto,\ San\ Pietro\ in\ Montorio,\ Rome.\ 1502\ (see\ colorplate\ on\ title\ page)$

Bramante

During the last thirty years of his long career, architecture became Michelangelo's main preoccupation. In order to understand his achievement in that field, we must discuss briefly his most important predecessor, Donato Bramante. Bramante had been working for the duke of Milan in the 1490s, together with Leonardo. After Milan fell, he went to Rome, and there he became the creator of High Renaissance architecture. The new style is fully evident in his Tempietto at San Pietro in Montorio (fig. 214), designed soon after 1500. Its nickname, "little temple," seems well deserved: in the three-step platform, and the severe Doric order of the colonnade, Classical temple architecture is more directly recalled than in any fifteenth-century structure. Equally striking is the "sculptural" treatment of the walls: deeply recessed niches "excavated" from heavy masses of masonry. These cavities are counterbalanced by the convex shape of the dome and by strongly projecting moldings and cornices. As a result, the Tempietto has a monumental weight that belies its modest size.

The Tempietto is the earliest of the great achievements that made Rome the center of Italian art during the first quarter of the sixteenth century. Most of them belong to the decade 1503-13, the papacy of Julius II. It was he who decided to replace the early Christian basilica of St. Peter's with a church so magnificent as to overshadow all the monuments of ancient imperial Rome. The task naturally fell to Bramante. His design, of 1506, is known to us mainly from a plan (fig. 215), which bears out the words Bramante reportedly used to define his aim: "I shall place the Pantheon on top of the Basilica of Constantine" (see figs. 70-72). Bramante's design is indeed of truly imperial magnificence: a huge dome crowns the crossing of the barrel-vaulted arms of a Greek cross, with four lesser domes and tall corner towers filling the angles. This plan fulfills all

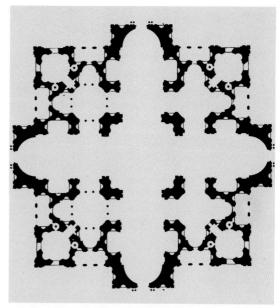

215. Donato Bramante. Original plan for St. Peter's, Rome (after Geymüller). 1506

216. Caradosso. Medal showing Bramante's design for St. Peter's. 1506. British Museum, London

the demands laid down by Alberti for sacred architecture (see p. 195); based entirely on the circle and the square, it is so rigidly symmetrical that we cannot tell which apse was to hold the high altar. Bramante envisioned four identical façades like that on the medal

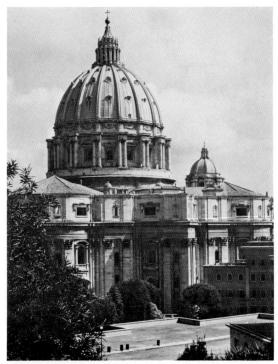

217. Michelangelo. St. Peter's (view from the west), Rome. 1546–64 (dome completed by Giacomo della Porta, 1590)

of 1506 (fig. 216), dominated by the same repertory of severely Classical forms we saw in the Tempietto: domes, half-domes, colonnades, pediments. These simple geometric shapes, however, do not prevail inside the church. Here the "sculptured wall" reigns supreme: the plan shows no continuous surfaces, only great, oddly shaped "islands" of masonry that have been well described by one critic as giant pieces of toast half-eaten by a voracious space. Their actual size can be visualized only if we compare the measurements of Bramante's church with those of earlier buildings. San Lorenzo in Florence, for instance, is 268 feet long, less than half the length of the new St. Peter's (550 feet). Each arm of Bramante's Greek cross has about the dimensions of the Basilica of Constantine. No wonder the construction of St. Peter's progressed at a snail's pace. At Bramante's death, in 1514, only the four crossing piers had actually been built.

For the next three decades the campaign was carried out hesitantly by architects trained under Bramante. A new and decisive phase began only in 1546, when Michelangelo took charge; the present appearance of the church (fig. 217) is largely shaped by his ideas. Michelangelo simplified Bramante's overly complex plan without changing its basic character; he also redesigned the exterior, using a colossal order to emphasize the compact body of the structure, thus setting off the dome more dramatically. Although largely built after his death, the dome reflects Michelangelo's ideas in every important respect. Bramante had planned a stepped hemisphere, somewhat like the dome of the Pantheon, which would have seemed to press down on the church below; Michelangelo's dome conveys the opposite sensation, a powerful thrust that draws energy upward from the main body of the structure. The high drum, the strongly projecting buttresses accented by double columns, the ribs, the raised curve of the cupola, the tall lantern-all contribute verticality at the expense of the horizontals. We may recall Brunelleschi's Florence Cathedral dome (see fig. 140), from which Michelangelo clearly borrowed a great deal. Yet the effect is immensely different: the Florence dome gives no hint of the internal stresses, while Michelangelo finds a sculptured shape for these contending forces and relates them to those in the rest of the building (the impulse of the paired colossal pilasters below is taken up by the double columns of the drum, continues in the ribs, and culminates in the lantern). The logic of this design is so persuasive that few domes built between 1600 and 1900 fail to acknowledge it.

Raphael

If Michelangelo exemplifies the solitary genius, Raphael belongs to the opposite type: the artist as a man of the world. Although each had his partisans, both enjoyed equal

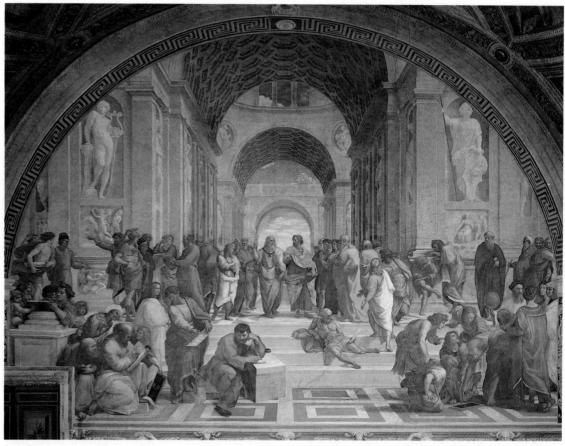

218. Raphael. The School of Athens. 1510-11. Fresco. Stanza della Segnatura, Vatican Palace, Rome

fame. Today our sympathies are less evenly divided—

In the room the women come and go Talking of Michelangelo

(T. S. ELIOT)

So do many of us, including the authors of historical novels and fictionalized biographies, whereas Raphael is usually discussed only by historians of art. His career is too much of a success story, his work too replete with seemingly effortless grace, to match the tragic heroism of Michelangelo. As an innovator, Raphael contributed less than either Leonardo or Michelangelo, yet he is the central painter of the High Renaissance; our conception of the entire style rests on his work more than on any other master's. His genius was a unique power of synthesis that enabled

him to merge the qualities of Leonardo and Michelangelo, creating an art at once lyric and dramatic, pictorially rich and sculpturally solid. At the time Michelangelo began to paint the Sistine Ceiling, Julius II summoned Raphael from Florence to decorate a series of rooms in the Vatican Palace. In the first, the Stanza della Segnatura, Raphael's frescoes refer to the four domains of learning—theology, philosophy, law, and the arts. Of these frescoes, The School of Athens (fig. 218) has long been acknowledged as the perfect embodiment of the Classical spirit of the High Renaissance. Its subject is "the Athenian school of thought"; a group of famous Greek philosophers is gathered around Plato and Aristotle, each in a characteristic pose or activity. Raphael must have already seen the Sistine Ceiling, then nearing completion, for

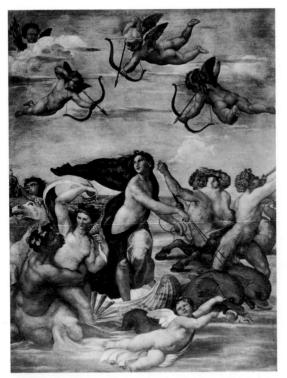

219. Raphael. *Galatea*. 1513. Fresco. Villa Farnesina, Rome

he evidently owes to Michelangelo the expressive energy, the physical power, and the dramatic grouping of his figures. Yet Raphael has not simply borrowed the older master's repertory of gestures and poses; he has absorbed it into his own style, and thereby given it different meaning. Body and spirit, action and feeling, are now balanced harmoniously, and every member of this great assembly plays his role with magnificent, purposeful clarity. The School of Athens suggests the spirit of Leonardo's Last Supper (see fig. 206) rather than that of the Sistine Ceiling (see fig. 210). This holds true of the way each philosopher reveals "the intention of his soul," of the formal rhythm linking individuals and groups, of the centralized, symmetrical design, and of the interdependence of the figures and their architectural setting. But compared with the hall of The Last Supper, Raphael's Classical edifice shares far more of the compositional burden. Inspired

by Bramante, it seems like an advance view of the new St. Peter's (see fig. 215). Its geometric precision and spatial grandeur bring to a climax the tradition begun by Masaccio (see fig. 195), continued by Domenico Veneziano and Piero della Francesca, and transmitted to Raphael by his teacher Perugino.

Raphael never again set so splendid an architectural stage. To create pictorial space, he relied increasingly on the movement of human figures, rather than on perspective vistas. In his Galatea (fig. 219), the subject is again Classical—the nymph Galatea, vainly pursued by Polyphemus, belongs to Greek mythology—but here the gay and sensuous aspect of antiquity is celebrated, in contrast to the austere idealism of *The School of Ath*ens. Its composition recalls The Birth of Venus (see fig. 199), which Raphael knew from his Florence days, yet their very resemblance emphasizes their profound dissimilarity. Raphael's full-bodied, dynamic figures take on their expansive spiral movement from the vigorously twisting pose of Galatea; in Botticelli's picture, the movement is not generated by the figures but imposed upon them from without, so that it never detaches itself from the surface of the canvas.

Giorgione: Titian

The distinction between Early and High Renaissance art, so marked in Florence and Rome, is far less sharp in Venice. Giorgione (1478–1510), the first Venetian painter to belong to the new, sixteenth century, left the orbit of Giovanni Bellini only during the final years of his short career. Among his very few mature works, *The Tempest* (fig. 220) is both the most individual and the most enigmatic. Our first glance may show us little more than a particularly charming reflection of Bellinesque qualities, familiar from the *St. Francis in Ecstasy* (see fig. 203). The difference is one of mood—and this mood, in *The*

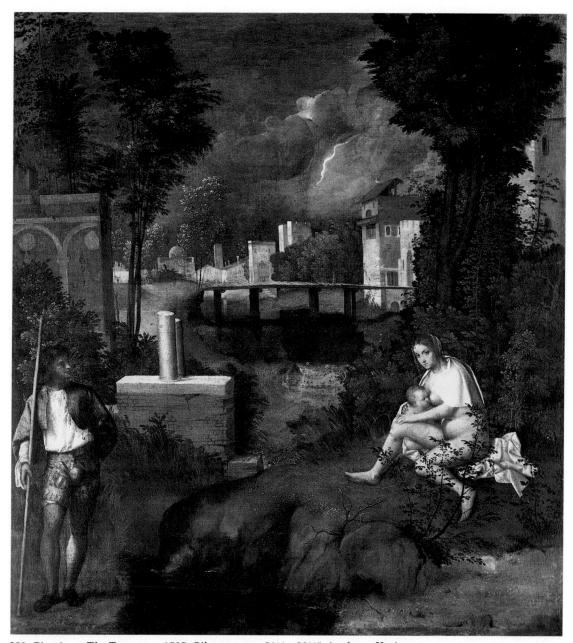

220. Giorgione. The Tempest. c. 1505. Oil on canvas, $31\frac{1}{4} \times 28\frac{3}{4}$ ". Academy, Venice

Tempest, is subtly, pervasively pagan. Bellini's landscape is meant to be seen through the eyes of St. Francis, as a piece of God's creation. Giorgione's figures, by contrast, do not interpret the scene for us; belonging themselves to nature, they are passive witnesses—victims, almost—of the thunderstorm about to engulf them. Who are they? So

far, the young soldier and the nude mother with her babe have refused to disclose their identity, and the subject of the picture remains unknown. The present title is a confession of embarrassment, yet it is not inappropriate, for the only "action" is that of the tempest. Whatever its intended meaning, the scene is like an enchanted idyll, a dream

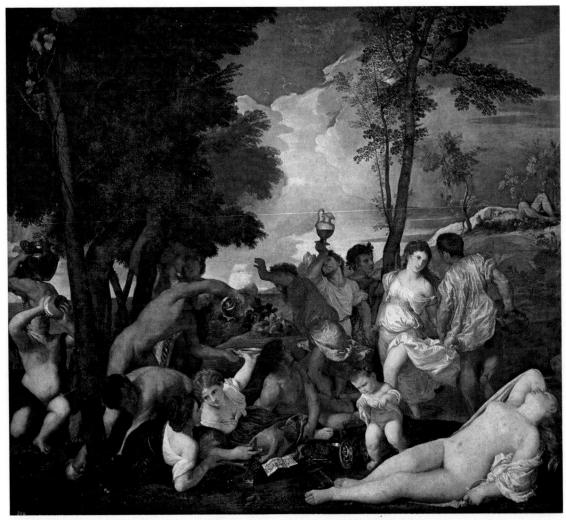

221. Titian. Bacchanal. c. 1518. Oil on canvas, 5'87's" × 6'4". The Prado, Madrid

of pastoral beauty soon to be swept away. Only poets had hitherto captured this air of nostalgic reverie; now, it entered the repertory of the painter. *The Tempest* initiates what was to become an important new tradition.

Giorgione died before he could explore in full the sensuous, lyrical world he had created in *The Tempest*. He bequeathed this task to Titian, an artist of comparable gifts who was decisively influenced by Giorgione, and who dominated Venetian painting for the next half-century. Titian's *Bacchanal* of about 1518 (fig. 221) is frankly pagan, inspired by an ancient author's description of

such a revel. The landscape, rich in contrasts of cool and warm tones, has all the poetry of Giorgione, but the figures are of another breed: active and muscular, they move with a joyous freedom that recalls Raphael's *Galatea*. By this time, many of Raphael's compositions had been engraved, and from these reproductions Titian became familiar with the Roman High Renaissance. A number of the celebrants in his *Bacchanal* also reflect the influence of Classical art. Titian's approach to antiquity, however, is very different from Raphael's; he visualizes the realm of Classical myths as part of the natural world,

inhabited not by animated statues but by beings of flesh and blood. The figures of the Bacchanal are idealized beyond everyday reality just enough to persuade us that they belong to a long-lost Golden Age. They invite us to share their blissful state in a way that makes Raphael's Galatea seem cold and remote by comparison.

Aside from all his other achievements, Titian also was the greatest portraitist of the century. His Man with the Glove (fig. 222), unlike the Mona Lisa (see fig. 207), offers no disquieting mysteries but a profound sense of the sitter's individuality. Casually posed and lost in thought, the young man seems quite unaware of us. The dreamy intimacy of this portrait, the hint of melancholy in its mood, the soft outlines and deep shadows, give it a haunting poetic appeal reminiscent of Giorgione's Tempest. In Titian's hands, the possibilities of oil technique—rich, creamy highlights, dark tones that are yet transparent and delicately modulated—are now fully realized; the separate brushstrokes, hardly visible before, become increasingly free, so

223. Titian. Christ Crowned with Thorns. c. 1570. Oil on canvas, 9'2"×6'. Alte Pinakothek, Munich

222. Titian. Man with the Glove. c. 1520. Oil on canvas, $39\frac{1}{2} \times 35$ ". The Louvre, Paris

that the personal rhythms of the artist's "handwriting" are an essential element of the finished work. In this respect, Titian seems infinitely more "modern" than Leonardo, Michelangelo, or Raphael.

The new broad manner of the Man with the Glove is pushed to its limits in the Christ Crowned with Thorns (fig. 223), a masterpiece of Titian's old age. The shapes emerging from the semidarkness now consist wholly of light and color; despite the heavy impasto, the shimmering surfaces have lost every trace of material solidity and seem translucent, aglow from within. In consequence, the violent physical action has been miraculously suspended. What lingers in our minds is not the drama but the strange mood of serenity—engendered by deep religious feeling.

Mannerism and Other Trends

What happened after the High Renaissance? About fifty years ago the answer would have been: the Late Renaissance, which was dominated by shallow imitators of the great masters of the previous generation and lasted until the Baroque style emerged at the end of the century. Today we take a far more positive view of the artists who reached maturity after 1520, but we have yet to agree on a name for the seventy-five years separating the High Renaissance from the Baroque. Any one label implies that the period had one style, and nobody has succeeded in defining such a style. But if there was no single style, why should the span 1525-1600 be regarded as a period at all? Perhaps the difficulty can be resolved by thinking of it as a time of crisis that gave rise to several competing tendencies rather than one dominant ideal-or as a time full of inner contradictions, not unlike the present and thus peculiarly fascinating to us.

PAINTING

Among these trends, that of Mannerism is the most discussed today. The scope and significance of the term remain problematic: its original meaning was narrow and derogatory, designating a group of painters in Rome and Florence whose self-consciously "artificial" style was derived from certain aspects of Raphael and Michelangelo. More recently, the cold formalism of their work has been recognized as part of a wider movement that placed "inner vision," however subjective and fantastic, above the twin authority of nature and the ancients. Its first signs appear shortly before 1520 in the work of some young painters in Florence. By 1521, Rosso

Fiorentino, the most eccentric member of this group, expressed the new attitude with full conviction in *The Descent from the Cross* (fig. 226). Nothing has prepared us for the shocking impact of this latticework of spidery forms spread out against the dark sky. The figures are agitated yet rigid, as if congealed by a sudden, icy blast; even the draperies have brittle, sharp-edged planes; the acid colors and the brilliant but unreal light reinforce the nightmarish effect of the scene. Here is what amounts to a revolt against the Classical balance of High Renaissance art—a profoundly disquieting, willful, visionary style that indicates a deep-seated anxiety.

Pontormo; Parmigianino

Pontormo, a friend of Rosso, had an equally strange personality. Introspective and shy, he shut himself up in his quarters for weeks on end, inaccessible even to his friends. His wonderfully sensitive drawings, such as the *Study of a Young Girl* (fig. 224), well reflect these facets of his character; the sitter, moodily gazing into space, seems to shrink from the outer world, as if scarred by the trauma of some half-remembered experience.

This "anti-Classical" style of Rosso and Pontormo, the first phase of Mannerism, was soon replaced by another aspect of the movement. This was less overtly anti-Classical, less laden with subjective emotion, but equally far removed from the confident, stable world of the High Renaissance. Parmigianino's *Self-Portrait* (fig. 225) suggests no psychological turmoil; the artist's appearance is bland and well groomed, veiled by a delicate Leonardesque haze. The distortions, too, are objective, not arbitrary, for the pic-

224. Pontormo. *Study of a Young Girl.* c. 1526. Red chalk drawing. Uffizi Gallery, Florence

ture records what Parmigianino saw as he gazed at his reflection in a convex mirror. Yet why was he so fascinated by this view "through the looking glass"? Earlier painters, such as Jan van Eyck, who used the same device as an aid to observation had "filtered out" the distortions (as in fig. 170), except when the mirror image was contrasted with a direct view of the same scene (see figs. 171, 172). But Parmigianino substitutes his painting for the mirror itself, even employing a specially prepared convex panel. Did he perhaps want to demonstrate that there is no single, "correct" reality, that distortion is as natural as the normal appearance of things? Characteristically, his scientific detachment soon changed into its very opposite. Vasari tells us that Parmigianino, toward the end of

225. Parmigianino. *Self-Portrait*. 1524. Oil on panel, diameter 95%". Kunsthistorisches Museum, Vienna

his brief career (he died in 1540 at thirty-seven), was obsessed with alchemy and became "a bearded, long-haired, neglected, and almost savage or wild man." Certainly his strange imagination is evident in his most famous work, The Madonna with the Long Neck (fig. 227), painted after he had returned to his native Parma from several years' sojourn in Rome. He had been deeply impressed with the rhythmic grace of Raphael's art (compare fig. 218), but he has transformed the older master's figures into a remarkable new breed: their limbs, elongated and ivorysmooth, move with effortless languor, embodying an ideal of beauty as remote from nature as any Byzantine figure. Their setting is equally arbitrary, with a gigantic—and apparently purposeless—row of columns looming behind the tiny figure of a Prophet; Parmigianino seems determined to prevent us from measuring anything in this picture by the standards of ordinary experience. Here we have approached that "artificial" style for which the term Mannerism was originally coined. The Madonna with the Long *Neck* is a vision of unearthly perfection, its

 $\textbf{226.} \ \text{Rosso Fiorentino}. \ \textit{The Descent from the Cross.} \ \textbf{1521.} \ \text{Oil on panel}, \ \textbf{11'} \times \textbf{6'5''}. \ \textbf{Pinacoteca, Volterra, Italy} \\ \textbf{11'} \times \textbf{11$

 $\textbf{227.} \ \text{Parmigianino.} \ \textit{The Madonna with the Long Neck.} \ \text{c. 1535.} \ \text{Oil on panel}, \ 7'1" \times 4'4". \ \text{Uffizi Gallery, Florence}$

228. Agnolo Bronzino. Eleanora of Toledo and Her Son Giovanni de' Medici. c. 1550. Oil on canvas, 45¼ × 37¾". Uffizi Gallery, Florence

cold elegance no less compelling than the violence in Rosso's *Descent*.

Keyed to a sophisticated, even rarefied taste, the "elegant" phase of Italian Mannerism appealed particularly to such aristocratic patrons as the grand duke of Tuscany and King Francis I of France, and soon became international (see fig. 247). The style produced splendid portraits, like that of Eleanora of Toledo, the wife of Cosimo I de' Medici, by Cosimo's court painter Agnolo Bronzino (fig. 228). The sitter here appears as the member of an exalted social caste, not as an individual personality; congealed into immobility behind the barrier of her lavishly ornate costume, Eleanora seems more akin to Parmigianino's Madonna—compare the hands—than to ordinary flesh and blood.

Tintoretto

In Venice, Mannerism appeared only toward the middle of the century. Its leading exponent, Tintoretto, was an artist of prodigious energy and inventiveness, combining elements of both "anti-Classical" and "elegant" Mannerism in his work. He reportedly wanted "to paint like Titian and to design like Michelangelo," but his relationship to these two masters, though real enough, was as peculiar as Parmigianino's was to Raphael. Tintoretto's last major work, The Last Supper (fig. 229), is also his most spectacular; it denies in every possible way the Classical values of Leonardo's version of the subject (see fig. 206), painted a century before. Christ, to be sure, still occupies the center of the composition, but now the table is placed at right angles to the picture plane, so that His small figure in the middle distance is distinguishable only by the brilliant halo. Tintoretto has given the scene an everyday setting, cluttering it with attendants, containers of food and drink, and domestic animals. But this serves only to dramatically contrast the natural with the supernatural, for there are also celestial attendants—the smoke from the blazing oil lamp miraculously turns into clouds of angels that converge upon Christ just as He offers His body and blood, in the form of bread and wine, to His Disciples. Tintoretto's main concern has been to make visible the institution of the Eucharist, the transubstantiation of earthly into divine food; he barely hints at the human drama of Judas' betraval (Judas is the tiny figure to the rear on the near side of the table).

El Greco

The last—and perhaps greatest—Mannerist painter was also trained in Venice. Domenicos Theotocopoulos, nicknamed El Greco, came from Crete. His earliest training must have been under a local master still working in the Byzantine tradition, but in Venice he quickly absorbed the lessons of Titian, Tintoretto, and other Venetian painters. Later, in Rome, he came to know the art of Michelangelo, Raphael, and the central Italian

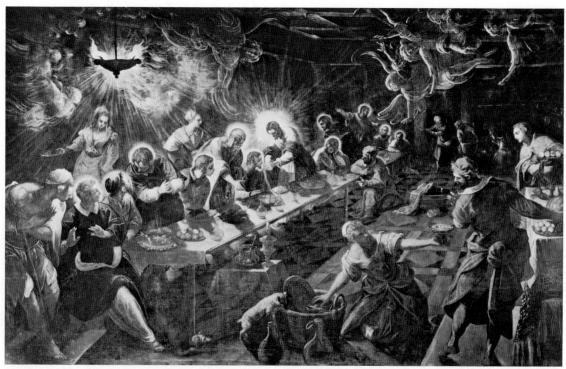

229. Tintoretto. The Last Supper. 1592-94. Oil on canvas, 12' × 18'8". San Giorgio Maggiore, Venice

Mannerists. In 1576–77 he went to Spain. settling in Toledo for the rest of his life. Yet he remained an alien in his new homeland; although the spiritual climate of the Counter Reformation, which was especially intense in Spain, may account for the exalted emotionalism of his mature work, his style had already been formed before he arrived in Toledo. Nor did he ever forget his Byzantine background—until the end of his career, he signed his pictures in Greek. The largest and most resplendent of El Greco's commissions is The Burial of Count Orgaz (fig. 230); the huge canvas honors a medieval benefactor of the Church who was so pious that St. Stephen and St. Augustine miraculously appeared at his funeral to lower the body into its grave. El Greco represents the burial as a contemporary event, portraying among the attendants many of the local nobility and clergy; the dazzling display of color and texture in the armor and vestments could hardly be surpassed by Titian himself. Directly above, the count's

soul (a small, cloudlike figure, like the angels in Tintoretto's Last Supper) is carried to Heaven by an angel. The celestial assembly filling the upper half of the picture is painted very differently from the lower half: every form—clouds, limbs, draperies—takes part in the sweeping, flamelike movement toward the distant figure of Christ. Here, even more than in Tintoretto's art, the various aspects of Mannerism fuse into a single ecstatic vision. Like an enormous window, the canvas fills one entire wall of this chapel, so that we must look sharply upward to see the upper half of the picture. El Greco's violent foreshortening is calculated to achieve an illusion of boundless space above, while the foreground figures appear as on a stage (note that their feet are cut off by the frame). El Greco's task may be compared to Masaccio's in his Trinity mural (see fig. 195). The contrast measures the dynamic evolution of Western art since the beginning of the Early Renaissance.

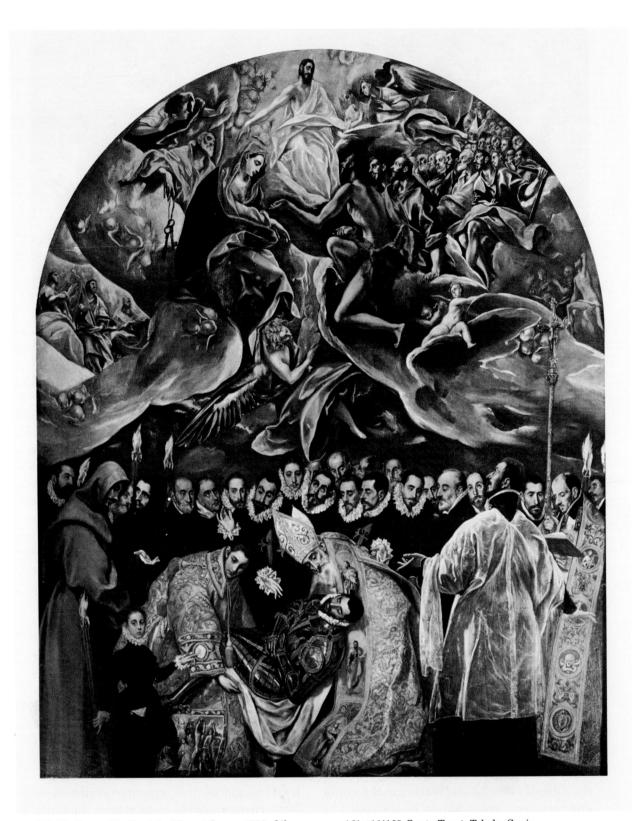

 $\textbf{230.} \ El \ Greco. \ \textit{The Burial of Count Orgaz}. \ 1586. \ Oil \ on \ canvas, \ 16' \times 11'10''. \ Santo \ Tomé, \ Toledo, \ Spain \ Santo \ Santo \ Santo \ Santo \ Spain \ Santo \ Sa$

Proto-Baroque: Correggio

If Mannerism produced the personalities that today seem most "modern"—El Greco's fame is greater now than it ever was before its dominance was not uncontested in the sixteenth century. Another trend that also emerged about 1520 anticipated so many features of the Baroque style that it might be labeled Proto-Baroque. Its most important representative, Correggio, was a phenomenally gifted painter who spent most of his brief career in Parma. He absorbed the influence of Leonardo and the Venetians, then of Michelangelo and Raphael, but their ideal of Classical balance did not attract him. His art is filled with movement that sweeps through the composition, carrying the figures along with it. His largest work, the fresco of the Assumption of the Virgin in the dome of Parma Cathedral (fig. 231), is a masterpiece of illusionistic perspective, a vast, luminous space filled with soaring figures. Although they move with such exhibitanting ease that the

231. Correggio. The Assumption of the Virgin (detail). c. 1525. Fresco. Dome, Parma Cathedral

force of gravity seems not to exist for them, they are healthy, energetic beings of flesh and blood, not disembodied spirits, and they frankly delight in their weightless condition. For Correggio there was little difference between spiritual and physical ecstasy, as we see by comparing The Assumption of the Virgin with his Jupiter and Io (fig. 232), one canvas in a series illustrating the Loves of the Classical Gods. The nymph, swooning in the embrace of a cloudlike Jupiter, is the direct kin of the jubilant angels in the fresco. Leonardesque atmosphere, combined with a Venetian sense of color and texture, produces an effect of exquisite voluptuousness that far exceeds Titian's in his *Bacchanal* (see fig. 221). Correggio had no immediate successors nor any lasting influence on the art of his century, but toward 1600 his work began to be widely appreciated. For the next century and a half he was admired as the equal of Raphael and Michelangelo—while the Mannerists, so important before, were largely forgotten.

Realism: Savoldo; Veronese

A third trend in sixteenth-century painting in Italy is to be associated with the towns along the northern edge of the Lombard plain, such as Brescia and Verona. A number of artists in that region worked in a style based on Giorgione and Titian, but with a stronger interest in everyday reality. One of the earliest and most attractive of these north Italian Realists was Girolamo Savoldo, from Brescia, whose St. Matthew (fig. 233) must be contemporary with Parmigianino's Madonna with the Long Neck. The broad, fluid manner of painting reflects the dominant influence of Titian, yet the great Venetian master would never have placed the Evangelist in such a thoroughly domestic environment. The humble scene in the background shows the saint's milieu to be lowly indeed, and makes the presence of the angel doubly miraculous. This tendency to visualize sacred events among ramshackle buildings

232. Correggio. *Jupiter and Io.* c. 1532. Oil on canvas, $64\frac{1}{2} \times 27\frac{3}{4}$ ". Kunsthistorisches Museum, Vienna

and simple people had been characteristic of Late Gothic painting; Savoldo must have acquired it from that source. The nocturnal lighting, too, recalls such Northern pictures as *The Nativity* by Geertgen tot Sint Jans (see fig. 175). But the main source of illumination in Geertgen's panel is the divine radiance of

233. Girolamo Savoldo. St. Matthew. c. 1535. Oil on canvas, $36\frac{3}{4} \times 49$ ". The Metropolitan Museum of Art, New York (Marquand Fund, 1912)

the Christ Child, and Savoldo uses an ordinary oil lamp for his similarly magic and intimate effect.

In the work of Paolo Veronese, north Italian Realism takes on the splendor of a pageant. Born and trained in Verona, Veronese became, after Tintoretto, the most important painter in Venice; although utterly unlike each other in style, both found favor with the public. The contrast is strikingly evident if we compare Tintoretto's Last Supper (see fig. 229) with Veronese's Christ in the House of Levi (fig. 234), which deals with a similar subject. Veronese avoids all reference to the supernatural; at first glance, the picture looks like a High Renaissance work born fifty years too late. Yet we miss one essentialthe elevated, ideal conception of man that underlies the work of the High Renaissance masters. Veronese paints a sumptuous banquet, a true feast for the eyes, but not "the intention of man's soul." We are not even sure which event from the life of Christ he originally meant to depict, for he gave the canvas its present title only after he had been summoned by a religious tribunal on the charge of filling his picture with "buffoons... and similar vulgarities" unsuited to its sacred character. Veronese's dogged refusal to admit the justice of the charge, his insistence

234. Paolo Veronese. Christ in the House of Levi. 1573. Oil on canvas, 18'2" × 42'. Academy, Venice

on his right to introduce directly observed details, however "improper," and his indifference to the subject of the picture spring from an attitude so startlingly "extroverted" that it was not generally accepted until the nineteenth century. The painter's domain, Veronese seems to say, is the entire visible world, and in it he acknowledges no authority other than his senses.

SCULPTURE

Cellini; Bologna

Italian sculptors of the later sixteenth century fail to match the achievements of the painters. Perhaps Michelangelo's overpowering personality discouraged new talent in this field, but the dearth of challenging new tasks is a more plausible reason. In any case, the anti-Classical phase of Mannerism, represented by the style of Rosso and Pontormo, has no sculptural counterpart.

The second, "elegant" phase of Mannerism, however, appears in countless sculptural examples. The best-known representative of the style is Benvenuto Cellini, the Florentine goldsmith and sculptor who owes much of his fame to his picaresque autobiography. The gold saltcellar for King Francis I of France

(fig. 235), Cellini's only major work in precious metal to escape destruction, well displays the virtues and limitations of his art. To hold condiments is obviously the lesser function of this lavish conversation piece. Because salt comes from the sea and pepper from the land, Cellini placed the boat-shaped salt container under the guardianship of Neptune, while the pepper, placed in a tiny triumphal arch on the other side, is watched over by a personification of Earth. Around

235. Benvenuto Cellini. Saltcellar of Francis I. 1539–43. Gold and enamel, $10\frac{1}{4} \times 13\frac{1}{8}$ ". Kunsthistorisches Museum, Vienna

the base are figures representing the four seasons and the four parts of the day. The entire object thus reflects the cosmic significance of the Medici tombs (compare fig. 213), but on this miniature scale Cellini's program turns into playful fancy; he wants to impress us with his ingenuity and skill, and to charm us with the grace of his figures. The allegorical significance of the design is simply a pretext for this display of virtuosity.

Cellini and the other Italians employed by Francis I made Mannerism the dominant style in mid-sixteenth-century France, and their influence went far beyond the royal court. It must have reached a gifted young sculptor from Douai, Jean de Boulogne, who went to Italy about 1555 for further training and stayed to become, under the Italianized name of Giovanni Bologna, the most important sculptor in Florence during the last third of the century. His over-lifesize marble group, The Rape of the Sabine Woman (fig. 236), won particular acclaim, and still has its place of honor near the Palazzo Vecchio. Actually, the artist designed the group with no specific subject in mind, to silence those critics who doubted his ability as a monumental sculptor in marble. He selected what seemed to him the most difficult feat, three figures of contrasting character united in a common action. Their identities were disputed among the learned connoisseurs of the day, who finally settled on The Rape of the Sabine Woman as the most suitable title. Here, then, is another artist who is noncommittal about subject matter, although his unconcern had a different motive from Veronese's. Giovanni Bologna's self-imposed task was to carve in marble, on a massive scale, a sculptural composition that was to be seen not from one but from all sides; this had hitherto been attempted only in bronze and on a much smaller scale (see fig. 189). He has solved this

236. Giovanni Bologna. *The Rape of the Sabine Woman*. Completed 1583. Marble, height 13'6". Loggia dei Lanzi, Florence

purely formal problem, but only by insulating his group from the world of human experience. These figures, spiraling upward as if confined inside a tall, narrow cylinder, perform a well-rehearsed choreographic exercise the emotional meaning of which remains obscure. We admire their discipline, but we find no trace of genuine pathos.

ARCHITECTURE

Palladio

Most late-sixteenth-century architecture is hardly Mannerist. Indeed, the work of Andrea Palladio—next to Michelangelo the most important architect of the period—stands in the tradition of the humanist and theoretician Leone Battista Alberti (see p. 195). Although his career centered on his native town of Vicenza, not far from Venice, his buildings and theoretical writings soon

brought him international renown. Architecture, according to Palladio, must be governed both by reason and by certain universal rules that were perfectly exemplified by the buildings of the ancients. He thus shared Alberti's basic outlook and his firm faith in the cosmic significance of numerical proportions. They differed in how each man related theory and practice. With Alberti, this relationship had been loose and flexible, whereas Palladio believed quite literally in practicing what he preached. His architectural treatise is consequently more practical than Alberti's-this helps to explain its huge success—while his buildings are linked more directly with his theories. It has even been said that Palladio designed only what was, in his view, sanctioned by ancient precedent. If the results are not necessarily Classical in style, we may call them "Classicistic" (to denote a conscious striving for Classical qualities); this is indeed the usual term for both Palladio's work and

237. Andrea Palladio. Villa Rotonda, Vicenza. 1567-70

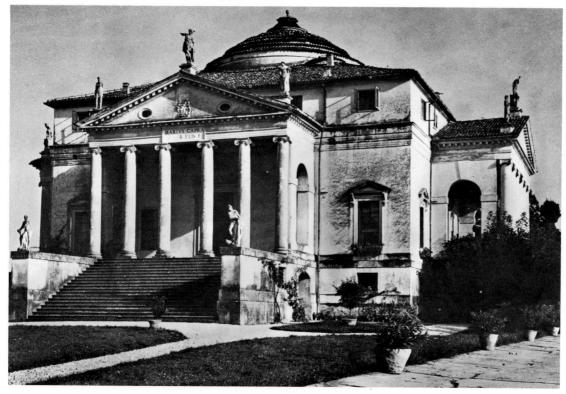

his theoretical attitude. The Villa Rotonda (fig. 237), one of his most famous buildings, perfectly illustrates the meaning of Classicism. An aristocratic country residence near Vicenza, it consists of a square block surmounted by a dome and is faced on all four sides with identical porches having the shape of temple fronts. Alberti defined the ideal church as a completely symmetrical, centralized design; Palladio evidently found in the same principles the ideal country house. But how could he justify the use of so solemn a motif as the temple front in this context? Sur-

prisingly enough, he was convinced that Roman private houses had porticoes such as these (excavations have since proved him wrong). Yet Palladio's use of the temple front here was not mere antiquarianism; he probably persuaded himself that it was legitimate because he regarded it as desirable for both beauty and utility. In any case, the porches of the Villa Rotonda, perfectly correlated with the walls behind, are an organic part of his design. They lend the structure an air of serene dignity and festive grace that still appeals to us today.

The Renaissance in the North

North of the Alps, the majority of fifteenthcentury artists had remained indifferent to Italian forms and ideas. Since the time of Robert Campin and the Van Eycks, they had looked to Flanders, not Tuscany, for leadership. This isolation ends suddenly, toward the year 1500. As if a dam had burst, Italian influence flows northward in an ever-widening stream, and Northern Renaissance art begins to replace Late Gothic. That term, however, is much less well defined than Late Gothic, which refers to a single, clearly recognizable stylistic tradition. The diversity of trends north of the Alps is even greater than in Italy during the sixteenth century. Nor does Italian influence provide a common denominator, for this influence is itself diverse: Early Renaissance, High Renaissance, and Mannerist, each in some regional variant from Lombardy, Venice, Florence, or Rome. And its effects may be superficial or profound, direct or indirect, specific or general. Moreover, the Late Gothic tradition remained very much alive, if no longer dominant, and its encounter with Italian art resulted in a kind of Hundred Years' War of styles which ended only when, about 1600, the Baroque emerged as an international movement. The course of this "war" was decisively affected by the Reformation, which had a far more immediate impact on art north of the Alps than in Italy. Our account, then, must be oversimplified, emphasizing the heroic phases of the struggle at the expense of the lesser engagements.

GERMANY

Grünewald

Let us begin with Germany, the home of the Reformation, where the main battles of the "war of styles" took place during the first quarter of the century. Between 1475 and 1500, it had produced such important masters as Schongauer (see p. 185), but these hardly prepare us for the astonishing burst of creative energy that was to follow. The achievements of this period—comparable in its brevity and brilliance to the Italian High Renaissance—are measured by the contrasting personalities of its greatest artists, Matthias Grünewald and Albrecht Dürer. Both died in 1528, probably at about the same age. Dürer quickly became internationally famous, while Grünewald remained so obscure that his real name, Mathis Gothart Nithart, was discovered only recently. His fame, like El Greco's, is almost entirely of our own century. In Northern art of his time, he alone overwhelms us in his main work. The Isenheim Altarpiece (figs. 238, 239), with something like the power of the Sistine Ceiling. Painted in 1509–15 for the monastery church of the Order of St. Anthony at Isenheim, in

238. Matthias Grünewald. The Crucifixion, from The Isenheim Altarpiece (closed). c. 1509–15. Oil on panel, $8'10'' \times 10'1''$. Musée Unterlinden, Colmar

239. Matthias Grünewald. The Annunciation; Virgin and Child with Angels; The Resurrection, from The Isenheim Altarpiece (open). c. 1509–15. Oil on panel; each wing $8'10'' \times 4'8''$, central scene $8'10'' \times 11'21/2''$. Musée Unterlinden, Colmar

Alsace, it is now in the museum of the nearby town of Colmar. The altarpiece has three stages, or "views." The first, when all the wings are closed, shows the Crucifixion (fig. 238)—probably the most impressive ever painted. In one respect it is very medieval: Christ's unbearable agony, and the desperate grief of the Virgin, St. John, and Mary Magdalen, recall older devotional images such as the Bonn *Pietà* (see fig. 148). But the body on

the Cross, with its twisted limbs, countless lacerations, and rivulets of blood, is on a heroic scale that raises it beyond the merely human: thus the two natures of Christ are revealed. The same message is conveyed by the flanking figures: the three historic witnesses on the left mourn Christ's death as a man, while John the Baptist, on the right, points with calm emphasis to Him as the Saviour. Even the background suggests this

duality: this Golgotha is not a hill outside Jerusalem, but a mountain towering above lesser peaks. The Crucifixion becomes a lonely event silhouetted against a deserted, ghostly landscape and a blue-black sky. Darkness is over the land, in accordance with the Gospels, yet brilliant light bathes the foreground with the force of sudden revelation. This union of time and eternity, of reality and symbolism, gives Grünewald's

Crucifixion its awesome grandeur.

When the outer wings are opened, the mood of *The Isenheim Altarpiece* changes dramatically (fig. 239). All three scenes in this second "view"—*The Annunciation*, the *Virgin and Child with Angels*, and *The Resurrection*—celebrate events as jubilant in spirit as *The Crucifixion* is austere. Most striking is the sense of movement prevading these panels—everything twists and turns

as though it had a life of its own. This vibrant energy has thoroughly reshaped the brittle. spiky contours and angular drapery patterns of Late Gothic art: Grünewald's forms are soft, elastic, fleshy. His light and color show a corresponding change: commanding all the resources of the great Flemish masters, he employs them with unexampled boldness and flexibility. His color scale is richly iridescent, its range matched only by the Venetians'. And his exploitation of colored light is altogether without parallel at that time. In the luminescent angels of the Virgin and Child and, most spectacularly, in the rainbow-hued radiance of the Risen Christ, Grünewald's genius has achieved miraclesthrough-light that are unsurpassed to this day.

How much did Grünewald owe to Italian art? Nothing at all, we are tempted to reply. Yet he must have learned from the Renaissance in more ways than one: his knowledge of perspective (note the low horizons) and the physical vigor of some of his figures cannot be explained by the Late Gothic tradition. Perhaps the most important effect of the Renaissance on him, however, was psychological. We know little about his career, but apparently he did not lead the settled life of a craftsman-painter controlled by the rules of his guild; he was also an architect, engineer, and entrepreneur who worked for many different patrons without staying anywhere for long. He was in sympathy with Martin Luther (who frowned upon religious images as "idolatrous") even though, as a painter, he depended on Catholic patronage. In a word, Grünewald seems to have shared the free, individualist spirit of Italian Renaissance artists. The daring of his pictorial vision likewise suggests a reliance on his own resources. The Renaissance, then, had a liberating effect on him but did not change the basic cast of his imagination. Instead, it helped him to epitomize the expressive aspects of the Late Gothic in a style of unique intensity and individuality.

Dürer

For Albrecht Dürer, the Renaissance held a different and richer meaning. He visited Venice as a young journeyman and returned to his native Nuremberg with a new conception of the world and the artist's place in it. The unbridled fantasy of Grünewald's art was to him "a wild, unpruned tree" which needed the discipline of the objective, rational standards of the Renaissance. Taking the Italian view that the fine arts belong among the liberal arts, he also adopted the ideal of the artist as a gentleman and humanistic scholar. By steadily cultivating his mind he came to encompass a vast variety of techniques and subjects. And since he was the greatest printmaker of the time, he had a wide influence on sixteenth-century art through his woodcuts and engravings, which circulated throughout the Western world. The first artist to be fascinated by his own

240. Albrecht Dürer. *Self-Portrait*. 1500. Panel, $26\frac{1}{4} \times 19\frac{1}{4}$ ". Pinakothek, Munich

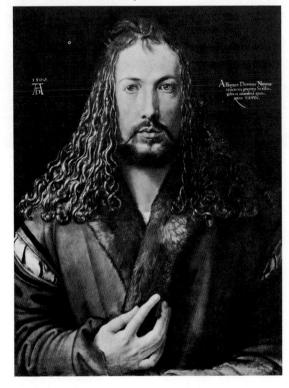

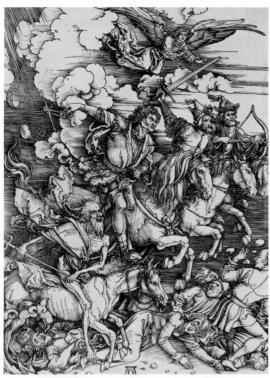

241. Albrecht Dürer. The Four Horsemen of the Apocalypse. c. 1497-98. Woodcut

image, Dürer was in this respect more of a Renaissance personality than any Italian. His earliest known work, a drawing made at thirteen, is a self-portrait, and he continued to produce them throughout his career. Most impressive, and peculiarly revealing, is the panel he painted in 1500 (fig. 240): pictorially, it belongs to the Flemish tradition (compare fig. 170), but the solemn, frontal pose and the Christlike idealization of the features assert an authority quite beyond the range of ordinary portraits. The picture looks, in fact, like a secularized icon, reflecting not so much Dürer's vanity as the seriousness with which he regarded his mission as an artistic reformer.

The didactic aspect of Dürer's art is evident in many of his greatest prints. The gruesome vision of The Four Horsemen of the Apocalypse (fig. 241) seems at first to return completely to the Late Gothic world of Martin Schongauer (compare fig. 181). Yet the physical energy and solid, full-bodied volume of these figures would have been impossible without Dürer's earlier experience in Italy. At this stage, Dürer's style has much in common with Grünewald's. The comparison with Schongauer's Temptation of St. Anthony, however, is instructive from another point of view; it shows how thoroughly Dürer has redefined his medium—the woodcut—by enriching it with the linear subtleties of engraving. In his hands, woodcuts lose their former charm as popular art, but gain the precise articulation of a fully matured graphic style. He set a standard that soon transformed the technique of woodcuts all over Europe.

Knight, Death, and Devil (fig. 242) is one of Dürer's most beautiful engravings. The knight on his mount, poised and confident like an equestrian statue, embodies an ideal both aesthetic and moral: he is the Christian Soldier, steadfast on the road of faith toward the Heavenly Jerusalem and undeterred by

242. Albrecht Dürer. Knight, Death, and Devil. 1513. Engraving. Museum of Fine Arts, Boston

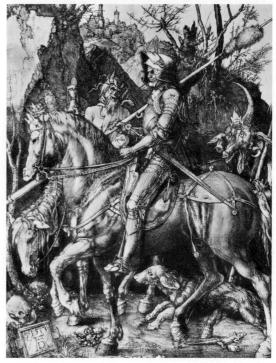

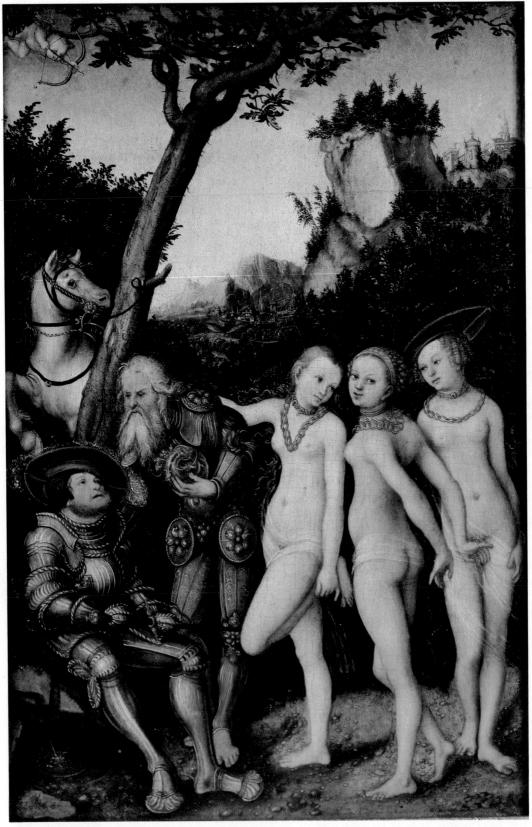

243. (above) Lucas Cranach the Elder. The Judgment of Paris. 1530. Oil on panel, $13\frac{1}{2}\times8\frac{3}{4}$ ". Staatliche Kunsthalle, Karlsruhe, Germany

 $\textbf{244.} \ (opposite) \ \textbf{Albrecht Altdorfer}. \ \textit{The Battle of Issus}. \ 1529. \ \textbf{Oil on panel}, \ 62 \times 47''. \ \textbf{Alte Pinakothek}, \ \textbf{Munich Pin$

the hideous horseman threatening to cut him off, or by the grotesque devil behind him. The dog, another symbol of virtue, loyally follows his master despite the lizards and skulls in his path. Italian Renaissance form, united with the heritage of Late Gothic symbolism (whether open or disguised), here takes on a new, characteristically Northern significance. The subject of Knight, Death, and Devil seems to have been derived from a book called the Manual of the Christian Soldier by Erasmus of Rotterdam, the greatest of Northern humanists. Dürer's own convictions were essentially those of Christian humanism; they made him an early and enthusiastic follower of Martin Luther, although, like Grünewald, he continued to work for Catholic patrons. In the 1520s he tried to create a monumental art embodying the Protestant faith, but his efforts were doomed by the spiritual leaders of the Reformation, who looked upon them with indifference, or, more often, outright hostility. Dürer thus turned to the theory of art, devoting a good part of his final years to this. His work includes a treatise on geometry based on a thorough study of Piero della Francesca's discourse on perspective.

Cranach; Altdorfer

Dürer's hope for a monumental art embodying the Protestant faith remained unfulfilled. Other German painters, notably Lucas Cranach the Elder, also tried to cast Luther's doctrines into visual form, but created no viable tradition. Lucas Cranach is best remembered today for his portraits and his delightfully incongruous mythological scenes. In his Judgment of Paris (fig. 243) nothing could be less Classical than the wriggly nakedness of these three coquettish damsels. Paris is a German knight clad in fashionable armor, indistinguishable from the nobles at the court of Saxony who were the artist's patrons. The playful eroticism, small size, and precise, miniature-like detail of the picture

make it plainly a collector's item, attuned to the tastes of a provincial aristocracy.

As remote from the Classical ideal, but far more impressive, is The Battle of Issus by Albrecht Altdorfer, a Bavarian painter somewhat younger than Cranach (fig. 244). Unless we read the text on the tablet suspended in the sky, we cannot possibly identify the subject, Alexander's victory over Darius. Altdorfer has tried to follow ancient descriptions of the actual number and kind of combatants, but this required him to adopt a bird's-eye view whereby the two protagonists are lost in the antlike mass of their own armies (in contrast, see the Hellenistic representation of the same subject, fig. 45). Moreover, the soldiers' armor and the town in the distance are unmistakably of the sixteenth century. The picture might well show some contemporary battle, except for one feature: the spectacular sky, with the sun triumphantly breaking through the clouds and "defeating" the moon. The celestial drama above a vast Alpine landscape, obviously correlated with the human contest below, raises the scene to the cosmic level. Altdorfer may be viewed as a later, and lesser, Grünewald; although he, too, was an architect, well acquainted with perspective and the Italian stylistic vocabulary, his paintings show the unruly imagination already familiar from the work of the older master. But, unlike Grünewald, Altdorfer makes the human figure incidental to its spatial setting. The tiny soldiers of The Battle of Issus have their counterparts in his other pictures, and he painted at least one landscape with no figures at all the earliest example of "pure" landscape.

Holbein and Portraiture

Although greatly gifted, Altdorfer and his German contemporaries evaded the main challenge of the Renaissance that was so bravely faced—if not always mastered—by Dürer: the image of man. Their style, antimonumental and miniature-like, set the pace

245. Hans Holbein the Younger. Erasmus of Rotterdam. c. 1523. Oil on panel, $16\frac{1}{2}\times12\frac{1}{2}$ ". The Louvre, Paris

for dozens of lesser masters; perhaps the rapid decline of German art after Dürer's death was due to a failure of ambition among artists and patrons alike. The career of Hans Holbein the Younger—the one painter of whom this is not true—confirms the general rule. Younger than Dürer by twenty-six years, Holbein grew up in Augsburg, a city in southern Germany particularly open to Renaissance ideas, and then became the leading artist of Basel, in Switzerland. His likeness of Erasmus of Rotterdam (fig. 245), painted soon after the famous author had settled in Basel, gives us a truly memorable image of Renaissance man: intimate yet monumental, this doctor of humane letters has an intellectual authority formerly reserved for the doctors of the Church. Yet Holbein must have felt confined in Basel, for in 1523-24 he traveled to France, apparently intending to offer his services to Francis I. In 1526, when Basel was in the throes of the Reformation crisis, he went to England, hoping for commissions at the court of Henry VIII. On his return to Ba-

246. Jean Clouet. Francis I. c. 1525–30. Oil on panel, $37^3\!\!/\!\!\!4 \times 29''$. The Louvre, Paris

sel two years later, he saw fanatical mobs destroying religious images as "idols," and in 1532 he settled permanently in London as court painter to Henry VIII. His portrait of the king (fig. 247) shares the rigid frontality of Dürer's self-portrait (see fig. 240), but its purpose is to convey the almost divine authority of the absolute ruler: the immobile pose, the air of unapproachability, the display of precisely rendered jewels and gold embroidery-all create an overpowering sensation of the monarch's ruthless, commanding presence. Both Holbein's portrait of Henry VIII and Bronzino's Eleanora of Toledo (see fig. 228) belong to the same species of court portrait. The link between Bronzino's picture and Holbein's may be such French works as Clouet's Francis I (fig. 246), which Holbein could have seen on his travels. (See p. 233 for Francis I as a patron of Italian Mannerists.) This type of portrait evidently was coined at the royal court of France and gained international currency between 1525 and 1550.

247. Hans Holbein the Younger. *Henry VIII*. 1540. Oil and tempera on panel, $32\frac{1}{2} \times 29^{\prime\prime}$. National Gallery, Rome

248. Pieter Bruegel the Elder. *The Land of Cockayne*. 1567. Oil and tempera on panel, 20½×30¾". Pinakothek, Munich

THE NETHERLANDS

Bruegel

The Netherlands in the sixteenth century had the most turbulent and painful history of any country north of the Alps. They were then part of the far-flung empire of the Hapsburgs under Charles V, who was also king of Spain. The Reformation quickly became powerful in the Netherlands, and the attempts of the Crown to suppress it led to open revolt against foreign rule. After a bloody struggle, the northern provinces (today's Holland) gained their independence, while the southern ones (now called Belgium) remained in Spanish hands. The religious and political strife might have had catastrophic effects on the arts, yet this, astonishingly, did not happen. While the Netherlands had no pioneers of the Northern Renaissance comparable to Dürer, they absorbed Italian elements more steadily than did Germany. Between 1550 and 1600, their most troubled time, the Netherlands produced the major painters of Northern Europe, who paved the way for the great Dutch and Flemish masters of the next century. Apart from the assimilation of Italian art, Netherlandish sixteenth-century painters had one main concern: to develop a repertory of subjects to supplement, and eventually replace, the traditional religious themes. The process was gradual, shaped less by individual achievement than by the need to cater to popular taste as Church commissions became steadily scarcer. Pieter Bruegel the Elder, the only genius among these painters, explored landscape, peasant life, and moral allegory, such as The Land of Cockayne (fig. 248). It shows a fool's paradise

249. Pieter Bruegel the Elder. The Return of the Hunters. 1565. Tempera on panel, $46 \times 63\%$. Kunsthistorisches Museum, Vienna

where tables are always laden with tasty dishes, houses have roofs made of pies, and pigs and chickens run about roasted to a turn. The lesson Bruegel teaches us here is philosophical rather than religious: the men under the tree are not sinners in the grip of evil, like those in Bosch's *Garden of Delights* (see fig. 177), they are simply not wise enough to know what is best for them. By becoming

slaves to their stomachs, they have given up all ambition, all self-respect, for the sake of a kind of animal happiness—the knight has dropped his lance, the farmer his flail, and the scholar his books. "Beware of the fool's paradise," Bruegel seems to say, "it's more dangerous than hell because people *like* going there." And the monumental design of the painting, in the shape of a great wheel turned on its side, proves that he must have thought his subject serious and important.

The sweeping landscape of *The Return of the Hunters* (fig. 249) belongs to a set of paintings depicting the months of the year. Series of this kind, we recall, began with medieval calendar illustrations, and this winter scene shows its descent from the *February* page in the *Very Rich Book of Hours of the Duke of Berry* (see fig. 162). Now, however, nature is more than a setting for human activities; it is the main subject of the picture. Men in their seasonal occupations are incidental to the majestic annual cycle of death and rebirth that is the breathing rhythm of the cosmos.

250. Pierre Lescot. Square Court of the Louvre, Paris. Begun 1546

FRANCE

Architecture and Sculpture

In architecture and sculpture, it took the Northern countries longer to assimilate Italian forms than in painting. France, more closely linked with Italy than the rest (we recall the French conquest of Milan), was the first to achieve an integrated Renaissance style. In 1546 King Francis I, who had shown his admiration for Italian art earlier by inviting Leonardo to France, decided to replace the old Gothic royal castle, the Louvre, with a new and much larger structure on the same site. The project, barely begun at the time of his death, was not completed until more than a century later; but its oldest portion, by Pierre Lescot (fig. 250), is the finest surviving example of Northern Renaissance architecture. The details of Lescot's façade are derived from Bramante and his successors and have an astonishing Classical purity, yet we would not mistake it for an Italian structure. Its distinctive quality comes not from Italian forms superficially applied, but from a genuine synthesis of the traditional Gothic castle with the Renaissance palace. Italian, of course, are the superimposed Classical orders, the pedimented window frames, and the arcade on the ground floor. But the continuity of the façade is interrupted by three projecting pavilions which take the place of the castle turrets, and the steep roof is also traditionally Northern. The vertical accents thus overcome the horizontal ones (note the broken architraves), their effect reinforced by the tall, narrow windows. Equally un-Italian is the rich sculptural decoration covering almost the entire wall surface of the third story. These reliefs, admirably adapted to the architecture, are by Jean Goujon, the finest French sculptor of the mid-sixteenth century. Unfortunately, they have been much re-

251. Jean Goujon. Reliefs from the *Fountain of the Innocents*. 1548–49. Paris

stored. To get a more precise idea of Goujon's style we must turn to the relief panels from the *Fountain of the Innocents* (two are shown in fig. 251), which have survived intact, although their architectural framework is lost. These graceful figures recall the Mannerism of Cellini (see fig. 235). Like Lescot's architecture, Goujon's figures combine Classical details with a delicate slenderness that gives them a uniquely French elegance.

The Baroque in Italy, Flanders, and Spain

Baroque has been the term used by art historians for almost a century to designate the style of the period 1600-1750. Its original meaning—"irregular, contorted, grotesque" -is now largely forgotten. There is also general agreement that the new style was born in Rome around 1600. What remains under dispute is the impulse behind it. Thus it has been claimed that the Baroque style expresses the spirit of the Counter Reformation: yet the Counter Reformation, a dynamic movement of self-renewal within the Catholic Church, had already done its work by 1600: Protestantism was on the defensive, and neither side any longer had the power to upset the new balance. The princes of the Church who supported the growth of Baroque art were known for worldly splendor rather than piety. Besides, the new style penetrated the Protestant North so quickly that we must be careful not to overstress its Counter Reformation aspect. Equally questionable is the claim that Baroque is "the style of absolutism," reflecting the centralized state ruled by an autocrat of unlimited powers. Although absolutism reached its climax in France in the later seventeenth century, during the reign of Louis XIV, it had been in the making since the 1520s. Moreover, Baroque art flourished in bourgeois Holland no less than in the absolutist monarchies; and the style officially sponsored under Louis XIV was a notably subdued, Classicistic kind of Baroque. There are similar difficulties if we try to relate Baroque art to the science and philosophy of the period. Such a link did exist in the Early and High Renaissance: an artist then could also be a humanist and scientist. But now scientific and philosophical thought became too complex, abstract, and systematic for him to share; gravitation, calculus, and *Cogito*, *ergo* sum could not stir his imagination. Baroque art, then, was not simply the result of religious, political, or intellectual developments. Interconnections surely existed, but we do not yet understand them fully. Until we do, let us think of the Baroque style as one among other basic features—the newly fortified Catholic faith, the absolutist state, and the new role of science—that distinguish the period 1600–1750 from what had gone before.

Rome: Caravaggio

Rome became the fountainhead of the Baroque, as it had of the High Renaissance a century earlier, by gathering artists from other regions to perform challenging tasks. The papacy once again patronized art on a large scale, aiming to turn Rome into the most beautiful city of the entire Christian world. At first, the artists on hand were Late Mannerists of feeble distinction, but the campaign soon attracted ambitious younger masters. They were the ones who created the new style. Foremost was a painter of genius, called Caravaggio after his birthplace near Milan, who did several monumental canvases for the Church of San Luigi dei Francesi, including The Calling of St. Matthew (fig. 252). The style shown in this extraordinary picture is remote from both Mannerism and the High Renaissance; its realism is so uncompromising that a new term, "naturalism," is needed to distinguish it from the earlier kind. Never have we seen a sacred subject depicted so entirely in terms of contemporary low life. Matthew the tax gatherer

252. Caravaggio. The Calling of St. Matthew. c. 1596–98. Oil on canvas, $11'1'' \times 11'5''$. Contarelli Chapel, San Luigi dei Francesi, Rome

sits with some armed men—evidently his agents—in what appears to be a common Roman tavern; he points questioningly at himself as two figures approach from the right. They are poor people, whose bare feet and simple garments contrast strongly with the colorful costumes of Matthew and his companions. Why do we sense a religious quality in this scene? What identifies one of the figures as Christ? Surely it is not the Saviour's halo, an inconspicuous gold band that we

might well overlook. Our eyes fasten instead on His commanding gesture, borrowed from Michelangelo's *Creation of Adam* (see fig. 211), which bridges the gap between the two groups. Most important of all, however, is the strong beam of sunlight above Christ that illuminates His face and hand in the gloomy interior, thus carrying His call across to Matthew. Without this light—so natural yet so charged with symbolic meaning—the picture would lose its magic, its power to make

us aware of the divine presence. Caravaggio here gives moving, direct form to an attitude shared by some of the great saints of the Counter Reformation: that the mysteries of faith are revealed not by intellectual speculation but spontaneously, through an inward experience open to all men. His paintings have a "lay Christianity," untouched by theological dogma, that appealed to Protestants no less than to Catholics. Hence his profound—though indirect—influence on Rembrandt, who was the greatest religious artist of the Protestant North.

Artemisia Gentileschi

We have not encountered a woman artist thus far. This does not mean that there were none. On the contrary, the names of women artists in Greece and Rome and descriptions of their work appear in Pliny's *Natural History* (book XXXV), and there are records of

253. Artemisia Gentileschi. *Judith and Maidservant with the Head of Holofernes*. c. 1625. Oil on canvas, $6'\frac{1}{2}''$ × $4'73\frac{1}{4}''$. The Detroit Institute of Arts (Gift of Leslie H. Green)

women's accomplishments during the Middle Ages. We must remember, however, that the vast majority of artists remained anonymous until the Late Gothic period, so that works specifically by women have proved difficult to identify. Women began to emerge as distinct artistic personalities about 1550, but until the middle of the nineteenth century they were largely restricted to painting portraits, genre scenes, and still lifes. Among other obstacles, they were rarely permitted to draw from the nude model in life classes, a practice which was at the heart of traditional academic training and provided the basis for narrative painting. Within those other realms, however, many women carved out successful careers, often emerging as the equals or superiors of the men in whose styles they were trained. The few exceptions to this general pattern were Italian women who were members of artistic families; their major role began in the seventeenth century.

The first woman artist to occupy an important position was Artemisia Gentileschi. The daughter of Caravaggio's disciple Orazio Gentileschi, she was born in Rome and became one of the leading painters and personalities of her day. Her characteristic subjects are Bathsheba, the unfortunate object of King David's passion, and Judith, who saved her people by beheading the Assyrian general Holofernes. These and other tragic heroines were popular subjects during the Baroque era, which delighted in erotic and violent scenes, but Artemisia's frequent depictions of them throughout her eventful career may also have stemmed from her rape at the age of fifteen by her teacher, who was acquitted of the crime in a sensational trial.

Artemisia's early paintings of Judith understandably take her father's and Caravaggio's work as their points of departure. Our example, *Judith and Maidservant with the Head of Holofernes* (fig. 253), is, however, a fully mature, independent painting. The inner drama is unique to Artemisia and is no less powerful for its restraint in immortaliz-

ing Judith's courage. Rather than the decapitation itself, the artist has chosen to illustrate the moment after, when the handmaiden is stuffing Holofernes' head into a sack. The object of the two women's attention remains hidden from view, heightening the air of intrigue. The active poses and hushed candlelight in turn establish a mood of exotic mystery that conveys Judith's complex emotions with incomparable understanding.

Carracci and His Followers

Although Caravaggio's work was acclaimed by artists and connoisseurs in Italy, to the man in the street, for whom it was intended. it lacked propriety and reverence. The simple people resented meeting their likes in his paintings; they preferred religious imagery of a more idealized and rhetorical sort. Their wishes were met by artists less radical—and less talented—than Caravaggio, who took their lead from another newcomer among Roman painters, Annibale Carracci. Annibale came from Bologna, where he and two other members of his family had evolved an anti-Mannerist style since the 1580s. In 1597-1604 he produced his most ambitious work, the ceiling fresco in the gallery of the Farnese Palace, which soon became so famous that it was thought second only to the murals of Michelangelo and Raphael. The historical significance of the Farnese Gallery is indeed great, though our enthusiasm for it as a work of art may no longer be undivided. Our detail (fig. 254) shows Annibale's rich and intricate design: the narrative scenes, like those of the Sistine Ceiling, are surrounded by painted architecture, simulated sculpture, and nude, garland-holding youths. Yet the Farnese Gallery does not merely imitate Michelangelo's masterpiece. The style of the main subjects, the Loves of the Classical Gods, is reminiscent of Raphael's Galatea (see fig. 219), and the whole is held together by an illusionistic scheme that reflects Annibale's knowledge of Correggio and the great

Venetians. Carefully foreshortened and illuminated from below (note the shadows), the nude youth and the simulated sculpture and architecture appear real; against this background the mythologies are presented as simulated easel pictures. Each of these levels of reality is handled with consummate skill. and the entire ceiling has an exuberance that sets it apart from both Mannerism and High Renaissance art. Annibale Carracci was a reformer rather than a revolutionary; like Caravaggio, with whom he was on the best of terms, he felt that art must return to nature, but his approach was less single-minded, balancing studies from life with a revival of the Classics (which to him meant the art of antiquity, and of Raphael, Michelangelo, Titian, and Correggio). At his best, he succeeded in fusing these diverse elements, although their union always remained somewhat precarious. To his disciples, the Farnese Gallery seemed to offer two alternatives: pursuing the Raphaelesque style of the mythological panels, they could arrive at a deliberate, "official" Classicism; or they could take their cue from the sensuous illusionism present in the framework. The first choice is best exemplified by Nicolas Poussin (see p. 275), the second by Pietro da Cortona. Figure 255

254. Annibale Carracci. Ceiling fresco (detail). 1597-1601. Gallery, Palazzo Farnese, Rome

shows a detail of Pietro's ceiling fresco in the great hall of the Barberini Palace in Rome glorifying the reign of the Barberini pope, Urban VIII. As in the Farnese Gallery, the ceiling area is subdivided by a painted framework simulating architecture and sculpture, but beyond it we now see the unbounded space of the sky. Clusters of figures, perched on clouds or soaring freely, swirl above as well as below this framework, creating a dual illusion: some figures appear to hover well inside the hall, perilously close to our heads, while others recede into a light-filled, infinite distance. Their dynamism almost literally sweeps us off our feet. Here the Baroque style reaches a thunderous climax.

St. Peter's: Maderno; Bernini

In architecture, the beginnings of the Baroque style cannot be defined as precisely as in painting. In the vast church-building program that got under way in Rome toward 1600, the most talented young architect was Carlo Maderno; in 1603 he was given the task of completing, at long last, the Church of St. Peter's, after the pope had decided to add a nave, converting Bramante's and Michelangelo's central-plan building into a basilica (fig. 256). Maderno's design for the façade follows the pattern established by Michelangelo for the exterior (compare fig. 217), but with a dramatic emphasis on the portals. There is what can only be called a crescendo effect

256. St. Peter's (aerial view), Rome. Nave and façade by Carlo Maderno, 1607–15; colonnade by Gianlorenzo Bernini, designed 1657

from the corners toward the center: the spacing of the colossal order becomes closer, pilasters turn into columns, and the facade wall projects step by step. This quickened rhythm became the dominant principle of Maderno's facade designs, not only for St. Peter's but for smaller churches as well; it replaced the traditional notion of the church facade as one continuous wall surface with the "facade-indepth" dynamically related to the open space before it. The possibilities implicit in this new concept were not to be exhausted for a hundred and fifty years. Maderno's work on the St. Peter's facade was completed by Gianlorenzo Bernini, the greatest sculptor-architect of the century. It was he who molded the open space in front of the façade into a magnificent oval "forecourt" framed by colonnades

257. Gianlorenzo Bernini. *David.* 1623. Marble, lifesize. Borghese Gallery, Rome

which Bernini himself likened to the motherly, all-embracing arms of the Church.

Such a charging of space with active energy is a key feature of Baroque art. Caravaggio had achieved it, with the aid of a sharply focused beam of light, in his St. Matthew; Bernini was a master of it, not only in architecture but in sculpture as well. If we compare his David (fig. 257) with Michelangelo's (see fig. 209), and ask what makes Bernini's Baroque, the simplest answer would be: the implied presence of Goliath. Bernini's David is conceived not as a self-contained figure but as "half of a pair," his entire action focused on his adversary. Did the artist, we wonder. plan a statue of Goliath to complete the group? He never did, for his David tells us clearly enough where he sees the enemy. Thus the space between David and his invisible opponent is charged with energy: it "belongs" to the statue. If we stand directly in front of this formidable fighter, our first impulse is to get out of the line of fire. Baroque sculpture, then, eschews the self-sufficiency of Early and High Renaissance sculpture for an illusion—the illusion of presences or forces that are implied by the behavior of the sculptured figure. Because of this "invisible complement," Baroque sculpture has been denounced as a tour de force, attempting illusionistic effects that are outside its province. The accusation is pointless, for illusion is the basis of every artistic experience, and we cannot very well regard some kinds or degrees of illusion as less legitimate than others. It is true, however, that Baroque art acknowledges no sharp distinction between sculpture and painting. The two may enter into a symbiosis previously unknown, or, more precisely, both may be combined with architecture to form a compound illusion, like that of the stage. Bernini was at his best when he could merge all three arts in this fashion. His masterpiece is the Cornaro Chapel, containing the famous group called *The Ecstasy of St.* Theresa (fig. 258), in the Church of Santa Maria della Vittoria. Theresa of Avila, one of the

258. Gianlorenzo Bernini. The Ecstasy of St. Theresa. 1645-52. Marble, lifesize. Cornaro Chapel, Santa Maria della Vittoria, Rome

259. Lodovico Burnacini. Stage design for "La Zenobia di Radamisto," opera by G. A. Boretti, Vienna, Hoftheater, 1662 (engraving by F. van den Steen). Theater Collection, Houghton Library, Harvard University, Cambridge, Massachusetts

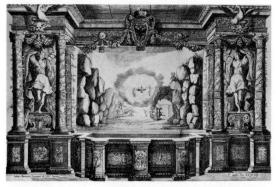

saints of the Counter Reformation, had described how an angel once pierced her heart with a flaming golden arrow: "The pain was so great that I screamed aloud; but at the same time I felt such infinite sweetness that I wished the pain to last forever." Bernini has made this visionary experience as sensuously real as Correggio's Jupiter and Io (see fig. 232); the angel, in a different context, would

be indistinguishable from Cupid, and the saint's ecstasy is palpably physical. Yet the two figures, on their floating cloud, are lit (from a hidden window above) in such a way as to seem almost dematerialized in their gleaming whiteness. The beholder experiences them as visionary. The "invisible complement" here, less specific than David's but equally important, is the force that carries the figures heavenward, causing the turbulence of their drapery. Its nature is suggested by the golden rays, which come from a source high above the altar: in an illusionistic fresco on the vault of the chapel, the glory of heaven is revealed as a dazzling burst of light from which tumble clouds of jubilant angels. It is this celestial "explosion" that gives force to the thrusts of the angel's arrow and makes the ecstasy of the saint believable. Such displays, designed to overwhelm the beholder emotionally, may well be termed "theatrical," both in spirit and in some of the devices employed. Bernini himself had a passionate interest in the theater. Looking at a typical Baroque stage with all its illusionistic devices, such as the one in figure 259 by Lodovico Burnacini, we sense its kinship with the Cornaro Chapel.

Borromini

As a personality type, Bernini represents the self-assured, expansive man of the world. His great rival in architecture, Francesco Borromini, was the opposite: a secretive and emotionally unstable genius, he died by suicide. The temperamental contrast between the two would be evident from their works alone, even without the testimony of their contemporaries. Both exemplify the climax of Baroque architecture in Rome, yet Bernini's design for the colonnade of St. Peter's is dramatically simple and unified, while Borromini's structures are extravagantly complex. Bernini himself agreed with those who denounced Borromini for disregarding the Classical tradition, enshrined in Renais-

260. Francesco Borromini. Façade and plan, San Carlo alle Quattro Fontane, Rome. 1638-67

sance theory and practice, that architecture must reflect the proportions of the human body. We understand this accusation when we look at Borromini's first project, the Church of San Carlo alle Quattro Fontane (fig. 260). The vocabulary is not unfamiliar, but the syntax is new and disquieting; the ceaseless play of concave and convex surfaces makes the entire structure seem elastic, "pulled out of shape" by pressures that no previous building could have withstood. The plan is a pinched oval suggesting a distended and half-melted Greek cross, as if it had been drawn on rubber. In the façade, designed almost thirty years later, these pressures and counterpressures reach their maximum intensity. Characteristically, it incorporates sculpture and even a painting, born aloft by flying angels. San Carlo alle Quattro Fontane established Borromini's local and international fame. "Nothing similar," wrote the head of the religious order for which the

261. Guarino Guarini. Palazzo Carignano, Turin. Begun 1679

church was built, "can be found anywhere in the world."

The wealth of new ideas introduced by Borromini was exploited not in Rome but in Turin, the capital of Savoy, which became the creative center of Baroque architecture in Italy toward the end of the seventeenth century. In 1666, that city attracted Borromini's most brilliant successor, Guarino Guarini, a monk whose architectural genius was deeply grounded in philosophy and mathematics. His design for the façade of the Palazzo Carignano (fig. 261) repeats on a larger scale the undulating movement of San Carlo alle Quattro Fontane, using a highly individual vocabulary. Incredibly, the exterior of the building is entirely of brick, down to the last ornamental detail.

Rubens

Although Rome was its birthplace, the Baroque style soon became international. Among the artists who helped bring this about, the great Flemish painter Peter Paul Rubens holds a place of special importance. It might be said that he finished what Dürer had started—the breaking down of artistic barriers between North and South. Rubens grew up in Antwerp, the capital of the "Spanish Netherlands" (see p. 247), and remained a devout Catholic all his life. Trained by local painters, he became a master in 1598, but developed a personal style only when, two years later, he went to Italy. During his eight years' stay he eagerly studied ancient sculpture, the masterpieces of the High Renaissance, and the work of Caravaggio, absorbing the Italian tradition far more thoroughly than had any Northerner before him. He competed, in fact, with the best Italians of his day on even terms, and could well have made his career in Italy. He chose instead to settle down in Antwerp as court painter to the Spanish regent, a special appointment that exempted him and his workshop from local taxes and guild rules. Rubens thus had the

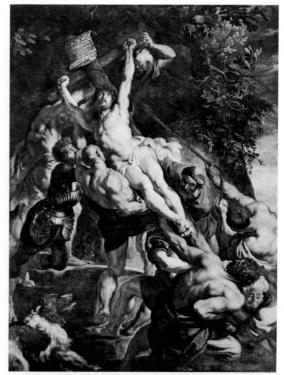

262. Peter Paul Rubens. The Raising of the Cross. 1609-10. Panel, 15'2"×11'2". Antwerp Cathedral

263. Peter Paul Rubens. Marie de' Medici, Queen of France, Landing in Marseilles. 1622-23. Oil on panel. 25 × 193/4". Alte Pinakothek, Munich

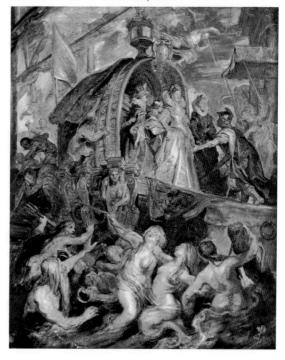

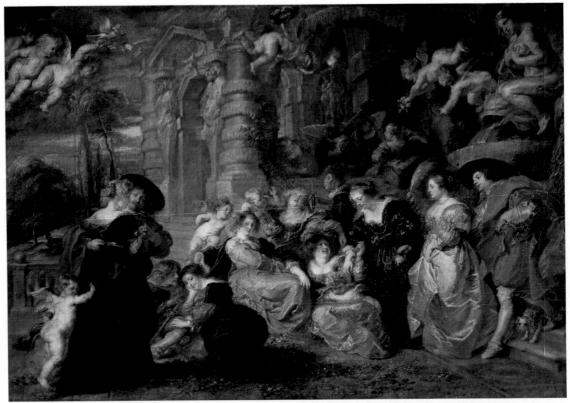

264. Peter Paul Rubens. The Garden of Love. c. 1632-34. Oil on canvas, 6'6" × 9'31/2". The Prado, Madrid

best of both worlds: at court, he was valued not only as an artist but as a diplomat, so that he had entree to the royal households of the major powers, while he was also free to carry out a vast volume of work for the city of Antwerp, for the Church, and for private patrons.

The Raising of the Cross (fig. 262), the first major altarpiece Rubens produced after his return, shows strikingly how much he owed to Italian art. The muscular figures, modeled to display their physical power and passionate feeling, recall the Sistine Ceiling and the Farnese Gallery; the lighting suggests Caravaggio's. The panel is more heroic in scale and conception than any previous Northern work, yet Rubens is also a meticulous Flemish realist in such details as the foliage, the armor of the soldier, and the curly-haired dog in the foreground. These varied elements, integrated with sovereign mastery, form a com-

position of tremendous dramatic force. The unstable pyramid of bodies, swaying precariously, bursts the limits of the frame in a characteristically Baroque way, making the beholder feel that he, too, participates in the action.

In the 1620s, Rubens' dynamic style reached a climax in his huge decorative schemes for churches and palaces. The most famous is the cycle for the Luxembourg Palace in Paris, glorifying Marie de' Medici, the widow of Henri IV and the mother of Louis XIII. Figure 263 shows the artist's oil sketch for one episode, the young queen landing in Marseilles. Hardly an exciting subject—yet Rubens has turned it into a spectacle of unprecedented splendor. As Marie de' Medici walks down the gangplank, Fame flies overhead sounding a triumphant blast on two trumpets, and Neptune rises from the sea

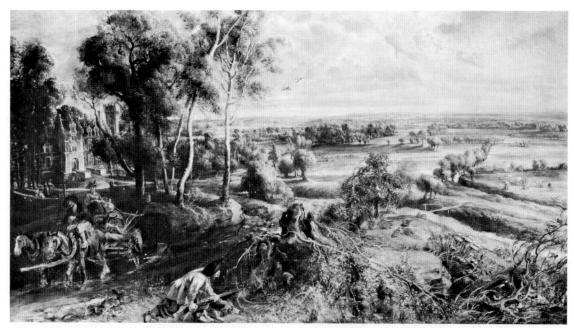

265. Peter Paul Rubens. Landscape with the Château of Steen. 1636. Panel, $4'5'' \times 7'9''$. The National Gallery, London (Reproduced by courtesy of the Trustees)

with his fishtailed crew; having guarded the queen's journey, they rejoice at her arrival. Everything flows together here in swirling movement: heaven and earth, history and allegory—even drawing and painting, for Rubens used oil sketches like this one to prepare his compositions. Unlike earlier artists, he preferred to design his pictures in terms of light and color from the very start. This unified vision, approached but never fully achieved by the great Venetians of the previous century, was Rubens' most precious legacy to subsequent painters.

Around 1630, the turbulent drama of Rubens' preceding work changes to a late style of lyrical tenderness inspired by Titian, whom Rubens rediscovered, as it were, in the royal palace while he visited Madrid. The Garden of Love (fig. 264) combines a traditional Northern subject with Titian's Classical mythologies, to create an enchanted realm where myth and reality become one. The picture must have had special meaning for him, since he had just married a beautiful girl of sixteen (his first wife died in 1626). He

also bought a country house, the Château of Steen, and led the leisurely life of a squire. This change induced a renewed interest in landscape painting, which he had practiced only intermittently before. Here, too, the power of his genius is undiminished. In the Landscape with the Château of Steen (fig. 265), a magnificent open space sweeps from the hunter and his prey in the foreground to the mist-veiled hills along the horizon. As a landscapist, Rubens is the heir of both Pieter Bruegel and the Venetians (compare figs. 249, 220), again creating a synthesis from his Northern and Southern sources.

Van Dyck

The only other Flemish Baroque artist to win international stature was Anthony van Dyck, Rubens' most valued assistant. His fame is based mainly on his portraits—for example, the *Portrait of Charles I Hunting* (fig. 266), done while the artist was court painter in England during 1632–41. It might be called a "dismounted equestrian por-

266. Anthony van Dyck. *Portrait of Charles I Hunting*. c. 1635. Oil on canvas, $8'11'' \times 6'11'/2''$. The Louvre, Paris

trait"—less rigid than a formal state portrait, but hardly less grand. Van Dyck has brought the Mannerist court portrait up-to-date, rephrasing it in the language of Rubens and Titian. He created a new aristocratic portrait tradition that continued in England until the late eighteenth century, and had considerable influence on the Continent as well.

Velázquez

In Madrid, Rubens befriended the recently appointed court painter, Diego Velázquez. The superbly gifted young artist had been deeply impressed with the style of Caravaggio; Rubens helped him to discover the beauty of Titian and develop a new fluency and richness. No picture displays Velázquez' mature style more fully than *The Maids of Honor* (fig. 267), which is both a group portrait and an everyday scene. It might be subtitled "the artist in his studio," for Velázquez shows

himself at work on a huge canvas; in the center is the little Princess Margarita, who has just posed for him, among her playmates and maids of honor. The faces of her parents, the king and queen, appear in the mirror on the back wall. Have they just stepped into the room, to see the scene exactly as we do, or does the mirror reflect part of the canvaspresumably a full-length portrait of the royal family—on which the artist has been working? This ambiguity is characteristic of Velázquez' fascination with light. The varieties of direct and reflected light in The Maids of Honor are almost limitless, and the artist challenges us to find them: we are expected to match the mirror image against the paintings on that wall, and against the "picture" of the man in the open doorway. The side lighting (from the right) and the strong contrasts of light and dark still suggest the influence of Caravaggio, but Velázquez' technique is far more varied and subtle, with delicate glazes setting off the impasto of the highlights, and brushwork even freer and more sketchy than that of Titian or Rubens. The colors, too, have a Venetian warmth and brilliance. Yet Velázquez does not seem interested in catching time on the wing; his aim is to show not figures in motion but the movement of light itself and the infinite range of its effects on form and color. For Velázquez, light creates the visible world. Not until two centuries later shall we meet painters capable of realizing the implications of this discovery.

The Golden Age of Dutch Painting

In contrast to Flanders, where painting was overshadowed by the majestic personality of Rubens, Holland produced a bewildering variety of masters and styles. The new nation was proud of its hard-won freedom. Though the cultural links with Flanders remained strong, several factors encouraged the rapid growth of Dutch artistic traditions. Unlike Flanders, where all artistic activity radiated from Antwerp, Holland had many flourishing local schools: besides Amsterdam, the commercial center, we find important groups of painters in Haarlem, Utrecht, Leyden, Delft, and other towns. Holland was a nation of merchants, farmers, and seafarers, and the Reformed faith was its official religion; thus Dutch artists lacked the large-scale public commissions sponsored by State and Church that were available throughout the Catholic world. As a consequence, the private collector now became the painter's chief source of support. There was no shrinkage of output; on the contrary, the Dutch public developed so insatiable an appetite for pictures that the whole country became gripped by a kind of collector's mania. Everyone invested in paintings, just as millions of Americans played the stock market in the 1920s. The comparison is not far-fetched, for pictures became an important commodity in Holland, and their trade followed the law of supply and demand. Many artists produced "for the market" instead of relying on commissions from individual patrons. The mechanism of the art

market has been said to raise a barrier between artist and public, and to falsify the "true worth" of the work of art. Such charges, however, are unrealistic: the true worth of a work of art is always unstable, and depends on time and circumstance; even those who believe in timeless values in art will concede that these values cannot be expressed in money. Because the art market reflects the dominant, rather than the most discerning, taste of the moment, works by artists now regarded as mediocre may once have been overpriced; others, highly valued today, seem once to have sold too cheaply. Yet the system that prevailed in antiquity and the Middle Ages, when artists were paid on standards of craftsmanship, was hardly fairer in rewarding aesthetic merit. The market does form a barrier between artist and public, but there are advantages in this as well as drawbacks. To subject the artist to the pressure of supply and demand is not necessarily worse than to make him depend on the favor of princes. The lesser men will tend to become specialists, steadily producing their marketable pictures, while artists of independent spirit, perhaps braving economic hardship, will paint as they please and rely for support on the discerning minority. From the collector's mania in seventeenth-century Holland came an outpouring of artistic talent comparable only to Early Renaissance Florence, although many Dutchmen were lured into becoming painters by hopes of success that failed to come true.

268. Frans Hals. The Jolly Toper. 1627. Oil on canvas, $31\% \times 26\%$. Rijksmuseum, Amsterdam

Even the greatest masters were sometimes hard-pressed (it was not unusual for an artist to keep an inn, or run a small business on the side). Yet they survived—less secure, but freer.

Hals; Leyster

The Baroque style came to Holland from Antwerp, through the work of Rubens, and from Rome, through direct contact with Caravaggio and his followers, some of whom were

269. Frans Hals. The Women Regents of the Old People's Home at Haarlem. 1664. Oil on canvas, $5'7'' \times 8'2''$. Frans Hals Museum, Haarlem

Dutchmen. One of the first to profit from this experience was Frans Hals, the great portrait painter of Haarlem. He was born in Antwerp, and what little is known of his early work suggests the influence of Rubens. His mature style, however, seen in such pictures as The Jolly Toper (fig. 268), combines Rubens' robustness and breadth with a concentration on the "dramatic moment" that was derived from the followers of Caravaggio who had settled in Utrecht. Everything here conveys complete spontaneity: the twinkling eves and the half-open mouth, the raised hand, the teetering wineglass, and-most important of all—the quick way of setting down the forms. Hals works in dashing brushstrokes, each so clearly visible as a separate entity that we can almost count the total number of "touches." With this open, split-second technique, the completed picture has the immediacy of a sketch. The impres270. Judith Leyster. Boy with Flute. 1630–35. Oil on canvas, 29½"×24¼". National Museum, Stockholm

sion of a race against time is, of course, deceptive; Hals spent hours, not minutes, on this lifesize canvas, but he maintains the illusion of having done it in the wink of an eye. In the artist's last canvases these pictorial fireworks are transmuted into an austere style of great emotional depth. His group portrait, The Women Regents of the Old People's Home at Haarlem (fig. 269), the institution where he spent his final years, has an insight into human character matched only in Rembrandt's late style (compare fig. 272). The daily experience of suffering and death has so etched the faces of these women that they seem themselves to have become images of death—gentle, inexorable, and timeless.

Hals' virtuosity was such that it could not

be imitated readily, and his followers were necessarily few. The only one of importance was Judith Leyster. Like many women artists before modern times, her career was partially curtailed by motherhood. Leyster's enchanting Boy with Flute is her masterpiece (fig. 270). The rapt musician is a memorable expression of a lyrical mood. To convey this mood, the artist investigates the poetic quality of light with a quiet intensity that anticipates the work of Jan Vermeer a generation later (see p. 271).

Rembrandt

Rembrandt, the greatest genius of Dutch art, was, like Hals, stimulated at the beginning of

271. Rembrandt. The Blinding of Samson. 1636. Canvas, 7'9"×9'11". Staedel Institute, Frankfurt

272. Rembrandt. Self-Portrait. c. 1660. Oil on canvas, 45×38 ". The Iveagh Bequest, Kenwood, London

his career by indirect contact with Caravaggio; his earliest pictures are small, sharply lit, and intensely realistic. From these he developed, in the 1630s, a full-blown High Baroque style. The Blinding of Samson (fig. 271) shows us the Old Testament world in Oriental splendor and violence, cruel yet seductive. The sudden flood of brilliant light pouring into the dark tent is unabashedly theatrical, heightening the drama to the pitch of Rubens' Raising of the Cross (see fig. 262).

Rembrandt was at this time an avid collector of Near Eastern paraphernalia, which serve as props in these pictures. He was now Amsterdam's most sought-after portrait painter and a man of considerable wealth. This prosperity petered out in the 1640s, although the artist's fall from public favor was less sudden and catastrophic than his romantic admirers would have us believe. Still, the 1640s were a period of crisis, of inner uncertainty and external troubles. Rembrandt's outlook changed profoundly: after about 1650, his style eschews the rhetoric of the

High Baroque for lyric subtlety and pictorial breadth. We sense the difference in his late *Self-Portrait* (fig. 272). While partially indebted to Titian's sumptuous portraits (compare fig. 222), Rembrandt scrutinizes himself with the same typically Northern frankness found in Jan van Eyck's *Man in a Red Turban* (see fig. 170). This self-analytical approach accounts for the simple dignity we see in the artist toward the end of his life.

In his later years, Rembrandt often adapted, in a very personal way, pictorial ideas from the Northern Renaissance, as in The Polish Rider (fig. 274). We cannot be sure that the rider is Polish—the title was given to him later—although his costume is of the kind worn by the local troops then fighting the Turks in Eastern Europe; nor is Rembrandt's exact purpose clear. But Dürer's famous engraving Knight, Death, and Devil (see fig. 242), which Rembrandt surely admired, may be the key to the picture. Is not the Polish Rider another Christian Soldier bravely making his way through a perilous world? The dangers in this case are ours to imagine in the gloomy landscape, but the rider's serious, alert glance suggests unseen threats. With such a relationship of form and content, the differences between the painting and the print make a rewarding study. Dürer's horseman, boxed into the composi-

273. Rembrandt. *Christ Preaching*. c. 1652. Etching. The Metropolitan Museum of Art, New York (Bequest of Mrs. H. O. Havemeyer, 1929)

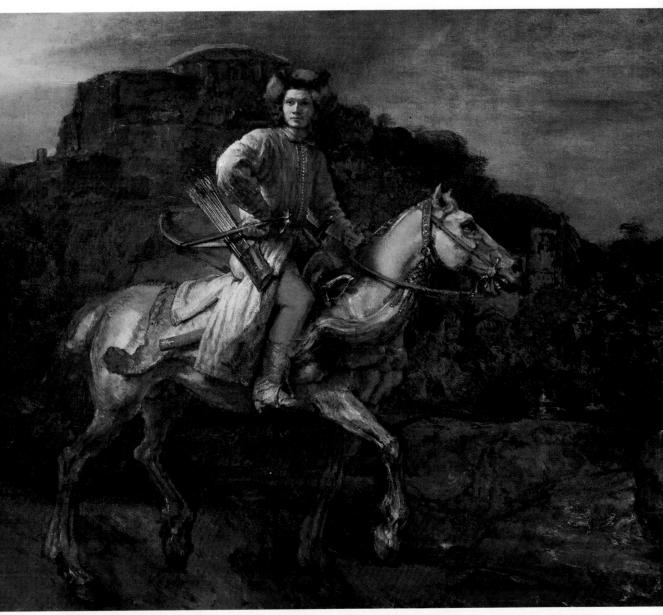

274. Rembrandt. The Polish Rider. c. 1655. Oil on canvas, $46 \times 53''$. The Frick Collection, New York (Copyright)

tion, is balanced and stationary like an equestrian statue; Rembrandt's, slightly foreshortened and off center, is in motionurged on, as it were, by the light from the left. The curving path he follows will soon lead him beyond the frame. This subtle imbalance implies a space far vaster than the compass of the picture and stamps Rembrandt's work as Baroque, despite the absence of the more obvious hallmarks of the style. Much the same may be said of the religious scenes that play so large a part in Rembrandt's later work, such as the etching Christ Preaching (fig. 273). It is a quiet scene, full of the artist's deep feeling of compassion for the poor and outcast who make up Christ's audience. Rembrandt had a special sympathy for the Jews, as the heirs of the biblical past and as the patient victims of persecution; they were often his models. This print strongly suggests some corner in the Amsterdam ghetto. As in *The Polish Rider*, it is the magic of Rembrandt's light that endows *Christ Preaching* with spiritual significance.

Rembrandt's importance as a graphic artist is second only to Dürer's, although we get no more than a hint from this single example. But we must add a word about his medium. By the seventeenth century, the techniques of woodcut and engraving were employed mainly to reproduce other works. The creative printmakers, including Rembrandt, preferred etching. An etching is made by coating a copper plate with resin to make an acid-resistant "ground," through which the design is scratched with a needle, laying bare the metal surface underneath. The plate is

then bathed in an acid that etches ("bites") the lines into the copper. To scratch a design into the resinous ground is, of course, an easier task than cutting it into the copper plate directly, hence an etched line is freer and more individual than an engraved line. The chief virtue of etching is its wide tonal range, including velvety dark shades not possible in engravings or woodcuts. No etcher ever exploited this quality more subtly than Rembrandt.

Van Ruisdael; Heda

Rembrandt's religious pictures demand an insight that was beyond the capacity of all but a few collectors. Most art buyers in Holland preferred subjects within their own experience—landscapes, still lifes, scenes of

275. Jacob van Ruisdael. The Cemetery. c. 1655. Canvas, 4'8" × 6'21/2". The Detroit Institute of Arts

276. Willem Heda. Still Life. 1634. Oil on panel, $17 \times 22^{1/2}$ ". Boymans-van Beuningen Museum, Rotterdam

everyday life. These were produced in ever greater volume and variety by specialists, so that we can here illustrate only a small sampling. Perhaps the richest of the newly developed "specialties" was landscape, both as a portrayal of familiar views and as an imaginative vision of nature. Of the latter kind is The Cemetery (fig. 275) by Jacob van Ruisdael: the thunderclouds passing over a wild, deserted mountain valley, the medieval ruin, the torrent that has forced its way between ancient graves, all create a mood of deep melancholy. Nothing endures on this earth, the artist tells us-time, wind, and water grind all to dust, the feeble works of man as well as the trees and rocks. This view of man's impotence in the face of natural forces has an aweinspiring quality on which the Romantics, a century later, were to base their concept of the Sublime. Even still life can be tinged with a melancholy sense of the passing of all earthly pleasures, sometimes through such established symbols as death's-heads and extinguished candles, or by more subtle means. Our example by Willem Heda (fig. 276) belongs to a widespread type, the "breakfast piece," showing the remnants of a meal. Food and drink are less emphasized than luxury objects—crystal goblets and silver dishes carefully juxtaposed for their contrasting shape, color, and texture. But virtuosity was

Steen; Vermeer

The pictures of everyday life (also known as "genre" pictures) range from tavern brawls to refined domestic interiors. The Eve of St. Nicholas (fig. 277) by Jan Steen is midway between these extremes. St. Nicholas has just paid his pre-Christmas visit to the household, leaving toys, candy, and cake for the children; everyone is jolly except the bad boy on the left, who has received only a birch rod. Steen tells this story with relish, embroidering it with many delightful details. Of all the Dutch painters of daily life, he was the sharpest, and most good-humored, observer. To supplement his earnings he kept an inn, which perhaps explains his keen insight into human behavior. His sense of timing often reminds us of Frans Hals (compare fig. 268), while his storytelling stems from the tradition of Pieter Bruegel (compare fig. 248).

In the genre scenes of Jan Vermeer, by contrast, there is hardly any narrative. Single figures, usually women, engage in simple, everyday tasks; when two are present, as in *The Letter* (fig. 278), they no more than exchange glances. They exist in a timeless "still-life" world, seemingly calmed by some magic spell. The cool, clear light that filters in from the left is the only active element, working its miracles upon all the objects in its path. As we look at *The Letter*, we feel as if a veil had been pulled from our eyes; the everyday world shines with jewel-like freshness, beautiful as we have never seen it before. No painter since Jan van Eyck *saw* as

277. Jan Steen. The Eve of St. Nicholas. c. 1660–65. Canvas, $32\frac{1}{4} \times 27\frac{3}{4}$ ". Rijksmuseum, Amsterdam

intensely as this. But Vermeer, unlike his predecessors, perceives reality as a mosaic of colored surfaces—or, perhaps more accurately, he translates reality into a mosaic as he puts it on canvas. We see *The Letter* as a perspective "window," but also as a plane, a

"field" composed of smaller fields. Rectangles predominate, carefully aligned with the picture surface, and there are no "holes," no undefined empty spaces. These interlocking shapes give to Vermeer's work a uniquely modern quality. How did he acquire it? We

278. Jan Vermeer. The Letter. 1666. Oil on canvas, $17\frac{1}{4} \times 15\frac{1}{4}$ ". Rijksmuseum, Amsterdam (see colorplate on title page)

know little about him except that he was born in Delft in 1632 and lived and worked there until his death at forty-three. The Dutch followers of Caravaggio had influenced him but this is hardly enough to explain the genesis of his style, so daringly original that his genius was not recognized until a century ago.

The Age of Versailles

Our discussion of Baroque art in Flanders, Spain, and Holland has been limited to painting; architecture and sculpture in these countries have no basic importance for the history of art. In France, however, the situation is different. Under Louis XIV France became the most powerful nation of Europe, militarily and culturally; by the late seventeenth century, Paris had replaced Rome as the world capital of the visual arts. How did this astonishing change come about? Because of the Palace of Versailles and other vast projects glorifying the king, we are tempted to think of French art in the age of Louis XIV as the expression of absolutism. This is true of the climactic phase of Louis' reign, 1660-85,

but by that time French seventeenth-century art had already formed its distinctive style. Frenchmen are reluctant to call this style Baroque; to them it is the Style of Louis XIV; often they also describe the art and literature of the period as "Classic." The term, so used, has three meanings: as a synonym for "highest achievement," it implies that the style of Louis XIV corresponds to the High Renaissance in Italy, or the age of Pericles in Greece; the term also refers to the emulation of the form and subject matter of ancient art; finally, "Classic" suggests qualities of balance and restraint, like those of the Classic styles of the High Renaissance and of ancient Greece. The second and third of these mean-

279. Louis Le Nain. Peasant Family. c. 1640. Canvas, $44\frac{1}{2} \times 62\frac{1}{2}$ ". The Louvre, Paris

ings describe what could be called, more accurately, "Classicism." And since the Style of Louis XIV reflects Italian Baroque art, however modified, we must label it either "Classicistic Baroque" or "Baroque Classicism."

PAINTING

This Classicism was the official court style by 1660–85, but its origin was not political. It sprang, rather, from the persistent tradition of sixteenth-century art, which in France was more intimately linked with the Italian Renaissance than in any other Northern country (see p. 245). Classicism was also nourished by French humanism, with its intellectual heritage of reason and Stoic virtue. These factors retarded the spread of the Baroque in France and modified its interpretation. Rubens' Medici cycle, for example, had no effect on French art until the very end of the century; in the 1620s, the young painters

280. Georges de La Tour. Joseph the Carpenter. c. 1645. Oil on canvas, $38\frac{1}{2} \times 25\frac{1}{2}$ ". The Louvre, Paris

in France were still assimilating Caravaggio. Some developed astonishingly original styles. Louis Le Nain's Peasant Family (fig. 279) has a human dignity and a compassion for the poor that seem akin to Rembrandt. The candle held by Jesus in Joseph the Carpenter (fig. 280) by Georges de La Tour gives the scene the intimacy and tenderness of Geertgen's Nativity (see fig. 175), in which light also reduces forms to geometric simplicity. Yet both Le Nain and De La Tour, like Vermeer, had to be rediscovered in modern times. In their day both were soon forgotten because from about 1650 on Classicism was supreme in France, and neither was a Classicist.

Poussin; Lorrain

The artist who did most to bring about this change of taste was Nicolas Poussin. The greatest French painter of the century, and the earliest French painter to win international fame, Poussin nevertheless spent almost his entire career in Rome. There, under the inspiration of Raphael (see figs. 218, 219), he formulated the style that was to become the ideal model for French painters of the second half of the century. Its qualities are well displayed in The Rape of the Sabine Women (fig. 281): the strongly modeled figures are "frozen in action," like statues, and many are in fact derived from Hellenistic sculpture (compare fig. 64). Behind them, Poussin has placed reconstructions of Roman architecture that he believed to be archaeologically correct. As in Giovanni Bologna's statue of the same subject (see fig. 236), emotion is abundantly in evidence, yet it so lacks spontaneity that it fails to touch us. All sensuous appeal has been consciously suppressed from the severe discipline of an intellectual style. Poussin strikes us as a man who knew his own mind only too well, an impression confirmed by the numerous letters in which he expounded his views. The highest aim of painting, he believed, is to represent noble

281. Nicolas Poussin. The Rape of the Sabine Women. c. 1636–37. Oil on canvas, $5'1'' \times 6'10^{1/2}''$. The Metropolitan Museum of Art, New York (Dick Fund, 1946)

and serious human actions. These must be shown in a logical and orderly way-not as they really happened, but as they would have happened if nature were perfect. To this end, the artist must strive for the general and typical; appealing to the mind rather than the senses, he suppresses such trivialities as glowing color, and stresses form and composition. In a good painting, the beholder should be able to "read" the exact emotions of each figure, and relate them to the event depicted. These ideas were not new—we recall Leonardo's statement that the highest aim of painting is to portray "the intention of man's soul"-but before Poussin no one had made the analogy between painting and literature so closely nor put it into practice so singlemindedly.

Poussin even painted landscapes according

to this theoretical view, with surprisingly impressive results. The careful order of the spaces in *Landscape with the Burial of Phocion* (fig. 282) is almost mathematically precise. Yet the effect of rational clarity has a somber calm. This mood is attuned to Poussin's theme, the burial of a Greek hero who died because he refused to conceal the truth: the landscape becomes itself a memorial to Stoic virtue. Although we may no longer read the scene so specifically, we still respond to its austere beauty.

282. (opposite above) Nicolas Poussin. Landscape with the Burial of Phocion. 1648. Oil on canvas, $44\% \times 68\%$ ". The Louvre, Paris

283. (opposite below) Claude Lorrain. A Pastoral. c. 1650. $15\% \times 21\%$ ". Yale University Art Gallery, New Haven, Connecticut

If Poussin celebrated the heroic aspects of antiquity, the great French landscapist Claude Lorrain brought out its idyllic aspects. He, too, spent almost his entire career in Rome, and explored the countryside nearby-the Campagna-more thoroughly and affectionately than any Italian. Countless drawings, each made on the spot, bear witness to his extraordinary powers of observation. These sketches, however, were only the raw material for his paintings, which do not aim at topographic exactitude but evoke the poetic essence of a countryside filled with echoes of antiquity. Often, as in A Pastoral (fig. 283), the compositions are suffused with the hazy, luminous atmosphere of early morning or late afternoon; the space expands serenely, rather than receding step-by-step as in Poussin's landscapes. An air of nostalgia hangs over such vistas, of past experience gilded by memory; hence they appealed especially to Northerners who had seen Italy only briefly—or, perhaps, not at all.

ARCHITECTURE

In France itself, meanwhile, Baroque Classicism in architecture became the official "royal style" when young Louis XIV took over the reins of government in 1661. Colbert, the king's chief adviser, built the administrative apparatus supporting the power of the absolute monarch. In this system, aimed at subjecting the thoughts and actions of the entire nation to strict control from above, the visual arts had the task of glorifying the king. The painter Charles Lebrun became supervisor of all the king's artistic projects. As chief dispenser of royal art patronage, he commanded so much power that for all practical purposes he was the dictator of the arts in France. Centralized control over the visual arts was exerted by Lebrun not only through the power of the purse; it also included a new system of educating artists in the officially approved style. In antiquity and the Middle Ages, artists had been trained by apprenticeship, and this time-honored practice still prevailed in the Renaissance. But as artists gained a liberal-arts status (see p. 190), they wished to supplement their "mechanical" training with theoretical knowledge. For this purpose, they founded "art academies," patterned after the academies of the humanists (the name is derived from the grove of Academe where Plato met with his disciples). Art academies first appeared in Italy; they seem to have been private associations of artists who met periodically to draw from the model and discuss questions of art theory. Later, these academies took over some functions from the guilds, but their teaching was limited and far from systematic. Such was the Royal Academy of Painting and Sculpture in Paris, founded in 1648; when Lebrun became its director, in 1663, he established a rigid curriculum of compulsory instruction in practice and theory, based on a system of "rules"; this set the pattern for all later academies, including their modern successors, the art schools of today. Much of this body of doctrine was derived from Poussin's views but carried to rationalistic extremes. The Academy even devised a method of tabulating, in numerical grades, the merits of artists past and present in such categories as drawing, expression, and proportion. The ancients received the highest marks, needless to say, then came Raphael and Poussin; the Venetians, who overemphasized color, ranked low, and the Flemish and Dutch lower still. Subjects were similarly classified, from history (Classical or biblical) at the top to still life at the bottom.

That Louis XIV's choice of Classicism was deliberate we know from the first great project of his reign, the completion of the Louvre. Work on the palace had proceeded intermittently for over a century, along the lines of Lescot's design (see fig. 250); what remained to be done was to close the court on the east side with an impressive façade. Colbert invited Bernini to Paris, hoping the famous mas-

284. Claude Perrault. East front, the Louvre, Paris. 1667-70

ter of the Roman Baroque would do for the French king what he had already done so magnificently for the Church. Bernini submitted three designs, all on a scale that would have dwarfed the existing parts of the palace. After much argument and intrigue, Louis XIV rejected these plans, and turned over the problem to a committee of three: Louis Le Vau, his court architect, who had worked on the project before; Charles Lebrun, his court painter; and Claude Perrault, who was a student of ancient architecture, not a professional architect. All three were responsible for the structure that was actually built (fig. 284), although Perrault is usually credited with the major share. The design in some ways suggests the mind of an archaeologist, but one who knew how to select those features of Classical architecture that would link Louis XIV with the glory of the Caesars and yet be compatible with the older parts of the palace. The center pavilion is a Roman temple front, and the wings look like the flanks of that temple folded outward to form one plane. The temple theme demanded a single order of freestanding columns, yet the Louvre had three stories—a difficulty skillfully resolved by treating the ground story as the base of the temple, and recessing the upper two behind the screen of the colonnade.

The entire design combines grandeur and elegance in a way that fully justifies its fame.

Ironically, this great exemplar of Classicism proved too pure. Perrault soon faded from the architectural scene, and Baroque

285. Jules Hardouin-Mansart, Charles Lebrun, and Antoine Coysevox. Salon de la Guerre, Palace of Versailles. Begun 1678

features reappeared in the king's vastest enterprise, the Palace of Versailles, Louis XIV himself was less interested in architectural theory and monumental exteriors than in the lavish interiors that would make appropriate settings for himself and his court. The man to whom he really listened was not an architect. but the painter Lebrun. Lebrun had studied under Poussin in Rome, but the great decorative schemes of the Roman Baroque must also have impressed him. He became a superb decorator, utilizing the combined labors of architects, sculptors, painters, and craftsmen for ensembles of unheard-of splendor, such as the Salon de la Guerre at Versailles (fig. 285). To subordinate all the arts to a single goal-here, the glorification of Louis XIV—was in itself Baroque: if Lebrun went less far than Bernini, he nevertheless drew freely on his memories of Rome. The Salon de la Guerre seems in many ways closer to Burnacini's stage design (see fig. 259) than to Perrault's Louvre façade. And, as in so many Italian Baroque interiors, the separate ingredients are less impressive than the effect of the whole.

The Palace of Versailles, just over eleven miles from the center of Paris, was begun by Le Vau. After his death, the entire project, under Jules Hardouin-Mansart, was vastly expanded to accommodate the ever-growing royal household. The Garden Front, intended as the principal view of the palace, was stretched to enormous length (fig. 286), so that the façade design, a less severe variant of Perrault's Louvre colonnade, looks repetitious and out of scale. The whole center block contains a single room, the famous Hall of Mirrors, with the Salon de la Guerre and its counterpart, the Salon de la Paix, at either end. Apart from its magnificent interior, the most impressive aspect of Versailles is the park extending west of the Garden Front for several miles (the aerial view in figure 286 shows only a small portion). Its design, by André Le Nôtre, is so strictly correlated with the plan of the palace that it becomes a continuation of the architectural space. Like the interior of Versailles, these formal gardens, with their terraces, basins, clipped hedges, and statuary, were meant to provide an appropriate setting for the king's appearances

286. Louis Le Vau and Jules Hardouin-Mansart. Palace of Versailles (aerial view from the west). 1669–85. (Gardens by André Le Nôtre, 1664–72)

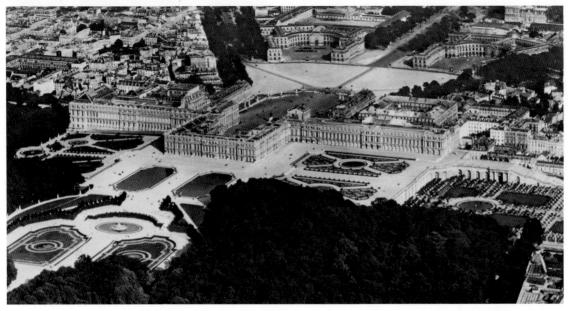

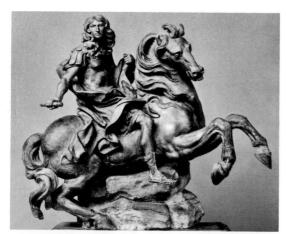

287. Gianlorenzo Bernini. *Model for Equestrian Statue of Louis XIV*. 1670. Terra-cotta, height 30". Borghese Gallery, Rome

in public. The spirit of absolutism is even more striking in this geometric regularity imposed upon an entire countryside than it is in the palace itself.

SCULPTURE

The official "royal style" was attained in sculpture by a process much like that in architecture. Bernini, while in Paris, had carved a marble bust of Louis XIV, and had also been commissioned to do an equestrian statue of the king. This project, for which he made a splendid terra-cotta model (fig. 287), shared the fate of his Louvre designs. Although he portrayed the king in Classical military garb, the statue was rejected; apparently it was too dynamic to safeguard the dignity of Louis XIV. This decision was farreaching, for equestrian statues of the king were later erected throughout France as symbols of royal authority, and Bernini's design, had it succeeded, might have set the

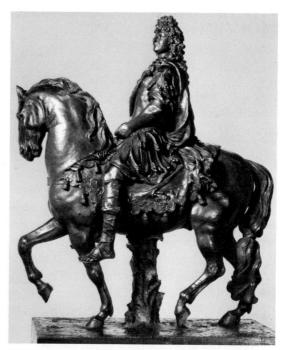

288. François Girardon. *Model for Equestrian Statue of Louis XIV*. 1687? Wax, height 30¹/₄". Yale University Art Gallery, New Haven, Connecticut (Gift of Mr. and Mrs. James W. Fosburgh, 1933)

pattern for these monuments. They were all destroyed in the French Revolution; we know them only from engravings, reproductions, and such models as that by François Girardon (fig. 288), who also did much garden sculpture at Versailles. Characteristically, this is an adaptation of the equestrian Marcus Aurelius on the Capitoline Hill (see fig. 76). While it may look static—lame, in fact next to Bernini's design, its Baroque qualities show up clearly in comparison with its ancient prototype: the fluid modeling, the windblown movement of the king's cloak. There is even a hint at an "invisible complement"-instead of looking at us, the king raises his head and leans back as if communicating with some celestial power.

Rococo

Architecture: Germany and France

The ultimate development of the style invented by Borromini took place north of the Alps, in Austria and southern Germany. In these countries, ravaged by the Thirty Years' War, there was little building activity until near the end of the seventeenth century; Baroque was an imported style, practiced mainly by visiting Italians. Not until the 1690s did native designers come to the fore. There followed a fifty-year period of intense activity that gave rise to some of the most imaginative creations in the history of architecture. We must be content with a small sampling of these monuments, erected for the glorification of princes and prelates who, generally speaking, deserve to be remembered only as lavish patrons of the arts. Johann Fischer von Erlach, the first great architect of the Late Baroque in Central Europe, is linked most directly to the Italian tradition. His design for the Church of St. Charles Borromaeus in Vienna (fig. 289) combines reminiscences of the exterior of St. Peter's and the portico of the Pantheon with a pair of huge columns which here substitute for facade towers. With these inflexible elements of Roman imperial art embedded in the elastic curvatures of his church, Fischer von Erlach expresses, more boldly than any Italian Baroque architect, the power of the Christian faith to absorb and transfigure the splendors of antiquity.

The architects of the next generation, among whom Balthasar Neumann was the most prominent, favored a tendency toward lightness and elegance. Neumann's largest project, the Episcopal Palace in Würzburg, includes the breathtaking Kaisersaal (fig. 290), a great oval hall decorated in white, gold, and pastel shades—the favorite color

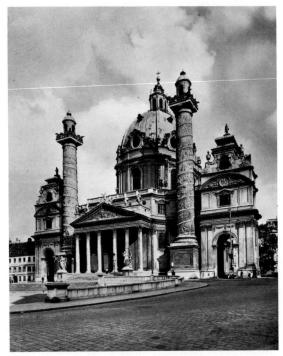

289. (above) Johann Fischer von Erlach. St. Charles Borromaeus, Vienna. 1716–37

290. (opposite) Balthasar Neumann. The Kaisersaal, Episcopal Palace, Würzburg. 1719–44

scheme of the mid-eighteenth century. The structural members, such as columns, pilasters, and architraves, are minimized; windows and vault segments are framed with continuous, ribbon-like moldings, and the white surfaces are spun over with irregular ornamental designs. This repertory of lacy, curling motifs, invented in France about 1700, is the hallmark of the Rococo style, which is here happily combined with German Late Baroque architecture. The membrane-like ceiling so often gives way to illusionistic openings of every sort that we no longer feel

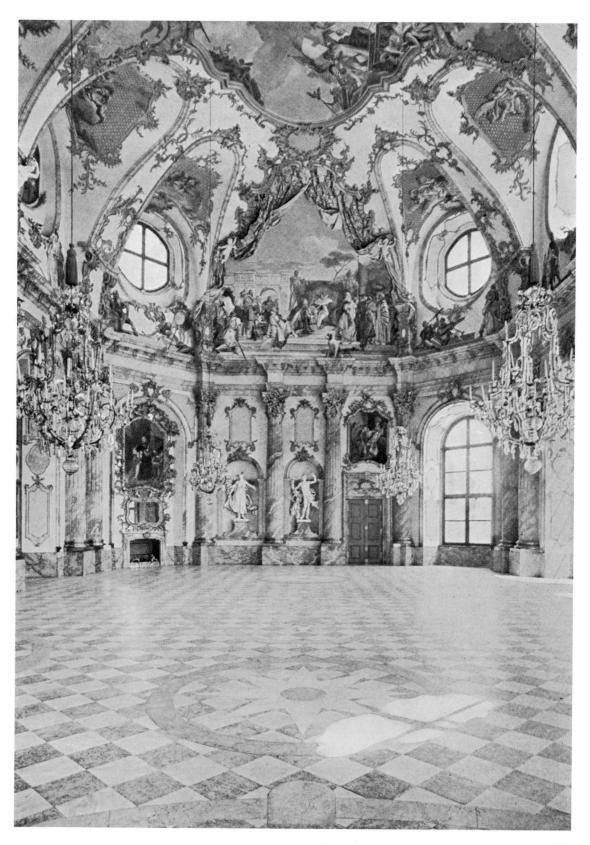

291. Giovanni Battista Tiepolo. Ceiling fresco (detail). 1751. The Kaisersaal, Episcopal Palace, Würzburg

292. Germain Boffrand. Salon de la Princesse, Hôtel de Soubise, Paris. Begun 1732

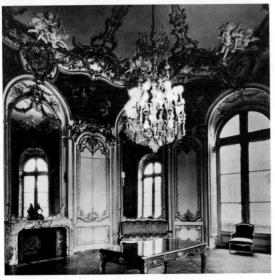

it to be a spatial boundary. These openings do not, however, reveal avalanches of figures amid dramatic bursts of light, like those of Roman ceilings (compare fig. 255), but blue sky and sunlit clouds, and an occasional winged creature soaring in this limitless expanse. Only along the edges are there solid clusters of figures (fig. 291). Here the last, and most refined, stage of illusionistic ceiling decoration is represented by its greatest master, Giovanni Battista Tiepolo. Venetian by birth and training, Tiepolo blended the tradition of High Baroque illusionism with the pageantry of Veronese. His mastery of light and color, the grace and felicity of his touch, made him famous far beyond his home territory. In the Würzburg frescoes his powers are at their height. He was afterward invited to decorate the Royal Palace in Madrid, where he spent his final years.

In France after the death of Louis XIV, the centralized administrative machine that Colbert had created ground to a stop. The nobility, hitherto attached to the court at Versailles, were now freer of royal surveillance. Many of them chose not to return to their ancestral homes in the provinces, but to live in Paris, where they built themselves elegant town houses, known as hôtels. Because these city sites were usually cramped and irregular, they offered scant opportunity for impressive exteriors; the layout and décor of the rooms became the architects' main concern. As the state-sponsored buildings became fewer, the field of "design for private living" took on new importance. The hôtels demanded a style of decoration less grandiloquent than Lebrun's—an intimate, flexible style that would give greater scope to individual fancy uninhibited by Classicistic dogma. French designers created the Rococo style in response to this need. Rococo was a refinement in miniature of the curvilinear, "elastic" Baroque of Borromini and Guarini, and thus could be happily united with Austrian and German Late Baroque architecture. In France, most examples of the style, such as the Salon de la Princesse in the Hôtel de Soubise, by Germain Boffrand (fig. 292), are smaller in scale and less exuberant than those in Central Europe; the ceiling frescoes

and the decorative sculpture in palaces and churches are unsuited to domestic interiors, however lavish. We must therefore remember that in France, Rococo painting and sculpture were less closely linked with their architectural settings than in Italy, Austria, and Germany, although they reflect the same taste that produced the Hôtel de Soubise.

Painting: France

It is hardly surprising that the straitjacket of the French academic system produced no significant artists. Its absurd rigidity generated a counterpressure that vented itself as soon as Lebrun's authority began to decline. Toward 1700, the members of the Academy formed two warring factions over the issue of drawing versus color: the conservatives (or "Poussinistes") against the "Rubénistes." The former defended Poussin's view that drawing, which appealed to the mind, was superior to color, while the latter advocated color as being more true to nature. They also pointed out that drawing, admittedly based on reason, appeals only to the expert few, whereas color appeals to everyone. This argument had revolutionary implications, for it proclaimed the layman to be the ultimate judge of artistic values, and challenged the Renaissance view that painting, as a liberal art, could be appreciated only by the educated mind. In 1717, soon after Louis XIV's death, the "Rubénistes" scored a final triumph when Antoine Watteau was admitted to the Academy on the basis of A Pilgrimage to Cythera (fig. 293). This picture violated all academic canons, and its subject did not conform to any established category. But the Academy, now very accommodating, invented for Watteau the new category of fêtes galantes (elegant fetes or entertainments). The term refers less to this one canvas than to the artist's work in general, which mainly shows scenes of elegant society, or comedy actors, in parklike settings. He characteristically interweaves theater and real life so that no

clear distinction can be made between the two. The Pilgrimage includes yet another element, Classical mythology: these young couples have come to Cythera, the island of love. to pay homage to Venus (whose garlanded image appears on the far right). As the enchanted day draws to a close, they are about to go aboard the boat, accompanied by swarms of cupids, and be transported back to the everyday world. The style at once recalls Rubens' Garden of Love (see fig. 264), but Watteau adds a poignant touch, a poetic subtlety of his own. His figures have not the robust vitality of Rubens': slim and graceful. they move with the studied assurance of actors who play their roles so superbly that they touch us more than reality ever could.

Watteau signals the shift in French art and French society. Most subsequent French Rococo painting follows the "Rubéniste" style of Watteau, intimate in scale and deliciously sensual in style and subject, although without the emotional depth that distinguishes Watteau's art. The finest painter in this vein was Jean Honoré Fragonard; his Bathers (fig. 294) must here suffice to represent its class. A franker "Rubéniste" than Watteau, Fragonard paints with a fluid breadth and spontaneity reminiscent of Rubens' oil sketches (see fig. 263). His figures move with a floating grace that also links him with Tiepolo, whose work he had admired in Italy (compare fig. 291).

Yet there were other painters whose style can be termed Rococo only with reservations, such as Jean Baptiste Siméon Chardin. The "Rubénistes" had cleared the way for a new interest in the Dutch masters as well, and Chardin was the finest painter of still life and genre representing this trend. His genre scenes, such as *Back from the Market* (fig. 295), show life in a Parisian middle-class household with such feeling for the beauty hidden in the commonplace, and so clear a sense of spatial order, that we can compare him only to Vermeer. But his remarkable technique is quite unlike any Dutch artist's.

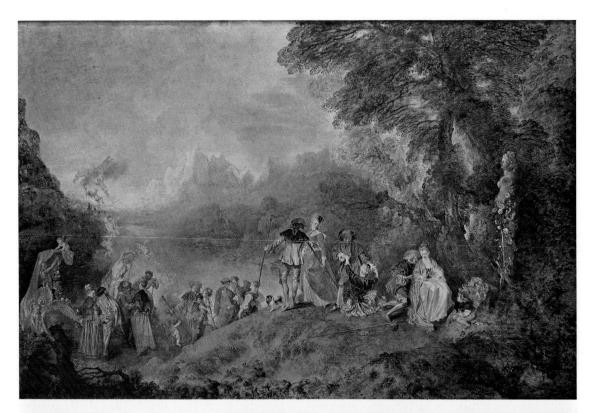

293. (opposite above) Antoine Watteau. A Pilgrimage to Cythera. 1717. Oil on canvas, $4'3'' \times 6'4\frac{1}{2}''$. The Louvre, Paris

294. (opposite below) Jean Honoré Fragonard. Bathers. c. 1765. Oil on canvas, $25\frac{1}{4} \times 31\frac{1}{2}$ ". The Louvre, Paris

295. (below) Jean Baptiste Siméon Chardin. Back from the Market. 1739. Oil on canvas, $18\frac{1}{2} \times 14\frac{3}{4}$ ". The Louvre, Paris

Devoid of brayura, his brushwork renders the light on colored surfaces with a creamy touch that is both analytical and subtly poetic. His still lifes usually reflect the same modest environment, eschewing the "object appeal" of their Dutch predecessors. In the example shown in figure 296, we see only the common objects that belong in any kitchen: earthenware jugs, a casserole, a copper pot, a piece of raw meat, smoked herring, two eggs. But how important they seem, each so firmly placed in relation to the rest, each so worthy of the artist's—and our—scrutiny! Despite his concern with formal problems, evident in the beautifully balanced design, Chardin treats these objects with a respect close to reverence. More than shapes, colors, and textures, they are to him symbols of the life of the common man. In spirit, if not in subject matter. Chardin is more akin to Louis Le Nain than to any Dutch painter.

It is from portraits that we can gain the clearest understanding of the French Rococo, for the transformation of the image of man lies at the heart of the era. In portraits of the aristocracy, men were endowed with the illusion of character as a natural attribute of their station in life, stemming from their noble birth. But the finest achievements of Rococo portraiture were reserved for women, hardly a surprising fact in a society that idol-

296. Jean Baptiste Siméon Chardin. *Kitchen Still Life*. c. 1730–35. Canvas, $12\frac{1}{2}\times15\frac{1}{4}$ ". Ashmolean Museum, Oxford

297. Marie Louise Elizabeth Vigée-Lebrun. *Princesse de Polignac.* 1783. Canvas, $38\% \times 28$ ". The National Trust, Waddesdon Manor

ized the cult of love and feminine beauty. One of the finest practitioners in this vein was herself a beautiful woman: Marie Louise Elizabeth Vigée-Lebrun.

Throughout Vigée's long life she enjoyed great fame, which took her to every corner of Europe—even Russia, when she fled the French Revolution. The Princesse de Polignac (fig. 297) was painted a few years after Vigée had become the portraitist for Queen Marie Antoinette, and it amply demonstrates her ability. The princess has the eternally youthful loveliness of Fragonard's Bathers (see fig. 294), made all the more persuasive by the artist's ravishing treatment of her clothing. At the same time, there is a sense of transience in the engaging mood which exemplifies the Rococo's whimsical theatricality. Interrupted in her singing, the lyrical princess becomes a real-life counterpart to the poetic creatures in Watteau's Pilgrimage to Cythera (see fig. 293), by way of the delicate sentiment she shares with the girl in Chardin's *Back from the Market* (see fig. 295).

Architecture: England

We have not considered English architecture since our discussion of the Perpendicular style (see p. 138). This insular form of Late Gothic proved extraordinarily persistent; it absorbed the stylistic vocabulary of the Italian Renaissance during the sixteenth century, but as late as 1600 English buildings still retained a "Perpendicular syntax." It was the influence of Palladio that finally brought this lingering Gothic tradition to an end, replac-

298. Christopher Wren. West façade, St. Paul's Cathedral, London. 1675–1710

ing it with an equally strong allegiance to Classicism. We can see this Classicism in some parts of St. Paul's Cathedral (fig. 298) by Sir Christopher Wren, the great English architect of the late seventeenth century: the dome looks like a vastly enlarged version of Bramante's Tempietto (see fig. 214). St. Paul's is otherwise an up-to-date Baroque design reflecting a thorough acquaintance with contemporary architecture in Italy and France. Sir Christopher came close to being a Baroque counterpart of the Renaissance artist-scientists. An intellectual prodigy, he studied anatomy first, then physics, mathematics, and astronomy, and was highly esteemed by Sir Isaac Newton. His serious interest in architecture did not begin until he was about thirty. There is, however, apparently no direct link between his scientific and artistic ideas. Had not the great London fire of 1666 destroyed the Gothic Cathedral of St. Paul, and many lesser churches, Sir Christopher might have remained an amateur architect. But after that catastrophe he was named to the royal commission for rebuilding the city, and a few years later he began his designs for St. Paul's. On his only trip abroad, he had visited Paris at the time of the dispute over the completion of the Louvre, and he must have sided with Perrault, whose design for the East Front is clearly reflected in the façade of St. Paul's. Yet, despite his belief that Paris provided "the best school of architecture in Europe," Sir Christopher was not indifferent to the achievements of the Roman Baroque. He must have wanted the new St. Paul's to be the St. Peter's of the Church of England, soberer and less large, but equally impressive.

Painting: England

England never accepted the Rococo style in architecture. French Rococo painting, on the other hand, had a decisive—though unacknowledged—effect across the Channel and helped to bring about the first school of En-

glish painting since the Middle Ages that had more than local importance. The earliest of these painters, William Hogarth, made his mark in the 1730s with a new kind of picture, which he described as "modern moral subjects...similar to representations on the stage." He wished to be judged as a dramatist, he said, even though his "actors" could only "exhibit a dumb show." These paintings, and the engravings he made from them for popular sale, came in sets, with details recurring in each scene to unify the sequence. Hogarth's "morality plays" teach, by horrid example, the solid middle-class virtues: they show a country girl who succumbs to the temptations of fashionable London; the evils of corrupt elections; aristocratic rakes who live only for ruinous pleasure, marrying wealthy women of lower status for their fortunes (which they promptly dissipate). In The Orgy (fig. 299), from The Rake's Progress, the young wastrel is overindulging in wine and women. The scene is so full of visual clues that a full account would take pages, plus constant references to adjoining episodes. Yet, however literal-minded, the picture has great appeal. Hogarth combines some of Watteau's sparkle with Jan Steen's narrative gusto, and so entertains us that we enjoy his sermon without being overwhelmed by its message. He is probably the first artist in history to become also a social critic in his own right.

Portraiture remained the only constant source of income for English painters. Here, too, the eighteenth century produced a style that differed from the Continental traditions that had dominated this field ever since the days of Holbein. Its greatest master, Thomas Gainsborough, began by painting land-scapes, but ended as the favorite portraitist of British high society. His early portraits, such as *Robert Andrews and His Wife* (fig. 300), have a lyrical charm that is not always found in his later pictures. Compared to Van Dyck's artifice in *Charles I Hunting* (see fig. 266), these two people, members of the landed gen-

299. William Hogarth. *The Orgy*, scene III from *The Rake's Progress*. c. 1734. Canvas, $24\frac{1}{2} \times 29\frac{1}{2}$ ". Sir John Soane's Museum, London

try, are naturally, and unpretentiously, at home in their setting. The landscape, although derived from Ruisdael and his school, has a sunlit, hospitable air never achieved (or desired) by the Dutch masters; and the casual grace of the figures indirectly recalls Watteau's style. Later portraits by Gainsborough, such as the very fine one of the great actress Mrs. Siddons (fig. 301), have other virtues: a cool elegance that translates Van Dyck's aristocratic poses into late-eighteenth-century terms, and a fluid, translucent technique reminiscent of Rubens. Gainsborough painted Mrs. Siddons in conscious opposition to his great rival on the London scene, Sir Joshua Reynolds, who a

year before had portrayed the same sitter as the Tragic Muse (fig. 302). Reynolds, the president of the Royal Academy since its founding in 1768, was the protagonist of the academic approach to art, which he had acquired during two years in Rome. Like his French predecessors, he formulated in his famous Discourses what he felt were necessary rules and theories. His views were essentially those of Lebrun, tempered by British common sense. Again like Lebrun, he found it difficult to live up to his theories in actual practice. Although he preferred history painting in the grand style, the vast majority of his works are portraits "ennobled," whenever possible, by allegorical additions

300. Thomas Gainsborough. *Robert Andrews and His Wife.* c. 1748–50. Oil on canvas, $27\frac{1}{2}\times47$ ". The National Gallery, London (Reproduced by courtesy of the Trustees)

or disguises like those in his picture of Mrs. Siddons. His style owed a good deal more to the Venetians, the Flemish Baroque, and even to Rembrandt (note the lighting in Mrs. Siddons) than he would concede in theory. While both portraits of Mrs. Siddons are distinctly English in character, their relationship to the Rococo style of France is unmistakable—notice their resemblance to Vigée's Princesse de Polignac (see fig. 297) of almost the same period.

One of the founding members of the Royal Academy was the Swiss-born artist Angelica Kauffmann. She spent fifteen years in London among the English Neoclassicists, whom she had met in critic and art historian Johann Winckelmann's circle in Rome (see p. 303). Her ambitions were as a narrative painter. One of her most beautiful works, Sappho (fig. 303), is notable for its charm and personal content. Inspired by Eros, the legendary Greek poet is seen writing a line (in Greek) from one of the verses of her *Ode to*

301. Thomas Gainsborough. *Mrs. Siddons.* 1785. Oil on canvas, $49\frac{1}{2} \times 39$ ". The National Gallery, London (Reproduced by courtesy of the Trustees)

302. Sir Joshua Reynolds. Mrs. Siddons as the Tragic Muse. 1784. Oil on canvas, 7'9" × 4'9½". Henry E. Huntington Library and Art Gallery, San Marino, California

303. Angelica Kauffmann. Sappho. 1775. Oil on canvas, $52 \times 57 \frac{1}{8}$ ". Ringling Museum of Art, Sarasota, Florida

Aphrodite: "So come again and deliver me from intolerable pain." As the artist John Henry Fuseli observed of Kauffmann, "Her heroines are herself," and this painting must have held particular meaning for her. Sappho was the symbol of women's achievement in the arts, which Kauffmann struggled successfully to gain. That the artist has invested the face of Sappho with some of her own features attests to her sense of identification with the poet.

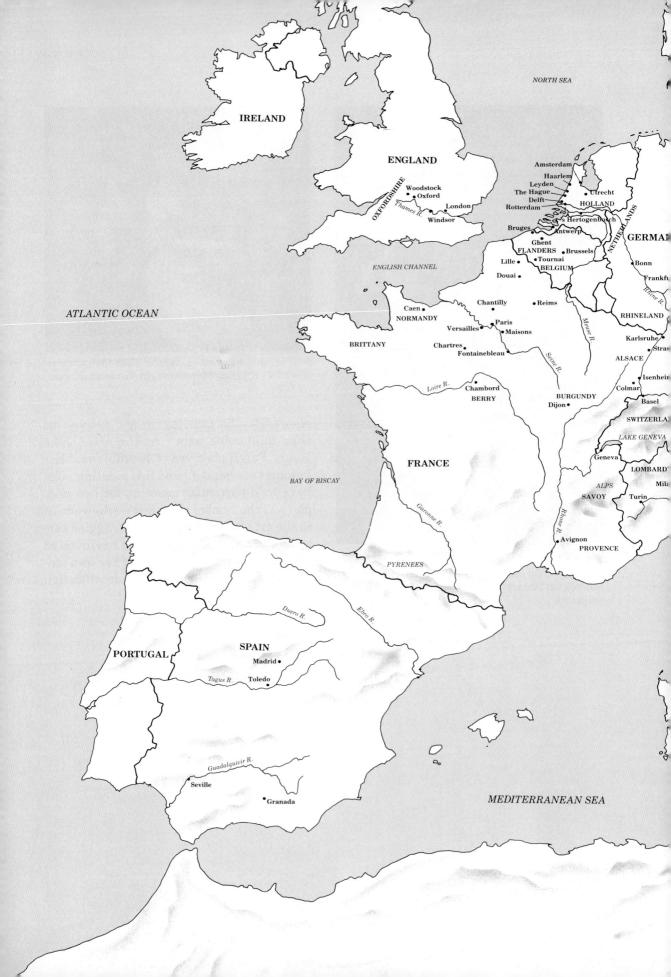

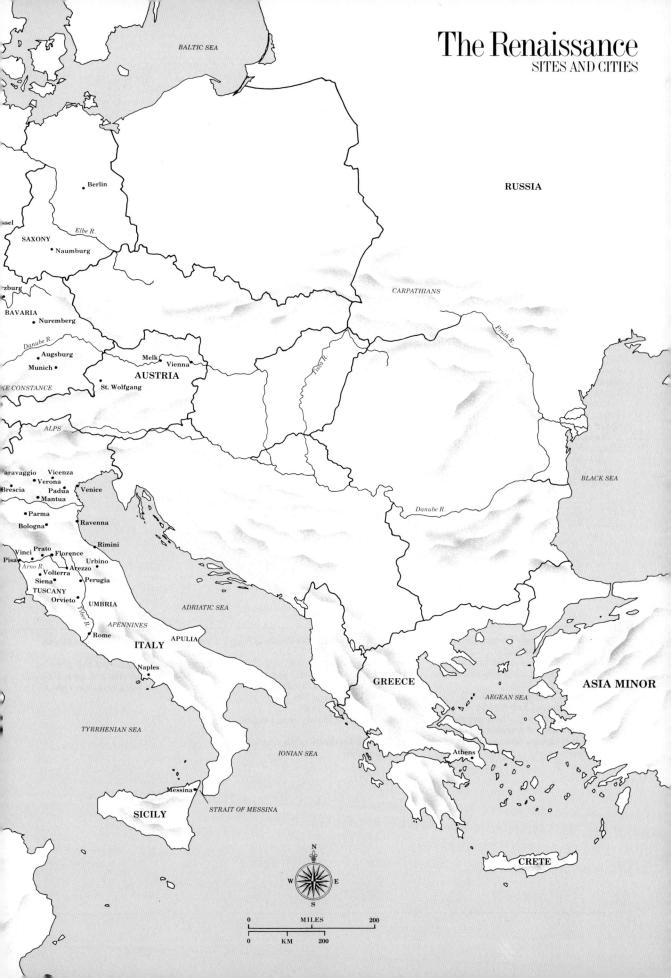

Synoptic Table III

POLITICAL HISTORY

RELIGION, LITERATURE

SCIENCE, TECHNOLOGY

Great Papal Schism (since 1378) settled 1417; pope returns to Rome Cosimo de' Medici leading citizen of Florence 1434–64 Leonardo Bruni (c. 1374–1444), History of Florence
Leone Battista Alberti (1404–1472), On Architecture; On Painting
Jan Hus, Czech reformer, burned at stake for heresy 1415; Joan of Arc burned at stake for heresy and sorcery 1431
Council of Florence attempts to reunite Catholic and Orthodox faiths 1439

(1394–1460) promotes geographic exploration
Gutenberg invents printing with movable type 1446–50

Prince Henry the Navigator of Portugal

1400

Hapsburg rule of Holy Roman Empire begins 1452
End of Hundred Years' War 1453
Constantinople falls to Turks 1453
Lorenzo de' Medici, "the Magnificent," virtual ruler of Florence 1469–92
Ferdinand and Isabella unite Spain 1469
Spain and Portugal divide southern New World 1493–94
Charles VIII of France invades Italy 1494–99
Henry VII (r. 1485–1509), first Tudor king of England

Marsilio Ficino, Italian Neo-Platonic philosopher (1433–1499)
Pius II, humanist pope (r. 1458–64)
Sebastian Brant's Ship of Fools 1494
Savonarola virtual ruler of Florence
1494; burned at stake for heresy 1498

Bartholomeu Diaz rounds Cape of Good Hope 1488 Christopher Columbus discovers America 1492 Vasco da Gama reaches India, returns to Lisbon 1497–99

1500

Hernando Cortés wins Aztec Empire in Mexico for Spain 1519; Francisco Pizarro conquers Peru 1532 Henry VIII of England (r. 1509–47) founds Anglican Church 1534 Wars of Lutheran vs. Catholic princes in Germany; Peace of Augsburg (1555) lets each sovereign decide religion of his subjects

Charles V elected Holy Roman Emperor

1519; Sack of Rome 1527

Erasmus of Rotterdam's In Praise of Folly 1511
Thomas More's Utopia 1516
Martin Luther (1483–1546) posts 95 theses 1517; excommunicated 1521
Castiglione's Courtier 1528
Machiavelli's Prince 1532
Ignatius of Loyola founds Jesuit order 1534
John Calvin's Institutes of the Christian Religion 1536

Vasco de Balboa sights Pacific Ocean 1513 First circumnavigation of the globe by Ferdinand Magellan and crew 1520–22 Copernicus refutes geocentric view of universe

ARCHITECTURE	SCULPTURE	PAINTING	
Brunelleschi begins career as architect 1419; Florence Cathedral dome (140); S. Lorenzo, Florence (191) Michelozzo, Palazzo Medici- Riccardi, Florence (192)	Donatello, St. George (182); Prophet (Zuccone) (183); David (184) Ghiberti, "Gates of Paradise," Baptistery, Florence (186) Luca della Robbia, Resurrection (187) Donatello, Equestrian statue of Gattamelata, Padua (185)	St. Dorothy, woodcut (180) Hubert and/or Jan van Eyck, Crucifixion; Last Judgment (166) Masaccio, Holy Trinity fresco, Sta. Maria Novella, Florence (195) Master of Flémalle, Merode Altarpiece (165) Jan van Eyck, Ghent Altarpiece (167–69); Man in a Red Turban (170); Wedding Portrait (171, 172) Rogier van der Weyden, Descent from the Cross (173) Conrad Witz, Geneva Cathedral altarpiece (178) Domenico Veneziano, Madonna and Child with Saints (196)	1400
Alberti, S. Andrea, Mantua (193) Giuliano da Sangallo, Sta. Maria delle Carceri, Prato (194)	Antonio Rossellino, Giovanni Chellini (188) Verrocchio, Putto with Dolphin, Florence (190) Pollaiuolo, Hercules and Antaeus (189)	Castagno, David (198) Mantegna, Ovetari Chapel frescoes, Padua (202) Piero della Francesca, Arezzo frescoes (197) Southern French Master, Avignon Pietà (179) Hugo van der Goes, Portinari Altarpiece (174) Botticelli, Birth of Venus (199) Ghirlandaio, Old Man and His Grandson (201) Schongauer, Temptation of St. Anthony, engraving (181) Leonardo, Adoration of the Magi (205) Perugino, Delivery of the Keys, Sistine Chapel, Rome (204) Giovanni Bellini, St. Francis in Ecstasy (203) Geertgen tot Sint Jans, Nativity (175) Leonardo, Last Supper, Sta. Maria delle Grazie, Milan (206) Dürer, Four Horsemen of the Apocalypse, woodcut (241) Piero di Cosimo, Discovery of Honey (200)	1450
Bramante, Tempietto, Rome (214); design for St. Peter's, Rome (215, 216) Michelangelo becomes architect of St. Peter's, Rome, 1546 (217) Lescot, Square Court of Louvre, Paris (250)	Michelangelo, David (209); Tomb of Guiliano de' Medici, Florence (213) Cellini, Saltcellar of Francis I (235) Goujon, Fountain of the Innocents, Paris (251)		1500

(cont.)

1550

Ivan the Terrible of Russia (r. 1547–84) Charles V retires 1556; son Philip II becomes king of Spain, Netherlands, New World

Elizabeth I of England (r. 1558–1603) Lutheranism becomes state religion in Denmark 1560, in Sweden 1593 Netherlands revolt against Spain 1586 Spanish Armada defeated by English

Henry IV of France (r. 1589–1610); Edict of Nantes (1598) establishes religious toleration Montaigne, French essayist (1533–1592) Council of Trent for Catholic reform 1545–63 St. Theresa of Avila, Spanish saint (1515–1582) Giorgio Vasari's *Lives* 1564 William Shakespeare, English dramatist

1600

Jamestown, Virginia, founded 1607; Plymouth, Massachusetts, 1620 Thirty Years' War 1618–48

Cardinal Richelieu, adviser to Louis XIII, consolidates power of king 1624–42

Cardinal Mazarin governs France during minority of Louis XIV 1643–61 (civil war 1648–53)

Charles I of England beheaded 1649; Commonwealth under Cromwell 1649–53 Miguel de Cervantes' Don Quixote 1605–16

(1564 - 1616)

John Donne, English poet (1572–1631) King James Bible 1611

René Descartes, French mathematician and philosopher (1596–1650)

Johannes Kepler establishes planetary system 1609–19

Galileo (1564–1642) invents telescope 1609; establishes scientific method William Harvey describes circulation of the blood 1628

1650

Charles II restores English monarchy 1660

English Parliament passes Habeas Corpus Act 1679

Frederick William, the Great Elector (r. 1640–88), founds power of Prussia

Louis XIV absolute ruler of France (r. 1661–1715); revokes Edict of Nantes 1685

Glorious Revolution against James II of England 1688; Bill of Rights Molière, French dramatist (1622–1673) Blaise Pascal, French scientist and philosopher (1623–1662)

Spinoza, Dutch philosopher (1632–1677) Racine, French dramatist (1639–1699) John Milton's Paradise Lost 1667 John Bunyan's Pilgrim's Progress 1678

John Locke's Essay Concerning Human Understanding 1690 Isaac Newton (1642–1727), theory of gravity 1687

1700

Peter the Great (r. 1682–1725) westernizes Russia, defeats Sweden
English defeat French at Blenheim 1704
Robert Walpole first prime minister
1721–42

Frederick the Great of Prussia defeats Austria 1740–45 Alexander Pope's Rape of the Lock 1714 Daniel Defoe's Robinson Crusoe 1719 Jonathan Swift's Gulliver's Travels 1726 Wesley brothers found Methodism 1738 Voltaire, French author (1698–1778) Carolus Linnaeus, Swedish botanist (1707–1778)

1750

Seven Years' War (1756–63): England and Prussia vs. Austria and France, called French and Indian War in America; French defeated in Battle of Quebec 1769

Catherine the Great (r. 1762–96) extends Russian power to Black Sea Thomas Gray's Elegy 1750 Diderot's Encyclopedia 1751–72 Samuel Johnson's Dictionary 1755 Edmund Burke, English reformer (1729–1797) James Watt patents steam engine 1769 Priestley discovers oxygen 1774 Coke-fed blast furnaces for iron smelting perfected c. 1760–75

ARCHITECTURE	SCULPTURE	PAINTING	1500
		Clouet, Francis I (246) Pontormo, Study of a Young Girl (224) Altdorfer, Battle of Issus (244) Cranach, Judgment of Paris (243) Correggio, Jupiter and Io (232) Michelangelo, Last Judgment fresco, Sistine Chapel, Rome (210, 212) Parmigianino, Madonna with the Long Neck (227) Girolamo Savoldo, St. Matthew (233) Holbein, Henry VIII (247)	
Palladio, Villa Rotonda, Vicenza (237)	Giovanni Bologna, Rape of the Sabine Woman, Florence (236)	Bronzino, Eleanora of Toledo and Her Son Giovanni de' Medici (228) Bruegel, Return of the Hunters (249); Land of Cockayne (248) Titian, Christ Crowned with Thorns (223) Veronese, Christ in the House of Levi (234) El Greco, Burial of Count Orgaz (230) Tintoretto, Last Supper (229) Caravaggio, Calling of St. Matthew, Contarelli Chapel, Rome (252) Annibale Carracci, Farnese Gallery ceiling, Rome (254))
Maderno, Nave and façade of St. Peter's, Rome; Bernini's colonnade (256) Borromini, S. Carlo alle Quattro Fontane, Rome (260)	Bernini, <i>David</i> (257); Cornaro Chapel, Rome (258)	Rubens, Raising of the Cross (262); Marie de' Medici, Queen of France, Landing in Marseilles (263) Artemisia Gentileschi, Judith and Maidservant with the Head of Holofernes (253) Hals, Jolly Toper (268) Leyster, Boy with Flute (270) Rubens, Garden of Love (264) Pietro da Cortona, Palazzo Barberini ceiling, Rome (255) Heda, Still Life (276) Van Dyck, Portrait of Charles I Hunting (266) Rubens, Landscape with the Château of Steen (265) Rembrandt, Blinding of Samson (271) Poussin, Rape of the Sabine Women (281) Le Nain, Peasant Family (279) De La Tour, Joseph the Carpenter (280) Poussin, Landscape with the Burial of Phocion (282)	
Perrault, East front of Louvre, Paris (284) Hardouin-Mansart and Le Vau, Palace of Versailles, begun 1669 (286); Salon de la Guerre (285) Wren, St. Paul's Cathedral, London (298) Guarini, Palazzo Carignano, Turin (261)	Bernini, Model for equestrian statue of Louis XIV (287) Girardon, Model for equestrian statue of Louis XIV (288)	Lorrain, Pastoral (283) Rembrandt, Christ Preaching (273) Ruisdael, The Cemetery (275) Rembrandt, Polish Rider (274) Velázquez, Maids of Honor (267) Steen, Eve of St. Nicholas (277) Hals, Women Regents of the Old People's Home at Haarlem (269) Vermeer, The Letter (278)	- 1650
Fischer von Erlach, St. Charles Borro- maeus, Vienna (289) Neumann, Episcopal Palace, Würzburg (290) Boffrand, Hôtel de Soubise, Paris (292)		Watteau, Pilgrimage to Cythera (293) Chardin, Kitchen Still Life (296) Hogarth, Rake's Progress (299) Chardin, Back from the Market (295) Gainsborough, Robert Andrews and His Wife (300)	- 1700
		Tiepolo, Würzburg ceiling fresco (291) Fragonard, Bathers (294) Kauffmann, Sappho (303) Vigée-Lebrun, Princesse de Polignac (297) Reynolds, Mrs. Siddons as the Tragic Muse (302) Gainsborough, Mrs. Siddons (301)	- 1750

1 ×

PART FOUR
The Modern World

Introduction

The era to which we belong has not yet acquired a name of its own. Perhaps this does not strike us as peculiar at first, but considering how promptly the Renaissance coined a name for itself, we may well wonder why no such key idea has emerged in the two centuries since our era began. Perhaps "revolution" is a suitable concept, since rapid and violent change has indeed characterized the development of the modern world. Our era began with revolutions of two kinds: the industrial revolution, symbolized by the steam engine, and the political revolution, under the banner of democracy, in America and France. Both revolutions are still continuing-industrialization and democracy are worldwide goals. Western science and Western political ideology (and in their wake the various other products of modern Western civilization, from food and dress to art and literature) will soon belong to all mankind. We tend to think of these two movements as different aspects of one process—with effects more far-reaching than any since the New Stone Age revolution (see p. 17)—yet the twin revolutions of modern times are not identical. The more we try to define their relationship, the more paradoxical it seems. Both are founded on the idea of progress, and both command an emotional allegiance that was once reserved for religion; but while progress in science and industry during the past two centuries has been continuous and palpable, we can hardly make this claim for man's pursuit of happiness, however we choose to define it.

Here, then, is the conflict fundamental to our era. Man today, having cast off the framework of traditional authority which confined and sustained him before, can act with a latitude both frightening and exhilarating. In a world where all values may be questioned, man searches constantly for his own identity, and for the meaning of human existence, both individual and collective. His knowledge about himself is now vastly greater, but this has not reassured him as he had hoped. Modern civilization thus lacks the cohesiveness of the past; it no longer proceeds by readily identifiable periods, nor are there clear period styles in art or in any other form of endeavor. Instead, we find another kind of continuity, that of movements and countermovements. Spreading like waves, these "isms" defy national, ethnic, and chronological boundaries; never dominant anywhere for long, they compete or merge with each other in endlessly shifting patterns. Hence our account of modern art must be by movements rather than by countries; for, all regional differences notwithstanding, modern art is as international as modern science.

Neoclassicism

ARCHITECTURE

If the modern era was born during the American Revolution of 1776 and the French Revolution of 1789, these cataclysmic events were preceded by a revolution of the mind that had begun half a century earlier. Its standardbearers were those thinkers of the Enlightenment in England and France-Hume, Voltaire, Rousseau, and others-who proclaimed that all human affairs ought to be ruled by reason and the common good, rather than by tradition and established authority. In the arts, as in economics, politics, and religion, this rationalist movement turned against the prevailing practice: the ornate and aristocratic Baroque-Rococo. In the mideighteenth century the call for a return to reason, nature, and morality in art meant a return to the ancients—after all, had not the Classical philosophers been the original "apostles of reason"? In 1755, when the German art historian Johann Winckelmann published a famous tract urging the imitation of the "noble simplicity and calm granof the Greeks, the first great monument of the new style was begun in Paris: the Panthéon (fig. 304) by Jacques Germain Soufflot, built as a church but secularized during the Revolution. smooth, sparsely decorated surfaces are abstractly severe, while the huge portico is modeled directly on ancient Roman temples. What distinguishes this cool, precise Neoclassicism from earlier Classicisms is less its external appearance than its motivation; instead of merely reasserting the superior authority of the ancients, it claimed to be more rational, and hence more "natural," than the Baroque. In England and America, the same trend produced the architectural style known as "Georgian." A fine example is Monticello,

304. Jacques Germain Soufflot. The Panthéon (Ste.-Geneviève), Paris. 1755–92

305. Thomas Jefferson. Garden façade, Monticello, Charlottesville, Virginia. 1770–84; 1796–1806

the home Thomas Jefferson designed for himself in Virginia (fig. 305). Executed in brick with wooden trim, it is less austere than the Panthéon, except for the use of the Doric order. Jefferson still preferred the Roman Doric, but late eighteenth-century taste began to favor the heavier and more "authentic" Greek Doric, in what is known as the Greek Revival phase of Neoclassicism. Greek Doric, however, was also the least flexible order, and so was particularly difficult to adapt to

306. Karl Langhans. The Brandenburg Gate, Berlin. 1788-91

modern requirements even when combined with Roman or Renaissance elements. Only rarely could it furnish a direct model for Neoclassical structures, as in the Brandenburg Gate in Berlin (fig. 306), derived from the Propylaea (see fig. 50).

PAINTING

Greuze; David

In painting, the anti-Rococo trend was initially a matter of content rather than style. This accounts for the sudden popularity, about 1760, of Jean Baptiste Greuze: *The Village Bride* (fig. 307), like the other pictures

307. Jean Baptiste Greuze. The Village Bride. 1761. Canvas, $36\times46^{1/2}$ ". The Louvre, Paris

he painted during those years, is a scene of lower-class family life. In contrast to earlier genre paintings (compare fig. 277) it has a contrived, stagelike character, borrowed from the "dumb-show" narratives of Hogarth (see fig. 299). But Greuze has neither wit nor satire. His pictorial sermon illustrates the social gospel of the Enlightenment-that the poor, unlike the immoral aristocracy, are full of "natural" virtue and honest sentiment. Everything is calculated to remind us of this, from the declamatory gestures and expressions of the actors to the hen with her chicks in the foreground: one chick has left the brood and sits alone on a saucer, like the bride who is about to leave her "brood." The Village Bride was acclaimed as a masterpiece. Here at last was a painter who appealed to the beholder's moral sense instead of merely giving him pleasure like the frivolous artists of the Rococo! The highest praise came from Diderot, that apostle of Reason and Nature, who accepted such narratives as "noble and serious human action" in Poussin's sense (see p. 275). Later, he modified his views when a far more gifted and rigorous "Neo-Poussinist" appeared on the scene-Jacques Louis David. In The Death of Socrates (fig. 308), David seems more "Poussiniste" than Poussin himself (compare fig. 281); the composition unfolds like a relief, parallel to the picture

308. Jacques Louis David. *The Death of Socrates*. 1787. Oil on canvas, 4'31/8" × 6'51/8". The Metropolitan Museum of Art, New York (Wolfe Fund, 1931. Catherine Lorillard Wolfe)

plane, and the figures are as solid—and as immobile—as statues. Yet there is one unexpected element: the lighting, with its precisely cast shadows, is derived from Caravaggio (see fig. 252), and so is the firmly realistic detail. Consequently, the picture has a quality of life rather astonishing in so doctrinaire a statement of the new ideal style. The very harshness of the design suggests that its creator was passionately engaged in the issues of his time, artistic as well as political. Socrates, about to drain the poison cup, is shown here not only as an example of Ancient Virtue but as a Christlike figure (there are twelve disciples in the scene).

David took an active part in the French Revolution, and for some years he practically controlled the artistic affairs of the nation. During this time he painted his greatest picture, *The Death of Marat* (fig. 309). David's deep emotion has created a masterpiece from a subject that would have embarrassed any lesser artist: for Marat, one of the political

309. Jacques Louis David. The Death of Marat. 1793. Oil on canvas, $65\times50^{1}/2^{"}$. Royal Museums of Fine Arts, Brussels

leaders of the Revolution, had been murdered in his bathtub. A painful skin condition caused him to do his paperwork there, with a wooden board for a desk. One day a young woman named Charlotte Corday burst in with a personal petition and plunged a knife into him while he read it. David has composed the scene with a stark directness that is truly awe-inspiring. In this canvas, a public memorial to the martyred hero, Classical art coincides with devotional image and historical account. Marat's pose was derived from the sleeping figure in a mythological relief, probably of Cupid and Psyche, which was traditionally associated with the name of Polyclitus. David could have known the work in any number of versions, including engravings. But because of the difference in subject matter Classical art could offer little further guidance here and the artist has again drawn upon the Caravaggesque tradition of religious art.

West; Copley

The martyrdom of another hero was immortalized by Benjamin West in *The Death of General Wolfe* (fig. 310). West came to Rome in 1760 from Pennsylvania and caused something of a sensation, since no American

310. Benjamin West. The Death of General Wolfe. 1770. Oil on canvas, $4'11'/2'' \times 7'$. National Gallery of Canada, Ottawa

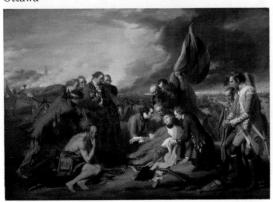

painter had appeared in Europe before. He relished his role of frontiersman and always took pride in his New World background, even after he had settled in London, where he succeeded Reynolds as president of the Royal Academy. We can sense this in The Death of General Wolfe, his most famous work. Wolfe's death in the siege of Quebec, during the French and Indian War, had aroused considerable feeling in London. When West decided to paint it, two approaches were open to him: he could give a factual account with the maximum of historical accuracy, or he could idealize it in the manner of the Neo-Poussinist painters, with the figures in "timeless" Classical costume. Although he had absorbed the influence of the Neo-Poussinists in Rome, he did not follow them in this painting; he knew the American locale of the subject too well for that. Instead, he merged the two approaches: his figures wear modern dress, and the conspicuous Indian places the event in the New World, yet all of the attitudes and expressions are "heroic." The composition indeed recalls an old and hallowed theme, the lamentation over the dead Christ (see fig. 173), dramatized by Baroque lighting. West thus endowed the death of a modern hero both with the rhetorical pathos of "noble and serious human action" as defined by Poussin, and with the trappings of a real event. He created an image that expresses a phenomenon basic to modern times, the shift of emotional allegiance from religion to nationalism. No wonder his picture had countless successors during the nineteenth century.

John Singleton Copley of Boston moved to London just two years before the American Revolution. Already an accomplished portraitist, he now turned to history painting in the manner of West. His first work in that field was *Watson and the Shark* (fig. 311). Watson, a young Englishman attacked by a shark while swimming in Havana harbor, had been dramatically rescued; many years later he commissioned Copley to depict his gruesome experience. Perhaps he thought

that only a painter from America could do full justice to the exotic nature of the subject. Copley, following West's example, has made every detail as authentic as possible (note the black, who serves the same purpose as the Indian in West's picture), while making use of all the resources of Baroque painting to invite the emotional participation of the be-

311. John Singleton Copley. Watson and the Shark. 1782. Oil on canvas, $36 \times 30 \frac{1}{2}$ ". The Detroit Institute of Arts (Purchase. The Dexter M. Ferry, Jr., Fund)

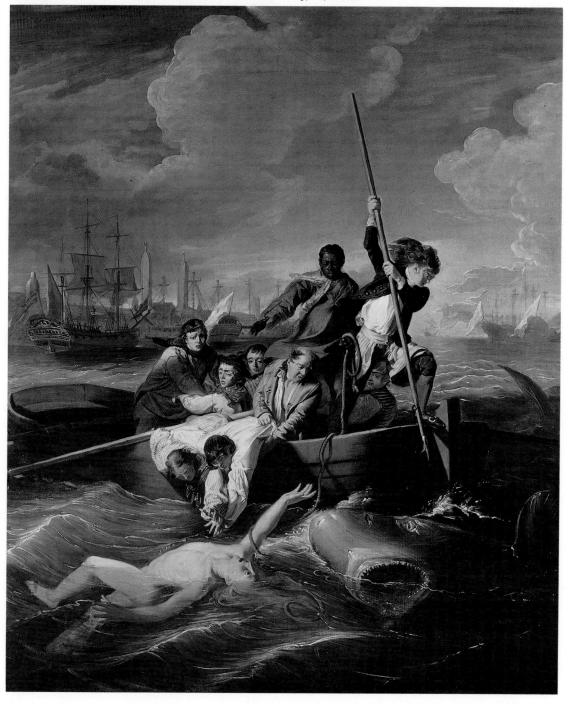

holder. The shark becomes a monstrous embodiment of evil, the man with the boat hook resembles an Archangel Michael fighting Satan, and the nude youth flounders helplessly between the forces of doom and salvation. This kind of moral allegory is typical of Neoclassicism as a whole, and despite its charged emotion, the picture has the same logic and clarity found in David's *Death of Socrates*.

SCULPTURE

The development of Neoclassical sculpture follows the pattern of architecture and painting but is less venturesome than either. Sculptors were overwhelmed by the authority accorded (since Winckelmann) to ancient statues; how could a modern artist compete with these works, which everyone acclaimed as the acme of sculptural achievement? At the same time, the new standard of uncompromising realistic "truth" embarrassed the sculptor. When a painter renders anatomical detail, clothing, or furniture with photographic precision he produces not a duplicate of reality but a representation of it, while to do so in sculpture comes dangerously close to mechanical reproduction—a handmade equivalent of the plaster cast. Thus, as we might deduce, portraiture proved the most viable field for Neoclassical sculpture. Its most distinguished practitioner, Jean Antoine Houdon, has an acute sense of individual character. His fine statue of Voltaire (fig. 312) does full justice to the sitter's skeptical wit and wisdom, and the Classical drapery

312. Jean Antoine Houdon. *Voltaire*. 1781. Terra-cotta model for marble, height 47". Fabre Museum, Montpellier, France

enveloping the famous sage—to stress his equivalence to ancient philosophers—is not incongruous, for he wears it as casually as a dressing gown. The more doctrinaire Neoclassical sculptors often adopted a less happy solution by portraying their sitters in Classical nudity.

The Romantic Movement

The Enlightenment, paradoxically, liberated not only reason but also its opposite: it helped to create a new wave of emotionalism that was to last for the better part of a century and came to be known as Romanticism. Those who, in the mid-eighteenth century, shared a revulsion against the established social order and religion—against established values of any sort—could either try to found a new order based upon their faith in the power of reason, or they could seek release in a craving for emotional experience. Their common denominator was a desire to "return to Nature." The rationalist acclaimed Nature as the ultimate source of reason, while the Romantic worshiped her as unbounded, wild and everchanging, sublime and picturesque. If man were only to behave "naturally," the Romantic believed, giving his impulses free reign, evil would disappear. In the name of nature, he exalted liberty, power, love, violence, the Greeks, the Middle Ages, or anything else that aroused him, although actually he exalted emotion as an end in itself. In its most extreme form, this attitude could be expressed only through direct action, not through works of art. (It has motivated some of the noblest—and vilest—acts of our era.) No artist, then, can be a wholehearted Romantic. for the creation of a work of art demands some detachment, self-awareness, and discipline. What Wordsworth, the great Romantic poet, said of poetry—that it is "emotion recollected in tranquility"—applies also to the visual arts. To cast his experience into permanent form, the Romantic artist needs a style. But since he is in revolt against the old order, this cannot be the established style of his time; he must search for some phase of the past to which he can feel linked by "elective

affinity" (another Romantic concept). Romanticism thus favors the revival, not of one style, but of a potentially unlimited number of styles. In fact, revivals—the rediscovery and utilization of forms hitherto neglected or disliked—became a stylistic principle: the "style" of Romanticism in art (also, to a degree, in literature and music). It can be argued that, seen in this context, Neoclassicism was nothing more than an aspect of Romanticism—at least during the nineteenth century.

ARCHITECTURE

Given the individualistic nature of Romanticism, we might expect the range of revival styles to be widest in painting, the most personal and private of the visual arts, and narrowest in architecture, the most communal and public form of expression. Yet the opposite is true. Painters and sculptors were unable to abandon Renaissance habits of representation, and they never really revived medieval art, or pre-Classical ancient art. Architects were not subject to this limitation, however, and the revival styles persisted longer in their work than in the other arts. Characteristically, at the time they launched the Classical revival, they also started a Gothic revival in architecture. England was far in advance here, as it was in the development of Romantic literature and painting. Horace Walpole, influential both as a man of letters and as an amateur of the arts, set the example for the others when, in 1749, he began to "gothicize" his country house, Strawberry Hill; its dainty, playful interiors (fig. 313) look almost as if decorated with lace-paper doilies. Gothic here is still an "exotic"

313. Horace Walpole with William Robinson and others. Strawberry Hill, Twickenham, England. 1749–77

style. It appeals because it is strange, like the Oriental tales of the *Thousand and One Nights*, or the medieval romances (such as the legends of King Arthur) that were being revived in the "Gothick" novels of the time.

After 1800, the choice between the Classi-

cal and Gothic modes was more often resolved in favor of Gothic. Nationalist sentiment. strengthened in the Napoleonic wars, favored the "native" style, for England, France, and Germany each tended to think that Gothic expressed its particular national genius. Thus, when a spectacular fire gutted the Houses of Parliament in London in 1834, the rebuilding had to be done in Gothic style (fig. 314). As the seat of a vast government apparatus, but at the same time a focus of patriotic feeling, it presents a curious mixture—repetitious symmetry governs the main body of the structure, and "picturesque" irregularity its silhouette. Meanwhile, the stylistic alternatives were continually increased for architects by other revivals. By the middle of the nineteenth century, the Renaissance and then the Baroque returned to favor, bringing the revival movement full circle. This last phase of Romantic architecture, which lingered on past 1900, is summed up in the Paris Opéra (fig. 315), de-

314. Charles Barry and A. Welby Pugin. The Houses of Parliament, London. Begun 1836

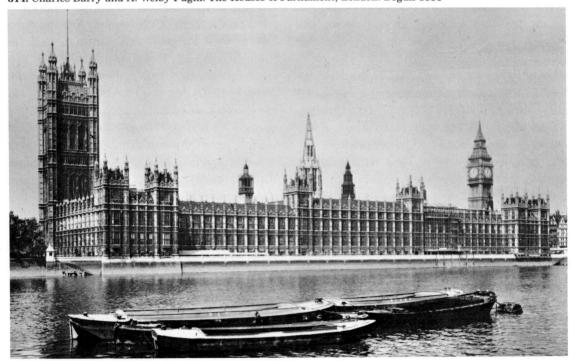

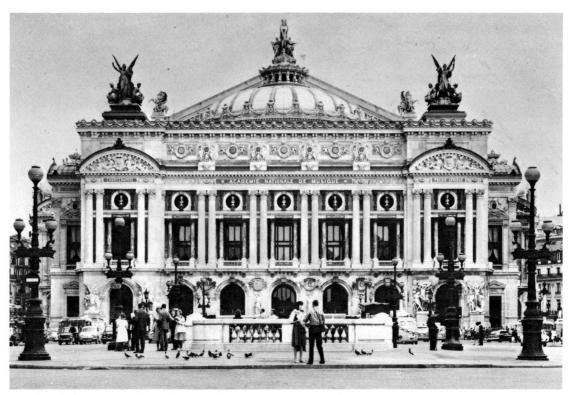

315. Charles Garnier. The Opéra, Paris. 1861-74

signed by Charles Garnier. Its Neo-Baroque quality stems more from the profusion of sculpture and ornament than from its architectural vocabulary: the paired columns of the façade, "quoted" from the Louvre (see fig. 284), are combined with a smaller order, in Italian Renaissance fashion (compare fig. 234). The whole building looks "overdressed," its luxurious vulgarity so naïve as to be ultimately disarming. It reflects the taste of the beneficiaries of the industrial revolution, newly rich and powerful, who saw themselves as the heirs of the old artistocracy and thus found prerevolutionary styles more appealing than Classical or Gothic. This "architecture of conscious display" was divorced from the practical demands of the industrial age-the factories, warehouses, stores, and city apartments that formed the bulk of building construction. There, in the world of commercial architecture, we find soon after 1800 the gradual introduction of new materi-

als and techniques that were to have a profound effect on architectural style by the end of the century. The most important was iron, never before used as an actual building material. Within a few decades of its first appearance, iron columns and arches had become the standard means of supporting the roofs over the large spaces required by railroad stations, exhibition halls, and public libraries. A noted early example is the Bibliothèque Ste.-Geneviève in Paris, built by Henri Labrouste (fig. 316); in the reading room a row of cast-iron columns supports two barrel roofs resting on cast-iron arches. Labrouste chose to leave this iron skeleton uncovered, and to face the difficulty of relating it to the massive Renaissance revival style of his building. If his solution does not fully integrate the two systems, it at least allows them to coexist. The iron columns are as slender as the new material permits; their collective effect is that of a space-dividing screen,

316. Henri Labrouste. Reading room, Bibliothèque Ste.-Geneviève, Paris. 1843–50

belying their structural importance, even though Labrouste has tried to make them weightier by putting them on tall pedestals of solid masonry. With the arches, Labrouste has gone to the other extreme: since there was no way to make them look as powerful as their masonry ancestors, he has perforated them with lacy scrolls as if they were pure ornament. This aesthetic use of exposed iron members has a fanciful and delicate air that links it, indirectly, to the Gothic revival.

SCULPTURE

In sculpture, as we suggested earlier, there was no Gothic revival, despite some isolated essays in that direction. Instead, we find at first an adaptation of the Neoclassical style to new ends by sculptors, especially older ones. The most famous of them, Antonio Canova, produced a colossal nude statue of Napoleon, inspired by portraits of ancient rulers whose nudity indicates their status as divinities. The elevation of the emperor to a god marks a shift away from the noble ideals of the Enlightenment that had given rise to Neoclassicism. The glorification of the hero as a noble example is abandoned in favor of the Romantic cult of the individual. Not to be

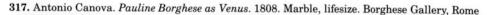

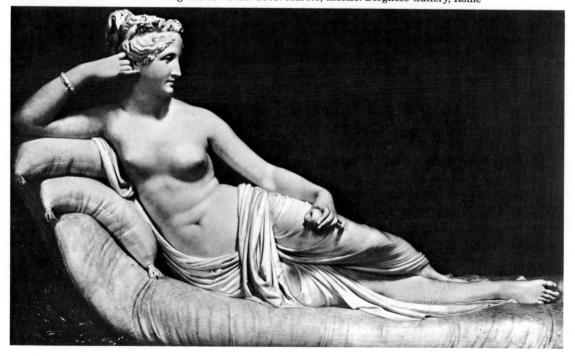

outdone, Napoleon's sister Pauline Borghese permitted Canova to sculpt her as a reclining Venus (fig. 317). The statue is so obviously idealized as to still any gossip; we recognize it as a precursor, more Classically proportioned, of Ingres' Odalisque (see fig. 323). It is equally typical of early Romanticism, which incorporated Rococo eroticism but in a less sensuous form. Strangely enough, Pauline Borghese seems less three-dimensional than the painting. It is designed like a "relief in the round," for front and back view only, and its very considerable charm radiates almost entirely from the fluid grace of its contours. Here we again encounter the problem of representation versus duplication (see p. 308), not in the figure itself but in the pillows, mattress, and couch.

Neoclassicism in sculpture was followed by a return to the emotionalism and theatricality of the Baroque, long before the Baroque revival in architecture. By the 1830s, Neo-Baroque sculpture had produced a master-

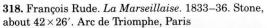

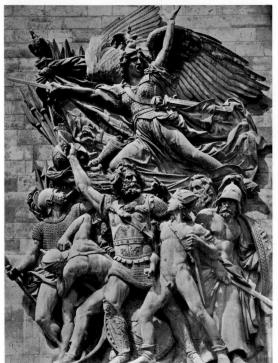

319. Jean Baptiste Carpeaux. *The Dance*. 1867–69. Plaster model, about $15' \times 8'6''$. Musée de l'Opéra, Paris

piece in the splendidly rhetorical *La Marseillaise* by François Rude (fig. 318) on the Arc de Triomphe in Paris. The soldiers, volunteers of 1792 rallying to defend the Republic, are still in Classical guise, but the Genius of Liberty above them imparts her great forward-rushing movement to the entire group. She would not be unworthy of Bernini (see figs. 257, 258).

Rude's successor in architectural sculpture was Jean Baptiste Carpeaux, whose famous *Dance* for the Paris Opéra may be seen in the bottom right of figure 315. Figure 319 shows us the plaster model for the group. It is both livelier and more precise than the final version. A perfect match for Garnier's architecture, it is very Rococo in feeling, being both gay and coquettish. Yet the figures look undressed rather than nude, so photographical-

ly realistic in detail that they seem more like real people acting out a Rococo scene than fanciful beings sprung from the realm of myth.

Romanticism produced few memorable works in sculpture. The unique virtue of sculpture, its solid, space-filling reality, was no more congenial to the Romantic temperament than the laborious process of translating a sketch into a permanent, finished work. Painting, in contrast, remains the greatest creative achievement of Romanticism in the visual arts, on a par with poetry and second only to music. Literature, both past and present, now became a more important source of inspiration for painters than ever before, and provided them with a new range of subjects, emotions, and attitudes. Romantic poets, in

turn, often saw nature with a painter's eye. Many had a strong interest in art criticism and theory; some were capable draftsmen; and William Blake cast his visions in pictorial as well as literary form. Within the Romantic movement, painting and literature had a complex, subtle, and by no means one-sided relationship.

PAINTING

Goya

Before we pursue Romantic painting in France, however, we must consider the great Spanish painter Francisco Goya, David's contemporary and the only artist of the age who

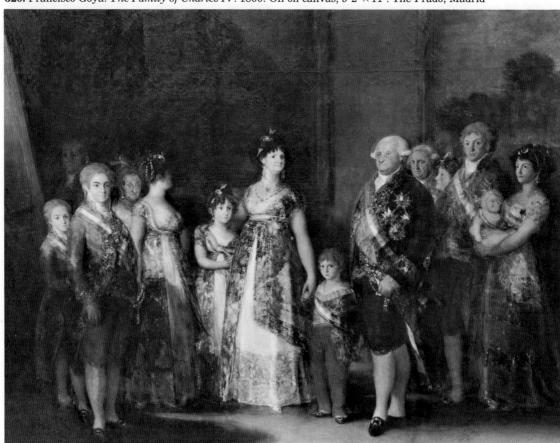

320. Francisco Goya. The Family of Charles IV. 1800. Oil on canvas, 9'2" × 11'. The Prado, Madrid

may be called, unreservedly, a genius. His early works, in a delightful late-Rococo vein, reflect the influence of Tiepolo and the French masters (Spain had produced no important painters for a century). During the 1780s, however, Goya absorbed the libertarian ideas of the Enlightenment; even though he was a court painter, he surely sympathized with the Revolution, and not with the king of Spain, who had joined other monarchs in war against the young French Republic. Yet Goya was much esteemed at court, especially as a portrait painter. He now abandoned the Rococo for a Neo-Baroque style based on Velázquez and Rembrandt, the masters he had come to admire most. The Family of Charles IV (fig. 320), his largest royal portrait, deliberately echoes The Maids of Honor (see fig. 267): the entire clan has come to visit the artist, who is painting in one of the picture galleries of the palace. As in the earlier work, shadowy canvases hang behind the group and the light pours in from the side, although its subtle gradations owe as much to Rembrandt as to Velázquez. The brushwork, too, has an incandescent sparkle rivaling that of The Maids of Honor. Measured against the Caravaggesque Neoclassicism of David, Goya's performance may seem thoroughly "prerevolutionary," not to say anachronistic. Yet Goya has more in common with David than we might think: he, too, practices a revival style and, in his way, is equally devoted to the unvarnished truth. Psychologically, The Family of Charles IV is almost shockingly modern. No longer shielded by

321. Francisco Goya. The Third of May, 1808. 1814-15. Oil on canvas, 8'9" × 13'4". The Prado, Madrid

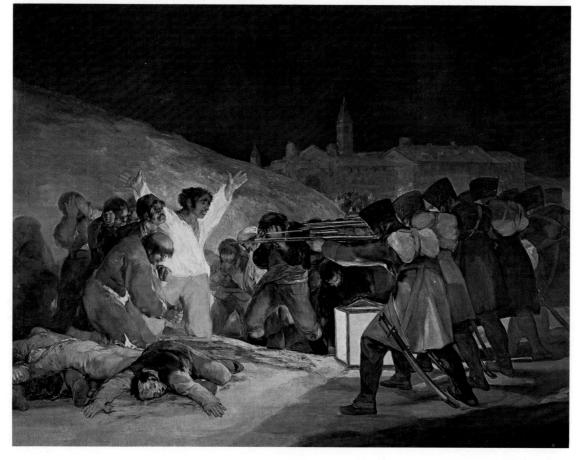

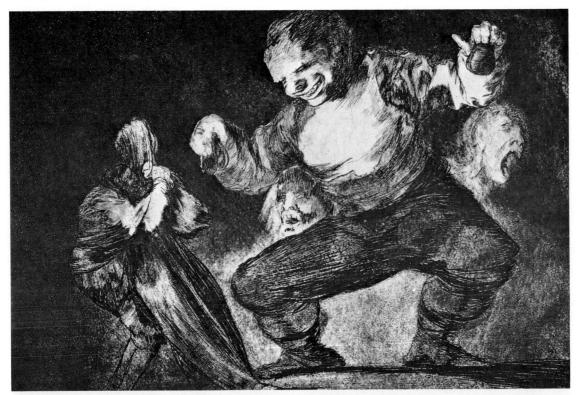

322. Francisco Goya. *Bobabilicon (Los Proverbios*, No. 4). c. 1818. Etching. The Metropolitan Museum of Art, New York (Dick Fund, 1931)

the polite conventions of Baroque court portraiture, the inner beings of these individuals have been laid bare with pitiless candor. They are like a collection of ghosts: the frightened children, the bloated vulture of a king, and—in a master stroke of sardonic humor—the grotesquely vulgar queen, posed like Velázquez' Princess Margarita (note the left arm, and the turn of the head). How, we wonder today, could the royal family tolerate this? Were they so dazzled by the splendid painting of their costumes that they failed to realize what Goya had done to them?

When Napoleon's armies occupied Spain in 1808, Goya and many of his countrymen hoped that the conquerors would bring the liberal reforms so badly needed. The savage behavior of the French troops crushed these hopes and generated a popular resistance of equal savagery. Many of Goya's works from 1810 to 1815 reflect this bitter experience.

The greatest is The Third of May, 1808 (fig. 321), commemorating the execution of a group of Madrid citizens. Here the blazing color, broad fluid brushwork, and dramatic nocturnal light are more emphatically Neo-Baroque than ever. The picture has all the emotional intensity of religious art, but these martyrs are dying for Liberty, not the Kingdom of Heaven; and their executioners are not the agents of Satan but of political tyranny-a formation of faceless automatons, impervious to their victims' despair and defiance. The same scene was to be reenacted countless times in modern history. With the vision of genius, Goya created an image that has become a terrifying symbol of our era.

After the defeat of Napoleon, the restored Spanish monarchy brought a new wave of repression, and Goya withdrew more and more into a private world of nightmarish visions such as *Bobabilicon* (Big Booby), an etching

from the series Los Proverbios (fig. 322). Although suggested by proverbs and popular superstitions, many of these scenes defy exact analysis. They belong to a realm of subjectively experienced horror even more terrifying than The Third of May, 1808. Finally, in 1824, he went into exile in France, where he died. Although Goya's influence made itself felt in France only after his death, his importance for the French Romantic painters was recognized by the greatest of them, Eugène Delacroix, who said that the ideal style would be a combination of Michelangelo's art and Goya's.

David; Ingres

French Romantic painting emerged from the studio of Jacques Louis David, who became an ardent admirer of Napoleon and executed several large pictures glorifying the emperor—although as a portrayer of the Napoleonic myth he was partially eclipsed by younger men who had been his students. After Napoleon's downfall, however, David spent his

last years in exile in Brussels, where his major works were playfully amorous subjects drawn from ancient myths or legends and painted in a coolly sensuous style he had initiated in Paris. His mantle eventually descended upon his pupil, Jean Auguste Ingres, who had been an artistic rebel as a youth. Never an enthusiastic Bonapartist, Ingres went to Italy in 1806, where he remained for eighteen years. Only after his return did he become the high priest of Davidian tradition. What had been a revolutionary style only half a century before, now congealed into rigid dogma, endorsed by the government and backed by the weight of conservative opinion. Fortunately, Ingres' pictures were far less doctrinaire than his theories. He always held that drawing was superior to painting, yet in a canvas such as his Odalisque (fig. 323) he sets off the petalsmooth limbs of this Oriental Venus ("odalisque" is a Turkish word for a harem slave girl) with a dazzling array of rich tones and textures. The subject itself, redolent with the enchantment of the Thousand and One Nights, is characteristic of Romanticism,

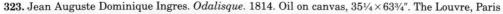

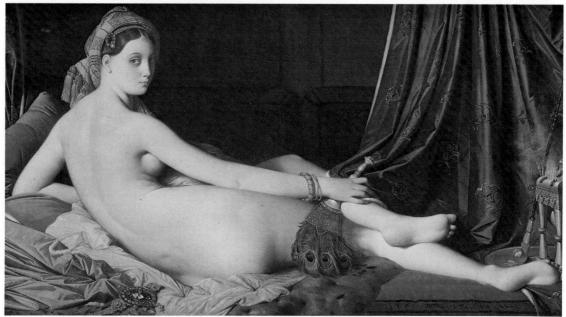

324. Jean Auguste Dominique Ingres. *Louis Bertin*. 1832. Oil on canvas, $46 \times 37 \frac{1}{2}$ ". The Louvre, Paris

which Ingres professed to despise. Nor does this nude embody a Classical ideal of beauty. Her proportions, her strange mixture of coolness and voluptuousness, remind us, rather, of Parmigianino (see fig. 227).

History painting as defined by Poussin and David remained Ingres' lifelong ambition, but he had great difficulties with it, while portraiture, which he pretended to dislike, was his strongest gift. He was, in fact, the last great professional in a field soon to be monopolized by the camera. Ingres' Louis Bertin (fig. 324) at first glance looks like a kind of "super-photograph." But this impression is deceptive. Upon closer inspection, we realize how much interpretation the portrait contains. The painting, through subtle shifts of emphasis and proportion, endows the sitter with a massive force of personality that has a truly frightening intensity. Only Ingres could so unify psychological depth and physical accuracy. His followers, on the other hand, concentrated on physical accuracy alone, competing vainly with the camera.

Gros; Géricault

Meanwhile, the reign of Napoleon, with its glamour, its adventurous conquests in remote parts of the world, had given rise to a Baroque revival among the younger painters, who felt the style of David too confining for the excitement of the age. David's favorite pupil, Antoine Jean Gros, shows us Napoleon as a twenty-seven-year-old general leading his troops at the Battle of Arcole in northern Italy (fig. 325). Painted in Milan, soon after the series of victories that gave the French the Lombard plain, it conveys Napoleon's magic as an irresistible "man of destiny" with a Romantic enthusiasm David could never match. Much as Gros respected his teacher's doctrines, his emotional nature impelled him toward the color and drama of the Baroque. What he accomplished in this case seems especially remarkable if we consider the circumstances, recounted by an evewitness: Napoleon, too impatient to pose, was made to sit still by his wife, who held him

325. Antoine Jean Gros. *Napoleon at Arcole*. 1796. Oil on canvas, $29\frac{1}{2} \times 23$ ". The Louvre, Paris

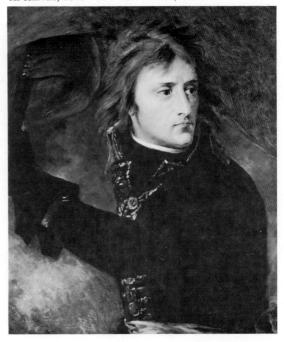

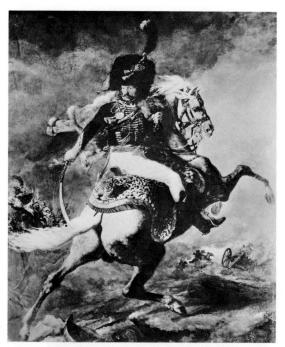

326. Théodore Géricault. *Mounted Officer of the Imperial Guard.* 1812. Oil on canvas, $9'7'' \times 6'41/2''$. The Louvre, Paris

firmly on her lap. The *Mounted Officer of the Imperial Guard* (fig. 326), painted by Théodore Géricault at the astonishing age of twenty-one, renders a vision of the Romantic hero with Rubens-like energy (see fig. 262). For Géricault, politics no longer had the force of a faith. All he saw in Napoleon's campaigns was the thrill—irresistible to the Romantic—of violent action.

Delacroix

The year 1824 was crucial for French painting. Géricault died (in consequence of a riding accident); Goya arrived from Spain; Ingres returned home and had his first public success; the first showing in Paris of works by Constable was a revelation to many French artists; and Eugène Delacroix established his reputation as the foremost Neo-Baroque Romantic painter. Like West's *Death of General Wolfe* (see fig. 310), Delacroix's painting of

Greece Expiring on the Ruins of Missolonghi (fig. 327) was inspired by a contemporary event: the Greek war of independence against the Turks, which stirred a sympathetic response throughout Western Europe. Delacroix, however, aimed at "poetic truth" rather than at recapturing a specific, actual event. He shows us an intoxicating mixture of sensuousness and cruelty: a dead Greek fighter lies crushed amidst marble blocks in the foreground; a Moor triumphs; and the defenseless maiden symbolizing Greece is fully as appealing as any martyred saint. Contemporary beholders, remembering that Lord Byron, the quintessential Romantic poet, had died at Missolonghi, must surely have found in the picture a special pathos. The painting has a great deal in common with the Mounted Officer of the Imperial Guard by Géricault, whom Delacroix admired. Sonorous color and the energetically fluid brushwork shows Delacroix to be a "Rubéniste" of the first order. In his Odalisque (see fig. 323), Ingres had also celebrated the exotic world of the Near East-alien, seductive, and violent—but how different the result! No wonder that for the next quarter-century, he and Delacroix were acknowledged rivals, and their polarity, fostered by partisan critics, dominated the artistic scene in Paris. The same contrast is found in the portraiture of these perennial antagonists. Delacroix rarely painted portraits on commission; he felt at ease only when portraying his personal friends and fellow victims of the "Romantic agony," such as the Polish composer Frédéric Chopin (fig. 328). Here is the Romantic hero at his purest, consumed by the fire of his genius, like Gros' Napoleon at Arcole.

Daumier

Delacroix reflects the attitude that eventually doomed the Romantic movement: its growing detachment from contemporary life. It is ironic that Honoré Daumier, the one great

327. Eugène Delacroix. Greece Expiring on the Ruins of Missolonghi. 1827. Oil on canvas, $6'11\frac{1}{2}"\times4'8\frac{1}{4}"$. Musée des Beaux-Arts, Bordeaux, France

328. Eugène Delacroix. *Frédéric Chopin*. 1838. Canvas, 18×15 ". The Louvre, Paris

Romantic artist who did not shrink from reality, remained practically unknown in his day as a painter. A biting political cartoonist, Daumier contributed masterly satirical drawings to various Paris weeklies for most of his life. He turned to painting in the 1840s. but found no public for his work. Only a few friends encouraged him, and, a year before his death, arranged his first one-man show. Daumier's mature paintings have the full pictorial range of the Neo-Baroque, but the subjects of many of them are scenes of daily life like those he treated in his cartoons. The Third-Class Carriage (fig. 329) is such a work. Painted very freely, it must have seemed raw and "unfinished" even by Delacroix's standards. Yet its power is derived

329. Honoré Daumier. *The Third-Class Carriage*. c. 1862. Oil on canvas, $26 \times 35 \frac{1}{2}$ ". The Metropolitan Museum of Art, New York (Bequest of Mrs. H. O. Havemeyer, 1929. The H. O. Havemeyer Collection)

from this very freedom, and for that reason Daumier cannot be labeled a Realist; his concern is not for the tangible surface of reality but for the emotional meaning behind it. In this picture, he captures a peculiarly modern human condition, "the lonely crowd" composed of people who have nothing in common apart from the fact that they are traveling together in the same railway car. Though physically crowded, they take no notice of one another-each is alone with his own thoughts. Daumier explores this state with an insight into character and a breadth of human sympathy worthy of Rembrandt, whose work he revered. His feeling for the dignity of the poor also suggests Louis Le Nain (see fig. 279), who had recently been rediscovered by French critics.

Millet: Bonheur

If the French public could not accept Daumier's painting style "straight," they nevertheless responded favorably to a diluted, simplified, yet powerful version of it in the work of François Millet. Millet was one of the artists of the Barbizon School who had settled in the village of Barbizon, near Paris, to paint landscapes and scenes of rural life. His Sower (fig. 330) reflects the compactness and breadth of Daumier's forms, now blurred in the hazy atmosphere. The "hero of the soil" flavor is somewhat self-conscious and quite alien to Daumier.

The popular revolution of 1848 elevated Millet and the Barbizon School into prominence in French art. That same year, Rosa Bonheur, also an artist of the out-of-doors, received a French government commission that led to her first great success and helped to establish her as a leading painter of animals—and eventually as the most famous woman artist of her time. Her painting *Plowing in the Nivernais* (fig. 331) was exhibited the following year, after a winter spent in making studies from nature. It takes up the theme of man's harmonious union with na-

330. François Millet. *The Sower.* c. 1850. Oil on canvas, $40 \times 32 \frac{1}{2}$ ". Museum of Fine Arts, Boston (Gift of Quincy Adams Shaw through Quincy A. Shaw, Jr., and Mrs. Marian Shaw Houghton)

ture, a subject that had been popularized in, among other works, the country romances of George Sand, the equally unconventional woman novelist.

The picture shares Millet's reverence for peasant life and the dignity of labor. But the real subject, as in all of Bonheur's work, is the animals within the landscape—a subject she depicts here with such accuracy that one can almost smell the fertile soil in the spring sunshine. In this, she became one of the originators of a strain of naturalism that endured throughout the rest of the century.

Constable

It was in landscape rather than in narrative painting that Romanticism reached its fullest expression, above all in England. During the eighteenth century, landscape paintings were, for the most part, imaginative exercises conforming to Northern and Italian examples, as in Gainsborough's *Robert An-*

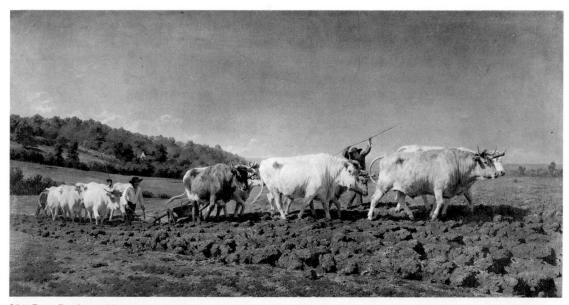

331. Rosa Bonheur. Plowing in the Nivernais. 1849. $5'9'' \times 8'8''$. Musée National du Château de Fontainebleau

drews and His Wife (see fig. 300). John Constable admired both Ruisdael and Lorrain, yet he strenuously opposed all flights of fancy. Landscape painting, he believed, must be based on observable facts; it should aim at "embodying a pure apprehension of natural effect." All his pictures show familiar views of the English countryside. And although he painted the final versions in his studio, he prepared them by making countless oil sketches out of doors. In these he was less concerned with concrete detail than with the qualities of light and atmosphere, so that the land often serves as a mere foil for the everchanging drama of wind, sunlight, and clouds. The sky, to Constable, was "the key note, the standard scale, and the chief organ of sentiment"; he studied it with a meteorologist's precision, the better to grasp its infinite variety as a mirror of those sweeping forces so dear to the Romantic view of nature. Trying to record these effects, he developed an increasingly broad, free technique, which explains why the large pictures of Constable's final years retained more and more of the quality of his oil sketches; in Stoke-by-Nayland (fig. 332) both the earth and the sky seem to have become "organs of sentiment" that pulsate with the artist's poetic sensibility.

Turner

Meanwhile, William Turner had arrived at a style which Constable, deprecatingly but acutely, called "airy visions, painted with tinted steam." Turner, too, made copious studies from nature (although in watercolor, not oils), but he chose scenery that satisfied the Romantic taste for the picturesque and

332. John Constable. Stoke-by-Nayland. 1836. Oil on canvas, $49\frac{1}{2} \times 66\frac{1}{2}$ ". The Art Institute of Chicago

333. Joseph Mallord William Turner. The Slave Ship. 1840. Oil on canvas, 35¾ × 48". Museum of Fine Arts, Boston

the sublime—mountains, the sea, or the site of historic events; in his large pictures he often changed these views so freely that they became quite unrecognizable. Many of his landscapes are linked with literary themes. When exhibiting them, Turner would add appropriate quotations from ancient or modern authors to the catalogue, or he would make up some lines himself and claim to be citing his own unpublished poem, "Fallacies of Hope." Yet these canvases are the opposite of history paintings as defined by Poussin: the titles indeed indicate "noble and serious human actions," but the tiny figures, lost in the seething violence of nature, suggest the ultimate defeat of all endeavor—"the fallacies of hope." The Slave Ship (fig. 333), one of Turner's most spectacular visions, shows how he transmuted his literary sources into "tinted steam." Originally entitled Slavers Throwing Overboard the Dead and Dying-Typhoon Coming On, the painting compounds several levels of meaning. In part, it has to do with a specific incident Turner had read about: when an epidemic broke out on a slave ship, the captain jettisoned his human cargo because he was insured against the loss of slaves at sea, but not by disease. Turner also thought of a passage from James Thomson's The Seasons, which describes how sharks follow a slave ship during a typhoon, "lured by the scent of steaming crowds, or rank disease, and death." But what is the relation between the slaver's action and the typhoon in the painting? Are the slaves being cast into the sea against the threat of the storm (perhaps to lighten the ship)? Is the typhoon Nature's retribution for the captain's greed and cruelty? Of the many storms at sea that Turner painted, none has quite this apocalyptic quality. A cosmic catastrophe seems about to engulf everything, not merely the slaver but the sea itself with its crowds of fantastic and oddly harmless-looking fish. While we still feel the force of Turner's imagination, most of us today, perhaps with a twinge of guilt, enjoy the "tinted steam" for its own sake, rather than as a vehicle of the awesome emotions the artist meant to evoke. Perhaps Turner himself sometimes wondered if his "tinted steam" had its intended effect on all beholders. In Goethe's Color Theory, then recently translated into English, he could have read that yellow has a "gay, softly exciting character," while orange-red suggests "warmth and gladness." Would The Slave Ship arouse the intended emotions in a viewer who did not know the title?

Friedrich

In Germany, as in England, landscape was the finest achievement of Romantic painting, and the underlying ideas, too, were often strikingly similar. When Caspar David Friedrich, the most important German Romantic artist, painted The Polar Sea (fig. 334), he may have known of Turner's "Fallacies of Hope," for in an earlier picture on the same theme, now lost, he had inscribed the name "Hope" on the crushed vessel. In any case, he shared Turner's attitude toward human fate. The painting, as so often before, was inspired by a specific event which the artist endowed with symbolic significance: a dangerous moment in William Parry's Arctic expedition of 1819-20. One wonders how Turner might have depicted this scene—perhaps it would have been too static for him. But Friedrich

334. Caspar David Friedrich. The Polar Sea. 1824. 381/2×501/2". Kunsthalle, Hamburg

was attracted by this immobility; he has visualized the piled-up slabs of ice as a kind of megalithic monument to man's defeat built by Nature herself. Infinitely lonely, it is a haunting reflection of the artist's own melancholy. There is no hint of "tinted steam"—the very air seems frozen-nor any subjective handwriting; we look right through the pigment-covered surface at a reality that seems to have been created without the painter's intervention. This technique, impersonal and meticulous, is peculiar to German Romantic painting. It stems from the early Neoclassicists-Mengs, Hamilton, and Vien-but the Germans, whose tradition of Baroque painting was weak, adopted it more wholeheartedly than the English or the French.

Bingham

The New World, too, had its Romantic landscape artists, even though most Americans
were far too busy carving out homesteads to
pay much attention to the poetry of Nature's
moods. Nature was everywhere, and while it
could be frightening it played a special role in
the United States. Because it determined the
American character, or so it was thought, it
became a symbol of the nation. Fur Traders
on the Missouri (fig. 335) by George Caleb
Bingham shows this closeness to the land.
The picture is both a landscape painting and
a genre scene. It is full of the vastness and silence of the wide-open spaces. The two trappers
in their dugout canoe with a black fox chained

335. George Caleb Bingham. Fur Traders on the Missouri. 1845. Canvas, $29\times36''$. The Metropolitan Museum of Art, New York (Morris K. Jesup Fund, 1933)

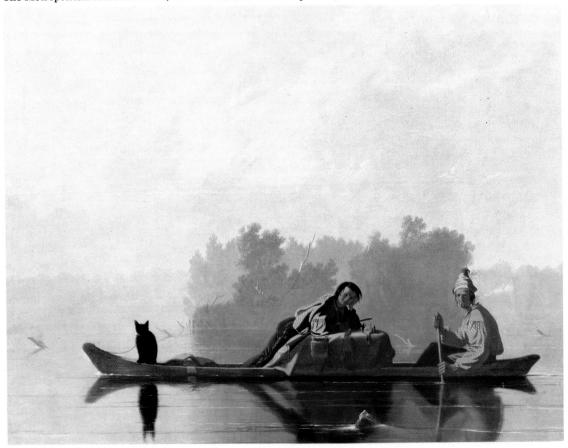

to the prow, soundlessly gliding downstream in the misty sunlight, are entirely at home in this idyllic setting and carry us right back to the river life of Mark Twain's childhood, to Tom Sawyer and Huck Finn.

Corot

Landscape in French Romantic art was of far less importance than in English art. France did, however, produce one great landscapist, Camille Corot, whose early work has an important place in the development of modern landscape painting. In 1825, Corot went to Italy and explored the countryside around Rome, like a latter-day Claude Lorrain (see fig. 283). But he did not transform his sketches into pastoral visions; what Lorrain recorded only in his drawings—the quality of a particular place at a particular time—Corot captured in small canvases done on the spot in an hour or two, which are paintings in their own right. Such a work is his view of Papigno, an obscure little hill town (fig. 336). In size and immediacy, these pictures are analogous to Constable's oil sketches, yet they stem from a different tradition. If Con-

336. Camille Corot. *Papigno*. 1826. Canvas, 13×15¾". Collection Dr. Fritz Nathan, Zurich

stable's view of nature, which emphasizes the sky as "the chief organ of sentiment," derives from Dutch seventeenth-century landscapes, Corot's instinct for architectural clarity and stability recalls Poussin and Lorrain. Yet he, too, insists on "the truth of the moment"—his exactness of observation, and his readiness to seize any view that attracted him during his excursions, show the same commitment to direct visual experience that we find in Constable.

Realism and Impressionism

PAINTING

"Can Jupiter survive the lightning rod?" asked Karl Marx, not long after the middle of the century. The French poet and art critic Charles Baudelaire was addressing himself to the same problem when, in 1846, he called for paintings that expressed "the heroism of modern life." At that time, only one painter was willing to make an artistic creed of this demand: Baudelaire's friend Gustave Courbet.

Courbet

Proud of his rural background and a socialist in politics, Courbet had begun as a Neo-Baroque Romantic, but by 1848, under the impact of the revolutionary upheavals then sweeping Europe, he had come to believe that

the Romantic emphasis on feeling and imagination was merely an escape from the realities of the time. The modern artist must rely on his own direct experience; he must be a Realist. ("I cannot paint an angel because I have never seen one," he said.) As a descriptive term, "realism" is not very precise. For Courbet, it meant something akin to the "naturalism" of Caravaggio (see p. 250). As an admirer of Louis Le Nain and Rembrandt he had, in fact, strong links with the Caravaggesque tradition, and his work, like Caravaggio's, was denounced for its supposed vulgarity and lack of spiritual content. The storm broke in 1849 over The Stone Breakers (fig. 337), the first canvas fully embodying Courbet's programmatic Realism. He had seen two men working on a road, and had

337. Gustave Courbet. *The Stone Breakers*. 1849. Oil on canvas, $5'3'' \times 8'6''$. Formerly State Picture Gallery, Dresden (destroyed 1945)

asked them to pose for him in his studio, where he painted them lifesize, solidly and matter-of-factly, without pathos or sentiment; the young man's face is averted, the old one's half hidden by a hat. Yet he cannot have picked them casually: their contrast in age is significant—one is too old for such heavy work, the other too young. Endowed with the dignity of their symbolic status, they do not turn to us for sympathy. Courbet's friend, the socialist Proudhon, likened them to a parable from the Gospels. Courbet's Realism, then, was a revolution of subject matter more than of style. Yet the conservatives' rage at him as a dangerous radical is understandable; his sweeping condemnation of all traditional subjects drawn from religion, mythology, allegory, and history only spelled out what many others had begun to feel, but had not dared to put into words.

Manet; Monet; Morisot

Courbet's art helps us to understand a picture that shocked the public even more than any of his: Edouard Manet's *Luncheon on the Grass* (fig. 338), which shows a nude model accompanied by two gentlemen in frock coats. Manet was the first to grasp Courbet's full importance—the *Luncheon* is, among other things, a tribute to the older artist. Renaissance masters had often juxtaposed nude and clothed figures in outdoor settings, but when Manet did so, he caused a scandal, since his painting gives no hint of a "higher" significance. Yet the group has so formal a pose

338. Edouard Manet. Luncheon on the Grass (Le Déjeuner sur l'Herbe). 1863. Oil on canvas, $7' \times 8'10''$. The Louvre, Paris

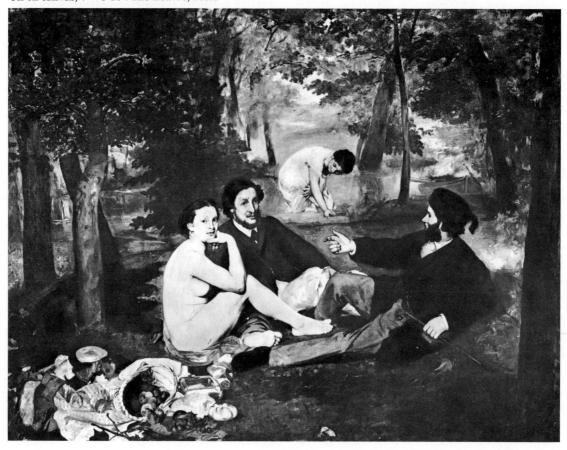

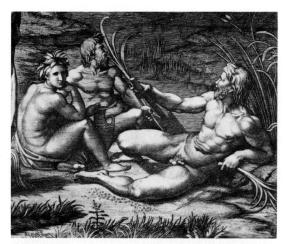

339. Marcantonio Raimondi, after Raphael. *The Judgment of Paris* (detail). c. 1520. Engraving. The Metropolitan Museum of Art, New York

that he could not possibly have intended to depict an actual event. In fact, the main figures were borrowed from a print after Raphael (fig. 339). Perhaps the meaning of the canvas lies in this denial of plausibility, for the scene fits neither the plane of everyday experience nor that of allegory. The Luncheon is a manifesto of artistic freedom, asserting the painter's privilege to combine whatever elements he pleases for aesthetic effect alone. The nudity of the model is "explained" by the contrast between her warm, creamy flesh tones and the cool black-andgray of the men's attire. Or, to put it another way, the *Luncheon* tells us that the world of painting has an internal logic distinct from the logic of familiar reality, and that the painter's first loyalty is to his canvas, not to the outside world. Here begins an attitude that was to become a bone of contention later under the slogan "art for art's sake" (see p. 336). Manet himself disdained controversy, but his work attests his lifelong devotion to "pure painting"—to the belief that brushstrokes and color patches, rather than the things they stand for, are the artist's primary reality. Among the old masters, he found that Hals, Velázquez, and Goya had come closest to this ideal. He admired their broad, open technique, their preoccupation with light and color values. Many of his canvases are, in fact, "pictures of pictures"—they translate into modern terms those older works that particularly challenged him. Yet he always filtered out the expressive or symbolic content of his models, lest the viewer's attention be distracted from the pictorial structure itself. His paintings have an emotional reticence that could easily be mistaken for emptiness unless we understand its purpose.

Courbet is said to have remarked that Manet's pictures were as flat as playing cards. Looking at *The Fifer* (fig. 340) we can see what he meant. Done three years after the *Luncheon*, it is a painting without shadows (there are a few, but it takes a real effort to find them), hardly any modeling, and no depth. The figure looks three-dimensional only because its contour renders the forms in realistic foreshortening; otherwise, Manet eschews all the methods devised since Giotto's time for transmuting a flat surface into a pictorial space. The gray background seems as near to us as the figure, and just as solid; if the fifer stepped out of the picture, he would leave a hole, like the cut-out shape of a stencil. Here, then, the canvas itself is no longer a "window," but a screen made up of patches of color. In retrospect, we realize that the revolutionary qualities of Manet's art already appear, less obviously, in the Luncheon; the three main figures form a unit almost as shadowless and stencil-like as the fifer. They would be more at home on a flat screen than they are in their Courbet-like landscape setting.

What brought about this "revolution of the color patch"? We do not know, and Manet himself surely did not reason it out beforehand. Perhaps he was impelled to create the new style by the challenge of photography. The "pencil of nature" had vindicated the objective truth of Renaissance perspective (see fig. 195), but it had also established a standard of representational accuracy that no handmade image could rival. Painting need-

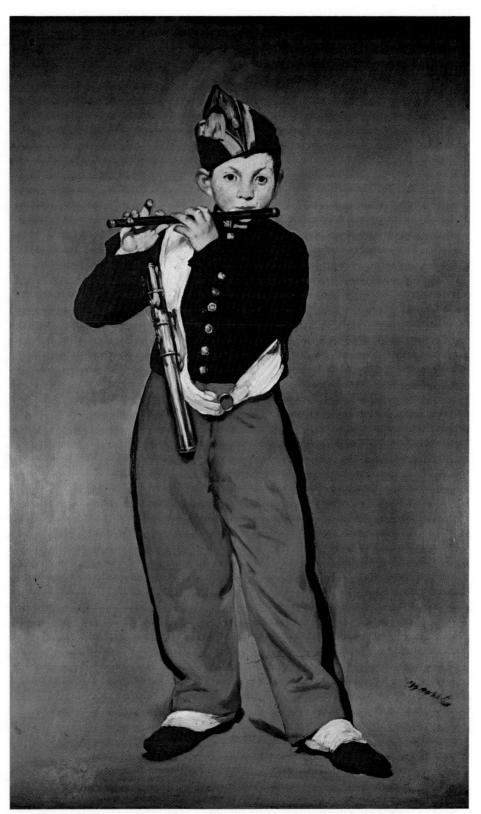

340. Edouard Manet. The Fifer. 1866. Oil on canvas, $63 \times 38\frac{1}{4}$ ". The Louvre, Paris

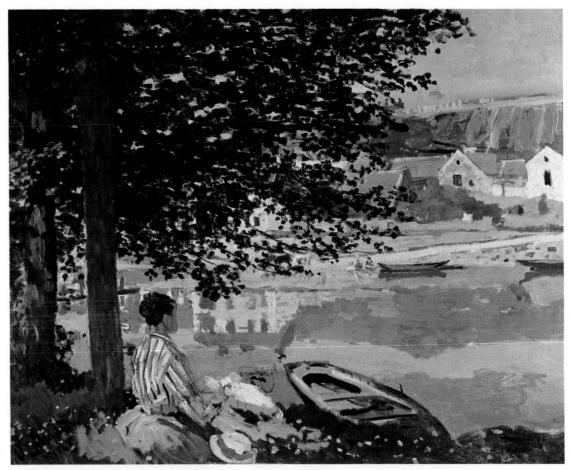

341. Claude Monet. The River. 1868. Canvas, 32 × 391/2". The Art Institute of Chicago (Potter Palmer Collection)

ed to be rescued from competition with the camera. This Manet accomplished by insisting that a painted canvas is, above all, a surface covered with pigments—that we must look at it, not through it. Unlike Courbet, he gave no name to the style he had created; when his followers began calling themselves Impressionists, he refused to accept that term for his own work. The word was coined in 1874, after a hostile critic had looked at a picture entitled Impression: Sunrise by Claude Monet—and it certainly fits Monet better than it does Manet. Monet had adopted Manet's concept of painting and applied it to landscapes done out of doors, such as The River (fig. 341). It is flooded with sunlight so bright that conservative critics claimed it made their eyes smart. In this flickering network of color patches, the reflections on the water are as "real" as the banks of the river Seine. Even more than *The Fifer*, Monet's painting is a "playing card"; were it not for the woman and the boat in the foreground, the picture could hang upside down with hardly any difference of effect. This inner coherence sets *The River* apart from earlier "impressions" such as Corot's *Papigno* (see fig. 336), even though both share the same on-the-spot immediacy and fresh perception.

These latter qualities came less easily to the austere and deliberate Manet; they appear in his work only after about 1870, under Monet's influence. Manet's last major picture, *A Bar at the Folies Bergère*, of 1881–82 (fig. 342), shows a single figure as calm—and as firmly set within the rectangle of the can-

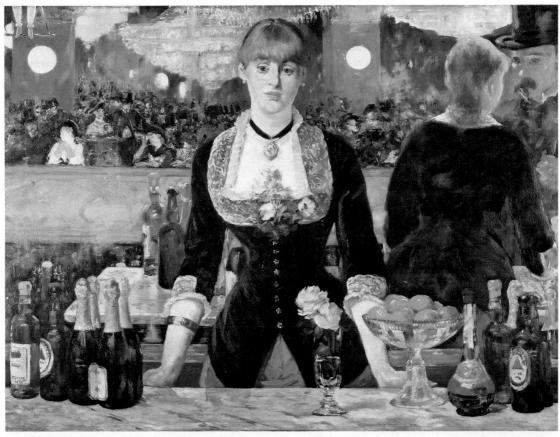

342. Edouard Manet. A Bar at the Folies Bergère. 1881–82. Oil on canvas, $37\frac{1}{2}\times51^{n}$. The Courtauld Collection, London

343. Berthe Morisot. The Artist's Sister Edma and Their Mother. 1869–70. Canvas, $39\frac{1}{2} \times 32^{"}$. National Gallery of Art, Washington, D.C. (Chester Dale Collection)

vas—as the fifer, but the background is no longer neutral. A huge shimmering mirror image now reflects the whole interior of the nightclub, but deprives it of three-dimensional reality. (The mirror, close behind the barmaid, fills four fifths of the picture.) The barmaid's attitude, detached and touched with melancholy, contrasts poignantly with the sparkling gaiety of her setting, which she is not permitted to share. For all its urbanity, the mood of the canvas reminds us oddly of Daumier's *Third-Class Carriage* (see fig. 329).

A similar introspection is found in the portrait of her mother and sister by Berthe Mori-

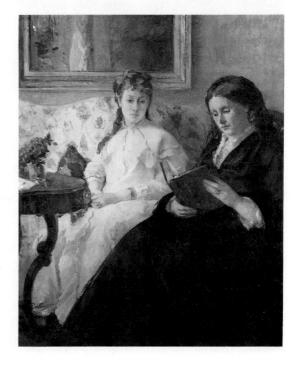

sot, who concentrated on such images of family members (fig. 343). It was painted a year after she met Manet (whose brother she later married). In fact, he partly reworked the mother's dark dress, but the picture remains Morisot's creation. The scene is deceptive in its repose. Distinctive to her early work is the subtle aura of alienation. Here it is not the heroism, but the pathos, of modern life that is revealed, yet with a delicacy of sentiment that is characteristic of Morisot's art.

Renoir; Degas; late Monet

Scenes from the world of entertainment—dance halls, cafés, concerts, the theater—were favorite subjects for Impressionist painters. Auguste Renoir, another important member of the group, filled his with the *joie*

de vivre of a singularly happy temperament. The flirting couples in Le Moulin de la Galette (fig. 344), under the dappled pattern of sunlight and shade, radiate a human warmth that is utterly entrancing, even though the artist permits us no more than a fleeting glance at any of them. Our role is that of the casual stroller, who takes in this slice of life as he passes. By contrast, Edgar Degas makes us look steadily at the disenchanted pair in his café scene (fig. 345), but, so to speak, out of the corner of our eye. The design of this picture, at first glance, seems as unstudied as a snapshot, yet the longer we look, the more we realize that everything has been made to dovetail precisely—that the zigzag of empty tables between us and the luckless couple reinforces their brooding loneliness. Compositions as boldly calculated as this set Degas apart from his fellow Impressionists.

344. Auguste Renoir. Le Moulin de la Galette. 1876. Oil on canvas, 511/2×69". The Louvre, Paris

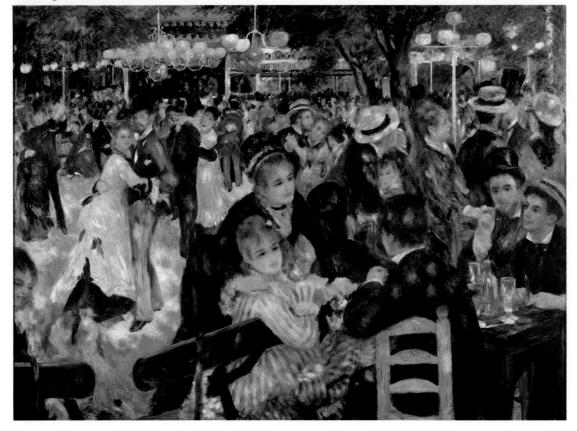

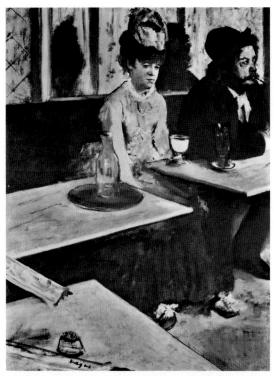

345. Edgar Degas. *The Glass of Absinthe*. 1876. Oil on canvas, 36×27 ". The Louvre, Paris

A wealthy aristocrat by birth, he had been trained in the tradition of Ingres, whom he greatly admired. Like Ingres, he was a masterful portraitist, although he portrayed only friends and relatives, people with whom he had emotional ties. His profound sense of human character lends weight even to seemingly casual scenes such as that in figure 345. A decade later, Degas again presents us with an oblique view in The Tub (fig. 346), but now the design has grown severe, almost geometric: the tub and the crouching woman, both vigorously outlined, form a circle within a square, and the rest of the rectangular format is filled by a shelf so sharply tilted that it almost shares the plane of the picture; yet on this shelf Degas has placed two pitchers (note how the curve of the small one fits the handle of the other!) that are hardly foreshortened at all. Here the tension between "two-D" and "three-D," surface and depth, comes close to the breaking point.

The Tub is Impressionist only in its shimmering, luminous colors. Its other qualities are more characteristic of the 1880s, the first post-Impressionist decade, when many artists showed a renewed concern with problems of form (see the next chaper). Among the major figures of the movement, Monet alone remained faithful to the Impressionist view of nature. About 1890, he began to paint pictures in series, showing the same subject

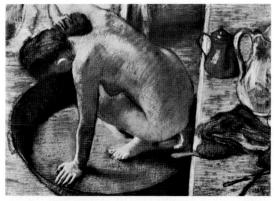

346. Edgar Degas. *The Tub*. 1886. Pastel, $23\frac{1}{2} \times 32\frac{1}{2}$ ". The Louvre, Paris

347. Claude Monet. Water Lilies, Giverny. 1907. Oil on canvas, $36\frac{1}{2}\times29$ ". Collection Jocelyn Walker, London

under various conditions of light and atmosphere. These tended increasingly to resemble Turner's "airy visions, painted with tinted steam" as Monet concentrated on effects of colored light (he had visited London, and knew Turner's work). But Monet never ventured into subjective fantasy, nor did he abandon the basic approach of his earlier work. His Water Lilies, Giverny (fig. 347) is a consistent sequel to The River, across a span of almost forty years. The pond surface now takes up the entire canvas, so that the effect of a weightless screen is stronger than ever; the artist's brushwork has a greater variety and a more personal rhythm; the theme, however, is still the endlessly fascinating interplay of reflection and reality.

Whistler

Courbet, during his later years, enjoyed considerable fame and influence abroad; the Impressionists gained international recognition more slowly. Americans were among their first patrons, responding to the new style more readily than did Europeans. At a time when no French museum would have them, Impressionist works entered public collections in the United States, and Ameri-

348. James McNeill Whistler. Arrangement in Black and Gray: The Artist's Mother. 1871. $57 \times 64\frac{1}{2}$ ". The Louvre, Paris

349. James McNeill Whistler. *Nocturne in Black and Gold: The Falling Rocket.* c. 1874. Oil on panel, 23³/₄ × 18³/₈". The Detroit Institute of Arts

can painters were among the earliest followers of Manet and his circle. James McNeill Whistler, who had settled in London in 1859 for the remainder of his life, was in close touch with the rising Impressionist movement in France during the 1860s. His bestknown picture, Arrangement in Black and Gray: The Artist's Mother (fig. 348), reflects the influence of Manet in its emphasis on flat areas. Its rise to fame as a symbol of our latter-day "mother cult" is a paradox of popular psychology that would have dismayed Whistler; he wanted the canvas to be appreciated for its formal qualities alone. A witty and sharp-tongued advocate of "art for art's sake," he thought of his pictures as analogous to pieces of music, often calling them "symphonies" or "nocturnes." The boldest of these is Nocturne in Black and Gold: The Falling Rocket (fig. 349); if it were not for the explanatory subtitle, we would have real difficulty figuring it out. No Frenchman had yet dared to produce a picture so "nonrepresentational," so reminiscent of Turner's "tinted steam" (see fig. 333). It was this painting, more than any other, that prompted the British critic John Ruskin to accuse Whistler of "flinging a pot of paint in the public's face." Since Ruskin had highly praised Turner's Slave Ship, it would seem that what he really liked was not the "tinted steam" itself but the Romantic sentiment behind it. During the subsequent libel suit, Whistler stated his aims in words that fit *The Falling Rocket* especially well: "I have perhaps meant rather to indicate an artistic interest alone in my work, divesting the picture from any outside sort of interest....It is an arrangement of line, form, and color, first, and I make use of any incident of it which shall bring about a symmetrical result." The last phrase is particularly significant, since Whistler acknowledges that in utilizing chance effects he does not look for resemblances but for a

purely formal harmony. His statement reads like a prophecy of modern American abstract painting (see fig. 407).

Homer; Eakins

Whistler's gifted contemporary in America, Winslow Homer, also came to Paris as a young man, but left too soon to receive the full impact of Impressionism. He was a pictorial reporter throughout the Civil War and continued as a magazine illustrator until 1875. Yet he did some of his most remarkable paintings in the 1860s. Such a work is The Morning Bell (fig. 350); the fresh delicacy of the sunlit scene might be called "pre-Impressionist"—halfway between Corot and Monet (compare figs. 336, 341). But the picture has an extraordinarily subtle design as well: the dog, the center girl, and those at the right turn the footpath into a seesaw, its upward slant balanced by the descending line of tree-

350. Winslow Homer. The Morning Bell. c. 1866. Canvas, 24 × 38". Yale University Art Gallery, New Haven, Connecticut (Stephen C. Clark Collection)

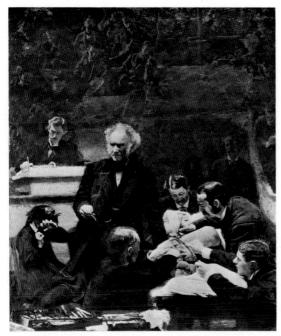

351. Thomas Eakins. *The Gross Clinic*. 1875. Oil on canvas, $96 \times 78''$. Jefferson Medical College, Philadelphia

tops. Thomas Eakins arrived in Paris from Philadelphia about the time Homer painted *The Morning Bell*; he returned, four years later, with decisive impressions of Courbet, Manet, and Velázquez. Elements from these three artists are combined in *The Gross Clinic* (fig. 351), the most imposing work of American nineteenth-century painting. A powerfully realistic canvas, it is a lifesize view of an operation in progress, glossing over none of the gruesome detail. Conservative critics denounced it as a "degradation of art," but to us it seems a splendid fulfillment of Baudelaire's demand for pictures that express the heroism of modern life.

Tanner; Cassatt

Eakins encouraged both women and blacks to study art seriously at a time when professional careers were closed to them. African-Americans had had no chance to enter the arts before Emancipation, and after the Civil War the situation improved only gradually. Thanks in large part to Eakins' enlightened attitude, Philadelphia became the leading center of minority artists in the United States, but they had to struggle to overcome traditional barriers. Henry O. Tanner, the first important black painter, studied with Eakins in the early 1880s. Tanner's masterpiece, *The Banjo Lesson* (fig. 352), painted after he moved permanently to Paris, bears Eakins' unmistakable impress: avoiding the sentimentality in similar subjects by other American painters, the scene is rendered with a light-filled realism based on personal experience, like *The Gross Clinic*.

Mary Cassatt's early training in Philadelphia was very similar to Eakins', but like Tanner she elected to settle in Paris, where she joined the Impressionists in 1877. Although her family objected to her vocation, she was able to pursue her career as an artist, at a time when it was frowned on as an occu-

352. Henry O. Tanner. The Banjo Lesson. c. 1893. Oil on canvas, $48\times35''$. Hampton University Museum, Hampton, Virginia

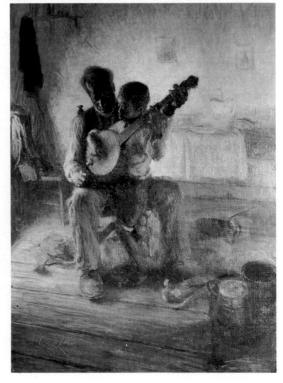

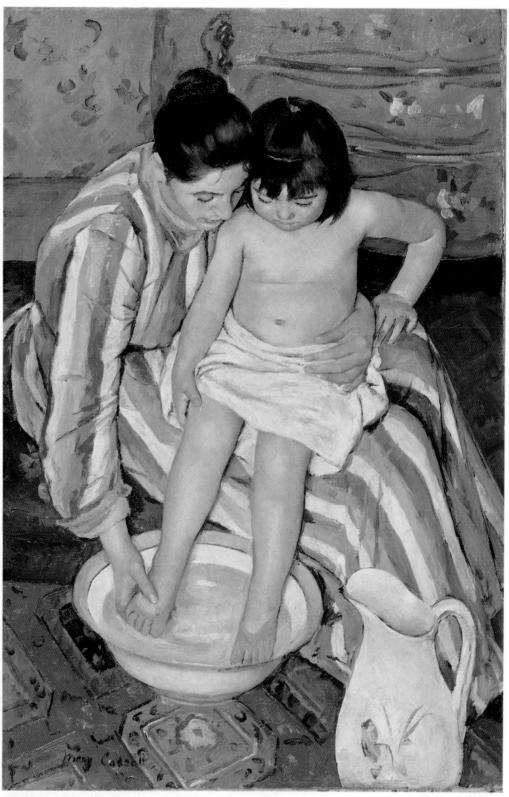

353. Mary Cassatt. The Bath. c. 1891. Oil on canvas, $39\frac{1}{2}\times26$ ". The Art Institute of Chicago (Robert A. Woller Collection)

pation for women, only because she was independently wealthy (like Berthe Morisot, another member of the group). A tireless champion of the Impressionists, Cassatt was instrumental in gaining early acceptance of their paintings in the United States through her social contacts with rich private collectors. She was never married, yet maternity provided her with the thematic material and formal focus of most of her work, which reached its maturity around 1890. In its oblique view, simplified color forms, and flat composition. The Bath (fig. 353) reflects Cassatt's debt to her colleagues Degas (see fig. 346) and Manet (see fig. 340), as well as her study of Japanese prints. These influences, however, have been assimilated into an individual and highly accomplished manner which made her America's leading Impressionist.

SCULPTURE

Rodin

Impressionism, it is often said, revitalized sculpture no less than painting. This claim is at once true and misleading. Auguste Rodin, the first sculptor of genius since Bernini, redefined sculpture during the same years that Manet and Monet redefined painting; in doing so, however, he did not follow these artists' lead. How indeed could the effect of such pictures as The Fifer or The River be reproduced in three dimensions and without color? What Rodin did accomplish is strikingly visible in The Thinker (fig. 354), originally conceived as part of a large unfinished project called The Gates of Hell. The welts and wrinkles of the vigorously creased surface produce, in polished bronze, an ever-changing pattern of reflections. But is this effect borrowed from Impressionist painting? Does Rodin dissolve three-dimensional form into flickering patches of light and dark? These fiercely exaggerated shapes pulsate with sculptural energy, and they retain this quality under whatever conditions the piece is viewed. For Rodin did not work directly in bronze: he modeled in wax or clay. How could he calculate in advance the reflections on the surfaces of the bronze casts that would be made from these models? He worked as he did, we must assume, for an entirely different reason: not to capture elusive optical effects, but to make emphatic the process of "growth"—the miracle of inert matter coming to life in the artist's hands. As the color patch, for Manet and Monet, is the primary reality, so are the malleable lumps from which Rodin builds his forms. By insisting on this "unfinishedness." he rescued sculpture from mechanical verisimilitude just as Manet had rescued painting from photographic realism.

Who is *The Thinker*? Partly Adam, no doubt, partly Prometheus, and partly the brute imprisoned by the passions of the flesh. Rodin wisely refrained from giving him a

354. Auguste Rodin. *The Thinker*. 1879–89. Bronze, height 27½". The Metropolitan Museum of Art, New York (Gift of Thomas F. Ryan, 1910)

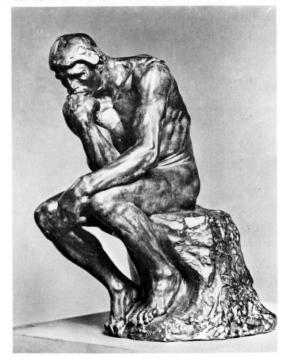

specific name, for the statue fits no preconceived identity. In this new image of man, form and meaning are one, instead of cleaving apart as in Carpeaux's Dance. Carpeaux produced naked figures that pretend to be nude, while *The Thinker*, like Michelangelo's superhuman bodies whose action-in-repose he shares, is free from subservience to the undressed model. But, despite his tremendous admiration for Michelangelo, Rodin was a modeler, not a carver. His works reveal their full strength only when we see them in plaster casts made directly from the clay originals, rather than in bronze. The Balzac monument (fig. 355), his most daring creation, remained in plaster for many years, rejected by the committee that had ordered it. The figure is larger than life, physically and spiritually; it has the overpowering presence of a specter. Like a huge monolith, the man of genius towers above the crowd—he shares the "sublime egotism of the gods" (as the Romantics put it.) Rodin has minimized the articulation of the body so that from a distance we see only its great bulk. As we approach, we become aware that *Balzac* is wrapped in a long, shroudlike cloak. From this mass the head thrusts upward with elemental force. When we are close enough to make out the features clearly, we sense beneath the dis-

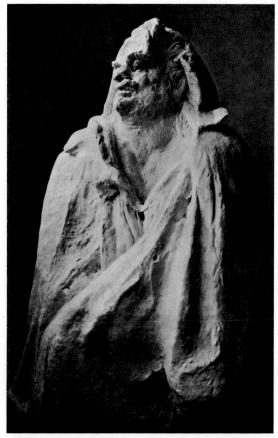

355. Auguste Rodin. *Balzac* (portion). 1892–97. Plaster, entire height 9'10". Rodin Museum, Paris

dain an inner agony that stamps *Balzac* as the kin of *The Thinker*.

Post-Impressionism

PAINTING

In 1882 Manet was made a Knight of the Legion of Honor by the French government. By that time Impressionism was gaining wide acceptance, but it had ceased to be a pioneering movement. The future belonged to the "Post-Impressionists." This colorless label designates a group of artists who had become dissatisfied with the limitations of Impressionism and ranged beyond it in various directions. It is difficult to come up with a more descriptive term for them, since they did not share a common goal. In any event, they were

not "anti-Impressionists." Far from trying to undo the effects of the "Manet Revolution," they wanted to carry it even further; in essence Post-Impressionism is just a later stage—although a very important one—of the development that had begun with such pictures as Manet's *Luncheon on the Grass*.

Cézanne

Paul Cézanne, the oldest Post-Impressionist painter, was born in Aix-en-Provence, near

356. Paul Cézanne. Fruit Bowl, Glass, and Apples. 1879-82. 18 × 21 ½". Collection René Lecomte, Paris

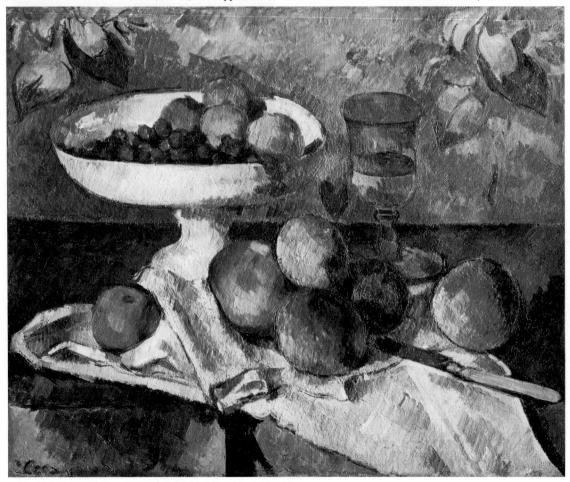

the Mediterranean coast. He came to Paris in 1861, imbued with enthusiasm for the Romantics, especially Delacroix. But he soon discovered Manet as well, and by the early 1870s he had become an Impressionist. Toward the end of the decade, however, he set out "to make of Impressionism something solid and durable, like the art of the museums." What he meant by this can be seen in Fruit Bowl, Glass, and Apples (fig. 356): every brushstroke is like a building block, firmly placed within the pictorial architecture, and the colors are deliberately controlled so as to produce "chords" of warm and cool tones that reverberate throughout the canvas. Not since Chardin have simple everyday objects assumed such importance in a painter's eye. We also notice another aspect of Cézanne's mature style: the forms are deliberately simplified, and outlined with dark contours; and the perspective is "incorrect" for both the fruit bowl and the horizontal surfaces, which seem to slant upward. The longer we study the picture, the more we realize the rightness of these apparently arbitrary distortions. When Cézanne takes these liberties with reality, his purpose is to uncover the permanent qualities beneath the accidents of appearance (all forms in nature, he believed, are based on the cone, the sphere, and the cylinder). This order underlying the external world was the true subject of his pictures, but he had to interpret it to fit the separate, closed world of the canvas. One detail of our painting is particularly instructive in this respect—the stem of the fruit bowl is slightly off center, as if the oval shape of the bowl, in response to the pressure of the other objects. were expanding toward the left.

To apply this method to landscape became the greatest challenge of Cézanne's career. From 1882 on, he lived in isolation near his home town, exploring its environs. One motif, the distinctive shape of a mountain called Mont Sainte-Victoire, seemed almost to obsess him; its craggy profile looming against the blue Mediterranean sky appears in a long

357. Paul Cézanne. Mont Sainte-Victoire Seen from Bibenus Quarry. c. 1898–1900. Canvas, 25½×32″. The Baltimore Museum of Art (The Cone Collection)

series of compositions, such as the monumental late work in figure 357. There are no hints of man's presence here—houses and roads would only disturb the lonely grandeur of this view. Above the wall of rocky cliffs that bar our way like a chain of fortifications, the mountain rises in triumphant clarity, infinitely remote yet as solid and palpable as the shapes in the foreground. For all its architectural stability, the scene is alive with movement; but the forces at work here have been brought into equilibrium, subdued by the greater power of the artist's will.

Seurat

Georges Seurat shared Cézanne's aim to make Impressionism "solid and durable," but he went about it very differently. His career was as brief as that of Masaccio, and his achievement just as astonishing. Seurat devoted his main efforts to a few very large paintings, for which he made endless series of preliminary studies. This painstaking method reflects his belief that art must be based on a system; but, as with all artists of genius, Seurat's theories do not really explain his pictures—it is the pictures, rather, that explain the theories. The subject of *A Sunday*

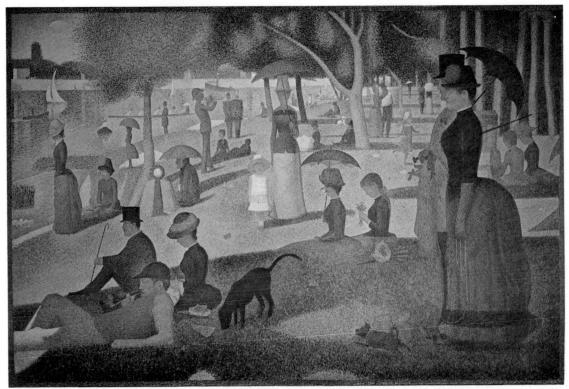

358. Georges Seurat. A Sunday Afternoon on the Grande Jatte. 1884–86. Oil on canvas, $6'9\frac{1}{4}" \times 10'$. The Art Institute of Chicago (Helen Birch Bartlett Memorial Collection)

Afternoon on the Grande Jatte (fig. 358) is of the sort that had long been popular among Impressionist painters. Impressionist, too, are the brilliant colors and the effect of intense sunlight. Otherwise, however, the picture is the direct opposite of a quick "impression"; the firm, simple contours and the relaxed, immobile figures give the scene a timeless stability that recalls Piero della Francesca (see fig. 197). Even the brushwork shows Seurat's passion for order and permanence; the canvas is covered by systematic, impersonal dots of color which were to merge in the beholder's eye and thereby produce intermediary tints more luminous than those obtainable from pigments mixed on the palette. This procedure he called Divisionism (others spoke of Neo-Impressionism, or Pointillism). The actual result, however, did not conform to the theory. Looking at the Grand Jatte from a comfortable distance, we find that the mixture of the colors in the eye is still incomplete; the dots are clearly visible, like the tesserae of a mosaic. Seurat must have liked this unexpected effect—otherwise he would have reduced the size of the dots—which gives the canvas the quality of a shimmering translucent screen.

Van Gogh

While Cézanne and Seurat were converting Impressionism into a more severe, Classical style, Vincent van Gogh was moving in the opposite direction, believing that Impressionism did not provide the artist with enough freedom to express his emotions. He is sometimes called an Expressionist, but the term ought to be reserved for certain later painters (see p. 357). Van Gogh, the first great Dutch master since the seventeenth century, did not become an artist until 1880;

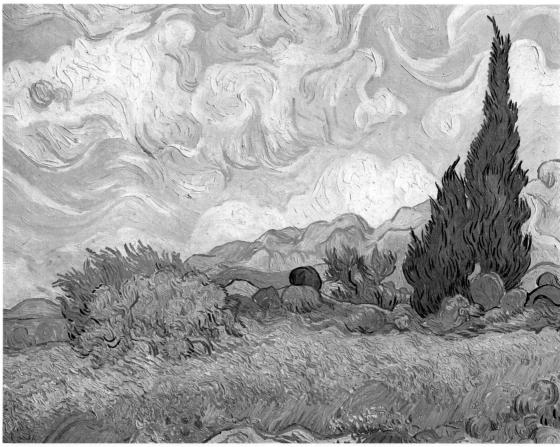

359. Vincent van Gogh. Wheat Field and Cypress Trees. 1889. Oil on canvas, $28\frac{1}{2} \times 36^{\circ}$. The National Gallery, London (Reproduced by courtesy of the Trustees)

since he died only ten years later, his career was even briefer than Seurat's. His early interests were in literature and religion. Profoundly dissatisfied with the values of industrial society, and imbued with a strong sense of mission, he worked for a while as a lay preacher among poverty-stricken coal miners. An intense sympathy for the poor pervades his early paintings. In 1886, however, he came to Paris and met Degas, Seurat, and other leading French artists. Their effect on him was electrifying: his pictures now blazed with color, and he even tried the Divisionist technique of Seurat. Although this Impressionist phase was vitally important for Van Gogh's development, he had to integrate it with the style of his earlier years before his genius could unfold fully. Paris had

opened his eyes to the sensuous beauty of the visible world and taught him the pictorial language of the color patch, but painting continued to be a vessel for his personal emotions. To investigate this spiritual reality with the new means at his command, he went to Arles, in the south of France. It was there, between 1888 and 1890, that he produced his greatest pictures. Like Cézanne, he now devoted his main energies to landscape painting, but the sun-drenched countryside evoked a very different response in him: he saw it filled with ecstatic movement, not architectural stability and permanence. In his Wheat Field and Cypress Trees (fig. 359), both earth and sky show an overpowering turbulence the wheat field resembles a stormy sea, the trees spring flamelike from the ground, and

the hills and clouds heave with a similar undulant motion. The dynamism that is in every brushstroke makes of each one not merely a deposit of color, but an incisive graphic gesture. Yet to Van Gogh himself it was the color, not the form, that determined the expressive content of his pictures. Although his desire "to exaggerate the essential and to leave the obvious vague" makes his colors look arbitrary by Impressionist standards, he nevertheless remained deeply committed to the visible world. The colors of Wheat Field are stronger, simpler, and more vibrant than those in Monet's River (compare fig. 341) but in no sense "unnatural." They speak to us of that "kingdom of light" Van Gogh had found in the South, and of his mystic faith in a creative force animating all forms of life. Like Dürer before him (see fig. 240), the missionary had now become a prophet. We see him in that role in the Self-Portrait (fig. 360), his emaciated, luminous head with its burning eyes set off against a whirlpool of darkness. At the time of this Self-Portrait, he had already begun to suffer fits of mental illness that made painting increasingly difficult for him. Despairing of a cure, he committed suicide a year later, for he felt that art alone had made his life worth living.

Gauguin

The quest for religious experience also played an important part in the work—if not in the life—of another great Post-Impressionist, Paul Gauguin. He began as a prosperous stockbroker in Paris, and an amateur painter and collector of modern art (he once owned Cézanne's *Fruit Bowl*, fig. 356). At thirty-five, however, he became convinced that he must devote himself entirely to art: he abandoned his business career and his family, and by 1889 he was the central figure of a new movement called Symbolism. His style, although less intensely personal than Van Gogh's, was an even bolder advance be-

360. Vincent van Gogh. *Self-Portrait*. 1889. Oil on canvas, 22½×17". Collection Mr. and Mrs. John Hay Whitney, New York

yond Impressionism. Gauguin believed that Western civilization was "out of joint," having forced men into an incomplete life dedicated to material gain while their emotions lay neglected. To rediscover for himself this hidden world of feeling, Gauguin went to live among the peasants of Brittany in western France. Here religion was still part of everyday life, and in works such as The Yellow Christ (fig. 361) he attempted to depict the simple, direct faith of country people. Here at last is what no Romantic painter had achieved: a style based on pre-Renaissance sources. Modeling and perspective have given way to flat, simplified shapes outlined heavily in black, and the brilliant colors are equally "unnatural." This style, inspired by folk art and medieval stained glass, is meant to re-create both the imagined reality of the Crucifixion and the trancelike rapture of the peasant women. Yet we sense that Gauguin did not share this experience: he could paint pictures about faith, but not from faith.

361. Paul Gauguin. The Yellow Christ. 1889. Oil on canvas, $36\% \times 28\%$ ". Albright-Knox Art Gallery, Buffalo

Two years later, Gauguin's search for the unspoiled life led him even farther afield. He voyaged to Tahiti as a sort of "missionary in reverse," to learn from the natives instead of teaching them. Yet none of his South Pacific canvases are as daring as those he had paint-

362. Paul Gauguin. *Offerings of Gratitude*. c. 1891–93. Woodcut. The Museum of Modern Art, New York

ed in Brittany. His strongest works of this period are woodcuts; Offerings of Gratitude (fig. 362) again presents the theme of religious worship, but with the image of a local god replacing Christ. In its frankly "carved" look and its bold white-on-black pattern, we can feel the influences of the native art of the South Seas and of other non-European styles. The renewal of Western civilization, and of Western art, Gauguin believed, must come from "the Primitives"; he advised his fellow Symbolists to shun the Greeks and to turn instead to Persia, ancient Egypt, and the Far East. This idea itself was not new. It stems from the Romantic myth of the Noble Savage, and its ultimate source is the age-old dream of an earthly paradise where Man had lived-and might live again-in a state of nature and innocence. But no one before Gauguin had gone so far in putting the doctrine of primitivism into practice. His pilgrimage to the South Pacific symbolizes the end of four hundred years of colonial expansion which had brought the entire globe under Western domination. The "white man's burden," once so cheerfully—and ruthlessly—shouldered, was becoming unbearable.

Symbolists

Gauguin's Symbolist followers, who called themselves Nabis (from the Hebrew word for "prophet"), were less remarkable for creative talent than for their ability to spell out and justify the aims of Post-Impressionism

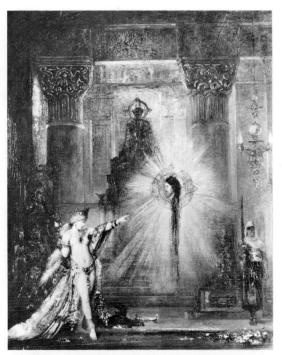

363. Gustave Moreau. *The Apparition (Dance of Salome)*. c. 1876. 211/4×171/2". Fogg Art Museum, Harvard University, Cambridge, Massachusetts (Grenville L. Winthrop Bequest)

in theoretical form. One of them, Maurice Denis, coined the statement that was to become the First Article of Faith for twentiethcentury painters: "A picture—before being a war horse, a female nude, or some anecdote is essentially a flat surface covered with colors in a particular order." The Symbolists also discovered that there were some older artists, descendants of the Romantics, whose work, like their own, placed inner vision above the observation of nature. One of these was Gustave Moreau, a strange recluse who admired Delacroix yet created a world of personal fantasy. The Apparition (fig. 363) shows one of his favorite themes: the head of John the Baptist, in a blinding radiance of light, appears to the dancing Salome. Her odalisque-like sensuousness, the stream of blood pouring from the severed head, the vast, mysterious space of the setting-suggestive of an exotic temple rather than of Herod's palace—summon up all the dreams

of Oriental splendor and cruelty so dear to the Romantic imagination, commingled with an insistence on the reality of the supernatural. Only late in life did Moreau achieve a measure of recognition; suddenly, his art was in tune with the times. During his last six years, he even held a professorship at the conservative Ecole des Beaux-Arts, the successor of the official art academy founded under Louis XIV (see p. 278). There he attracted the most gifted students, among them such future leaders as Matisse and Rouault.

How prophetic Moreau's work was of the taste prevailing at the end of the century is

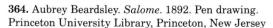

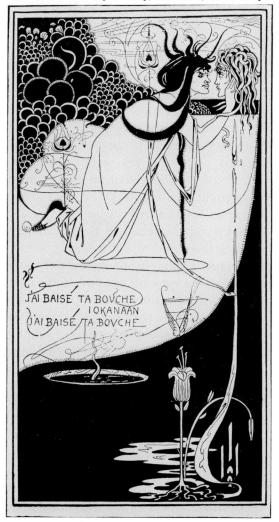

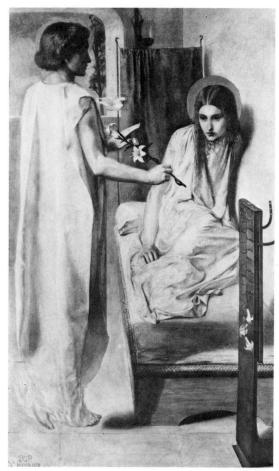

365. Dante Gabriel Rossetti. *Ecce Ancilla Domini*. 1850. $28\frac{1}{2} \times 16\frac{1}{2}$ ". The Tate Gallery, London

evident from a comparison with Aubrey Beardsley, a talented young Englishman whose elegantly "decadent" black-and-white drawings were the very epitome of that taste. They include a *Salome* illustration (fig. 364) that might well be the final scene of the drama depicted by Moreau: Salome has grasped that head and triumphantly kissed it. Whereas Beardsley's erotic meaning is plain—Salome is passionately in love with John and has asked for his head because she could not have him in any other way-Moreau's remains ambiguous: did his Salome perhaps conjure up the vision of the head? Is she, too, in love with John? Nevertheless, the parallel is striking, and there are formal similarities as well, such as the "stem" of trick-

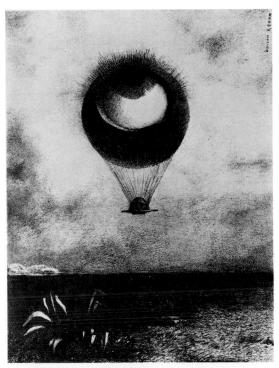

366. Odilon Redon. *The Balloon Eye*, from the series À *Edgar Poe*. 1882. Lithograph

ling blood from which John's head rises like a flower. Yet Beardsley's Salome cannot be said to derive from Moreau's. The sources of his style are English, with a strong admixture of Japanese influence. Its affinity is to the work of the painter and poet Dante Gabriel Rossetti, who in 1848 helped to found an artists' society called the Pre-Raphaelite Brotherhood. The basic aim of the Pre-Raphaelites was to do battle against the frivolous art of the day by producing "pure transcripts...from nature" and by having "genuine ideas to express." As the name of the Brotherhood proclaims, its members took their inspiration from the "primitive" masters of the fifteenth century; to that extent, they belonged to the Gothic revival, which had long been an important aspect of the Romantic movement. What set the Pre-Raphaelites apart from Romanticism pure-andsimple was an urge to reform the ills of modern civilization through their art. But Rossetti was not concerned with social problems; he thought of himself, rather, as a reformer of aesthetic sensibility. His early masterpiece, *Ecce Ancilla Domini* (fig. 365), although realistic in detail, is full of self-conscious archaisms such as the pale tonality, the limited range of colors, the awkward perspective, and the stress on the verticals, not to mention the title in Latin. At the same time, this Annunciation radiates an aura of repressed eroticism that became the hallmark of Rossetti's work and exerted a powerful influence on other Pre-Raphaelites.

Another solitary artist whom the Symbolists discovered and claimed as one of their own was Odilon Redon. Like Moreau, he had a haunted imagination, but his imagery was even more personal and disturbing. A master of etching and lithography, he drew inspiration from the fantastic visions of Goya (see fig. 322) as well as Romantic literature. The lithograph shown in figure 366 is one of a set he issued in 1882 and dedicated to Edgar Allan Poe. The American poet had been dead for thirty-three years; but his tormented life and his equally tormented imagination made him the very model of the poète maudit, the doomed poet, and his works, excellently translated by Baudelaire and Mallarmé, were greatly admired in France. Redon's lithographs do not illustrate Poe; they are, rather, "visual poems" in their own right, evoking the macabre, hallucinatory world of Poe's imagination. In our example, the artist has revived a very ancient device, the single eye representing the all-seeing mind of God. But, in contrast to the traditional form of the symbol, Redon shows the whole eyeball removed from its socket and converted into a balloon that drifts aimlessly in the sky. Disquieting visual paradoxes of this kind were to be exploited on a large scale by the Dadaists and Surrealists in our own century.

Toulouse-Lautrec

Van Gogh's and Gauguin's discontent with the spiritual ills of Western civilization was part of a sentiment widely shared at the end of the nineteenth century. A self-conscious preoccupation with decadence, evil, and darkness pervaded the artistic and literary climate. Even those who saw no escape analyzed their predicament in fascinated horror. Yet this very awareness proved to be a source of strength (the truly decadent do not realize their plight). The most remarkable instance of this strength was Henri de Toulouse-Lautrec; physically an ugly dwarf, he was an artist of superb talent who led a dissolute life in the nightspots of Paris and died of alcoholism. He was a great admirer of Degas, and his *At the Moulin Rouge* (fig. 367) recalls the zig-

zag composition of Degas' Glass of Absinthe (see fig. 345). But this view of the well-known nightclub is no Impressionist "slice of life": Toulouse-Lautrec sees through the gay surface of the scene, viewing performers and customers with a pitilessly sharp eye for their character (including his own; he is the tiny bearded man next to the very tall one in the background). The large areas of flat color and the emphatic, smoothly curving outlines reflect the influence of Gauguin. Although Toulouse-Lautrec was no Symbolist, the Moulin Rouge that he shows us here has an atmosphere so joyless and oppressive that we can only regard it as a place of evil.

367. Henri de Toulouse-Lautrec. At the Moulin Rouge. 1892. Oil on canvas, $48\% \times 55\%$. The Art Institute of Chicago (Helen Birch Bartlett Memorial Collection)

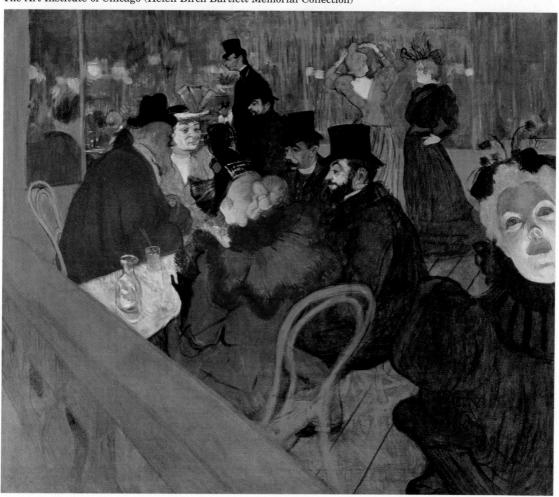

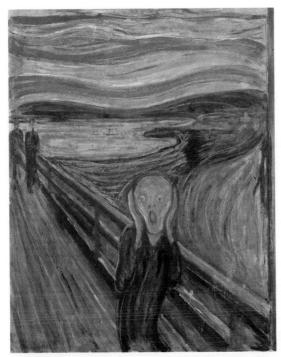

368. Edvard Munch. *The Scream*. 1893. Oil on canvas, $36 \times 29''$. National Museum, Oslo

369. Gustav Klimt. The Kiss. 1907–8. Oil on canvas, $70\% \times 70\%$ ". Österreichische Galerie, Vienna

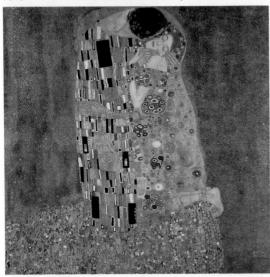

Munch; Klimt

Something of the same macabre quality pervades the early work of Edvard Munch, a gifted Norwegian who came to Paris in 1889 and based his starkly expressive style on Tou-

louse-Lautrec, Van Gogh, and Gauguin. The Scream (fig. 368) was done in Berlin, where Munch settled after the controversy raised by his paintings had led to the Berlin Secession, but it still shows the influence of all three. The picture is an image of fear, the terrifying, unreasoning fear we feel in a nightmare. Munch visualizes this experience without the aid of frightening apparitions, and his achievement is the more persuasive for that very reason. The rhythm of the long, wavy lines seems to carry the echo of the scream into every corner of the picture, making earth and sky one great sounding board of terror. By the same token, the erotic anxiety in The Kiss (fig. 369) by Gustav Klimt, the most important member of the Vienna Secession, is more telling than in Beardsley's Salome. Engulfed in their mosaic-like robes, the angular figures steal a brief moment of passion, which emphasizes their joyless existence.

Picasso

The young Pablo Picasso shared a similar sense of tragedy. Upon arriving in Paris in 1900, he came under the spell of the same artistic atmosphere that had generated the style of Munch. His so-called Blue Period (referring to the prevailing color of his canvases as well as to their mood) consists almost entirely of pictures of beggars and derelicts such as The Old Guitarist (fig. 370)—outcasts or victims of society whose pathos reflects the artist's own sense of isolation. Yet these figures convey poetic melancholy more than outright despair. The aged musician accepts his fate with a resignation that seems almost saintly, and the attenuated grace of his limbs reminds us of El Greco (see fig. 230). The Old Guitarist is a strange amalgam of Mannerism and the art of Gauguin and Toulouse-Lautrec (note the smoothly curved contours) imbued with the personal gloom of a twenty-two-year-old genius.

370. Pablo Picasso. The Old Guitarist. 1903. Oil on panel, $47\% \times 32\%$ ". The Art Institute of Chicago (Helen Birch Bartlett Memorial Collection)

371. Henri Rousseau. The Dream. 1910. Oil on canvas, $6'81/2'' \times 9'91/2''$. The Museum of Modern Art, New York (Gift of Nelson A. Rockefeller)

Rousseau

A few years later, Picasso and his friends discovered a painter who until then had attracted no attention, although he had been exhibiting his work since 1886. He was Henri Rousseau, a retired customs collector who had started to paint in his middle age without training of any sort. His ideal—which, fortunately, he never achieved—was the arid academic style of the followers of Ingres. Rousseau is that paradox, a folk artist of genius. How else could he have done a picture like *The Dream* (fig. 371)? The artist himself described the scene in a little poem:

Yadwigha, peacefully asleep Enjoys a lovely dream:
She hears a kind snake charmer Playing upon his reed.
On stream and foliage glisten The silvery beams of the moon.
And savage serpents listen To the gay, entrancing tune.

What goes on in the enchanted world of this canvas needs no explanation, because none is possible, but perhaps for that very reason its magic becomes unbelievably real to us. Here at last is that innocent directness of feeling which Gauguin thought was so necessary for the age, and traveled so far to find. Picasso and his friends were the first to recognize this quality in Rousseau's work. They revered him, quite justifiably, as the godfather of twentieth-century painting.

SCULPTURE

No tendencies to be equated with Post-Impressionism appear in sculpture until about 1900. Sculptors of a younger generation had by then been trained under the dominant influence of Rodin, and were ready to go

their own ways. The finest of these, Aristide Maillol, began as a Symbolist painter, although he did not share Gauguin's anti-Greek attitude. Maillol might be called a "Classical primitivist"; admiring the simplified strength of early Greek sculpture, he rejected its later phases. The Seated Woman (fig. 372) evokes memories of the Archaic and Early Classical styles (compare figs. 55, 56) rather than of Phidias and Praxiteles (see figs. 58, 60). The solid forms and clearly defined volumes also recall Cézanne's statement that all natural forms are based on the cone, the sphere, and the cylinder. But the most notable quality of the figure is its harmonious, self-sufficient repose, which the outside world cannot disturb. A statue, Maillol thought, must above all be "static," structurally balanced like a piece of architecture; it must represent a state of being that is detached from the stress of circumstance, with none of the restless, thrusting energy of Rodin's work. In this respect, the Seated Woman is the exact opposite of *The Thinker* (see fig. 354). Maillol later gave it the title Méditerranée—The Mediterranean—to suggest the source from which he drew the timeless serenity of his figure.

372. Aristide Maillol. Seated Woman (Méditerranée). c. 1901. Height 41". Collection Dr. Oskar Reinhart, Winterthur, Switzerland

A state of brooding calm is also apparent in the *Standing Youth* (fig. 373) by the German sculptor Wilhelm Lehmbruck; here a Gothic

373. Wilhelm Lehmbruck. Standing Youth. 1913. Cast stone, height 92". The Museum of Modern Art, New York (Gift of Mrs. John D. Rockefeller, Jr.)

374. Ernst Barlach. *Man Drawing a Sword*. 1911. Wood, height 31". Museum, Cranbrook Academy of Art, Bloomfield Hills, Michigan

elongation and angularity are conjoined with a fine balance derived from Maillol's art, and also with some of Rodin's expressive energy. The total effect is a looming monumental figure well anchored in space, yet partaking of that poetic melancholy we observed in Picasso's Blue Period. Ernst Barlach, another important German sculptor who reached maturity in the years before the First World War, seems the very opposite of Lehmbruck; he is a "Gothic primitivist," and more akin to Munch than to the Western Symbolist tradition. What Gauguin had experienced in Brittany and the tropics, Barlach found by going to Russia: the simple humanity of a preindustrial age. His figures, such as the Man Drawing a Sword (fig. 374), embody elementary emotions—wrath, fear, grief—that seem imposed upon them by invisible presences. When they act they are like somnambulists, unaware of their own impulses. Man, to Barlach, is a humble creature at the mercy of forces beyond his control; he is never the master of his fate. Characteristically, these figures do not fully emerge from the material substance (often, as here, a massive block of wood) of which they are made; their clothing is like a hard chrysalis that hides the body, as in medieval sculpture. Barlach's art has a range that is severely restricted in both form and emotion, yet its mute intensity within these limits is not easily forgotten.

Art in Our Time

In our account of modern art we have already discussed a succession of "isms": Neoclassicism, Romanticism, Realism, Impressionism, Post-Impressionism, Divisionism, Symbolism. There are many more to be found in twentieth-century art—so many, in fact, that no one has made an exact count. These "isms" can form a serious obstacle to our understanding; they make us feel that we cannot hope to comprehend the art of our time unless we immerse ourselves in a welter of esoteric doctrines. Actually, we can disregard all but the most important "isms"; like the names for the styles of earlier periods, they are merely labels to help us put things in their proper place. If an "ism" fails the test of usefulness, we need not bother with it. This is true of many "isms" in contemporary art; the movements they designate either cannot be seen clearly as separate entities or have so little importance that they interest only the specialist. It has always been easier to invent a new label than to create a new movement that truly deserves one.

Still, we cannot do without "isms" altogether. Among the international trends of twentieth-century art, we find three main currents, each comprising a number of "isms," that began with the Post-Impressionists and have developed greatly since then: Expression, Abstraction, and Fantasy. The first stresses the artist's emotional attitude toward himself and the world; the second, the formal structure of the work of art; and the third explores the realm of the imagination. especially in its spontaneous and irrational qualities. But we must not forget that feeling, order, and imagination are all present in every work of art: without imagination, it would be deadly dull; without some degree of

order, it would be chaotic; without feeling, it would leave us unmoved. These currents, therefore, are not mutually exclusive. We shall find them interrelated in many ways, and the work of one artist may belong to more than one current. Moreover, each current embraces a wide range of approaches, from the realistic to the completely nonrepresentational (or nonobjective). Thus these three currents do not correspond to specific styles, but to general attitudes. The primary concern of the Expressionist is the human community; of the Abstractionist, the structure of reality; and of the artist of Fantasy, the labyrinth of the individual human mind.

In addition, we will encounter modernism, a concept peculiar to the twentieth century, though its roots can be traced to Romanticism. To the artist it is a trumpet call which both asserts his freedom to create in a new style and provides him with the mission to define the meaning of his times—and even to reshape society through his art. This is a role for which the problematic term "avant-garde" (literally, vanguard) is hardly sufficient. Of course artists have always responded to the changing world around them, but rarely have they risen to the challenge as now, with so fervent a sense of personal cause.

EXPRESSIONISM

The Fauves

The twentieth century may be said, so far as painting is concerned, to have begun five years late. Between 1901 and 1906, several comprehensive exhibitions of the work of Van Gogh, Gauguin, and Cézanne were held

375. Henri Matisse. *The Joy of Life*. 1905–6. Oil on canvas, 5'8½"×7'9¾". Copyright Barnes Foundation, Merion, Pennsylvania

in Paris. The young painters who had grown up in the "decadent," morbid mood of the 1890s were profoundly impressed, and some of them developed a radical new style, full of violent color and bold distortions. Their first public appearance, in 1905, so shocked the critics that they were dubbed the *Fauves* ("wild beasts"), a label they wore with pride. Actually, it was not a common program that brought them together, but their shared sense of liberation and experiment. Thus Fauvism comprised a number of loosely related individual styles, and the group dissolved after a few years.

Matisse

Its leading member was Henri Matisse, the oldest of the founding fathers of twentieth-century painting. *The Joy of Life* (fig. 375),

probably the most important picture of his long career, sums up the spirit of Fauvism better than any other single work. It obviously derives its flat planes of color, its heavy undulating outlines, and the "primitive" flavor of its forms from Gauguin (see fig. 361); even its subject suggests the vision of Man in a state of Nature that Gauguin had pursued in Tahiti (see fig. 362). But we soon realize that these figures are not Noble Savages under the spell of a native god; the subject is a pagan scene in the Classical sense—a bacchanal, like Titian's (compare fig. 221). Even the poses of the figures have for the most part a Classical origin, and in the apparently careless draftsmanship resides a profound knowledge of the human body (Matisse had been trained in the academic tradition). What makes the picture so revolutionary is its radical simplicity, its "genius of omission": every-

376. Henri Matisse. Harmony in Red $(Red\ Room)$. 1908–9. Oil on canvas, $5'11^{1/4}'' \times 8'^{7/8}''$. The Hermitage Museum, Leningrad

thing that possibly can be, has been left out or stated by implication only, yet the scene retains the essentials of plastic form and spatial depth. Painting, Matisse seems to say, is the rhythmic arrangement of line and color on a flat plane, but it is not only that; how far can the image of nature be pared down without destroying its basic properties and thus reducing it to mere surface ornament? "What I am after, above all," he once explained, "is expression....[But]...expression does not consist of the passion mirrored upon a human face....The whole arrangement of my picture is expressive. The placement of figures or objects, the empty spaces around them, the proportions; everything plays a part." But what, we wonder, does *The Joy of Life* express? Exactly what its title says. Whatever his debt to Gauguin, Matisse was never stirred by the same agonized discontent with the "decadence" of our civilization. He had strong feelings about only one thing—the act of painting: this to him was an experience so profoundly joyous that he wanted to transmit it to the beholder in all its freshness and immediacy. The purpose of his pictures, he always asserted, was to give pleasure.

The radical new balance Matisse struck between the "two-D" and "three-D" aspects of painting is particularly evident in his *Harmony in Red* (fig. 376); he spreads the same flat blue-on-red pattern on the tablecloth and

on the wall, yet he distinguishes the horizontal from the vertical planes with complete assurance. Cézanne had pioneered this integration of surface ornament into the design of a picture (see fig. 356), but Matisse here makes it the mainstay of his composition. Equally bold—but perfectly readable is the view of a garden with flowering trees, seen through the window; the house in the distance is painted the same bright pink as the interior, and is thereby brought into relation with the rest of the picture. Likewise the blue of the sky, the greens of the foliage, and the bright yellow dots (for flowers) all recur in the foreground. Matisse's "genius of omission" is again at work: by reducing the number of tints to a minimum, he makes of color an independent structural element. It has such importance that Harmony in Red would be meaningless in a black-and-white reproduction.

377. Georges Rouault. The Old Clown. 1917. Oil on canvas, $40\times29\%$ ". Collection Mr. and Mrs. Stavros Niarchos, Paris

Rouault; Soutine

Another member of the Fauves, Georges Rouault would not have used Matisse's definition of "expression." For him this had still to include, as it had in the past, "the passion mirrored upon a human face." Rouault is the true heir of Van Gogh's and Gauguin's concern for the corrupt state of the world. He, however, hoped for spiritual renewal through a revitalized Catholic faith. His pictures, whatever their subject, are personal statements of that ardent hope. Trained in his youth as a worker in stained glass, he was better prepared than the other Fauves to accept Gauguin's enthusiasm for medieval art. Rouault's later paintings—for example, The Old Clown (fig. 377), who acts as his Everyman—are made up of areas of glowing color

378. Chaim Soutine. $Dead\ Fowl.$ c. 1926. Canvas, $38\frac{1}{2} \times 24\frac{1}{2}$ ". The Art Institute of Chicago (Joseph Winterbotham Collection)

outlined by heavy black borders in the manner of Gothic stained-glass windows (compare fig. 153). Here the mood of resignation and inner suffering reminds us of Rembrandt and Daumier.

Rouault's Expressionism was unique among French painters. The only artist in Paris to follow his lead was Chaim Soutine, an immigrant from Eastern Europe. The tempestuous, violent brushwork in Dead Fowl (fig. 378) clearly reflects the influence of the older master. Although the picture belongs conventionally to the class of still life, the dead bird is a terrifying symbol of death. As we look at the plucked, creamy-white body, we realize with sudden horror its close resemblance to a human shape. It evokes the earthward plunge of Icarus; or it is, perhaps, a cruelly direct image of Plato's definition of Man as a "featherless biped." For his power to transmute sheer anguish into visual form. Soutine has no equal among modern artists.

Nolde; Kokoschka; Beckmann

It was in Germany that Fauvism had its most enduring impact, especially among the members of a society called *Die Brücke* (The Bridge), a group of like-minded painters who lived in Dresden in 1905. One Brücke artist, Emil Nolde, stands somewhat apart; older

379. Emil Nolde. The Last Supper. 1909. Canvas, $32\frac{1}{2} \times 41\frac{3}{4}$ ". Stiftung Seebüll Ada und Emil Nolde, Neukirchen (Schleswig), Germany

380. Oskar Kokoschka. Self-Portrait. 1913. Oil on canvas, $32\times19^{1/2}$ ". The Museum of Modern Art, New York (Purchase)

than the rest, he shared Rouault's predilection for religious themes, although he was a far less articulate painter. The thickly encrusted surfaces and the deliberately clumsy draftsmanship of his Last Supper (fig. 379) make it clear that Nolde rejected all pictorial refinement in favor of a primeval, direct expression inspired by Gauguin. Another artist of highly individual talent, related to Die Brücke although not a member of it, was the Austrian painter Oskar Kokoschka. His outstanding works are his portraits painted before World War I, such as his splendid Self-Portrait (fig. 380). Like Van Gogh, Kokoschka saw himself as a visionary, a witness to the truth and reality of his inner experiences (see fig. 360); the hypersensitive features

381. Max Beckmann. Departure. 1932–33. Oil on canvas; center panel $7'34'' \times 3'9\%''$, side panels $7'34'' \times 3'3^{1}4''$ each. The Museum of Modern Art, New York (Given anonymously, by exchange)

seem lacerated by a great ordeal of the imagination. It may not be fanciful to find in this tortured psyche an echo of the cultural climate that also produced Sigmund Freud. A more robust descendant of the Brücke artists was Max Beckmann, who did not become an Expressionist until after he had experienced the First World War, which left him in despair at the state of modern civilization. The wings of his triptych, Departure (fig. 381), completed when, under Nazi pressure, he was on the point of leaving his homeland, show a nightmarish world crammed with puppet-like figures, as disquieting as Bosch's vision of Hell (see right panel of fig. 176). Their symbolism, however, is even more difficult to interpret, since it is necessarily subjective, though no one would deny its evocative power. In the hindsight of today, the topsy-turvy quality of these two scenes, full of mutilations and meaningless rituals, seems to have the force

of prophecy. The stable design of the center panel, in contrast, with its expanse of sea and its sunlit brightness, conveys the hopeful spirit of an escape to distant shores. After living through the Second World War in occupied Holland, under the most trying conditions, Beckmann spent the final three years of his career in America.

Nonobjective Painting: Kandinsky

But the most daring and original step beyond Fauvism was taken in Germany by a Russian, Wassily Kandinsky, the leading member of a group of artists in Munich called *Der Blaue Reiter* (The Blue Horseman). After 1910, Kandinsky abandoned representation altogether. Using the rainbow colors and the free, dynamic brushwork of the Paris Fauves, he created a completely nonobjective style. These works have titles as abstract as their

382. Wassily Kandinsky. Sketch I for "Composition VII". 1913. Canvas, 30¾×39¾". Collection Felix Klee, Bern

forms: our example, one of the most striking, is called *Sketch I for "Composition VII"* (fig. 382). Perhaps we should avoid the term "abstract," which is often taken to mean that the artist has analyzed and simplified the shapes of visible reality (remember Cézanne's dictum that all natural forms are based on the cone, the sphere, and the cylinder). This was not Kandinsky's method. Whatever traces of representation his work contains are quite involuntary—his aim was to charge form and color with a purely spiritual meaning (as he put it) by eliminating all resemblance to

the physical world. Whistler, too, had spoken of "divesting his picture from any outside sort of interest"; he even anticipated Kandinsky's use of "musical" titles. But it was the liberating influence of the Fauves that permitted Kandinsky to put this theory into practice. How valid is the analogy between painting and music? When Kandinsky carries it through so strictly, does he really lift his art to another plane of freedom? Or could it be that his declared independence from representation now forces him instead to "represent music," which limits him even

more severely? Kandinsky's advocates like to point out that representational painting has a "literary" content, and to deplore such dependence on another art. But why should the "musical" content of nonobjective painting be more desirable? Is painting less alien to music than to literature? The case is difficult to argue, nor does it matter whether this theory is right or wrong; the proof of the pudding is in the eating, not the recipe. Kandinsky'sor any other artist's-ideas are important to us only if we are convinced of the importance of his pictures. Did he create a viable style? Admittedly, his work demands an intuitive response that may be difficult for some of us, yet the painting reproduced here has density and vitality, and a radiant freshness of feeling that impresses us even though we are uncertain what exactly the artist has expressed.

O'Keeffe; Orozco

Americans became familiar with the Fauves through exhibitions from 1908 on, and after World War I there was a growing interest in the German Expressionists as well. The driving force behind the modernist movement in the United States was the photographer Alfred Stieglitz (see p. 435), who almost single-handedly supported many of its early members. To him, modernism meant abstraction and its related concepts. The modern movement proved short-lived in America, largely because the utopian ideals associated with abstraction were dashed by "the war to end all wars." After 1920, most of the painters in the Stieglitz circle concentrated on landscapes, which they treated in representational styles indebted chiefly to Expressionism.

The most original members of the Stieglitz group, Arthur Dove and Georgia O'Keeffe, practiced forms of abstraction that owed a great deal to Kandinsky. Throughout her long career, O'Keeffe (who married Stieglitz in 1924) covered a wide range of subjects and styles, but all embodied the same personal

383. Georgia O'Keeffe. *Dark Abstraction*. 1924. Oil on canvas, 24% × 20%". St. Louis Art Museum (Gift of Charles E. and Mary Merrill)

approach: as she assimilated a subject into her imagination, she altered and simplified its appearance. Among her finest works are the organic abstractions from the mid-1920s (fig. 383). Part plant, part landscape, they seem to reveal the secret life of nature from within. These paintings have a monumental spirit that belies their often modest size.

By the 1930s, the center of Expressionism in the New World was Mexico, rather than the United States. The Mexican Revolution began in 1911 with the fall of the dictator Porfirio Díaz, and continued for more than two decades; it inspired a group of young painters to search for a national style incorporating the great native heritage of pre-Columbian art. They also felt that their art must be "of the people," expressing the spirit of the Revolution in vast mural cycles in public buildings. Although each developed his own distinctive style, they shared a common point of departure: the Symbolist art of Gauguin. This art had shown how non-Western forms could be integrated with the Western

384. José Clemente Orozco. *Victims* (detail from a mural cycle). 1936. University of Guadalajara, Mexico

tradition, and the flat, decorative quality was moreover particularly suited to murals. The involvement of these artists in the political turmoil of the day often led them to overburden their works with ideological significance.

The artist least subject to this imbalance of form and subject matter was José Clemente Orozco, a passionately independent artist who refused to get embroiled in factional politics. Our detail from the mural cycle at the University of Guadalajara (fig. 384) illustrates his most powerful trait, a deep humanitarian sympathy with the silent suffering masses.

ABSTRACTION

The second of our main currents is the one

we called Abstraction. Literally, to abstract means to draw away from, to separate. If we have ten apples, and then separate the ten from the apples, we get an "abstract number," a number that no longer refers to particular things. But "apples," too, is an abstraction, since it places ten apples in one class, without regard for their individual qualities. The artist who sets out to paint ten apples will find no two of them alike, yet he cannot possibly take all of their differences into account: even the most painstaking portrayal of these particular pieces of fruit is bound to be some sort of an abstraction. Abstraction, then, goes into the making of any work of art, whether the artist knows it or not. The process was not conscious and controlled, however, until the Renaissance, when artists first analyzed the shapes of nature in terms of mathematical bodies (see p. 199). Cézanne and Seurat revitalized this approach and explored it further; they are the direct ancestors of the abstract movement in twentieth-century art. Its real creator, however, was Pablo Picasso.

Facet Cubism

About 1905, stimulated both by the Fauves and by the great Post-Impressionists, Picasso gradually abandoned the melancholy lyricism of his Blue Period for a more robust style. He shared Matisse's enthusiasm for Gauguin and Cézanne, but he viewed these masters very differently; in 1906–7, he produced a monumental canvas (fig. 385) so challenging that it outraged even Matisse. The title, Les Demoiselles d'Avignon ("The Girls of Avignon"), refers not to the town of that name but to Avignon Street in a notorious section of Barcelona; when Picasso started the picture, it was to be a temptation scene, but he ended up with a composition of five nudes and a still life. But what nudes! The three on the left are angular distortions of Classical figures, while the violently dislocated features and bodies of the other two

385. Pablo Picasso. Les Demoiselles d'Avignon. 1907. Oil on canvas, $8' \times 7'8''$. The Museum of Modern Art, New York (Acquired through the Lillie P. Bliss Bequest)

have all the barbaric qualities of primitive art (see figs. 9, 10). Following Gauguin, the Fauves had discovered the aesthetic appeal of African and Oceanic sculpture, yet it was Picasso, rather than they, who used primitive art as a battering ram against the Classical conception of beauty. Not only the proportions, but the organic integrity and continuity of the human body are denied here, so that the canvas (in the apt words of

one critic) "resembles a field of broken glass." Picasso, then, has destroyed a great deal; what has he gained in the process? Once we recover from the initial shock, we begin to see that the destruction is quite methodical: everything—the figures as well as their setting—is broken up into angular facets. These, we will note, are not flat, but shaded in a way that gives them a certain three-dimensionality. We cannot always be sure

whether they are concave or convex; some look like chunks of solidified space, others like fragments of translucent bodies. They constitute a unique kind of matter, which imposes a new kind of integrity and continuity on the entire canvas. Unlike Matisse's *Harmony in Red*, the *Demoiselles* can no longer be read as an image of the external world; its world is its own, analogous to nature but built along different principles. Picasso's revolutionary "building material," compounded of voids and solids, is hard to describe. The early critics, who saw only the prevalence of sharp edges and angles, dubbed the new style "Cubism."

That the *Demoiselles* owes anything to Cézanne may seem hard to believe. Nevertheless, Picasso had studied Cézanne's late work with care (see fig. 357), finding in its abstract treatment of volume and space the translu-

386. Pablo Picasso. Ambroise Vollard. 1909–10. Oil on canvas, $36 \times 25 \frac{1}{2}$ ". Pushkin Museum, Moscow

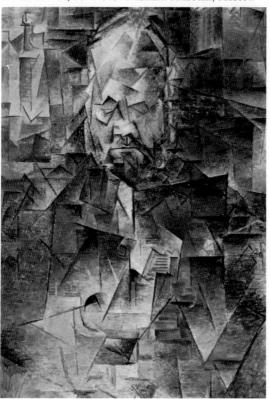

cent structural units from which he derived the facets of Cubism. The link is clearer in Picasso's portrait of Ambroise Vollard (fig. 386), painted four years later: the facets are now small and precise, more like prisms, and the canvas has the balance and refinement of a fully mature style. Contrasts of color and texture are reduced to a minimum, so as not to compete with the design. And the structure has become so intricate a web that it would seem wholly cerebral if the "imprismed" sitter's face did not emerge with such dramatic force. Cubism here has become an abstract style within the purely Western sense, as against the "barbaric" distortions of the Demoiselles. But its distance from observed reality has not significantly increased —Picasso may be playing an elaborate game of hide-and-seek with nature, but he still needs it to challenge his creative powers. The nonobjective realm held no appeal for him, then or later.

Collage Cubism

By 1910, Cubism was well established as an alternative to Fauvism, and Picasso had been joined by other artists—notably Georges Braque, with whom he collaborated so intimately that their work at that time is hard to tell apart. Both of them initiated the next phase of Cubism, which was even bolder than the first, as evidenced by Braque's Le Courrier of 1913 (fig. 387). It is composed almost entirely of cut-and-pasted scraps of material. with only a few lines added to complete the design; we recognize strips of imitation wood graining, part of a tobacco wrapper with a contrasting stamp, half the masthead of a newspaper, and a bit of newsprint made into a playing card (the ace of hearts). This technique came to be known as collage (French for "paste-up"). Why did Picasso and Braque suddenly prefer the contents of the wastepaper basket to brush and paint? Because they had come to think of the picture surface as a sort of tray on which to "serve" the still

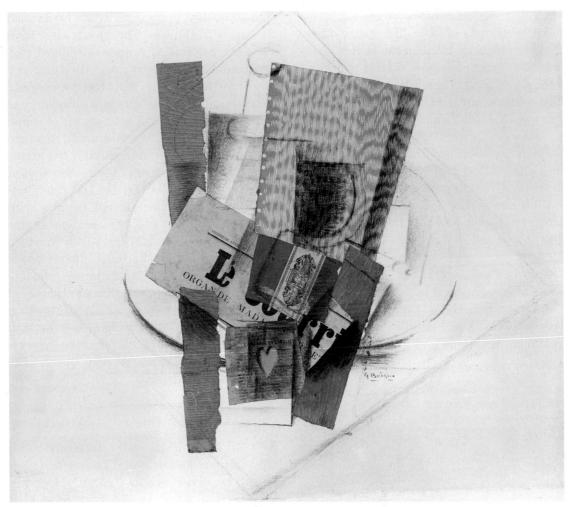

387. Georges Braque. Le Courrier. 1913. Collage, 20×22^{1} /2". The Philadelphia Museum of Art (A. E. Gallatin Collection)

life to the beholder, and they found the best way to explore this new concept was to put real things on the tray. The ingredients of a collage actually play a double role; they have been shaped and combined, then drawn or painted upon so as to give them a representational meaning, but they retain their original identity as scraps of material. Thus their function is both to *represent* (to be part of an image) and to *present* (to be themselves). In the latter role, they endow a collage with a self-sufficiency that no facet-Cubist picture could have. A tray, after all, is a self-contained area, detached from the rest of the physical world; unlike a painting, it cannot

show more than is actually on it. The difference between the two phases of Cubism may also be defined in terms of picture space: facet Cubism retains a certain kind of depth, the painted surface acts as a window through which we still perceive remnants of the familiar perspective space of the Renaissance. This space lies behind the picture plane and has no visible limits; it may contain objects that are hidden from our view. In collage Cubism, on the contrary, the picture space lies in front of the plane of the "tray"; space is created not by illusionistic devices, such as modeling or foreshortening, but by the actual overlapping of layers of pasted materials.

Collage Cubism, then, offers a basically new space concept, the first since Masaccio: it is a true landmark in the history of painting.

Before long Picasso and Braque discovered that they could retain this new pictorial space without the use of pasted materials; they had only to paint as if they were making collages. Picasso's *Three Musicians* (fig. 388) shows this "cut-paper style" so consistently that we cannot tell from the reproduction whether it is painted or pasted. It is, in any event, one of the great masterpieces of collage Cubism, monumental in size and conception. The separate pieces are fitted together as firmly as architectural blocks, yet the artist's primary concern is not with the surface pattern (if it were, the painting would resemble a patchwork guilt), but with the image of the three musicians, traditional figures of the comedy stage. Their human presence, solemn and even sinister, may be sensed behind the screen of costumes and

By now, Picasso was internationally famous. Cubism had spread throughout the Western world: it influenced not only painters, but sculptors and even architects. Picas-

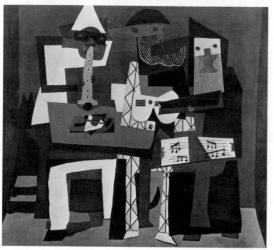

389. Pablo Picasso. *Mother and Child.* 1921–22. Oil on canvas, 38×28". The Alex L. Hillman Family Foundation, New York

so himself, however, was already striking out in a new direction. By 1920, he was working simultaneously in two separate styles: collage Cubism and a Neoclassical style of strongly modeled, heavy-bodied figures such as his Mother and Child (fig. 389). To many, this seemed a kind of betrayal, but in retrospect the cause of Picasso's double-track performance is evident: chafing under the limitations of collage Cubism, he needed to resume contact with the Classical tradition, the "art of the museums." The figures of Mother and Child have a mock-monumental quality that suggests colossal statues rather than flesh-and-blood human beings, yet the theme is treated with surprising tenderness. The forms, however, are carefully dovetailed within the frame, not unlike the way a collage is put together. A few years later the two tracks of Picasso's style began to converge,

390. Pablo Picasso. *Three Dancers*. 1925. Oil on canvas, $7'1/2'' \times 4'81/4''$. The Tate Gallery, London

making an extraordinary synthesis that was the basis of his art thereafter. The Three Dancers of 1925 (fig. 390) shows how he managed this seemingly impossible feat. Structurally, the picture is pure collage Cubism, even though, instead of cutting and pasting, the artist has imitated the appearance of collage with his brush; the canvas even shows painted imitations of specific materials patterned wallpaper, and samples of various fabrics cut out with pinking shears. But the figures, a wildly fantastic version of a Classical dance, are an even more violent assault on convention than the Demoiselles d'Avignon (see fig. 385). Human anatomy is here simply the raw material for Picasso's incredibly fertile inventiveness; limbs, breasts, and faces are handled with the same sovereign freedom as the fragments of external reality in Braque's Le Courrier. Their original identity no longer matters-breasts may turn into eyes, profiles merge with frontal views. shadows become substance, and vice versa, in an endless flow of transformations. They are "visual puns," offering wholly unexpected possibilities of expression—humorous, grotesque, macabre, even tragic.

Futurism

As originally conceived by Picasso and Braque, Cubism offered a formal discipline of subtle balance, used for traditional subjects—still life, portraiture, the nude. Other painters, however, saw in the new style a special affinity with the geometric precision of engineering that made it uniquely attuned to the dynamism of modern times. The shortlived Futurist movement in Italy exemplifies this attitude; in 1910 its founders issued a manifesto violently rejecting the past and exalting the beauty of the machine. At first they used techniques developed from Post-Impressionism to convey the surge of industrial society in otherwise static compositions still dependent upon representational images. But by adopting the simultaneous

391. Umberto Boccioni. *Dynamism of a Cyclist.* 1913. Canvas, $27\frac{1}{8} \times 37\frac{3}{8}$ ". Collection Gianni Mattioli, Milan

views of facet Cubism in Dynamism of a Cyclist (fig. 391), Umberto Boccioni, the most original of the Futurists, was able to communicate furious pedaling across time and space far more tellingly than if he had actually depicted the human figure, which could be seen in only one time and place in traditional art. In the flexible vocabulary provided by Cubism, Boccioni found the means of expressing the twentieth century's new sense of time. space, and energy, as it was soon to be defined in Albert Einstein's theory of relativity. Moreover, Boccioni suggests the unique quality of the modern experience. With his pulsating movement, the cyclist has become an extension of his environment, from which he is now indistinguishable. Futurism literally died out in World War I; its leaders were killed by the same vehicles of destruction they had glorified only a few years earlier in their revolutionary manifesto.

Strong echoes of Futurism appear, however, in *Brooklyn Bridge* (fig. 392), painted by the Italo-American Joseph Stella just before the end of the war. With its maze of vigorous luminescent cables, powerful diagonal thrusts, and crystalline "cells" of space, it miraculously equals Walt Whitman's poem as a paean to that monument of modern technology. In a similar vein, *The City* (fig. 393), by

392. Joseph Stella. $Brooklyn\,Bridge.$ 1917. Oil on canvas, $7'\times 6'4''$. Yale University Art Gallery, New Haven, Connecticut (Collection The Société Anonyme)

the Frenchman Fernand Léger, is a beautifully controlled industrial landscape that is stable without being static, and its collage Cubism reflects the clean geometric shapes of modern machinery. Buoyant with optimism and pleasurable excitement, it conjures up a

mechanized utopia. In this instance, the term "abstraction" applies more to the choice of design elements and their manner of combination than to the shapes themselves, since these (except for the two figures on the staircase) are "prefabricated" entities.

393. Fernand Léger. *The City.* 1919. Oil on canvas, 7'7"×9'9½". The Philadelphia Museum of Art (A. E. Gallatin Collection)

Cubo-Futurism; Suprematism

Cubo-Futurism, which arose in Russia a few years before World War I as the result of close contacts with the leading European art centers, took its style from Picasso and based its theories on Futurist tracts. The Russian Futurists were above all modernists. They welcomed industry, which was spreading rapidly throughout Russia, as the foundation of a new society and the means for conquering that old Russian enemy, nature. Unlike the Italian Futurists, however, the Russians never glorified the machine, least of all as an instrument of war. Central to Cubo-Futurist thinking was the concept of zaum, a term which has no counterpart in the West: invented by Russian poets, zaum was a transsense (as opposed to the Dadaists' non-sense; see p. 381) language based on new word forms and syntax. In theory, zaum could be understood universally, since it was thought that meaning was implicit in the basic sounds and patterns of speech. When applied to painting, zaum provided the artist with complete freedom to redefine the style and content of art. The picture surface was now seen as the sole conveyer of meaning through its appearance; hence, the subject of a work of art became the visual elements and their formal arrangement. However, because Cubo-Futurism was

concerned with means, not ends, it failed to provide the actual content that is found in modernism.

Although the Cubo-Futurists were more important as theorists than artists, they provided the springboard for later Russian movements. The new world envisioned by the Russian modernists led to a broad redefinition of the roles of man and woman, and the finest painter of the group was Liubov Popova. For the first time in history women emerged as artistic equals to an extent not achieved in Europe or America until considerably later. Popova studied in Paris in 1912 and visited Italy in 1914. The combination of Cubism and Futurism that she absorbed is seen in The Traveler (fig. 394). The treatment of forms remains essentially Cubist, but the painting shares the Futurist obsession with representing dynamic motion in time and space. The jumble of image fragments creates the impression of objects seen in rapid succes-

394. Liubov Popova. *The Traveler.* 1915. Oil on canvas, $56\times41^{1}\sqrt{2}$ ". Norton Simon Museum, Pasadena, California

395. Kazimir Malevich. *Black Quadrilateral*. c. 1913–15. Oil on canvas, $9\% \times 6\%$ ". Copyright 1981 George Costakis

sion; across the plane the furious interaction of forms with their environment threatens to extend the painting into the surrounding space. At the same time, the strong modeling draws attention to the surface, lending it a relief-like quality which is enhanced by the vigorous texture.

The first purely Russian art of the twentieth century, however, was that of Suprematism. In one of the greatest leaps of the symbolic and spatial imagination in the history of art, Kazimir Malevich invented the Black Quadrilateral seen in figure 395. How is it that such a disarmingly simple image should be so important? By reducing art to the fewest possible elements—a single shape repeated in two tones and fixed firmly to the picture plane—he emphasized the painting as a painting even more radically than had his predecessors. At the same time, he trans-

formed it into a concentrated symbol having multiple layers of meaning, thereby providing the content missing from Cubo-Futurism. The inspiration for *Black Quadrilateral* came in 1913 while Malevich was working on designs for the opera "Victory over the Sun," a production that was one of the most important collaborations in the modern era. In the context of the opera, the black quadrilateral represents the eclipse of the sun of Western painting and of everything based upon it. Further, the work can be seen as the triumph of the new order over the old, of the East over the West, man over nature, idea over matter. The black quadrilateral (which is not even a true rectangle) was intended to stand as a modern icon, superseding the traditional Christian trinity and symbolizing a "supreme" reality, because geometry is an independent abstraction in itself: hence the movement's name, Suprematism.

According to Malevich, Suprematism was also a philosophical color system constructed in time and space. His space was an intuitive one, having both scientific and mystical overtones. The flat plane replaces volume, depth, and perspective as a means of defining space; each side or point represents one of the three dimensions, the fourth side standing for the fourth dimension, time. Like the universe itself, the black surface would be infinite were it not delimited by an outer boundary which is the white border and shape of the canvas. Black Quadrilateral thus constitutes the first satisfactory redefinition, visually and conceptually, of time and space in modern art. Like Einstein's formula $E = mc^2$ for the theory of relativity, of which Malevich was certainly aware, it has an elegant simplicity that belies the intense effort required to synthesize a complex set of ideas and reduce them to a fundamental "law." When it appeared for the first time, Suprematism had much the same impact on Russian artists that Einstein's theory had on scientists: it unveiled a world never seen before, one that was unequivocally modern.

396. Piet Mondrian. Composition with Red, Blue, and Yellow. 1930. Canvas, $20 \times 20''$. Collection Mr. and Mrs. Armand P. Bartos. New York

The heyday of Suprematism was over by the early 1920s. Reflecting the growing diversity and fragmentation of Russian art, its followers defected to other movements, above all to the Constructivism led by Vladimir Tatlin (see p. 405).

De Stijl: Mondrian

The most radical extension of Cubism may be found in the work of a Dutch painter nine

years older than Picasso, Piet Mondrian. He came to Paris in 1912 as a mature Expressionist in the tradition of Van Gogh and the Fauves. Under the impact of Cubism, his ideas underwent a complete change, and within the following decade he developed a totally nonobjective style that he called Neo-Plasticism (the movement as a whole is also known as $De\ Stijl$, after the Dutch magazine advocating his ideas). $Composition\ with\ Red$, Blue, and Yellow (fig. 396) shows Mondrian's

style at its most severe: he restricts his design to horizontals and verticals and his colors to the three primary hues, plus black and white, thus eliminating every possibility of representation. Yet Mondrian sometimes gave his works such titles as Trafalgar Square or Broadway Boogie-Woogie, which hint at some degree of relationship with observed reality. Unlike Kandinsky, Mondrian did not strive for pure, lyrical emotion; his goal, he asserted, was "pure reality," and he defined this as equilibrium "through the balance of unequal but equivalent oppositions." Perhaps we can best understand what he meant if we think of his work as "abstract collage" that uses black bands and colored rectangles, instead of recognizable fragments of everyday materials. He was interested only in relationships, and wanted no distracting elements or fortuitous associations. But, by establishing the "right" relationship among his bands and rectangles, he transforms them as thoroughly as Braque transformed the snippets of pasted paper in Le Courrier (see fig. 387). How did he go about discovering the "right" relationship? And how did he determine the shape and number of the bands and rectangles? In Le Courrier, the ingredients are to some extent "given" by chance; Mondrian, apart from his self-imposed rules, constantly faced the dilemma of unlimited possibilities. He could not change the relationship of the bands to the rectangles without changing the bands and rectangles themselves. When we consider his task, we begin to realize its infinite complexity. If we measure the various units in Composition with Red, Blue, and Yellow, we find that only the proportions of the canvas itself are truly rational, an exact square; Mondrian arrived at all the rest "by feel," and must have undergone agonies of trial and error. Strange as it may seem, Mondrian's exquisite sense of nonsymmetrical balance is so specific that critics well acquainted with his work have no difficulty telling fakes from genuine pictures. Designers who work with nonfigurative shapes, such as architects and typographers, are most likely to be sensitive to this quality, and Mondrian has had a greater influence among them than among painters (see figs. 450, 452, 453).

FANTASY

The third current, which we termed Fantasy, follows a course less clear-cut than the other two, since it depends on a state of mind more than on any particular style. The one thing all painters of fantasy have in common is the belief that imagination is more important than the outside world. And since every artist's imagination is his own private domain, the images it provides for him are likely to be equally private, unless he subjects them to a deliberate process of selection. But how can such "uncontrolled" images have meaning to the beholder, whose own inner world is not the same as the artist's? Psychoanalysis has taught us that we are not so different from each other in this respect as we like to think. Our minds are all formed according to the same basic pattern, and the same is true of our imagination and memory. They belong to the unconscious part of the mind where experiences are stored, whether we want to remember them or not. At night, or whenever conscious thought relaxes its vigilance, our experiences return and we seem to live through them again. However, the unconscious mind does not usually reproduce our experiences as they actually happened. They will often be admitted into the conscious part of the mind in the guise of "dream images"in this form they seem less vivid, and we can live with our memories more easily. This digesting of experience is surprisingly alike in all of us, although the process works better with some individuals than with others. Hence we are always interested in imaginary things, provided they are presented to us in such a way that they seem real. What happens in a fairy tale, for example, would be very dull in the matter-of-fact language of a

news report, but when it is told to us as it should be told, we are enchanted. The same is true of paintings—we recall *The Dream* by Henri Rousseau (see fig. 371). But why does private fantasy loom so large in present-day art? There seem to be several interlocking causes: first, the cleavage that developed between reason and imagination in the wake of rationalism, which tended to dissolve the heritage of myth and legend that had been the common channel of private fantasy in earlier times; second, the artist's greater freedom—and insecurity—within the social fabric, giving him a sense of isolation and favoring an introspective attitude; and, finally, the Romantic cult of emotion that prompted the artist to seek out subjective experience, and to accept its validity. In nineteenth-century art, private fantasy was still a minor current. After 1900, it became a major one.

Nostalgia: De Chirico; Chagall

The heritage of Romanticism can be seen most clearly in the astonishing pictures painted in Paris just before World War I by Giorgio de Chirico, such as Mystery and Melancholy of a Street (fig. 397). This large and deserted square with its endless receding arcades, illuminated by the cold light of the full moon, has all the poetry of Romantic reverie. But it also has a strangely sinister air: it is "ominous" in the full sense of that term-everything suggests an omen, a portent of unknown and disquieting significance. De Chirico himself could not explain the incongruities in these paintings—the empty furniture van, the girl with the hoop-that trouble and fascinate us. Later on he adopted a conservative style and repudiated his early work, as if he were embarrassed at having put his dream world on public display. The power of nostalgia, so evident in Mystery and Melancholy of a Street, also dominated the fantasies of Marc Chagall, a Russian Jew who came to Paris in 1910. I and the Village (fig. 398) is a Cubist fairy tale that weaves

397. Giorgio de Chirico. *Mystery and Melancholy of a Street.* 1914. Canvas, $34\frac{1}{4} \times 28\frac{1}{8}$ ". Resor Collection, New Canaan, Connecticut

398. Marc Chagall. *I and the Village*. 1911. Oil on canvas, 6'35's" × 4'115's". The Museum of Modern Art, New York (Mrs. Simon Guggenheim Fund)

dreamlike memories of Russian folk tales, Jewish proverbs, and the Russian country-side into one glowing vision. Here, as in many later works, Chagall relives the experiences of his childhood; they were so important to him that his imagination shaped and reshaped them for years without diminishing their persistence.

Klee

The "fairy tales" of the German-Swiss painter Paul Klee are more purposeful and controlled than Chagall's, although at first they may strike us as more childlike. Klee, too, had been influenced by Cubism; but primitive art, and the drawings of small children, held an equally vital interest for him. During the First World War, he molded from these disparate elements a pictorial language of his own, marvelously economical and precise. Twittering Machine (fig. 399), a delicate pen drawing tinted with watercolor, demonstrates the unique flavor of Klee's art; with a few simple lines, he has created a ghostly mechanism that imitates the sound of birds, mocking our faith in the miracles of the machine age as well as our sentimental appreciation of bird song. The little contraption (which is not without its sinister aspect—the heads of the four sham birds look like fishermen's lures, as if they might entrap real birds) thus condenses into one striking invention a complex of ideas about present-day civilization. The title has an indispensable role; it is characteristic of the way Klee works that the picture itself, however visually appealing, does not reveal its full evocative quality unless the artist tells us what it means. The title, in turn, needs the picture the witty concept of a twittering machine does not kindle our imagination until we are shown such a thing. This interdependence is familiar to us from cartoons. Klee lifts it to the level of high art, yet retains the playful character of these visual-verbal puns. To him art was a "language of signs," of shapes that

399. (above) Paul Klee. Twittering Machine. 1922. Watercolor and pen and ink on paper, $25\frac{1}{4} \times 19$ ". The Museum of Modern Art, New York (Purchase)

400. (opposite) Paul Klee. Park near Lu(cerne). 1938. Oil and newsprint on burlap, $39\% \times 27\%$. Paul Klee Foundation, Kunstmuseum, Bern

are images of ideas as the shape of a letter is the image of a specific sound, or an arrow the image of the command, "This way only." But conventional signs are no more than "triggers"; the instant we perceive them, we automatically invest them with their meaning, without stopping to ponder their shape. Klee wanted his signs to impinge upon our awareness as visual facts, yet also to share the quality of "triggers." Toward the end of his life, he immersed himself in the study of ideographs, such as hieroglyphics, hex signs, and the mysterious markings in prehistoric caves— "boiled-down" representational images that appealed to him because they had the twin qualities he strove for in his own graphic language. This "ideographic style" is very pronounced in figure 400, Park near Lu(cerne);

as a lyric poet may use the plainest words, these deceptively simple shapes sum up a wealth of experience and sensation: the innocent gaiety of spring, the clipped orderliness peculiar to captive plant life in a park.

Dada: Duchamp

In Paris, on the eve of World War I, we encounter still another painter of fantasy, the Frenchman Marcel Duchamp. After basing his early style on Cézanne, he had initiated a dynamic version of facet Cubism, similar to Futurism, by superimposing successive phases of movement on each other, as in multiple-exposure photography. Almost immediately, however, Duchamp's art took a far more disturbing turn. In *The Bride* (fig. 401)

we will look in vain for any resemblance to the human form; what we see is a mechanism—part motor, part distilling apparatus; the opposite of Klee's twittering machine, it is beautifully engineered to serve no purpose whatever. Its title puzzles us (Duchamp has emphasized its importance by lettering it right onto the canvas). Did he intend to satirize the scientific view of man, by "analyzing" the bride until she is reduced to a complicated piece of plumbing? If so, the picture may be the negative counterpart of that glorification of the machine so stridently proclaimed by the Futurists.

It is hardly surprising that the organized mass killing during World War I should have driven Duchamp to despair. With a number of others who shared his attitude, he

401. Marcel Duchamp. *The Bride.* 1912. Canvas, $34\frac{3}{4} \times 21\frac{1}{2}$ ". The Philadelphia Museum of Art (Louise and Walter Arensberg Collection)

402. Max Ernst. 1 Copper Plate 1 Zinc Plate 1 Rubber Cloth 2 Calipers 1 Drainpipe Telescope 1 Piping Man. 1920. Collage, 12×9". Succession Arp, Meudon, France

launched in protest a movement called Dada (or Dadaism). The term, French for "hobbyhorse," was reportedly picked at random from a dictionary, but as an infantile "allpurpose word" it perfectly fitted the spirit of the movement. Dada has often been called nihilistic, and its declared purpose was indeed to make clear to the public that all established values, moral or aesthetic, had been rendered meaningless by the catastrophe of World War I. During its short life from 1916 to 1922, Dada preached non-sense and antiart with a vengeance. Duchamp put his signature, and a provocative title, on readymade objects such as bottle racks and snow shovels, exhibiting them as works of art. Not even modern art was safe from the Dadaists' assaults; one of them exhibited a toy monkey inside a frame, entitled Portrait of Cézanne. On the other hand, they adopted the technique of collage Cubism for their own purposes: figure 402, by the German Dadaist Max Ernst, an associate of Duchamp, is largely composed of cuttings from illustrations of machinery. The caption pretends to enumerate these ingredients, which include "1 piping man." Actually there are two figures made of piping, who stare at us blindly through their goggles, the one on the left a postwar version of Duchamp's *Bride*.

Surrealism

Yet Dada was not completely negative. In its calculated irrationality there was also liberation, a voyage to unknown provinces of the creative mind. The only law respected by the Dadaists was that of chance, and the only reality that of their own imaginations. This is the message of Duchamp's Ready-Mades, which the artist created simply by shifting their context from the utilitarian to the aesthetic. Certainly they are extreme demonstrations of a principle. But the very principle—that artistic creation does not depend on manual craftsmanship—is an important discovery. Duchamp himself, having made

his point, soon withdrew from artistic activity altogether; some of his fellow "chancetakers" founded, in 1924, Dada's successor, Surrealism. Led by the poet André Breton, they defined their aim as "pure psychic automatism . . . intended to express . . . the true process of thought . . . free from the exercise of reason and from any aesthetic or moral purpose." Surrealist theory is heavily larded with concepts borrowed from psychoanalysis, and its overwrought rhetoric is not always to be taken seriously. The notion that a dream can be transposed directly from the unconscious mind to the canvas, bypassing the conscious awareness of the artist, did not work out in practice; some degree of control was simply unavoidable.

Dali; Ernst; Miró

We see this in *The Persistence of Memory* (fig. 403) by Salvador Dali, the most notorious of the Surrealists, who uses the meticulous verism of De Chirico to render a "paranoid" dream in which time, forms, and space have been distorted in a frighteningly real way. Nevertheless, the Surrealists devised several novel techniques for soliciting and exploiting chance effects. Max Ernst, the most inven-

403. Salvador Dali. The Persistence of Memory. 1931. Oil on canvas, $9\frac{1}{2} \times 13^n$. The Museum of Modern Art, New York (Given anonymously)

404. Joan Miró. *Painting*. 1933. Oil on canvas, 5'8¹/₄"×6'5¹/₄". The Museum of Modern Art, New York (Gift of Advisory Committee)

tive member of the group, often combined collage with "frottage" (rubbings from pieces of wood, pressed flowers, etc.—the process we all know from the children's pastime of rubbing with a pencil on a piece of paper covering a coin). In *Totem and Taboo* (fig. 405) he has obtained fascinating shapes and textures by "decalcomania" (the transfer, by pressure, of wet paint to the canvas from some other surface). Ernst has certainly found and elaborated

upon an extraordinary wealth of images among his stains. The end result does have some of the qualities of a dream, but it is a dream born of a strikingly Romantic imagination.

Surrealism, however, has a more vigorously imaginative branch: such works by Picasso as the *Three Dancers* (see fig. 390) have affinities with it, and its greatest exponent is another Spaniard, Joan Miró, who produced the

405. Max Ernst. *Totem and Taboo*. 1941. Canvas, 28×36 ". Collection William N. Copley, New York

striking *Painting* (fig. 404). His style has been labeled "biomorphic abstraction," since his designs are fluid and curvilinear rather than geometric. "Biomorphic concretion" might be a more suitable name, for the shapes in Miró's pictures have their own vigorous life. They seem to change before our eyes, expanding and contracting like amoebas until they approach human individuality closely enough to please the artist. Their spontaneous "becoming" is the very opposite of abstraction, although Miró's formal discipline is no less rigorous than that of Cubism (he began as a Cubist).

406. Arshile Gorky. The Liver Is the Cock's Comb. 1944. Canvas, $6' \times 8'2''$. Albright-Knox Art Gallery, Buffalo (Gift of Seymour H. Knox)

NEWER TRENDS

Abstract Expressionism (Action Painting)

Equally misleading as "Surrealism" is the term Abstract Expressionism, which is often applied to the style of painting that prevailed for about a dozen years following the end of World War II. It was initiated by a group of artists in reaction to the anxiety brought on by the nuclear age and subsequent cold war. Under the influence of existentialist philosophy, the Abstract Expressionists—or Action Painters—developed from Surrealism a new approach to art. Painting became a counterpart to life itself: an ongoing process in which the artist faces comparable risks and overcomes the dilemmas confronting him through a series of conscious and unconscious decisions in response to both inner and external demands. The Color-Field Painters (see p. 387) later coalesced the frenetic gestures and violent hues of the Action Painters into broad forms of poetic color that partly reflect the spirituality of Oriental mysticism. In a sense, Color-Field Painting resolved the conflicts expressed by Action Painting. They are, however, two sides of the same coin, separated by the thinnest differences of approach.

Gorky

Arshile Gorky, an Armenian who came to America at sixteen, was the pioneer of the movement and the single most important influence on its other members. It took him twenty years—painting first in the vein of Cézanne, then in that of Picasso—to arrive at his mature style as we see it in *The Liver Is the Cock's Comb* (fig. 406). The enigmatic title suggests Gorky's close contact with André Breton, the Surrealist poet who found refuge in New York during the war, as well as his own experience in camouflage, gained from a class he conducted earlier. Everything here is in the process of turning into something

else. The biomorphic shapes clearly owe much to Miró, while their spontaneous handling and the glowing color reflect Gorky's enthusiasm for Kandinsky (see figs. 404, 382). Yet the dynamic interlocking of the forms, their aggressive power of attraction and repulsion, are uniquely his own.

Pollock

Had Gorky lived into the 1950s, he would surely have been the leading figure among the Abstract Expressionists. His principal heir proved to be Jackson Pollock, who in 1950 did the huge and original picture entitled *One* (fig. 407) mainly by pouring and spattering his colors instead of applying them with the brush. The result, especially when viewed at close range, suggests both Kandinsky and Max Ernst. Kandinsky's nonobjective Expressionism, and the Surrealists' exploitation of chance effects, are indeed the main sources of Pollock's work, but they do not sufficiently account for his revolutionary technique and the emotional ap-

peal of his art. Why did Pollock "fling a pot of paint in the public's face" (as Ruskin accused Whistler of doing)? Not, surely, to be more abstract than his predecessors, for the strict control implied by abstraction is just what Pollock gave up when he began to dribble and spatter. A more plausible explanation is that he came to regard paint itself not as a passive substance to be manipulated at will but as a storehouse of pent-up forces for him to release. The actual shapes are largely determined by the internal dynamics of his material and his process: the viscosity of the paint, the speed and direction of its impact upon the canvas, its interaction with other layers of pigment. The result is a surface so alive, so sensuously rich, that all earlier painting looks pallid by comparison. But when he releases the forces within the paint by giving it a momentum of its own—or, if you will, by "aiming" it at the canvas instead of "carrying" it on the tip of his brush-Pollock does not simply "let go" and leave the rest to chance. He is himself the ultimate source of energy for these forces, and he

407. Jackson Pollock. *One* (*Number 31, 1950*). 1950. Oil and enamel paint on canvas, 8'10"×17'55%". The Museum of Modern Art, New York (Sidney and Harriet Janis Collection Fund, by exchange)

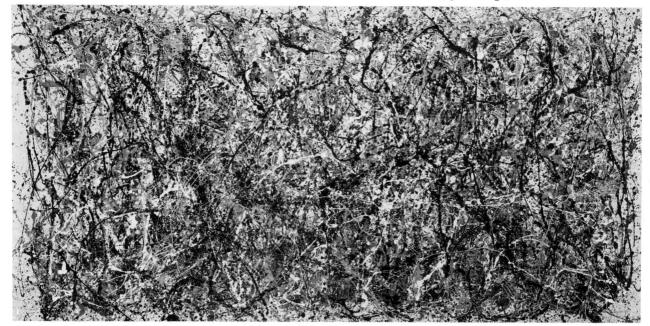

"rides" them as a cowboy might ride a wild horse, in a frenzy of psychophysical action. He does not always stay in the saddle, yet the exhilaration of this contest, which strains every fiber of his being, is well worth the risk. Our simile, although crude, points up the main difference between Pollock and his predecessors: his total commitment to the *act* of painting. Hence his preference for huge canvases that provide a "field of combat" large enough for him to paint not merely with his arms but with the motion of his whole body. "Action Painting," the term coined some years ago for this style, conveys its essence far better than does Abstract Expressionism.

Krasner; De Kooning

Pollock's drip technique, however, was not in itself essential to Action Painting, and he stopped using it in 1953. Lee Krasner, his wife, never abandoned the brush. She struggled to establish her artistic identity, and emerged from his long shadow only after undergoing several changes in direction and

destroying much of her early work. After Pollock's death, she succeeded in doing what he had been attempting to do for the last three years of his life: to reintroduce the figure into Abstract Expressionism while retaining its automatic handwriting. The potential had always been there in Pollock's work; in *One*, we can easily imagine people dancing wildly. In *Celebration* (fig. 408) Krasner defines these nascent shapes from within the tangled network of lines by using the broad gestures of Action Painting to suggest human forms without actually depicting them.

The work of Willem de Kooning, another prominent member of the group and a close friend of Gorky, always retains a link with the world of images, whether or not it has a recognizable subject. In some paintings, such as *Woman II* (fig. 409), the image emerges from an insistent, jagged welter of brushstrokes. What De Kooning has in common with Pollock is the furious energy of the process of painting, the sense of risk, of a challenge successfully—but barely—met.

Dubuffet

Action Painting marked the international coming-of-age for American art. The movement had a powerful impact on European art, which in those years had nothing to show of comparable force and conviction. One French artist, however, was of such prodigal originality as to constitute a movement all by himself: Jean Dubuffet, whose first exhibition soon after the Liberation electrifiedand antagonized—the art world of Paris. As a young man Dubuffet had received formal instruction in painting, but he responded to none of the various trends he saw around him nor to the art of the museums; all struck him as divorced from real life, and he turned to other pursuits. Only in middle age did he experience the breakthrough that permitted him to discover his creative gifts: he suddenly realized that for him true art had to come from outside the ideas and traditions of the artistic elite, and he found inspiration in the art of children and of the insane. The distinction between "normal" and "abnormal" struck him as no more tenable than established notions of "beauty" and "ugliness." Not since Marcel Duchamp (see pp. 380–81) had anyone ventured so radical a critique of the nature of art. Dubuffet made himself the champion of what he called l'art brut, "art-inthe-raw." Compared with Paul Klee, who had first utilized the style of children's drawings (see p. 378), Dubuffet's art is "raw" indeed; its stark immediacy, its explosive, defiant presence, are the opposite of the older painter's formal discipline and economy of means. Even De Kooning's wildly distorted Woman II seems gentle when matched against the shocking assault on our inherited sensibilities of Le Metafisyx (fig. 410). The paint is as heavy and opaque as a rough coating of plaster, and the lines articulating the blocklike body are scratched into this surface like graffiti made by an untrained hand. But appearances can often be deceiving; the fury and concentration of Dubuffet's attack should

410. Jean Dubuffet. *Le Metafisyx (Corps de Dame)*. 1950. 45¾ × 35¼". Collection Mr. and Mrs. Arnold Maremont, Winnetka, Illinois

convince us that his demonic female is not "something any child can do." In an eloquent statement the artist has explained the purpose of images such as this: "The female body... has long been associated with a very specious notion of beauty ... which I find miserable and most depressing. Surely I am for beauty, but not that one.... I intend to sweep away everything we have been taught to consider-without question-as grace and beauty [and to] substitute another and vaster beauty, touching all objects and beings, not excluding the most despised.... I would like people to look at my work as an enterprise for the rehabilitation of scorned values, and ... a work of ardent celebration."

Color-Field Painting: Rothko

After the mid-1950s, Action Painting gradually lost its dominant position, but its force

411. Mark Rothko. Earth and Green. 1955. $7'61/4'' \times 6'11/2''$. Collection Gallery Beyeler, Basel

was far from spent. A number of artists who had been in the movement transformed it into a style called Color-Field Painting, in which the canvas is stained with thin, trans-

lucent color washes. Chief among these was Mark Rothko. In the mid-1940s he, too, had worked in a style derived from Gorky, yet within less than a decade he subdued the aggressiveness of Action Painting so completely that his pictures breathe the purest contemplative stillness. Earth and Green (fig. 411) consists of two rectangles with blurred edges—one dark red, the other green—on a purplish-blue ground; the canvas is very large, over seven and one half feet tall, and the thin washes of paint permit the texture of the cloth to be seen throughout. But to use such bare factual terms to describe what we see hardly touches the essence of the work, or the reasons for its mysterious power to move us. These are to be found in the delicate equilibrium of the two shapes, their strange interdependence, the subtle variations of hue (note how the dark blue "halo" around the upper rectangle seems to immerse it in the blue ground, while the green rectangle stands out more assertively in front of the blue). Not every beholder responds to the works of this withdrawn, introspective artist, but for those who do, the experience is akin to a trancelike rapture.

Frankenthaler; Louis

The stained canvas was also pioneered by Helen Frankenthaler. In *Blue Causeway* (fig. 412) Frankenthaler uses the same biomorphic forms basic to early Action Painting but

412. Helen Frankenthaler. Blue Causeway. 1963. Oil on canvas, $4'9\%''\times 6'$. Collection Dr. and Mrs. Max Garber, Southfield, Michigan

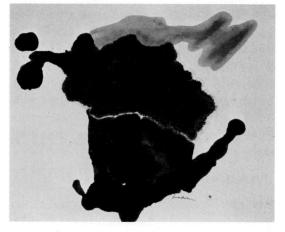

413. Morris Louis. Blue Veil. 1958–59. Acrylic resin paint on canvas, 8'4½" × 12'5". Fogg Art Museum, Harvard University, Cambridge, Massachusetts (Gift of Lois Orswell and Gifts for Special Uses Fund)

eliminates the personal handwriting found in the brushwork of Gorky and De Kooning, with results that are at once more lyrical and more decorative but no less impressive than theirs. The image will remind us of an inkblot (see fig. 1). And just as with a Rorschach inkblot test, the associations it conjures are entirely individual; the shapes may mean one thing to the artist, as is indicated by the title, but may suggest something totally different to us.

Among the many other artists who soon adopted the stained canvas, the most gifted was Morris Louis. The successive veils of color in *Blue Veil* (fig. 413) appear to have been "floated on" without visible marks of the brush, mysteriously beautiful like the aurora borealis. It is their harmonious interaction, their delicately shifting balance, that gives the picture enduring appeal.

Black Artists; Williams

Abstract Expressionism made a vital contribution to one of the most significant developments in contemporary American art, and one that has received little attention: the growth of black art. Following World War II, blacks began to attend art schools in growing numbers at the very time that Action Painting marked the coming of age of American art. The civil rights movement helped blacks to establish their artistic identities and to find appropriate styles for expressing them. The turning point proved to be the assassinations of Malcolm X in 1965 and Martin Luther King, Jr., in 1968, which provoked an outpouring of black art. Simultaneously, the generation of African-Americans born about 1940 were bringing black painting and sculpture to artistic maturity. Abstraction has sometimes been denounced by activists who, stirred by social consciousness and political ideology, advocate highly expressive representational styles as a means of communicating a distinctive black perspective directly to the people in their communities. But abstraction has nevertheless opened up new avenues of expression that allow the black artist, however individual his concerns may be, to achieve a universal, not solely an ethnic, appeal.

Faced with such aesthetic, personal, and social issues, many artists such as William T. Williams have withdrawn from the conflicting demands of critics, white and black alike, into the privacy of their studios. Williams belongs to the generation of lyrical Expressionists from the early 1970s whose contribution has been largely overlooked. After a period of intense self-scrutiny, he developed the extremely sophisticated technique seen in Batman (fig. 414). His method can be compared to jazz improvisation, a debt the artist himself has acknowledged. He interweaves his color and brushwork within a clear two-part structure that permits endless variations on the central theme. Although Williams is concerned primarily with the presentation of the encrusted surface, the patterns, light, and space evoke a landscape. Instead of depicting nature, however, the painting uses color and texture to capture an evanescent memory of the artist's past.

Kelly: Stella

Many artists who came to maturity in the 1950s turned away from Action Painting altogether in favor of hard-edge painting. Red Blue Green (fig. 415) by Ellsworth Kelly, an early leader of this tendency, abandons Rothko's impressionistic softness. Instead, flat areas of color are circumscribed within carefully delineated forms as part of the formal investigation of color and design problems for their own sake. The brilliant and precocious Frank Stella, having conceived an early enthusiasm for Mondrian, soon evolved a nonfigurative style that was even more self-contained; unlike Mondrian (see p. 375 and fig. 396), Stella did not concern himself with

415. Ellsworth Kelly. Red Blue Green. 1963. 7' × 11'4". Collection Mr. and Mrs. Robert Rowan, Los Angeles

the vertical-horizontal balance which relates the older artist's work to the world of nature. Logically enough, he also abandoned the traditional rectangular format; in order to make quite sure that his pictures bore no resemblance to windows. The shape of the canvas now became an integral part of the design. In one of his largest works, the majestic Em-

press of India (fig. 416), this shape is determined by the thrust and counterthrust of four huge chevrons, identical in size and shape but sharply differentiated in color and in their relationship to the whole. The paint, moreover, contains powdered metal which gives it an iridescent sheen—yet another way to stress the impersonal precision of the

416. Frank Stella. $Empress\ of\ India.\ 1965.$ Metallic powder in polymer emulsion on canvas, $6'5'' \times 18'8''$. Collection Irving Blum, Los Angeles

surfaces and to remove the work from any comparison with the "hand-made" look of easel pictures. In fact, to speak of *Empress of India* as a picture seems decidedly awkward. It demands to be called an object, sufficient unto itself.

Op Art

Another direction can also be traced back to Mondrian: the trend—actually, a whole cluster of related trends—known as "Op Art" because of its concern with optics (that is, the physical and psychological process of vision). Despite the fact that it gathered force in the mid-1950s, Op Art has undergone a relatively slow development. Op Art does not have the topical impetus and the emotional appeal of Pop (see p. 395); by comparison it seems overly cerebral and systematic, more akin to the sciences than to the humanities. On the other hand, its possibilities appear to be as unlimited as those of science and technology.

When we use our eyes in everyday life, we take it for granted that the world around us is exactly the way it looks to us. Only when our eyes "deceive" us do we begin to realize that vision is a very complicated process, that our brain has to interpret the constant stream of information being transmitted from our eyes. Normally things work well, but they can go wrong by accident or intent and make us see a misleading image, one that differs from what we think is true: this is an optical illusion. Art has been making use of optical illusion in one way or another since the Old Stone Age; without illusion, we would not find foreshortening so convincing, to take one example. What is new in Op Art is that it extends optical illusion to nonrepresentational art, and makes it work in apparently every conceivable way. Much of it consists of constructions or "environments" dependent upon light and motion for their effects. These cannot be reproduced in photographs, since they exploit those aspects of our visual apparatus that are least like the camera. We must confine ourselves in this book to the kind of Op Art which does not lose all of its essential qualities when illustrated.

Vasarely; Albers; Anuszkiewicz

The present development of Op Art stems largely from the work of Victor Vasarely, a Hungarian long domiciled in France, who has been its chief theoretician as well as its most inventive practitioner. Many of his paintings, drawings, and constructions are in stark black-and-white, such as the large canvas Vega (fig. 417), named after the brightest star in the constellation Lyra. It is a huge checkerboard whose regularity has been disturbed by bending the lines that make the squares. But such a description is no more than a list of ingredients—it does not tell us what we actually see. The size of the standard

417. Victor Vasarely. Vega. 1957. 6'5" × 4'3". Collection the artist

squares in relation to that of the entire field has been carefully chosen so as to tempt us to link the black squares into a network of diagonals when we view the picture from a certain distance (about thirty inches from our reproduction). But since many of these squares have been subjected to distortion, their sizes vary considerably, the largest having over ten times the area of the smallest. Consequently, no matter what our viewing distance, our eyes receive contradictory data: we read parts of the field in terms of diagonals, others in terms of verticals and horizontals. The picture thus practically forces us to move back and forth, and as we do so the field itself seems to move, expanding, undulating, contracting. If Vega were a threedimensional object, the variety of effects to be observed as we move in relation to it would be greater still, for we would then receive different sets of contradictory data from each eye.

In America Josef Albers, who came here after 1933, when Hitler closed the Bauhaus school at Dessau (see p. 418), became the founding father of another, more austere kind of Op Art based on subtle color relations among simple geometric shapes. His gifted pupil Richard Anuszkiewicz paints in the same vein, but his self-imposed restrictions are less severe. In Entrance to Green (fig. 418) the ever-decreasing series of rectangles creates a sense of infinite recession toward the center; this is counterbalanced by the color pattern which brings the center close to us by the gradual shift from cool to warm tones as we move inward from the periphery. Surprising for such an avowedly abstract work is its expressive impact. The resonance of the colors within the strict geometry intensifies the optical push-pull, producing a hypnotic effect of almost mystical power. The painting can be likened to a modern icon, capable of providing a deeply moving experience to those attuned to its vision.

418. (opposite) Richard Anuszkiewicz. Entrance to Green. 1970. Acrylic on canvas, $9\times 6'$. Collection Sidney Janis Gallery, New York

Pop Art

Other artists who made a name for themselves in the mid-1950s rediscovered what the layman continued to take for granted despite all efforts to persuade him otherwise: that a picture is not "essentially a flat surface covered with colors" (as Maurice Denis had insisted) but an image wanting to be recognized. If art was by its very nature representational, then the modern movement, from Manet to Pollock, was based on a fallacy, no matter how impressive its achievements. The artists who felt this way seized upon those products of commercial art catering to "lowbrow," popular taste: photography, advertising, magazine illustrations, and comic strips. Here, they realized, was an essential aspect of our present-day visual environment that had been entirely disregarded as vulgar and anti-aesthetic by the representatives of "highbrow" culture, and cried out to be examined. Only Marcel Duchamp and some of his fellow Dadaists, with their contempt for all orthodox opinion, had dared to penetrate this realm (see p. 381). It was they who now became the patron saints of "Pop Art," as the new movement came to be called. Pop Art actually began in London in the mid-1950s, but from the very start its imagery was largely based on American mass media, which had been flooding England ever since the end of World War II. It is not surprising, therefore, that the new art had a special appeal for America, and that it reached its fullest development here during the following decade. Unlike Dada, Pop is not motivated by despair or disgust at present-day civilization; it views commercial culture as its raw material, an endless source of pictorial subject matter, rather than as an evil to be attacked. Nor does Pop share Dada's aggressive attitude toward the established values of modern art.

Johns; Lichtenstein

Among the pioneers of Pop Art in America perhaps the most important is Jasper Johns,

419. Jasper Johns. *Three Flags*. 1958. Encaustic on canvas, 30%×451/4". Collection Mr. and Mrs. Burton Tremaine, Meriden, Connecticut

who began by painting, meticulously and with great precision, such familiar objects as flags, targets, numerals, and maps. His Three Flags (fig. 419) presents an intriguing problem: just what is the difference between the image and reality? We instantly recognize the Stars and Stripes, but if we try to define what we actually see here, we find that the answer eludes us. These flags behave "unnaturally"—instead of waving or flopping they stand at attention, as it were, rigidly aligned with each other in a kind of reverse perspective. Yet there is movement of another sort: the reds, whites, and blues are not areas of solid color but subtly modulated. Can we really say, then, that this is an image of three flags? Clearly, no such flags can exist anywhere except in the artist's head. And we begin to marvel at the picture as a feat of the imagination—probably the last thing we expected to do when we first looked at it.

The artist who best represents Pop may well be Roy Lichtenstein. He has seized upon

comic strips—or, more precisely, upon the standardized imagery of the traditional strips devoted to violent action and sentimental love, rather than those bearing the stamp of an individual creator. His paintings, such as Girl at Piano (fig. 420), are greatly enlarged copies of single frames, including the balloons, the impersonal, simplified black outlines, and the dots used for printing colors on cheap paper. These pictures are perhaps the most paradoxical in the entire field of Pop Art: unlike any other paintings past or present, they cannot be reproduced on the pages of this book, for they then become indistinguishable from the comic strip on which they are based. Enlarging a design meant for an area about 6 square inches to one no less than 3,264 square inches must have given rise to a host of formal problems that could be solved only by the most intense scrutiny: how, for example, to draw the girl's nose so it would look "right" in comic-strip terms, or how to space the colored

420. Roy Lichtenstein. *Girl at Piano*. 1963. Magna on canvas, 68×48 ". Harry N. Abrams Family Collection, New York

dots so they would maintain the proper weight in relation to the outlines. Clearly, our picture is not a mechanical copy, but an interpretation which remains faithful to the spirit of the original only because of the countless changes and adjustments of detail the artist has introduced. What fascinates Lichtenstein about comic strips—and what he makes us see for the first time—are the rigid conventions of their style, as firmly set and as remote from life as those of Byzantine art. Like an icon, his painting thus holds up a mirror to the ideals and hopes of our culture in ways that everybody knows how to "read."

Photo Realism

Although it is sometimes referred to as "the new realism," Pop Art, while sharply obser-

vant of its sources, uses images which are themselves rather abstract. A recent offshoot of Pop Art is the trend known as Photo Realism because of its fascination with camera images. Photographs had been utilized by nineteenth-century painters soon after the invention of the "pencil of nature"—one of the earliest to do so, surprisingly, was Delacroix—but they were no more than a convenient substitute for reality. For the Photo Realists, on the other hand, the photograph itself is the reality from which they build their pictures.

Eddy

At its best, their work, as in New Shoes for H by Don Eddy (fig. 421), has a visual complexity that challenges the most acute observer. In preparing New Shoes for H, Eddy took a series of pictures of the window display of a shoe store on Union Square in Manhattan. One photograph (fig. 422) served as the basis for the painting. What intrigued him, clearly, was the way glass filters (and transforms) everyday reality. Only a narrow strip along the left-hand edge offers an unobstructed view; everything else—shoes, bystanders, street traffic, buildings—is seen through two or more layers of glass, all of them at oblique angles to the picture surface. The combined effect of these panes-displacement, distortion, and reflection—is the transformation of a familiar scene into a dazzlingly rich and novel visual experience. Comparing the painting with the photograph, we realize that the two are related in much the same way as Lichtenstein's Girl at Piano (see fig. 420) is to the comic-strip frame from which it is derived. Unlike Eddy's photograph, however, his canvas shows everything in uniformly sharp focus, articulates details lost in the shadows, and, most important of all, gives pictorial coherence to the scene by means of a brilliant color scheme whose pulsating rhythm plays over the entire surface. At the time that he painted New Shoes

421. Don Eddy. New Shoes for H. 1973–74. Acrylic on canvas, 44×48 ". The Cleveland Museum of Art (Purchased with a grant from the National Endowment for the Arts matched by gifts from members of The Cleveland Society for Contemporary Art)

422. Don Eddy. Photograph for *New Shoes for H*. 1973. $6\frac{1}{4} \times 6\frac{1}{2}$ ". The Cleveland Museum of Art (Gift of the artist)

423. Audrey Flack. *Queen.* 1975–76. Acrylic on canvas, $6'8'' \times 6'8''$. Private collection

for H, color had become newly important in Eddy's thinking; the H of the title pays homage to Henri Matisse and to Hans Hofmann, the latter a painter linked to Abstract Expressionism whom Eddy had come to admire.

Flack

Photo Realism was part of a general tendency that marked American painting in the 1970s: the resurgence of realism. It has taken on a wide range of themes and techniques, from the most personal to the most detached, depending on the artist's vision of objective reality and its subjective significance. Women artists such as Audrey Flack have used realism to explore the world around them and their relation to it from a personal as well as a feminist viewpoint. Like most of Flack's paintings, Queen (fig. 423) is an extended allegory. The queen is the most powerful figure on the chessboard yet she remains expendable in defense of the king. Equally apparent is the meaning inherent to the queen of hearts, but here the card also refers to the passion for gambling in members of the artist's family, who are present in the locket with photos of Flack's mother and sister; the contrast of youth and age is central to *Queen*. The watch is a traditional emblem of life's brevity, and the dewy rose stands for the transience of beauty, which is further conveyed by the makeup on the dressing table. The shapes of the flower and fruits can also be taken as symbols of feminine sexuality.

Queen is successful not so much for its provocative statement, however, as for its compelling imagery. Flack creates a purely artistic reality by superimposing two separate photographs. Critical to the illusion is the gray border, which acts as a framing device and also establishes the central space and color of the painting. The objects that seem to project from the picture plane are shown in a different perspective from those on the tilted tabletop behind. The picture space is made all the more active by the play of its colors within the neutral gray. For all of its liveliness, the careful composition prevents the picture from being cluttered.

424. Francesco Clemente. Untitled. 1983. Oil and wax on canvas, 6'6" × 7'9". Collection Thomas Ammann, Zurich

Conceptual Art

A later trend, Conceptual Art, has the same "patron saint" as Pop Art: Marcel Duchamp. It arose during the 1960s out of the Happenings staged by Alan Kaprow, in which the event itself became the art. Conceptual Art, however, challenges our definition of art even more radically by insisting that only the leap of the imagination, not the execution, is art. Thus, since works of art are incidental byproducts, they can be dispensed with altogether, as can galleries and, by extension, even the artist's public. The creative process need only be documented in some way-usually in a verbal, sometimes in a photographic or cinematic, form. This deliberately anti-art approach, which stems from Dada (see p. 381), poses a series of stimulating paradoxes. As soon as the documentation achieves any visible form, it begins to come perilously close to more traditional forms of art (especially if it is placed in a gallery where it can be seen by an audience), since it is impossible to fully divorce the imagination from aesthetics. We see this, for example, in Joseph Kosuth's One and Three Chairs (fig. 425), which is clearly indebted to Duchamp's Ready-Mades: it "describes" a chair by combining in one installation an actual chair, a full-scale photograph of the same chair, and a printed dictionary definition of a chair. Whatever the artist's intention, this making, no matter how minimal, is as essential to the Conceptual artist as it was for Michelangelo. In the end, all art is the final document of the creative process, because without execution, no idea can ever be fully realized. Without such "proof of performance," the Conceptual artist becomes like the emperor with his new clothes which no one else can see. And, in fact, Conceptual Art has embraced all media in one form or another.

Painting in the 1980s

Since 1980 our culture has been undergoing rapid change. An indication of the state of flux is the reemergence of many traditional European and regional American art centers. For all the recent ferment, the direction of art has yet to appear in sufficient clarity to let us chart the future. Having received a rich heritage, artists are sorting through a wide variety of alternatives without yet arriving at durable conclusions. The first sign of this transition occurred in the early 1970s with the widespread use of "Neo-" to describe the current tendencies. Art in the 1980s has been called more simply Post-Modern. The term is, of course, incongruous: modernity can never be outdated, because it is simply whatever is contemporary.

It is true, though, that modernism as an ideal defining twentieth-century art as we have known it has reached a crisis. The principal symptoms are a ubiquitous eclecticism and a bewildering array of styles reflecting narrow causes and personal concerns. Taken together, these pieces provide a jigsaw puzzle of our times, but it is doubtful whether any of them makes a major contribution to the history of art. We are, in this sense, the new Victorians. Painting seems in particular disarray, but we need not despair of the future. A century ago, Impressionism underwent a like crisis, from which Post-Impressionism emerged as the direction for the next twenty years. Doubtless a new Seurat will somewhere soon proclaim a bold style and outlook that will constitute the next phase of modernism.

425. Joseph Kosuth. One and Three Chairs. 1965. Photograph of chair, $36\times24^{1}\!/s''$; wooden folding chair, $32\%\times14\%\times20\%''$; photographic enlargement of dictionary definition of chair, $24\%\times24\%''$. The Museum of Modern Art, New York (Larry Aldrich Foundation Fund)

An artist who seems on the verge of such a breakthrough is the young Italian Francesco Clemente. In many respects he is symptomatic of his artistic generation. Without the certitudes of abstraction, he has been forced back upon himself and has developed a potent Neo-Expressionism. Clemente is fearless in recording urges and memories that the rest of us repress. Thus art becomes for him an act of cathartic necessity which releases, but never resolves, the impulses that assault his acute self-awareness. Alternately fascinating and repellent, his images place extreme demands on the viewer, yet their expressiveness is riveting. Since his work responds to fleeting states of mind, he utilizes any style that is appropriate to the moment without, however, losing his individuality. He has an extraordinary talent for watercolor; the fluidity and speed of that medium seem perfectly suited to capturing the transient phenomena of his inner world. Clemente's career took a decisive turn in 1982 when he decided to devote himself to oil and fresco, and came to New York in order "to be where the great painters have been." His canvases and wall paintings have an ambitiousness that seemingly points to the next phase of contemporary art. Partly inspired by Hinduism, they can assume the form of allegorical cycles addressed directly to the Italian painters who worked on a grand scale, starting with Giotto. His most compelling paintings are those having as their subject matter the artist's moods, fantasies, and appetites. These remain curiously unsensual. A recent self-portrait (fig. 424) suggests a soul bombarded by drives and sensations that can never be truly enjoyed. Clemente is unusual among Italians in being influenced heavily by Northern European Symbolism and Expressionism, with an occasional reminiscence of Surrealism. Here indeed is his vivid nightmare, having the psychological terror of Munch, and the haunted vision of De Chirico.

The new Expressionism has found its most gifted American representative in Susan Rothenberg. In the mid-1970s the contours of the horse seen in profile provided a thematic focus and personal emblem for her highly for-

426. Susan Rothenberg. Mondrian. 1983–84. Oil on canvas, $9'1'' \times 7'$. Willard Gallery, New York

mal paintings, but, toward the end of the decade, she turned to more emotive subjects. The sheer beauty of the surface in *Mondrian* (fig. 426) belies the intensity of her vision. The figure emerges from the welter of feathery brushstrokes like an apparition from a nightmare. The face, which bears Mondrian's unmistakable features, conjures up a vision of madness. The picture is a highly charged commentary on an artist whose rigorous discipline is so antithetical to Rothenberg's painterly freedom.

SCULPTURE

The main currents we have followed in painting may be found also in sculpture. The parallelism, however, should not be overstressed. While painting has been the richer and more adventurous of the two arts, its leadership has not remained unchallenged in the last half century, and the development of sculpture has often followed its own path.

Primevalism: Brancusi; Moore; Hepworth

Expressionism, for instance, is a much less important current in sculpture than in painting—which is rather surprising, since the rediscovery of primitive sculpture by the Fauves might have been expected to evoke a strong response among sculptors. Only one important sculptor shared in this rediscovery: Constantin Brancusi, a Rumanian who came to Paris in 1904. But he was more interested in the formal simplicity and coherence of primitive carvings than in their savage expressiveness: this is evident in The Kiss (fig. 427), executed in 1909 and now placed over a tomb in a Parisian cemetery. The compactness and self-sufficiency of this group is a radical step beyond Maillol's Seated Woman (see fig. 372). The embracing lovers are differentiated just enough to be separately identifiable, and seem more primeval than primitive. They are a timeless symbol of generation, innocent and anonymous.

427. Constantin Brancusi. *The Kiss.* 1908. Height 22¾". The Philadelphia Museum of Art (Louise and Walter Arensberg Collection)

Brancusi's "Primevalism" was the starting point of a sculptural tradition that still continues today. It has appealed particularly to English sculptors, as we may see in the early works of Henry Moore: his majestic Two Forms of 1936 (fig. 428) are, as it were, the second-generation offspring of Brancusi's Kiss. More abstract and subtle in shape, they are nevertheless "persons," even though they can be called "images" only in the metaphoric sense. This family group—the forked slab evolved from the artist's studies of the mother-and-child theme—is mysterious and remote like the monoliths of Stonehenge, which greatly impressed the sculptor (see fig. 7). His Recumbent Figure (fig. 429) retains both a Classical motif—one thinks of a reclining river god—and a primeval look, as if the forms had resulted from the slow erosion of a thousand years. The design of the figure is in complete harmony with the natural striations of the stone.

Barbara Hepworth, for long the preeminent woman sculptor of modern times, was closely associated with Moore during the early 1930s; they became leaders of the modern movement in England and influenced one another. Like Moore's, her sculpture originally had a biological foundation, but during World War II she developed the unique style seen in Sculpture with Color (Oval Form), Pale Blue and Red (fig. 430). This piece flawlessly synthesizes painting and sculpture, Surrealist biomorphism and organic abstraction, molding of space and shaping of mass. Carved from wood and immaculately finished, Hepworth's sculpture reduces the natural shape of an egg to a timeless ideal that has the lucid perfection of a Classical head, yet the elemental expressiveness of the face

428. Henry Moore. *Two Forms*. 1936. Hornton stone, height about 42". Collection Mrs. H. Gates Lloyd, Haverford, Pennsylvania

429. Henry Moore. Recumbent Figure. 1938. Green Hornton stone, length about 54". The Tate Gallery, London

430. Barbara Hepworth. *Sculpture with Color (Oval Form)*, *Pale Blue and Red.* 1943. Wood with strings, length 18". Collection Mrs. N. Gray

of a primitive mask (compare fig. 10). The colors accentuate the play between the interior and exterior of the hollowed-out form; the strings seeming to suggest a life force within.

Kinetic Sculpture: Brancusi; Boccioni; Duchamp-Villon

Hepworth's egg undoubtedly has something in common with Brancusi, although their work is very different in appearance. About 1910, Brancusi began to produce nonrepresentational pieces in marble or metal, reserving his "primeval" style for wood and stone. The former fall into two groups: variations on the egg shape, and soaring vertical "bird" motifs (Bird in Space, fig. 431, is one of these). He was fascinated by the antithesis of life as potential energy and as kinetic energy—the self-contained perfection of the egg, which hides the mystery of all creation, and the pure dynamics of the creature released from this shell. Bird in Space is not the

abstract image of a bird; rather, it is flight itself, made visible and concrete. Its disembodied quality is emphasized by the high polish that gives the surface the transparency of a mirror, and thus establishes a new continuity between the molded space within and the free space without.

Other sculptors at this time were tackling the problem of body-space relationships with the formal tools of Cubism. The running figure entitled *Unique Forms of Continuity in* Space (fig. 432), by the Futurist Umberto Boccioni (see p. 371), is as breathtaking in its complexity as Bird in Space is simple. Boccioni has tried to represent not the human form itself but the imprint of its motion upon the medium in which it moves; the figure remains concealed behind its "garment" of aerial turbulence. The statue recalls the famous Futurist statement that "the automobile at full speed is more beautiful than the Winged Victory," although it obviously owes more to the Winged Victory (see fig. 63) than to the design of motor cars (in 1913, streamlining was still to come). Raymond Duchamp-Villon, an elder brother of Marcel Duchamp, achieved a bolder solution in The Great Horse (fig. 433). He began with abstract studies of the animal, but his final version is an image of "horsepower," where the body has become a coiled spring and the legs resemble piston rods. Because of their very remoteness from the original anatomical model, these quasimechanical shapes have a dynamism that is more persuasive—if less picturesque—than that of Boccioni's figure.

Constructivism

In facet Cubism, we recall, concave and convex were postulated as equivalents; all volumes, whether positive or negative, were "pockets of space." The Constructivists, a group of Russian artists led by Vladimir Tatlin, applied this principle to sculpture and arrived at what might be called three-dimen-

431. Constantin Brancusi. Bird in Space. 1928? Bronze, height 54". The Museum of Modern Art, New York (Given anonymously)

432. Umberto Boccioni. *Unique Forms of Continuity in Space*. 1913. Bronze, height 43%". The Museum of Modern Art, New York (Acquired through the Lillie P. Bliss Bequest)

433. Raymond Duchamp-Villon. *The Great Horse*. 1914. Bronze, height 39%". The Art Institute of Chicago (Gift of Miss Margaret Fisher)

sional collage. Eventually the final step was taken of making the works freestanding. According to Tatlin and his followers, these "constructions" were actually four-dimensional: since they implied motion, they also implied time. Suprematism (see p. 374) and Constructivism were therefore closely related, and in fact overlapped, for both had their origins in Cubo-Futurism, but they were nonetheless separated by a fundamental difference in approach. For Tatlin, art was not the Suprematists' spiritual contemplation but an active process of formation that was based on material and technique. He believed that each material dictates specific forms which are inherent in it, and that these must be followed if the work of art was to be valid according to the laws of life itself. In the end, Constructivism won out over Suprematism because it was better suited to the post-Revolution temperament of Russia, when great deeds, not great thoughts, were needed.

Cut off from artistic contact with Europe during World War I, Constructivism developed into a uniquely Russian art that was little affected by the return of some of the country's most important artists, such as Kandinsky and Chagall. The Revolution galvanized the modernists, who celebrated the overthrow of the old regime with a creative outpouring throughout Russia. Tatlin's model for a Monument to the Third International (fig. 434) captures the dynamism of the technological utopia envisioned under communism: pure energy is expressed as lines of force that establish new time-space relationships as well. The work also implies a new social structure, for the Constructivists believed in the power of art literally to reshape society. This extraordinary tower revolving at three speeds was conceived on a monumental scale, complete with Communist Party offices; like other such projects, it was wildly impractical in a society still recovering from the ravages of war and revolution, and was never built.

Constructivism subsequently proceeded to a Productivist phase, which ignored any contradiction between true artistic creativity and purely utilitarian production. After the

434. Vladimir Tatlin. Model for *Monument to the Third International*. 1919–20. Wood, iron, and glass; height 20' (destroyed; contemporary photograph)

movement had been suppressed as "bourgeois formalism," some of its members emigrated to the West and joined forces with the Dutch group De Stijl (see p. 375).

Surrealism

Dada uncompromisingly rejected formal discipline in sculpture, as it did in the other arts—perhaps even more so, since only three-dimensional objects could become Ready-Mades, the sculpture of Dada. Some of Duchamp's examples consist of combinations of found objects: these "assisted" Ready-Mades approach the status of constructions, or three-dimensional collage. This technique, later baptized "assemblage," proved to have unlimited possibilities. It has produced such striking pieces as Picasso's *Bull's Head*

(see fig. 2), and numerous younger artists have explored it since, especially in junk-ridden America. The Surrealist contribution to sculpture is harder to define: it was difficult to apply the theory of "pure psychic automatism" to painting, but still harder to live up to it in sculpture. How indeed could solid, durable materials be given shape without the sculptor being consciously aware of the process? Thus, apart from the devotees of the Ready-Made, few sculptors were associated with the movement.

Giacometti; Gonzalez

One who was a member of the Surrealist movement was Alberto Giacometti, a Swiss sculptor and painter working in Paris. *The Palace at 4 A.M.* (fig. 435), an airy cage made of wood, glass, wire, and string, is the three-dimensional equivalent of a Surrealist picture; unlike earlier pieces of sculpture, it creates its own spatial environment that clings to it as though this eerie miniature world were protected from everyday reality by an invisible glass bell. The space thus trapped is mysterious and corrosive; it gnaws away at the forms until only their skeletons

435. Alberto Giacometti. *The Palace at 4 A.M.* 1932–33. Wood, wire, glass, and string; height 25". The Museum of Modern Art, New York (Purchase)

436. Julio Gonzalez. *Head.* c. 1935. Wrought iron, height 17¾". The Museum of Modern Art, New York (Purchase)

are left. Even they, we feel, will disappear before long. Surrealism may also have contributed to the astonishing sculptural imagination of Julio Gonzalez, a wrought-iron craftsman from Catalonia who had come to Paris in 1900. Although he was a friend of Brancusi and Picasso, he produced no work of any consequence until the 1930s, when his creative energies suddenly came into focus. It was he who established wrought iron as an important medium for sculpture, taking advantage of the very difficulties that had discouraged its use before. The *Head* (fig. 436) combines extreme economy of form with an aggressive reinterpretation of anatomy that is derived from Picasso (see fig. 390, especially the head of the dancer on the left): the mouth is an oval cavity with spikelike teeth, the eyes two rods that converge upon an "optic nerve" linking them to the tangled mass of the "brain." Similar gruesomely expressive metaphors have since been created by a whole generation of younger sculptors, in wrought iron and welded steel, as if the violence of their working process mirrored the violence of modern life.

Mobiles: Calder

The early 1930s, which brought Giacometti and Gonzalez to the fore, produced another important development, the mobile sculpture—mobiles, for short—of the American Alexander Calder. These are delicately balanced constructions of metal wire, hinged together and weighted so as to move with the slightest breath of air. They may be of any size, from tiny tabletops to the huge *Lobster* Trap and Fish Tail (fig. 437). At first, Calder had made motor-driven mobiles. It was his contact with Surrealism that made him realize the poetic possibilities of "natural" as against fully controlled movement; he borrowed biomorphic shapes from Miró, and began to think of mobiles as similes of organic structures—flowers on swaying stems, foliage quivering in the breeze, marine animals floating in the sea. Such mobiles are infinitely responsive to their environment. Unpredictable and ever-changing, they incorporate the fourth dimension, time, as an essential element in their structure. Within their limited sphere, they are more truly alive than any other man-made thing.

437. Alexander Calder. Lobster Trap and Fish Tail.
1939. Wire and aluminum, 8'6"×9'6". The Museum of Modern Art, New York (Commissioned by The Advisory Committee)

The New Scale; Primary Structures

Scale has assumed fundamental significance for a recent sculptural movement that extends the scope—indeed, the very concept of sculpture in an entirely new direction. "Primary Structure," the most suitable name so far suggested for this type, conveys its two salient characteristics: extreme simplicity of shapes, and a kinship with architecture. The radical abstraction of form is known as "Minimalism," which implies an equal reduction of content. Another term, "Environmental Sculpture" (not to be confused with the mixed-medium "environments" of Pop), refers to the fact that many Primary Structures are designed to envelop the beholder, who is invited to enter or walk through them. It is

this space-articulating function that distinguishes Primary Structures from all previous sculpture and relates them to architecture. They are, as it were, the modern successors, in structural steel and concrete, to such prehistoric monuments as Stonehenge (see figs. 7, 8).

Goeritz; Bladen

The first to explore these possibilities was Mathias Goeritz, a German working in Mexico City. As early as 1952–53, he established an experimental museum, The Echo, for the display of massive geometric compositions, some of them so large as to occupy an entire patio (fig. 438). His ideas have since been tak-

438. Mathias Goeritz. Steel Structure. 1952-53. Height 14'9". The Echo (Experimental Museum), Mexico City

439. Ronald Bladen. *The X* (in the Corcoran Gallery, Washington, D.C.). 1967. Painted wood, to be constructed in steel; $22'8'' \times 24'6'' \times 12'6''$. Fischbach Gallery, New York

en up on either side of the Atlantic. Often, these sculptors limit themselves to the role of designer and leave the execution to others, to emphasize the impersonality and duplicability of their invention. If no patron is found to foot the bill for carrying out these very costly structures, they remain on paper, like unbuilt architecture. Sometimes these works reach the mock-up stage, with painted wood substituting for metal, as in The X (fig. 439), by the Canadian Ronald Bladen, which was built for an exhibition inside the two-story hall of the Corcoran Gallery in Washington, D.C. Its commanding presence, dwarfing the Neoclassical colonnade of the hall, seems doubly awesome in such a setting.

Earth Art; Smithson

The ultimate medium for Environmental Sculpture is the earth itself, since it provides complete freedom from the limitations of the human scale. Some designers of Primary Structures have, logically enough, turned to "Earth Art," inventing projects that stretch over many miles. These latter-day successors to the mound-building Indians of Neolithic America have the advantage of modern earth-moving machinery, but this is more than outweighed by the problem of cost and the difficulty of finding suitable sites on our crowded planet. The few projects of theirs that have actually been carried out are found mostly—and the finding itself is often difficult enough—in the more remote corners of western America. Spiral Jetty, the work of Robert Smithson, jutted out into Great Salt Lake in Utah (fig. 440) and is now much eroded. Its appeal rests in part on the Surrealist irony of the concept: a spiral jetty is as selfcontradictory as a straight corkscrew. But it can hardly be said to have grown out of the

440. Robert Smithson. *Spiral Jetty.* 1970. Total length 1,500', width of jetty 15'. Great Salt Lake, Utah

natural formation of the terrain like the Great Serpent Mound in Ohio. No wonder it has not endured long, nor was it intended to—the process of erosion by which nature is reclaiming *Spiral Jetty*, already twice submerged, was integral to Smithson's design from the start. The project nevertheless lives on in photographs.

Smith

The American sculptor David Smith, whose earlier work had been strongly influenced by the wrought-iron constructions of Julio Gonzalez (see fig. 436), evolved during the last years of his life a singularly impressive form of Primary Structure in his *Cubi* series. Figure 441 shows three of these against the open sky and rolling hills of the artist's farm at Bolton Landing, New York (all are now in major museums). Only two basic components

are employed—cubes (or multiples of them) and cylinders—yet Smith has created a seemingly endless variety of configurations. The units which make up the structures are poised one upon the other as if they were held in place by magnetic force, so that each represents a fresh triumph over gravity. Unlike the younger members of the Primary Structure movement, Smith executed these pieces himself, welding them of sheets of stainless steel whose shiny surfaces he finished and controlled with exquisite care. As a result, his work displays an "old-fashioned" subtlety of touch that reminds us of the polished bronzes of Brancusi.

Nevelson; Chase-Riboud

Sculpture has traditionally been reserved for men because of the manual labor involved. Thanks to the woman's suffrage movement

441. David Smith. *Cubi* series. Stainless steel. (*left) Cubi XVIII*. 1964. Height 9'8". Museum of Fine Arts, Boston. (*center) Cubi XVII*. 1963. Height 9'. Dallas Museum of Fine Arts. (*right) Cubi XIX*. 1964. Height 9'5". The Tate Gallery, London

442. Louise Nevelson. Black Chord. 1964. Painted wood, $8' \times 10' \times 11^{1/2}"$ (including base). Collection Anne and Joel Ehrenkranz (Promised gift to the Whitney Museum of American Art, New York)

in the United States during the second half of the nineteenth century, Harriet Hosmer and her "White Marmorean Flock" (as the novelist Henry James called her and her followers in Rome) succeeded in legitimizing sculpture as "women's work." This school of sculpture lapsed, however, when the sentimental, idealizing Neoclassical style fell out of favor after the Philadelphia Centennial of 1876. America did not produce another important woman sculptor until Louise Nevelson. Unhappy with external reality, Nevelson began in the 1950s to construct her separate realities, using her collection of found pieces of wood, both carved and rough. These selfcontained realms were initially miniature cityscapes, but soon they grew into large

environments of freestanding "buildings," encrusted with decorations that were inspired by the sculpture on Mayan ruins. Nevelson's work has generally taken the form of large wall units which flatten her architecture into reliefs (fig. 442). Assembled from individual compartments, the whole is always painted a single color, usually a matte black to suggest the shadowy world of dreams. Each compartment is elegantly designed, and is itself a metaphor of thought or experience. While the organization of the ensemble is governed by an inner logic, the whole statement remains an enigmatic monument to the artist's fertile imagination.

Nevelson's success has encouraged other American women to become sculptors. One of the most remarkable is Barbara Chase-Riboud. A prize-winning author who now resides in Paris, she belongs to a generation of black women who have made significant contributions to several of the arts at once. Chase is heir to a unique American tradition. It is a paradox that, whereas black women never carve in traditional African cultures, in America they found their first artistic outlet in sculpture. They were attracted to it by the example set by Harriet Hosmer at a time

443. Barbara Chase-Riboud. Confessions for Myself. 1972. Bronze painted black and black wool, $10' \times 3'4'' \times 1'$. University Art Museum, University of California, Berkeley (Purchased with funds from the H. W. Anderson Charitable Foundation. Selected by The Committee for the Acquisition of Afro-American Art)

when abolitionism and feminism were closely allied liberal causes. Chase received a traditional academic training in her native Philadelphia, the first center of minority artists (see p. 338). In search of an artistic identity, she then turned to African art for inspiration. Her monumental sculpture makes an indelible impression on the viewer, and in Confessions for Myself (fig. 443) she has conjured up a demonic archetype of awesome power. Its sources can be found in cast bronze figures from Benin and in the Senufo tribe's carved wooden masks, which are sometimes embellished with textiles. From them she developed her highly individual aesthetic. which utilizes a combination of bronze that has been painted black and braided fibers to express a distinctly ethnic sensibility, as well as a feminist outlook.

Oldenburg

Primary Structures are obviously monuments. But just as obviously they are not monuments commemorating or celebrating anything except their designer's imagination. To the man in the street they offer no ready frame of reference, nothing to be reminded of, even though the original meaning of "monument" is "a reminder." Presumably, monuments in this traditional sense died out when contemporary society lost its consensus of what ought to be publicly remembered. Yet the belief in the possibility of such monuments has not been abandoned altogether. One artist, Claes Oldenburg, has proposed a number of unexpected and imaginative solutions to the problem; he is, moreover, an exceptionally precise and eloquent commentator on his ideas. All his monuments are heroic in size, though not in subject matter; all share one common feature, their origin in humble objects of everyday use.

In 1969 Oldenburg conceived and executed a work shaped like a gigantic ice bag (fig. 444) with a mechanism inside to make it move—"movements caused by an invisible

444. Claes Oldenburg. *Giant Ice Bag.* 1969–70. Plastic and metal, with interior motor; extended height 15'6", diameter 18'. Thomas Segal Gallery, Boston

hand," as the artist described them. For a piece of outdoor sculpture he wanted a form that combined hard and soft and did not need a base. An ice bag met these demands, so he bought one and started playing with it. He soon realized, he says, that the object was made for manipulation, "that movement was part of its identity and should be used." He sent the Giant Ice Bag to the U.S. Pavilion at EXPO 70 in Osaka, Japan, where crowds were endlessly fascinated to watch it heave, rise, and twist like a living thing, then relax with an almost audible sigh. What do these monuments celebrate? What is the secret of their appeal? Part of it, which they share with Pop Art, is that they reveal the aesthetic potential of the ordinary and all-too-familiar. There is one dimension, however, that is missing in Oldenburg's monuments. They delight, astonish, amuse-but they do not move us. Yet they do have an undeniable grandeur. We might say, with Baudelaire, that they express "the heroism of modern life."

445. Robert Rauschenberg. *Odalisk.* 1955–58. Construction, $6'9'' \times 2'1'' \times 2'1''$. Museum Ludwig, Cologne

Assemblages: Rauschenberg

Other artists associated with Pop embrace in their work the entire range of their physical environment, including the people. They usually find the flat surface of a canvas too confining; in order to bridge the gap between image and reality, they often introduce three-dimensional objects into their pictures, or they may even construct full-scale models of everyday things and real-life situations, utilizing every conceivable kind of material. These "assemblages" combine the qualities of painting, sculpture, collage, and stagecraft.

Robert Rauschenberg pioneered this approach as early as the mid-1950s. Like a composer making music out of the noises of everyday life, he constructed works of art from the trash of urban civilization. Odalisk (fig. 445) is a box covered with a miscellany of pasted images—comic strips, photos, clippings from picture magazines—held together only by the skein of brushstrokes the artist has superimposed on them; the box perches on a foot improbably anchored to a pillow on a wooden platform, and is surmounted by a stuffed chicken. The title, a witty blend of "odalisque" and "obelisk," refers both to the nude women among the collage of clippings (for the original meaning of "odalisque" see p. 317) and to the shape of the construction as a whole: the box shares its verticality and slightly tapering sides with real obelisks, slender four-sided pillars of stone erected by the ancient Egyptians. The Romans brought many obelisks to Italy (one marks the center of the colonnaded piazza of St. Peter's; see fig. 256), and these inspired a number of later monuments in Europe and America. Rauschenberg's unlikely "monument" has at least one element in common with its predecessors—compactness and self-sufficiency.

Environments: Segal; Grooms

George Segal, in contrast, creates "environments," lifesize three-dimensional pictures showing real people and real objects in every-day situations, such as *Cinema* (fig. 446). The subject is ordinary enough to be instantly recognizable: a man changing the letters on a movie theater marquee. Yet the relation of

446. George Segal. *Cinema*. 1963. Plaster, metal, Plexiglas, and fluorescent light; $9'10'' \times 8' \times 3'3''$. Albright-Knox Art Gallery, Buffalo (Gift of Seymour H. Knox)

image and reality is far more subtle and complex than the obvious authenticity of the scene suggests. The man's figure is cast from a live model by a technique of Segal's invention, and retains its ghostly white plaster surface. Thus it is one crucial step removed from our world of daily experience, and the neon-lit sign has been carefully designed to complement and set off the shadowed figure. Moreover, the scene is brought down from its natural context, high above the entrance to the theater where we might have glimpsed it in passing, and presented at eye-level, in isolation, so that we grasp it completely for the first time.

Perhaps the most ambitious environment undertaken to date was *Ruchus Manhattan*, created in 1975–76 by Red Grooms and his "Ruckus Construction Company." The huge installation (now dismantled) offered a riotous tour of Manhattan, featuring a subway

447. Red Grooms and The Ruckus Construction Co. Lexington Local (detail) from Ruckus Manhattan. 1976. Mixed mediums, papier-mâché; $10' \times 9' \times 36'$. Courtesy Marlborough Gallery, New York

station complete with train (fig. 447). Bright and colorful, it was truly popular art, for it was intended to appeal to the man in the street. People flocked to see the show, which became a festive Happening in its own right. With the zany humor of an underground comic, *Ruckus Manhattan* held up a witty mirror to New York and its denizens, who were depicted as grotesque figures living in a fascinating but crazy-quilt world.

Installations: Pfaff

"Installations" are expansions of environments into room-size settings. Judy Pfaff uses painting together with sculptural and other materials to activate architectural space. Her works can be likened to exotic indoor landscapes. The inspiration of nature is apparent in the jungle-like density of *Dragons* (fig. 448), aptly named for its fiery forms and colors. The treatment of the wall surface will remind us of the collage on *Odalisk* (see fig. 445), but Pfaff's playfulness is closer to Calder's whimsy (see fig. 437) than to Rauschenberg's ironic wit. The nearest equivalent to Pfaff's spontaneous energy is the Action Painting of Jackson Pollock. It is as if the

448. Judy Pfaff. *Dragons*. Mixed mediums. Installation view at 1981 Biennial, Whitney Museum of American Art, New York (see colorplate on title page)

poured paint had been released from the canvas and left free to roam in space. The swirling profusion around the viewer makes for an experience that is at once pleasurable and disorienting.

ARCHITECTURE

For more than a century, from the mideighteenth to the late nineteenth, architecture had been dominated by a succession of "revival styles" (see p. 309). The use of this term, we will recall, does not imply that earlier forms were slavishly copied; the best work of the time has both individuality and high distinction. Yet the architectural wisdom of the past, however freely interpreted, proved in the long run to be inadequate for the needs of the present. The authority of historical modes had to be broken if the industrial era was to produce a truly contemporary style. The search for such a style—the analogue of

Manet's achievement in painting—began in earnest about 1880. It demanded more than a reform of architectural grammar and vocabulary: to take full advantage of the expressive—not merely the utilitarian—qualities of the new building techniques and materials that the engineer had placed at his disposal, the architect needed a new philosophy. He had to redefine the traditional concepts regarding form and function, as well as the broader role of architecture in society. The leaders of modern architecture have characteristically been vigorous and articulate thinkers, in whose minds architectural theory is closely linked with ideas of social reform. It is equally significant that the movement began in commercial architecture (stores, offices, apartments), outside the range of traditional building types; that its symbol was the skyscraper; and that its birthplace was Chicago, then a burgeoning metropolis not yet encumbered by any firm allegiance to the styles of the past.

Sullivan

Chicago was the home of Louis Sullivan, the first indisputably modern architect. His achievements are summed up in the department store of Carson Pirie Scott & Company (fig. 449), which he designed shortly before the turn of the century. If it is not a skyscraper by present-day standards, it is at least a potential one, for its structural skeleton, a steel frame, embodies the same principle on which the much taller skyscrapers of today are built. The Carson Pirie Scott store also illustrates Sullivan's dictum that "form follows function." The external walls do not pretend to support anything, since they no longer do; they have been reduced to a "skin" or sheathing over the steel beams, with most of the surface given over to huge windows. Yet Sullivan's dictum meant not rigid dependence but a flexible relationship capable of a wide variety of expressive effects. Here the

449. Louis Sullivan. Carson Pirie Scott & Company Department Store, Chicago. 1899–1904

white terra-cotta sheathing emphasizes the horizontal continuity of the flanks as well as the vertical accent at the corner by subtle differences in spacing and detail.

Wright

If Sullivan represents, as it were, the Post-Impressionist stage of modern architecture, his great disciple, Frank Lloyd Wright, represents its Cubist phase. This is certainly true of his brilliant early style, between 1900 and 1910, which had vast international influence. (His late work, beginning with the 1930s, will be omitted from this account.) During that first decade, Wright's main activity was the design of suburban houses in the Chicago area; these were known as "Prairie Houses," because their low, horizontal lines were meant to blend with the flat landscape around them. The last, and most accomplished, example is the Robie House (figs. 450, 451). Its "Cubism" is not merely a mat-

450. Frank Lloyd Wright. Robie House, Chicago. 1909

451. Frank Lloyd Wright. Plan of Robie House, Chicago

ter of the clean-cut rectangular elements composing the structure, but of Wright's handling of space. It is designed as a number of "space blocks" grouped around a central core, the chimney; some of the blocks are closed and others are open, yet all are defined with equal precision. Thus the space that has been architecturally shaped includes the balconies, terrace, court, and garden, as well as the house itself: voids and solids are seen to be equivalent, analogous in their way to facet Cubism in painting, and the entire complex enters into active and dramatic relationship with its surroundings. Wright did not aim simply to design a house, but to create a complete environment. He even took command of the details of the interior, designing fabrics and furniture for it. The controlling factor here was not so much the individual client and his special wishes as Wright's conviction that buildings profoundly influence the people who live, work, or worship in them, so that the architect is really a molder of men, whether or not he consciously assumes this responsibility.

International Style: Gropius

Among the first Europeans to recognize Wright's importance were some Dutch architects who, at the end of World War I, joined forces with Mondrian. They found his principle of "the balance of unequal but equivalent oppositions" fully compatible with Wright's architecture. Their influence was so pervasive that the movement they represented soon became international. The largest and most complex example of this "International Style of the 1920s" is the group of buildings created in 1925-26 by the German architect Walter Gropius for the Bauhaus at Dessau (fig. 452), a famous art school whose curriculum embraced all the visual arts, linked by the root concept of "structure," Bau. The most dramatic is the Shop Block, a four-story box with walls that are a continuous surface of glass. This radical step had been possible ever since the introduction of the structural

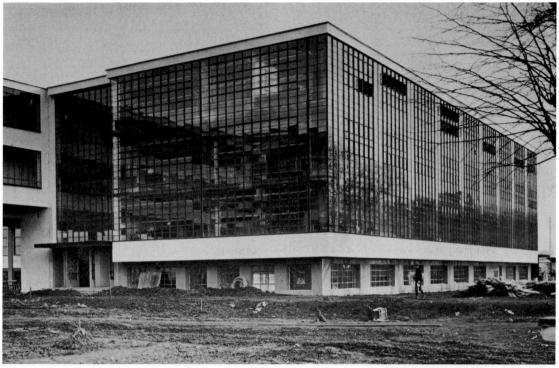

452. Walter Gropius. Shop Block, the Bauhaus, Dessau. 1925-26

steel skeleton; Sullivan had approached it, but he could not yet free himself from the old notion of the window as a "hole in the wall." Gropius frankly acknowledged, at last, that in modern architecture the wall is no more than a curtain or climate barrier, which may consist entirely of glass if maximum daylight is desired.

Le Corbusier: Mies van der Rohe

In France, the most distinguished representative of the International Style during the 1920s was Le Corbusier. At that time he built only private houses—from necessity, not choice—but these are as important as Wright's Prairie Houses. Le Corbusier called them *machines à habiter* (machines to be lived in), a term meant to suggest his admiration for the clean, precise shapes of machinery, not a desire for "mechanized living." Perhaps he also wanted to convey that his houses were so different from conventional

ones as to constitute a new species. Such is indeed our impression as we approach the most famous of them, the Savoye House at Poissy-sur-Seine (fig. 453); it resembles a low, square box resting on stilts—pillars of reinforced concrete that form part of the structural skeleton and reappear to divide the "ribbon windows" running along each side of the box. The flat, smooth surfaces stress Le Corbusier's preoccupation with abstract "space blocks." To find out how the box is subdivided, we must enter it; we then realize that this simple "package" contains living spaces that are open as well as closed, separated by glass walls. Indoors, we are still in communication with the outside world (views of the sky and of the surrounding terrain are everywhere to be seen), yet we enjoy complete privacy, since an observer on the ground cannot see us unless we stand next to a window. The functionalism of the Savoye House, then, is governed by a "design for living," not by mechanical efficiency.

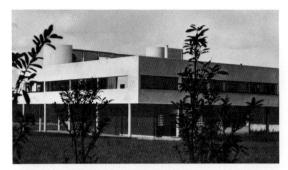

 $\bf 453.$ Le Corbusier. Savoye House, Poissy-sur-Seine. 1929-30

454. Ludwig Mies van der Rohe and Philip Johnson. Seagram Building, New York. 1958

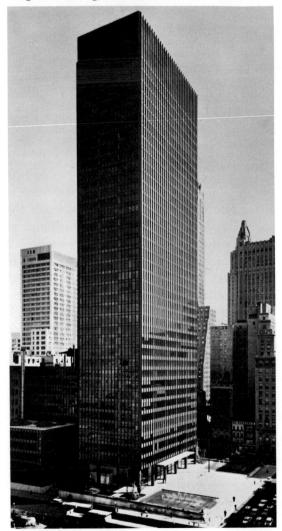

America, despite its position of leadership at first, lagged behind in the 1920s. Not until

the very end of the decade did the impact of the International Style begin to be felt on this side of the Atlantic. A few years later, the best German architects, whose work Hitler condemned as "un-German," came to this country and greatly stimulated the development of American architecture. Gropius, appointed chairman of the architecture department at Harvard University, had an important educational influence: Ludwig Mies van der Rohe, his former colleague at Dessau, settled in Chicago as a practicing architect. His severely elegant Seagram Building in New York (fig. 454) exemplifies his dictim that "less is more." Mies van der Rohe is the great spiritual heir of Mondrian among recent designers, possessed of the same "absolute pitch" in determining proportions and spatial relationships.

Le Corbusier, in contrast to Mies van der Rohe, abandoned the geometric purism of the International Style in his later years. Instead, he showed a growing preoccupation with sculptural, even anthropomorphic effects. His Church of Notre-Dame-du-Haut at Ronchamp in southeastern France is the most revolutionary building of the mid-twentieth century. Rising like a medieval fortress from the crest of a mountain (fig. 455), it has a design so irrational that it defies analysis. The massive walls seem to obey an unseen force that makes them slant and curl like paper; and the overhanging roof suggests the brim of a huge hat, or the bottom of a ship split lengthwise by the sharp-edged buttress from which it is suspended. There is a conscious evocation of the dim, prehistoric past here; asked to create a sanctuary on a mountaintop, Le Corbusier must have felt that this was the primeval task of architecture, placing him in a direct line of succession with the men who had built Stonehenge, the ziggurats of Mesopotamia, and the Greek temples. Hence, he also avoids any correlation between exterior and interior. The doors are concealed: we must seek them out like clefts in a mountainside, and to pass through them

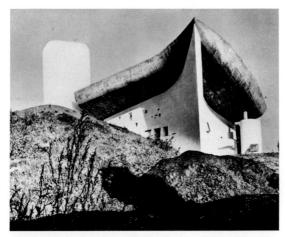

455. Le Corbusier. Notre-Dame-du-Haut (view from the southeast), Ronchamp. 1950–55

456. Le Corbusier. Interior, south wall, Notre-Damedu-Haut, Ronchamp

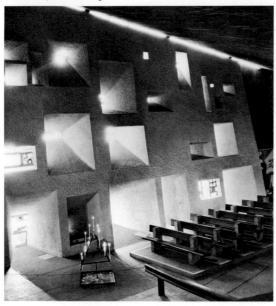

is much like entering a secret—and sacred—cave. Only inside do we sense the specifically Christian aspect of Ronchamp. The light, channeled through windows so tiny that they seem hardly more than slits or pinpricks on the exterior, cuts widening paths through the thickness of the wall, and thus becomes once more what it had been in medieval architecture—the visible counterpart of the Light Divine (fig. 456). There is true magic in the interior of Ronchamp, but also a strangely

disquieting quality, a nostalgia for the certainties of a faith that is no longer unquestioned. Ronchamp thus mirrors the spiritual condition of Modern Man—which is a measure of its greatness as a work of art.

Post-Modernism

Le Corbusier belongs to the same heroic generation as Gropius and Mies van der Rohe; all were born in the 1880s. It was these men who in the course of their long, fruitful careers coined the language of twentieth-century architecture. Their successors continue to use it, adapting its vocabulary to new building types and materials. Lately, however, younger architects have begun to question its internal logic. Among the freshest buildings in recent years is the Georges Pompidou National Arts and Cultural Center in Paris (fig. 457). Selected in an international competition, the design by an English-Italian team looks like the Bauhaus (see fig. 452) turned inside out. The architects have eliminated any trace of Le Corbusier's elegant façades (see fig. 453) to expose the inner mechanics while disguising the underlying structure. The interior itself has no fixed dividing walls, so that it can be rearranged to meet any need. This stark utilitarianism reflects the populist sentiment current in France. Yet it is enlivened by eye-catching colors, each keyed to a different function. The festive display is as vivacious and imaginative as Léger's City (see fig. 393), which, with the Eiffel Tower, can be regarded as the Pompidou Center's true ancestor.

The Pompidou Center represents a reaction against the International Style without abandoning its functionalism. However, Post-Modern architecture (as its name suggests) constitutes a far broader repudiation of the mainstream of modern architecture. It rejects not only the formal harmony of Gropius and his followers, but also the social and ethical ideas implicit in their lucid proportions.

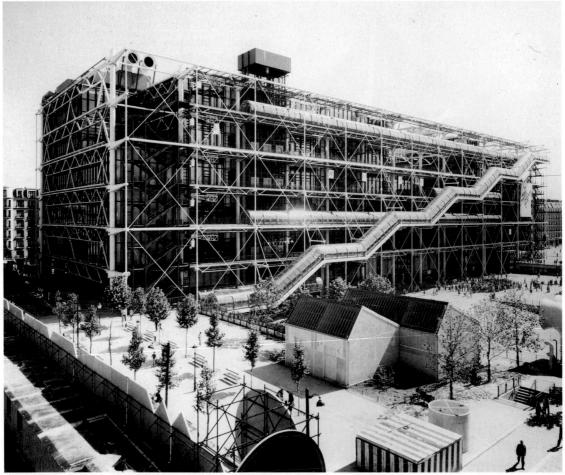

457. (above) Renzo Piano and Richard Rogers. Georges Pompidou National Arts and Cultural Center, Paris. 1971–77

458. (opposite) James Stirling. Neue Staatsgalerie, Stuttgart. Completed 1984

To create more human environments, Post-Modern architects have reverted to what can only be called premodernist architecture by adopting styles that were in vogue before the International Style. The Neue Staatsgalerie in Stuttgart (fig. 458) by the Englishman James Stirling has the grandiose scale befitting a "palace" of the arts, but instead of the monolithic cube of the Pompidou Center, it incorporates more varied shapes and more complex spatial relationships. There is, too, an overtly decorative quality that will remind us, however indirectly, of Garnier's Paris Opéra (see fig. 315). The similarity does not stop there. Beginning with the primly

Neoclassical masonry façade, Stirling has also invoked a form of historicism through paraphrase which is far more subtle than Garnier's opulent revivalism, but no less self-conscious. This eclecticism is more than a veneer—it lies at the heart of the building's success. The site, centering on a circular sculpture court, is designed along the lines of ancient temple complexes from Egypt through Rome, complete with a monumental entrance stairway. This plan enabled Stirling to solve a wide range of practical problems with ingenuity and to provide a stream of changing vistas which fascinate and delight the visitor.

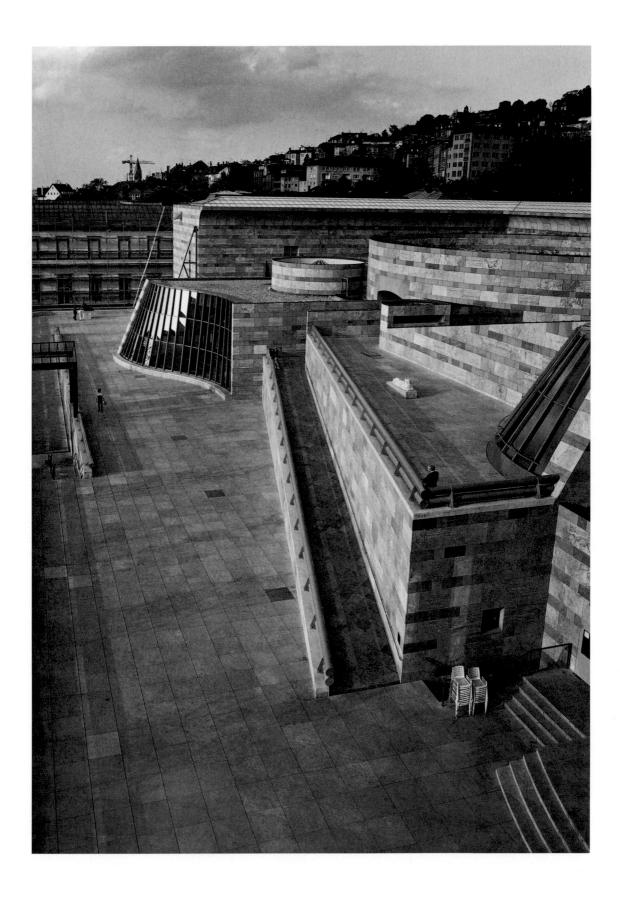

Photography

Is photography art? The fact that we still pose the question testifies to the continuing debate. The answers have varied with the changing definition and understanding of art. In itself, of course, photography is simply a medium, like oil paint or pastel, used to make art but having no inherent claim to being art. After all, what makes something an art instead of a craft is why, not how, it is done. But photography shares creativity with art because, by its very nature, its performance necessarily involves the imagination. Any photograph, even a casual snapshot, represents both an organization of experience and the record of a mental image. Furthermore, photography participates in much the same process of seek-and-find as art. Often the photographer does not realize what he responded to until after he sees the image that has been printed.

Photography and art represent parallel responses to their times and have generally expressed the same world view. Indeed, the camera's power to extend our way of seeing has sometimes been realized first by the painter's creative vision. The two nevertheless have enjoyed an uneasy relationship from the start. Artists have generally treated the photograph something like a preliminary sketch. Photography has in turn been judged according to how well it can imitate paintings, prints, and drawings.

Like woodcut, etching, engraving, and lithography, photography is a form of print-making which is dependent on mechanical processes. But in contrast to the other graphic media, photography has always been tainted as the product of a new technology. Moreover, the camera has usually been considered to be little more than a recording

device. Photography is by no means so neutral a medium, however; it never renders a completely faithful reproduction of reality. Whether we realize it or not, the camera alters appearances and reinterprets the world around us, making us literally see it in new terms.

ROMANTIC PHOTOGRAPHY

The Founding Fathers

In 1822 a French inventor named Joseph Nicephore Niépce succeeded, at the age of fifty-seven, in making the first permanent photographic image, although his earliest surviving example (fig. 459) dates from four years later. He then joined forces with a younger man, Louis Jacques Mandé Daguerre, who had devised an improved camera. After ten more years of chemical and mechanical research, the daguerreotype, using positive exposures, was unveiled publicly

459. Joseph Nicéphore Niépce. View from His Window at Le Gras. 1826. Heliograph, 6½×7%". Gernsheim Collection, Harry Ransom Humanities Research Center, University of Texas at Austin

in 1839 and the age of photography was born. The announcement spurred the Englishman William Henry Fox Talbot to complete work on his own photographic process, involving a paper negative from which positives could be made, which he had been pursuing independently since 1833.

What motivated the fathers of photography? They were searching for an artistic medium, not for a device of practical utility. Though Niépce was a research chemist rather than an artist, his achievement was an outgrowth of his efforts to improve the lithographic process. Daguerre was a skilled painter, who probably turned to the camera to heighten the illusionism in his huge painted dioramas, which were the sensation of Paris during the 1820s and 1830s. Fox Talbot saw in photography a substitute for drawing, after using a camera as a tool to sketch landscapes while on vacation. The interest that all of these men had in the artistic potential of the medium they had created is reflected in their photographs.

That the new medium should have a me chanical aspect was particularly appropriate. It was as if the industrial revolution, having forever altered man's way of life, had now to invent its own new method for recording itself. The basic mechanics and chemistry of photography, however, had been known for a long time. The camera obscura, a box with a small hole in one end, became widely used as an aid in drawing architectural scenes by the 1720s, the same time that silver salts were discovered to be light sensitive. Why, then, did it take another hundred years for someone to put this knowledge together? Photography was neither inevitable in the history of technology, nor necessary to the history of art; yet it was an idea whose time had clearly come. If we try for a moment to imagine that photography was invented a hundred years earlier, we will find this to be impossible simply on artistic, apart from technological, grounds: the eighteenth century was too devoted to fantasy to be interested in the literalness of photography. Rococo portraiture, for example, was more concerned with providing a flattering image than an accurate likeness, and the camera's straightforward record would have been totally out of place.

The invention of photography was a response to the artistic urges and historical forces underlying Romanticism. Much of the impulse came from a quest for the True and the Natural. The desire for "images made by Nature" can already be seen in David's *Death of Marat* (see fig. 309), which proclaimed the cause of unvarnished truth; so did Ingres' *Louis Bertin* (see fig. 324), which established the standards of physical reality and character portrayal that photographers would follow.

Portraiture

Romantic art was largely art for the middle class, who replaced the aristocracy as the main patrons of culture. Like lithography, which was invented only in 1797, photography met the growing middle-class demand for images of all kinds. By 1800, large numbers of the bourgeoisie were having their likenesses painted, and it was in portraiture that photography found its readiest acceptance. Soon after the daguerreotype was introduced, photographic studios sprang up everywhere. Anyone could have his portrait taken cheaply and easily. In the process, the average man himself became notable. Photography thus became an outgrowth of the democratic values fostered by the American and French revolutions.

There was also keen competition among photographers to get the famous to pose for portraits. Gaspard Félix Tournachon, better known as Nadar, managed to attract most of France's leading lights to his studio. Like many early photographers, he started out as an artist and initially used the camera to capture the likenesses of 280 sitters whom he caricatured in an enormous lithograph *Le Panthéon Nadar*; he came to prefer the lens to

the brush. The actress Sarah Bernhardt posed for him several times, and his photographs of her (fig. 460) are the direct ancestors of modern glamour photography. With

460. Nadar. *Sarah Bernhardt*. 1859. International Museum of Photography at George Eastman House, Rochester, New York

her romantic pose and expression, she is a counterpart to the soulful maidens who inhabit much of nineteenth-century painting. Nadar has treated her in remarkably sculptural terms: indeed, the play of light and sweep of drapery are reminiscent of the sculptured portrait busts that were so popular with collectors at the time.

The Restless Spirit; Stereophotography

Early photography reflected the outlook and temperament of Romanticism, and indeed the entire nineteenth century had a pervasive curiosity and an abiding belief that everything could be discovered. While this fascination sometimes manifested itself as a serious interest in science, witness Darwin's voyage on the Beagle from 1831 to 1836, it more typically took the form of a restless quest for new experiences and places. Photography had a remarkable impact on the imagination of the period by making the rest of the world widely available, or by simply revealing it in a new way. A love of the exotic was fundamental to Romantic escapism, and by 1850 photographers had begun to cart

their equipment to faraway places.

The thirst for this kind of vicarious experience soon became unquenchable, and it accounts for the expanding popularity of stereoscopic daguerreotypes. Invented in 1849, the two-lens camera produced two photographs that correspond to the slightly different images perceived by our two eyes. When seen through a special viewer called a stereoscope, the stereoptic photographs fuse to create a remarkable illusion of three-dimensional depth. They became the rage at the Crystal Palace exposition held in 1851 in London. Countless thousands of double views were taken, such as that in fig. 461; virtually every corner of the earth became accessible to practically any household, with a vividness second only to being there. Stereophotography was an important breakthrough, for its binocular vision marked a distinct departure from perspective in the pictorial tradition and demonstrated for the first time photography's potential to enlarge man's vision. Curiously enough, this success waned: people were simply too habituated to viewing pictures as if with one eye. Later on stereophotographs revealed another drawback: as our illustration shows, they were unsuitable for reproduction on the printed page, a process that became possible with the invention of the halftone plate in the 1880s. From then on, single-lens photography was inextricably linked with the mass media of the day.

Photojournalism

Fundamental to the rise of photography was the pervasive nineteenth-century sense that the present was already history in the making. Only with the advent of the Romantic hero did great acts other than martyrdom become popular subjects for contemporary artists, and it is surely no accident that photography was invented a year after the death of Napoleon, who had been the subject of more paintings than any secular leader ever before. At about the same time, Goya's *Third*

462. Alexander Gardner. *Home of a Rebel Sharpshooter, Gettysburg.* 1863. Wet-plate photograph. Chicago Historical Society

of May, 1808 (see fig. 321) signaled a decisive shift in the Romantic attitude, toward representing the reality of contemporary events. This outlook brought with it a new kind of photography: photojournalism.

Its first great representative was Mathew Brady, who with twenty assistants covered the Civil War. Home of a Rebel Sharpshooter, Gettysburg (fig. 462) by Alexander Gardner, who left Brady to form his own team, is a landmark in the history of art. Never before had both the grim reality and, above all, the significance of death on the battlefield been conveyed in a single image. Compared with the heroic act celebrated by Benjamin West (see fig. 310), this tragedy is as anonymous as the slain soldier himself. The photograph is all the more persuasive for having the same harsh realism found in David's Death of Marat (see fig. 309), and the limp figure, hardly visible between the rocks framing the scene, is no less poignant.

REALIST PHOTOGRAPHY

Documentary Photography

During the second half of the nineteenth century, the press played a leading role in the social movement which brought the harsh realities of poverty to the public's attention.

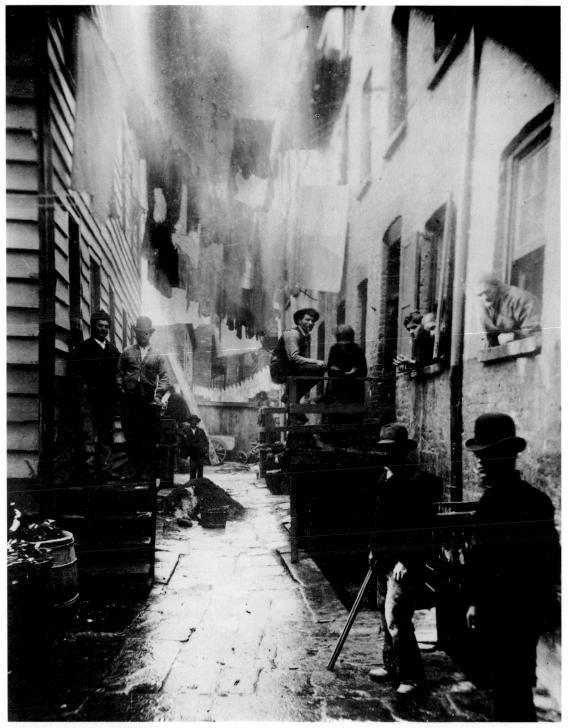

463. Jacob Riis. *Bandits' Roost*. c. 1888. Gelatin-silver print. Museum of the City of New York

The camera became an important instrument of reform through the photodocumentary, which tells the story of people's lives in a pictorial essay. It responded to the same conditions that had stirred Courbet (see p. 328), and its factual reportage likewise fell within the Realist tradition. Before then, photographers had been content to present the same romanticized image of the poor found in genre paintings of the day. The first photodocumentary, published in 1877, was by John Thomson, who had to pose his subjects in order to get his pictures. The invention of gunpowder flash ten years later allowed Jacob Riis to rely for the most part on the element of surprise. Riis was a police reporter in New York City, where he learned first-hand about the crime-infested slums and their appalling living conditions. He kept up a steady campaign of illustrated newspaper exposés, books, and lectures which in some cases led to major revisions of the city's housing codes and labor laws. His photographs' unflinching realism has lost none of its force. Certainly it would be difficult to imagine a more nightmarish scene

than *Bandits' Roost* (fig. 463). With good reason we sense a pervasive air of danger in the eerie light. The Lower East Side's notorious gangs sought their victims by night, killing them without hesitation. The motionless figures seem to look us over with the practiced casualness of hunters coldly sizing up potential prey.

Pictorialism

The raw subject matter and realism of documentary photography had little impact on art and were shunned by most other photographers as well. England, through such organizations as the Photographic Society of London, founded in 1853, became the leader of the movement to convince doubting critics that photography, by imitating painting and printmaking, could indeed be art. To Victorian England, beauty above all meant art with a high moral purpose or noble sentiment, preferably in a Classical style. Oscar Rejlander's *Two Paths of Life* (fig. 464) fulfills these ends by presenting an allegory clearly descended from Hogarth's *Rake's Progress*

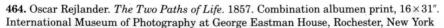

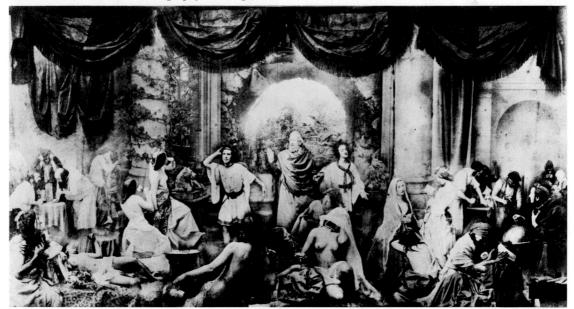

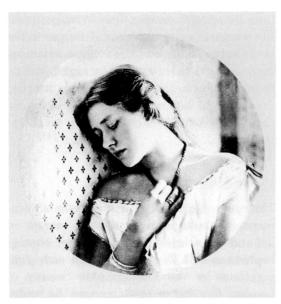

465. Julia Margaret Cameron. *Portrait of Ellen Terry*. 1864. Albumen print. The Metropolitan Museum of Art, New York

series (see fig. 299). A tour de force combining thirty negatives through composite printing, it shows a young man (in two images) choosing between the paths of virtue and of vice, the latter represented by a half dozen nudes. The picture created a sensation in 1857 and Queen Victoria herself purchased a print.

The photographer who pursued ideal beauty with the greatest passion was Julia Margaret Cameron. An intimate of leading poets, scientists, and artists, she took up photography at the age of forty-eight when given a camera, and went on to create a remarkable body of work. In her own day Cameron was known for her allegorical and narrative pictures, but now she is remembered primarily for her portraits of the men who shaped Victorian England. Her finest photographs, however, are of the women who were married to her closest friends. An early study of the actress Ellen Terry (fig. 465), the young wife of the painter G. F. Watts, has the lyricism and grace of the Pre-Raphaelite aesthetic that shaped Cameron's style (compare fig. 365).

Photo-Secession

The issue of whether or not photography could be art came to a head in the early 1890s with the Secession movement (see p. 352), which was spearheaded in 1893 by the founding in London of the Linked Ring, a rival group to the renamed Royal Photographic Society of Great Britain. Seeking a pictorialism independent of science and technology, the Secessionists steered a course between academicism and naturalism by imitating every form of late Romantic art that did not involve narrative. Equally antithetical to their aims were Realist and Post-Impressionist painting, then at its zenith. In the group's approach to photography as art for art's sake, the Secession had the most in common with Whistler's aestheticism. To resolve the dilemma between art and mechanics, the Secessionists tried to make their photographs look as much like paintings as possible. Rather than resorting to composite or multiple images, however, they exercised total control over the printing process, chiefly by add-

466. Gertrude Käsebier. *The Magic Crystal.* n.d. Platinum print. Royal Photographic Society, Bath

467. Edward Steichen. *Rodin with His Sculptures* "Victor Hugo" and "The Thinker." 1902. Gum print. The Art Institute of Chicago (Alfred Stieglitz Collection)

ing special materials to their printing paper to create different effects. Pigmented gum brushed on coarse drawing paper yielded a warm-toned, highly textured print that in its way approximated Impressionist painting. Paper impregnated with platinum salts was especially popular among the Secessionists for the clear grays in their prints. Their subtlety and depth lend a remarkable ethereality to Gertrude Käsebier's *Magic Crystal* (fig. 466), in which spiritual forces are almost visibly sweeping across the photograph.

Through Käsebier and Alfred Stieglitz (see p. 435), the Linked Ring had close ties with America, where Stieglitz opened his Photo-Secession gallery in New York in 1902.

Among his protégés was the young Edward Steichen, whose photograph of Rodin in his sculpture studio (fig. 467) is without doubt the finest achievement of the entire Photo-Secession movement. The head in profile contemplating The Thinker expresses the essence of the confrontation between the sculptor and his work of art. His brooding introspection hides the inner turmoil evoked by the ghostlike monument to Victor Hugo that rises dramatically like a genius in the background. Not since The Creation of Adam by Michelangelo (see fig. 211), who was Rodin's ideal, have we seen a more telling use of space or an image that penetrates the mystery of creativity so deeply.

468. Eadweard Muybridge. Female Semi-nude in Motion, from Human and Animal Locomotion, vol. 2, pl. 271. 1887. International Museum of Photography at George Eastman House, Rochester, New York

Motion Photography

An entirely new direction was charted by Eadweard Muybridge, the father of motion photography. He wedded two different technologies, devising a set of cameras capable of photographing action at successive points. After some trial efforts, Muybridge managed in 1877 to get a set of pictures of a trotting horse which forever changed artistic depictions of the horse in motion. Of the 100,000 photographs he devoted to the study of animal and human locomotion, the most astonishing were those taken from several vantage points at once (fig. 468). The idea was surely in the air, for we occasionally find similar experiments in the art of the period. But Muybridge's photographs must nevertheless have come as a revelation to artists. The simultaneous views present an entirely new treatment of motion across time and space which challenges the imagination. Like a complex visual puzzle, they can be combined in any number of ways that are endlessly fascinating. The photographs by Muybridge convey a peculiarly modern sense of dynamics reflecting the new tempo of life in the machine age. However, because the gap was then so great between scientific fact on the one hand and visual perception and artistic representation on the other, their farreaching aesthetic implications were to be realized only by the Futurists (see p. 371).

TWENTIETH-CENTURY PHOTOGRAPHY

During the nineteenth century, photography struggled to establish itself as art but failed to find an identity. Only under extraordinary conditions of political upheaval and social reform did it address the most basic subject of art, which is life itself. In developing an independent vision, photography would combine the aesthetic principles of the Secession and the documentary approach of photojournalism with lessons learned from motion photography. At the same time, modern painting, with which it soon became allied, forced a decisive change in photography by undermining its aesthetic assumptions and posing a

new challenge to its credentials as one of the arts. Like the other arts, photography responded to the three principal currents of our time: Expressionism, Abstraction, and Fantasy. But because it has continued to be devoted for the most part to the world around us, modern photography has adhered largely to realism and, hence, has followed a separate development. We must therefore discuss twentieth-century photography primarily in terms of different schools and how they have dealt with those often conflicting currents.

The course pursued by modern photography was facilitated by technological advances. It must be emphasized, however, that these have enlarged but never dictated the photographer's options. Surprisingly, even the introduction of color photography by Louis Lumière in 1907 had relatively little

impact on the content, outlook, or aesthetic of photography, even though it did remove the last barrier cited by nineteenth-century critics of photography as an art. Photography did create one new art form, the cinema. An outgrowth of motion photography, it too was first perfected in 1894 by Lumière and his brother. Unfortunately, we are unable to treat it in our survey, because the printed page cannot reproduce continuous action or sound.

THE SCHOOL OF PARIS

Atget

Modern photography began quietly in Paris with Eugène Atget, who turned to the camera only in 1898 at the age of forty-two. From

469. Eugène Atget. *Pool, Versailles.* 1924. Gold-toned printing-out paper, $7 \times 9\%$ ". The Museum of Modern Art, New York (The Abbott-Levy Collection. Partial gift of Shirley C. Burden)

then until his death in 1927, he toted his heavy equipment around Paris, recording the city in all its variety. Atget was all but ignored by the art photographers, for whom his commonplace subjects had little interest. He himself was a humble man whose studio sign read simply "Atget-Documents for Artists," and indeed, he was patronized by the fathers of modern art—Braque, Picasso, Duchamp, and Man Ray, to name only the best known. It is no accident that these artists were also admirers of Henri Rousseau, for Rousseau and Atget had in common a naïve vision, though Atget found inspiration in unexpected corners of his environment rather than in magical realms of the imagination. His pictures are marked by a subtle intensity and technical perfection that heighten the reality, and hence the significance, of even the most mundane subject. Few photographers have equaled Atget's ability to compose simultaneously in two- and three-dimensional space. Like *Pool*, *Versailles* (fig. 469), his scenes are often desolate, bespeaking a strange and individual outlook. The viewer has the haunting sensation that time has been transfixed in the past by the stately composition and the photographer's obsession with textures. His photographs are directly related to a strain of magic realism that was a forerunner of Surrealism. It is easy to understand why Atget was rediscovered by the Dada and Surrealist artist-photographer Man Ray (see p. 442).

Cartier-Bresson

The culmination of this Paris school is no doubt Henri Cartier-Bresson. The son of a wealthy thread manufacturer, he studied under a Cubist painter in the late 1920s before taking up photography in 1932. Strongly af-

470. Henri Cartier-Bresson. Mexico, 1934. 1934. Gelatin-silver print

fected at first by Atget, Man Ray, and even by the cinema, he soon developed into the most influential photojournalist of his time, and he still thinks of himself primarily as one. His purpose and technique are nevertheless those of an artist. Cartier-Bresson is the master of what he has termed "the decisive moment." This to him means the instant recognition and visual organization of an event at the most intense moment of action and emotion, in order to reveal its inner meaning, not simply to record its occurrence. His work is distinguished by an interest in composition for its own sake, derived from modern abstract art. He also has a particular fascination with motion, which he invests with all the dynamism of Futurism and the irony of Dada. The key to his work is his use of space to establish relations which are suggestive and often astonishing. Indeed, for all that he deals with reality, Cartier-Bresson is a Surrealist at heart and has admitted as much. The results can be disturbing, as in Mexico, 1934 (fig. 470). By omitting the man's face, Cartier-Bresson prevents us from identifying the meaning of the gesture, yet we respond to its tension no less powerfully.

THE STIEGLITZ SCHOOL

Stieglitz

The father of modern photography in the United States was Alfred Stieglitz, whose influence remained dominant throughout his life. From his involvement with the Photo-Secession, he was a tireless spokesman for photography-as-art, although he defined this more broadly than did other members of the movement. He backed his words by publishing the magazine *Camera Work* and supporting the other pioneers of American photography through exhibitions of their work in his New York galleries, especially the first one, known as "291." The bulk of his early work adheres to Secessionist conven-

tions, treating photography as a pictorial equivalent to painting. During the mid-1890s, however, he took some pictures of street scenes that are harbingers of his mature photographs. His classic statement, and the one he regarded as his finest effort, is The Steerage (fig. 471), taken in 1907 on a trip to Europe. It captures the feeling of a voyage, but does so by letting the shapes and composition tell the story. The gangway bridge divides the scene visually, emphasizing the contrasting activities of the people below in the steerage, which was reserved for the cheapest fares, and the observers on the upper deck. What it lacks in obvious sentiment it makes up for by remaining true to life. This kind of "straight" photography is deceptive in its simplicity, for the image mirrors the feelings that stirred Stieglitz. For that reason, it marks an important step in his evolution and a turning point in the history of photography. Its importance emerges only in comparison with earlier photographs such as Steichen's Rodin (see fig. 467) and Riis' Bandits' Roost (see fig. 463). The Steerage is a pictorial statement independent of painting on the one hand and free from social commentary on the other. It represents the first time that documentary photography achieved the level of art in America.

Stieglitz' "straight" photography formed the basis of the American school. It is therefore ironic that it was Stieglitz, with Steichen's encouragement, who became the champion of abstract art. This is not as surprising as it seems at first glance, however: for Stieglitz, photography was less a means of recording things than of expressing his experience and philosophy of life, much as a painter does. This attitude culminated in his "Equivalents"; in 1922 Stieglitz began to photograph clouds to show that his work was independent of subject and personality. Like O'Keeffe's paintings (see fig. 383), these are akin to Expressionism in their intent, for their power lies outside of representation. A remarkably lyrical cloud photograph from

471. Alfred Stieglitz. The Steerage. 1907. The Art Institute of Chicago (Alfred Stieglitz Collection)

1930 (fig. 472) corresponds to a state of mind waiting to find full expression rather than merely responding to the moonlit scene. The study of clouds is as old as Romanticism itself, but no one before Stieglitz had made

them a major theme in photography. As in Käsebier's *Magic Crystal* (see fig. 466), unseen forces are evoked that make *Equivalent* a counterpart to Kandinsky's *Composition VII* (see fig. 382).

472. Alfred Stieglitz. *Equivalent*. 1930. Chloride print. The Art Institute of Chicago (Alfred Stieglitz Collection)

473. Edward Weston. *Pepper*. 1930. Center for Creative Photography, Tucson

Weston

Stieglitz' concept of the Equivalent opened the way to "pure" photography as an alternative to "straight" photography. The leader of this new approach was Edward Weston, who,

although not Stieglitz' protégé, was decisively influenced by him. During the 1920s he pursued abstraction and realism as separate paths, but by 1930 he fused them both in images which are wonderful in their design and miraculous for their detail. *Pepper* (fig. 473) is a splendid example which is anything but a straightforward record of this familiar fruit. Like Stieglitz' clouds, Weston's photography makes us see the mundane with new eyes. The pepper is shown with preternatural sharpness and so close up that it seems larger than life. Thanks to the tightly cropped composition, we are forced to contemplate the form, whose every undulation is revealed by the dramatic lighting. Pepper possesses the inner life of O'Keeffe's Dark Abstraction (see fig. 383), but with a surprising sensuousness that lends the Equivalent a new meaning. Here the shapes are intentionally suggestive of the photographs of the female nude that Weston also pioneered.

Bourke-White

Stieglitz was among the first to photograph skyscrapers, the new architecture that came to dominate the horizon of America's growing cities in the revitalized post—World War I economy that led to unprecedented industrial expansion on both sides of the Atlantic. Surprisingly, even during the Depression industrial photography continued to grow with the new mass-circulation magazines that ushered in the great age of photojournalism and, with it, of commercial photography. In the United States, most of the important photographers were employed by the leading journals and corporations.

Margaret Bourke-White was the first staff photographer hired by *Fortume* magazine and then by *Life* magazine, both published by Henry Luce; her cover photograph of Fort Peck Dam in Montana for *Life*'s inaugural issue on November 23, 1936, remains a classic example of the new photojournalism (fig. 474). The decade was witnessing enormous

474. Margaret Bourke-White. Fort Peck Dam, Montana. 1936 (first cover of Life magazine). Copyright 1936 Time, Inc.

building campaigns, and with her keen eye for composition, Bourke-White draws a visual parallel between the dam and the massive constructions of ancient Egypt (compare fig. 21). In addition to their architectural power, the dam's columnar forms have a remarkable sculptural quality and an almost human presence, looming like colossal statues at the entrance to a temple. But unlike the pharaohs' passive timelessness, these "guardian figures" have the spectral alertness of Henry Moore's abstract monoliths (see fig. 428). Bourke-White's rare ability to suggest multiple levels of meaning made this cover and her accompanying photo essay an astonishing revelation.

THE NEW OBJECTIVITY

Sander

With the New Objectivity movement in Germany during the late 1920s and early 1930s, photography achieved a degree of excellence

that has never been surpassed. Fostered by the invention of superior German cameras and the boom in publishing everywhere, this German vision of straight photography emphasized materiality at a time when many other photographers were turning away from the real world. The intrinsic beauty of things was brought out through the clarity of form and structure in their photographs. This approach accorded with Bauhaus principles of design and deliberately avoided any personal statement. When applied to people rather than things, the New Objectivity could be disarming: August Sander's book Face of Our Time, published in 1929, concealed its intention behind a straightforward surface; the sixty portraits in it provide a devastating survey of Germany during the rise of the Nazis, who later suppressed the book. Clearly proud of his position, Sander's Pastry Cook,

475. August Sander. Pastry Cook, Cologne. 1928. Courtesy August Sander Archive and Sander Gallery, Inc., New York

476. Robert Capa. Death of a Loyalist Soldier. 1936

Cologne (fig. 475), the "good citizen," seems oblivious to the evil that other artists of the time were depicting so vividly. While the photograph passes no individual judgment, the subject's unconcern stands as a strong indictment, particularly in light of later history.

THE HEROIC AGE

Capa

The years from 1930 to 1945 can be called the heroic age of photography for its photographers' notable response to the challenges of their times. Their physical bravery was exemplified by the combat photographer Robert Capa, who covered wars around the world for twenty years before being killed by a land mine in Vietnam. While barely adequate technically, his picture of a Loyalist soldier

being shot during the Spanish Civil War (fig. 476) captures fully the horror of death at the moment of impact. Had it been taken by someone else, it might seem a freak photograph, but it is altogether typical of Capa's battle close-ups, for he was as fearless as Mathew Brady.

Lange

Photography in those difficult times demonstrated moral courage as well. Under Roy Stryker, staff photographers of the Farm Security Administration compiled a comprehensive photodocumentary archive of rural America during the Depression. While the FSA photographers presented a balanced and objective view, most of them were also reformers whose work responded to the social problems they confronted daily in the field. The concern of Dorothea Lange for people

477. Dorothea Lange. *Migrant Mother, California*. 1936. Library of Congress, Washington, D.C.

and her sensitivity to their dignity made her the finest documentary photographer of the time in America.

At a pea-pickers' camp in Nipomo, California, Lange discovered 2,500 virtually starving migrant workers and took several pictures of a young widow with her children, much later identified as Florence Thompson; when *Migrant Mother*, *California* (fig. 477) was published in a news story on their plight the government rushed in food, and eventually migrant relief camps were opened. More than any painting of the period, *Migrant Mother* has come to stand for that entire era. Unposed and uncropped, this photograph has an unforgettable immediacy no other medium can match.

PHOTOMONTAGE AND PHOTOGRAM

"Impersonality," the very liability that had precluded the acceptance of photography in the eyes of many critics, became a virtue in the 1920s. Precisely because photographs are produced by mechanical devices, the camera's images now seemed to some artists the perfect means for expressing the modern era. This change in attitude did not stem from the Futurists, who contrary to what might be expected, never fully grasped the camera's importance for modern art. The new view of photography arose as part of the Berlin Dadaists' assault on traditional art. Toward the end of World War I, the Dadaists "invented" the photomontage and the photogram. Both had actually been practiced early in the history of photography, but they were now placed in the service of anti-art.

Heartfield

Photomontages are simply parts of photographs cut out and recombined into new im-

ages. Composite negatives originated with the art photography of Rejlander (see p. 429). Dadaist photomontages, however, utilize the techniques employed in collage Cubism to ridicule social and aesthetic conventions. These imaginative parodies destroy all pictorial illusionism and therefore stand in direct opposition to straight photographs, which use the camera to record and probe the meaning of reality. Dada photomontages might be called Ready-Images, after Duchamp's Ready-Mades. Like other collages, they are literally torn from popular culture and given new

478. John Heartfield. As in the Middle Ages, So in the Third Reich. 1934. Poster, photomontage. Akademie der Künste, Heartfield Archive, West Berlin

meaning. Although the photomontage relies more on the laws of chance, the Surrealists later claimed it to be a form of automatic handwriting, on the grounds that it responds to a stream of consciousness.

Photomontages were soon incorporated into carefully designed posters as well. In Germany, posters became a double-edged sword in political propaganda, used by Hitler's sympathizers and enemies alike. The most acerbic anti-Nazi commentaries were provided by John Heartfield, who changed his name from the German Herzfeld as a sign of protest. His horrific poster (fig. 478) of a Nazi victim crucified on a swastika appropriates a Gothic image of mankind punished for its sins on the wheel of divine judgment. Obviously, Heartfield was not concerned about misinterpreting the original meaning in his montage, which communicates its new message to powerful effect.

479. Man Ray. Rayograph. 1924. Gelatin-silver print, $15\frac{1}{2} \times 11\frac{1}{8}$ ". The Museum of Modern Art, New York (Gift of James Thrall Soby)

Man Ray

The photogram does not take pictures but makes them; objects are placed directly onto photographic paper and exposed to light. This technique, too, was not new. The Dadaists' photograms, however, like their photomontages, were intended to alter nature's forms, not to record them, and to substitute impersonal technology for the work of the individual. Since the results in a photogram are so unpredictable, making one involves even greater risks than does a photomontage. Man Ray, an American working in Paris, was not the first to make photograms but his name is the most closely linked to them through his "Rayographs." Fittingly enough, he discovered the process for making his Rayographs by accident. The amusing face in figure 479 was made according to the laws of chance by dropping a string, two strips of paper, and a few pieces of cotton onto the photographic paper, then coaxing them here and there before exposure. The resulting image is a witty creation that shows the playful, spontaneous side of Dada and Surrealism as against Heartfield's grim satire.

PHOTOGRAPHY TODAY

White

Photography, like painting, was marked by abstraction for nearly two full decades after World War II, especially in the United States. Minor White's work is close in spirit to that of the Abstract Expressionists. He was decisively influenced by Stieglitz' concept of the Equivalent. During his most productive period, from the mid-1950s to the mid-1960s, he worked in a highly individual style, using the alchemy of the darkroom to transform reality into a mystical metaphor. His *Ritual Branch* (fig. 480) evokes a primordial image: what it shows is not so important as what it stands for, but the meaning that we sense is there remains elusive.

480. Minor White. *Ritual Branch*. 1958. International Museum of Photography at George Eastman House, Rochester, New York (Courtesy The Minor White Archive, Princeton University. Copyright 1982 Trustees of Princeton University)

Leonard

Fantasy gradually reasserted itself on both sides of the Atlantic in the mid-1950s. Photographers first manipulated the camera for the sake of extreme visual effects by using special lenses and filters to alter appearances, sometimes virtually beyond recognition. Since

481. Joanne Leonard. *Romanticism Is Ultimately Fatal*, from "Dreams and Nightmares." 1982. Positive transparency selectively opaqued with collage, $9\frac{3}{4} \times 9\frac{1}{4}$ ". Collection M. Neri, Benica, California

about 1970, however, they have employed mainly printing techniques, with results that are frequently even more startling.

Photographers have also increasingly turned to fantasy as autobiographical expression. Both the image and the title of Joanne Leonard's *Romanticism Is Ultimately Fatal* (fig. 481) suggest a highly personal meaning. The clarity of the presentation turns the apparition at the window into a real and terrifying personification of despair. This is no romantic knight in shining armor but a grim reaper whose ancestors can be found in Dürer's woodcut *The Four Horsemen of the Apocalypse* (see fig. 241).

Frank

The birth of a new school of straight photography in the United States was largely the responsibility of one man, Robert Frank. His book The Americans, compiled from a cross-country odyssey in 1955-56, created a sensation upon its publication in 1959, for it expressed the same restlessness and alienation as *On the Road*, written by his traveling companion, the Beat poet Jack Kerouac, and published in 1957. This friendship suggests that words have an important role in Frank's photographs; yet his social point of view is often hidden behind a façade of disarming neutrality. It is with shock that we finally realize the ironic intent of Santa Fe, New Mexico (fig. 482): the gas pumps face the sign SAVE in the barren landscape like members of a religious cult vainly seeking salvation at a revival meeting. Frank holds up an image of American culture that is as sterile as it is joyless. Even spiritual values, he tells us, become meaningless in the face of vulgar materialism.

Hockney

The most recent demonstration of photography's power to extend our vision has come, fittingly enough, from an artist. The photo-

482. Robert Frank. Santa Fe, New Mexico. 1955–56. Gelatin-silver print. Collection Pace/MacGill Gallery, New York (Copyright Robert Frank, 1958, from The Americans)

graphic collages that the English painter David Hockney has been making since 1982 are like revelations that overcome the traditional limitations of a unified image, fixed in time and place, by closely approximating how we actually see. In Gregory Watching the Snow Fall, Kyoto, Feb. 1983 (fig. 483), each frame is analogous to a discrete eye movement containing a piece of visual data that must be stored in our memory and synthesized by the brain. Just as we process only essential information, so there are gaps in the matrix of the image, which becomes more fragmentary toward its edge, though without the loss of acuity experienced in vision itself. The resulting shape of the collage is a masterpiece of design. The scene appears to bow curiously as it comes toward us. This ebb and

flow is more than simply the result of optical physics. In the perceptual process, space and its corollary, time, are not linear but fluid. Moreover, by including his own feet as reference points to establish our position clearly, Hockney helps us to realize that vision is less a matter of looking outward than an egocentric act which defines the viewer's visual and psychological relationship to the world around him. The picture is as expressive as it is opulent. Hockney has recorded his friend several times to suggest his reactions to the serene landscape outside the door.

Hockney's approach is embedded in the history of modern painting, for it shows a self-conscious awareness of an earlier art. It combines the faceted views of Picasso (see fig. 386) and the dynamic energy of Popova (see

483. David Hockney. Gregory Watching the Snow Fall, Kyoto, Feb. 1983. 1983. Photographic collage, $43\frac{1}{2} \times 46\frac{1}{2}$ ". Collection the artist (see colorplate on title page)

fig. 394). Gregory Watching the Snow Fall is nonetheless a distinctly contemporary work, for it incorporates the fascinating effects of Photo Realism (see fig. 421) and the illusionistic potential of Op Art (see fig. 417). Hockney has begun to explore further implications in-

herent in these photo collages, such as continuous narrative. No doubt others will be discovered as well. Among these is the possibility of showing an object or scene simultaneously from multiple vantage points to let us see it completely for the first time.

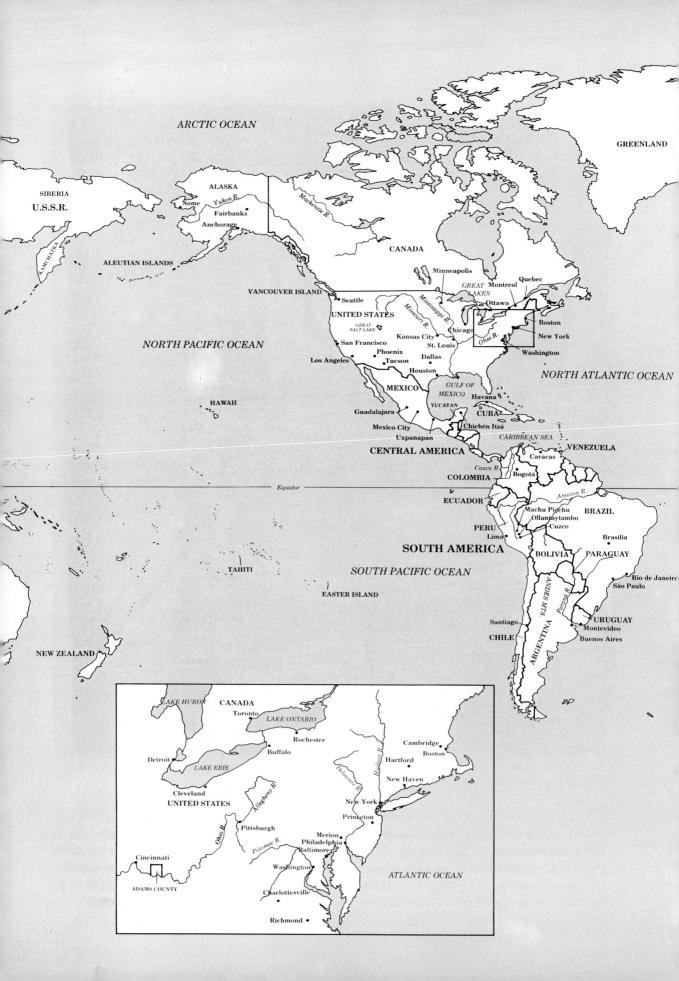

The World

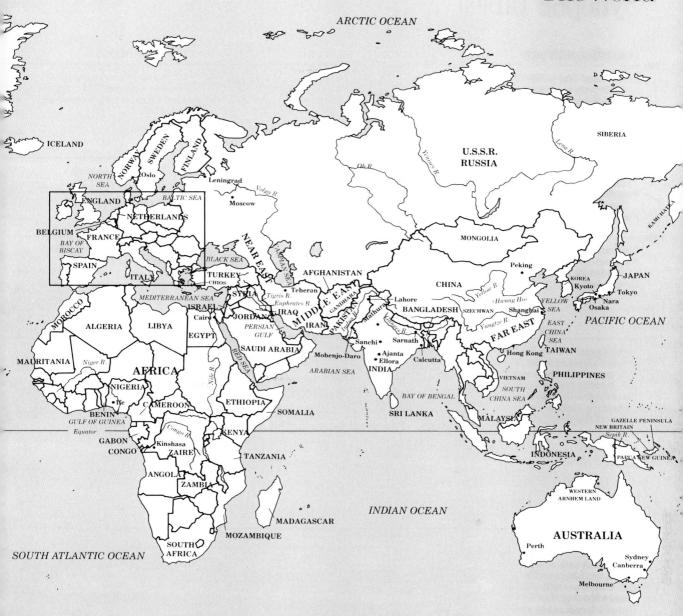

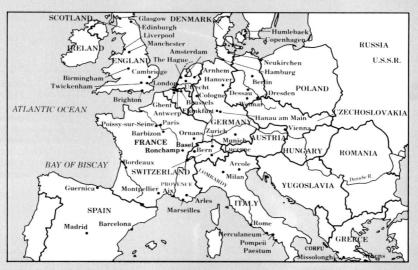

Synoptic Table IV

POLITICAL HISTORY	RELIGION, LITERATURE	SCIENCE, TECHNOLOGY
Seven Years' War (1756–63); England and Prussia vs. Austria and France, called French and Indian War in America; French defeated in Battle of Quebec 1769 Catherine the Great (r. 1762–96) extends Russian power to Black Sea	Thomas Gray's Elegy 1750 Diderot's Encyclopedia 1751–72 Samuel Johnson's Dictionary 1755 Edmund Burke, English reformer (1729–1797)	James Watt patents steam engine 1769 Priestley discovers oxygen 1774 Coke-fed blast furnaces for iron smelting perfected c. 1760–75
American Revolution 1775–85; Constitution adopted 1789 French Revolution 1789–97; Reign of Terror under Robespierre 1793 Consulate of Napoleon 1799	Edward Gibbon's Decline and Fall of the Roman Empire 1776–87 Thomas Paine's The Rights of Man 1790 William Wordsworth and Samuel Taylor Coleridge, Lyrical Ballads, 1798	Power loom 1785; cotton gin 1792 Jenner's smallpox vaccine c. 1798
Louisiana Purchase 1803 Napoleon crowns himself emperor 1804; exiled to St. Helena 1815 Greeks declare independence 1822	Johann Wolfgang von Goethe's Faust (part I) 1808 George Gordon Byron's Childe Harold's Pilgrimage 1812–18 John Keats, English poet (1795–1821) Percy Bysshe Shelley, English poet (1792–1822) Walter Scott's Waverly novels 1814–25	First voyage of Fulton's steamship 1807; first Atlantic crossing 1819 Stephenson's first locomotive 1814 Faraday discovers principle of electric dynamo 1821
Revolution of 1830 in France Queen Victoria crowned 1837 U.S. treaty with China opens ports 1844 U.S. annexes western land areas 1845–60 Revolution of 1848; fails in Germany, Hungary, Austria, Italy; France sets up Second Republic (Louis Napoleon)	Aleksandr Pushkin, Russian writer (1799–1837) Victor Hugo, French writer (1802–1885) Charles Dickens' Oliver Twist 1838 William Thackeray's Vanity Fair 1847 Karl Marx's Communist Manifesto 1848 Edgar Allan Poe, American poet (1809–1849)	Erie Canal opened 1825 First railway completed (England) 1825 McCormick invents reaper 1831 Daguerreotype process of photography introduced 1839 Morse perfects telegraph 1844
Louis Napoleon takes title of emperor 1852 Perry's visit ends Japan's isolation 1854 Russia abolishes serfdom 1861 U.S. Civil War (1861–65) ends slavery Franco-Prussian War 1870–71 Disraeli British prime minister 1874–80	Herman Melville's Moby Dick 1851 Walt Whitman's Leaves of Grass 1855 Charles Baudelaire, French poet (1821– 1867) Leo Tolstoy's War and Peace 1864–69 Feodor Dostoyevsky's Crime and Punishment 1867 Karl Marx's Das Kapital 1867–94	Darwin publishes Origin of Species 1859 Bessemer patents tilting converter for turning iron into steel 1860 Pasteur develops germ theory 1864 Mendel publishes first experiments in ge- netics 1865 Nobel invents dynamite 1867 First transcontinental railroad completed in America 1869 Suez Canal opened 1869
Spanish-American War 1898; U.S. gains Philippines, Guam, Puerto Rico, annexes Hawaii	Mark Twain's Tom Sawyer 1876 Henrik Ibsen, Norwegian dramatist (1828–1906) Emile Zola, French novelist (1840–1902) Oscar Wilde, Irish writer (1854–1900) Henry James, American novelist (1843– 1916) G. B. Shaw, British writer (1856–1950)	Bell patents telephone 1876 Edison invents phonograph 1877; invents electric light bulb 1879 First internal combustion engines for gasoline 1885 Roentgen discovers X-rays 1895 Marconi invents wireless telegraphy 1895 Edison invents motion picture 1896 The Curies discover radium 1898

 $\label{eq:note:prop:continuous} \begin{tabular}{l} NOTE: Figure numbers of black-and-white illustrations are in (italics). Colorplate numbers are in (bold face). \\ Duration of papacy or reign is indicated by the abbreviation r. \\ \end{tabular}$

ARCHITECTURE	SCULPTURE	PAINTING	PHOTOGRAPHY	—175 0
Horace Walpole, Strawberry Hill, Twickenham (313) Soufflot, Panthéon, Paris (304)		Greuze, Village Bride (307) West, Death of General Wolfe (310)		-1750
Jefferson, Monticello, Charlottesville (305) Langhans, Brandenburg Gate, Berlin (306)	Houdon, Voltaire (312)	Copley, Watson and the Shark (311) David, Death of Socrates (308); Death of Marat (309) Gros, Napoleon at Arcole (325)		—1775 —1225
	Canova, Pauline Borghese as Venus (317)	Goya, Family of Charles IV (320) Géricault, Mounted Officer of the Imperial Guard (326) Ingres, Odalisque (323) Goya, Third of May, 1808 (321); Bobabilicon (322) Friedrich, Polar Sea (334)		— 1 80 0
Barry and Pugin, Houses of Parliament, London (314) Labrouste, Bibliothèque Ste Geneviève, Paris (316)	Rude, <i>La Marseillaise</i> , Arc de Triomphe, Paris (318)	Corot, Papigno (336) Delacroix, Greece Expiring on the Ruins of Missolonghi (327) Ingres, Louis Bertin (324) Constable, Stoke-by-Nayland	Niépce, View from His Win- dow at Le Gras (459)	— 182 5
		(322) Delacroix, Frédéric Chopin (328) Turner, Slave Ship (333) Bingham, Fur Traders on the Missouri (335) Bonheur, Plowing in the Nivernais (331) Courbet, Stone Breakers (337)		1050
Garnier, Opéra, Paris (315)	Carpeaux, The Dance (319)	Rossetti, Ecce Ancilla Domini (365) Millet, The Sower (330) Daumier, Third-Class Car- riage (329) Manet, Luncheon on the Grass (338); The Fifer (340) Homer, Morning Bell (350) Monet, The River (341) Morisot, Artist's Sister Edma and Their Mother (343) Whistler, Artist's Mother (348); Falling Rocket (349)	Rejlander, Two Paths of Life (464) Nadar, Sarah Bernhardt (460) Gardner, Home of a Rebel Sharpshooter, Gettysburg (462) Cameron, Portrait of Ellen Terry (465) Tsar Cannon Outside the Spassky Gate, Moscow (461)	— 1850 — 1975
Sullivan, Carson Pirie Scott & Company Department Store, Chicago (449)	Rodin, The Thinker (354); Balzac (355)	Eakins, Gross Clinic (351) Moreau, The Apparition (363) Renoir, Moulin de la Galette (344) Degas, Glass of Absinthe (345) Cézanne, Fruit Bowl, Glass, and Apples (356) Manet, Bar at the Folies Bergère, (342) Redon, À Edgar Poe (366) Seurat, Sunday Afternoon on the Grande Jatte (358)	Käsebier, Magic Crystal (466) Muybridge, Female Semi- nude in Motion (468) Riis, Bandits' Roost (463)	—1875

1875 - (cont.)

1900

T. Roosevelt (1901–09) proclaims Open Door policy; Panama Canal opened

Internal strife, reforms in Russia 1905 Revolution in China, republic set up 1911 First World War 1914–18; U.S. enters 1917

Bolshevik Revolution 1917; Russia signs separate peace with Germany 1918

Gandhi agitates for Indian independence after First World War Irish Free State established 1921

Mussolini's Fascists seize Italian government 1922

Turkey becomes republic 1923

Marcel Proust, French novelist (1871–1922)

W. B. Yeats, Irish poet (1865–1939) André Gide, French novelist (1869–1951) T. S. Eliot, British poet (1888–1964) James Joyce, Irish writer (1882–1941) Eugene O'Neill, American dramatist (1888–1953)

D. H. Lawrence, English novelist (1885–1930)

Planck formulates quantum theory 1900 Freud's Interpretation of Dreams 1900 Pavlov's first experiments with conditioned reflexes 1900 Wright brothers' first flight with powerdriven airplane 1903 Einstein's theory of relativity 1905 Ford begins assembly-line automobile production 1909 First radio station begins regularly

scheduled broadcasts 1920

1925

Stalin starts Five-Year Plan 1928
Hitler seizes power in Germany 1933
Roosevelt proclaims New Deal 1933
Mussolini conquers Ethiopia 1936
Spanish Civil War 1936–39; won by
Franco
Hitler annexes Austria 1938
Second World War 1939–45
Atomic bomb dropped on Hiroshima 1945
United Nations Charter signed 1945
Israel becomes independent 1948

Communists under Mao win in China

1949

Sinclair Lewis, American novelist (1885–1951)

William Faulkner, American novelist (1897–1962)

Ernest Hemingway, American writer (1898–1961)

Thomas Wolfe, American novelist (1900–1938)

Bertolt Brecht, German dramatist (1898– 1956) André Malraux, French writer (1901–

1976)
Jean Paul Sartre, French philosopher

Jean Paul Sartre, French philosopher (1905–1980)

Albert Camus, French novelist (1913–1960)

First regularly scheduled TV broadcasts in U.S. 1928, in England 1936 Atomic fission demonstrated on laboratory scale 1942

Penicillin discovered 1943

Computer technology developed 1944

Van Gogh, Self-Portrait
(360); Wheat Field and Cypress Trees (359)
Gauguin, Yellow Christ
(361); Offerings of Gratitude (362)
Cassatt, The Bath (353)
Toulouse-Lautrec, At the Moulin Rouge (367)
Beardsley, Salome (364)
Munch, The Scream (368)
Tanner, Banjo Lesson (352)
Cézanne, Mont Sainte-Victoire Seen from Bibemus
Quarry (357)

Picasso, Old Guitarist (370)

Matisse, Joy of Life (375)

1900

Wright, Robie House, Chicago (450, 451)

Maillol, Seated Woman (Méditerranée) (372) Brancusi, The Kiss (427) Barlach, Man Drawing a Sword (374) Lehmbruck, Standing Youth (373)Boccioni, Unique Forms of Continuity in Space (432) Duchamp-Villon, Great Horse (433) Tatlin, Model for Monument to the Third International (434)Brancusi, Bird in Space (431) Ancestor figure from New Guinea (9) Mask from the Cameroons (10)Mask from New Britain (11) Eskimo mask from Alaska (12)

Picasso, Demoiselles d'Avignon (385) Monet, Water Lilies, Giverny (347)Klimt, The Kiss (369) Matisse, Harmony in Red (376)Nolde, Last Supper (399) Picasso, Ambroise Vollard (386)Rousseau, The Dream (371) Chagall, I and the Village Duchamp, The Bride (401) Braque, Le Courrier (387) Kokoschka, Self-Portrait (380)Boccioni, Dynamism of a Cubist (391) Kandinsky, Sketch I for "Composition VII" (382) Malevich, Black Quadrilateral (395) De Chirico, Mystery and Melancholy of a Street (397) Popova, The Traveler (394) Joseph Stella, Brooklyn Bridge (392) Rouault, Old Clown (377) Léger, The City (393) Ernst, 1 Copper Plate ... (402)Picasso, Three Musicians (388); Mother and Child Klee, Twittering Machine (399)O'Keeffe, Dark Abstraction

Steichen, Rodin with His Sculptures "Victor Hugo" and "The Thinker" (467) Stieglitz, The Steerage (471) Atget, Pool, Versailles (469) Man Ray, Rayograph (479)

Gropius, Bauhaus, Dessau (452) Le Corbusier, Savoye House, Poissy-sur-Seine (453)

(435)
Gonzalez, Head (436)
Moore, Two Forms (428); Recumbent Figure (429)
Calder, Lobster Trap and
Fish Tail (437)
Picasso, Bull's Head (2)
Hepworth, Oval Form (430)

Giacometti, Palace at 4 A.M.

Soutine, Dead Fowl (378)
Mondrian, Composition with Red, Blue, and Yellow (396)
Dali, Persistence of Memory (403)
Beckmann, Departure (381)
Miró, Painting (404)
Orozco, Victims (384)
Klee, Park near Lu(cerne) (400)
Ernst, Totem and Taboo (405)
Gorky, Liver Is the Cock's

Comb (406)

Picasso, Three Dancers (390)

(383)

Sander, Pastry Cook, Cologne (475)
Stieglitz, Equivalent (472)
Weston, Pepper (473)
Heartfield, As in the Middle
Ages, So in the Third Reich (478)
Cartier-Bresson, Mexico, 1934 (470)
Bourke-White, Fort Peck
Dam, Montana (474)
Capa, Death of a Loyalist Soldier (476)
Lange, Migrant Mother, California (477)

1925

	POLITICAL HISTORY, RELIGION	LITERATURE, SCIENCE, TECHNOLOGY	ARCHITECTURE, SCULPTURE, PAINTING, PHOTOGRAPHY
1950	Korean War 1950–53 U.S. Supreme Court outlaws racial segregation in public schools 1954 Common Market established in Europe 1957 African colonies gain independence after 1957	Samuel Beckett, Irish author (born 1906) Eugene Ionesco, French dramatist (born 1912) Jean Genet, French dramatist (born 1910) Lawrence Durrell, English novelist (born 1912) Genetic code cracked 1953 First hydrogen bomb (atomic fusion) exploded 1954 Sputnik, first satellite, launched 1957	Pollock, One (407) Dubuffet, Le Metafisyx (410) Le Corbusier, Notre-Dame-du-Haut, Ronchamp (455, 456) De Kooning, Woman II (409) Goeritz, Steel Structure (438) Rothko, Earth and Green (411) Frank, Sante Fe, New Mexico (482) Rauschenberg, Odalisk (445) Vasarely, Vega (417) Mies van der Rohe and Johnson, Seagram Building, New York (454) White, Ritual Branch (480) Johns, Three Flags (419) Louis, Blue Veil (413) Krasner, Celebration (408)
1960	John F. Kennedy assassinated 1963 Johnson begins massive U.S. interven- tion in Vietnam 1965 Martin Luther King assassinated 1968 Russia invades Czechoslovakia 1968	First manned space flight 1961 First manned landing on the moon 1969	Lichtenstein, Girl at Piano (420) Frankenthaler, Blue Causeway (412) Kelly, Red Blue Green (415) Segal, Cinema (446) David Smith, Cubi series (441) Nevelson, Black Chord (442) Frank Stella, Empress of India (416) Kosuth, One and Three Chairs (425) Bladen, The X (439) Oldenburg, Giant Ice Bag (444)
1970	Civil war in Pakistan gains independence for People's Republic of Bangladesh 1972–73 Vietnam War ends 1973 Nixon resigns presidency 1974 Death of Franco 1975	First orbiting laboratory (Skylab) 1973 Viking I and II Space Probes land on Mars 1976 First non-Italian pope elected since Adri- an VI in 1522—Pope John Paul II (from Poland) 1978 Voyager I Space Probe orbits Jupiter 1979	Anuszkiewicz, Entrance to Green (418) Smithson, Spiral Jetty, Great Salt Lake, Utah (440) Piano and Rogers, Georges Pompidou National Arts and Cultural Center, Paris (457) Chase-Riboud, Confessions for Myself (443) Eddy, New Shoes for H. (421, 422) Flack, Queen (423) Grooms, Ruckus Manhattan (447) Williams, Batman (414)
	Socialization of French banks 1981 Lech Walesa, Polish Solidarity leader, wins Nobel Peace Prize 1983	Space shuttle initiated by U.S. 1981 First artificial heart implanted 1982 Alice Walker, <i>The Color Purple</i> 1983	De Andrea, Artist and His Model (3) Pfaff, Dragons (448) Leonard, Romanticism Is Ultimately Fatal (481) Hockney, Gregory Watching the Snow Fall, Kyoto, Feb. 1983 (483) Clemente, Untitled (424) Rothenberg, Mondrian (426) Stirling, Neue Staatsgalerie, Stuttgart (458)

Cross references are indicated by words in SMALL CAPITALS.

- ABSTRACT. Having little or no reference to the appearance of natural objects; pertaining to the nonrepresentational art styles of the twentieth century.
- AMBULATORY. A passageway, especially around the CHANCEL of a church. An ambulatory may also be outside a church.
- AMPHORA. A Greek vase having an egg-shaped body, a narrow cylindrical neck, and two curving handles joined to the body at the shoulder and neck.
- APSE. A large niche facing the NAVE of a church, usually at the east end. See BASILICA.
- ARCADE. A series of ARCHES and their supports.
- ARCH. A structural member, often semicircular, used to span an opening; it requires support from walls, PIERS, or COL-UMNS, and BUTTRESSING at the sides.
- ARCHAIC. A relatively early style, as Greek sculpture of the seventh and sixth centuries B.C.; or any style adopting characteristics of an earlier period.
- ARCHITRAVE. The main horizontal beam, and the lowest part of an ENTABLATURE.
- ASSEMBLAGE. Two or more accidentally "found" objects placed together as a construction. See READY-MADE.
- ATMOSPHERIC PERSPECTIVE. A means of showing distance or depth in a painting by changing the tone of objects that are far away from the picture plane, especially by reducing in gradual stages the contrast between lights and darks.
- BARREL VAULT. A semicylindrical VAULT.
- BASE. The lowest element of a COLUMN, wall, DOME, etc.
- BASILICA. In the Roman period, the word refers to the function of the building—a large meeting hall—rather than to its form, which may vary according to its use; as an official public building, the Roman basilica had certain religious overtones. The term was used by the Early Christians to refer to their churches. An Early Christian basilica had an oblong plan, flat timber ceiling, trussed roof, and an APSE. The entrance was on one short side and the apse projected from the opposite side, at the farther end of the building.
- BAYS. Compartments into which a building may be subdivided, usually formed by the space between consecutive architectural supports.
- BLACK-FIGURED. A type of Greek vase painting, practiced in the seventh and sixth centuries B.C., in which the design was painted mainly in black against a lighter-colored background, usually the natural clay.
- BOOK OF HOURS. A book for individual private devotions with prayers for different hours of the day; often elaborately ILLUMINATED.
- BUTTRESS, BUTTRESSING. A masonry support that counteracts the THRUST exerted by an ARCH or a VAULT. See FLYING BUTTRESS, PIER BUTTRESS.
- CAMERA OBSCURA. Latin for dark room. A darkened enclosure or box with a small opening or lens on one wall through which light enters to form an inverted image on the opposite wall. The principle had long been known but was not used as an aid in picture making until the sixteenth century.
- CAPITAL. The crowning member of a COLUMN, PIER, or PILASTER on which the lowest element of the ENTABLATURE rests. See CORINTHIAN COLUMN, DORIC COLUMN, IONIC COLUMN.

- CARTOON. A preliminary SKETCH or DRAWING made to be transferred to a wall, a panel, or canvas as a guide in painting a finished work.
- CASTING. A method of reproducing a three-dimensional object or RELIEF. Casting in bronze or other metal is often the final stage in the creation of a piece of SCULPTURE; casting in plaster is a convenient and inexpensive way of making a copy of an original. See SCULPTURE.
- CHANCEL. In a church, the space reserved for the clergy and CHOIR, set off from the NAVE by steps, and occasionally by a
- CHAPEL. A compartment in a church containing an altar dedicated to a saint.
- CHOIR. See CHANCEL.
- CLASSICAL. Used generally to refer to the art of the Greeks and the Romans.
- CLERESTORY. A row of windows in a wall that rises above the adjoining roof.
- collage. A composition made by pasting cut-up textured materials, such as newsprint, wallpaper, etc., to form all or part of a work of art; may be combined with painting or drawing or with three-dimensional objects.
- COLONNADE. A series of COLUMNS placed at regular intervals.

 COLOR. The choice and treatment of the hues in a painting.
 COLUMN. A vertical architectural support, usually consisting of a BASE, a rounded SHAFT, and a CAPITAL.
- COMPOSITION. The arrangement of FORM, COLOR, LINE, etc., in any given work of art.
 - COMPOUND PIER. A PIER with COLUMNS, PILASTERS, or SHAFTS attached.
- CORINTHIAN COLUMN. First appeared in fifth-century Greece, apparently as a variation of the IONIC. The CAPITAL differentiates the two: the Corinthian capital has an inverted bell shape, decorated with acanthus leaves, stalks, and volute scrolls. The Corinthian ORDER was widely used by the Romans.
- CORNICE. The crowning, projecting architectural feature, especially the uppermost part of an ENTABLATURE.
- COUNTERPOISE (contrapposto). The disposition of the parts of the body so that the weight-bearing leg, or engaged leg, is distinguished from the raised leg, or free leg, resulting in a shift in the axis between the hips and shoulders. Used by the Greek sculptors as a means of showing movement in a figure.
- CROSSING. In a cross-shaped church, the area where the NAVE and the TRANSEPT intersect.
- CUPOLA. A rounded, domed roof or ceiling.
- DAGUERREOTYPE. Originally, a photograph on a silver-plated sheet of copper that had been treated with fumes of iodine to form silver iodide on its surface and, after exposure, was developed by fumes of mercury. The process, invented by L. J. M. Daguerre and made public in 1839, was modified and accelerated as daguerreotypes gained worldwide popularity.
- DOME. A large CUPOLA supported by a circular DRUM or square
- DORIC COLUMN. The Doric column stands without a BASE directly on the top of the stepped platform of a temple. Its SHAFT has shallow FLUTES.
- DRAWING. A SKETCH, design, or representation by LINES.

 Drawings are usually made on paper with pen, pencil,

charcoal, pastel, chalk, etc.

DRUM. One of several sections composing the SHAFT of a COL-UMN; also a cylindrical wall supporting a DOME.

ENCAUSTIC. A method of painting in colors mixed with wax and applied with a brush, generally while the mixture is hot. The technique was practiced in ancient times and in the Early Christian period and has been revived by some modern painters.

ENGAGED COLUMN. A COLUMN that is part of a wall and projects somewhat from it. Such a column often has no structural

purpose.

ENGRAVING. A design incised in reverse on a copper plate; this is coated with printer's ink, which remains in the incised lines when the plate is wiped off. Damp paper is placed on the plate, and both are put into a press; the paper soaks up the ink and produces a print of the original.

ENTABLATURE. The upper part of an architectural ORDER.

ETCHING. Like ENGRAVING, etching is an incising process. However, the design is drawn in reverse with a needle on a plate thinly coated with wax or resin. The plate is placed in a bath of nitric acid; the etched lines are produced on the plate by the coating. The coating is then removed, and the prints are made as in engraving.

FACADE. The front of a building.

FLUTE, FLUTES. Vertical channels on a column SHAFT; see DOR-IC COLUMN, IONIC COLUMN.

FLYING BUTTRESS. An ARCH that springs from the upper part of the PIER BUTTRESS of a Gothic church, spans the aisle roof, and abuts the upper NAVE wall to receive the THRUST from the nave VAULTS; it transmits this thrust to the solid pier buttresses.

FORESHORTENING. A method of representing objects as if seen at an angle and receding or projecting into space; not in a frontal or profile view.

 FORM. The external shape or appearance of a representation, considered apart from its COLOR or material.

FREESTANDING. Used to refer to a work of SCULPTURE in the round, that is, in full three-dimensionality; not attached to architecture and not in RELIEF.

FRESCO. A technique of wall painting known since antiquity; the PIGMENT is mixed with water and applied to a freshly plastered area of a wall. The result is a particularly permanent form of painted decoration.

FRIEZE. In CLASSICAL architecture an architectural element that rests on the ARCHITRAVE and is immediately below the CORNICE; also, any horizontal band decorated with mold-

ings, RELIEF sculpture, or painting.

GABLE. The triangular part of a wall, enclosed by the lines of a sloping roof. See PEDIMENT.

GALLERY. A roofed promenade. See AMBULATORY, COLONNADE. GOSPELS, GOSPEL BOOK. Contains the four Gospels of the New Testament that tell the life of Christ, attributed to the Evangelists Matthew, Mark, Luke, and John. Often elaborately illustrated.

GROIN. The sharp edge formed by the intersection of two VAULTS.

GROIN VAULTS. A VAULT formed by the intersection at right angles of two BARREL VAULTS of equal height and diameter so that the GROINS form a diagonal cross.

GROUND PLAN. See PLAN.

HIEROGLYPHICS. The characters and picture-writing used by the ancient Egyptians.

ICON. A panel painting of Christ, the Virgin, or saints; regarded as sacred, especially by Eastern Christians.

ILLUMINATION. A term used generally for manuscript paintings. Illuminated manuscripts may contain separate ornamental pages, marginal illustrations, ornament within the text, entire $\ensuremath{\mathsf{MINIATURE}}$ paintings, or any combination of these.

ILLUSIONISM, ILLUSIONISTIC. The effort of an artist to represent the visual world with deceptive reality.

ILLUSTRATION. The representation of an idea, scene, or text by artistic means.

IONIC COLUMN. The Ionic column stands on a molded BASE.

The SHAFT normally has FLUTES more deeply cut than DORIC flutes. The Ionic CAPITAL is identified by its pair of spiral scroll-like ornaments.

JAMB. The side of a doorway or window frame.

KORE. An ARCHAIC Greek statue of a draped maiden. KOUROS. An ARCHAIC Greek statue of a standing nude youth.

LINE. A mark made by a moving tool such as a pen or pencil; more generally, an outline, contour, or silhouette.

LINEAR PERSPECTIVE. A mathematical system for representing three-dimensional objects and space on a two-dimensional surface. All objects are represented as seen from a single viewpoint.

MASS. The expanse of COLOR that defines a painted shape; the three-dimensional volume of a sculptured or architectural form.

MEDIUM. The material with which an artist works, such as marble, OIL PAINT, TERRA-COTTA, WATERCOLOR, etc.

METOPE. An oblong panel between the TRIGLYPHS on the ENTABLATURE of the DORIC ORDER.

MINIATURE. A painting or drawing in an ILLUMINATED manuscript; also a very small portrait, sometimes painted on ivory.

MOBILE. A type of sculpture made of movable parts that can be set in motion by the movement of air currents.

MODELING. See SCULPTURE. In painting or DRAWING, the means by which the three-dimensionality of a form is suggested on a two-dimensional surface, usually through variations of COLOR and the play of lights and darks.

MONUMENTAL. Frequently used to describe works that are larger than lifesize; also used to describe works giving the impression of great size, whatever their actual dimen-

sions

MOSAIC. A design formed by embedding small pieces of colored stone or glass in cement. In antiquity, large mosaics were used chiefly on floors; from the Early Christian period on, mosaic decoration was increasingly used on walls and vaulted surfaces.

 MOTIF. A distinctive and recurrent feature of theme, shape, or figure in a work of art.

MURAL. A wall painting. See FRESCO.

NAVE. The central aisle of a BASILICAN church, as distinguished from the side aisles; the part of a church between the main entrance and the CHANCEL.

OIL PAINTING. Though known to the Romans, it was not systematically used until the fifteenth century. In the oil technique of early Flemish painters, PIGMENTS were mixed with drying oils and fused while hot with hard resins; the mixture was then diluted with other oils.

ORDER. In architecture, a CLASSICAL system of proportion and interrelated parts. These include a COLUMN, usually with BASE, SHAFT, and CAPITAL, and an ENTABLATURE with ARCHITRAVE, FRIEZE, and CORNICE.

PAINTING MEDIUMS: See ENCAUSTIC, FRESCO, OIL PAINTING, TEMPERA, WATERCOLOR.

PASTEL. Powdered PIGMENTS mixed with gum and molded into sticks for drawing; also a picture or SKETCH made with this type of crayon.

PEDIMENT. In CLASSICAL architecture, the triangular part of

the front or back wall that rises above the entablature. The pediments at either end of a temple often contained sculpture, in high relief or freestanding.

PERISTYLE. A COLONNADE (or ARCADE) around a building or open court.

PERSPECTIVE. See ATMOSPHERIC PERSPECTIVE, LINEAR PERSPECTIVE

PHOTOGRAM. A shadow-like picture made by placing opaque, translucent, or transparent objects between light-sensitive paper and a light source and developing the latent photographic image.

PHOTOMONTAGE. A photograph in which prints in whole or in part are combined to form a new image. A technique much

practiced by the Dada group in the 1920s.

PIER. A vertical architectural element, usually rectangular in section; if used with an ORDER, often has a BASE and CAPITAL of the same design.

PIER BUTTRESS. An exterior PIER in Romanesque and Gothic architecture, buttressing the THRUST of the VAULTS within. PIETÀ. In painting or SCULPTURE, a representation of the Vir-

gin Mary mourning the dead Christ whom she holds. PIGMENT. Dry, powdered substances that, when mixed with a suitable liquid, or vehicle, give color to paint. See ENCAUS-

suitable liquid, or vehicle, give color to paint. See ENCAUS-TIC, FRESCO, OIL PAINTING, TEMPERA, WATERCOLOR.

PILASTER. A flat vertical element having a CAPITAL and BASE, engaged in a wall from which it projects. Has a decorative

rather than a structural purpose.

PLAN. The schematic representation of a three-dimensional structure, such as a building or monument, on a two-dimensional plane. A GROUND PLAN shows the outline shape at the ground level of a given building and the location of its various interior parts.

PORTAL. An imposing doorway with elaborate ornamentation in Romanesque and Gothic churches.

POST AND BEAM. A system or unit of construction consisting solely of vertical and horizontal elements.

PROPORTION, PROPORTIONS. The relation of the size of any part of a figure or object to the size of the whole. For architecture, see ORDER.

PYLON. In Egyptian architecture, the entranceway set between two broad oblong towers with sloping sides.

READY-MADE. A manufactured object exhibited as being aesthetically pleasing. When two or more accidentally "found" objects are placed together as a construction, the piece is called an ASSEMBLAGE.

RED-FIGURED. A type of Greek vase painting in which the design was outlined in black and the background painted in black, leaving the figures the reddish color of the baked clay after firing. This style replaced the BLACK-FIGURED style toward the end of the sixth century B.C.

RELIEF. Forms in SCULPTURE that project from the background, to which they remain attached. Relief may be carved or modeled shallowly to produce low relief, or deeply to produce high relief; in very high relief, portions may be entirely detached from the background.

REPRESENTATIONAL. As opposed to ABSTRACT, means a portrayal of an object in recognizable form.

RHYTHM. The regular repetition of a particular form; also, the suggestion of motion by recurrent forms.

RIB. An ARCH or a projecting arched member of a VAULT.
RIBBED VAULT. A compound masonry VAULT, the GROINS of
which are marked by projecting stone ribs.

SARCOPHAGUS. A coffin made of stone, marble, terra-cotta (less frequently, of metal). Sarcophagi are often decorated with paintings or RELIEF.

SCALE. Generally, the relative size of any object in a work of art, often used with reference to normal human scale.

SCULPTURE. The creation of a three-dimensional form, usually in a solid material. Traditionally, two basic techniques have been used: carving in a hard material, and modeling in a soft material such as clay, wax, etc. For types of sculpture, see FREESTANDING and RELIEF.

SHAFT. A cylindrical form; in architecture, the part of a COL-UMN or PIER intervening between the BASE and the CAPITAL.

Also, a vertical enclosed space.

SKETCH. A rough DRAWING representing the main features of a composition; often used as a preliminary study.

STAINED GLASS. The technique of filling architectural openings with glass colored by fused metallic oxides; pieces of this glass are held in a design by strips of lead.

STILL LIFE. A painting or drawing of an arrangement of inanimate objects.

TEMPERA. A painting process in which PIGMENT is mixed with an emulsion of egg yolk and water or egg and oil. Tempera, the basic technique of medieval and Early Renaissance painters, dries quickly, permitting almost immediate application of the next layer of paint.

TERRA-COTTA. Clay, modeled or molded, and baked until very hard. Used in architecture for functional and decorative parts, as well as in pottery and SCULPTURE. Terra-cotta

may have a painted or glazed surface.

THRUST. The downward and outward pressure exerted by an ARCH or VAULT and requiring BUTTRESSING.

TRANSEPT. In a cross-shaped church, an arm forming a right angle with the NAVE, usually inserted between the latter and the CHANCEL or APSE.

TRIGLYPH. A vertical block with V-cut channels, placed between METOPES on the ENTABLATURE of the DORIC ORDER.

TYMPANUM. The space above the beam and enclosed by the ARCH of a medieval PORTAL or doorway; a church tympanum frequently contains RELIEF sculpture.

VAULT. An arched roof or covering, made of brick, stone, or concrete. See BARREL VAULT, GROIN VAULT, RIBBED VAULT.

VELLUM. Thin, bleached calfskin, a type of parchment on which manuscripts are written or printed.

WATERCOLOR. PIGMENTS mixed with water instead of oil or other mediums, or a picture painted with watercolor, often on paper.

WOODCUT. A printing process in which a design or lettering is carved in RELIEF on a wooden block; the areas intended not to print off are hollowed out.

ZIGGURAT. An elevated platform, varying in height from several feet to the size of an artificial mountain, built by the Sumerians to support their shrines.

Books for Further Reading

Asterisks (*) indicate that titles are available in paperback.

Introduction

- *Arnheim, Rudolf, Art and Visual Perception, 2nd ed., University of California Press, Berkeley, 1974
- *Elsen, Albert E., *Purposes of Art*, 3rd ed., Holt, Rinehart and Winston, New York, 1972
- *Goldwater, Robert, and Treves, Marco, Artists on Art, 3rd ed., Pantheon Books, New York, 1974
- *Gombrich, Ernst H., Art and Illusion, 4th ed., Pantheon Books, New York, 1972
- Lommel, Andreas, Shamanism, The Beginnings of Art, McGraw-Hill, New York, 1967
- *Panofsky, Erwin, Meaning in the Visual Arts, Doubleday, Garden City, 1955; reprint, Overlook Press, Woodstock, 1974
- *Read, Herbert E., Art and Society, 2nd ed., Pantheon Books, New York, 1950
- *Rosenberg, Harold, The Anxious Object: Art Today and Its Audience, 2nd ed., Horizon, New York, 1966

PART ONE: HOW ART BEGAN

The Magic Art of Cavemen and Primitive Peoples

- *Bascom, William R., African Art in Cultural Perspective, Norton, New York, 1973
- *Boas, Franz, Primitive Art, new ed., Dover, New York, 1955 Leroi-Gourhan, André, Treasures of Prehistoric Art, Abrams, New York, 1967
- *Leuzinger, Elsy, *The Art of Black Africa*, Rizzoli, New York, 1979
- Trachtenberg, Marvin, and Hyman, Isabelle, Architecture: From Prehistory to Post-Modernism, Abrams, New York, 1985
- *Wingert, Paul S., Primitive Art: Its Traditions and Styles, Oxford University Press, New York, 1962

Art for the Dead-Egypt

- *Groenewegen-Frankfort, Henriette A., and Ashmole, Bernard, Art of the Ancient World, Abrams, New York, 1975
- Lange, Kurt, and Hirmer, Max, Egypt: Architecture, Sculpture, Painting in Three Thousand Years, 4th ed., Phaidon, London, 1968
- *Panofsky, Erwin, Tomb Sculpture: Its Aspects from Ancient Egypt to Bernini, Abrams, New York, 1969
- *Smith, William S., and Simpson, William K., *The Art and Architecture of Ancient Egypt*, rev. with additions, Pelican History of Art, Penguin Books, New York, 1981
- Woldering, Irmgard, *The Art of Egypt*, Greystone, New York, 1963
- Wolf, Walther, The Origins of Western Art: Egypt, Mesopotamia, the Aegean, Universe Books, New York, 1971

Temples, Palaces, and Citadels—The Ancient Near East and the Aegean

- Akurgal, Ekrem, Art of the Hittites, Abrams, New York, 1962
- Demargne, Pierre, Aegean Art: The Origins of Greek Art, tr. by Stuart Gilbert and James Emmons, Golden Press, New York, 1964

- *Frankfort, Henri, *The Art and Architecture of the Ancient Orient*, 4th rev. impression, with additional bibliography, Pelican History of Art, Penguin Books, Baltimore, 1969
- Hood, Sinclair, *The Minoans: The Story of Bronze Age Crete*, Praeger, New York, 1971
- Lloyd, Seton, The Archaeology of Mesopotamia: From the Old Stone Age to the Persian Conquest, Thames and Hudson, London, 1978
- Marinatos, Spyridon N., and Hirmer, Max, Crete and Mycenae, Abrams, New York, 1960
- Mylonas, George E., Mycenae and the Mycenaean Age,
- Princeton University Press, 1966 Renfrew, Colin, The Emergence of Civilization: The Cy-
- Renfrew, Colin, The Emergence of Civilization: The Cyclades and the Aegean in the Third Millennium B.C., Methuen, London, 1972
- Strommenger, Eva, and Hirmer, Max, 5000 Years of the Art of Mesopotamia, tr. by Christina Haglund, Abrams, New York, 1964

Greek Art

- Beazley, John D., and Ashmole, Bernard, Greek Sculpture and Painting to the End of the Hellenistic Period, Cambridge University Press, London, 1966
- *Boardman, John, *Greek Art*, rev. ed., Praeger, New York, 1973
- Brilliant, Richard, Arts of the Ancient Greeks, McGraw-Hill, New York, 1973
- *Carpenter, Rhys, Greek Sculpture, University of Chicago Press, 1971
- *Cook, Robert M., Greek Art: Its Development, Character and Influence, Farrar, Straus and Giroux, New York, 1973
- Havelock, Christine M., Hellenistic Art, New York Graphic Society, Greenwich, 1970
- *Lullies, Reinhard, and Hirmer, Max, Greek Sculpture, Abrams, New York, 1960
- Pollitt, Jerry J., The Art of Greece: Sources and Documents, Prentice-Hall, Englewood Cliffs, 1965
- Richter, Gisela M. A., A Handbook of Greek Art, 6th ed., redesigned, Phaidon, London, 1969
- ——, The Sculpture and Sculptors of the Greeks, 4th ed., rev., Yale University Press, New Haven, 1970
- Robertson, Martin, *Greek Painting*, Skira, Geneva, 1959
 ————, *History of Greek Art*, 2 vols., Cambridge University
 Press, 1975

Etruscan Art

- *Brendel, Otto J., Etruscan Art, Pelican History of Art, Penguin Books, Harmondsworth, New York, 1978
- Pallottino, Massimo, Etruscan Painting, Skira, Geneva, 1952
- Richardson, Emeline, The Etruscans: Their Art and Civilization, University of Chicago Press, 1964

Roman Art

- Andreae, Bernard, The Art of Rome, Abrams, New York, 1978
- *Brilliant, Richard, Roman Art: From the Republic to Con-

stantine, Phaidon/Dutton, New York, 1974

*Hanfmann, George M. A., Roman Art, New York Graphic Society, Greenwich, 1964

*L'Orange, Hans P., Art Forms and Civic Life in the Late Roman Empire, Princeton University Press, 1965

Maiuri, Amedeo, Roman Painting, Skira, Geneva, 1953

- *Pollitt, Jerry J., The Art of Rome and Late Antiquity: Sources and Documents, Prentice-Hall, Englewood Cliffs,
- *Ward-Perkins, John B., Roman Imperial Architecture, Pelican History of Art, Penguin Books, Harmondsworth, New York, 1981
- *Wheeler, Robert Eric Mortimer, Roman Art and Architecture, Praeger, New York, 1964

PART TWO: THE MIDDLE AGES

Early Christian and Byzantine Art

*Beckwith, John, Early Christian and Byzantine Art, 2nd integrated ed., Pelican History of Art, Penguin Books, Harmondsworth, New York, 1979

Demus, Otto, Byzantine Art and the West, New York University Press, 1970

Grabar, André, The Beginnings of Christian Art, 200-395, tr. by Stuart Gilbert and James Emmons, Thames and Hudson, London, 1967

-, Byzantium: Byzantine Art in the Middle Ages, tr. by Betty Forster, Methuen, London, 1969

*Krautheimer, Richard, Early Christian and Byzantine Architecture, Pelican History of Art, Penguin Books, Baltimore, 1965

*Mango, Cyril, The Art of the Byzantine Empire, 312-1453: Sources and Documents, Prentice-Hall, Englewood Cliffs,

Morey, Charles Rufus, Early Christian Art, 2nd ed., Princeton University Press, 1953

*Rice, David Talbot, Art of the Byzantine Era, Praeger, New York, 1966

*Runciman, Steven, Byzantine, Style and Civilization, Penguin Books, Harmondsworth, Baltimore, 1975

Zarnecki, George, Art of the Medieval World, Abrams, New York, 1976

The Earlier Middle Ages in the West

*Conant, Kenneth J., Carolingian and Romanesque Architecture, 800-1200, new ed., Pelican History of Art, Penguin Books, Norwich, 1974

*Davis-Weyer, Caecilia, Early Medieval Art: 300-1150: Sources and Documents, Prentice-Hall, Englewood Cliffs, 1971

Grabar, Andr'e, and Nordenfalk, Carl, Early Medieval Painting, Skira, Geneva, 1957

*Martindale, Andrew, The Rise of the Artist in the Middle Ages and Early Renaissance, McGraw-Hill, New York,

*Pevsner, Nikolaus, An Outline of European Architecture, 6th ed., Penguin Books, Baltimore, 1960

*Saalman, Howard, Medieval Architecture, Braziller, New York, 1962

Romanesque Art

Demus, Otto, Romanesque Mural Painting, Abrams, New York, 1971

*Focillon, Henri, The Art of the West in the Middle Ages, ed. by Jean Bony, tr. by Donald King, 2 vols., Phaidon, New York, 1963

Stoddard, Whitney S., Art and Architecture in Medieval France, Harper and Row, New York, 1972

*Swarzenski, Hanns, Monuments of Romanesque Art: The

Art of Church Treasures in North-Western Europe, 2nd ed., University of Chicago Press, 1967

Zarnecki, George, Romanesque Art, Universe History of Art, Universe Books, New York, 1971

Towns, Cathedrals, and Gothic Art

*Branner, Robert, Chartres Cathedral, Norton, New York,

Cole, Bruce, Giotto and Florentine Painting, 1280–1375, Harper and Row, New York, 1976

Deuchler, Florens, Gothic Art, Universe Books, New York, 1973

Evans, Joan, Art in Medieval France, Oxford University Press, New York, 1952

*Frisch, Teresa G., Gothic Art: 1140-1450: Sources and Documents, Prentice-Hall, Englewood Cliffs, 1971

*Holt, Elizabeth Gilmore, ed., A Documentary History of Art: Vol. 1, The Middle Ages and the Renaissance, 2nd ed., Doubleday, Garden City, 1957

*Mâle, Emile, The Gothic Image: Religious Art in France of the Thirteenth Century, tr. by Dora Nussey, Harper, New York, 1958

*Meiss, Millard, Painting in Florence and Siena after the Black Death, Princeton University Press, 1951

*Panofsky, Erwin, Gothic Architecture and Scholasticism, Archabbey Press, Latrobe, Pennsylvania, 1951

Pope-Hennessy, John W., Italian Gothic Sculpture, 2nd ed., Phaidon, New York, 1970

Sauerländer, Willibald, Gothic Sculpture in France, Abrams, New York, 1973

*Simson, Otto G. von, The Gothic Cathedral: Origins of Gothic Architecture and the Medieval Concept of Order, 2nd ed., Princeton University Press, 1974

PART THREE: THE RENAISSANCE

Late Gothic Painting North of the Alps

Châtelet, Albert, Early Dutch Painting, Rizzoli, New York, 1981

*Cuttler, Charles D., Northern Painting: From Pucelle to Bruegel, Holt, Rinehart and Winston, New York, 1968

*Friedländer, Max J., From Van Eyck to Bruegel: Early Netherlandish Painting, Phaidon, New York, 1969

*Hind, Arthur M., History of Engraving and Etching, 3rd ed., rev., Houghton, Mifflin, Boston, 1923

-, An Introduction to a History of Woodcut, 2 vols., Houghton, Mifflin, Boston, 1935

*Ivins, William M., Jr., How Prints Look, Metropolitan Museum of Art, New York, 1943

Meiss, Millard, French Painting in the Time of Jean de Berry: The Limbourgs and Their Contemporaries, 2 vols., Braziller, New York, 1974

*Panofsky, Erwin, Early Netherlandish Painting, 2 vols., Harvard University Press, Cambridge, 1958

Snyder, James, Northern Renaissance Art, Abrams, New York, 1985

The Early Renaissance in Italy

*Baxandall, Michael, Painting and Experience in Fifteenth-Century Italy, Clarendon Press, Oxford, 1972

Beck, James, Italian Renaissance Painting, Harper and Row, New York, 1981

*Berenson, Bernard, Italian Painters of the Renaissance, rev. ed., Phaidon, London, 1967

Borsook, Eve, The Mural Painters of Tuscany, Phaidon, London. 1960

Gilbert, Creighton, History of Renaissance Art Throughout Europe: Painting, Sculpture, Architecture, Abrams, New York, 1973

- *Gombrich, Ernst H., Norm and Form: Studies in the Art of the Renaissance, Phaidon, London, 1966
- Hartt, Frederick, History of Italian Renaissance Art, 2nd ed., Abrams, New York, 1980
- *Panofsky, Erwin, Renaissance and Renascences in Western
- Art, Humanities Press, New York, 1970 Pope-Hennessey, John, Italian Renaissance Sculpture, Phaidon, New York, 1971
- *Turner, Almon R., The Vision of Landscape in Renaissance Italy, Princeton University Press, 1966

The High Renaissance in Italy

- *Freedberg, Sydney J., Painting in Italy, 1500–1600, rev. ed., Pelican History of Art, Penguin Books, Harmondsworth, Baltimore, 1975
- , Painting of the High Renaissance in Rome and Florence, 2 vols., Harvard University Press, Cambridge, 1961
- *Klein, Robert, and Zerner, Henri, Italian Art, 1500-1600: Sources and Documents, Prentice-Hall, Englewood Cliffs,
- *Levey, Michael, High Renaissance, Style and Civilization, Penguin Books, Baltimore, 1975
- *Wittkower, Rudolf, Architectural Principles in the Age of Humanism, Random House, New York, 1965
- *Wölfflin, Heinrich, Classic Art: An Introduction to the Italian Renaissance, 3rd ed., Phaidon, New York, 1968

Mannerism and Other Trends

- *Friedlaender, Walter F., Mannerism and Anti-Mannerism in Italian Painting, Columbia University Press, New York, 1957
- *Shearman, John K. G., Mannerism, Style and Civilization, Penguin Books, Baltimore, 1967

The Renaissance in the North

- *Benesch, Otto, The Art of the Renaissance in Northern Europe, rev. ed., Phaidon, London, 1965
- German Painting from Dürer to Holbein, tr. by H. S. B. Harrison, Skira, Geneva, 1966
- *Blunt, Anthony, Art and Architecture in France, 1500-1700, 4th ed., Pelican History of Art, Penguin Books, Harmondsworth, New York, 1981
- Leymarie, Jean, Dutch Painting, tr. by Stuart Gilbert, Skira, Geneva, 1956
- Panofsky, Erwin, The Life and Art of Albrecht Dürer, 4th ed., Princeton University Press, 1955
- *Stechow, Wolfgang, Northern Renaissance Art, 1400-1600: Sources and Documents, Prentice-Hall, Englewood Cliffs,
- *Waterhouse, Ellis K., Painting in Britain, 1530-1790, 4th ed., Pelican History of Art, Penguin Books, Baltimore,

The Baroque in Italy, Flanders, and Spain

- Enggass, Robert, and Brown, Jonathan, Italy and Spain, 1600-1750: Sources and Documents, Prentice-Hall, Englewood Cliffs, 1970
- Freedberg, S. J., Circa 1600: A Revolution of Style in Italian Painting, Harvard University Press, Cambridge, 1983
- *Friedlaender, Walter F., Caravaggio Studies, Princeton University Press, 1955
- Gerson, Horst, and Ter Kuile, E. H., Art and Architecture in Belgium, 1600-1800, Pelican History of Art, Penguin Books, Baltimore, 1978
- Held, Julius, and Posner, Donald, Seventeenth and Eighteenth Century: Baroque Painting, Sculpture, Architecture, Abrams, New York, 1971
- *Waterhouse, Ellis K., Italian Baroque Painting, 2nd ed.,

- Phaidon, New York, 1969
- *Wittkower, Rudolf, Art and Architecture in Italy, 1600-1750, 3rd rev. ed., with corrections and augmented bibliography, Pelican History of Art, Penguin Books, Harmondsworth, New York, 1980
- , Gian Lorenzo Bernini: The Sculptor of the Roman Baroque, 3rd rev. ed., Cornell University Press, Ithaca, 1981
- *Wölfflin, Heinrich, Principles of Art History, tr. by Mary D. Hottinger, Holt, New York, 1932

The Golden Age of Dutch Painting

- Haak, Bob, The Golden Age: Dutch Painters of the Seventeenth Century, Abrams, New York, 1984
- *Rosenberg, Jakob, Rembrandt, Life and Work, rev. ed., Cornell University Press, Ithaca, 1980
- -, Slive, Seymour, and Ter Kuile, E. H., Dutch Art and $Architecture, 1600-1800, 3rd \, (2nd \, integrated) \, ed., Pelican$ History of Art, Penguin Books, Harmondsworth, New York, 1977

The Age of Versailles

- Friedlaender, Walter F., Nicholas Poussin, A New Approach, Abrams, New York, 1966
- Thuillier, Jacques, and Châtelet, André, French Painting from Le Nain to Fragonard, Skira, Geneva, 1964

*Levey, Michael, Rococo to Revolution: Major Trends in Eighteenth Century Painting, Oxford University Press, New York, 1977

PART FOUR: THE MODERN WORLD

Neoclassicism

- Brown, Milton W., American Art to 1900, Abrams, New York, 1977
- *Eitner, Lorenz, Neoclassicism and Romanticism, 1750-1850: Sources and Documents, 2 vols., Prentice-Hall, Englewood Cliffs, 1970
- *Friedlaender, Walter F., From David to Delacroix, Harvard University Press, Cambridge, 1952
- *Honour, Hugh, Neoclassicism, Style and Civilization, Penguin Books, Harmondsworth, 1968
- *Rosenblum, Robert, Transformations in Late Eighteenth Century Art, Princeton University Press, 1967

The Romantic Movement

- Boime, Albert, The Academy and French Painting in the 19th Century, Phaidon, New York, 1970
- Clark, Kenneth, The Romantic Rebellion: Romantic Versus
- Classical, Harper and Row, New York, 1974 Hamilton, George Heard, Nineteenth and Twentieth Century Art: Painting, Sculpture, Architecture, Abrams, New
- York, 1970 *Honour, Hugh, Romanticism, Harper and Row, New York, 1979
- Janson, H. W., 19th Century Sculpture, Abrams, New York, 1985
- Rosenblum, Robert, and Janson, H. W., Nineteenth Century
- Art, Abrams, New York, 1984 *Vaughan, William, Romantic Art, Oxford University Press, New York, 1978

Realism and Impressionism

Hansen, Ann Coffin, Manet and the Modern Tradition, Yale

- University Press, New Haven, 1977
- Kelder, Diane, The French Impressionists and Their Century, Praeger, New York, 1970
- *McCoubrey, John, American Art, 1700–1960: Sources and Documents, Prentice-Hall, Englewood Cliffs, 1965
- *Nochlin, Linda, Impressionism and Post Impressionism, 1874–1904: Sources and Documents, Prentice-Hall, Englewood Cliffs, 1966
- *—, Realism and Tradition in Art, 1848–1900: Sources and Documents, Prentice-Hall, Englewood Cliffs, 1966
- *______, Realism, Style and Civilization, Penguin Books, Baltimore, 1971
- *Pool, Phoebe, Impressionism, Oxford University Press, New York, 1967
- Rewald, John, The History of Impressionism, 4th rev. ed., New York Graphic Society, Greenwich, for the Museum of Modern Art, New York, 1973
- Weisberg, Gabriel P., The Realist Tradition: French Painting and Drawing, 1830–1900, Cleveland Museum of Art, 1981

Post-Impressionism

- *Delevoy, Robert L., Symbolists and Symbolism, Rizzoli, New York, 1982
- Doty, Robert, Photo-Secession: Stieglitz and the Fine Arts Movement in Photography, Dover, New York, 1978
- *Hamilton, George Heard, Painting and Sculpture in Europe, 1800–1940, 3rd ed., Pelican History of Art, Penguin Books, Harmondsworth, Baltimore, 1981
- Herbert, Robert L., Neo-Impressionism, New York Graphic Society, Greenwich, 1968
- Rewald, John, Post-Impressionism from Van Gogh to Gauguin, 2nd ed., Museum of Modern Art, New York, 1962
- Scharf, Aaron, Art and Photography, Penguin Books, Baltimore, 1974
- Schmutzler, Robert, Art Nouveau, tr. by Edouard Roditi, Abrams, New York, 1962

Art in Our Time

- Arnason, H. H., History of Modern Art: Painting, Sculpture, Architecture, 3rd ed., Abrams, New York, 1986
- *Barr, Alfred H., Jr., Matisse, His Art and His Public, reprint of 1951 ed. of the Museum of Modern Art, Arno Press, New York, 1966
- *Brown, Milton W., American Painting from the Armory Show to the Depression, Princeton University Press, 1955
- *Cooper, Douglas, *The Cubist Epoch*, Phaidon, New York, 1971
- Drexler, Arthur, Transformations in Modern Architecture, New York Graphic Society, Boston, 1980
- Fine, Elsa, The Afro-American Artist: A Search for Identity, Holt, Rinehart and Winston, New York, 1973
- Fry, Edward F., Cubism, McGraw-Hill, New York, 1966
- *Goldwater, Robert J., Primitivism in Modern Art, rev. ed., Vintage Books, New York, 1967

- *Gray, Camilla, *The Russian Experiment in Art, 1863–1922*, Abrams, New York, 1970
- *Haftmann, Werner, Painting in the Twentieth Century, expanded ed., 2 vols., Praeger, New York, 1965
- *Herbert, Robert L., ed., Modern Artists on Art, Prentice-Hall, Englewood Cliffs, 1965
- *Hitchcock, Henry-Russell, Architecture: Nineteenth and Twentieth Centuries, Pelican History of Art, Penguin Books, Baltimore, 1971
- Hunter, Sam, and Jacobus, John, American Art of the Twentieth Century: Painting, Sculpture, Architecture, Abrams, New York, 1973
- Lambert, J.-C., Cobra, Abbeville, New York, 1984
- *Lippard, Lucy R., Pop Art, Praeger, New York, 1966
- *Muller, Joseph-Emile, Fauvism, Praeger, New York, 1967
- *Pevsner, Nikolaus, *Pioneers of Modern Design*, 2nd ed., Museum of Modern Art, New York, 1949
- *Read, Herbert, A Concise History of Modern Painting, Oxford University Press, New York, 1974
- *——, A Concise History of Modern Sculpture, Oxford University Press, New York, 1964
- *Rose, Barbara, American Art Since 1900, rev. ed., Praeger, New York, 1975
- *Rosenblum, Robert, Cubism and Twentieth-Century Art, rev. ed., Abrams, New York, 1976
- Rubin, William, Dada and Surrealist Art, Abrams, New York, 1968
- Sandler, Irving, The Triumph of American Painting: A History of Abstract Expressionism, Praeger, New York, 1970
- *Selz, Peter, German Expressionist Painting, University of California Press, Berkeley, 1957
- Tafuri, Manfredo, and Dal Co, Francesco, Modern Architecture, Abrams, New York, 1979
- Taylor, Joshua C., Futurism, Museum of Modern Art, New York, 1961

Photography

- Cartier-Bresson, Henri, *The Decisive Moment*, Simon and Schuster, New York, 1952
- Coke, Van Deren, *The Painter and the Photograph from Delacroix to Warhol*, rev. ed., University of New Mexico Press, Albuquerque, 1972
- Gidal, Tim, Modern Photojournalism: Origins and Evolution 1910–33, Macmillan, New York, 1973
- Green, Jonathan, American Photography: A Critical History, 1945 to the Present, Abrams, New York, 1984
- Homer, William, Alfred Stieglitz and the American Avant-Garde, New York Graphic Society, Greenwich, 1977
- Hurley, F. Jack, Portrait of a Decade: Roy Stryker and the Development of Documentary Photography in the Thirties, Louisiana State University Press, Baton Rouge, 1972
- *Newhall, Beaumont, The History of Photography from 1830 to the Present Day, 5th rev. ed., New York Graphic Society, Boston, 1982
- Szarkowski, John, Mirrors and Windows: American Photography since 1960, Museum of Modern Art, New York, 1978

Index

Page numbers are in roman type. Figure numbers of black-and-white illustrations are in *italic* type. Colorplates are denoted with an asterisk*.

Aachen, West Germany, 103, 110; Pal-Annunciation, sculpture from Reims ace Chapel of Charlemagne (Odo of Metz), 107; 104 Abstract Expressionism, 383-85, 390, 399, 442; see also Action Painting Abstraction, 357, 365-76, 433 Achilles Painter, 50; Attic whiteground vase, 50-51; 44 Acropolis, Athens: Parthenon (Ictinus and Callicrates), 54, 61; 49; pediment sculpture from (Phidias), 63, 76; 58; Propylaea (Mnesicles), 54, 56, 304; 50; Temple of Athena Nike, 56; 50 Action Painting, 383, 385, 387-88, 390; see also Abstract Expressionism Adam and Eve, from The Ghent Altarpiece (Van Eyck, H. and J.), 175-76; *168 $Adam \ and \ Eve \ Reproached \ by \ the \ Lord,$ from doors of Bishop Bernward, St. Michael's, Hildesheim, 113-14; 112 Adoration of the Magi (Gentile da Fabriano), 161, 180, 196; *164 Adoration of the Magi (Leonardo da Vinci), 207-208, 209; 205 Aegean art, 40-45 Aegina, Greece: pediment sculpture from Temple at, 60, 66; 55 African art, 18, 20-21 Agesander, Athenodorus, and Polydorus of Rhodes, 66; Laocoon Group, 66, 74, 212, 275; 64 Akhenaten (king of Egypt), 29, 30 Akhenaten (Amenhotep IV), 30; 22 Albers, Josef, 395 Alberti, Leone Battista, 195-96, 206, 217, 235, 236; Sant' Andrea, Mantua, 195; 193 Alexander the Great (king of Macedonia), 40, 51, 116 Altamira, Spain, cave painting at, 14, Altdorfer, Albrecht, 244; Battle of Issus, 244; *244 Ambroise Vollard (Picasso), 367, 444;

Anthemius of Tralles, 97; Hagia Sophia, Constantinople, 97-99, 117; 95, 96 Antwerp, Belgium, 264; Cathedral, altarpiece for (Rubens), 260; 262 Anuszkiewicz, Richard, 395; Entrance to Green, 395; *418 Apollo, from Veii, 67-68; 65 Apostle, from St.-Sernin, Toulouse, 124: 122 Apparition (Dance of Salome) (Moreau), 348-50; 363 April, from Very Rich Book of Hours of the Duke of Berry (Limbourg Brothers), 161; *163 Ara Pacis, Rome, 76-77, 142, 188, 189; portion from frieze of, 79 Arc de Triomphe, Paris, sculpture for (Rude), 313; 318 Archaic style, see Greek art Archangel Michael, ivory leaf, 95-96, 124; 92 Arch of Titus, Rome, relief sculpture from, 79, 90, 92; 80 Arezzo, Italy: San Francesco, frescoes for (Piero della Francesca), 199, 200; Aristotle, 219 Arnolfo di Cambio: Florence Cathedral, 139; 140 Arrangement in Black and Gray: The Artist's Mother (Whistler), 336; 348 art brut (art-in-the-raw), 387 "art for art's sake," 330, 336, 430 Artist and His Model (De Andrea), 10; Artist's Sister Edma and Their Mother (Morisot), 333-34; 343 As in the Middle Ages, so in the Third Reich (Heartfield), 442; 478 assemblage, 407, 414-15 Assumption of the Virgin (Correggio), 231; 231 Assyrian art, 37-38, 39, 51 Atget, Eugène, 433-34, 435; Pool, Versailles, 434; 469 Athens, Greece, 54, 63; see also Acropo-Attalus I (king of Pergamum), 66 At the Moulin Rouge (Toulouse-Lautrec), 351; *367 Attic white-ground vase (Achilles Painter), 50-51; 44 Audience Hall of Darius, Persepolis, 40:34

Augustus Caesar (Roman emperor), 76

Autun Cathedral: Last Judgment, de-

tail of west tympanum, 125; 124

Aurignacians, 14

Cathedral, 142-43, 146; 145

Avignon Pietà (Southern French Master), 184; 179 Babylonian art, 35-37, 39 Bacchanal (Titian), 222-23, 231, 358; Back from the Market (Chardin), 285, 288, 289; *295 Balloon Eye (Redon), 350; 366 Balzac (Rodin), 341; 355 Bandits' Roost (Riis), 429, 435; 463 Banjo Lesson (Tanner), 338; 352 baptismal font, from Liège (Renier of Huy), 125-26, 129; 125 Baptistery, Florence, 123, 139; 121; competition for bronze doors for, 145-46, 187, 189, 193; 152; "Gates of Paradise," bronze doors for (Ghiberti), 189; 186 Baptistery, Pisa, 122, 195; 120; pulpit for (Pisano, N.), 145; 150 Bar at the Folies Bergère (Manet), 332-33; *342 Barberini Palace, Rome, see Palazzo Barberini, Rome Barbizon School, 322 Barlach, Ernst, 356; Man Drawing a Sword, 356; 374 Baroque art, 250-81; in Flanders, painting, 259-62, 264; in France: 274-81: architecture, 278-80; painting, 275-78; sculpture, 281; in Germany (Late Baroque): architecture, 282, 284; painting, 284; in Holland, painting, 264-73; in Italy: 250-59; architecture, 255-56,257-59; painting, 250-55; sculpture, 256-57; in Spain, painting, 262; see also Neo-Baroque style Baroque Classicism, 275, 278; see also Baroque art, in France Baroque revival style, see Neo-Baroque style Barry, Charles: Houses of Parliament, London, 310; 314 "Basilica," Paestum, Italy, 53–54; 48 Basilica of Constantine, Rome, 72, 76, 98, 217, 218; 72 basilicas: Early Christian, 90, 92, 97; Roman, 72, 90 Bath (Cassatt), 340; *353 Bathers (Fragonard), 285, 288; *294 Batman (Williams), 390; *414 Battle of Gods and Giants, frieze sculpture from Treasury of the Siphnians, Delphi, 59-60, 189; 54 Battle of Hastings, from Bayeux Tapestry, 128; 128 Battle of Issus (Altdorfer), 244; *244 $Battle\ of\ Issus\ (Battle\ of\ Alexander\ and$ the Persians), mosaic from Pompeii,

386

Amenhotep IV, see Akhenaten

ancestor worship, 18, 73

133, 134, 137

ial, 104; 101

American Revolution, 302, 303, 425

Anglo-Norman architecture, 120-21,

Animal Head, from Oseberg Ship-Bur-

animal style, 39, 103-104, 106, 125,

Annunciation, from Isenheim Altar-

piece (Grünewald), 239-40; *239

176, 177, 196, 199; *165

Annunciation, from Merode Altarpiece

(Master of Flémalle), 170-72, 173,

51, 79, 92, 128, 244; 45

Baudelaire, Charles, 328, 338, 350, 414

Bauhaus, Dessau, Germany, 395, 438; architecture of (Gropius), 376, 418– 19, 421; Shop Block, 452

Bayeux Tapestry, 128; 128

Beardsley, Aubrey, 349–50; Salome, 349–50, 352; 364

Beckmann, Max, 362; Departure, 362; *381

Bellini, Giovanni, 205–206, 220; St. Francis in Ecstasy, 205–206, 220–21; *203

Berlin: Brandenburg Gate (Langhans), 304; 306

Berlin Secession, 352

Bernini, Gianlorenzo, 256–57, 280, 281, 313, 340; David, 256, 313; 257; Ecstasy of St. Theresa, 256–57, 313; 258; Louvre, Paris, designs for, 278–79, 281; Model for Equestrian Statue of Louis XIV, 281; 287; St. Peter's, Rome, colonnade, 256, 257; 256

Bernward (bishop of Hildesheim), 112, 113, 123, 126; see also St. Michael's, Hildesheim

Berry, duke of, 160

Bibliothèque Ste.-Geneviève, Paris (Labrouste), 311–12; reading room, 316

Billy Goat and Tree, from Ur, 35; *28 Bingham, George Caleb, 326–27; Fur Traders on the Missouri, 326–27; *335

biomorphic abstraction, 383

Bird in Space (Brancusi), 404–405; 431 Birth of the Virgin (Lorenzetti, P.), 153, 156, 176; *158

Birth of Venus (Botticelli), 201, 202, 220; *199

Black Chord (Nevelson), 412; 442 Black Quadrilateral (Malevich), 374; 395

Bladen, Ronald, 410; X, 410; 439 Blaue Reiter, Der (The Blue Horseman), 362

Blinding of Samson (Rembrandt), 268; 271

Blue Causeway (Frankenthaler), 389–90; 412

Blue Veil (Louis), 390; *413

Bobabilicon (Los Proverbios, No. 4) (Goya), 316–17, 350; 322

Boccioni, Umberto, 371; Dynamism of a Cyclist, 371; 391; Unique Forms of Continuity in Space, 405; 432

Boffrand, Germain, 284–85; Salon de la Princesse, Hôtel de Soubise, Paris, 284–85; 292

Bohemian Master, 156; Death of the Virgin, 156, 172; *160

Bologna, Giovanni, 234–35; Rape of the Sabine Woman, 234–35, 275; 236 Bonheur, Rosa, 322; Plowing in the Nivernais, 322; 331

Borghese, Pauline, 313; statue of (Canova), 313; 317

Borromini, Francesco, 257-59, 282, 284; San Carlo alle Quattro Fontane, Rome, 258-59; 260

Bosch, Hieronymus, 180–83; Garden of Delights, 181–83, 248, 362; 176, *177

Botticelli, Sandro, 200–202, 203, 206, 208; Birth of Venus, 201, 202, 220; *199

Bourke-White, Margaret, 437–38; Fort Peck Dam, Montana, 437–38; 474

Boy with Flute (Leyster), 267; 270 Brady, Mathew, 427, 439

Bramante, Donato, 207, 217–18, 220, 249; St. Peter's, Rome, 217–18, 220, 255; 215, 216; Tempietto, San Pietro in Montorio, Rome, 217, 290; 214

Brancusi, Constantin, 402–403, 404– 405, 408, 411; Bird in Space, 404– 405; 431; Kiss, 402, 403; 427

Brandenburg Gate, Berlin (Langhans), 304; 306

Braque, Georges, 367, 369, 371, 434; *Courrier*, 367, 371, 376; 387 Breton, André, 381, 383

Bride (Duchamp), 380, 381; 401

Broadway Boogie-Woogie (Mondrian), 376

Broederlam, Melchior, 156; Flight into Egypt, 156, 161, 170; *161; Presentation in the Temple, 156, 161, 170; *161

Bronzino, Agnolo, 228; Eleanora of Toledo and Her Son Giovanni de' Medici, 228, 245; 228

Brooklyn Bridge (Stella, J.), 371; 392 Brücke, Die (The Bridge), 361, 362

Bruegel, Pieter, the Elder, 247–48, 261; Land of Cockayne, 247–48, 271; *248; Return of the Hunters, 248, 261; 249

Brunelleschi, Filippo, 189–90, 193– 94, 195, 196, 199, 211; Florence Cathedral, dome, 139, 218; 140; San Lorenzo, Florence, 193–94, 196; 191

Building of the Tower of Babel, wall painting from St.-Savin-sur-Gartempe, 128; 129

Bull's Head (Picasso), 8, 407; 2 Burial of Count Orgaz (El Greco), 229, 352: *230

Burnacini, Lodovico, 257; stage design for "La Zenobia di Radamisto," 257, 280: 259

Byzantine art, 89, 96–101, 148–49; architecture, 96–99, 117; mosaics, 99, 100; painting, 99, 100, 114; sculpture, 99

Byzantine Empire, 88, 102, 111; see also Eastern Roman Empire Byzantium, 88; see also Constantinople

Coon France, St. Etionne, 120, 124

Caen, France: St.-Etienne, 120, 134; 118

Caesar, Gaius Julius, 74, 76

Calder, Alexander, 408; Lobster Trap and Fish Tail, 408, 416; 437

Callicrates, 56; Parthenon, Acropolis, 54, 61; 49

Calling of St. Matthew (Caravaggio), 250-52, 256, 305; *252

Cameron, Julia Margaret, 430; Portrait of Ellen Terry, 430; 465

Campanile, Pisa, 122; 120

Campin, Robert, see Master of Flémalle

Canova, Antonio, 312–13; Pauline Borghese as Venus, 313; 317

Capa, Robert, 439; Death of a Loyalist Soldier, 439; 476

Caradosso, Cristoforo: medal showing Bramante's design for St. Peter's, 217–18; 216

Caravaggio (Michelangelo Merisi), 250–52, 253, 259, 260, 262, 265, 266, 268, 273, 275, 305, 306, 328; Calling of St. Matthew, 250–52, 256, 305; *252

Carolingian art, 107–11, 125; architecture, 107–108, 110, 117; illuminated manuscripts, 107, 110–11, 114, 119

Carpeaux, Jean Baptiste, 313–14; Dance, 313–14, 341; 315, 319 Carracci, Annibale, 253; Palazzo Far-

Carracci, Annibale, 253; Palazzo Farnese, Rome, ceiling fresco for, 253, 255, 260; 254

Carson Pirie Scott & Company Department Store, Chicago (Sullivan), 417; 449

Cartier-Bresson, Henri, 434–35; Mexico, 1934, 435; 470

Cassatt, Mary, 338, 340; Bath, 340; *353

Castagno, Andrea del, 192, 200, 208; David, 192, 200; *198

Catacomb of SS. Pietro e Marcellino, Rome, painted ceiling from, 89–90, 92, 94, 117; 85

Catholic Church, 88, 102–3, 117, 250 cave art (Old Stone Age), 14–16

Celebration (Krasner), 385; 408 Cellini, Benvenuto, 233–34; Saltcellar of Francis I, 233–34, 249; 235

Celto-Germanic art, 103–107, 111, 128 Cemetery (van Ruisdael), 271; 275

Cézanne, Paul, 342–43, 344, 345, 355, 357, 360, 363, 365, 367, 380, 383; Fruit Bowl, Glass, and Apples, 343, 346, 360; 356; Mont Sainte-Victoire Seen from Bibemus Quarry, 343, 367; 357

Chagall, Marc, 377–78, 406; I and the Village, 377–78; 398

Chardin, Jean Baptiste Siméon, 285, 343; *Back from the Market*, 285, 288, 289; *295; *Kitchen Still Life*, 288; 296

Charlemagne (Frankish king), 102, 103, 107, 110, 111, 112, 116, 132

Charles IV (Holy Roman emperor), 156 Charles V (Holy Roman emperor), 247 Charles the Bald (West Frankish king), 111

Charlottesville, Virginia: Monticello (Jefferson), 303; 305

Chartres Cathedral, 135; 135; sculpture from west portal, 140–42, 156; 143; jamb statues, 144

Chase-Riboud, Barbara, 413; Confessions for Myself, 413; 443

Chefren (king of Egypt), 28

Chicago, 417; Carson Pirie Scott & Company Department Store (Sullivan), 417; 449; Robie House (Wright),

376, 417-18; 450, 451

Chios, Greece: sculpture from, 58; 53 Chirico, Giorgio de, 377, 381, 402; Mystery and Melancholy of a Street, 377; 397

Chopin, Frédéric, 319; portrait of (Delacroix), 319; 328

Christ Crowned with Thorns (Titian), 223: 223

Christ Entering Jerusalem, from Maestà Altar (Duccio), 150, 153; *156

Christ in the House of Levi (Veronese), 232–33, 311; 234

Christ Preaching (Rembrandt), 269–70; 273

Christ's Entry into Jerusalem (Giotto), 148, 150, 153; *155

Christ Washing the Feet of Peter, from Gospel Book of Otto III, 114, 119; *113

Cinema (Segal), 415; 446 City (Léger), 371–72, 421; 393 Civil War, 337, 338, 427

Classical revival style, 309, 310, 312–

Classical style, see Greek art

Classicians, 116, 207; in Baroque art, 253, 274–75, 278, 279; in Byzantine art, 100; in Carolingian art, 107, 110; in Early Christian art, 95, 96; in Gothic art, 141, 142, 144–45, 147, 148–50; Palladian, 235–36; in Renaissance art: Early, 168, 169, 187, 188, 193–94, 201–202, 204–205; High, 211–12, 217, 219, 222–23; in Rococo English art, 290, 292–93; in Romanesque art, 122, 123, 124, 125, 126, 129; in twentieth-century art, 358, 369; see also Neoclassicism

Claude Lorrain, 278, 323, 327; Pastoral, 278, 327; 283

Clement VII (pope), 215

Clemente, Francesco, 401–402; Untitled, 402: *424

Clouet, Jean, 245; *Francis I*, 245; 246 Colbert, Jean Baptiste, 278, 284

collage Cubism, 367–69, 371, 372, 381 Cologne Cathedral: *The Gero Crucifix*

from, 112, 113, 123, 143; 109 colonnade and court of Amenhotep III, Luxor, Egypt, 29, 40, 438; 21 Color-Field Painting, 383, 387–90

Colosseum, Rome, 71, 119; 69 Composition with Red. Blue, and

Composition with Red, Blue, and Yellow (Mondrian), 375–76, 390; *396 Conceptual Art, 400–401

Confessions for Myself (Chase-Riboud), 413: 443

Constable, John, 319, 322–23, 327; Stoke-by-Nayland, 323; 332

Constantine the Great (Roman emperor), 75, 88, 89, 90, 96, 97; Basilica of, 72, 76, 98; 72; statue of, 75–76, 81; 78

Constantine the Great, 75–76, 81; 78 Constantinople, 88, 97, 102, 148; Hagia Sophia (Anthemius of Tralles and Isidorus of Miletus), 97–99, 117; 95. 96

Constructivism, 375, 405–407 Copley, John Singleton, 306–308; Watson and the Shark, 306–308; *311 Corcoran Gallery, Washington, D.C., sculpture for (Bladen), 410; 439

Corinthian order, 51, 71

Cornaro Chapel, Santa Maria della Vittoria, Rome, sculpture for (Bernini), 256-57; 258

Corot, Camille, 327; Papigno, 327, 332, 337; 336

Correggio (Antonio Allegri), 231, 253; Assumption of the Virgin, 231; 231; Jupiter and Io, 231, 257; 232

Cortona, Pietro da, 253, 255; Glorification of the Reign of Urban VIII, 253, 255, 284; *255

Counter Reformation, 168, 229, 250, 252, 257

Courbet, Gustave, 328–29, 330, 332, 336, 338, 429; Stone Breakers, 328–29; 337

Courrier (Braque), 367, 371, 376; 387 court and pylon of Ramesses II, Luxor, Egypt, 29, 40, 438; 21

Coysevox, Antoine: Salon de la Guerre, Palace of Versailles, 280; 285

Cranach, Lucas, the Elder, 244; Judgment of Paris, 244; *243

Creation of Adam (Michelangelo), from Sistine Ceiling, 214, 251, 431; 211

Crossing of the Red Sea, enamel plaque from Klosterneuburg Altar, 128–30; 130

cross page, from Lindisfarne Gospels, 106, 128; *102

Crucifixion (Van Eyck, H. and J.), 173; *166

Crucifixion, book cover, 106–107; 103 Crucifixion, from Isenheim Altarpiece (Grünewald), 238–39; 238

Crucifixion, mosaic from Monastery Church, Daphnē, 100, 112; 98 Crusades, 116–17, 123, 131, 148 Cubi series (Smith), 411; 441

Cubism, 365–71, 373, 375, 378, 383, 405; collage, 367–69, 371, 372, 381; facet, 365–67, 368, 371, 380, 405, 418; photography and, 441

Cubo-Futurism, 373–74, 406 Cycladic art, 40, 41–42

Cycladic idol, from Amorgos, 41–42; 35 Cyrus (king of Babylon), 39

Dada, 350, 373, 381, 395, 400, 407; photography and, 434, 441, 442

Daguerre, Louis Jacques Mandé, 424, 425

daguerreotypes, 424–25, 427 Dali, Salvador, 381; Persistence of

Memory, 381; 403 Dance (Carpeaux), 313–14, 341; 315; model for, 319

Daphnē, Greece: Monastery Church, mosaic from, 100, 112; 98

Darius I (king of Persia), 40, 51 Dark Abstraction (O'Keeffe), 364, 435, 437; 383

Dark Ages, art from, 103–104, 106–107, 111, 116

Daumier, Honoré, 319, 321–22, 361; *Third-Class Carriage*, 321–22, 333; 329

David, Jacques Louis, 304–306, 314, 315, 317, 318; Death of Marat, 305–

306, 425, 427; 309; Death of Socrates, 304-305, 308; *308

David (Bernini), 256, 313; 257

David (Castagno), 192, 200; *198 David (Donatello), 188, 212; 184

David (Michelangelo), 212, 256; 209 David and Goliath, from Prayer Book of Philip the Fair (Master Honoré), 148, 150; 154

Dead Fowl (Soutine), 361: 378

De Andrea, John: Artist and His Model, 10; 3

Death of a Loyalist Soldier (Capa), 439; 476

Death of General Wolfe (West), 306, 307, 319, 427; *310

Death of Marat (David), 305–306, 425, 427; 309

Death of Socrates (David), 304–305, 308; *308

Death of the Virgin (Bohemian Master), 156, 172; *160

Degas, Edgar, 334–35, 345, 351; Glass of Absinthe, 334, 335, 351; 345; Tub, 335, 340: 346

Déjeuner sur l'Herbe (Luncheon on the Grass) (Manet), 329–30; 338

De Kooning, Willem, 385, 390; Woman II, 385, 387; *409

De La Tour, Georges, 275; Joseph the Carpenter, 275; 280

Delacroix, Eugène, 317, 319, 321, 343, 348, 397; Frédéric Chopin, 319; 328; Greece Expiring on the Ruins of Missolonghi, 319; *327

Delivery of the Keys (Perugino), 206; 204

Delphi, Greece: Treasury of the Siphnians, frieze sculpture from, 59–60; 54

Demoiselles d'Avignon (Picasso), 365–67, 371; 385

Denis, Maurice, 348, 395

Departure (Beckmann), 362; *381

Descent from the Cross (Rosso Fiorentino), 224, 228; *226

Descent from the Cross (Van Der Wey-

den), 177, 306; *173

Dessau, Germany: Bauhaus (Gropius), 376, 395, 418–19, 421; 452 Diderot. Denis, 304

Diocletian (Roman emperor), 90; Palace of, Split, 73; 73

Dipylon vase, 47; 40

Discovery and Proving of the True Cross (Piero della Francesca), 166– 67, 199, 200, 344; *197

Discovery of Honey (Piero di Cosimo), 202–203; *200

Divisionism, 344, 345

documentary photography, 427, 429, 435, 439, 441

Donatello, 187–89, 190, 192, 193, 199, 205, 212; David, 188, 212; 184; Equestrian Monument of Gattamelata, 188–89; 185; Prophet (Zuccone), 187–88, 196, 199; 183; St. George, 187; 182

Dorians, 46, 47, 48

Doric order, 51-54, 56; 46-50

Dove, Arthur, 364

Dragons (Pfaff), 416; 448

Dream (Rousseau), 354, 377; *371 Dubuffet, Jean, 387; Metafisyx (Corps

de Dame), 387; 410

Duccio di Buoninsegna, 150, 153; Christ Entering Jerusalem, from Maestà Altar, 150, 153; *156

Duchamp, Marcel, 380–81, 387, 395, 400, 405, 407, 434, 441; *Bride*, 380, 381; 401

Duchamp-Villon, Raymond, 405; Great Horse, 405; 433

Dürer, Albrecht, 237, 240–41, 244, 245, 247, 259, 270, 346; Four Horsemen of the Apocalypse, 241, 443; 241; Knight, Death, and Devil, 241, 244, 268–69; 242; Self-Portrait, 241, 245, 346; 240

Durham Cathedral, England, 120–21, 133; 119

Dyck, Anthony van, 261–62; Portrait of Charles I Hunting, 261–62, 290; 266

Dying Gaul, from Pergamum, 66; 62 Dying Lioness, from Nineveh, 38; 31 Dying Warrior, pediment sculpture from Temple at Aegina, 60, 66, 355;

Dynamism of a Cyclist (Boccioni), 371; 391

Eakins, Thomas, 338; Gross Clinic, 338; 351

Early Christian art, 89–96, 100; architecture, 90, 92, 117; illuminated manuscripts, 92–94, 106; mosaics, 92; painting, 89–90; sculpture, 94–96

Early Renaissance art, see Renaissance art

Earth and Green (Rothko), 388–89; *411

Earth Art, 410

Eastern Roman Empire, 88, 89, 96, 103
Ebbo Gospels, see Gospel Book of Archbishop Ebbo of Reims

Ecce Ancilla Domini (Rossetti), 350, 430; 365

Ecole des Beaux-Arts, Paris, 349 Ecstasy of St. Theresa (Bernini), 256– 57, 313; 258

Eddy, Don, 397, 399; New Shoes for H, 397, 399; 421; photograph for, 422

Egyptian art, 22–31, 59, 92–93; Middle Kingdom, 28; New Kingdom: 28–31; architecture, 28–29, 40; sculpture, 30; Old Kingdom: 24–28; architecture, 26–28, 53; sculpture, 24–26, 35; Roman portraits from Faiyum region, 81

Eleanora of Toledo and Her Son Giovanni de' Medici (Bronzino), 228, 245; 228

Embryo in the Womb (Leonardo da Vinci), 211; 208

Empress of India (Stella, F.), 392–93; *416

engravings, 270; Late Gothic, 185; Northern Renaissance, 240, 241, 244 Enlightenment, 303, 304, 309, 312, 315

Entrance to Green (Anuszkiewicz), 395; *418

Environmental Sculpture, 409, 410–11 environments, 415–16

Episcopal Palace, Würzburg: Kaisersaal (Neumann), 282, 284; *290; ceiling fresco for (Tiepolo), 284, 285; 291

Equestrian Monument of Gattamelata (Donatello), 188–89; 185

Equestrian Statue of Marcus Aurelius, 74, 188, 281; 76

Equivalent (Stieglitz), 435–36, 437, 442; 472

Erasmus of Rotterdam, 244, 245 Erasmus of Rotterdam (Holbein), 245; 245

Eremitani Church, Padua, frescoes for (Mantegna), 203–205; 202

Ernst, Max, 381–82, 384; 1 Copper Plate 1 Zinc Plate 1 Rubber Cloth 2 Calipers 1 Drainpipe Telescope 1 Piping Man, 381; 402; Totem and Taboo, 382; 405

Eskimo mask, from southwest Alaska, 21: 12

etchings: Baroque, 269–70; Romantic, 316–17

Etruscan art, 67-69, 70

Eve of St. Nicholas (Steen), 271, 304; 277

ewer, from Meuse Valley, 126; 126 Expressionism, 357–65, 384, 390, 433,

435; see also Abstract Expressionism Eyck, Hubert van, 172–73, 175, 184, 237; Crucifixion, 173; *166; Ghent Altarpiece, 173, 175–76; *167–69; Last Judgment, 173; *166

Eyck, Jan van, 172–77, 180, 184, 237, 271; Crucifixion, 173; *166; Ghent Altarpiece, 173, 175–76; *167–69; Last Judgment, 173; *166; Man in a Red Turban (Self-Portrait?), 176–77, 225, 241, 268; 170; Wedding Portrait, 177, 225; *171, 172

facet Cubism, 365-67, 368, 371, 380, 405, 418

Faiyum, Egypt, portraits from, 81; *84 Family of Charles IV (Goya), 315–16; 320

Fantasy, 357, 376-83, 433, 443

Farnese Palace, Rome, see Palazzo Farnese, Rome

Fauves (Fauvism), 357–60, 361, 362, 363, 364, 365, 366, 367, 375, 402

February, from Very Rich Book of Hours of the Duke of Berry (Limbourg Brothers), 160-61, 248; *162

Female Semi-nude in Motion (Muy-bridge), 432; 468

Fifer (Manet), 330, 332, 333, 340; *340 Fischer von Erlach, Johann, 282; St. Charles Borromaeus, Vienna, 282; 289

Flack, Audrey, 399; Queen, 300–301, 399: *423

Flamboyant Gothic style, 135, 138 Flight into Egypt (Broederlam), 156, 161, 170; *161

Florence, Italy, 132, 153, 170, 177, 186, 188, 209; Baptistery: 123, 139; 121; competition for bronze doors for, 145–46, 187, 189, 193; 152; "Gates of Paradise," bronze doors for (Ghiber-

ti), 189; 186; Cathedral (Arnolfo di Cambio and Brunelleschi): 139, 218; 140; sculpture for (Donatello), 187–88; 183; Or San Michele, niche sculpture for (Donatello), 187; 182; Palazzo Medici-Riccardi (Michelozzo), 194–95; 192; Palazzo Vecchio, 140, 193, 195, 212, 234; 142; Santa Croce, 138–39, 194; 139; San Lorenzo (Brunelleschi): 193–94, 196, 218; 191; Medici Chapel in (Michelangelo), 215, 234; 213; Santa Maria Novella, fresco for (Masaccio), 196; *195

Fort Peck Dam, Montana (Bourke-White), 437–38: 474

Foundry Painter, 50; Lapith and Centaur, 50, 51; 43

Fountain of the Innocents, Paris (Goujon), 249; reliefs from, 251

Four Horsemen of the Apocalypse (Dürer), 241, 443; 241

Fragonard, Jean Honoré, 285, 288; Bathers, 285; *294

Francis I (king of France), 228, 233, 234, 245, 249

Francis I (Clouet), 245; 246

Frank, Robert, 443; Santa Fe, New Mexico, 443; 482

Frankenthaler, Helen, 389–90; Blue Causeway, 389–90; 412

Frédéric Chopin (Delacroix), 319; 328 Frederick II (Holy Roman emperor), 144–45

French Revolution, 281, 288, 302, 303, 305, 315, 425

Friedrich, Caspar David, 325–26; *Polar Sea*, 325–26; *334

Frieze of Animals, Cave of Lascaux (Dordogne), France, 14, 15; 4

Fruit Bowl, Glass, and Apples (Cézanne), 343, 346, 360; 356

Fur Traders on the Missouri (Bingham), 326-27; *335

Fuseli, John Henry, 293

Futurism, 371–72, 373, 380, 405; photography and, 432, 441

Gainsborough, Thomas, 290–91; Mrs. Siddons, 291, 292; 301; Robert Andrews and His Wife, 290–91, 322–23; *300

Galatea (Raphael), 220, 222, 223, 253, 275; 219

Garden of Delights (Bosch), 181–83, 248, 362; 176, *177

Garden of Love (Rubens), 261, 285; *264

Gardner, Alexander, 427; Home of a Rebel Sharpshooter, Gettysburg, 427;

Garnier, Charles, 311; Opéra, Paris, 310–11, 313, 422; 315

Gates of Hell (Rodin), 340

"Gates of Paradise" (Ghiberti), bronze doors for Baptistery, Florence, 189; panel of, 186

Gattamelata, 188; equestrian monument of (Donatello), 188–89; 185

Gauguin, Paul, 346–48, 350, 351, 352, 354, 355, 356, 357–58, 359, 360, 361, 364, 365, 366; Offerings of Gratitude,

348, 358; 362; Yellow Christ, 346, 358: *361

Geertgen tot Sint Jans, 180; Nativity, 180, 232, 275; 175

Geneva Cathedral, altarpiece for (Witz), 183-84; 178

genre painting: Baroque, 271–72; Neoclassical, 304; Rococo, 285

Gentile da Fabriano, 161; Adoration of the Magi, 161, 180, 196; *164

Gentileschi, Artemisia, 252–53; Judith and Maidservant with the Head of Holofernes, 252–53; 253

Geometric style, see Greek art

Georgian architecture, 303; see also Neoclassicism

Géricault, Théodore, 319; Mounted Officer of the Imperial Guard, 319; 326 German Expressionism, 361–64

Gero Crucifix, from Cologne Cathedral, 112, 113, 123, 143; 109

Ghent Altarpiece (Van Eyck, H. and J.), 173, 175–76; Adam and Eve, *168; closed, *169; open, *167

Ghiberti, Lorenzo, 145, 146–47, 188, 189, 190, 192, 196; Sacrifice of Isaac, 145–47, 156, 189; 152; Story of Jacob and Esau, from "Gates of Paradise," bronze doors for Baptistery, Florence, 189, 208; 186

Ghirlandaio, Domenico, 203, 206; Old Man and His Grandson, 203; 201

Giacometti, Alberto, 407–408; *Palace* at 4 A.M., 407–408; 435

Giant Ice Bag (Oldenburg), 413-14;

Giorgione da Castelfranco, 220-22, 231; Tempest, 220-22, 223, 261; 220 Giotto (Giotto di Bondone), 148, 149, 150, 153, 170, 184, 196, 212, 330; Christ's Entry into Jerusalem, 148,

150, 153; *155 Giovanni Chellini (Rossellino), 191; 188

Girardon, François, 281; Model for Equestrian Statue of Louis XIV, 281; 288

Girl at Piano (Lichtenstein), 396–97; 420

Giza, Egypt: *Great Sphinx*, 27–28; 20; Pyramids of Mycerinus, Chefren, and Cheops, 26, 27, 28; 19

Glass of Absinthe (Degas), 334, 335, 351; 345

Glorification of the Reign of Urban VIII (Da Cortona), 253, 255, 284; *255

Gloucester Cathedral, England, 138;

Goeritz, Mathias, 409–10; Steel Structure for The Echo, Mexico City, 409; 438

Goes, Hugo van der, 177, 179–80; Portinari Altarpiece, 179–80, 203; 174 Goethe, Johann Wolfgang von, 325

Gogh, Vincent van, 344–46, 350, 352, 357, 360, 375; Self-Portrait, 346, 361; 360; Wheat Field and Cypress Trees, 345–46; *359

Gonzalez, Julio, 408, 411; Head, 408, 411; 436

Good Government (Lorenzetti, A.), 86–87, 153; *159

Gorky, Arshile, 383–84, 385, 388, 390; Liver Is the Cock's Comb, 383–84; 406

Gospel Book of Abbot Wedricus, 128;**

Gospel Book of Archbishop Ebbo of Reims, 110-11, 112, 125; 108

Gospel Book of Charlemagne, 110; 107 Gospel Book of Otto III. 114, 119: *113 Gothic art, 116, 129, 131-61; architecture, 120, 131-40; Early Gothic, 120, 131, 137; in England, architecture. 137-38; Flamboyant style, 135, 138; in France: architecture, 132-37. 138; painting, 147-48; sculpture, 140-44; in Germany, sculpture, 143-44; International style, 131-32, 145-46, 156-61, 170, 171, 180; in Italy: architecture, 138-40; painting, 148-54; sculpture, 144-47; painting, 131, 147-61; Perpendicular style, 138, 289-90; sculpture, 131, 140-47, 156; see also Late Gothic art

Gothic revival style, 309–10, 312, 350 Goujon, Jean, 249; Fountain of the Innocents, 249; 251

Goya, Francisco, 314–17, 319, 330; Bobabilicon (Los Proverbios, No. 4), 316–17, 350; 322; Family of Charles IV, 315–16; 320; Third of May, 1808, 316, 317, 427; *321

graphic art: Baroque, 269, 270; Late Gothic, 184–85; Northern Renaissance, 240, 241, 244; photography as, 424, 425; Post-Impressionist, 348; Romantic, 316–17

Great Horse (Duchamp-Villon), 405;

Great Sphinx, 27-28; 20

Greco, El (Domenicos Theotocopoulos), 228–29, 231, 237; Burial of Count Orgaz, 229, 352; *230

Greece Expiring on the Ruins of Missolonghi (Delacroix), 319; *327

Greek art, 46–66, 100; Archaic style: 67, 116; architecture, 53–54; painting, 47–50, 68 (black-figure, 47–49; red-figure, 49–50); sculpture, 53, 57–61, 63; architecture: 51–56, 57, 70–71; Doric order, 51–54, 56; Ionic order, 51, 56; Classical style: 116, 207; architecture, 54, 56; painting, 47, 50–51; sculpture, 60–64; Geometric style, painting, 46–47; Hellenistic style: 93, 207; sculpture, 63, 64, 66; influence on Roman art, 70, 71, 73, 79, 81; painting, 46–51, 57, 68; sculpture: 56–66; architectural, 59–60, 63

Greek Revival style, 303–304; see also Neoclassicism

Greeks Battling Amazons (Scopas?), frieze from Mausoleum, Halicarnassus, 63; 59

Gregory Watching the Snow Fall, Kyoto, Feb. 1983 (Hockney), 444–45; 483

Greuze, Jean Baptiste, 304; Village Bride, 304; 307

Grooms, Red, 415-16; Ruckus Manhattan, 415-16; 447 Gropius, Walter, 418–19, 420, 421; Bauhaus, Dessau, 376, 395, 418–19, 421; 452

Gros, Antoine Jean, 318–19; Napoleon at Arcole, 318–19; 325

Gross Clinic (Eakins), 338; 351

Grünewald, Matthias (Mathis Gothardt Nithardt), 237–40, 244; Isenheim Altarpiece, 237–40; 238, *239; panels from: Annunciation, 239–40; *239; Crucifixion, 238–39; 238; Resurrection, 239–40; *239; Virgin and Child with Angels, 239–40; *239

Guarini, Guarino, 259, 284; Palazzo Carignano, Turin, 259; 261

Habakkuk, stained-glass window, 147–48, 184, 361; 153

Hagia Sophia, Constantinople (Anthemius of Tralles and Isidorus of Miletus), 97–99, 117; 95, 96

Halicarnassus, Greece: Mausoleum, frieze sculpture from, 63: 59

Hals, Frans, 266–67, 330; Jolly Toper, 266–67, 271; *268; Women Regents of the Old People's Home at Haarlem, 267: 269

Hammurabi (king of Babylon), 37; law code of, 30

Happenings, 400

hard-edge painting, 390, 392–93 Hardouin-Mansart, Jules, 280; Palace of Versailles: Garden Front, 280; 286; Salon de la Guerre at. 280; 285

Harmony in Red (Red Room) (Matisse), 359–60, 367; *376

Head (Gonzalez), 408, 411; 436 Heartfield, John, 442; As in the Middle Ages, So in the Third Reich, 442; 478 Heda, Willem, 271; Still Life, 271; 276 Hell, from Garden of Delights (Bosch), 181, 183, 362; 176

Helladic art, 41, 44; see also Mycenae-

an art Hellenistic style, *see* Greek art Henry IV (king of France), 260

Henry VIII (king of England), 245 Henry VIII (Holbein), 228, 245; *247 Hepworth, Barbara, 403; Sculpture

Hepworth, Barbara, 403; Sculpture with Color (Oval Form), Pale Blue and Red, 403–404; 430

"Hera," from Samos, 54, 58, 141; 52 Hercules and Antaeus (Pollaiuolo), 192, 193, 234; 189

Hercules Strangling the Nemean Lion (Psiax), 47–49, 50, 51; 41, *42 Hermes (Praxiteles), 63–64, 355; 60

Hiberno-Saxon style, 106–107, 128 High Renaissance art, see Renaissance art

Hildesheim: St. Michael's, 112–14, 123, 126; 110–112

Hockney, David, 444–45; Gregory Watching the Snow Fall, Kyoto, Feb. 1983, 444–45; 483

Hofmann, Hans, 399

Hogarth, William, 290, 304; Orgy, from The Rake's Progress, 290, 304, 429–30; 299

Holbein, Hans, the Younger, 244–45, 290; Erasmus of Rotterdam, 245; 245; Henry VIII, 228, 245; *247

Holy Trinity (Masaccio), 196, 199, 204, 220, 229; *195

Home of a Rebel Sharpshooter, Gettysburg (Gardner), 427; 462

Homer, 45, 46

Homer, Winslow, 337; Morning Bell, 337, 338; *350

Hosmer, Harriet, 412, 413

Hôtel de Soubise, Paris: Salon de la Princesse (Boffrand), 284-85; 292

Houdon, Jean Antoine, 308; Voltaire, 308: 312

House of the Vettii, Pompeii, Ixion Room, 79, 100, 114, 145; 82

Houses of Parliament, London (Barry and Pugin), 310; 314

Hugo, Victor, 431; sculpture of (Rodin), 431: 467

humanism, 168-69, 186, 244, 275

I and the Village (Chagall), 377-78;

Iconoclastic Controversy, 99–100 icons, 100

Ictinus: Parthenon, Acropolis, 54, 61;

illuminated (illustrated) manuscripts: Byzantine, 114; Carolingian, 107, 110-11, 114, 119; Celtic, 106, 111, 124, 128; Early Christian, 92-94; Gothic, 147, 148, 156, 160-61; Ottonian, 114; Romanesque, 126, 128 Imhotep, 26-27, 29

Imperial Procession, from frieze of Ara Pacis, Rome, 76-77, 142, 188, 189;

Impressionism, 332-37, 338, 340-41, 342, 343, 345

industrial revolution, 302, 311, 425 Ingres, Jean Auguste Dominique, 317-18, 319, 335, 354; Louis Bertin, 318, 425; 324; Odalisque, 313, 317-18, 319; *323

inkblot on folded paper, 6, 390; 1 installations, 416

Interior of the Pantheon (Pannini), 72;

International Gothic style, 131–32, 145-46, 156-61, 170, 171, 180

International Style architecture, 418-20, 421, 422

Ionians, 40, 46, 48

Ionic order, 51, 56; 46, 47, 50

Isenheim Altarpiece (Grünewald), 237-40; closed, 238; open, *239

Ishtar Gate, Babylon, 39; 32

Isidorus of Miletus, 97; Hagia Sophia, Constantinople, 97–99, 117; 95, 96 Islam, 102, 103

Istanbul, see Constantinople

Ixion Room, House of the Vettii, Pompeii, 79, 100, 114, 145; 82

Jacob Wrestling with the Angel, from Vienna Genesis, 93-94; 90

Japanese art, influence of, 340, 350 Jefferson, Thomas, 303; Monticello, Charlottesville, 303; 305

Johns, Jasper, 395-96; Three Flags, 396; *419

Johnson, Philip: Seagram Building, New York City, 420; 454

Jolly Toper (Hals), 266-67, 271; *268 Joseph the Carpenter (La Tour), 275; 280

Joy of Life (Matisse), 358-59; 375 Judgment of Paris (Cranach), 244;

Judgment of Paris (Raimondi), 330; engraving after Raphael, 339

Judith and Maidservant with the Head of Holofernes (Gentileschi), 252-53; 253

Julius II (pope), 212, 217, 219

Junius Bassus, 94, 95; sarcophagus of, 94-95, 100, 111, 120; 91

Jupiter and Io (Correggio), 231, 257; 232

Justinian (Byzantine emperor), 88, 89, 90, 96, 97, 99, 100, 103

Justinian and Attendants, mosaic from San Vitale, Ravenna, 99, 100; 97

Kaisersaal, Episcopal Palace, Würzburg (Neumann), 282, 284; *290; ceiling fresco (Tiepolo), 284, 285; 291

Kandinsky, Wassily, 362–64, 376, 384, 406; Sketch I for "Composition VII," 363, 384, 436; *382

Käsebier, Gertrude, 431; Magic Crystal, 431, 436; 466

Kauffmann, Angelica, 292-93; Sappho, 292-93; 303

 $Kelly, Ellsworth, 390; Red\ Blue\ Green,$ 390; *415

Kiss (Brancusi), 402, 403; 427 Kiss (Klimt), 352; *369

Kiss of Judas, relief sculpture on choir screen, Naumburg Cathedral, 143;

147 Kitchen Still Life (Chardin), 288; 296 Klee, Paul, 378-80, 387; Park near Lu-(cerne), 378, 380; *400; Twittering

Machine, 378, 380; 399 Klimt, Gustav, 352; Kiss, 352; *369 Klosterneuburg Altar (Nicholas of Verdun), 128-30; enamel plaque from,

Knight, Death, and Devil (Dürer), 241, 244, 268-69; 242

Knossos, Crete: Palace of Minos at, 42; 36

Kokoschka, Oskar, 361-62; Self-Portrait, 361-62; 380

Kore statues, 58 Kosuth, Joseph, 400-401; One and Three Chairs, 400-401; 425

Kouros statues, 53, 57-58, 60-61 Krasner, Lee, 385; Celebration, 385; 408

Kritios Boy (Standing Youth), 61-62, 188, 355; 56

Labrouste, Henri: Bibliothèque Ste.-Geneviève, Paris, 311–12; 316

Laestrygonians Hurling Rocks at the Fleet of Odysseus, panel from Odyssey Landscapes, 79; *81

Land of Cockayne (Bruegel), 247-48, 271; *248

landscape painting: Baroque, 261, 271, 276, 278; Late Gothic, 184; Northern Renaissance, 244, 248; Post-Impressionist, 343, 345; Romantic: in America, 326-27; in England, 322-25; in France, 327; in Germany, 325 - 26

Landscape with the Burial of Phocion (Poussin), 276; 282

Landscape with the Château of Steen (Rubens), 261; 265

Lange, Dorothea, 439, 441; Migrant Mother, California, 441; 477

Langhans, Karl: Brandenburg Gate, Berlin, 304; 306

Laocoön Group (Agesander, Athenodorus, and Polydorus of Rhodes), 66, 74, 212, 275; 64

Lapith and Centaur (Foundry Painter), 50, 51; 43

Lascaux (Dordogne), France, cave painting at, 14, 16; Frieze of Animals from, 14, 15; 4

Last Judgment (Michelangelo), 214, 215; 210, 212

Last Judgment (Van Eyck, H. and J.), 173; *166

Last Judgment, west tympanum, Autun Cathedral, 125; 124

Last Supper (Leonardo da Vinci), 208– 209, 220, 228; 206

Last Supper (Nolde), 361; 379 Last Supper (Tintoretto), 228, 229,

232; 229 Late Baroque art, see Baroque art

Late Gothic art: architecture, 131, 135, 138, 170, 289-90; in France, 184; in Germany, 183-85; graphic arts, 184-85; in the Netherlands, 180-83; painting, 170-84, 237; sculpture,

La Tour, see De La Tour, Georges law code of Hammurabi, 37; stone slab inscribed with, 30

Leaning Tower, Pisa, 122, 139; 120 Lebrun, Charles, 278, 279, 280, 284, 285, 291; Salon de la Guerre, Palace of Versailles, 280; 285

Le Corbusier (Charles Edouard Jeanneret), 419, 420-21; Notre-Damedu-Haut, Ronchamp, 420-21; 455, 456; Savoye House, Poissy-sur-Seine, 376, 419, 421; 453

Léger, Fernand, 371-72; City, 371-72, 421: 393

Lehmbruck, Wilhelm, 355-56; Standing Youth, 355-56; 373

Le Nain, Louis, 275, 288, 322, 328; Peasant Family, 275, 322; 279

Le Nôtre, André, 280; Palace of Versailles, park for, 280-81; 286 Leo X (pope), 215

Leonard, Joanne, 443; Romanticism Is Ultimately Fatal, 443; 481

Leonardo da Vinci, 193, 207-11, 217, 219, 223, 231, 249, 276; Adoration of the Magi, 207-208, 209; 205; Embryo in the Womb, 211; 208; Last Supper, 208–209, 220, 228; 206; Mona Lisa, 209, 211, 223; *207

Lescot, Pierre, 249; Louvre, Paris, Square Court of, 249, 278; 250

Letter (Vermeer), 271-72; 278

Le Vau, Louis, 279, 280; Palace of Versailles, Garden Front, 280; 286

Lexington Local, from Ruckus Manhattan (Grooms), 415-16; 447

Leyster, Judith, 267; Boy with Flute, 267; 270

Lichtenstein, Roy, 396-97; Girl at Piano, 396-97; 420

Liège, Belgium: baptismal font from (Renier of Huy), 125-26, 129; 125

Limbourg, Pol de, 160; see also Lim-

bourg Brothers

Limbourg Brothers, 160; Very Rich Book of Hours of the Duke of Berry, 156, 160-61; April from, 161; *163; February from, 160-61, 248; *162 Lindau Gospels, cover of, 111, 112, 113,

125; *106

Lindisfarne Gospels, 106, 128; *102 Lion Gate, Mycenae, 45, 53, 59; 39

lithographs, 350; photography and, 424, 425

Liver Is the Cock's Comb (Gorky), 383-84: 406

Lobster Trap and Fish Tail (Calder), 408, 416; 437

Lombards, 51, 88, 107, 112

London: Houses of Parliament (Barry and Pugin), 310; 314; St. Paul's Cathedral (Wren), 290; 298

Lorenzetti, Ambrogio, 153, 156; Good Government, 86-87, 153; *159

Lorenzetti, Pietro, 153, 156; Birth of the Virgin, 153, 156, 176; *158

Lorrain, Claude, see Claude Lorrain Louis, Morris, 390; Blue Veil, 390; *413 Louis VI (king of France), 132

Louis XIII (king of France), 260

Louis XIV (king of France), 250, 274, 278, 279, 280, 284, 285, 349; bust of (Bernini), 281; models for equestrian statue of: (Bernini), 281; 287; (Girardon), 281; 288

Louis Bertin (Ingres), 318, 425; 324 Louvre, Paris, 249, 278-79; designs for (Bernini), 278-79, 281; East front (Perrault), 279, 280, 290, 311; 284; Square Court of (Lescot), 249, 278; 250; sculpture for (Goujon), 249

Lumière, Louis, 433 Luncheon on the Grass (Déjeuner sur l'Herbe) (Manet), 329-30, 342; 338 Luther, Martin, 240, 244

Luxembourg Palace, Paris, paintings

for (Rubens), 260; 263

Luxor, Egypt: colonnade and court of Amenhotep III, 29, 40, 438; 21; court and pylon of Ramesses II, 29, 40, 438; 21; Temple of Amun-Mut-Khonsu, 29, 40, 438; 21

Maderno, Carlo, 255; St. Peter's, Rome, 255-56, 282; 256

Madonna (Pisano, G.), 145, 150; 151 Madonna and Child with Saints (Veneziano), 198–99; *196

Madonna Enthroned, panel painting, 100; *99

Madonna with the Long Neck (Parmigianino), 225, 228, 231, 318; *227

Maestà Altar (Duccio), panel from, 150, 153; *156

Magdalenians, 14, 16

Magic Crystal (Käsebier), 431, 436; 466

Maiden, from Chios(?), 58; 53

Maids of Honor (Velázquez), 262, 315,

Maillol, Aristide, 355, 356; Seated Woman (Méditerranée), 355, 402; 372

Maitani, Lorenzo: Orvieto Cathedral, 139-40, 195; 141

Male Figure Surmounted by a Bird, from Sepik River, New Guinea, 18, 366: 9

Malevich, Kazimir, 374; Black Quadrilateral, 374; 395

Mallarmé, Stéphane, 350

Man Drawing a Sword (Barlach), 356; 374

Manet, Edouard, 329-30, 332-33, 334, 336, 338, 340, 342, 343, 395, 417; Bar at the Folies Bergère, 332-33; *342; Fifer, 330, 332, 333, 340; *340; Luncheon on the Grass (Déjeuner sur l'Herbe), 329-30, 342; 338

Man in a Red Turban (Self-Portrait?) (Van Eyck, J.), 176-77, 225, 241, 268; 170

Mannerism, 224-29, 231, 233-35, 250 Mantegna, Andrea, 203–205; St. James Led to His Execution, 203-205, 208; 202

Mantua, Italy: Sant' Andrea (Alberti), 195; *193*

manuscript illumination, see illuminated (illustrated) manuscripts

Man with the Glove (Titian), 223, 268; 222

Marat, Jean Paul, 306; painting of (David), 305-306; 309

Marcus Aurelius (Roman emperor), 74; equestrian statue of, 74, 188, 281; 76

Marie de' Medici, Queen of France, Landing in Marseilles (Rubens), 260-61, 285; 263

Marseillaise (Rude), 313; 318

Martini, Simone, 153; Road to Cavalry, 153; *157

Masaccio (Tommaso di Giovanni), 196, 199, 203, 212, 220, 343, 369; Holy Trinity, 196, 199, 204, 220, 229; *195 mask, from Bamenda area, Came-

roons, Africa, 20-21, 366, 404; 10 mask, from Gazelle Peninsula, New Britain, South Pacific, 21; 11

mask (Eskimo), from southwest Alaska, 21; 12

mastabas, 26, 28

Master Honoré, 148; David and Goliath, from Prayer Book of Philip the Fair, 148, 150; 154

Master of Flémalle (Robert Campin?), 170-72, 176, 177, 184, 196, 237; Annunciation, from Merode Altarpiece, 170-72, 173, 176, 177, 196, 199; *165

Matisse, Henri, 349, 358-60, 365, 399; Harmony in Red (Red Room), 359-60, 367; *376; Joy of Life, 358-59; 375

Mausoleum, Halicarnassus, frieze sculpture from, 63; 59

Medici, Cosimo I de', 228

Medici, Giuliano de', 215; tomb of (Michelangelo), 215; 213

Medici, Lorenzo de' (the Magnificent), 201

Medici, Marie de', 260; painting of (Rubens), 260–61; 263

Medici Chapel, San Lorenzo, Florence (Michelangelo), 215, 234; tomb from,

Medici family, 194, 201, 209, 215

Méditerranée (Seated Woman) (Maillol), 355; 372

Melchizedek and Abraham, sculpture from Reims Cathedral, 143, 148; 146 Merode Altarpiece (Master of Flémalle), 170, 176; Annunciation from,

170-72, 173, 176, 177, 196, 199; *165Mesopotamian art, 32-39; Assyrian, 37-38, 39, 51; Babylonian, 35-37, 39; Neo-Babylonian, 38-39; Sumeri-

an, 32-35, 38 Metafisyx (Corps de Dame) (Dubuffet),

387; 410 Meuse Valley, 125; Romanesque sculpture from, 125-26; 125, 126

Mexico, 1934 (Cartier-Bresson), 435;

Michelangelo Buonarroti, 9, 66, 207, 211-15, 217, 218, 219, 220, 223, 224, 228, 231, 233, 235, 253, 317, 341, 401; Creation of Adam, 214, 251, 431; 211; David, 212, 256; 209; Day, 215; 213; Last Judgment, 214, 215; 210, 212; Medici Chapel, San Lorenzo, Florence, 215, 234; 213; Night, 215; 213; St. Peter's, Rome, 218, 255; 217; Sistine Chapel, The Vatican, frescoes for, 212-14, 215, 219-20, 253, 260; *210–12*; Tomb of Giuliano de' Medici, 215; 213

Michelozzo, 194; Palazzo Medici-Riccardi, Florence, 194-95; 192

Mies van der Rohe, Ludwig, 420, 421; Seagram Building, New York City, 420; 454

Migrant Mother, California (Lange), 441; 477

Milan, Italy, 186, 188, 209, 217, 249 Millet, François, 322; Sower, 322; 330 Minimalism, 409

Minoan art, 40, 42-44

Miraculous Draught of Fishes (Witz), 183-84; 178

Miró, Joan, 382-83, 384, 408; Painting, 382-83, 384; *404

Mnesicles: Propylaea, Acropolis, 54, 56, 304; 50

Model for Equestrian Statue of Louis XIV (Bernini), 281; 287

Model for Equestrian Statue of Louis XIV (Girardon), 281; 288

Modernism, 357, 373-74, 401

Moissac, France: St.-Pierre, 124-25, 140; 123

Mona Lisa (Leonardo da Vinci), 209, 211, 223; *207

monasteries: Carolingian, 107-108, 110, 113, 117-18; 105; Celtic (Irish), 104, 106

Monastery Church, Daphnē, Greece, mosaic from, 100: 98

Mondrian, Piet, 375–76, 390, 392, 393,418; Composition with Red, Blue,and Yellow, 375–76, 390; *396

Mondrian (Rothenberg), 402; 426 Monet, Claude, 332, 335–36, 340; River, 332, 336, 337, 340, 346; *341; Water Lilies, Giverny, 336; 347

Monticello, Charlottesville, Virginia (Jefferson), 303; garden façade, 305 Mont Sainte-Victoire Seen from Bibemus Quarry (Cézanne), 343, 367; 357 Monument to the Third International (Tatlin), 406; model for, 434

Moore, Henry, 403; Recumbent Figure,
 403; 429; Two Forms, 403, 438; 428
 Moreau, Gustave, 348–49, 350; Apparition (Dance of Salome), 348–50;
 363

Morisot, Berthe, 333–34, 340; Artist's Sister Edma and Their Mother, 333– 34: 343

Morning Bell (Homer), 337, 338; *350 Moses Well (Sluter), 144, 156, 177, 187; 149

Mother and Child (Picasso), 369; 389 motion photography, 432

Moulin de la Galette (Renoir), 334; *344

Mounted Officer of the Imperial Guard (Géricault), 319; 326

Mrs. Siddons (Gainsborough), 291, 292; 301

Mrs. Siddons as the Tragic Muse (Reynolds), 291–92; 302

Munch, Edvard, 352, 402; Scream, 352;

Muybridge, Eadweard, 432; Female Semi-nude in Motion, 432; 468

Mycenaean art, 44–45, 53, 59 Mycerinus and His Queen, 25, 57, 58;

Mystery and Melancholy of a Street (De Chirico), 377; 397

Nabis, 348; see also Symbolism Nadar (Gaspard Félix Tournachon), 425–26; Sarah Bernhardt, 426; 460 Napoleon, 316, 317, 318, 319, 427; por-

Napoleon, 316, 317, 318, 319, 427; portrait of (Gros), 318–19; 325; statue of (Canova), 312

Napoleon at Arcole (Gros), 318–19; 325 Narmer (king of Egypt), 24; palette of, 24–25, 30; 15

Nativity (Geertgen tot Sint Jans), 180, 232, 275; 175

Nativity (Pisano, N.), from pulpit, Baptistery, Pisa, 145, 147, 150; 150

Nativity, from Portinari Altarpiece (Van Der Goes), 180; 174

naturalism: Baroque, 250; Romantic, 322; see also Realism

Naumburg Cathedral, relief sculpture on choir screen from, 143; 147

Navaho sand painting ritual, Arizona, 21; *13*

Nazism, 362, 438, 442

Nebuchadnezzar (king of Babylon), 38,

Neo-Babylonian art, 38–39

Neo-Baroque style: in France, 310–11, 313–14, 318–19, 321, 328; in Spain, 315–17

Neoclassicism, 292, 303–308, 309, 312; in America, 303, 306–308; architecture, 303–304; in England, 303; in France, 303, 304–306, 308; in Germany, 304, 326; painting, 304–308, 326; sculpture, 308, 412; see also Classical revival style

Neo-Expressionism, 401–402

Neo-Impressionism, 344

Neo-Plasticism, 375; see also *Stijl*, *De* Neo-Platonism, 201–202, 211, 212

Neo-Poussinism, 304, 306 Neue Staatsgalerie, Stuttgart (Stir-

ling), 422; 458 Neumann, Balthasar, 282; Kaisersaal, Episcopal Palace, Würzburg, 282, 284; *290

Nevelson, Louise, 412; Black Chord, 412; 442

New Guinea: sculpture from, 18; 9 New Objectivity movement, 438–39 New Shoes for H (Eddy), 397, 399; *421; photograph for, 422

New Stone Age, 17–18, 24

New York City: Seagram Building (Mies van der Rohe and Johnson), 420; 454

Nicholas of Verdun, 128, 130, 147–48; *Klosterneuburg Altar*, 128–30; 130 Niépce, Joseph Nicéphore, 424, 425;

Niepce, Joseph Nicephore, 424, 425; View from His Window at Le Gras, 424; 459

Nike of Samothrace, 66, 96, 405; 63 Nineveh, Mesopotamia, 38; relief sculpture from, 31

Nocturne in Black and Gold: The Falling Rocket (Whistler), 336–37; 349 Nofretete (queen of Egypt), 30; portrait sculpture of, 30; *23

Nolde, Emil, 361; Last Supper, 361;

nonobjective painting, 362–64; see also Abstraction

Normandy (Normans), 88, 111; Romanesque architecture in, 120, 133, 134

Northern Renaissance art, 237–49 Notre-Dame, Paris, 132–35, 139, 140; 131–34

Notre-Dame-du-Haut, Ronchamp (Le Corbusier), 420–21; 455, 456

Notre.- Dame - la - Grande, France, 119–20, 134; 117

 $\begin{array}{c} Odalisk \, ({\rm Rauschenberg}), 415, 416; 445 \\ Odalisque \, ({\rm Ingres}), \, 313, \, 317{-}18, \, 319; \\ *323 \end{array}$

Odo of Metz, 107; Palace Chapel of Charlemagne, Aachen, 107; 104 Odyssey Landscapes, 79; panel from, *81

Offerings of Gratitude (Gauguin), 348, 358; 362

O'Keeffe, Georgia, 364; *Dark Abstraction*, 364, 435, 437; 383

Old Clown (Rouault), 360–61; 377 Oldenburg, Claes, 413–14; Giant Ice Bag, 413–14; 444 Old Guitarist (Picasso), 352; 370 Old Man and His Grandson (Ghirlandaio), 203; 201

Old Stone Age, 14-17, 18

One and Three Chairs (Kosuth), 400–401; 425

1 Copper Plate 1 Zinc Plate 1 Rubber Cloth 2 Calipers 1 Drainpipe Telescope 1 Piping Man (Ernst), 381; 402 One (Number 31, 1950) (Pollock), 384,

Op Art, 393, 395, 445

385; 407

Opéra, Paris (Garnier), 310–11, 313, 422; 315; sculpture for (Carpeaux), 313–14: 315

Orgy, from The Rake's Progress (Hogarth), 290, 304; 299

Orozco, José Clemente, 365; Victims, 365; 384

Or San Michele, Florence, niche sculpture for (Donatello), 187; 182

Orthodox Church, 88, 97, 102–103 Orvieto Cathedral (Maitani and others), 139–40, 195; 141

Oseberg Ship-Burial, Animal Head from, 104; 101

Otto I (Holy Roman emperor), 111, 117 Otto II (Holy Roman emperor), 112 Otto III (Holy Roman emperor), 112 Ottonian art, 111–15

Padua, 203; Eremitani Church, frescoes for (Mantegna), 203–205; 202 Paestum, Italy: "Basilica," 53–54; 48;

Temple of Poseidon, 53–54; 48 Painting (Miró), 382–83, 384; *404 Palace at 4 A.M. (Giacometti), 407–408;

Palace Chapel of Charlemagne, Aachen (Odo of Metz), 107; 104

Palace of Diocletian, Split, Yugoslavia, 73; 73

Palace of Minos, Knossos, Crete, 42–43; frescoes from, 43–44; 36, *37; Queen's Chamber, 43; 36

Palace of Versailles, 274, 280, 281, 284; Garden Front (Le Vau and Hardouin-Mansart), 280; 286; Hall of Mirrors, 280; park for (Le Nôtre), 280–81; 286; Salon de la Guerre (Hardouin-Mansart, Lebrun, and Coysevox), 280; 285; Salon de la Paix, 280

Palazzo Barberini, Rome, ceiling fresco for (Da Cortona), 255; *255

Palazzo Carignano, Turin (Guarini), 259; 261

Palazzo Farnese, Rome, ceiling fresco for (Carracci), 253, 255, 260; 254

Palazzo Medici-Riccardi, Florence (Michelozzo), 192, 194–95; 192

Palazzo Vecchio, Florence, 140, 193, 195, 212, 234; 142

Palette of King Narmer, 24–25, 30, 35; 15

Palladio, Andrea, 235–36, 289; Villa Rotonda, Vicenza, 236; 237

Pannini, G. P.: Interior of the Pantheon, 72; 71

Pantheon, Rome, 71–72, 90, 96, 98, 123, 192, 217, 218, 282; 70, 71

Panthéon (Ste.-Geneviève), Paris (Soufflot), 303; 304

Panthéon Nadar (Nadar), 425–26 Papigno (Corot), 327, 332, 337; 336

Paris, 131, 156, 274; Bibliothèque Ste.-Geneviève (Labrouste), 311–12; 316; Hôtel de Soubise, Salon de la Princesse (Boffrand), 284-85; 292; Louvre: 249, 278-79, 281; designs for (Bernini), 278-79, 281; East front (Perrault), 279, 280, 290, 311; 284; sculpture for (Goujon), 249; Square Court of (Lescot), 249, 278; 250; Luxembourg Palace, paintings for (Rubens), 260; 263; Notre-Dame, 132-35, 139, 140; 131-34; Opéra (Garnier): 310-11, 313, 422; 315; sculpture for (Carpeaux), 313-14; 315; Panthéon (Ste.-Geneviève) (Soufflot), 303; 304; Pompidou National Arts and Cultural Center (Piano and Rogers), 421, 422; 457; St.-Denis, Abbey Church of, 132, 133, 134, 135, 137, 140, 147

Park near Lu(cerne) (Klee), 378, 380; *400

Parma Cathedral, dome frescoes for (Correggio), 231; 231

Parmigianino (Francesco Mazzola), 224–25, 228; *Madonna with the Long Neck*, 225, 228, 231, 318; *227; *Self-Portrait*, 224–25; 225

Parthenon, Acropolis, Athens (Ictinus and Callicrates), 54, 61; 49; pediment sculpture from (Phidias), 63, 76; 58

Parting of Lot and Abraham, mosaic from Santa Maria Maggiore, Rome, 92, 93, 114, 145; 88

92, 93, 114, 145; 88

Pastoral (Claude Lorrain), 278, 327;

Pastry Cook, Cologne (Sander), 438–39; 475

Pauline Borghese as Venus (Canova), 313; 317

Peasant Family (Le Nain), 275, 322;

Peloponnesian War, 46, 63

Pepper (Weston), 437; 473

Perpendicular Gothic style, 138, 289–90

Perrault, Claude, 279; Louvre, Paris, East front, 279, 280, 290, 311; 284 Persepolis, Iran; Audience Hall of Darius, 40; 34

Persian art, 39-40

Persistence of Memory (Dali), 381; 403 perspective: atmospheric, 173; linear, 173; scientific, 189–90, 193, 196, 199–200, 206, 209, 330; worm's eye, 203–204

Perugino, Pietro, 206, 220; Delivery of the Keys, 206; 204

Petrarch, 168-69

Pfaff, Judy, 416; *Dragons*, 416; *448* Phidias, 355; *Three Goddesses*, 63, 355; *58*

Philippus the Arab, 75, 188, 191; 77 photograms, 441, 442

photography, 318, 330–32, 424–45; nineteenth-century, 424–32; twentieth-century, 432–45; see also Photo Realism

photojournalism, 427, 432, 435, 437, 439

photomontage, 441-42

Photo Realism, 397, 399, 445

Photo-Secession, 430-31, 432, 435

Piano, Renzo: Pompidou National Arts and Cultural Center, Paris, 421, 422; 457

Picasso, Pablo, 352, 354, 365–67, 369, 371, 373, 375, 383, 408, 434; Ambroise Vollard, 367, 444; 386; Blue Period of, 352, 356, 365; Bull's Head, 8, 407; 2; Demoiselles d'Avignon, 365–67, 371; 385; Mother and Child, 369; 389; Old Guitarist, 352; 370; Three Dancers, 371, 382, 408; *390; Three Musicians, 369; 388

Piero della Francesca, 199–100, 206, 220, 244, 344; Discovery and Proving of the True Cross, 166–67, 199, 200, 344: *197

Piero di Cosimo, 202–203; Discovery of Honey, 202–203; *200

Pietà, from Bonn, 143-44, 177, 238;

Pilgrimage to Cythera (Watteau), 285, 288: *293

Pisa, Italy, 117; Baptistery, 122, 195; 120; sculpture for (Pisano, N.), 145; 150; Campanile, 122; 120; Cathedral, 122, 139, 140; 120; Leaning Tower, 122, 139; 120

Pisano, Giovanni, 145; *Madonna*, 145, 150: 151

Pisano, Nicola, 145; Nativity, from pulpit, Baptistery, Pisa, 145, 147, 150; 150

Plato, 186, 202, 219, 278, 361 Pliny, 66, 81, 252

Plowing in the Nivernais (Bonheur), 322; 331

Poe, Edgar Allan, 350 Pointillism, 344

Poissy-sur-Seine, France: Savoye House (Le Corbusier), 376, 419, 421; 453

Poitiers, France: Notre-Dame-la-Grande, 119–20, 134; 117

Polar Sea (Friedrich), 325–26; *334 pole top ornament, from Luristan, 39; 33

Polish Rider (Rembrandt), 268–69, 270; *274

Pollaiuolo, Antonio del, 192, 193; *Hercules and Antaeus*, 192, 193, 234; 189

Pollock, Jackson, 384–85, 395, 416; One (Number 31, 1950), 384, 385;

Pompeii: House of the Vettii, Ixion Room, wall paintings from, 79, 100, 114, 145; 82; mosaic from, 51, 92, 128; 45; Villa of the Mysteries, wall paintings from, 79, 81; 83

Pompidou National Arts and Cultural Center, Paris (Piano and Rogers), 421, 422; 457

Pontormo (Jacopo Carucci da Pontormo), 224, 233; Study of a Young Girl. 224: 224

Pool, Versailles (Atget), 433–34; 469 Pop Art, 393, 395–97, 400, 409; sculpture, 414–15

Popova, Liubov, 373–74; *Traveler*, 373–74, 444–45; 394

Portinari Altarpiece (Van Der Goes), 179–80, 203; 174

Portrait Head, from Delos, 64, 66; 61 Portrait of a Boy, from Faiyum, Egypt, 81; *84

Portrait of a Roman, 73–74, 75, 191; 74 Portrait of Charles I Hunting (Van Dyck), 261–62, 290; 266

portraits (painting and sculpture): Baroque, 261–62; Egyptian, 25–26; Greek, 64; Late Gothic, 176–77; Neoclassical, 308; photography and, 425–26, 430; Renaissance, 192, 223; Rococo, 288, 290–92; Roman, 73–76 Poseidon (Zeus?), 62–63; 57

Post-Impressionism, 335, 342–54, 365, 371; sculpture, 354–56

Post-Modern architecture, 421–22 Poussin, Nicolas, 253, 275–76, 278, 280, 285, 304, 306, 318, 324, 327; Landscape with the Burial of Phocion, 276; 282; Rape of the Sabine Women, 275, 304; 281

Prairie Houses (Wright), 417–18, 419; 450, 451

Prato, Italy: Santa Maria delle Carceri (Sangallo), 196; 194

Praxiteles, 355; *Hermes*, 63–64, 355; 60

Prayer Book of Philip the Fair (Master Honoré), 148, 150; 154

Pre-Raphaelite Brotherhood, 350, 430 Presentation in the Temple (Broederlam), 156, 161, 170; *161

Primary Structures, 409, 411, 413; see also Environmental Sculpture

Primevalism, 403, 404 primitive art, 18–21; influence on modern art, 366, 378

Prince Rahotep and His Wife Nofret, 25–26, 68; *14

Princesse de Polignac (Vigée-Lebrun), 288-89, 292; 297

printing, development of, 184; see also graphic art

Prophet (Zuccone) (Donatello), 187–88, 196, 199; 183

Propylaea, Acropolis, Athens (Mnesicles), 54, 56, 304; 50

Protestant religion, 250, 264; see also Reformation

Proto-Baroque painting, 231

Proverbios, Los (Goya), 316–17; etching from, 322

Psiax, 47, 49–50; Hercules Strangling the Nemean Lion, 47–49, 50, 51; 41, *42

Pugin, A. Welby: Houses of Parliament, London, 310; 314

purse cover, from Sutton Hoo Ship-Burial, 103, 104, 106; 100

Putto with Dolphin (Verrocchio), 193; 190

pyramids, Egyptian, 26–28; see also ziggurats

Pyramids of Mycerinus, Chefren, and Cheops, Giza, Egypt, 26, 27, 28; 19

Queen (Flack), 300–301, 399; *423 Queen Nofretete, 30; *23 Queen's Chamber, Palace of Minos, Knossos, Crete, 43; 36 Raimondi, Marcantonio: Judgment of Paris, engraving after Raphael, 330; 339

Raising of the Cross (Rubens), 260, 268, 319; 262

Rake's Progress (Hogarth), 290, 304, 429–30; The Orgy from, 299

Ramesses III (king of Egypt), 28 Rape of the Sabine Woman (Bologna), 234–35, 275; 236

Rape of the Sabine Women (Poussin), 275, 304; 281

Raphael (Raffaello Sanzio), 206, 207, 218–20, 223, 224, 225, 228, 231, 253, 275, 278; Galatea, 220, 222, 223, 253, 275; 219; School of Athens, 219–20, 225, 275; *218; Stanza della Segnatura, The Vatican, Rome, frescoes for, 219–20, 253; *218

Rauschenberg, Robert, 415; Odalisk, 415, 416; 445

Ravenna, Italy, Sant' Apollinare in Classe, 90, 92, 96, 97, 117, 119, 122, 139; 86, *87; San Vitale, 96–97, 107; 93, 94; mosaics from, 99, 100; 97

Ray, Man, 434, 435, 442; Rayograph, 442: 479

Rayograph (Ray), 442; 479

Ready-Mades (Duchamp), 381, 400, 407, 441

Realism, 328–29; photography and, 429; sixteenth-century Italian, 231– 33

Recumbent Figure (Moore), 403; 429 Red Blue Green (Kelly), 390; *415 Redon, Odilon, 350; Balloon Eye, 350; 366

Reformation, 168, 215, 237, 244, 245, 247

Reims Cathedral, sculpture from, 142–43, 144–45, 146, 147, 148; center portal, west façade, 145; interior, west wall, 146

Rejlander, Oscar, 429–30, 441; Two Paths of Life, 429–30; 464

Rembrandt van Rijn, 252, 267–70, 275, 292, 315, 322, 328, 361; Blinding of Samson, 268; 271; Christ Preaching, 269–70; 273; Polish Rider, 268–69, 270; *274; Self-Portrait, 267, 268; 272

Renaissance art, 168-69, 170, 186-223, 365; Early, in Italy: 186-206, 208; architecture, 170, 189, 193–96; painting, in Florence, 170, 196-99, 200-203; in Northern Italy, 203-206; in Rome, 206; sculpture, in Florence, 170, 186-93; High, in Italy: 207-23; architecture, 217-18; painting, 207-11, 212-15, 218-23; sculpture, 212, 215; Late, 207; Northern: 237-49; architecture, in France, 249; painting, in France, 245; in Germany, 237-45; in the Netherlands, 247-48; sculpture, in France, 249; see also Late Gothic art; Mannerism

Renaissance revival style, 310, 311–12 Renier of Huy, 126; baptismal font, from Liège, 125–26, 129; 125

Renoir, Auguste, 334; Moulin de la Galette, 334; *344 Resurrection (Della Robbia), 190; 187 Resurrection, from Isenheim Altarpiece (Grünewald), 239–40; *239 Return of the Hunters (Bruegel), 248,

Reynolds, Joshua, 291–92, 306; Mrs. Siddons as the Tragic Muse, 291–92; 302

261; 249

Riis, Jacob, 429; Bandits' Roost, 429, 435; 463

Ritual Branch (White), 442; 480 River (Monet), 332, 336, 337, 340, 346; *341

Road to Cavalry (Martini), 153; *157 Robbia, Luca della, 190; Resurrection, 190: 187

Robert Andrews and His Wife (Gainsborough), 290–91, 322–23; *300

Robie House, Chicago (Wright), 376, 417–18; 450, 451

Robinson, William: Strawberry Hill, Twickenham, 309–10; 313

Rococo style, 282, 284–93, 313; in England: architecture, 289–90; painting, 290–93; in France: architecture, 282, 284–85; painting, 285, 288–89, 290

Rodin, Auguste, 340–41, 354, 356; Balzac, 341; 355; photograph of (Steichen), 431, 435; 467; Thinker, 340–41, 355, 431; 354

Rodin with His Sculptures "Victor Hugo" and "The Thinker" (Steichen), 431, 435; 467

Rogers, Richard: Pompidou National Arts and Cultural Center, Paris, 421, 422; 457

Roman art, 70–81; architecture, 70–73, 90, 96; Greek influence on, 70, 71, 73, 79, 81; literature, 107; mosaics, 51, 92; painting, 79, 81; sculpture, 73–79

Roman Empire, 70, 73, 74, 88; see also Eastern Roman Empire; Western Roman Empire

Romanesque art, 116–30; architecture: 116, 117–23, 126, 133–34; in England, 120–21; in France, 117–20; in Italy, 122–23; in Normandy, 120, 133, 134; painting, 126–30; sculpture: 123–26; in France, 123–25; in the Meuse Valley, 125–26; in Spain, 123

Romanticism, 271, 309–27, 348–49, 350, 357, 377; architecture: 309–12; in England, 309–10; in France, 310–12; painting: 314–27, 328; in America, 326–27; in England, 322–25; in France, 317–22, 327; in Germany, 325–26; in Spain, 314–17; photography and, 425, 426, 427, 430; sculpture: 312–14; in France, 313–14; in Italy, 312–13

Romanticism Is Ultimately Fatal (Leonard), 443: 481

Rome, 67, 89, 117, 123, 217, 250, 274; Basilica of Constantine, 72, 76, 98, 217, 218; 72; Catacomb of SS. Pietro e Marcellino, painted ceiling from, 89–90, 92, 94, 117; 85; Colosseum, 71, 119; 69; Palazzo Barberini, ceiling fresco for (Da Cortona), 255; *255; Palazzo Farnese, ceiling fresco for (Carracci), 253, 255, 260; 254; Pantheon, 71-72, 90, 96, 98, 123, 196, 217, 218, 282; 70, 71; San Carlo alle Quattro Fontane (Borromini), 257-59; 260; San Luigi dei Francesi, paintings for (Caravaggio), 250-52; *252; Santa Maria della Vittoria, Cornaro Chapel, sculpture for (Bernini), 256-57; 258; Santa Maria Maggiore, mosaic from, 92, 93, 114, 145; 88; St.-Maclou, 135; 136; St. Peter's: 415; bronze tombs for (Pollaiuolo), 192; colonnade (Bernini), 256, 257, 415; 256; dome (Michelangelo), 218, 255; 217; nave and façade (Maderno), 255-56, 282; 256; plan (Bramante), 217-18, 220, 255; 215, 216; Sistine Chapel, The Vatican: ceiling frescoes for (Michelangelo), 212-14, 219-20, 253, 260; 210, 211; wall frescoes for (Botticelli), 206; (Ghirlandaio), 206; (Michelangelo), 214, 215; 210, 212; (Perugino), 206, 253; 204; Stanza della Segnatura, The Vatican, frescoes for (Raphael), 219-20; *218; Tempietto, San Pietro in Montorio (Bramante), 217, 290;

Ronchamp, France: Notre-Dame-du-Haut (Le Corbusier), 420–21; 455, 456

Rossellino, Antonio, 191, 193; Giovanni Chellini, 191; 188

Rossetti, Dante Gabriel, 350; Ecce Ancilla Domini, 350, 430; 365

Rosso Fiorentino, 224, 233; *Descent* from the Cross, 224, 228; *226

Rothenberg, Susan, 402; Mondrian, 402; 426

Rothko, Mark, 388–89, 390; Earth and Green, 389; *411

Rouault, Georges, 349, 360–61; Old Clown, 360–61; 377

Rousseau, Henri, 354, 434; *Dream*, 354, 377; *371

Royal Academy, London, 291, 292, 306 Royal Academy of Painting and Sculpture, Paris, 278, 285, 349

Royal Photographic Society of Great Britain, 430

Rubens, Peter Paul, 259–61, 262, 264, 265, 266, 275, 285, 291; Garden of Love, 261, 285; *264; Landscape with the Château of Steen, 261; 265; Marie de' Medici, Queen of France, Landing in Marseilles, 260–61, 285; 263; Raising of the Cross, 260, 268, 319: 262

Ruckus Manhattan (Grooms), 415–16;

Rude, François, 313; Marseillaise, 313; 318

Ruisdael, Jacob van, 271, 291, 323; *Cemetery*, 271; 275 Ruskin, John, 337

Sacra Conversazione (sacred conversation) paintings, 198, 199; *196 Sacrifice of Isaac (Ghiberti), 145–47, 156, 189; 152

Saints include S., San, Sant', Santa, St., Ste.

Sant'Andrea, Mantua (Alberti), 195;

Sant' Apollinare in Classe, Ravenna, 90, 92, 96, 97, 117, 119, 122, 139; 86,

St. Bernard of Clairvaux, 124, 125 San Carlo alle Quattro Fontane, Rome (Borromini), 257–59; 260

St. Charles Borromaeus, Vienna (Fischer von Erlach), 282; 289

Santa Croce, Florence, 138-39, 194;

St.-Denis, Abbey Church of, near Paris, 132, 133, 134, 135, 137, 140, 147 St. Dorothy, woodcut, 184; 180

St.-Etienne, Caen (Normandy), France, 120, 134; 118

San Francesco, Arezzo, frescoes for (Piero della Francesca), 199, 200; *197

St. Francis in Ecstasy (Bellini), 205-206, 220-21; *203

St. Gall, Switzerland, plan for a monastery, from Chapter Library 107-108, 110, 113, 117-18; 105

Ste.-Geneviève, Paris, see Panthéon, Paris

St. George (Donatello), 187; 182

St. James Led to His Execution (Mantegna), 203-205, 208; 202

St. John the Evangelist, from Gospel Book of Abbot Wedricus, 128; *127

San Lorenzo, Florence (Brunelleschi), 193-94, 196, 218; 191; Medici Chapel in (Michelangelo), 215, 234; tomb from, 213

San Luigi dei Francesi, Rome, paintings for (Caravaggio), 250-52; *252

St.-Maclou, Rouen, France, 135; 136 Santa Maria della Vittoria, Rome, Cornaro Chapel, sculpture for (Bernini), 256-57; 258

Santa Maria delle Carceri, Prato (Sangallo), 196; 194

Santa Maria Maggiore, Rome, mosaic from, 92, 93, 114, 145; 88

Santa Maria Novella, Florence, fresco for (Masaccio), 196; *195

St. Mark, from Gospel Book of Archbishop Ebbo of Reims, 110-11, 112, 125; 108

St. Matthew (Savoldo), 231-32; 233 St. Matthew, from Gospel Book of Charlemagne, 110; 107

St. Michael's, Hildesheim, 112-14; 110, 111; doors of Bishop Bernward, 123, 126; 112

St. Paul's Cathedral, London (Wren), 290: 298

St. Peter's, Rome, 415; bronze tombs for (Pollaiuolo), 192; colonnade (Bernini), 256, 257, 415; 256; dome (Michelangelo), 218, 255; 217; nave and façade (Maderno), 255-56, 282; 256; plan (Bramante), 217-18, 220, 255; 215.216

St.-Pierre, Moissac, 124-25, 140; south portal (portion), 123

San Pietro in Montorio, Rome: Tempietto (Bramante), 217, 290; 214

St.-Savin-sur-Gartempe, France, wall painting from, 128; 129

St.-Sernin, Toulouse, France, 117-19, 120, 121, 122, 133; 114–16; relief sculpture from, 124; 122

San Vitale, Ravenna, 96-97, 107; 93, 94; mosaics from, 99, 100; 97

Salisbury Cathedral, England, 137-38; 137

Salome (Beardsley), 349-50, 352; 364 Salon de la Guerre, Palace of Versailles (Hardouin-Mansart, Lebrun, and Coysevox), 280; 285

Salon de la Princesse, Hôtel de Soubise, Paris (Boffrand), 284-85; 292 Saltcellar of Francis I (Cellini), 233-34, 249; 235

Samos, Greece: Temple of Hera, sculpture from, 58; 52

Sander, August, 438-39; Pastry Cook, Cologne, 438-39; 475

sand painting ritual (Navaho), Arizona, 21; 13

Sangallo, Giuliano da, 196; Santa Maria delle Carceri, Prato, 196; 194

Santa Fe, New Mexico (Frank), 443; 482

Sappho (Kauffmann), 292-93; 303 Saqqara, Egypt: Funerary District of King Zoser, 27; papyrus half-columns from North Palace, 27, 29, 53, 56; 18; Step Pyramid from, 26, 28, 34; 17

Sarah Bernhardt (Nadar), 426; 460 Sarcophagus of Junius Bassus, 94–95, 100, 111, 120; relief sculpture from,

Savoldo, Girolamo, 231-32; St. Matthew, 231-32; 233

Savoye House, Poissy-sur-Seine (Le Corbusier), 376, 419, 421; 453

Scenes of a Dionysiac Cult, wall painting from Villa of the Mysteries, Pompeii, 79, 81; 83

Schongauer, Martin, 185, 237, 241; Temptation of St. Anthony, 185, 241; 181

School of Athens (Raphael), 219-20, 225, 275; *218

Scopas(?), 63, 66; Greeks Battling Amazons, 63; 59

Scream (Munch), 352; *368

scriptoria (writing workshops), 106, 110, 128

 $Sculpture\ with\ Color\ (Oval\ Form), Pale$ Blue and Red (Hepworth), 403-404;

Seagram Building, New York City (Mies van der Rohe and Johnson), 420; 454

Seated Woman (Méditerranée) (Maillol), 355, 402; 372

Segal, George, 415; Cinema, 415; 446 Self-Portrait (Dürer), 241, 245, 346; 240

Self-Portrait (Kokoschka), 361–62;

Self-Portrait (Parmigianino), 224-25; 225

Self-Portrait (Rembrandt), 267, 268;

Self-Portrait (Van Gogh), 346, 361; 360 Seurat, Georges, 343-44, 345, 365, 401; Sunday Afternoon on the Grande Jatte, 343-44; *358

She-Wolf, 68, 74; 66

Sistine Chapel, The Vatican, Rome: ceiling frescoes for (Michelangelo), 212-14, 219-20, 253, 260; 210, 211; wall frescoes for: (Botticelli), 206: (Ghirlandaio), 206; (Michelangelo), 214, 215; 210, 212; (Perugino), 206, 253; 204

Sketch I for "Composition VII" (Kandinsky), 363, 384, 436; *382

Slave Ship (Turner), 324-25, 337; *333 Sluter, Claus, 144; Moses Well, 144, 156, 177, 187; 149

Smith, David, 411; Cubi series, 411;

Smithson, Robert, 410-11; Spiral Jetty, 410-11; 440

Soufflot, Jacques Germain, 303; Panthéon (Ste.-Geneviève), Paris, 303;

soundbox of a harp, from Ur, 35, 49, 103: 29

Southern French Master: Avignon Pietà. 184: 179

Soutine, Chaim, 361; Dead Fowl, 361; 378

Sower (Millet), 322; 330

Spiral Jetty (Smithson), 410-11; 440 Split, Yugoslavia: Palace of Diocletian, 73; 73

Spoils from the Temple in Jerusalem, relief sculpture from Arch of Titus, Rome, 79, 90, 189; 80

stained-glass, 147-48 Standing Youth (Kouros), 53, 57, 60-61; 51

Standing Youth (Lehmbruck), 355–56;

Standing Youth (The Kritios Boy), 61-62, 188, 355; 56

Stanza della Segnatura, The Vatican. Rome, frescoes for (Raphael), 219-20, 253; *218

Steel Structure (Goeritz), for The Echo, Mexico City, 409; 438

Steen, Jan, 271, 290; Eve of St. Nicholas, 271, 304; 277

Steerage (Stieglitz), 435; 471

Steichen, Edward, 431, 435; Rodin with His Sculptures "Victor Hugo" and "The Thinker," 431, 435; 467

Stella, Frank, 390, 392-93; Empress of India, 392-93; *416

Stella, Joseph, 371; Brooklyn Bridge, 371: 392

Step Pyramid, Funerary District of King Zoser, Saqqara, Egypt, 26, 28,

Stieglitz, Alfred, 364, 431, 435-36, 437; Equivalent, 435-36, 437, 442; 472; Steerage, 435; 471

Stijl, De, 375-76, 407 Still Life (Heda), 271; 276

still-life painting: Baroque, 271; Post-Impressionist, 343; Rococo, 285, 288; twentieth-century, 361

Stirling, James, 422; Neue Staatsgalerie, Stuttgart, 422; 458

Stoke-by-Nayland (Constable), 323;

Stone Breakers (Courbet), 328-29; 337

Stonehenge, Salisbury Plain, Wiltshire, England, 18, 403, 409; 7; Great Circle, 8

Story of Jacob and Esau (Ghiberti), from "Gates of Paradise," bronze doors for Baptistery, Florence, 189,

Strawberry Hill, Twickenham, England (Walpole, Robinson, and others), 309-10; 313

Study of a Young Girl (Pontormo), 224; 224

Stuttgart, West Germany: Neue Staatsgalerie (Stirling), 422; 458

Suger (abbot), 132, 133, 135, 141, 147; see also St.-Denis, Abbey Church of Sullivan, Louis, 417, 419; Carson Pirie Scott & Company Department Store, Chicago, 417; 449

Sumerian art, 32-35, 38

Sunday Afternoon on the Grande Jatte (Seurat), 343-44; *358

Suprematism, 374-75, 406

Surrealism, 350, 381-83, 384; photography and, 434, 435, 442; sculpture, 407 - 408

Sutton Hoo Ship-Burial, purse cover from, 103, 104, 106; 100 Symbolism, 346-50, 355, 364

Talbot, William Henry Fox, 425 Tanner, Henry O., 338; Banjo Lesson, 338; 352

Tatlin, Vladimir, 375, 405, 406; Monument to the Third International, 406;

Tell Asmar, Mesopotamia: statues from Abu Temple at, 34-35, 37, 57; 27 tempera painting, 172

Tempest (Giorgione), 220-22, 223, 261;

Tempietto, San Pietro in Montorio, Rome (Bramante), 217, 290; 214

Temple at Aegina, Greece, pediment sculpture from, 60, 66; 55

Temple of Amun-Mut-Khonsu, Luxor, 29, 40, 438; 21

Temple of Athena Nike, Acropolis, Athens, 56; 50

Temple of Hera, Samos, Greece, 58; sculpture from, 52

Temple of Poseidon, Paestum, Italy, 53-54; 48

Temptation of St. Anthony (Schongauer), 185, 241; 181

Terry, Ellen, 430; photograph of (Cameron), 430; 465

Thinker (Rodin), 340-41, 355, 431; 354 $Third ext{-}Class\,Carriage\,(Daumier),\,321-$ 22, 333; 329

Third of May, 1808 (Goya), 316, 317, 427; *321

Three Dancers (Picasso), 371, 382, 408; *390

Three Flags (Johns), 396; *419

Three Goddesses (Phidias?), pediment sculpture from the Parthenon, Athens, 63, 355; 58

Three Musicians (Picasso), 369; 388 Tiepolo, Giovanni Battista, 284, 285, 315; Kaisersaal, Episcopal Church, Würzburg, ceiling fresco for, 284, 285; 291

Tintoretto (Jacopo Robusti), 228, 232; Last Supper, 228, 229, 232; 229

Titian (Tiziano Vecellio), 207, 222-23, 228, 229, 231, 253, 261, 262; Bacchanal, 222-23, 231, 358; *221; Christ Crowned with Thorns, 223; 223; Man with the Glove, 223, 268; 222

Titus (Roman emperor), 79; Arch of, Rome, 79; 80

Tomb of Giuliano de' Medici, Medici Chapel, San Lorenzo, Florence (Mi-

chelangelo), 215, 234; 213 "Toreador Fresco," from the Palace of Minos, Knossos, 43-44; *37

Totem and Taboo (Ernst), 382; 405 Toulouse, France: St.-Sernin, 117-19, 120, 121, 122, 133; 114-16; relief sculpture from, 124; 122

Toulouse-Lautrec, Henri de, 351, 352; At the Moulin Rouge, 351; *367 Tournachon, Gaspard Félix, see Nadar Tower of Babel, Babylon, 33, 38 Trafalgar Square (Mondrian), 376 Trajan, 74, 191; 75

Traveler (Popova), 373-74, 444-45;

Treasury of Atreus, Mycenae, 45; 38 Tsar Cannon Outside the Spassky Gate, Moscow (stereophotograph), 427; 461

Tub (Degas), 335, 340; 346

Turin, Italy, 259; Palazzo Carignano (Guarini), 259; 261

Turner, Joseph Mallord William, 323-25, 336; Slave Ship, 324-25, 337; *333

Tutankhamen (king of Egypt), 30; coffin cover of, 30; *24

Twickenham, England: Strawberry Hill (Walpole, Robinson, and others), 309-10; 313

Twittering Machine (Klee), 378, 380; 399

Two Dancers, from Tomb of the Lionesses, Tarquinia, 12-13, 68; *67 Two Forms (Moore), 403, 438; 428

Two Paths of Life (Rejlander), 429-30;

Unique Forms of Continuity in Space (Boccioni), 405; 432

Untitled (Clemente), 402; *424 Ur, Mesopotamia: Sumerian tombs from, 32, 35; sculpture from, 35; *28,

Urban II (pope), 117 Urban VIII (pope), 255 urban development, 117, 132, 148 Uruk (now Warka), Mesopotamia: 'White Temple" on its ziggurat, 33-34; 25, 26

Van der Goes, see Goes, Hugo van der Van der Weyden, see Weyden, Rogier van der

Van Dyck, see Dyck, Anthony van Van Eyck, see Eyck, Hubert van; Jan

Van Gogh, see Gogh, Vincent van

Vasarely, Victor, 393, 395; Vega, 393, 395; 417

Vasari, Giorgio, 225

vase painting, Greek, 46-51, 57 Vatican, Rome, see Rome

Vatican Vergil, illuminated manuscript, 93; 89

Vega (Vasarely), 393, 395; 417 Velázquez, Diego, 262, 315, 330, 338;

Maids of Honor, 262, 315, 316; 267 Veneziano, Domenico, 196, 198-99, 220; Madonna and Child with Saints, 198-99; *196

Venice, Italy, 117, 203, 205, 220, 228 Venus of Willendorf, 17, 41; 6

Vermeer, Jan, 267, 271-73, 275, 285; Letter, 271-72; 278

Veronese, Paolo, 232-33, 234, 284; Christ in the House of Levi, 232–33, 311; 234

Verrocchio, Andrea del, 192-93, 206, 207; Putto with Dolphin, 193; 190

Versailles, Palace of, 274, 280, 281, 284; Garden Front (Le Vau and Hardouin-Mansart), 280; 286; Hall of Mirrors, 280; park for (Le Nôtre), 280-81; 286; Salon de la Guerre (Hardouin-Mansart, Lebrun, and Coysevox), 280; 285; Salon de la Paix. 280

Very Rich Book of Hours of the Duke of Berry (Limbourg Brothers), 156, 160–61, 248; *162, *163

Vicenza, Italy: Villa Rotonda (Palladio), 236; 237

Victims (Orozco), 365; 384

Vienna, Austria: St. Charles Borromaeus (Fischer von Erlach), 282;

Vienna Genesis, 93-94; 90

Vienna Secession, 352

View from His Window at Le Gras (Niépce), 424; 459

Vigée-Lebrun, Marie Louise Elizabeth, 288-89, 292; Princesse de Polignac, 288-89; 297

Vikings, 111 Village Bride (Greuze), 304; 307

Villa of the Mysteries, Pompeii, wall paintings from, 79, 81; 83

Villa Rotonda, Vicenza (Palladio), 236; 237

Virgin and Child with Angels, from Isenheim Altarpiece (Grünewald), 239-40; *239

Visitation, sculpture from Reims Cathedral, 142, 144-45, 147; 145

Vitruvius, 72

Voltaire (François Marie Arouet), 303 Voltaire (Houdon), 308; 312

Walpole, Horace, 309; Strawberry Hill, Twickenham, 309-10; 313

Water Lilies, Giverny (Monet), 336; 347 Watson and the Shark (Copley), 306-308; *311

Watteau, Antoine, 285, 290, 291; Pilgrimage to Cythera, 285, 288; *293

Wedding Portrait (Van Eyck, J.), 177, 225; *171, 172

Wedricus (abbot), 128

West, Benjamin, 306; Death of General Wolfe, 306, 307, 319, 427; *310

Western Roman Empire, 88, 89, 96, 102, 103, 111

Weston, Edward, 437; Pepper, 437; 473 Weyden, Rogier van der, 177, 184, 185; Descent from the Cross, 177, 306; *173

Wheat Field and Cypress Trees (Van Gogh), 345–46; *359

Whistler, James Abbott McNeill, 336–37, 363, 430; Arrangement in Black and Gray: The Artist's Mother, 336; 348; Nocturne in Black and Gold: The Falling Rocket, 336–37; 349

White, Minor, 442; *Ritual Branch*, 442; 480

"White Temple" on its ziggurat, Uruk, Mesopotamia, 33–34; 25, 26

Williams, William T., 390; Batman, 390; *414

William the Conqueror (king of Eng-

land), 111, 120, 128

Wiltshire, England: Stonehenge, Salisbury Plain, 18, 403, 409; 7, 8 Winckelmann, Johann, 292, 303, 308

Witz, Conrad, 183–84; Miraculous Draught of Fishes, 183–84; 178

Woman II (De Kooning), 385, 387; *409 Women Regents of the Old People's Home at Haarlem (Hals), 267; 269

woodcuts, 270; Late Gothic, 184, 185; Northern Renaissance, 240, 241; Post-Impressionist, 348

World War I, 362, 364, 371, 380, 381, 406

World War II, 362, 383

Wounded Bison, Cave of Altamira, Spain, 14; 5

Wren, Christopher, 290; St. Paul's Cathedral, London, 290; 298

Wright, Frank Lloyd, 417–18, 419; Robie House, Chicago, 376, 417–18; 450, 451

Würzburg, Germany: Episcopal Palace, Kaisersaal (Neumann), 282, 284; *290; ceiling fresco for (Tiepolo), 284, 285; 291

X, The (Bladen), 410; 439 Xerxes (king of Persia), 40

Yellow Christ (Gauguin), 346, 358; *361

Youth and Demon of Death, cinerary container, 69; 68

"Zenobia di Radamisto, La," stage design for (Burnacini), 257, 280; engraving of, 259

Zeus (Poseidon?), 62-63; 57

ziggurats, 33–34; 25, 26

Zoroaster, 40

Zoser (king of Egypt), 26, 28; Funerary District of, Saqqara, 26–27, 28, 29, 34, 53, 56; 17, 18

List of Credits

The authors and publisher wish to thank the libraries, museums, and private collectors for permitting the reproduction in black-and-white and in color of paintings, prints, and drawings in their collections. Photographs have been supplied by the owners or custodians of the works of art except for the following, whose courtesy is gratefully acknowledged:

Alinari (including Anderson and Brogi), Florence: 45, 62, 76, 79, 80, 82, 87, 88, 121, 140-42, 150-52, 158, 159, 182-92,194, 201, 202, 205, 206, 209–13, 217, 219, 228–29, 231, 234, 236, 258, 260, 317; American Museum of Natural History: 13; Amman, Thomas, Zurich: 424; Andrews, Wayne, Grosse Pointe, Mich.: 305; Copyright Archives Centrales Iconographiques, Brussels: 125, 167-69, 262; Art Institute of Chicago: 352, 367, 467, 471-72; Copyright The Barnes Foundation, Merion, Pa.: 375; Bildarchiv Oesterr, Nationalbibliothek, Vienna: 86; Boesch, Ferdinand, New York: 442; Borsig, Arnold von, Berlin: 139; Brassaï, Paris: 2; Bruckmann, F., Munich: 225; Bulloz, Paris: 124, 251, 318; Burckhardt, Rudolph, New York: 332, 337, 412, 420; Caisse Nationale des Monuments Historiques, Paris: 4, 30, 123, 149, 153, 222, 245, 270, 282, 285, 292, 307, 319, 344, 346; Leo Castelli Gallery, New York: 416; Commissione Pontificale d'Archaeologia Sacra, Rome: 85; Copyright Cosmopress, Geneva: 400; Copyright Country Life, London: 313; Courtauld Institute of Art, London: 297; Detroit Institute of Arts, Copyright © 1984, Founders Society: 253; Deutsche Fotothek, Dresden: 337; Deutscher Kunstverlag, Munich: 104, 306; Devinoy, Pierre, Paris: 129; Dingjan, A., The Hague: 269; Documentation Photographiques de la Réunion des Musées Nationaux: 331; Dolinski, A. E., San Gabriel, Calif.: 394; Elkind, Roy M., Jackson Heights, N.Y.: 426; André Emmerich Gallery, New York: 483; Fleming, R. B. and Co., Ltd., London: 347; Fotocielo, Rome: 59, 256; Fototeca Unione, Rome: 68-70; Franz, Alison, Athens: 39, 49-50; Gabinetto Fotografico Nationale, Rome: 214, 254, 257, 287; German Archaeological Institute, Rome: 25, 94; Giraudon, Paris: 117, 129, 246, 284, 312, 315, 324-26, 338, 345, 348; Gorgoni, Gianfranco, New York: 440; Photo-Verlag Gundermann, Würzburg: 291; Hahn, E., Berlin: 10; Hervé, Lucien, Paris: 452-54; Hirmer Fotoarchiv, Munich: 17-21, 23, 36, 38, 44, 52, 55, 57, 60, 63, 64, 78, 90, 96; Hürlimann, Martin, from France: 353; Hursley, Timothy, Little Rock, Ark.: 458; Istituto Centrale del Restauro, Rome: 156; Kersting, A. F., London: 119, 138, 304; Kidder-Smith, G. E., New York: 48, 72, 93, 95, 120, 133; Kühn, H., Mainz: 5; Levy, Et., and Neurdein Réunis, Paris: 136; Copyright London County Council: 272; Magnum, Paris: 470; Magnum Pictures, Inc.: 476; Foto-Marburg, Marburg/Lahn: 109, 143, 144, 146, 147, 316; Marlborough Gallery, New York: 441; A. and R. Mas, Barcelona: 267, 320; McKenna, Rollie, New York: 193, 237; Louis K. Meisel Gallery, New York: 423; Robert Miller Gallery, New York: 408; Ministry of Works, London, Crown Copyright: 7; National Monuments Record, London: 298, 314; Nelson, Otto, New York: 414; Nickel, Richard, Park Ridge, Ill.: 449; Oldenburg, Claes, Copyright, courtesy Gemini Gel, Los Angeles: 444; Oriental Institute, University of Chicago: 27, 34; Pace/MacGill Gallery, New York: 482; Plaut, Richard L., Jr., New York: 447; Powell, Josephine, Rome: 98; Rabin, Nathan, New York: 405; Rheinisches Bildarchiv, Cologne: 148; Roubier, Jean, Paris: 116, 118, 132, 145, 147; St. Joseph, Dr. J. K.: 8; Salas, Armando, Portugal: 438; Scala, Florence: 197; Schmidt-Glassner, Helga, Stuttgart: 289; Smith, Edwin, London: 31, 137; Holly Solomon Gallery, New York: 448; Sunami, S., New York: 9, 397-99, 407, 431, 435; Vizzavona, Paris: 263, 355; Ward, Clarence, Oberlin, Ohio: 131, 134; Wehmeyer, Hermann, Hildesheim: 110, 112; Weill, Etienne Bertrand, Paris: 457; Yan Photo Reportage, Toulouse: 115, 122; Yugoslav State Tourist Office, New York: 73

MEDIA CENTER RAYMOND MIDDLE SCHOOL